Mainstreams
of Modern Art

reproduced on the cover

Claude Monet. *Terrace at Sainte-Adresse,* detail.
1866. Oil on canvas, entire work 23½ × 31½''
(60 × 80 cm). Metropolitan Museum of Art,
New York (purchased with special contribu-
tions and purchase funds given or bequeathed
by friends of the Museum, 1967).
(See Plate 15, page 220.)

Mainstreams of Modern Art

Second Edition

John Canaday

Holt, Rinehart and Winston
New York Chicago San Francisco Philadelphia
Montreal Toronto London Sydney
Tokyo Mexico City Rio de Janeiro Madrid

Photographic Sources (References are to figure numbers unless indicated Pl. [plate].) Alinari/Editorial Photocolor Archives, New York (56, 285, 319); Jörg P. Anders, West Berlin (186); Anderson/Editorial Photocolor Archives, New York (2); Archives Photographiques, Paris (145, 152, 250, 357); Courtauld Institute of Art, London (57); Elsam, Mann & Cooper Ltd., Liverpool (197); Giraudon, Paris (4–5, 10, 14, 48, 63, 73, 127–128, 133, 139, 156, 160, 242; Pls. 10, 13, 18); Bruno Jarret, Paris (362); Lucien Hervé, Paris (461); Ralph Kleinhempel, Hamburg (Pl. 2); Lauros–Giraudon, Paris (181, 184, 246, 295; Pl. 3); Robert E. Mates and Mary Donlon, New York (547); Museum of Modern Art, New York (468, 470); Hans Peterson, Copenhagen (187, Pl. 32); Photo Studios Ltd., London (46); Roger–Viollet, Paris (359); Service de Documentation Photographique de la Réunion des Museés Nationaux, Paris (61, 66, 72, 129, 302; Pl. 9); Bill J. Strehorn, Dallas (119); Soichi Sunami, New York (510, 540).

Acquiring Editor	**Thomas E. Hitchings**
Editor	**H. L. Kirk**
Production Manager	**Nancy J. Myers**
Art Director	**Louis Scardino**
Picture Coordinator	**Barbara Curialle**
Publisher	**Rita Pérez**

Library of Congress Cataloging in Publication Data

Canaday, John Edwin, 1907–
 Mainstreams of modern art.

 Includes index.
 1. Art, Modern—19th century. 2. Art,
Modern—20th century. I. Title.
N6447.C36 1981 709′.03′4 80–25696

ISBN: 0–03–057638–5

Copyright © 1981, 1959 by John Canaday

Address correspondence to:
383 Madison Avenue, New York, N Y 10017

5 6 7 046 7 6 5

CBS COLLEGE PUBLISHING
Holt, Rinehart and Winston
The Dryden Press
Saunders College Publishing

To Katherine

Preface

Mainstreams of Modern Art is a history of painting and sculpture in the nineteenth century with their immediate genesis in the late eighteenth and immediate continuations in the first decades of the twentieth. Once regarded as a not very distinguished transitional passage from the centuries of the Old Masters to our own century of fireworks, the nineteenth now bears comparison with any other. If we make a mistake today it is in rejecting the transitional idea and thinking of the century as self-contained. But the earliest painting illustrated in this edition goes back to the fifteenth (the head of the goddess from Botticelli's *Birth of Venus,* a back reference in connection with Modigliani) and one of the latest is Jackson Pollock's *Autumn Rhythm,* a reference forward from Monet's *Water Lilies.* Along with illustrations of Greek archaic, Hellenistic, and baroque sculpture, these are evidence that the courses traced as mainstreams in any century could be followed as far back as the origins of art and could be continued in what has been called the delta of art at this moment, where, at such close range, they seem to be finding their way in a multitude of channels.

Art in the nineteenth century was even more various than it is today, but as we see it with the advantage of increasing distance it is less a delta. From year to year the course of the mainstreams becomes more sharply defined and a new unity is discernable. It is with such perspective that this book, which first appeared in 1959, has been revised.

First of all, the international neoclassic/romantic impulses that culminated in the great French adventures are recognized as common to European and American art at large; the drama of their climactic expression in France has not been allowed this time around to obscure their early manifestations elsewhere. A chapter on Jacques-Louis David as the archneoclassicist of them all opens this edition as it did the first, but where the first edition continued

to follow the story in France up through impressionism and then back-tracked to, for instance, early German romanticism, this revision integrates the history chronologically without losing one of its most interesting aspects—the philosophical nuances that differentiate neoclassic/romantic idealism as it developed simultaneously in different countries. Paris is still the major locale of the events narrated here, but Rome, London, Berlin, Munich, and the American countryside play larger roles than before. In considering American luminism, appropriate attention has been given to Frederic Edwin Church, Martin Johnson Heade, and Fitz Hugh Lane, who had been skimped in an otherwise unusually extensive consideration of the Hudson River School.

There is new material on Thorvaldsen, Canova, and their circle in Rome—including Fuseli during his visit there and his career in London. The German romantics were well covered in the first edition, but the wonderful Philipp Otto Runge has been given additional emphasis. Millet and Couture are among French artists who appear with increased stature, while among earlier French painters, Girodet with his once half-forgotten but now famous *Riots in Cairo* becomes a major figure. Another Napoleonic romantic, Jean-Pierre Franque, whose name was virtually unknown until recently, joins the band. The extensive chapter on Degas has been further expanded with a discussion of his monotypes.

In considering the art of England, the chapter on the Pre-Raphaelites has been rewritten (much more sympathetically) and enlarged. The Macchiaioli in Italy have been given their due. Adolf von Menzel in Germany and William Merritt Chase in America are now present, with apologies for their earlier omission.

Among obscure names that demanded attention, Jacques-Laurent Agasse, Johann Erdmann Hummel, and Wilhelm Bendz appear in context with the persistence of realism against the current of neoclassicism and romanticism. More important, two famous names that have become even more famous since *Mainstreams of Modern Art* was first written, Gustav Klimt and Egon Schiele, have been added to the reorganization of material that now composes a chapter called *Fin-de-Siècle*.

Such details aside, it is hoped that *Mainstreams of Modern Art* in its new form offers a comprehensible view of a wonderful period that, of all centuries since medieval times, is rivaled only by the fifteenth and early sixteenth in the imaginative exploration and invention of its artists, and only by the seventeenth in the variety of international expressions unified by shared ideals.

With this hope, this book is now left to the reader.

<div style="text-align:right">J. C.</div>

New York
February 1981

Contents

part one

Classic and Romantic Idealism

chapter 1

Revolution

Modern Art, Tradition, and David

Where does modern art begin? And why does this version of its story begin with a man named Jacques-Louis David, born more than two hundred years ago?

Modern art begins nowhere because it begins everywhere. It is fed by a thousand roots, from cave paintings twenty-five thousand years old to the spectacular novelties of last week's exhibitions. We are pressed upon by bewildering accumulations of every art from every period; a painter may live in South Dakota and find major stimulation in the sculpture of ancient China. Modern artists have synthesized personal styles from their reactions to objects and ideas as diverse as the structure of the internal-combustion engine, the theories of Sigmund Freud, and the painting of Rembrandt. The public museum is something new; we think of it as having always existed, but it is a modern institution, and what the old masters knew of the art of the past was only a fraction of what any casual student can see today in museums—and cannot avoid seeing in floods of reproductions that have added their special complication by taking the Sistine Ceiling, for instance, and transforming it into a miniature painting the size of an ordinary envelope.

For the artist, the past used to be a stream; now it is an ocean. It used to be a road; now it is a forest. Tradition in art used to mean a steady sequence of change within boundaries. Today the boundaries are vague, if they exist at all. Horizons are infinite; the artist is tempted to explore in a hundred directions at once.

As an example more obvious than most, the art of the modern Italian painter Amedeo Modigliani (1884–1920) reflects in about equal parts the

3

wonderful linear contours of his compatriot of nearly five hundred years before, Botticelli, and the stylizations of African tribal sculpture. African sculpture [1] is part of the magic and incantation of tribal rituals. Botticelli's Venus [2] is a Renaissance intellectual's revery upon classical antiquity. Yet these two arts, so wildly separated, are harmoniously unified in another that is concerned with the Parisian bohemia of the early twentieth century [3]. Half a dozen other influences contributed to Modigliani's painting, quite aside from the infinite number that are bound into it in secondary ways. They would include the French classical master Ingres; Modigliani's contemporaries, the expressionists; probably the late-medieval religious paintings of the Sienese school; the revolutionary art of Cézanne, the fin-de-siècle art of Toulouse-Lautrec. But the most important factor in the compound of Modigliani's art is not Botticelli or African sculpture. Nor is it Ingres or the expressionists or the Sienese or Cézanne or Toulouse-Lautrec. It is Modigliani, an artist of creative talent, sensitive intelligence, and aesthetic discretion, who imitates none of these men or schools but fuses whatever he takes from them with his own perception of the world into an expressive art of great individuality.

We talk about "traditional" painting today, meaning the opposite of "modern" painting. Yet if tradition means the transmission of ideas or ways of doing things from ancestors to posterity as the dictionary says it does, Modigliani must be one of the most traditional painters

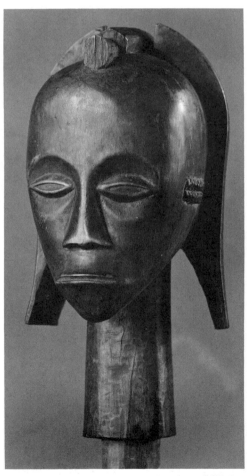

1 Head, from Zaire. Wood, height 13¾'' (35 cm). University Museum, Philadelphia.

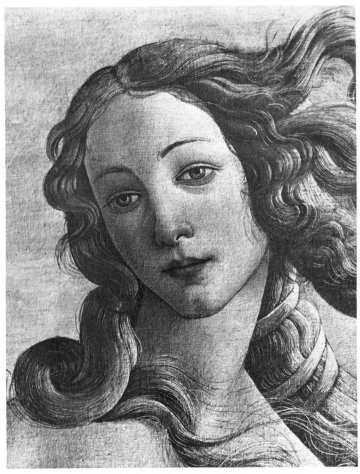

2 Sandro Botticelli. *Birth of Venus,* detail. After 1482. Tempera on canvas, entire work 6'7'' × 9'2'' (2.01 × 2.79 m). Uffizi, Florence.

3 Amedeo Modigliani. *Female Portrait*. 1918. Oil on canvas, 39½ × 25½'' (100 × 65 cm).
Philadelphia Museum of Art (Louis E. Stern Collection).

who ever lived. But, like other modern artists, he has found his ancestors in the most diverse and unexpected combinations. The orderly sequence from one generation of painters to the next has given way to a series of abrupt dislocations to such an extent that, if we have a tradition, it is the contradictory one that each new generation is under some kind of obligation to refute and violate the ideas of the preceding one.

When yesterday's successful revolutionists become today's entrenched conservatives, they have to be ousted in turn. The century and a half covered by this book, from about 1770 up through World War I, was marked by rapid and extreme shifts in the social and political structure of Europe and America, inevitably accompanied by corresponding movements in the arts. The changes were so rapid during the nineteenth century that the history of art is the story of battle after battle. Any military analogy is not very good, however. Instead of spreading death and devastation, this continuous aesthetic warfare generated a marvelous flourishing of the arts. Revolutions and counterrevolutions developed so rapidly that one was hardly established before it was being shouldered aside by the next. We will see that as successive groups of artists (mostly painters) seek to establish a norm within this infinitely rich chaos, other groups arise, determined to upset whatever norm is temporarily achieved. Of all centuries, including even the most fertile periods of the Renaissance, the nineteenth is hardly rivaled in the richness and variety of its painting.

Classicism and Romanticism: A Civil War

The opening conflict of the century was between two armies of idealists, the classicists* and the romantics, who shared the same dissatisfaction with the state of the world but had different ideas about how to change it. At least their ideas seemed very different to the participants at the time—even irreconcilable. In ret-

*Neoclassicism, strictly speaking, should be used to distinguish nineteenth-century revived classicism from the genuine classicism of antiquity. But this is a nuisance and the difference is usually clear in context, so classicism will usually be the term used for both in this book.

rospect we see their differences as superficial, so that what we used to call the classic–romantic conflict has become a single idealistic revolution. That point is the subject of the next several chapters, but we had best begin with an explanation of the differences between the classic and romantic points of view as the participants saw them in the excitement of their civil war.

Fundamentally—in the broadest, unqualified terms—it was a question of whether the head or the heart should govern us, a matter of choosing between the intellect and the emotions. Jacques-Louis David (1748–1825), the archclassicist we are about to meet, declared that "art should have no other guide than the torch of Reason," but this dictum is opposed by a sentiment held dear by the French: "The heart has its reasons which Reason does not know." The romantic movement was a revolt of the heart against Reason, of the mysterious against the rational, of the individual against formula— in short, of the senses and the imagination against everything else.

No art of much consequence is created without some fusion of emotional and intellectual values, and this truth the romantic artists did not deny. But they trusted their hearts before their heads, put their intellect at the service of their instincts. If a conflict between emotional and intellectual values forced them to a choice, they dropped the torch of Reason to follow their unreasonable impulse, even when they were not certain where it might lead them. They would abandon moderation for excess, when necessary, accept confusion rather than run the risk of sacrificing spontaneity to lucidity, were willing to be utterly illogical if within their hearts they felt that they might stifle emotional truth by subjecting it to analysis. The classicists spoke rationally of "Beauty, sublime and severe, which can be defined only by theory and understood only by Reason" (Quatremère de Quincy). But the romantics worshiped a beauty sublime and passionate, which could not be defined and could be appreciated only by the heart.

David offers the best starting point for a story of modern art not because he was the earliest classicist (we will see earlier ones) but because he is alone in the severity, the purity of his demonstration of neoclassical doctrine. He represents the beginning of the story of modern art in the way that the French Revolution, in

which he was a conspicuous figure, marks the beginning of the history of modern Europe. He crystallized an international impulse in art that was already under way but was given its most sharply defined expression in France—as so often happens in nineteenth-century art.

David's Life

As often as not, a knowledge of the events of a painter's life is unnecessary to understanding his art, but David's is one of those cases where some acquaintance is imperative. Early disappointments, an attempted suicide, a Roman experience, and thereafter his participation in the turbulent political events of his time not only determined the character of his own art but redirected the course of European painting. During twenty years of roaring success David painted a series of sensational pictures that annihilated not only every living competitor of the old school but the tradition of the most eminent painters for several generations back as well. He established himself as art dictator of France, where his paintings influenced everything from philosophical morality to interior decoration. Political theorists used his paintings to support their arguments, and every woman in Europe with any pretensions to chic discarded her wardrobe and changed her hair-do to make herself over in the pattern of the female type he invented to enact his pictorial dramas. It was the most drastic "new look" in the history of fashion, but it was only a footnote to David's career.

As a student David was a protégé of the Royal Academy of Painting and Sculpture (an institution he would later cut down, then make over in his own image). He attempted suicide after four consecutive failures to win its *Prix de Rome.* This "Rome Prize" was (and still is) the most coveted official student award in France. It took the winner to the Academy's branch in Rome for three years; during this time his only obligation was to produce one work annually to send back to Paris. A *Prix de Rome* man was also assured of very considerable advantages upon his return to France, since his career was sponsored by established academicians in a position to throw commissions and attention his way. The whole situation was, of course, based on the premise that a *Prix de Rome* winner was dedicated to the perpetuation of the academic tradition.

David failed in his suicide when fellow students broke into his studio in the Louvre, suspicious because it had been locked for days. (The Louvre was not then a museum; the buildings included, among many other things, quarters for the talented young men who, like David, received stipends from the king to follow their studies.) He had intended to starve himself to death and probably would have done so. The choice of method says a great deal about David's temperament, at once intense and dogged, sensitive yet Spartan. These characteristics appear in his art, where emotion is held in check by icy control.

In 1774 David competed once again for the *Prix de Rome* and won it. He was twenty-six, unusually mature for a *Prix de Rome* winner and—even more unusual—full of hidden resentment against the Academy and suspicious of its standards.

By a unique extension of artistic success into the field of government, possible only in the one country in the world where art was debated as fervently as politics, the pictures David painted during the next fifteen years lifted him from the position of a near-failure to the eminence of the Revolution's prophet and then made him one of its leading participants. (Just how this happened we will see when we look at the pictures themselves.) He served among other capacities as a member of the legislative body voting life or death for his former patron, Louis XVI. David's vote was among those that sent this ineffectual, confused, incompetent aristocrat to the guillotine. David also guillotined the Royal Academy in which he had been nurtured, crying out for its abolition "in the name of humanity, in the name of justice, for the love of art, and above all for the love of youth." He called the Academy's schools *funeste,* an adjective that pales in translation as "fatal" or "deadly." Fatal or deadly they may have been, but a few years after David abolished them they rose from their own ashes, more funeste than ever, dominated this time by the theories of David himself.

The French Revolution was followed by the period of violence and confusion so appropriately called the Terror, when no one's neck was safe from the knife. During these days David, still among the powerful, abandoned personal friends to the executioner with an expedient callousness for which he has never been forgiven. Some of his actions at this time make it

difficult not to see him as a fanatic. Mrs. Sarah Siddons, the English actress, reported to a friend that she was present when David, told that eighty people had been beheaded that morning, answered "Not more?" He used to sit outside the Café de la Régence sketching the prisoners on their way to the scaffold. When Marie Antoinette was beheaded, he did a heart-rending sketch of her [4], bound hand and foot as he saw her from a window on the way to execution, bedraggled, emaciated, prematurely aged by her frightful imprisonment, with no suggestion of beauty left, yet with something more—a dignity she had never managed to achieve as queen of France.

This man David was a curious personality, given to passionate loyalties and passionate grudges, a man of fervent temperament who imposed upon himself a frigid manner, of sensitive perceptions he rejected as unworthy. Because his career and his art are full of contradictions, his biographers have taken sides according to their own convictions. Some see in him a bloodthirsty despot never forgiving the men who for so long had denied him the *Prix de Rome,* using his power vengefully to destroy the tradition they represented. Others find him devoted to high principles, even if a little prone to inflict them on others as severely as he imposed them upon himself. Frequently the same facts support either judgment, since they must be evaluated in the unnatural lights of the Revolution and the Terror.

Despot or idealist, David himself narrowly escaped the guillotine. He fell from power with his Jacobin partner Robespierre, whose terrorist excesses had become intolerable. Robespierre was beheaded. But there was a delay before David came to trial; when he did, his defense was that he had never been sympathetic to Robespierre's policies, that he had strung along with him only to give what service and protection he could to the arts of France. It is recorded that he "sweated enormously" on the witness stand, that he was pale and trembling, mumbling and stammering pitifully in his own defense against the murderous oratory of the prosecutor, one of the finest speakers of the day. It is not surprising that a man in danger of his life, with no reason to expect clemency, should sweat, nor is it damning that, in the circumstances, one should mumble whose upper lip was disfigured, as David's was, with a tumor that impeded his speech even in the happiest

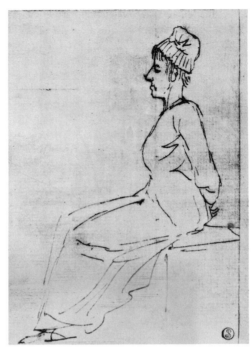

4 Jacques-Louis David. *Marie Antoinette on the Way to Execution.* 1793. Pen and ink, 5¾ × 4'' (15 × 10 cm). Louvre, Paris.

situations. In any case, David escaped execution and was imprisoned instead.

But for this extraordinary man even the circumstances of prison were exceptional and redounded ultimately to his advantage. His cell was a room in the Luxembourg Palace overlooking a corner of some of the loveliest gardens in the world. The family governess made daily trips to the palace gardens, where David's children played as he watched from his window. Former students kept him supplied with painting materials, and he began work on sketches for one of his most ambitious pictures, *The Battle of the Romans and Sabines* [10], a work that was to re-establish him more firmly than ever in a career that had seemed lost. When he was released in a general amnesty, he had been in prison only a few months.

David completed *The Sabines* in a studio where women of fashion begged to pose for him as if they already knew the picture was to be one of the most famous in the world. In the meanwhile France had come under the leadership of the young general Napoleon Bonaparte. He visited David's studio to see *The Sabines* and

recognized the potential of this man's art as propaganda that could be as effective for the empire he planned as it had been for the Revolution. Napoleon conceived an image of himself as a modern version of a conquering Roman emperor, partly because of his personal conviction that he was just that and partly as a matter of what would now be called public relations. Official architecture had been a recombination of classical elements under the dictates of the Royal Academy, but now Napoleon demanded an architecture that would be true archeologically. Paris was to become a second Rome—but larger—as a setting for the new conqueror. For his church, La Madeleine, Napoleon demanded of his architects the most perfect classical temple since antiquity. The Arc de Triomphe is a handsomely inflated version of ancient Roman models, so large that the originals would look like guard stalls alongside it. David's painting was the perfect accessory to these conceptions, and Napoleon took the artist under his wing.

Thus the young man who had begun his career under the patronage of the king of France, who had continued it as spokesman for the Revolution and the Terror, finally became First Painter to the Emperor and art dictator of the country that was to dominate the course of Western painting for the next hundred and fifty years.

Napoleon once said "David, I salute you." He was commenting on a painting, recognizing its success without risking a critical judgment. But the same comment, with the same reservation, could refer in all appropriateness to David's conduct of his life.

David's Painting

David won his *Prix de Rome* with a respectful exercise giving no indication except by hindsight of the Davidian revolution to come. *Antiochus and Stratonice* [5] is full of derivative references flattering to the leading academicians of the day. Like any other student involved in a school competition, David produced a demonstration of how well he had learned his

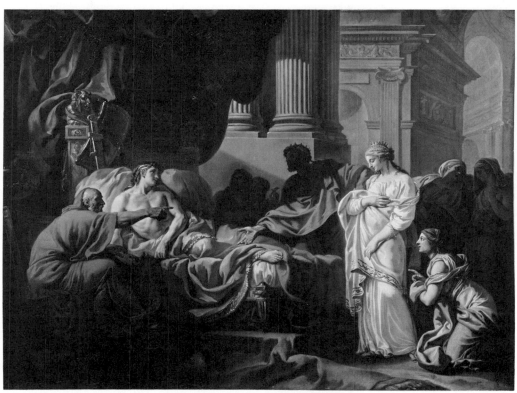

5 Jacques-Louis David. *Antiochus and Stratonice.* 1774 *(Prix de Rome).* Oil on canvas, 3′11¼″ × 5′1″ (1.2 × 1.55 cm). École des Beaux-Arts, Paris.

lessons. The picture includes a nude torso to prove that he knew muscular anatomy and could draw and paint the human body accurately with conventional heroic modifications; his skill with drapery is demonstrated to the point of excess in great billowing areas wherever he needs filler; the male figure leaning forward just to the right of the picture's center, reduced almost to silhouette in the head and shoulders and emerging into brilliant illumination in the hand and the spread of cloak just below, is a sort of final examination passed with honors in chiaroscuro, the revelation of forms in strong light and dark shadow. The elaborated architectural background shows that the candidate had mastered perspective and also supplies the air of pomp and circumstance necessary to a picture obliged to take itself so seriously. Compositionally—in the way the objects and figures are arranged in the picture space—these various exercises are nicely, if conventionally, pieced together with, as well, some sense of style.

The story, for whatever bearing it has, tells of the young prince Antiochus (supine upon the couch) who languished to the point of death from an unidentifiable malady until the doctor Erasistratus (seated beside him, at the left) diagnosed it for what it was: Antiochus was lovesick for his father's wife, the beautiful Stratonice (standing at the right). Such a tale of repressed passion offers material for tense and personal expression—and received it, later on, in a painting by one of David's own pupils [133]—but David uses it only as a framework for a charade posed by models in appropriate attitudes. Even so, hindsight shows us that if most of the picture is blowzy and pointlessly complicated, the figure of Erasistratus has an aggressive force in which we can imagine the germ of the style of the picture that redirected the course of French painting and began the history of modern art—David's *The Oath of the Horatii*.

«*The Oath of the Horatii*»

With *The Oath of the Horatii* [Plate 1, p. 53], which he completed in 1784, David came fully into his own as an original creative painter. It is a superb picture. It is called stiff and cold; such adjectives as *harsh* and *wiry* are habitually applied to its color and drawing, with only partial justice, as if they were entirely derogatory. Ac-

tually these qualities are in themselves remarkable, and they have a legitimate expressive reason for being.

The Oath of the Horatii contrasts on every hand with *Antiochus and Stratonice*. Its surface is as hard as enamel, the edges of its forms are mercilessly uncompromising, revealed in a flat, uniform illumination instead of theatrical spotlights. In drapery passages the windy profligacy of the earlier picture has been chastened into order and definition. Everywhere the antithesis continues. Compositionally, *Antiochus and Stratonice* is extravagant; *The Oath of the Horatii* is spare, organized almost mathematically into unit variations of the number three. Against three simple arches the participants are divided into three groups of generally triangular shapes—the three sons, the father holding their three swords, and the group of women. In this last group the triangular severity is appropriately relaxed (but not abandoned), and the linear patterns are appropriately more graceful. The three groups, considered as a unit, are united in a final triangle binding the picture into a decisive whole. The subterfuge of the "academic machine" (a picture organized on standard formulas with all their complicated trappings) has been rejected for a rigid structure where economy, precision, and force must reveal any weak or extraneous element. *The Oath of the Horatii* offers the artist no refuge behind the facile piling up of incidentals; he must be revealed as the master of his expression or be exposed as inadequate to its uncompromising demands.

That David invented a new style of painting need not have had any importance in itself; the important thing is that he had to invent it in order to express what amounted to a moral and philosophical revolution in art as an expression of French thought at that moment, which also explains his choice of subject. The three stalwart young Romans are vowing to their father that they will return victorious or give their lives in a duel with three warrior brothers of the city of Alba, a duel to be fought in the presence of the armies of both cities to determine which will rule the other. The special complication in this situation is that one of the grieving women to the right is not only the wife of one of the Roman warriors but the sister of one of the Albans as well. In addition, the youngest of the women is a sister of the Romans but the fiancée of one of the Albans.

Thus the subject of *The Oath of the Horatii* is dedication and sacrifice. Instead of a lovesick Antiochus we have vigorous young males pledging their lives to the defense of their honor, their family, and their country. The chaste matron and the swooning girl express their grief with admirable reserve, submissive to the will of the dominant men. Their dignity is a rebuke to Stratonice's simpering grace, just as the virility of the young Horatii is contemptuous of Antiochus' amorous languor. Service to a moral and social ideal is glorified as a virtue opposed to its parallel vice, the indulgence of personal yearning. Just so, severity and masculine force replace elegance and feminine sensitivity in David's new style. Rich complications have given way to austerity; fashionable invention has been rejected for philosophical order.

Composition of this kind is not achieved in a single step; the rule in picture-making is that simplicity is reached by reduction from complexity. When he first began work, David chose another incident from the story of the Horatii as dramatized by Pierre Corneille, the god of French classical drama. In this tragedy the three Albans and two of the Roman brothers are killed; the remaining son returns covered with the blood of his sister's fiancé, and she denounces him and Rome. As a patriot, he runs her through with his sword.

An early sketch for the picture represents this final scene, where the elder Horatius pleads for his son while the body of his daughter lies on the steps of the platform where they stand. The composition was to have been even more elaborate than *Antiochus and Stratonice*. The old father, swathed in a toga, gestures grandiloquently in one direction while two male figures rush past him in another. The son stands in elaborate theatrical battle gear, including a voluminous cape. The background was to have been a palatial architectural invention on several levels, rising above masses of incidental figures in the foreground and supporting other agitated groups on a balcony. For good measure, there was to have been a full landscape in the distance, including a large temple.

Such a fulsome arrangement was out of key with the ideal of sincerity and moral strength, and David abandoned it (perhaps upon the advice of friends) for the scene showing the sons taking their oath before departure. The palace in the background was reduced to a stark enclosure; the landscape was eliminated as having

nothing to do with the action; costumes were simplified. The new composition was less obviously dramatic but more forceful, and with the narrative reduced to a minimum its symbolism was emphasized.

The Oath of the Horatii was a sensation when David exhibited it in his studio in Rome. He completed it there during a second sojourn made possible by his father-in-law, who supplied him with funds to support himself, his wife and family, and an entourage of servants and assistants. The investment was a good one. The picture was brought back to Paris for the Salon (the annual official exhibition dominated by the Academy) and, although badly placed, it caused such riotous excitement that it was rehung in a better position. A few pedants criticized the composition as oversimplified and on a single plane—stretching across the picture surface rather than, so to speak, "puncturing" the canvas and going back into space. But these objections were lost in the general enthusiasm, which was increased by a factor that was to affect the reception of David's work from this time on: *The Oath of the Horatii* was interpreted as an allegory of contemporary events.

To adherents of the burgeoning Revolution, the picture seemed to proclaim the vigor of new republican ideals in opposition to the degeneracy of the old regime. It is unlikely that David intended any such specific political reference. Rather, the painting was meant to glorify high-minded human behavior as a virtue that could include an idealized contract between a citizen and his state. But it is certain enough that David's own temperament was sympathetic to the new ideals—or at least unsympathetic to the established order, of which the Academy was a manifestation. With the explosive success of *The Horatii* David became identified with antiroyalist thought. Ironically, the picture had been commissioned by the King and was so admired by one high-living member of the court, the Comte de Vaudreuil, an intimate of Marie Antoinette, that he commissioned David to do a copy in a smaller size (and had to sell it later to pay gambling debts). This smaller version is illustrated here. It differs from the larger one in the Louvre by the addition of the spindle lying on the floor near the grieving women.

David followed *The Horatii* with an even icier painting reflecting again the theme of self-sacrifice with moral and philosophical associations translatable into terms of revolutionary

political ideas, *The Death of Socrates* [6]. The philosopher whose thought was based on the idea of studying man instead of inventing systems of false rhetoric, who sought the moral bases for human conduct, who did his teaching where crowds of the people gathered instead of within a closed circle of sophisticates, and who died for the defense of his ideas, was even more directly identifiable with the principles of the Revolution than *The Horatii* had been. David shows Socrates about to carry out the sentence of death by drinking hemlock, while his disciples do their best to conceal the weakness of emotionalism.

These "Stoic" pictures with political overtones reached their climax—not aesthetically, but politically—in a picture of Brutus, First Consul of Rome, sternly repressing his grief as the bodies of his two sons, whom he had condemned to death for conspiring against Roman liberty, are carried home for burial. *Lictors*

Bringing Back to Brutus the Bodies of His Sons [7] was completed and exhibited in 1789, the very year of the Revolution. Even more than *The Horatii* it was a sensation as political allegory. Just as Brutus had sacrificed his own sons to the cause of Roman liberty, so must the French people purify their country at no matter what costs. Brutus' strength was openly compared with the weakness of Louis XVI, who had allowed members of his family to emigrate and take up arms for other countries against France. Again the pedants objected, this time because the figure of Brutus, the main character, was thrown into deep shadow. The dramatic and psychological effectiveness of this device is obvious, of course, but it went against the rules. No one else cared; the picture was a fantastic success, talked of everywhere, and in the theater where Voltaire's drama on the same subject was being performed, the actors assumed the attitudes painted by David. *Brutus* was pur-

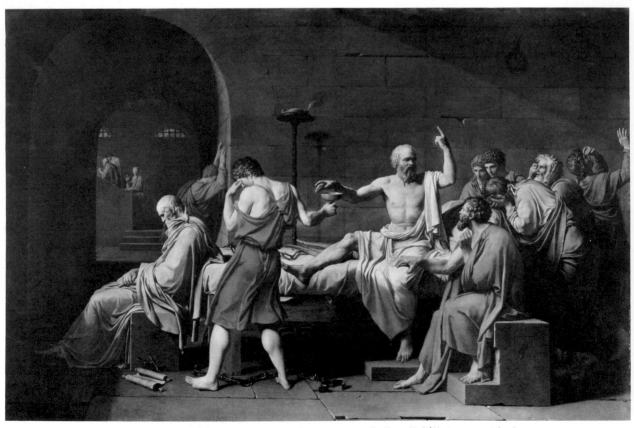

6 Jacques-Louis David. *The Death of Socrates.* 1787. Oil on canvas, 4′3″ × 6′5¼″ (1.3 × 1.96 m) Metropolitan Museum of Art, New York (Wolfe Fund, 1931).

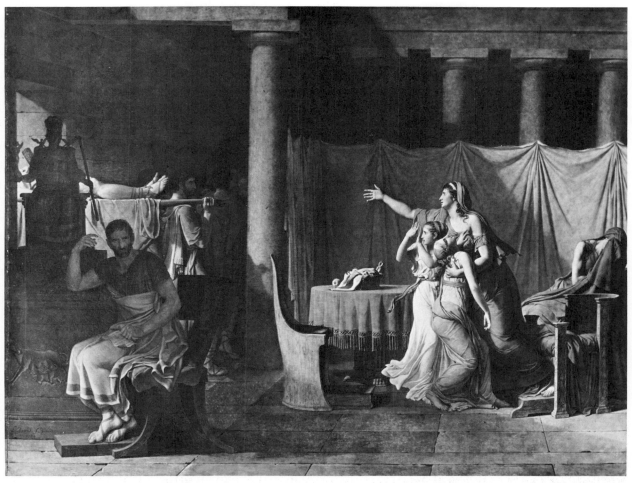

7 Jacques-Louis David. *Lictors Bringing Back to Brutus the Bodies of His Sons.* 1789. Oil on canvas, 10′8″ × 13′10½″ (3.25 × 4.23 m). Louvre, Paris.

chased by Louis XVI. When later he voted for the death of the King, his apologists pointed out that David could not have done otherwise without giving the lie to the moral themes of *The Horatii* and *Brutus.*

David and the Revolution

With the Revolution achieved, David found himself its spokesman and propagandist, the pictorial historian of its great events. One of the most important of these events was the Oath of the Tennis Court, when on the twenty-eighth of June 1789 the deputies of the Third Estate swore not to disband until they had given France a constitution. Louis had refused them their usual room for assembly and they had met

instead in the indoor tennis court from which the event and David's picture of it are named. But the picture was never finished: before it was nearly done too many of the men represented in it had become suspect.

For a few years after the Revolution David turned his hand to professional chores for the new government. He was the official supervisor of state ceremonies and designed celebrations on such a scale that virtually the entire population of Paris was directed to take part in them. The citizens grumbled somewhat at this; it seemed a little out of line with the new freedom. David designed playing cards—eliminating the king, queen, and knave, now too suggestive of royalty. He designed a new costume for the citizens' everyday dress; it failed to catch on. He was involved with the seizure of the royal

collections and others, which were declared the property of the people and have been so ever since as the core of the Louvre Museum. And he produced a painting that may be his masterpiece: *Marat* [8].

David is always a contradictory figure. No sooner is he identified in one character than he reveals himself in another. In the *Marat,* painted four years after the *Brutus,* he abandons the harshness of his Stoic conceptions for a compassionate nobility all the more surprising in a subject that in essence is both violent and grotesque.

Jean-Paul Marat, a leading figure in the Reign of Terror and a close friend of David, was assassinated in his bathtub by a woman named Charlotte Corday. Although she was a revolutionary sympathizer, Corday was outraged by the excesses of the Terror and appointed herself judge and executioner of at least one of the guilty, Marat, and was herself guillotined for his assassination. All this occurred, and David's picture was painted, in 1793.

The idea of a dedicated lady in full visiting regalia attacking a naked man in his tub has associations with the ludicrous as well as with the terrible, even after we know that the bath was a medicinal one in which Marat spent his days because he was afflicted with an eczema. Lining the tub with sheets and wrapping his head in a turban, no doubt also medicated, he received callers and carried on business as usual—or as best he could in the circumstances. Corday gained an audience by sending a note saying she had information of vital importance to France. Marat's tub was rigged to serve as a desk; only his head and shoulders emerged above it, and thus imprisoned he had no defense against Corday's dagger.

From this situation, which would seem impossibly guignolesque, David extracted a great picture. How he went about it may be revealed by a feeble treatment of the same subject [9] included in a pictorial history of the Revolution published in Paris in 1802. Here various people, attracted by the victim's cries, have rushed into the room and seized Corday (hat either knocked askew or set at a modish angle; it is impossible to tell which). But in spite of all that is supposed to be going on, no feeling of excitement is relayed to the observer. The story is not even clearly told, although presumably it is faithful to fact. Included in the general clutter of incidental figures is each detail selected by

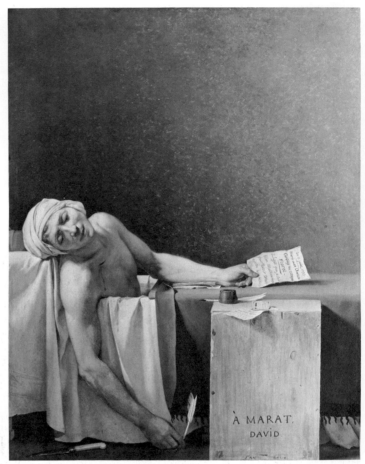

8 Jacques-Louis David. *Marat.* 1793. Oil on canvas, 5'5'' × 4'2⅜'' (1.65 × 1.28 m). Musée Royal des Beaux-Arts, Brussels.

David: the tub, the cloth hanging over its side, Marat in his turban, some writing materials on a stand by the tub's side, Corday's letter requesting an audience. But where one picture remains an ill-told anecdote at best, the other—by selection, modification, and arrangement of a few meager elements—distills from the event its essence as David felt it.

Bathed in a gentle fall of light with quiet modulations of shadow, each ugly, ordinary, or utilitarian object is invested with dignity, and all are unified with one another in quiet harmony. From a particularized subject full of sordid and commonplace details, David developed a generalized statement in noble and ideal terms. Here he approaches a classicism truer than that of his classical subjects with their trappings imitated from ancient Rome.

David: The Triumph of Classicism

David's preoccupation with the ancient classical world, while not specifically mentioned, has been implied in the early series of "Stoic" pictures: *The Horatii,* the *Socrates,* and the *Brutus.* Classicism in one form or another is a constant in French art, and David's art was the climax of a vogue for classical decoration that had already been stimulated by the first excavations of the buried cities of Pompeii and Herculaneum. One of David's masters was Joseph Marie Vien (1716–1809), who made considerable but quite superficial use of classical motifs in his painting and who was appointed director of the Academy's school in Rome the same year David won the *Prix.* Student and master left Paris together, David declaring that he would not be "seduced by the antique" because it lacked vivacity and life (which it certainly did in Vien's hands). But when David saw the remains of Pompeii he said it was as if "cataracts had been removed" from his eyes.

Neoclassicism usually manifested itself in superficial borrowing from the forms of ancient art, capitalizing on their grace and novelty with no concern for corresponding philosophical

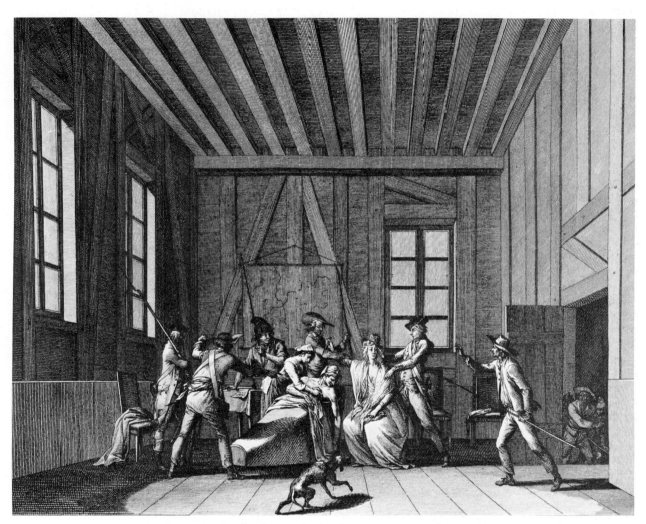

9 Jean-Pierre Berthault, after Swebach. *The Assassination of Marat,* from *Collection Complète des Tableaux Historiques de la Révolution Française,* Paris. 1802. Engraving. Philadelphia Museum of Art (gift of Mr. and Mrs. Adrian Siegel).

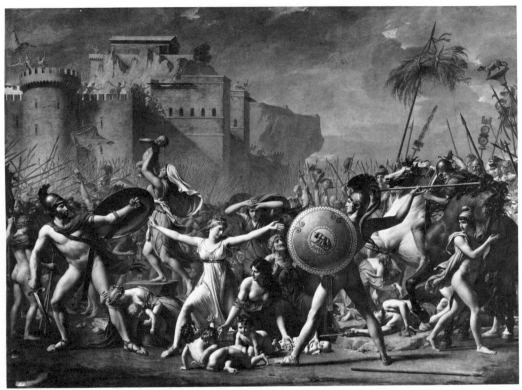

10 Jacques-Louis David. *The Battle of the Romans and Sabines.* 1799. Oil on canvas, 12'8'' × 17'3¾'' (3.87 × 5.2 m). Louvre, Paris.

ideas. But David's classical reference is a double one. Like the other classicists, he used classical forms parasitically, copying them outright from fragments of painting and sculpture.* But unlike the others, David wanted through these borrowed forms to revive the supposed moral virtues of ancient Rome.

Even so, David was under one misconception as to the nature of classical art that was common to his century and to a great extent remains common to this one. A German, Johann Joachim Winckelmann (1717–1768), the first archeologist to study the monuments of antiquity with scientific method, had written a celebrated history of ancient art in which he defined beauty as synonymous with perfection. He codified the characteristics of classical art and insisted that all great art must be static because movement is an "accident." What Winckelmann

* In *The Oath of the Horatii* the head of the father is copied from the Roman equestrian statue of Marcus Aurelius, to name one example in a long list of specific borrowings.

did not understand was that classical art was warm, even sensuous. He confused its repose, reserve, and calm with a kind of frigidity, and his followers confused its idealization with prettification. A sculptor friend of David's in Rome, Quatremère de Quincy, introduced David to the theories of Winckelmann as a law permitting no exception and no variation, and David retained all his life this limited and inaccurate concept of the classical spirit.

David's archeological neoclassicism reached its climax in *The Sabines* [10], which he completed in 1799—nearly five years after his trial and the brief imprisonment during which he made the first sketches for it. According to the legend, the Sabine women were abducted by the Romans, who took them to wife. Later, when the fathers marched against the ravishers, the women threw themselves and their children between their Sabine fathers and their Roman husbands to stop the carnage. In David's picture the Sabine woman in the center is Hercelia; her husband Romulus is about to throw his javelin at Tatius, who bends to parry the blow. Accord-

ing to one story, David selected the subject because he was moved by the devotion of his wife, who returned to him when he was sent to prison (she had left him when he voted for the death of the King). According to another version, Hercelia symbolized France throwing herself between the warring parties in the civil conflict that tore the country after the Revolution. By the time David finished the picture, France had finally reached unity under Napoleon, and David is supposed to have agreed when the latter explanation was suggested, saying that was exactly what he had in mind. In that case, he had been extraordinarily prophetic in the first sketches five years earlier. A likely explanation is simply that the subject attracted him as a subject, all symbolism aside. It recalls his first success, *The Horatii,* in the conflicting loyalties of wives to their husbands at war with their families; also it must have given David pleasure to return to a purely classical subject after devoting himself for several years to pictures of the Revolution. Whatever his reasons for painting *The Sabines,* the uncanny dovetailing of his pictures with current political events, which had worked with *The Horatii* and the *Brutus,* worked again. When Napoleon saw *The Sabines* in David's studio, he knew that he had found the man to direct French painting in his course toward empire.

In *The Sabines* David sought an extreme accuracy of archeological truth. In addition, he modifies the severity of his "Roman" classicism for a more "Greek" refinement. The words have to be put in quotes because the archeology is as faulty as the idea that Roman art was as severe as the ideals of the early Republic. Actually, all such inaccuracies or misconceptions are quite beside the point, since the neoclassical style is important only as itself, not as a re-creation of the past.

The Sabines is a fascinating picture with many faults. Even its admirers admit that it is rather chilly. For all the violence of the subject, the figures are of an extreme and even disturbing rigidity. Inspired by classical sculpture, they are not so much sculpturesque as stony. The vivacity, the sense of life, that David had once found lacking in classical art is certainly lacking here. Also, the architectural background is divorced from the friezelike grouping of women and warriors; it hangs behind them like a rented backdrop. Seen at full scale (it is a large picture, seventeen feet wide), *The Sabines* tends to break into beautifully designed studies competing with one another, although individually the passages are of great attraction. The theatrical elegance of the central standing female figure and the nude warrior to the right—Hercelia and Romulus—cannot be denied, and if a single pair of figures had to be selected to represent neoclassical types at their typically most ornamental, these might well be the ones. But the words used here are *theatrical* and *elegance,* and neither is particularly associated with the high moral disciplines that can be read into David's earlier work. He has changed. In *The Sabines* these disciplines are patently specious, although the technical disciplines of concise drawing and calculated balance are exaggerated. Classicism is again a decorative style, as it was in the work of David's precursors and as it continued to be in the work of his followers, though upon its technical disciplines David insisted to the end.

Academic drawing had always been based on a study of the nude; it was standard practice to make preliminary drawings from the nude even for draped figures. In a study for the figure of Tatius in *The Sabines* David begins with the skeleton, builds the muscles on it, and finally indicates the helmet sketchily [11]. From studies

11 Jacques-Louis David. Study for Tatius in Figure 10. Whereabouts unknown.

like this one David went ahead to refine or idealize nature to one degree or another. In *The Horatii* the anatomy is realistic, but in *The Sabines* David's stated purpose was to go beyond realism to an ideal beauty. He had wanted to leave the figures of the Horatii nude, in accordance with the forms of classical sculpture, but dared not. Compositional studies for *The Sabines* [12] show that David still felt under this restraint when he began the picture. (They also show that the rigidity of the final scheme was imposed by degrees upon a much freer one.) But by the time he was ready to complete it, modes and manners had relaxed to such an extent that he not only stripped the male figures but also clothed the female ones in diaphanous garments that would have been altogether inappropriate to the severity of conception that he imposed on his early work.

David violated precedent by setting up *The Sabines* in his studio and charging admission to see it, a practice forbidden by the Royal Academy. But now there was no more Royal Academy and people flocked to see the picture as they had flocked to the Salons to see *The Horatii* and the *Brutus*. As they paid their entrance fee, visitors were given a printed statement defending the admission charge. David made enough money to buy himself a comfortable country place outside Paris.

David and Napoleon

Now, under Napoleon, social Paris became a carnival. Freed from the moralistic restrictions of the Revolution and confident once more that the ground was not going to open beneath their feet or the guillotine descend on their necks, people with money indulged in pleasures as vain and often as licentious as the former excesses of the vanished world of the French court. David's influence on the mode reached a point without parallel in the history of the arts. A fashionable ball was a phantasmagoria of classical goddesses; a well-appointed room was as Greek or Roman as a working compromise with contemporary living would allow. The styles of

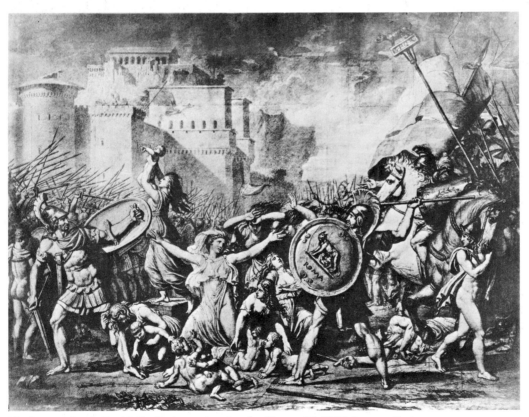

12 Jacques-Louis David. Preliminary drawing for Figure 10. 1795. Louvre, Paris.

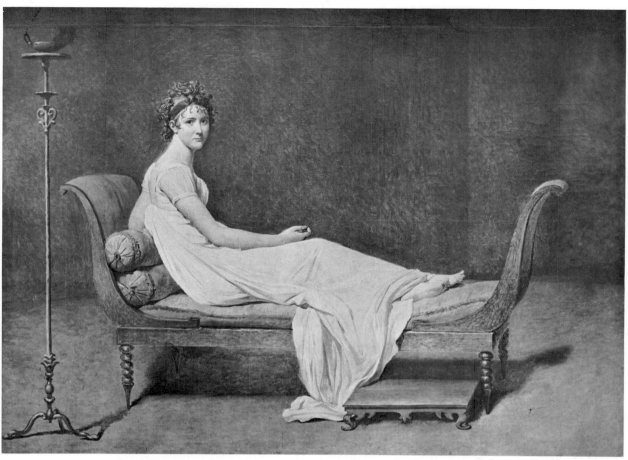

13 Jacques-Louis David. *Madame Récamier.* 1800. Oil on canvas, 5'8'' × 7'11¾'' (1.73 × 2.43 m). Louvre, Paris.

decoration and costume called Directoire and Empire (after the divisions of Napoleon's reign) owe everything to David. The classical furniture he had designed and built for studio use was imitated in tens of thousands of pieces not only in Paris but everywhere in Europe and even in America. He now occupied himself with official paintings for Napoleon, plus whatever other commissions it interested him to accept. After the wild success of *The Sabines,* Madame Juliette Récamier, an ambitious charmer who put the highest premium on her position as a leader of social and intellectual Paris, was not too proud to write him "I have arranged things so that I can sit for my portrait under the conditions you explain. I hope that you understand the great value I attach to a work by you. I will be at your orders for the sittings: let me know when it is convenient for you to begin."

The portrait [13] is one of the most delicate of David's works, an exquisite summary of the spirit of the Directoire style at its purest. It is also one of the most painterly; because it was never finished, it never received the final polish to which David reduced the surface of his other work. Madame Récamier is not posed in costume for an archeological costume ball but is in fashionable toilette with the exception of the bare feet, a detail David insisted on although it pushed the vogue for classical imitation beyond the point acceptable even to Madame Récamier. A more serious disagreement arose when David insisted on another point; he painted the hair light brown in harmony with the color scheme of the rest of the picture and in line with the formula for classical beauty. Madame Récamier's hair was coal-black and she was proud of it. Without telling David, she went to his most suc-

cessful pupil, Gérard, who could be depended on to do the kind of portrait she wanted. Gérard reported to David, who told him to go ahead but refused to finish the first commission. Left thus, the portrait reveals the touch of David's brush as so deft, so sensitive, yet without any sacrifice of precision and assurance, that we realize how much was polished out of the rest of his work. With the exception of the *Marat,* this is the only painting David regarded as a major one where his personal sensitivity as an artist is not impinged upon by the cruelly self-disciplined exaggerations of craftsmanship.

When Napoleon assumed the title of Emperor in 1804, David was given the title of First Painter. He had long since relinquished all political activity, and he painted now to commemorate the events of Napoleon's reign but not to comment on them beyond a general presentation of the Emperor in dignified and glorified terms. The spirit of the Napoleonic commissions is best summarized in *Le Sacre* [14], a vast canvas of some 500 square feet that was to have been one of a series of four (two were completed) apotheosizing the Emperor after his coronation. *Le Sacre* is a mass portrait of superhuman dimensions. A church was commandeered to serve as a studio; similarly, in 1792, a

church had been commandeered for work on *The Oath of the Tennis Court. Le Sacre* was begun in 1805; David was nearly sixty and had a corps of assistants. There was a specialist in perspective, named Degotti, for the backgrounds; a pupil, Georges Rouget, was the chief of several other lieutenant painters. Even so, David did a portrait drawing for each of the heads. The assistants transferred these to the canvas and roughed them in. David scrupulously finished each one himself.

Le Sacre shows Napoleon, already crowned, crowning his Empress in the presence of the Pope, a host of dignitaries, and the distressingly unimpressive members of the family. Napoleon preferred to be represented at this moment rather than the one in which he knelt to be crowned by the Pope, since thus he was not put on record at any man's feet. It has been objected that the attendant figures of the court have the air of parvenus in their Sunday best—which, of course, is exactly what they were.

For this as for the other pictures David painted of him Napoleon refused to pose. "Why do you need a model?" he asked. "Do you think the great men of antiquity posed for their portraits? Who cares whether the busts of Alexander the Great look like him? It is enough that

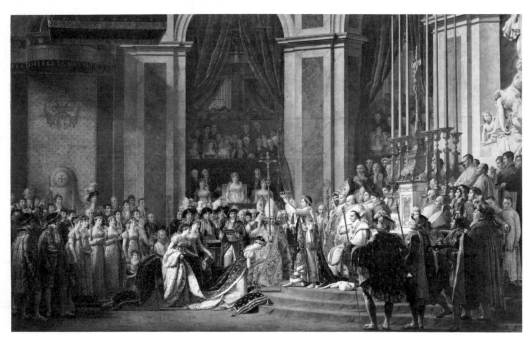

14 Jacques-Louis David. *Le Sacre.* 1805–1808. Oil on canvas, 20′ × 30′6½″ (6.1 × 9.31 m). Louvre, Paris.

we have an image of him that conforms to his genius. That is the way great men should be painted." In *Le Sacre* the great man is painted as handsome and almost boyish; he places the crown upon the head of an outrageously rejuvenated Josephine, for whose figure one of David's daughters posed. When an acquaintance objected to this flattering transformation of a woman who was a badly preserved forty-one and six years older than her husband, David suggested that the objection be made directly to the Empress.

In *Le Sacre* David had a next-to-impossible assignment. It was not only that the picture had to be so large. Mythological or ancient historical references were ruled out by Napoleon's demand for a straightforward record of the event, and without them David was forced into a rather pedestrian realism, saved from dullness only by the magnificence of the staging of the actual ceremony. On the whole, *Le Sacre* is a ponderous and wearisome picture in spite of everything David could do. But it is probably the most familiar of all pictures to French schoolchildren and remains for the French a symbol of the glorious days of Napoleon's zenith.

Given the initial handicaps, David's solution was more than adequate. He solved the problem of organizing so many figures partly by grouping, but even more by a less apparent device: a consistent illumination that binds each participant into convincing relationship to the others. There is nothing subtle about this light; it unifies the picture only because it falls so logically everywhere. As a help, David studied a scaled mock-up of the scene, built for him complete with costumed miniature figures. Yet in the end *Le Sacre* is not a stirring picture except by association. In it David is the soundest of craftsmen, but he is not an artist of emotional or intellectual force.

David: The Artist

What about David as an artist of personal sensitivity, an artist who can respond to human joy and sorrow, gaiety and confusion, hope and disappointment, revery and excitement, and communicate with us as other human beings?

In this respect David often denies himself, on the Stoic principle that the expression of emotions of either pleasure or pain is a weakness. Even in a picture of the stature of *The Oath of the Horatii,* the observer is likely to feel not so much that the artist is sharing an experience or an idea as that he is teaching a lesson—which happens to be exactly what the encyclopedist Denis Diderot, just before the Revolution, stated as the function of painting.

But in his portraits David frequently relented, especially when the sitters were close friends and the pictures not intended for formal public exhibition. After David's release from prison he stayed for a while with his wife's sister, Émélie Sériziat, and her husband. David had been bitterly chastised, had narrowly escaped execution, and his career seemed to be in ruins. He had always been a man with a reputation for severity, yet during his imprisonment his friends and his family had shown him loyalty and affection. During the two months he spent with the Sériziats he must have been conscious of his good fortune, grateful for the kindness of people, perhaps even aware of and regretful for his own iciness. There was a particularly affectionate bond between David and Émélie; the portrait he now painted of her [15] is a delight and a revelation of gentle sensitivities rarely suggested in his work up until this time. The informality of the pose, the freshness of the

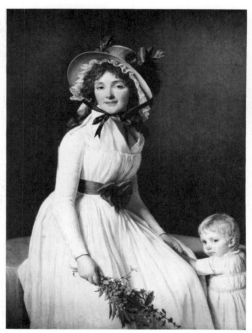

15 Jacques-Louis David. *Madame Sériziat.* 1795. Oil on panel, 4'3½'' × 3'1¾'' (1.3 × .96 m). Louvre, Paris.

color, the loving attention to engaging details of costume and the sweetness of the little bouquet of flowers—all are specific attractions but only partially account for something more elusive, a tenderness and human warmth, an intimacy of personal response between painter and subject.

The air of intimacy and informality is not accidental, for the picture is carefully composed. The placement of the child is masterly. In a more conspicuous position he would have detracted from the picture as David conceived it, since this is a portrait of Émélie Sériziat, not a picture of a mother and child. As it is, the child is very nearly crowded out of the picture, which would have been unpleasant if David had not turned the head so that we are regarded with open curiosity. The child seems almost to have slipped into the range of the picture by accident, without knowledge that he would be painted; he is held in perfect balance, neither detracting from the main subject nor altogether subjugated to it. The companion portrait of Monsieur Sériziat [16] is closer to Davidian formula, but not close enough for its precision to turn frigid.

The Sériziats were painted in 1795. Seventeen years later David painted a double portrait of his friend Antoine Mongez and his wife [17]. Like the Sériziat portraits, this one was a labor of love. It is inscribed "Amicos Antonium Mongez et Angelicam uxorem amicus Ludovicus David. Anno MDCCCXII."

The Latin is not an affectation but appropriate in a portrait of Mongez, the author of a scholarly dictionary of antiquities. His hand rests on this volume and also holds a coin, symbol of his function as an administrator in the government's department of finance. His wife Angelica had been a student of David; she costumed the figures for his mock-up of *Le Sacre* and executed minor passages in that gigantic picture. The Mongez portrait is more formal than those of the Sériziats but no less warm, and as a presentation of two rich personalities it even surpasses them. It is as if we are meeting the young Sériziats after a passage of years and a happy transition into middle age.

When Napoleon fell David was exiled. He finished his life in Brussels, working away at whatever assignments it pleased him to set himself, venerated by followers of the tradition he had established, the grand old man of French painting. In his youth, still competing for the *Prix de Rome,* he had painted *Mars Vanquished by Mi-*

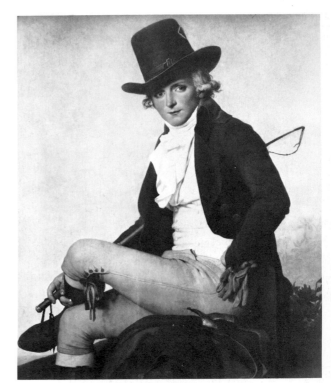

16 Jacques-Louis David. *Monsieur Sériziat*. 1795. Oil on panel, 4'2¾'' × 3'1¾'' (1.29 × .96 m). Louvre, Paris.

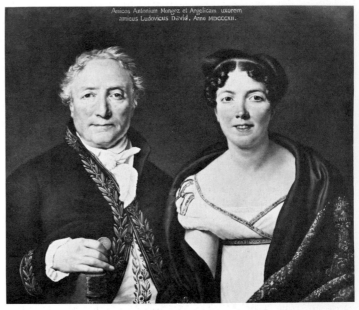

17 Jacques-Louis David. *Antoine Mongez and His Wife Angelique.* 1812. Oil on panel, 3'1¾'' × 4'6'' (.96 × 1.37 m). Louvre, Paris.

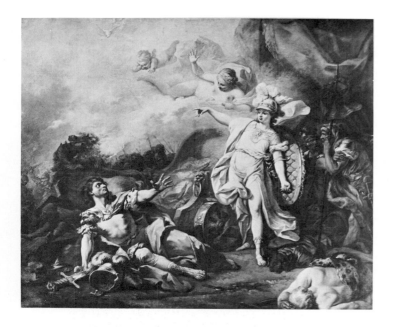

nerva [18]—the forces of violence and confusion conquered by the intellect. It is a windy picture, full of the kind of artificialities and mannerisms typical of the eighteenth century that David later annihilated with his classical style. His last work, completed in exile fifty-three years later, in 1824, the year before his death, is another version of the defeat of Mars [19]. In the early picture Venus floats nearby in support of Minerva, in the later one she replaces her. In *Mars Disarmed by Venus and the Graces* violence and confusion are conquered not by the intellect but by the heart. Cupid unbinds the sandals of the god of war, who, reclining upon a couch in what seems to be an Olympian boudoir, relinquishes his sword and shield to the Graces. Venus places a wreath of blossoms on his head; a pair of doves bills and coos on his muscular thigh. The picture is a little cloying, a little overgraceful. It may be an old man's revery, but it may be also his apology for the fanatic severity of his earlier convictions.

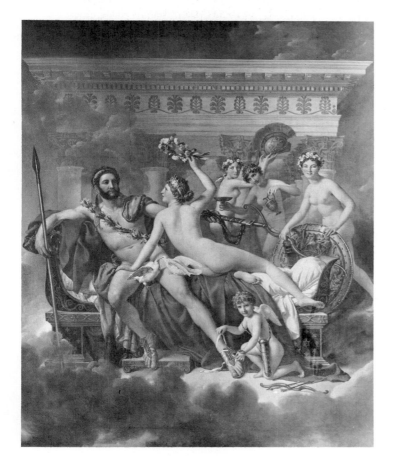

18 (Above, left) Jacques-Louis David. *Mars Vanquished by Minerva*. 1771. Oil on canvas, 3′9″ × 4′7″ (1.14 × 1.4 m). Louvre, Paris.

19 Jacques-Louis David. *Mars Disarmed by Venus and the Graces*. 1824. Oil on canvas, 9′10″ × 8′7″ (3 × 2.62 m). Musée Royal des Beaux-Arts, Brussels.

chapter 2

Early Classicism and Romanticism: England, Germany, and America

An American Pioneer: Benjamin West

Because the exhibition of *The Oath of the Horatii* happened to coincide sensationally with a crucial moment in the history of France—a nation that regarded art as part of the fabric of national life—we tend to think of the picture as the battle cry of neoclassicism. And in France *The Oath of the Horatii* was indeed just that, opposing its stylistic severity and high moral purpose to the caprice and artifice of the court painters. But in the overall history of art, *The Horatii* was the climax rather than the initial declaration of an international preoccupation with antiquity. It is true that classicism outside France never touched Davidian purity or intensity, but its most celebrated theorist was the German Winckelmann, and one of the earliest painters of neoclassical historical subjects was a provincial American youth who went to Rome and then to England, where he became president of the Royal Academy—Benjamin West (1738–1820).

Some twenty years before David completed *The Oath of the Horatii* in 1784, West was painting classical subjects of the type of *Cleombrotus Ordered into Banishment by Leonidas II, King of Sparta* [20]. While West's classical efforts do not approach the icy intensity and disciplined simplifications that are the essence of *The Oath of the Horatii,* and while they offer nothing

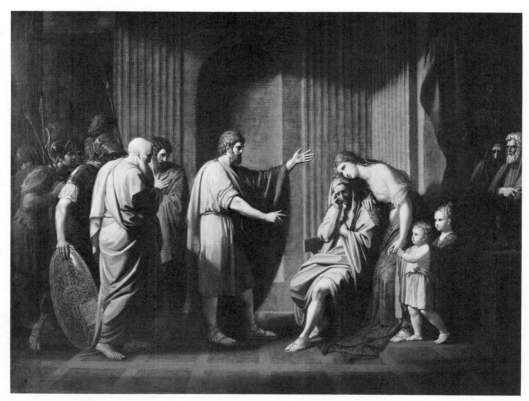

20 Benjamin West. *Cleombrotus Ordered into Banishment by Leonidas II, King of Sparta.* c. 1768. Oil on canvas, 4′6½″ × 6′1″ (1.38 × 1.86 m). Tate Gallery, London.

more than obvious sentiment where *The Horatii* is charged with moral force, they do frequently anticipate David's composition on a single plane suggestive of classical bas-reliefs, the precise definition of neoclassical draftsmanship, and the reference to classical models that were parts of David's sensational departure from French tradition.

Strictly speaking, West is not altogether an American painter. He was the son of an innkeeper near colonial Philadelphia but demonstrated such an early talent (he was painting portraits when he was thirteen) that a group of prosperous Philadelphians sent him to Rome to study. He was twenty-one years old at the time; David was still a boy of eleven. West was an attractive fellow with a flair for social showmanship that came to him as naturally as his talent for painting. A handsome man and a picturesque American claiming to have had his first painting lessons from wandering Indians who had shown him how they made colors from clay to paint their faces, he became the rage in Italian society; when he went to London three

years later he repeated his success. He remained an adopted Londoner for the rest of his life, a favorite of George III, a leader in the founding of the English Royal Academy and its second president. But if he was a Londoner by adoption and if he became an English painter in effect, he was an important influence on American painting because two generations of American students passed through his London studio. By the time David finally won his *Prix de Rome* (1774) West was an established London success, and by the time *The Oath of the Horatii* set a new direction for French painting and began the story of modern art, West at nearly fifty had virtually abandoned the nascent classicism of pictures like *Cleombrotus.*

West as Innovator

Except for those American writers whose judgments are affected by pride in a native son, critics have tended to condescend to West. It is true that his talents were exceeded by his success.

And it is true also that he does not emerge as a great intellect or even an especially brilliant and stimulating painter. But if he had painted in hardship and obscurity, his originality might have received more sympathetic emphasis than it has.

West made his English reputation with the exhibition in 1770 of *The Death of General Wolfe* [21], and, in 1772, of *Penn's Treaty with the Indians* [22], both innovational. *The Death of General Wolfe* is full of borrowings from a variety of sources, but it was a courageous departure from convention in representing a contemporary event in contemporary costume and factual detail at exactly the time when Sir Joshua Reynolds had formulated the Royal Academy's standards for the grand manner in painting, demanding reference to poetry or the past in-stead of to the present and generalization instead of particularization. If contemporary costume, as Sir Joshua contended, lessened the heroic impression of a painting in the grand manner, the loss in this case was more than made up by religious overtones: the dying general and the soldiers surrounding him are posed in a group that recalls the dead Christ and mourning saints of a Lamentation. In addition, the presence of an American Indian brave at the left was a novelty that heightened the picture's sensational reception. Europe was fascinated by stories of the Indians, who were sometimes regarded as exotic savages and sometimes as personifications of nature's nobleman, and young West was never averse to capitalizing on his personal association with these half-mythical beings.

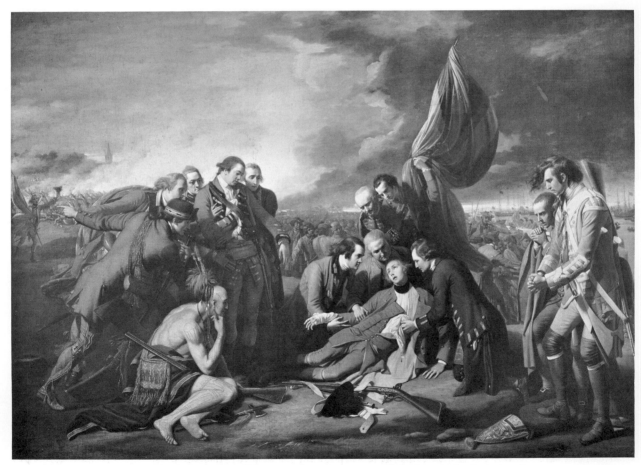

21 Benjamin West. *The Death of General Wolfe.* 1770. Oil on canvas, 5 × 7′ (1.52 × 2.13 m). National Gallery of Canada, Ottawa.

As for factual representation, West had minor historical precedents, but this was a major picture on the grand scale by a young man eager to maintain a position in academic favor. Again West anticipated David, who became the first Frenchman to approach a contemporary event in realistic detail when he relaxed the severity of his neoclassical idealizations to paint *The Oath of the Tennis Court.* David might even have known West's picture and the sensation it caused, since *The Death of General Wolfe* was such a success that it was engraved and widely distributed in France as well as in England.

If this left any question as to West's eminence, it was settled by the appearance of his *Penn's Treaty with the Indians.* *Penn's Treaty* follows the classical tenet that a painting should justify itself by propounding a moral truth or a lesson

(the same idea, of course, that David would apply with such force and intensity in his Stoic pictures). In *Penn's Treaty* the lesson is that conflict can be settled without bloodshed, but the lesson takes second place to the interest of the subject. The locale and the participants are sufficiently picturesque to approach genre painting, although West was only following his own precedent in presenting another recent historical event in appropriate factual terms rather than allegory. The dress of the Indians may not be entirely accurate, but it is as nearly so as West knew how to make it from Indian souvenirs in his own collection. The picture is cluttered in spots with distracting incidentals and there is a certain rather engaging naïveté about it. But it is an honest picture, more original than it looks today, and its virtues plus the

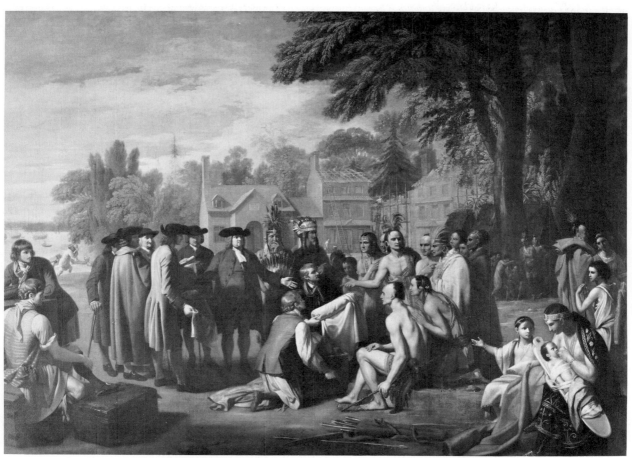

22 Benjamin West. *Penn's Treaty with the Indians.* 1771. Oil on canvas, 6′3½″ × 8′11½″ (1.92 × 2.73 m). Pennsylvania Academy of the Fine Arts, Philadelphia (Harrison Collection).

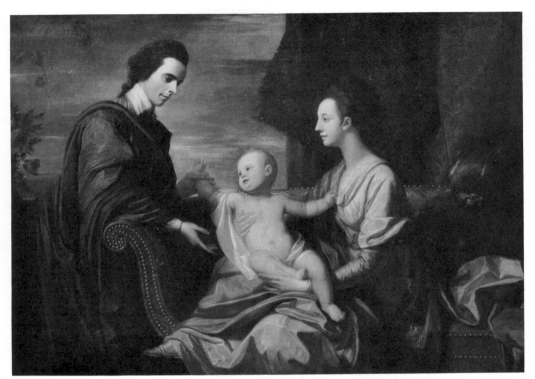

23 Benjamin West. *Arthur Middleton, His Wife and Son.* 1771. Oil on canvas, 3'8¾'' × 5'6'' (1.14 × 1.68 m). Collection Dr. Henry Middleton Drinker, Philadelphia.

exotic interest of its subject made it a tremendous success and established West in a career that never wavered for the rest of his life. Placidly enough, with no effort either to curry favor or to break new ground, West kept busy with portraits and murals, sometimes deadly dull and dry, sometimes of great charm, as in *Arthur Middleton, His Wife and Son* [23], where the straightforward representation of the attractive young man's features, the semiclassical idealization of his wife's, and the absurd artificiality of the baby combine to produce a piquant flavor probably unplanned by a painter who was following several conventions at once without pondering any of them very deeply. On the other hand, West's *Self-Portrait* [24] is perfectly consistent—a masterpiece of assurance without bravado, richly painted, altogether an impressive demonstration by an accomplished craftsman in a distinguished tradition.

Near the end of his life West's originality flared up again; he was nearly eighty when he painted the wildly romantic *Death on a Pale Horse,* exhibiting it in 1817. This was only two years before French romanticism declared itself

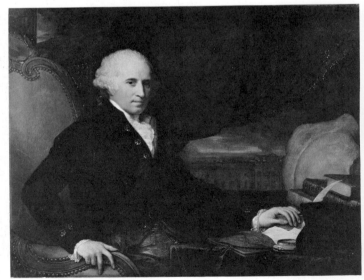

24 Benjamin West. *Self-Portrait.* c. 1795(?). Oil on canvas, 3'4''× 4'4½'' (1.02× 1.33 m). Royal Academy of Arts, London.

in the Salon with Théodore Géricault's *Raft of the Medusa* [73], a painting comparable as a romantic declaration to *The Oath of the Horatii* as a neoclassical one. But even earlier—seventeen years before the appearance of Géricault's romantic landmark—West had caused a flurry in classical Paris by exhibiting there a study for *Death on a Pale Horse* [25]. Where classical standards demand order, romantic ideals more often involve turmoil; against classical repose romanticism pits excitement; instead of classicism's precise definition, romantic forms may depend to one degree or another on suggestion—blazing lights and mysterious moods ranging from gentle revery to wild passion, from dejection to exaltation—whereas the classical canon demands the clear, steady light of sheer intellectual control even in treating emotional or violent subject matter.

Death on a Pale Horse exhibited all these romantic earmarks in the version Paris saw in 1802, in which year Géricault was only eleven and Eugène Delacroix, who was to become to French romanticism what David had been to classicism, was a toddler of three. The picture, we have said, created a sensation; if it had been a full-size Salon demonstration piece by a Frenchman it would no doubt have created a riot. But the French have never been able to take English painting quite seriously, and *Death on a Pale Horse,* while something of a show-stopper, was regarded as a fascinating but essentially isolated novelty within the more significant context of the ruling (that is, French) tradition.

With such a startling record as a forerunner of both neoclassicism and the romanticism that convulsed Paris a little later, why is West not fully recognized as the important figure that he is? The answer is that his work has neither quite the technical mastery nor anywhere near the intellectual and emotional concentration that must combine to create paintings of the absolutely first rank. Whatever his sensitivities to nascent classicism and nascent romanticism, West never explored these sensitivities deeply enough to carry them to a full expression of what was in the air. Even if he had, it is difficult to imagine either movement assuming in England the importance that both did in France. In England, painting had never established itself as a manifestation of national morals or policy. And if such response was unlikely in England it was impossible in America, as another American painter discovered about the time West was exhibiting *Death on a Pale Horse* in London.

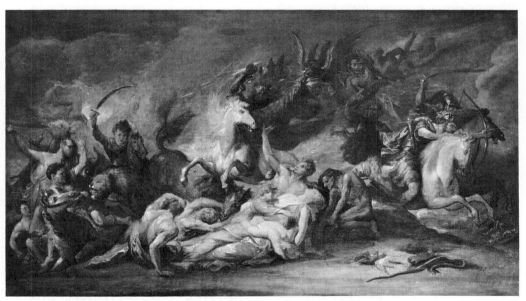

25 Benjamin West. Study for *Death on a Pale Horse*. c. 1787. Oil on paper, mounted on panel; 11½ × 22½'' (29 × 57 cm). Philadelphia Museum of Art (purchase, John D. McIlhenny Fund).

John Vanderlyn:
A Failure of Classicism

John Vanderlyn (1775–1852) was a long generation younger than West, and where West left America as a colonial subject, Vanderlyn grew up as an American citizen. But Vanderlyn adopted a tradition even more foreign to the taste of his own country; he went to Paris for five years in 1796 (as a protégé of Aaron Burr) and then for twelve more in 1803 and made a good Davidian classicist of himself. He returned to America with the tightest and purest example of neoclassical painting his country had seen, *Marius amid the Ruins of Carthage* [26]—which had been enthusiastically received in Paris—and the best-drawn nude, an *Ariadne* [27]. Neither painting was a success, nor was his circular panorama of Versailles. This was a tour de force of perspective painting that placed the observer directly in the center of the palace gardens, illusionistically surrounded by hedges, palatial architecture, and strolling ladies and gentlemen. To exhibit the three thousand square feet of canvas making up the panorama Vanderlyn had to build his own rotunda in New York, but

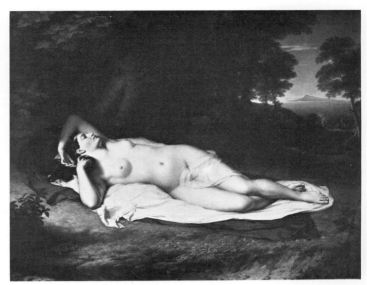

27 John Vanderlyn. *Ariadne Asleep on the Island of Naxos.* 1809–1814. Oil on canvas, 5'8'' × 7'3'' (1.73 × 2.21 m). Pennsylvania Academy of the Fine Arts, Philadelphia (Joseph and Sarah Harrison Collection).

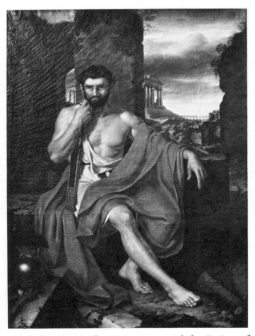

26 John Vanderlyn. *Marius amid the Ruins of Carthage.* 1807. Oil on canvas, 7'3''× 5'8½'' (2.21× 1.74 m). M. H. de Young Memorial Museum, San Francisco.

not even the novelty of the work appealed to Americans, perhaps because they had already been left cold by the *Marius* and deeply offended by Ariadne's nakedness. Vanderlyn never recovered from this defeat and died in obscurity, an American who had made a skillful French classical painter of himself only to fail to make the grade in his own country.

Part of the reason for the classical near-vacuum in American painting is that art in America began as an offshoot of art in England, where the neoclassical disciplines as seen in France never took root, at least not deeply. This is not surprising in England, but in America circumstances arose that might have been expected to favor at least a provincial version of French classicism. At the time of the American Revolution, when the new nation's bonds with France became so close, when it was engaged in a struggle and was then creating a government drawing philosophically on some of the same ideals that inspired French thought and French political struggle—at this time one might have expected a flourishing of Franco-American classical painting. But at first the new nation was too busy pulling itself together to have much time or money or energy left over for the arts, and then whatever roots French neoclassical painting might have established in

America were nipped, in the last decade of the eighteenth century, when American horror at the excesses of the Terror in France created an aversion to everything French. The didacticism of *The Oath of the Horatii* or the *Brutus,* which might have appealed to the strong moral sense of the young American republic, rang false as a background for the guillotine, and the Napoleonic career and legend did not offer substitute attractions.

In architecture the story was different: American faith in the column and pediment as a symbol of high moral and political ideals was never shaken by disillusion with European events. When Thomas Jefferson designed the state capitol for Virginia he went directly to the architecture of ancient Rome and adapted the well-preserved temple at Nîmes into a design of great sobriety and purity. In hundreds of other examples, American architects built some of the loveliest classical structures since those of ancient Greece. But when French neoclassical painting abandoned its moral preachments and became a stylish exercise in high polish and sensuous grace, it became altogether foreign to American taste. For along with their elevated moral standard the Americans developed a provincial prudery that could not tolerate the naked gods and goddesses—or the Ariadnes—who replaced the stalwart warriors and the chaste matrons of David's early pictures.

These are specific reasons for the failure of neoclassicism to catch on in a country where Europe still furnished the models for most ambitious painters. But the strongest reason of all was a general one: the new country was raw. No matter what comparative felicities of good living had been developed in such centers as Boston and Philadelphia, American patrons of the arts were not ready for the aesthetic sophistications of French painting. The most cultivated Americans were earthy and practical people compared with the dilettantes and the professional intellectuals who set the pace for the intelligent layman or amateur in France.

Early German Romantics

In truth, classicism as a disciplined philosophical ideal was "too severe to please for long" even in France, as David himself had lamented. His own followers were unable to pull themselves up to it by their bootstraps even when they wanted to. If we accept the evidence of painting alone, the nineteenth century was overwhelmingly a century of romantics who were often attracted by logic and common sense and often put great faith in the literal fact of nature and the world around them, but who always ended by yielding to emotion or sentiment even when they attempted to cast themselves in the roles of classicists or realists. Outside France, those painters who followed the classical formula most closely were the ones with so little intellect or imagination that a formula was necessary to them.

Among the dozens of German classicists who are all but forgotten, Gottlieb Schick (1776–1812) is better remembered than most. He produced some of the most tedious historical paintings of the century, but he also did the portrait of Frau Heinrich von Dannecker [28], the wife of a German sculptor, his teacher and

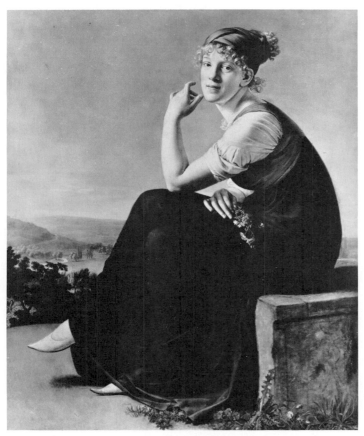

28 Gottlieb Shick. *Frau Heinrich von Dannecker.* 1802. Oil on canvas, 46¾ × 39½'' (119 × 100 cm). Nationalgalerie, West Berlin.

friend. The picture is full of the usual artificialities and it has the rather dry and mannered drawing that might be expected, but it is also full of unclassical exceptions—the ordinary weeds that spring casually around the base of the stone, the sweetness of the little spray of flowers held in one hand, the peaceful informality of the landscape in the distance, and of course above all the direct, realistic, individualized and sympathetic representation of the face, which manages to counteract the drawing-exercise affectation of the oversmooth, excruciatingly posed arm and hand beside it. It is reminiscent, in its engagingly awkward way, of David's exceptional portrait of Émélie Sériziat—which is not surprising since Schick passed through David's studio, even though briefly, as a student.

The romantic spirit was so pervasive that it transformed the classical vision of antiquity, emotionalizing a concept that was thought of as a rational one. The young Germans, Englishmen, Americans, and others who converged on Rome as the eighteenth century turned into the nineteenth discovered the ancient world as a dream of lost beauty. Their classicism became a nostalgic revery upon a golden past. They might borrow forms from Poussin, the great seventeenth-century classicist (as the young American Washington Allston did in his *Italian Landscape* [29]), but they transplanted them into a world where "perfection" was less a matter of perfection reached by distillation, less a matter of order and discipline than a dream of a paradise where the hazards and deteriorations and the evils and misfortunes of life were unknown. When the German Karl Friedrich Schinkel (1781–1841) painted an imagined *Greek City by the Sea* [30], the world he invented was not the closed and ordered one of the neoclassical ideal but a wonderful wide-flung land where pearly marble monuments rose undefiled from an undefiled landscape inhabited by men free from all vicissitudes moving beneath radiant skies. All this, of course, has remained a standard dream of Hellas; it is also romantic yearning, the romantic escape into the faraway. In Germany and America, painters soon abandoned all classical reference for a vision of unspoiled nature as a mystical and often a specifically religious symbol. When the works of man appear in these landscapes they appear as monuments in ruin; to contemplate the fragments of a vanished world, the romantic finds, is more

29 Washington Allston. *Italian Landscape.* 1805–1808. Oil on canvas, 3'3'' × 4'3'' (.99 × 1.3 m). Addison Gallery of American Art, Andover, Mass.

30 Karl Friedrich Schinkel. *Greek City by the Sea.* 1815. Oil on canvas, 2'11''× 4'3'' (.89 × 1.3 m). Nationalgalerie, West Berlin.

evocative of the past than is an effort to recreate it as it had actually been. Melancholy and desolation offer their own fulfillment.

Thus a ruined Gothic chapel in the snow [31] replaces the immaculate Greek temple bathed in sun; the broken trees surrounding it,

32 Caspar David Friedrich. *Two Men Looking at the Moon.* 1819–1820. Oil on panel, 11¾ × 17¼″ (30 × 44 cm). Staatliche Kunstsammlungen, Dresden.

31 Caspar David Friedrich. *Cloister Grave-yard in the Snow.* 1810. Oil on panel, 3′11⅝″ × 5′10″ (1.21 × 1.78 m). Formerly Nationalgalerie, West Berlin (now lost).

gnarled, black, and frozen, rise above the crosses and headstones of abandoned graves. Or in a darkling world two friends stand beneath a half-uprooted tree [32] where the forms of nature in disarray are silhouetted with all their grotesque accidents and haphazard tumbling against a moon-filled sky. This romantic contemplation of our aloneness and transience, this pondering of fate in full awareness that it is impossible for us to reach a conclusion as to its meaning or to place ourselves as a logical part of a universe scaled to our being, is of course pleasurable to the romantic temperament. Sometimes the romantic's world is a gentler one within which human beings may exist more placidly, sitting on rocks along the shore, for instance, while they watch a sunset or

moonrise over the sea [33], aware of solemn immensities but not of threatening mysteries. There may be comfort in desolation, warmth and even a certain protection in the acceptance of frailty and mortality. The romantics are content to be received into the universal mystery, absorbed into it without examining it. They abandon themselves to the idea that time and mysterious forces may shatter their works and consume their bodies yet at the same time must recognize their presence by the very inevitability of their inclusion within a system of laws beyond their comprehension.

French romanticism edged up to this conclusion but was never quite able to accept it. The pictures we have just seen by Caspar David Friedrich (1774–1840) have no parallels in French painting. Technically, they combine the sharp definition of classical draftsmanship with the contradictory subject matter of accident and decay; they make their emotional or mystical statement in terms that are pictorially didactic, where the French romantic painter freed the

brush to dash across the canvas in a way expressive of romantic excitement or agony.

Friedrich's Germanism was conscious. His twisted trees have their counterparts in German medieval painting, and his preoccupation with Gothic architecture came in part from his belief that it was an essentially Germanic expression. It is a cruel inconsistency that medievalism in architecture was to catch on while Friedrich's painting was repudiated by his contemporaries, especially those who were busy following French classicism as an academic formula.

Although the romantic spirit stirred earlier and more restlessly in Germany than it did in France, it somehow did not manage to come into full blossom in painting. Several factors combined to stunt it, including the early death of Friedrich's friend Philipp Otto Runge (1777–1810), who might have joined forces with him to establish a strong romantic tradition if he had not died at thirty-three. On his sickbed Runge destroyed much of his work, and even among the few examples he left, the ma-

33 Caspar David Friedrich. *Moonrise over the Sea.* 1823. Oil on canvas, 21¾ × 28″ (55 × 71 cm). Formerly Nationalgalerie, West Berlin (destroyed by fire, 1931).

jority are studies for large projects he was never able to complete. But from his few remaining pictures and from his letters and notes he emerges as a man who, as Delacroix was to do later on in France, could have imposed intellectual discipline on German romanticism yet who much more than Delacroix was a romantic in the most personal, emotional way.

Like Friedrich, Runge wanted to revivify German art, and he began by rejecting his own early classicism because "works of art show how mankind has changed, how a stage that has once appeared never reappears." How, then, he asked, could painters hold the "unhappy notion of wanting to revive the art of long ago . . . of recreating a past art?" Above all, he put his faith in innocence, in nature, and in love. His startling *Naked Infant in a Meadow* [34], its eyes wide with wonder at the world around it, is his symbol of the innocence with which he would have liked to perceive the universe. It is an arresting picture, whatever its flavor of absurdity for the uninnocent eye. If not passed over as a

34 Philipp Otto Runge. *Naked Infant in a Meadow*. 1808–1809. Oil on canvas, 12½ × 12″ (32 × 30 cm). Kunsthalle, Hamburg.

sentimental fantasy, it may take on a magical enchantment; it is difficult to forget.

Magic is present too in Runge's *Rest on the Flight into Egypt* [Plate 2, p. 53]. The tree over the Holy Child unexpectedly becomes an intertwining of infant angels and heavenly blossoms. At the extreme left, the ass grazes on thistly plants; the forms of his lowered head, his long neck, and the saddle chair with its drapery are silhouetted against the sky in foreshortened combinations naturalistic in detail yet fantastic in total effect. The landscape background is as meticulous as any of Friedrich's, but its mood is serenely joyful rather than sad or sinister. Runge held that subject painting, history painting, was a worn-out form and that painters who might have found themselves as landscapists had been hampered for two centuries because landscape was considered an accessory to subject rather than an independent means of expression. The revival of landscape painting in England and America, which we will see shortly, gives some support to this idea, and of course Friedrich carried it on in Germany after Runge's death. "How could a painter want for a subject," Runge asked, "when awakened to nature through what we see in ourselves, in our love, and in the heavens?"

The *Rest on the Flight into Egypt* is not first of all a religious picture in spite of its religious subject. Its air of miracle has more to do with the miracle of innocence and the miracle of landscape as a reflection of the soul. But a group of Runge's contemporaries who flourished just after his death sought a similar return to innocence by dedicating their art to religion. Founded in Vienna in 1809 as the *Lukasbrüder,* or Brotherhood of St. Luke, the group later adopted a name originally given them in derision—Nazarenes. Moving to Rome, they set themselves up as a religious brotherhood in a former convent. The Nazarenes hoped to find spiritual grace by returning to the style of the painters of the early Renaissance. This, of course, is putting the cart before the horse.

The Nazarenes insisted on exactitude in drawing just as Friedrich and Runge had done, but unlike them they imitated the past, attempting unsuccessfully to emulate old forms rather than referring to nature and inventing new ones. They ended as one of the most sterile groups in the history of painting anywhere, but their return to Christianity has some interest in early German romanticism. The most important

35 Washington Allston. *Jason Returning to Demand His Father's Kingdom.* 1807–1808. Oil on canvas, 14 × 20′ (4.27 × 6.1 m). Lowe Art Museum, Coral Gables, Fla. (gift of Washington Allston Trust).

of the Nazarenes was Friedrich Overbeck (1789–1869), but the one who eventually came into honors was Peter Cornelius (1783–1867), whom we will meet, aged seventy-two, in the Paris Salon of 1855.

An American Romantic: Washington Allston

While Friedrich with his broken trees and ruined cathedrals was trying to revive a German romantic tradition, an American one was established by a man who was his contemporary almost to the years of birth and death. Washington Allston (1779–1843) was also an immediate contemporary of the unhappy John Vanderlyn who so gallicized his art that when he came home with it he found himself a foreigner. Allston was more fortunate. Although he studied in London and in Paris in the Louvre, which had just opened, and in Rome, he never accepted any single tradition unquestioningly.* He was clear-headed, well educated, an inti-

mate of intellectuals in both England and America, not only capable of thinking for himself but quite determined to do so. He began with the expected dedication to classical antiquity; in Rome he painted and exhibited with Vanderlyn. We have already seen, in his *Italian Landscape* [29], that he reflected the romantic dream of the classical world. As a matter of fact Allston had the makings of a very respectable classical painter. In Rome he began a large classical subject, *Jason Returning to Demand His Father's Kingdom* [35], where exceptional control, precision, and clarity are suggested even though the picture is unfinished. When he left Italy in 1808 the canvas was boxed for shipment but he did not recover it until eight or nine years later. By that time Allston had grown dissatisfied with classicism and had already set himself a different kind of problem (and solved it) in a contrasting picture, *The Dead Man Restored to Life by Touching the Bones of the Prophet Elisha* [36], a subject of mystery and miracle. Instead of the classical friezelike grouping of forms arranged across the canvas from side to side and illumi-

* Allston (born in South Carolina) went to England in 1801 and studied under Benjamin West; in 1803 he went to Paris with Vanderlyn. From 1804 to 1808 he was in Rome; he knew Samuel Taylor Coleridge and Washington Irving among others there, and also

Vanderlyn again. In 1808 or 1809 he returned to America. Then from 1811 to 1818 he was in Europe once more, mostly in London. Thereafter he lived in Boston, where he had been a student at Harvard. He also published poetry and composed music.

36 Washington Allston. *The Dead Man Restored to Life by Touching the Bones of the Prophet Elisha.* 1811–1813. Oil on canvas, 13 × 10′ (3.96 × 3.05 m). Pennsylvania Academy of the Fine Arts, Philadelphia (purchase).

37 Washington Allston. *Moonlit Landscape.* 1819. Oil on canvas, 24 × 35″ (61 × 89 cm). Museum of Fine Arts, Boston (gift of William Sturgis Bigelow).

nated in a clear, uniform light, *The Dead Man Restored* is constructed of forms building upward through several levels, emerging dramatically from obscuring shadows. Allston's model was no longer the art of classical antiquity but the emotionalized painting of the Italian seventeenth century.

Allston became an example of that contradiction in terms, the rational romantic. In addition to a clear intelligence he had a quick intuitive response to the world. He respected this response, but was unwilling to let it run away with him. At this time considerable theorizing went on among painters about something called "primitivism" in not quite the same sense the word has today. It had to do with the artist's abandonment to his spontaneous reaction to nature as opposed to the "artificialities" of civilized life. Allston rejected this idea. The world is with us, and to deny our place in it as civilized beings contemporary with our own age is foolish and, for that matter, impossible. He preferred to be a part of his time and saw no reason why he should reject either it or the past. If he rejected anything, it was the skepticism of the eighteenth century, but he rejected it only as an extreme, and when he returned to religious subjects like *The Dead Man Restored,* he was re-establishing the legitimacy of the mystical, emotional, and hence romantic Christian tradition without denying the legitimacy of an analytical one. He saw no conflict between tradition and originality. The aim of the artist, he thought, was to be true to "that within man which is ever answering to that without, as life to life—which must be life and which must be true." Allston recognized intuitive response as a basis for creation, but he was wary of a distortion away from "truth," either in the direction of blind trust in intuition or excessive suspicion denying intuition's validity.

In his theorizing, Allston was part of a new coalescence in American thought. But all theorizing aside, his most satisfying pictures today, simply as pictures, are his moody landscapes. There is a great distance between his *Italian Landscape* [29] and his *Moonlight Landscape* [37] painted about fourteen years later, the year after his return to America. *Moonlit Landscape* is the progenitor, or at least one of the earliest examples, of a type of moonstruck romanticism filled with an agreeable loneliness, suggestive of our melancholy journey through the mysteries of life yet speaking comfortingly of our union

38 Albert Pinkham Ryder. *Death on a Pale Horse (The Racetrack)*. Oil on canvas, 28¼ × 35¼″ (72 × 90 cm). Cleveland Museum of Art (purchase, J. H. Wade Fund).

with the forces behind those mysteries, that has been recurrent in American painting. This minor but persistent tradition finds variation in the art of Albert Pinkham Ryder (1847–1917), a solitary and eccentric painter who may be introduced out of chronological order here since he was one of those painters whose art is essentially unconnected with time and place [38].

Allston's final divorce from his European models is indicated in another revery with the elaborate title *American Scenery: Time, Afternoon with a Southwest Haze* [39], painted after seventeen years of repatriation. The two earlier landscapes are fantasies, but in the later one the specific references to place, time, and even the kind of day are symptoms of a revolution in landscape painting that was already flourishing in the United States.

Where Allston and other idealists fabricated their landscapes or imposed a mood arbitrarily on a free variation of an existing one, a new

39 Washington Allston. *American Scenery: Time, Afternoon with a Southwest Haze*. 1835. Oil on canvas, 18½ × 24½″ (47 × 62 cm). Museum of Fine Arts, Boston (bequest of Edmund Dwight).

school of American landscapists was discovering mood and poetry as an emanation of the exact appearance of an actual scene. They were discovering American landscape as a new aspect of nature, not only scenically but psychologically differentiated from that of Europe. That they turned to American scenery for subject matter and transcribed its appearance in meticulous detail means nothing in itself except for whatever interest such representations have as factual record (which may be considerable); but that they felt and recorded new responses to landscape, and that these responses were peculiarly inspired by the American wilderness, meant that America had produced its first school independent of European inspiration. We will see these painters, the Hudson River School, in another chapter.

Two Individualists: Blake and Fuseli

Romanticism in general was a reaction against the rational thought of the eighteenth-century philosophers who made a cult of Reason. Romanticism had common bases wherever it appeared, but it also took on characterizing differences in the different countries in which it put down its deepest roots. In France, the individualizing element was a yearning for personal fulfillment through sensation, through exaggerated emotionalism, through violent or swooning passions. In Germany, by the evidence of Runge's naked infant, wide-eyed in the blossoming meadow of a wondrous world, the romantics were filled with a nostalgia for innocence. By the evidence of Friedrich's Gothic ruins and moonlit forests, romanticism was a search for union with mysteries that were doors to the supernatural. The revival of Christianity (which was not much more than a romantic fashion in France) was basic to German romanticism, because it supplied a God Who was beyond the formulas of Reason, Who demanded acceptance through the innocence of faith and manifested Himself through miracle.

In England there had already appeared a man who could have served Friedrich and Runge as a concrete example of their theoretical recipe for the purified human spirit. His name was William Blake (1757–1827). He was a poet and a painter, and he was an innocent—as innocent as a lamb from his cradle to his grave. He lived in intimacy with the supernatural, for angels spoke to him from the branches of trees, and he accepted their shining miraculous presence as a part of his life. He was a benign eccentric to the point of madness. But the brooding, nostalgic melancholy of German romanticism was never a part of Blake's art. He was fulfilled within the areas of the soul—innocence and miraculous experience—that the Germans could only look back upon as lost. Reason had corrupted them; they might cultivate innocence, but the cultivation of innocence is a contradiction on the face of it. They might theorize about the supernatural, but the supernatural, on the face of it, is self-generated and cannot be materialized by any amount of theorizing. Blake was temperamentally immune to these frustrations. His art is lyrical, joyous—a paean.

Blake is a precursor or a very early member of the romantic movement by this description, and he might be called a rebel against academic classicism because he constantly fumed and fulminated against Sir Joshua Reynolds (head of the British Royal Academy, whom he called Sir Sloshua) and his "gang of hired knaves." But one cannot help but feel that Blake would have painted, believed, and behaved as he did no matter when he had been born, or where, and that his appearance at the beginning of the romantic movement is only an accident of chronology. And he had virtually no influence on painting until the romantic movement had matured and been replaced by other revolutions. For that matter, his influence even now, when he has become the deity of a solid, enduring cult, is vague and more closely connected with literature and bibliophilia than with painting. If he had never painted a picture, his

> Tyger, tyger, burning bright
> In the forests of the night

would atone for the loss of his pictorial images. The poem is the most vivid single picture he ever created.

Blake was apprenticed to an engraver at fourteen, and from that time on he painted and drew as a corollary to literature. All his work depends on its literary source; it is first poetry—including his own, Dante's, and the Bible's—and second pictorial art. He held to the idea that a dream or a vision was not a shadowy nothing but should be represented in terms more concise than those of the visual world, and he ap-

plied this idea consistently in translating words into his swirling, bending, twisting compositions. His forms, derived from Michelangelo and Raphael, are of the utmost clarity of definition, and his swirling, bending, and twisting arrangements are controlled in every detail of their movement. As a pictorial artist he is a draftsman rather than a painter. The majority of his paintings are watercolors by definition, but tinted drawings in fact.

Blake produced illuminated editions of his own poetry in a technique he evolved for himself, a printing method not far removed from hand coloring. He was poor all his life, but he would not accept patronage, in the custom of the day, because patronage was likely to involve compromise. He had a saint of a wife, Kate—an adoring, good, simple woman who accepted him at his own face value and probably kept not only his body and soul but his soul and his sanity together. In the last decade of his life he attracted a small group of disciples, headed by John Linnell (1792–1882), who was thirty-five years younger than Blake, and they obtained commissions for him to illustrate, among other texts, the Book of Job [40] and Dante's *Divine Comedy* [41]. These illustrations may be the finest expressions of his eccentric genius.

The disciple Linnell was a landscape painter who did extremely pleasant, sometimes moody, pictures of the English countryside as well as some portraits and biblical subjects. But Samuel Palmer (1805–1881), who studied with Linnell and through him was drawn into Blake's small, late circle, was a painter of great imaginative originality, unaccountably neglected today except by a few enthusiastic supporters. His tiny etchings [42] and his compact paintings [43] where a pastoral world is made half-visionary by lights sometimes spectral, sometimes golden, are the one extension of Blake's fantasy into the realm where English romanticism was finding its typical expression—landscape. Palmer was only twenty-two when Blake died at seventy, so he belongs to the middle of the nineteenth century while Blake belongs to its transition from the eighteenth. In his late work Palmer lost much of his imaginative power when he failed to assimilate the influence of another imaginative genius, Turner. Turner was in midcareer at the time of Blake's death, and we will see him shortly.

The only other artist of importance who is thought of as a sympathetic colleague of Blake

40 William Blake. Illustration for the Book of Job. 1825. Engraving, 7¾ × 5⅞'' (20 × 15 cm). Philadelphia Museum of Art (gift of Staunton B. Peck).

41 William Blake. *The Whirlwind of Lovers,* illustration for Dante's *Inferno,* Canto V. 1827. Engraving, 10⅞ × 13⅞'' (28 × 35 cm). National Gallery of Art, Washington, D.C. (Rosenwald Collection).

42 Samuel Palmer. *Opening the Fold*. 1880. Etching, 4⅝ × 7″ (12 × 18 cm). Philadelphia Museum of Art (William S. Pilling Collection).

43 Samuel Palmer. *Coming from Evening Church*. 1830. Oil on canvas, 11⅞ × 7⅞″ (30 × 20 cm). Tate Gallery, London.

is Henry Fuseli (1741–1825), born Johann Heinrich Füssli, a Swiss who moved to London at the age of twenty-four. (Four years earlier he had taken holy orders, but never practiced as a priest.) Fuseli was a strange and contradictory personality who appears in the guise of a confirmed classicist, an eccentric romantic, a rational intellectual, a wit, a scholar, or any combination of these according to which of his paintings or drawings we are looking at. Blake, who once wrote that Fuseli was "The only Man that e'er I knew / Who did not make me almost spue," was at one pole of Fuseli's close friends, with Blake's bête noire Sir Joshua Reynolds at the other. In between were social radicals whose causes he espoused and conservative patrons of the Royal Academy, where he was elected Professor of Painting. Among his aphorisms, published as a book, are "Fashion is the bastard of vanity dressed by art" and "Art among a religious race produces reliques; among a military one, trophies; among a commercial one, articles of trade"—an observation pertinent today, when some critics feel art has indeed become "articles of trade" serving a consumer culture.

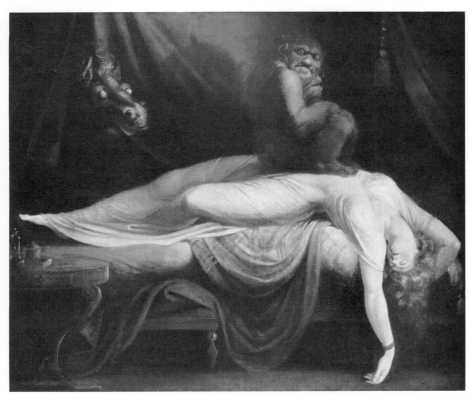

44 Henry Fuseli. *The Night-mare.* c. 1780–1790. Oil on can-vas, 3'4'' × 4'2''(1.02 × 1.27 m). Detroit Institute of Arts.

Fuseli is best known as a fantasist on the score of a subject he repeated several times, a nightmare of erotic demonism in which a young woman, surmounted by a curious ape-like creature and menaced by a leering horse with blazing eyes, swoons upon a couch in what seems to be a fit of sexual abandon [44]—a charade that has endeared Fuseli to contemporary painters of psychopathic subjects. But Fuseli in no circumstances can be thought of as a vision-ary or mystical painter of the kind Blake was, even though his unbounded range of interests included the metaphysical speculations of the Swiss theologian and mystic Johann Kaspar Lavater. Fuseli's fantasies are not visionary but essentially literary in conception; *The Night-mare* is no more "visionary" than another Eng-lish contribution to the art of romantic terror by one of his close friends, Mary Wollstonecraft Shelley's *Frankenstein.* In a direct literary con-nection Fuseli drew upon Shakespeare, who has never been called a visionary writer, capital-izing on the ghoulish, macabre, or ghostly as-pects of such subjects as the witches in *Macbeth.*

Fuseli spent the years 1770–1778 in Rome, where he apparently knew everybody in the

45 Henry Fuseli. *Fuseli Visiting Sergel's Studio in Rome,* 1770–1778. Pencil, pen, and brown wash. National Museum, Stockholm.

crowded international artistic colony. One of his drawings from those years [45] shows him visiting the studio of the determinedly neoclas-sical Swedish sculptor Sergel, who is at work on

46 Henry Fuseli. *The Artist Moved by the Grandeur of Ancient Ruins.* 1778–1780. Pencil, pen, and wash. 16 × 14″ (41.5 × 35.5 cm). Royal Academy of Arts, London.

a large marble. Fuseli was not exactly a great draftsman, but his drawings—there are more than 800 of them—are so lively and so personal, no matter what their subjects, that their technical imperfections become part of their attraction, much as faulty syntax can be engaging in a sprightly conversationalist.

Fuseli is the extreme example of the ambivalence of the terms *classic* and *romantic.* If he studied Lavater, he also translated Winckelmann's *Reflections on the Painting and Sculpture of the Greeks* (1765). He revered antiquity, but the giveaway is inherent in a drawing done at the end of his stay in Rome, or just afterward, *The Artist Moved by the Grandeur of Ancient Ruins* [46], where a figure nude except for a light cloak thrown back over his shoulders

mourns beside a colossal marble left foot and right hand—fragments of an imagined supercolossal Olympian Zeus. The mood is wildly, unabashedly, uncompromisingly romantic; the artist is stirred emotionally rather than inspired intellectually; he broods upon vanished grandeur and weeps for it, filled with the pleasurable sorrow with which the romantics dwelt upon lost pleasures, lost beauty, and lost love.

Virtually all the sculptures and paintings that we have been seeing were done during David's lifetime (1748–1825).* Fuseli's romantic lament for the ancient world dates from the years when the young David was first absorbing neoclassical doctrines as a *Prix de Rome* winner in that city; by the coincidence of dates, its romanticism is almost like the curse of an evil witch at the christening of a royal child.

It is well to keep in mind what was happening outside France and to compare dates occasionally, since the history of art in that art-minded country is so self-contained and makes such an eventful, continuous story that the temptation is always to use that story as a main theme to which the arts in other countries become addenda. It is true that, since the early eighteenth century, art movements have had a way of coming to their climax in France, but the movements themselves originated as international responses to changing ideas that were common to art throughout Europe and America, no matter with what local differences. In a political parallel, the French and American revolutions—for all their differences—were inspired by a common basic ideal.

David's classicism was the climax of a movement—and after a climax the rest of the way, by definition, is down. When he said that his ideals were too severe to last for long in France, David could also have said that they were too severe ever to have coalesced elsewhere. The breakdown of Davidian classicism under the stress of romantic impulses inherent in the times was occurring in France during the same years that we have been following the interactions of classicism and romanticism in Italy, England, Germany, and America.

Remembering this, we may now return to classicism's crumbling bastion in Paris.

*The exceptions: the two Matthew Palmers, the late Allston landscape, Blake's *Whirlwind of Lovers* (only two years after David's death), and, of course, the out-of-sequence Ryder.

chapter 3

The Failure of Davidian Classicism

David's Followers

No painter of comparable eminence during his lifetime stands more alone than Jacques-Louis David when we see him, his contemporaries, and the second generation of French neoclassical painters in retrospect. There were dozens of French painters who mastered the demanding technique that David developed as appropriate to the expression of the moral and philosophical goals of his art—but not one of them understood those goals.

His contemporary rival was a man seldom thought of today, Jean-Baptiste Regnault (1745–1829),* who won the *Prix de Rome* in 1776, two years after David. Unlike David, who was suspicious of antiquity until Rome "removed the cataracts" from his eyes Regnault was dedicated to classicism from the beginning, but only in its superficial aspect as a storehouse of graceful forms. He remained a painter of the eighteenth-century court style with all its seductive posturings. In his *Three Graces* [47], as a single example, he borrows an arrangement directly from a popular and often-repeated piece of classical sculpture, but the luscious girls he paints are classical in pose only; otherwise they remain the little courtesans and coquettes popularized by the eighteenth-century court painter Boucher [295].

The second generation of classicists paid brush-service to the master, imitating his technical polish without understanding the philosophical intention behind it. This was true even of David's favorite pupil, François Gérard (1770–1837). At sixteen Gérard was studying in David's studio, and David remained his sponsor from then on. For a while he gave up painting when David succeeded in getting him named a member of the Revolutionary Tri-

*Not to be confused with Alexandre Regnault (1843–1871).

47 Jean-Baptiste Regnault. *The Three Graces.* 1799. Oil on canvas, 6'6¾'' × 5'1¼'' (2 × 1.53 m). Louvre, Paris.

bunal; it is difficult to think of Gérard in this capacity after acquaintance with his sugary *Psyche Receiving the First Kiss from Cupid* [48] or for that matter any of his other pictures. It is customary to deny virtues of any kind to Gérard, as if his art were entirely detestable, and it is true that in comparison with David's strength Gérard's affectations are appalling. But if the standard of judgment is shifted to that of the fashionable exercise, which is Gérard's proper level, he is at the top of his field.

Gérard's reputation during his own time was so inflated that critics ever since seem to have been trying to cut him down to size. He had a series of brilliant Salon successes, of which *Psyche Receiving the First Kiss from Cupid* was the climax. He painted Napoleon's family and leading dignitaries. After Napoleon fell and David was exiled, Gérard continued his dazzling career. The statesman Talleyrand presented him to Louis XVIII, the restored Bourbon, and he became the favorite painter of the court and the world surrounding it. In 1819 he was created a baron. His father, a Frenchman, and his mother, an Italian, had been servants before the Revolution.

Whatever his shortcomings as a philosophical moralist or an intellectual classicist, Gérard is a tower of strength in comparison with his immediate contemporary Pierre-Narcisse Guérin (1774–1833), a pupil not of David's but of Regnault's. Another *Prix de Rome* winner, Guérin made an exaggerated success in the Salon of 1799. The Royalist party interpreted his picture of *Marcus Sextus Returned from Exile* as a symbol of the return to France of the emigrés who had left during the Revolution, a stroke of luck. Among biographies of successful men, Guérin's is refreshing, because he was a lazy student who had not been interested in becoming a painter in the first place. Whether he ever became much of one is open to question, but everything fell into his lap, including finally the directorship of the Academy's school in Rome. *Phaedra and Hippolytus* [49, p. 46], imitating David's spareness and precision, shows how well Guérin learned to go through the classical motions and how little connection he had with the classical spirit. *Phaedra and Hippolytus* is not so much a painting as it is a scene from a drama performed by some of the most incompetent actors ever to have become involved in a

48 François Gérard. *Psyche Receiving the First Kiss from Cupid.* 1798. Oil on canvas, 4'4'' × 3'6½'' (1.32 × 1.08 m). Louvre, Paris.

49 Pierre-Narcisse Guérin. *Phaedra and Hippolytus.* 1802. Oil on canvas, 8′5¼″ × 11′7¾″ (2.57 × 3.55 m). Louvre, Paris.

classical tragedy. Yet from Guérin's studio came two of the most important painters of the century, Géricault and Delacroix, as well as many incompetent painters of less importance who are secure enough in their small niches.

Finally, one man, Pierre Paul Prud'hon (1758–1823), is in nineteenth-century classicism that anomaly which turns up in every school: the painter of talent and originality who was accepted by the school yet seems to bear no relationship to it. While the other classicists were sharpening their lines to razor-edge precision and polishing their forms to tinny brilliance, Prud'hon developed a style based on soft, yielding volumes emerging from and melting into smoky shadows, a style derived from Leonardo da Vinci and, even more, from Correggio, although these late-fifteenth- and early sixteenth-century Italians were not much in classical favor. Prud'hon was an enthusiastic user of the new bitumen pigments, which gave wonderful velvety depth to shadows. As it turned out, these pigments blistered, cracked, darkened, and peeled with age, hence many of

50 Pierre Paul Prud'hon. *Justice and Divine Vengeance Pursuing Crime.* 1808. Oil on canvas, 7′11¾″ × 9′7″ (2.43 × 2.92 m). Louvre, Paris.

46 *The Failure of Davidian Classicism*

Prud'hon's canvases are indecipherable in part. His best-known painting, *Justice and Divine Vengeance Pursuing Crime* [50], is a ghost of itself but still suggests the moody poetry, a little forced sometimes, that marked Prud'hon at his best. Slightly younger than David, but within his generation, Prud'hon was befriended by David during a difficult, unsavory, and emotionally disturbed life.

Prud'hon's drawings are often more satisfying than his paintings. As an example, a nude study in black and white chalk on gray-blue paper [51] combines sound formal description with the effect of soft, spreading illumination he cultivated. Perhaps his paintings had more of this quality before they deteriorated; or perhaps the drawing is more successful than the paintings ever were simply because Prud'hon's talent was not strong enough to encompass more ambitious conceptions.

Sculptors in Rome

By Davidian standards of Stoic control and high moral purpose, neoclassical sculpture from the beginning was as faulty as the post-Davidian

51 Pierre Paul Prud'hon. *Bust of a Female Figure.* c. 1814. Black and white chalk on blue-gray paper, $11 \times 8\frac{5}{8}''$ (28 × 22 cm). Collection Henry P. McIlhenny, Philadelphia.

52 Jean-Antoine Houdon. *Thomas Jefferson.* 1789. Marble. Museum of Fine Arts, Boston (George Nixon Black Fund).

paintings we have just seen. Finding no David to discipline it, sculpture followed the same speciously classical formula of prettiness and high polish. It is true that the eighteenth century's great sculptor, Jean-Antoine Houdon (1741–1828), continued to work well into the nineteenth, but he remained a man and artist of the Age of Reason whose portrait busts, like the one of Thomas Jefferson [52] done in the year of the Revolution, are brilliantly incisive revelations of character having little to do with the formulas of classical idealism. Charm rather than strength characterizes the best examples of French neoclassical sculpture. An example is a bust of Madame Récamier (who never tired of commissioning images of herself) by Joseph Chinard (1756–1813), where sensitive modeling brings life to classically derived elements of the kind that were worked to death in the majority of cases [53, p. 48].

Not Paris but Rome, with its collections of antique statues as inspiration, was the natural center for an international revival of classical sculpture. Among dozens of other foreigners who maintained studios there was one who might have become sculpture's David if his work had lived up to his theories—the pedantic Dane Bertel Thorvaldsen (1770–1844). Thorvaldsen was, if anything, too respectful of

53 Joseph Chinard. *Madame Récamier*. 1802–1805. Marble, 31¼ × 15⅝ × 11¾″ (80 × 40 × 30 cm). Musée des Beaux-Arts, Lyon.

his sources: in spite of his direct study of early Greek sculpture (which included the restoration of the recently excavated statues from Aegina, destined for the Munich Glyptotek), and in spite of his conscientious effort to achieve the noble simplicity and calm grandeur demanded by Winckelmann (we have mentioned Winckelmann's definition of beauty as synonymous with perfection), Thorvaldsen's simplified, perfected forms have a way of looking as if they had been overcleaned by sandblasting that destroyed any interesting subtleties the forms might originally have had. His *Cupid Received by Anacreon* [54] illustrates the song in which the poet tells of giving shelter from a storm to the boy god, who, while the old man dries and warms him, slyly strikes a dart into his breast. The trouble is that Thorvaldsen has been so preoccupied with incidental archeological paraphernalia such as the lamp, brazier, harp, pitcher, and lion skin that the literally central motif—the dart—all but disappears. No emotion of one kind or another is evident in either

the stances or the faces of the ennobled poet or the prettified boy—which is carrying the principle of classical reserve beyond the point of diminishing returns. Classical reserve in antiquity was anything but the frozen beauty Winckelmann confused with classical perfection. Greek sculpture of the period Thorvaldsen admired could be filled with passionate energy at no expense to purity, as evidenced in the sculptures from another great pediment that fortunately escaped his restorations [55]. (His restorations of the Aegina sculptures have now been removed.)

Objections of this kind, however, are made by hindsight. In his own day Thorvaldsen was immensely successful and universally admired, second in reputation only to Antonio Canova (1757–1822). Canova's was one of the great careers in the history of art, with England, France, Russia, Austria, and America among his conquests as well as Italy, where he was hailed as the redeemer of his country's lost preeminence in the arts. By any standard Canova was a supreme virtuoso; by recent standards of excellence he has seemed even too virtuosic, content to astonish by his magicianship in the carving of marble rather than to offer any significant content beneath his theatrical surfaces. But by one of those pendulum swings that keep the history of art in flux, Canova is beginning to be seen again as a true artist who invested the neoclassical ideal with a personal variation as valid as it is seductive. His most famous statue is the semi-

54 Bertel Thorvaldsen. *Cupid Received by Anacreon*. 1823. Marble, 19 × 27⅜″ (49 × 70 cm). Thorvaldsen Museum, Copenhagen.

55 *Lapith Woman and Centaur,* from west pediment, Temple of Zeus, Olympia. c. 470–456 B.C. Marble. Archeological Museum, Olympia.

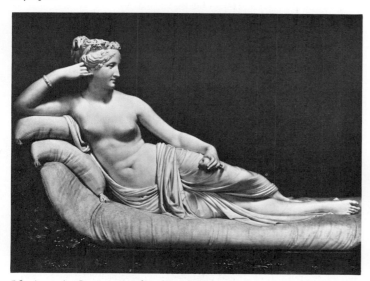

56 Antonio Canova. *Pauline Bonaparte as Venus.* 1808. Marble, life-size. Borghese Gallery, Rome.

nude portrait of Napoleon's scandalous sister, Pauline Bonaparte Borghese, as Venus Victrix [56], which may be the epitome of neoclassical grace in the service of sexual allure.

Confronted by a more difficult subject, Napoleon's not very attractive mother, Canova performed with equal skill. At about the time of Napoleon's coronation in 1804, Letizia Ramolino Bonaparte commissioned a portrait statue of herself. Four years later she presented the completed marble [57] to her son with the expecta-

tion that it would be placed facing his throne in the Tuileries. Napoleon promptly put it into storage instead, but his decision could not have been justified on aesthetic grounds. The statue is a superb translation of a Napoleonic subject into terms echoing the Roman Empire, a superior example of exactly the kind of art and decoration with which the self-created Emperor—with David's help—was intent upon surrounding himself. Letizia, costumed as a Roman matron, is posed in an attitude derived from an antique statue of Agrippina. But rather than being a dried-out copy, which could have left the subject seemingly embalmed in the past, the figure is remarkable for its relaxation, invested with a living quality achieved by very few sculptors who revered the art of antiquity as Canova did. It may not be fair to pit a sculpture against a painting, but David's portrait of "Madame Mère" in *Le Sacre,* which we have seen, is a bedizened effigy by comparison.

In contrast with Thorvaldsen's admiration for the austerity of early Greek sculpture, Canova was attracted to the sensuousness of Hellenistic statues. His "classical" influences for that matter were frequently secondhand; he was as strongly influenced by the sculptures of Bernini [531] as by the antique sculptures that had influenced this seventeenth-century baroque

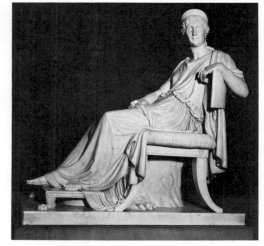

57 Antonio Canova. *Letizia Ramolino Bonaparte (Madame Mère).* 1808. Marble, 4′8½″ × 4′8½″ × 2′1¾″ (1.45 × 1.45 × .66 m). Devonshire Collection, Chatsworth (reproduced by permission of the Trustees of the Chatsworth Settlement).

master. But whatever his sources, Canova una-
bashedly extracted from them the full potential
of their physical allure. His *Perseus Holding the
Head of Medusa* [58] is openly derived from the
famous Hellenistic *Apollo Belvedere* [59], which
was the most admired example of antique
sculpture in Rome, but the *Perseus* is much
more than an imitation. Sensing the almost ef-
feminate appeal of a boyish Apollo convention-
ally admired for a manly nobility it did not pos-
sess, Canova, in his special way, perfected his
source by making the most of its rather per-
verse theatricalism.

The most meager survey of international
neoclassic sculpture would have to include,
among others, the vigorous German Johann
Gottfried von Schadow (1764–1850), the melan-
choly Swede Johan Tobias Sergel (1740–1814),
and the sensitive Englishman John Flaxman
(1755–1826), all of whom worked in Rome at
one time or another. But we must content our-
selves here with a note on America's most fer-
vent neoclassicist, Horatio Greenough (1805–
1852), a Bostonian who decided during his stu-
dent days at Harvard to become a sculptor and

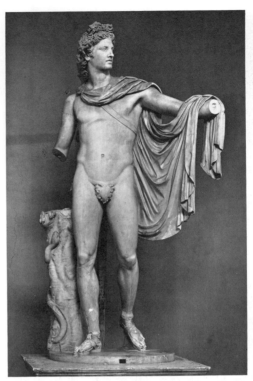

59 *Apollo Belvedere.* Roman copy after Greek
original of late fourth century B.C. Marble,
height 7'4'' (2.24 m). Vatican Museums, Rome.

upon graduation went to Rome—he was twenty
years old—to study with Thorvaldsen. Thor-
valdsen's inflexible and simplistic conception
of the classical spirit is reflected in Green-
ough's most ambitious project, a colossal statue
of George Washington for the new national
Capitol, monumentally classical in style, in Wash-
ington [60].

Classicism occupied a special place in Ameri-
can intellectual circles in the early nineteenth
century. The monumental style and scale of the
new Capitol, unprecedented on this continent
and the equal of some of the greatest buildings
in Europe, were intentional declarations that
the new nation was no backwoods settlement.
Nothing but an equally monumental sculpture
of George Washington would do when Con-
gress voted appropriations for a statue to be
placed in the Capitol Rotunda; it was an addi-
tional reason for pride that a native son was
capable of executing it.

In what now seems an excess of classical ref-
erence, Greenough conceived his figure of the
father of his country in terms of the supreme

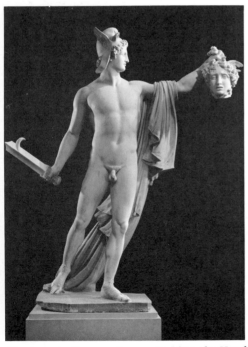

58 Antonio Canova. *Perseus Holding the Head
of Medusa.* 1800. Marble, height 7'2⅝'' (2.2 m).
Metropolitan Museum of Art, New York
(Fletcher Fund, 1967).

60 Horatio Greenough. *George Washington.* 1832–1841. Marble, height 11′4″ (3.45 m). National Collection of Fine Arts, Smithsonian Institution, Washington, D.C. (transfer from U.S. Capitol).

deity of the ancient Greeks, modeling it after the fifth-century-B.C. Olympian Zeus of Phidias—with, perhaps, some regret that he could not represent Washington with the Greek god's luxuriant beard. When the statue (carved by Italian craftsmen after Greenough's plaster model) was installed in the Rotunda, it delighted American literary and other intellectual circles, but the general public was puzzled and disappointed. Washington had been dead for only forty-two years; about half the population of the United States—the middle-aged and aged—could remember Washington as a living hero. He was not yet a legend for anybody, and it was disconcerting to find this man, whom they had always thought of as a human being who moved among other human beings, posing naked to the waist to display a magnificently muscled torso. Time has proved that in this case the public was right. The portrait head seems to be attached incongruously to the symbolic body, and Greenough's *Washington,* although it occupies a secure place in the history books, has come to be regarded less as a work of art than as a colossal curiosity in the field of Americana.

Canova, the great man of neoclassical sculpture, had been dead for nineteen years by the time Greenough's combined tribute to Zeus and Washington was completed, and a second aesthetic revolution in Europe—the full-fledged romantic movement—had challenged and undermined the authority of the classical establishment. The *Washington,* then, was not only conservative but somewhat retardataire by European standards. We may now drop back, chronologically, to continue the story of painting in France, where the romantic spirit first declares itself in classical disguise.

chapter 4

The Flowering
of Romanticism

The Romantic Spirit

Classicism's assumption of the existence of a perfect order, hidden but discoverable beneath the chaos of human experience, is not often justified by the world around us and certainly was not justified by the succession of events in France for several decades after 1789—the tumult of the Revolution, the hysteria of the Terror, the bloody grandeur of Napoleon's triumphs, the shattering disillusion after his fall, and all the subsequent corruption and dissension. Yet classical artists continued to put a premium on balance, precision, and rule in a world that was lopsided, confused, and unpredictable. The romantics would have none of their outworn formulas.

David's art had been an expression of eighteenth-century philosophy that deified Reason, but the century had also produced a philosopher who gave the romantics a different point of departure: Jean-Jacques Rousseau (1712–1778), who preached a return to nature, the essential goodness of simple people and the rights of the individual. It is only a step from Rousseau's idea of natural nobility to the idea that our untrammeled emotions, our instincts "in the raw," are merely sterilized, not refined, by the classical process of intellectualization. The romantics took this step. The classical artists and philosophers had tried to stand aside from human experience to see it in breadth and to discover a serene harmony within its confusions. The romantics refused to stand aside; they plunged into the midst of experience to savor its contradictions, and when the world was too much for them, when their battered souls demanded surcease, they found it not in the contemplation of synthetic order but in imagined worlds of curi-

Plate 1 Jacques-Louis David. *The Oath of the Horatii*. 1784. Oil on canvas, 4′3¼″ × 5′5⅝″ (1.3 × 1.66 m). Toledo Museum of Art (gift of Edward Drummond Libbey).

Plate 2 Philipp Otto Runge. *Rest on the Flight into Egypt*. 1805–1806. Oil on canvas, 3′2½″ × 4′4″ (.98 × 1.32 m). Kunsthalle, Hamburg.

Plate 3 Anne-Louis Girodet-Trioson. *The Entombment of Atala*. 1808. Oil on canvas, 6'11¾" × 8'9" (2.13 × 2.67 m). Petit Palais, Paris.

Plate 4 Eugène Delacroix. *The Lion Hunt*. 1861. Oil on canvas, 30 × 38½" (76 × 98 cm). Art Institute of Chicago (Potter Palmer Collection).

ous and exotic invention. Like the classicists, the romantics haunted Rome. But to the romantic eye, the ruins of the ancient world were not reminders of Reason but of mortality. Choked by vines and grasses among the crumbling stones, the broken monuments of antiquity became settings for melancholy revery, for trysts, for episodes of sweetness or of violence. For the romantic, even the classical world was fodder for emotional yearnings.

Yet—was not the neoclassical attitude toward antiquity only a less fervent manifestation of the same idea? Antiquity as envisioned by Benjamin West (and his forebears) on through the most devoted followers of David was after all an invention, an imagined world, a dream of an ideally ordered society that had never existed. By one way of thinking, neoclassicism, rather than being an independent movement, was an integral part of the early years of a romantic ferment that was perceptible as early as 1750 and in its multiple aspects dominated European and American art for more than a century.

Romantic Classicism: Girodet

In painting, the romantic spirit appeared first in classical disguise. It is hinted at in the sentiment of some of David's followers, as we have already seen, and is strong in the work of Anne-Louis Girodet-Trioson (1767–1824). Girodet was a student of David's as well as a *Prix de Rome* winner (in 1789, with Gérard second). He was busy with *The Entombment of Atala* [Plate 3, p. 54] while David was putting the finishing touches on *Le Sacre*. Technically *The Entombment of Atala* is a fine classical showpiece. But conceptually it belongs to the opposing camp.

This camp had hardly begun to gather its forces. The first indications of what was about to happen were literary ones, and *The Entombment of Atala* was the result of one of them. In 1801 a young aristocrat, adventurer, and romantic spirit named René de Chateaubriand published a brief novel, *Atala,* a curious compound of the fantastic, the irrational, the beautiful, and the absurd, except that in romantic conception nothing is absurd simply because it appeals to the heart at the expense of all logic. Chateaubriand's *Atala* was a great success; it was sensational on several scores. The scene was laid in the mysterious and fascinating American wilderness; the characters were American Indians (Atala, the heroine, was a half-breed girl); and the plot had a strong, if artificial, flavoring of religious sentiment. (Christianity had become fashionable with Napoleon's re-establishment of the Church after the Revolution.)

Girodet's picture was painted seven years after the appearance of the novel and illustrates its final episode. The maiden Atala has died rather than yield her virginity in marriage to her lover, in observance of a vow made not by Atala but by her mother many years before. (This is only a minor complexity in a plot that would sound ludicrous in summary.) The other characters in the picture are her lover Choctas and a priest attached to a never-never mission in the Florida jungles. The several romantic elements here had better be examined one at a time:

First, the story of Atala is romantic because it is preoccupied with personal emotionalism. The problems faced by the Horatii, by Socrates, by Brutus, and by the Sabines may have involved personal distress, but this was incidental to the importance of a general social–moral ideal. The reverse is true in Atala's case. Although she has sacrificed herself, it is not for the state or a political theory. Her difficulties were entirely personal and hence puny by Davidian standards.

Second, the picture violates the ideal of reserve nominally demanded by classicism. Everything in it seeks to stir the observer's emotions—the exaggerated light dramatizing a moody setting, the pathetic beauty of the dead girl, the anguish of her lover.

The Christian element, being nonrational, is unclassical; and finally, the Atala story is romantic in its exoticism. A yearning for the faraway and the long ago, for the high colors and fantastic peoples and curiosities of the Orient or the wilderness or of any place offering escape into the vivid and the mysterious—this yearning was a trait of the romantics in their search for release, stimulation, and fulfillment.

These romantic heresies announce themselves rather hesitantly in Girodet's picture, however, and are all but concealed beneath its classical veneer. Atala might be a beautiful Greek maiden, and her gauzy robe is inexplicable in any but classical terms. The nudity of her mourning lover is the idealized nudity of classical sculpture, not the rough nudity of a savage: Choctas might be a gladiator. And technically

the painting is tight and smooth enough to satisfy the eye of any classical pedant.

The traditional recognition of *The Entombment of Atala* as a tentative romantic expression has obscured the importance of an earlier painting by Girodet, an extremely curious hybrid that, with a slightly different history, might have become the manifesto of romantic painting. *Ossian Receiving the Generals of Napoleon* [61] is a fantastic and complicated allegory celebrating the Continental Peace of 1801; it shows the ghosts of Napoleon's generals being received into a light-shot otherworld by the ghost of Ossian, a Gaelic bard of the third century. This extraordinary juxtaposition of characters is an offshoot of a grandiose literary forgery. In 1760–1763 the Scotch writer James Macpherson published some audacious and somber poems of his own invention, presenting them as translations of Ossian. The poems were received with enthusiasm, and Ossianism reached the proportions of a cult in France, an early indication that the romantic yearning for the exotic and the grandiloquent was already stirring. Girodet's Napoleonic allegory fitted current events into parallel with Macpherson's forged Gaelic legends—an obvious violation of classical doctrine, which demanded parallels with ancient Rome or Greece. The picture further violates every classical regulation in its swirling, visionary composition, especially as Girodet first conceived it in a preliminary study [62]. In the final version he compromised to some extent, polishing his romantic fantasy into superficial accord with classical disciplines as far as the individual forms are concerned. Yet even this compromise is interesting as a final contradiction, between reason and fantasy, in a conception paradoxical from the beginning. Fantastical invention seems to have been natural to Girodet's talent, but *Ossian Receiving the Generals of Napoleon* was badly received at the Salon; what could have been a romantic manifesto ended as the most curiously isolated, artificial concoction of the neoclassical school.

Girodet never again pushed as close to the borders of forbidden romantic territory as he had in the Ossian picture and *The Entombment of Atala,* but in the Salon of 1810, two years after the success of *Atala,* he exhibited a large painting of a type that was appearing with increasing frequency under the shelter of academic acceptance—a classic–romantic hybrid on a Napoleonic subject executed in accord

61 Anne-Louis Girodet-Trioson. *Ossian Receiving the Generals of Napoleon.* 1802. Oil on canvas, 6′3½″ × 5′11½″ (1.92 × 1.82 m). Malmaison, Paris.

62 Anne-Louis Girodet-Trioson. Preliminary study for Figure 61. Oil on canvas, 13 × 11¼″ (33 × 29 cm). Louvre, Paris.

63 Anne-Louis Girodet-Trioson. *The Revolt at Cairo, 1798* 1798–1810. Oil on canvas, 11'6⅞'' × 16'3'' (3.65 × 5 m). Musée du Chateau de Versailles.

with the technical formula of neoclassicism but bursting with romantic excitement and romantic exoticism. *The Revolt at Cairo, 1798* [63], painted twelve years after the event, illustrates the reprisals taken by the French following an Arab conspiracy in which General Dupuy was fatally wounded. A preliminary drawing [64] indicates that Girodet had planned to use two struggling figures, a Napoleonic dragoon and a robed Arab, as his central motif. That they are separated on opposite sides of the completed painting, with the Arab now inexplicably naked, hints that Girodet had reconsidered, reverting to David's *Sabines* as a source. The pose of the Arab is close to that of Tatius in *The Sabines*. Instead of holding to *The Sabines*' symmetrical balance, however, Girodet built a composition that lunges violently across the canvas from left to right, countering this with a brilliant device, the dead Arab at lower left. This figure, an arbi-

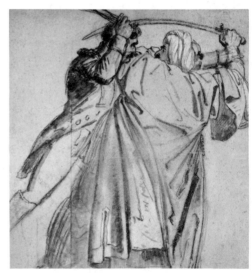

64 Anne-Louis Girodet-Trioson. Detail study for Figure 63. c. 1810. Cleveland Museum of Art (purchase, J. H. Wade Fund).

trary accessory to the scene, is raised to prime importance so that our attention is drawn back from the other side of the composition [65]. In addition, the exposition of the anatomy, along with the beauty of the drapery, makes a perfect studio exercise in the neoclassical manner, a badge of allegiance to academic standards, whatever the extent of its romantic overtones.

In the same Salon, 1810, a more daringly romantic painting, also inspired by Napoleon's Egyptian campaign, was given a mixed reception with the balance on the negative side: *Allegory of the Condition of France before the Return from Egypt* [66], by Jean-Pierre Franque (1774–1860). The unfavorable comments were directed toward exactly the imaginative qualities that make the picture more than a proficient Salon exercise. Franque had been an apprentice to David and had helped on *The Sabines,* but there is little that is Davidian in this visionary scene. The vaporous image of a female figure symbolizing France, riding on misty clouds and on the point of succumbing to evil figures led by Crime, extends an arm in supplication to an impossibly young and handsome Napoleon, who is about to arise to rescue France from the opportunists who have been ravishing the country during his absence. (The Egyptian locale is set by a pyramid in the background.) Perhaps because of the picture's tepid reception, Franque's subsequent work reverts to formula and is of little distinction.

Napoleonic Romanticism: Gros

In its precision and balance, *The Entombment of Atala* implies that life is harmonious and orderly even when mildly compromised with sentiment. True romanticism could not allow such a compromise, and Napoleonic France produced a generation unwilling to accept it, a generation accustomed to violence, thirsty for strong experiences, goaded by an acute awareness of the transience of life. Anguish this generation could understand, and exaltation and despair, but not serenity or repose. To the young officers back from the Napoleonic battlefields, the classical tragedies in the Parisian theaters and the classical paintings in the Salons seemed, somehow, not so stirring as they had remembered.

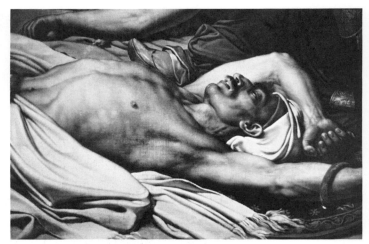

65 Anne-Louis Girodet-Trioson. Detail of Figure 63.

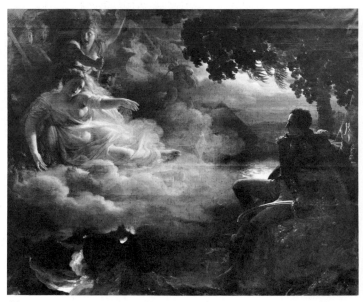

66 Jean-Pierre Franque. *Allegory of the Condition of France before the Return from Egypt.* 1810. Oil on canvas, 8′5¾″ × 10′7⅛″ (2.61 × 3.26 m). Louvre, Paris.

Much more than in the graceful *Entombment of Atala,* the new ferment is at work in the painting of Antoine Jean Gros (1771–1835), a member of Napoleon's staff and a pupil of David, by temperament a romantic of an extreme type—melancholy; brooding; impressed with the prescience of death, the suffering of the world, and the tragedy that not even greatness (as exemplified for Gros in Napoleon,

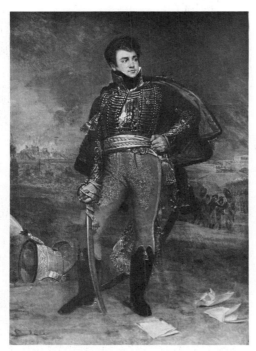

67 Antoine Jean Gros. *Colonel Fournier-Sarlovèze*. 1812. Oil on canvas, 8′ × 5′8″ (2.46 × 1.73 m). Louvre, Paris.

In Italy, where his Napoleonic service had taken him, Gros saw works of Michelangelo, Rubens, and Van Dyck. The first two especially were the antithesis of the neoclassical ideal in their swirling movement, emotional intensity, twisting forms, and (in the case of Rubens) opulent color applied with dash and freedom. Gros was a fine painter with a superb feeling for dramatic composition, a painterly painter with a natural painter's love for the manipulation of pigment, which he sought to repress in accord with David's dictum *"pas d'emportement du pinceau."* But his brush very nearly carried him away—by Davidian standards—in some passages of his portrait of Colonel Fournier-Sarlovèze [67]. The romantic pose—hand on hip; head thrown back while he scans the distance; sword drawn from scabbard as he stands debonair, dashing, confident, handsome, and elegant against the dramatic background—cries aloud for equally dramatic brushwork. In the lining of

whom he idolized) is immune to error, confusion, and malevolence. Romantic sensibility could find exaltation in suffering; melancholy was often cultivated as a pose; yearning, not fulfillment, was the basic romantic pleasure, and the voluptuousness of spiritual torment became the ultimate ecstasy, especially when this torment could be displayed in attitudes becoming to the tormented.

But the suffering could be real, and with Gros it was. Five years after the date generally accepted as the victory year of romanticism, 1830 (when Victor Hugo's romantic drama *Hernani* was tempestuously presented in declared opposition to the standards of the classical theater), Gros committed suicide in three feet of water, at sixty-four. It may seem absurd to suggest that his inability to reconcile the classical ideal he yearned to believe in with the romantic one he could not help believing in was a contributing factor to his suicide. But it seems absurd only because it is difficult to imagine today the furor of the romantic–classic conflict at a time when the arts were so much a part of French national life.

68 Antoine Jean Gros. *Christine Boyer*. c. 1800. Oil on canvas, 7′1¼″ × 4′4″ (2.14 × 1.32 m). Louvre, Paris.

69 Antoine Jean Gros. *Napoleon Visiting the Pesthouse at Jaffa.* 1804. Oil on canvas, 17′5″ × 23′7″ (5.31 × 7.19 m). Louvre, Paris.

the cape, the crumpled papers tossed on the ground, and especially the ornamentation of gold braid and tassels, Gros yields to temptation; the paint is thick and rich and freely applied in character with the subject.

The portrait of Christine Boyer [68, p. 59] is an even greater departure from classicism, because its romantic mood is more arbitrarily selected and the means of creating the mood are more artificial. To paint a general's portrait reflecting the color and excitement of battle is only to capitalize on circumstantial material. But the *Christine Boyer* is deliberately romanticized. A lovely woman in elegant indoor attire is moodily and inexplicably posed by the side of a stream in a shady woods. Her crimson shawl falls on a rocky bed; the stream flows toward us through the darkening wood from a little cave of light in the distance. The trees are dense and dark along the banks and behind the beautiful quiet face. This face is turned slightly away from

70 Detail of Figure 69.

71 Rembrandt. *Christ Healing the Sick ("Hundred Guilder Print")*. c. 1649. Etching, 10⅞ × 15⅜'' (28 × 39 cm). National Gallery of Art, Washington, D.C. (Rosenwald Collection).

us to gaze upon a single rose floating on the current (at the extreme lower-right corner of the picture), which in a moment will be carried beyond our vision, and beyond hers—a symbol of the transience of youth and love.

The picture's exceptional quality is a poetic mood created by romantic emphasis on details like these to stir our sensibilities. Romanticism is first of all a state of sensibility; the romantic temperament feels an obligation to develop sensibilities to their utmost rather than to discipline them. The braggadocio and display of the *Fournier-Sarlovèze* portrait are one manifestation of these ideas; the feminine languor and sentimental melancholy of *Christine Boyer* are another.

But these are portraits, where a painter is less vulnerable to rule and regulation than in official pictures. In official subjects intended for public display the contradiction between Gros' temperament and the classical style is more apparent and his struggle more painful. In 1804 he was commissioned to commemorate an incident when Napoleon, during his Near Eastern campaign of 1798–1799, visited the pesthouse in Jaffa where members of his troops were dying of the plague [69]. Actually the pesthouse was an ordinary hospital, but in the interest of

dramatization Gros shifted the scene to a mosque. In doing so he reversed the approach used by David in, for instance, *Marat*: instead of eliminating details to reduce the episode to its essentials, as David had done, and then reducing those essentials to an ultimate purity and simplicity almost abstract, Gros romantically adds details and then uses every possible means to increase their emotive impact. Colors are heightened, intensified, and contrasted. Whole passages are thrown into obscurity while others are pulled into strong light, reviving and going beyond David's theatrical lapse in his *Brutus* with its shadowed foreground figure. Hardly a detail remains unromanticized, but at the same time the picture clings to token observance of the official tradition. For all their Orientalism, the arches of the mosque arranged across the background suggest the architectural flats of *The Horatii*. The nude figure lying face down in the foreground tearing at itself in agony may be romantic in its violence, but it is also a meticulous anatomical study in David's studio tradition. But the romantic focus of the picture is the nude bearded man who, dying, turns his head worshipfully toward the general [70]. The flexibility and the individualization of this figure make it the reverse of the conventionally proportioned, idealized, sculpturally modeled Davidian figure. And Gros' emotional conception of the subject, where Napoleon appears as a sort of Christ, touching the plague sores as if his bare hands would heal them miraculously, relates *Napoleon Visiting the Pesthouse at Jaffa* less closely to David than to a great romantic etching of the seventeenth century, Rembrandt's "Hundred Guilder Print," *Christ Healing the Sick* [71].

With the *Pesthouse* Gros came as close as he ever would to realizing his potential as a romantic painter on the grand scale. (His *Battle of Eylau* is a second, but not very close second.) After the fall of Napoleon, he attempted to find in idolization of the restored Bourbons the same spiritual support he had found in idolizing Napoleon I, but if his painting from that time on is any indication of his emotional life, this life was remarkably sterile. By 1820 the romantic movement was flourishing, but Gros, still obdurate, tried to go back to the sources of classical style in order to recultivate it in noble purity. The experiment was a debilitating one. His work became mannered instead of noble, empty instead of pure, and his last picture,

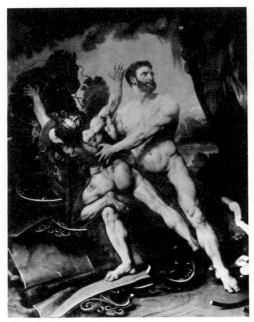

Hercules and Diomedes [72], was laughed at in the Salon of 1835, the year of his suicide.

The romantic banner Gros might have carried had been picked up in the meanwhile by the young Théodore Géricault (1791–1824), and on Géricault's early death at thirty-three, had passed to Eugène Delacroix (1798–1863), an even younger painter whose work Gros had first admired and then, with the recoil from his spontaneous sympathies so typical of him, disparaged.

The Romantic Declaration: Géricault and the «Raft of the Medusa»

On the second of July 1816, the French frigate *Medusa* was wrecked in a storm off the west coast of Africa. When it became obvious that the

72 Antoine Jean Gros. *Hercules and Diomedes.* 1835. Oil on canvas, 13′11½″ × 10′7¼″ (4.25 × 3.23 m). Musée des Augustins, Toulouse.

73 Théodore Géricault. *Raft of the Medusa.* 1818. Oil on canvas, 16′1¼″ × 23′6″ (4.91 × 7.16 m). Louvre, Paris.

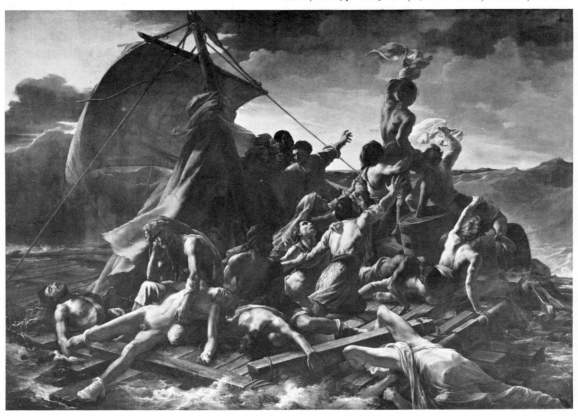

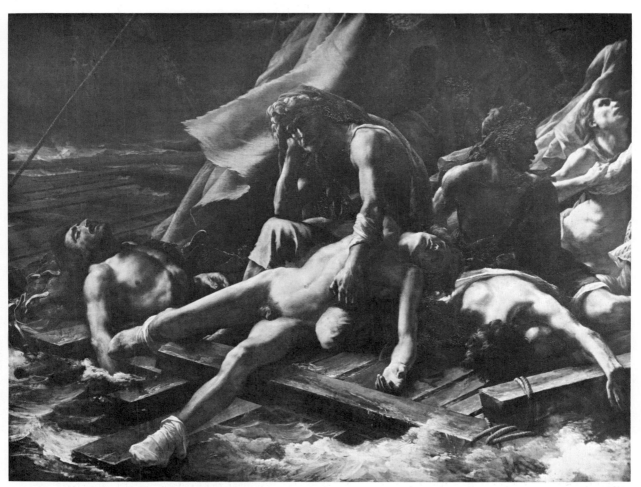

74 Detail of Figure 73.

vessel was lost, a raft was improvised from parts of it as it sank. Onto this makeshift were crowded 149 passengers and members of the crew. By the time they were sighted, only fifteen men had survived thirst, madness, and cannibalism. Géricault's picture of this horror [73] became for romanticism what *The Oath of the Horatii* had been for classicism a generation earlier, a public declaration of new principles and a standard around which a new school rallied in revolt.

Like David's earliest successes, the *Raft of the Medusa* attracted general attention because of its connection with exciting current events. Unlike David's, Géricault's picture actually represented the contemporary event in a contemporary way instead of allegorizing or symbolizing it in images of the past. The classicists fumed that the picture was vulgar and sensational, but this did not disturb a vulgar public interested in sensationalism. Nor was the public much impressed by the academic objection that here ordinary seamen were represented with the seriousness and on the grand scale appropriate only to the gods, heroes, and events of the ancient world. The *Medusa* had sunk in circumstances that were seized upon by the liberal party to attack the corruption of the administration (officers towing the raft from a lifeboat were accused of having cut it loose and left it adrift).

Géricault exhibited the picture in the Salon of 1819 (the official catalogue naïvely listed it only as *A Shipwreck,* to no one's confusion), and it was such an attraction that thereafter he traveled with it to England and made a considera-

ble sum in gate receipts. The public that flocked to see the *Raft of the Medusa* came to see a sideshow novelty as much as it came to see a work of art. Certainly not one person in a hundred came to see a romantic manifesto, but this back-door introduction of large numbers of people to romantic painting was valuable to the movement, whether or not people were conscious of the picture's revolutionary character or its merits.

These merits were considerable, but their revolutionary character was only relative. To abandon David for new gods, Rubens and Michelangelo; to use color as an emotive element instead of as a decorative tint applied to sculpturesque forms; to subject the composition of a picture to its expressive character rather than to force expression into a standard composition—all this was counterrevolution against the Davidian revolution that had congealed into a formula, but none of it was innovational by historical precedent.

The composition of the *Raft of the Medusa* skips backward more than a century to recall the pictorial arrangements of seventeenth-century Italian painters—for example Caravaggio, who made a similar revolution against the classical compositions of his own time. The survivors are shown in every attitude of anguish and despair. Sighting the rescue ship in the far distance, they have raised one of their number aloft on their shoulders.* He waves a shirt in a pitiable effort to attract attention. Straining, gesticulating, swooning, the *Medusa*'s survivors are intertwined in a turbulent mass of forms recalling the cascades of damned souls in Last Judgments by Michelangelo and Rubens. The forms rush upward across the canvas from left to right, culminating off balance in a jagged peak like a wave about to break and topple. Such grouping is obviously more expressive of movement and excitement and confusion than David's neat seesaw in *The Sabines,* frozen forever into the classical demand for symmetrical balance— although *The Sabines* is as much a subject of movement and excitement and confusion as is the *Raft.* Géricault's departure from seesaw balance seemed outrageous to the academicians, although he quite adequately brought his com-

position into equilibrium, countering the strong upward left-to-right movement by reversing it in the lines of the mast and ropes, lines that are continued and echoed in various of the figures on the raft itself.

What means does Géricault use to convey emotions of pity, terror, and horror? These emotions are not merely the result of the subject. Where David would have "purified," Géricault has intensified [74, p. 63]. Irregular broken forms are more suggestive of excitement than smooth, even ones. Hence Géricault exaggerates all the natural irregularities, the hollows and protrusions, of heads and bodies that David would have ironed out in submission to a preconceived ideal. Above all, Géricault dramatizes his forms by revealing them at maximum intensity in brilliant light and dense shadow. And where David's color—rather flat, very ornamental, "tasteful"—is simply color, the turgid darks and ominous greens of the *Raft of the Medusa* are correlated to its subject. The picture is not a masterpiece of color, and it has darkened so much that we cannot be certain of its original scheme, but the concept of color as an expressive element is unquestionably present.

For his models David used the best-muscled and most perfectly proportioned human beings available to the studio, made precise imitative

75 Théodore Géricault. *After Death* (study). c. 1818. Oil on canvas, 17¾ × 22″ (45 × 56 cm). Art Institute of Chicago (Munger Collection, McKay Fund).

* This particular survivor is a black; his presence is justified by historical fact, but his introduction into Géricault's picture is often pointed out as evidence of the romantic interest in exotic types.

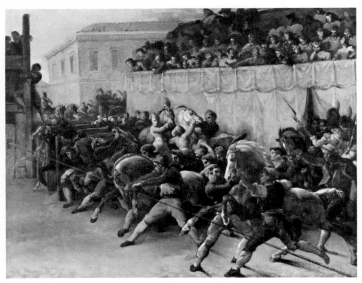

76 Théodore Géricault. *Riderless Races at Rome,* 1817. Oil on canvas, 17 × 23″ (43 × 58 cm). Walters Art Gallery, Baltimore.

studies from them, and then modified his studies to bring them into correspondence with his recipe for the ideal type. Géricault abandons this idea that beauty is synonymous with perfection. A romantic, he finds beauty even in ugliness if ugliness reveals a state of soul. Instead of the athletes who posed for David, Géricault sought out the survivors of the *Medusa* and made sketches of them. One survivor was the ship's carpenter; he constructed for the artist a model of the raft. But all this was only documentation of literal fact. Valuable as it was, it did not necessarily correspond with expressive truth. So Géricault visited hospitals and sketched men as they were dying. He sketched in morgues [75] and madhouses. According to one story, he kept corpses in his room to make studies from them—until the neighbors complained.

For all its merits, the *Raft of the Medusa* has some conspicuous disharmonies. The old man with his head supported on his fist [74] near the left edge of the raft is altogether out of key; he suggests a classical philosopher strayed from David's studio into this improbable situation. The body of the nude youth he partially supports, and that of the one to the lower right, head trailing in the water, are magnificent studies in themselves and give the impression of being the parts of the picture that most interested the painter, but they are a little over-conspicuous, becoming demonstration pieces. The whole picture, for that matter, may be only a first-rate studio exercise, admirable for the originality and courage of the devices it employs. But this is picking flaws in the work of a very young man whose achievement was to crystallize a new direction for painting. It is difficult to remember that the battle cry of romanticism was sounded by a student of Guérin, that candy-box classicist.

Géricault's reputation as a painter could rest on the *Raft of the Medusa* alone, and for that matter it very nearly does. The *Raft* was the only large or complicated composition he ever completed, although he left numerous sketches and some small versions for a similarly ambitious project, *Riderless Races at Rome* [76], races in which riderless horses were goaded into frenzies.

Subjects of cruelty and morbidity occur so frequently in Géricault's work that his detractors hint at unhealthy preoccupations. But an interest in acute sensitivities even to the point of abnormal states of mind was inherent in romantic emotionalism. For the greatest romantics, suffering and violence may be transmuted into expressions of the human spirit struggling for release; and in exploring the dark areas of life the romantic finds beauty in unexpected places. Rembrandt was a romantic in the seventeenth century when he used derelicts and outcasts as models for tragic kings; in faces eroded by suffering he found inner beauties more expressive than the beauty of conventionally handsome sets of features or classically idealized ones. If Géricault is asked to meet such a standard, then it is true that he often seems merely a fascinated observer of madness and physical anguish for their own sakes. But his accurate studies of the insane have a special significance, because they were made at a time when different kinds of insanity were first being recognized by a few doctors, among them Géricault's friend Doctor Georget, for whom he did a series of portraits from models in the madhouses

When Géricault died at thirty-three,* his friend Delacroix was twenty-five. In a lifetime of battle against pedantry, Delacroix was to bring French romantic painting to fruition.

* In 1824; David died the following year. Géricault, who had once had ambitions to be a jockey, died of complications following a fall from a horse.

chapter 5

Delacroix

The Personality

As a student and young painter Eugène Delacroix was closely attached to Géricault, who was eight years older, wealthy, adventurous, fond of high living, and knowledgeable about the world—about several worlds, in fact. Bohemianism was a natural by-product of the romantic premise that the artist's innate sensitivities are a gift so special that he is under a kind of moral obligation to develop them by indulging them to the fullest. Since these indulgences involve forays outside the bounds of the bourgeois conventions that dominated the nineteenth century, the early romantics confirmed the idea (which still persists) of the artist as a loose-living renegade from society. Géricault was Delacroix's mentor as a youthful bohemian in Paris, although both men by birth were wealthy and of high social position.

After his companion's death, Delacroix abandoned this experimental slumming for his natural habitat, the brilliant world where the upper bohemia of successful actors, writers, and painters overlapped the established order of social position and political intrigue. Here he was admired and sought after, but even while he was still a young man he began to withdraw into his work, seeing only the few people who continued to interest him as his own ideas began to crystallize. That the names of these people were great names (Chopin was his most intimate friend) was only coincidental.

Toward the end of his life Delacroix saw almost no one, remaining at work in his studio as a recluse, but still so glamorous a figure that when he did go out he was followed in the streets as a demigod by the young artists for whom he had become the symbol of revolution, independence, and integrity.

Nothing in Delacroix's life was so important to him as the theories he was developing through experiment and research. He never married, and although he had several liaisons and any number of what he described as "charming encounters," his grand passion was painting. But he was never one of those painters who could dash off a picture. He worked continuously and hard; his total works are estimated at more than twelve thousand, although he was handicapped by various physical ailments, including a recurrent debilitating fever. The man Delacroix is well summed up in his own self-portrait [77] with its attraction, its suggestion of romantic fire, but in the end its hauteur. He was handsome, febrile, yet somehow unapproachable. Above all he disdained the emotional profligacy and the lack of discipline thought of as typically romantic, which was why he resented classification with such other romantic rebels as the writer Hugo, the musician Berlioz, and above all the painter Boulanger (today forgotten), who was Hugo's choice as the official leader of the romantic school. As for Aurore Dupin, the woman who called herself George Sand and led her own life with the romantic lack of discipline of the heroines of her novels, Delacroix knew her long and

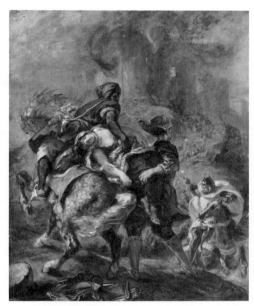

78 Eugène Delacroix. *The Abduction of Rebecca.* 1846. Oil on canvas, 39½ × 32¼'' (100 × 82 cm). Metropolitan Museum of Art, New York (Wolfe Fund, 1903).

intimately but referred to her commiseratingly as "poor Aurore."

Delacroix's Classicism

By the standard of swooning emotionalism and self-indulgence, Delacroix was not a romantic spirit at all. By any standard he was one of the most acutely, objectively analytical artists who ever painted a picture. And to understand his art in such typical pictures as *The Lion Hunt* [Plate 4, p. 54] and *The Abduction of Rebecca* [78], we must recognize certain qualities that seem contradictory to romanticism. Delacroix's romanticism is theoretical rather than felt, calculated rather than inborn. He regarded himself as a true classicist, as opposed to the false classicists who merely imitated classical precedents without understanding the classical spirit. True classicism is concerned with generalizing human experience into universal symbols. Venus is not a beautiful woman, but all beauty; Minerva is not a local bluestocking, but a symbol of the majesty and power of the intellect. The kings in classical tragedy are not certain men who had certain experiences as rulers of kingdoms, but symbols

77 Eugène Delacroix. *Self-Portrait.* 1837/1838. Oil on canvas, 25¼ × 20'' (64 × 51 cm). Louvre, Paris.

of humanity in its nobility and frailty. Romanticism, on the other hand, is concerned with the individual and the search not so much for the meaning of life as for the meaning of one's own individual life. But the art of Delacroix shows us that creative genius transcends the limits of a category. Categorized as romantic, his Arabs, lions, pashas, warriors, and all the rest do not end as specific individuals represented in one dramatic moment of their lives. They are images of the total emotional life of humanity. The poet and critic Charles Baudelaire called Delacroix's work "a kind of remembrance of the greatness and native passion of the universal man."

Delacroix's effect of romantic vehemence was achieved painstakingly; he invented ways and means to achieve it; his turbulent forms in all their complexity are as carefully patterned as are David's static, stylized ones. The famous "drunken broom" with which the classicists accused him of painting was not drunken at all. The breadth, irregularity, and apparent spontaneity of his brush stroke was produced with as much care as any classical painter took in smoothing out his surface to an impeccable polish. The colors that appear to swarm across Delacroix's canvases, as if jostling and interrupting one another, are selected and juxtaposed by no chance but in accord with theories so highly developed that alongside them the classicist's use of color as a decorative accessory is elementary. Romanticism is emotional, but Delacroix's emotionalism is achieved intellectually. This paradox must be accepted if his work is to be understood.

Early Works and Salon Scandals

Delacroix's career was opened with an early success, *Dante and Vergil in Hell* [79]. This painting, showing the two poets crossing the River Styx, was exhibited in the Salon of 1822 when Delacroix was twenty-four years old. Géricault's true masters, Rubens and Michelangelo, had become Delacroix's also, and they inspired the agitated and tormented forms of the picture. The nude male in the water alongside the boat is especially Michelangelesque; he might be the Adam from the creation scene on the Sistine ceiling in a variation of pose. Delacroix's teacher Guérin was horrified by *Dante and Vergil* and

79 Eugène Delacroix. *Dante and Vergil in Hell.* 1822. Oil on canvas, 6'1½'' × 7'10½'' (1.87 × 2.4 m). Louvre, Paris.

advised him not to exhibit it, but Gros, who was a member of the Salon jury that year, admired it so much that he had it framed at his own expense. Delacroix could not afford a frame; he had lost the fortune he would have inherited from his parents, now dead, in a disastrous lawsuit with another family.

It was at this time that Adolphe Thiers, a shrewd statesman but a man of little taste in the arts, came to Delacroix's rescue with the "mysterious" official patronage that continued, with only occasional interruptions, throughout the artist's life. Although he was the putative son of the French minister to The Netherlands, a man well established in influential circles, Delacroix was probably the actual son of a much more influential man, the statesman Talleyrand. Various coincidences support conclusions that could be drawn from his strong resemblance to Talleyrand, and nothing but the presence of an influential behind-the-scenes sponsor explains why Delacroix was virtually a ward of the state after his parents' deaths. His pictures were loathed and feared by the Salon juries and vituperated by official critics, but again and again they appeared in the official exhibitions and were purchased by the government. Delacroix was awarded important commissions for murals in public buildings (the Palais Royal, the Palais Bourbon, the Luxembourg, and the Louvre among them) over the heads of the established hacks who would ordinarily have re-

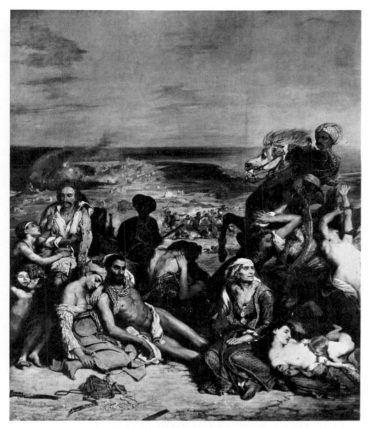

80 Eugène Delacroix. *Massacre at Chios.* 1824. Oil on canvas, 13′7″ × 11′10″ (4.19 × 3.64 m). Louvre, Paris.

81 Detail of Figure 80 (extreme left of painting)

ceived these lucrative plums, as well as other semiofficial and private commissions where influence was usually more important than talent. Thus the government unwittingly acquired masterpiece after masterpiece and became, in effect, the medium for discrediting the classical hangers-on who were entrenched in its official schools. The dismay of the academicians can be imagined when Thiers manipulated the purchase of *Dante and Vergil* by the state. Delacroix was regarded as an irreverent upstart from this time forward.

Two years later, in 1824, Delacroix came into greater prominence with his *Massacre at Chios* [80, 81], of which the Academy made a scandal. (This, by the way of orienting ourselves chronologically, was the year that David— seventy-six years old, with another year to live— painted *Mars Disarmed by Venus and the Graces* [19].) Even Gros, who had defended *Dante and Vergil,* reversed his opinion of Delacroix and called the *Massacre at Chios* the massacre of painting.

There were routine objections to Delacroix's choice of a contemporary subject,* but what really appalled Gros and the other academicians was Delacroix's use of color. *Massacre at Chios* had come to the jury as a fine example of sound, adequately conventional painting and had been accepted for exhibition. But in the interval between acceptance and the opening of the Salon, Delacroix repainted it. Painters were customarily allowed to retouch or varnish their work after acceptance, but it happened that Delacroix experienced one of the transforming revelations of his artistic life and was impelled to transform *Massacre at Chios* as a result: he had seen a picture called *The Hay Wain* [105] by the English landscapist John Constable that had been accepted for exhibition in the Paris Salon that year.

*As an episode in the Greek-Turkish War, the population of the island of Chios, where 100,000 Greeks had lived, had just been reduced to 9000 in one of the most horrible massacres in the history of human cruelty. *Massacre at Chios* was in part inspired by Delacroix's admiration of the archromantic spirit and romantic poet Lord Byron, whose chivalrous participation in the Greek war cost him his life at Missolonghi in the same year. Delacroix also painted a *Greece Expiring on the Ruins of Missolonghi* as a tribute to Byron and a lament for him as well as a memorial to the Greek insurrectionists.

Constable painted by juxtaposing spots of color rather than blending them. By French academic technique of the time, a passage changing from one tint to another would be meticulously smoothed out or "blended" (there were special brushes for this), but Constable applied his colors in strokes of graduated shades so that the transition was made in a series of easily perceived jumps, juxtaposed rather than mushed together. The result was a greater freshness, vividness, and life to the color, as well as a sense of more immediate contact between painter and observer. The painter's presence is suggested when we can follow each stroke of his brush; whether we are aware of it or not, our participation in such a painting is greater than it is when we stand before a highly polished work where the technique is, so to speak, invisible. Delacroix once said that painting is a bridge between the thought of the painter and the thought of the observer, and Constable's bridge must have seemed to him a more direct and effective one than he had known before. In repainting *Massacre at Chios* under the inspiration of *The Hay Wain* Delacroix began the experiments with color that were to occupy him for the rest of his life and were to be enlarged upon by several generations of painters into our own century.* He freed color from the restrictions David had put on it; he revived some of its uses as he observed them in the eighteenth-century painters David had rejected, and he added new ones of his own.

By Davidian formula color is, in effect, nothing more than a decorative dye applied to carefully drawn and modeled forms, as though each object had been completely

modeled without color, as though it had been carved in white stone, and the color then washed over it as a photograph might be tinted. The color of each form—blue drapery, green leaf, gray wall—is held concisely within neat, unyielding contours. But with Delacroix the color explodes, shattering boundaries and unifying all forms with flecks and bits of pigment related to other areas. "Color is a merging of reflections," Delacroix said. An area of blue may be shot through with purples and greens and oranges; a passage of flesh (to which David would have given a smooth, uniform, pinkish tint) will be enriched with green in the shadow, blue in the highlights.

Obviously this aspect of painting is difficult to cope with in verbal description. Even color illustration is not too much help, with the reduction in size and loss of texture involved. But even in black and white it may be sensed that David's color exists only as an overlay. It may be bright and clear, but in Delacroix it is vivid and rich because variations are bound into variations of form; form and color enhance one another. A shift from one color to

82 Eugène Delacroix. *The Death of Sardanapalus,* detail. 1827. Figures about life-size. Louvre, Paris.

The Hay Wain is a large picture and loses pertinence as a technical example when reduced to the size of a page. But some of Constable's freshness and freedom as a manipulator of paint may be seen in other illustrations of his work [106, 107]. The question may be asked why Constable's picture was acceptable to the jury if Delacroix's adoption of its technique was found so shocking. One answer is that *The Hay Wain* is a picturesque landscape and hence, by academic category, not a picture of first importance. A formal and pretentious subject had to observe the rules more closely. Also, *The Hay Wain* was painted by an Englishman, and hence did not have to be taken very seriously. Delacroix, who later visited England, was one of the few French painters to recognize the virtues of his English colleagues.

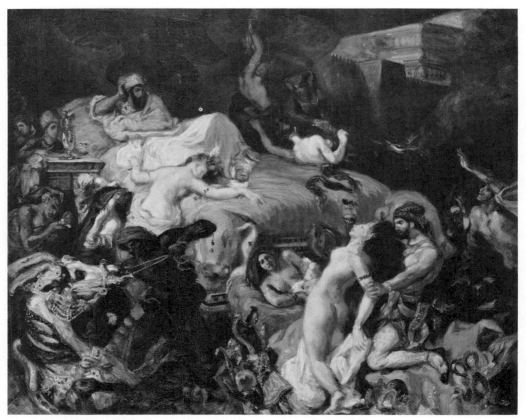

83 Eugène Delacroix. *The Death of Sardanapalus.* 1844. Oil on canvas, 29⅛ × 35⅝″ (74 × 90 cm). Collection of Henry P. McIlhenny, Philadelphia.

another as a form projects or recedes in painted space may either emphasize or minimize the projection or recession. Impossible as it is to demonstrate these simple points except in the presence of the paintings themselves, it is important nevertheless to remember that for Delacroix color *was* painting, it was the structure of painting as well as the basis of painting's expressive nature. All this will be more clear in retrospect as we see the painting of the century following Delacroix, because his color is the foundation of theories that build on one another in regular sequence— and are still developing.

Delacroix's Orientalism

In 1827 Delacroix painted his largest and most ambitious demonstration picture, and the only one that was a failure with both clas-

sicists and romantics, *The Death of Sardanapalus.* The subject reflects the vogue for the Oriental that was a strong element in romantic painting and literature, offering as it did all the exotic color and savage passion denied by classical moderation. But among the romantics only Victor Hugo liked *Sardanapalus,* which was at least consistent since, having shown little perception of Delacroix's virtues, he now found virtues in a painting where everyone else found defects.

The potentate Sardanapalus, preparing to immolate himself, is shown on his funeral pyre, which is concealed beneath cushions and a glorious rose-colored fabric, while slaves bring in his favorite wives, horses, and dogs and cut their throats in order that nothing Sardanapalus has enjoyed in life may be enjoyed by anyone else after his death. Jewels and great heaps of other objects are spread around in opulent confusion. The confusion

was objected to, also the "vulgarity," a favorite word with the critics, who were to continue to apply it over a period of some seventy-five years to the quality of life in any painting not classically stillborn. Oddly enough, if any shortcomings are apparent in *Sardanapalus* today, they do not lie in its confusion, which is calculated, but in the excess of this calculation, which reduces the vitality of the frenzied subject. *Sardanapalus* has passages of superb painting; the flesh of the central female figure [82, p. 70], the jewels, the stuffs are as rich as even Rubens could have made them. But the total effect, while gorgeous, is more gorgeous than passionate. Delacroix himself was dissatisfied, and seventeen years later, in 1844, he repeated the picture in much smaller dimensions [83, p. 71]. In the years between the two versions he had brought his theories to maturity.

The remarkable thing about the late version is that while it was virtually seventeen years in the painting, it has all the effect of spontaneous emotional fervor. When Delacroix said "All precautions have to be taken to make execution swift and decisive" in order not to lose "the extraordinary impression accompanying the conception" of a picture, he was denying the laborious methods of classicism. But he was denying as well, by the words *precautions* and *decisive,* the hit-or-miss improvisation by which an artist may try to capture the "extraordinary impression accompanying the conception" in the heat of the moment. Delacroix's sketches frequently have this quality of improvisation; there is a sketch in the Louvre for *Sardanapalus* that has it, but the sketch also has the formless, ambiguous passages that are inevitable at the same time. Delacroix's problem was the problem of the romantic creator in any of the arts— to give form to emotional experience without sacrificing the quality of immediacy.

In a subject of violent action the quality of immediacy cannot be retained within the seesaw balance of Davidian composition, as has already been pointed out in the *Raft of the Medusa,* where the composition was built on a strong diagonal movement. But the upward rush of Géricault's shipwrecked figures is still essentially an upward rush across the surface of the picture. In *Sardanapalus* we are led *back into* "space" created by the painter, something like the space of a large stage. The Sabines and the Horatii enact their dramas on the shallow area between footlights and curtain. In the *Raft of the Medusa* the space is hardly deeper, although theoretically the ocean background stretches to the horizon. But in *The Death of Sardanapalus* the curtain has gone up and the stage is filled with figures and trappings surging into its depths, backward and across to the climactic figure of the dying potentate. It is fine theater, and very romantic theater. It is also composition into the picture depth on a diagonal. The advantages of this kind of composition should be apparent if the effect of turbulence in Delacroix's picture is contrasted with the rigidity of David's. Each type of composition, of course, achieves its own end. By Delacroix's aesthetic, David's composition was obvious and limited. By David's, Delacroix's would have seemed overcomplicated, overdramatic. These contrasting uses of space—shallow and defined or deep and free—characterize, respectively, neoclassical and romantic composition.

Between the two versions of *Sardanapalus* Delacroix absorbed the second determining experience of his life—second only to his discovery of color in *Massacre at Chios.* He had tried to develop his theories of color in various Oriental subjects, as offering the most appropriate raw material, but his Orientalism, as in *Sardanapalus,* was of a storybook kind, concocted from hearsay, legend, and the accumulated fantasies of other writers and painters. Then in 1832 he made a trip to Morocco, attached to a mission organized under a young aristocrat, the Comte de Morny. The year before, France had made its conquest of Algeria, and the sultan of Morocco was a touchy neighbor. Mornay's mission was to conclude a treaty of good will. He had met Delacroix in the upper bohemia of the arts that they both frequented and attached the artist to his mission at the urging of a sprightly creature named Mlle. Mars, a comedienne and an enthusiastic collector of scalps among the infatuated gallants and intellectuals of her day. From the silvery light of Paris and the civilized emotional climate of that city, with its pale and cultivated inhabitants, Delacroix was plunged into a world where he was surrounded by half-barbaric figures, golden-skinned or black, robed, turbaned, or naked, moving among strange vegetation and strange architecture or against the even stranger blankness of desert sand and desert sky. Everything was revealed in a blazing light with colors ignited and contrasts exaggerated beyond anything Delacroix had imagined.

The first entries about this trip, in the journal where for years he had kept an orderly record of his activities and theories, are the fragmentary and disconnected scribblings of a man clutching at new images so exciting that he is in terror of being unable to absorb them: ". . . the sea a dark greenish blue like a fig, the hedges yellow at the top because of the bamboo, green at the base on account of the aloes . . . the sons of the caïd. The oldest one, his dark blue burnous; caftan of a canary yellow . . . a Jewess, red skullcap, white drapery, black dress. Heads of Moors like those of Rubens, nostrils and lips rather coarse, bold eyes. Rusty cannon. Graves amid the aloes and the iris. The almond trees in flower. The Persian lilacs. The little white house in the shadow amidst the dark orange trees. The horse through the trees. The red veil. The beautiful eyes. Wax torches. Tumult." Everywhere these notes are interspersed with sketches, quick, vivid, spotted with bright notes of watercolor [84]. Delacroix saw everything he had ever imagined, and more—fantastic banquets and entertainments in the sultan's palace, local ceremonies among the people, weddings and funerals, and from a window in Tangiers the hysteria of a fanatic religious sect. Everywhere the world was strange, wild, and wonderful.

His notebooks and his recollections were his storehouse after his return. Other painters might have been content to use the exotic material for its inherent color and novelty. But Delacroix was not interested in painted travelogues. The value of the material to him was that he found through it, at last, his synthesis of human emotion and the intellectual devices for its interpretation; the picturesqueness of the material is incidental; the depth of the Moroccan experience is apparent not only in pictures directly connected with it, such as *The Lion Hunt* [Plate 4, p. 54], but also in literary subjects like *The Abduction of Rebecca,* which is an incident from Sir Walter Scott's *Ivanhoe,* where he realizes Baudelaire's "remembrance of the greatness and native passion of the universal man."

Recognition and Followers

French artists may revile the Academy and may be reviled by it, may abhor the practices of the men who control it, may oppose everything it stands for at the moment—but they continue to venerate it as an institution and as an abstract idea, a symbol of the prestige of the arts in the national life of their country. No matter what their experience of academic abuses, all French authors, scholars, scientists, and practitioners of the fine arts eligible for election to the Institute of France* covet one of its chairs, and Delacroix was no exception. He made eight applications, which were rejected, and a ninth which was accepted in 1857, six years before his death.

Even so, the official world continued to snub him on most occasions. In 1861 he completed a set of three murals in the Church of St. Sulpice, after twelve years of work filled with interrup-

84 Eugène Delacroix. Page from his Moroccan journal, April 11, 1832. Ink and watercolor. Louvre, Paris.

* The Institute of France is composed of five Academies: (1) the French language, (2) literature, (3) social sciences and history, (4) mathematics and physical sciences, (5) fine arts. Each Academy is self-perpetuating; upon the death of a member a new one is elected for life from aspirants who have presented applications. Intrigue and favoritism are inevitable in the elections, and Academy membership has included some of the most trifling talents, but also eventually most of the great ones who have lived long enough.

tions. The Superintendent of Fine Arts, the philistine Count de Nieuwerkerke, refused to look at them; the court and the world of official painting also stayed away from the opening exhibition. Such men as Théophile Gautier and Baudelaire came and admired the pictures tremendously, but whether they were admiring them as mural paintings or as a manifestation of Delacroix's perseverance and integrity in the solution of a difficult problem is a real question. Today, similarly, the St. Sulpice murals are likely to be most praised by those admirers of Delacroix who like to see, in his mural of *Jacob Wrestling with the Angel,* a symbol of the painter's struggle for the fulfillment of his admirable theories. The other subjects were *Heliodorus Driven from the Temple* and, on the ceiling vault, so small and so poorly illuminated that it is seldom noticed, *St. Michael Killing the Dragon.* Compared with his great easel pictures, these are curiously static and dry.

Even while Delacroix was being snubbed, the romantic ideal had been vulgarized by his imitators in ways sufficiently emasculated to establish a pseudoromantic product as a standard Salon item. Thus on the coattails of secondraters he was finally accepted as the leader of a recognized school. In the important Salon of 1855, which will be described in some detail later, a room was set aside for some forty of his paintings, amounting to a retrospective of his career. He was elected to the Institute two years later, and he exhibited in the Salon for the last time two years after that, in 1859, with eight pictures. The year of his death, 1863, coincides with the date of the Salon des Refusés, also to be treated in detail later, an event that divides the art of the nineteenth century with a boundary as sharp as the one established between the eighteenth and nineteenth centuries by the Revolution and David.

Like David among classical painters, Delacroix is unapproached by any of his romantic contemporaries. This is less surprising than in the case of David, since Delacroix did not teach. But he was imitated. His most superficial imitator was a tremendous success: while Delacroix struggled to achieve his synthesis of human emotions, Paul Delaroche (1797–1856) capitalized on the romantic sentiment of the period by plagiarizing whatever elements of Delacroix's art had become generally palatable. Delaroche was not a true romantic. He was an unimaginative illustrator of historical anecdotes possessed

of romantic interest. Historical novels were in great vogue, and Delaroche offered their pictorial counterparts. His pictures are quite objective reproductions of models posed in medieval and Renaissance trappings against period backgrounds. The best known are *The Children of Edward* [85], showing the two little sons of Edward IV in the Tower awaiting execution, and *The Death of Queen Elizabeth.* Both pictures are still seen now and then; they used to be illustrations in every other schoolbook on English history and literature. Delaroche, only a few months older than Delacroix, was elected to the Institute on the strength of such tepid narratives. Upon Delaroche's death Delacroix, finally elected, assumed his imitator's chair, an irony that comes to mind first when Delaroche's name is mentioned nowadays, because it is the only circumstance lending any interest to his career. He was a student of Gros.

Some other mentionable French romantic painters are listed here, in order of birth:

Alexandre-Gabriel Decamps (1803–1860), a respectable painter, was trained as a classicist but revolted early against the tradition. He is discussed later in connection with the Salon of 1855, where he shared honors with Delacroix.

Eugène Devéria (1805–1865), a pupil of Girodet, for a while seemed on the point of

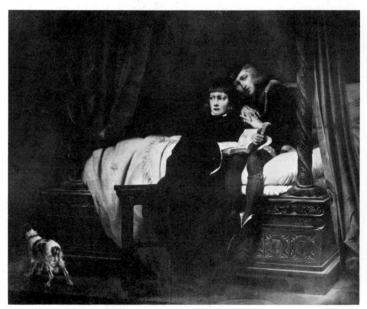

85 Paul Delaroche. *The Children of Edward.* 1830. Oil on canvas, 5′11″ × 7′ (1.8 × 2.13 m). Louvre, Paris.

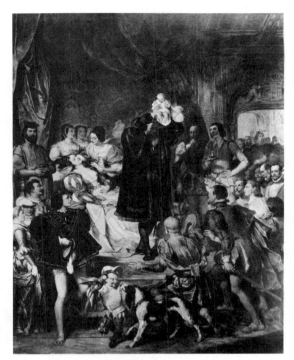

86 Eugène Devéria. *The Birth of Henry IV.* 1827. Oil on canvas, 15'10'' × 12'10'' (4.83 × 3.91 m). Louvre, Paris.

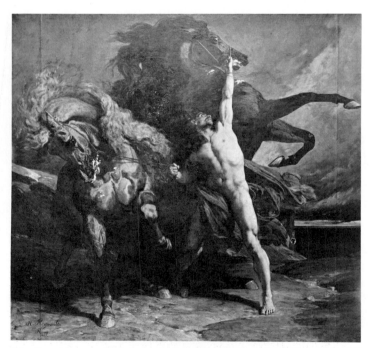

87 Henri Regnault. *Automedon and the Horses of Achilles.* 1868. Oil on canvas, 10'4'' × 10'9½'' (3.15 × 3.29 m). Museum of Fine Arts, Boston (gift by subscription).

major romantic achievement. After a great success in his Salon debut of 1827 with *The Birth of Henry IV* [86], he failed his promise and became a dry and unoriginal painter of history pictures, ending as a second-rate Delaroche. *The Birth of Henry IV* has recently been cleaned up and rehung in the Louvre. For such a huge painting, it is rather easy to pass by; perhaps the competition of *The Death of Sardanapalus* facing it on the opposite wall is too much. But upon examination it is seen to contain many passages of good solid craftsmanship but not much more.

Prosper Marilhat (1811–1847) painted with an agreeable illustrative honesty and a nice feeling for pigment.

Eugène Fromentin (1820–1876) was a painter and writer whose Orientalism was derived first from Marilhat, later from Delacroix. As a painter he had considerable facility, but as time goes on his pictures look more and more like attractive exercises in the manner of other men. His writing has retained the freshness that has begun to stale in his painting. Much of his criticism is unusually perceptive.

Henri Regnault (1843–1871), as his dates show, was a long generation younger than Delacroix. In 1866, at which time Delacroix had been dead for three years, Regnault won the *Prix de Rome* with a classical subject. In Italy he painted his well-known *Automedon and the Horses of Achilles* [87], a stirring picture that might have struck Delacroix himself as promising in its romantic excitement, although it still smacks a bit of brilliant student work. With a first medal in the Salon, a superb colorist, intelligent and industrious, he seemed set not only to make a conventional success but, at the same time, to continue and build upon the art of Delacroix. But Regnault was killed at the age of twenty-eight in the Franco-Prussian War.

One other name should be remembered, this time a man who was born even earlier than Géricault, Georges Michel (1783–1848). He is a rather isolated painter who is frequently grouped with Géricault among the first romantics. He painted picturesque squalor, bent trees, lonely ruined towers in dramatic silhouette against golden skies, referring to Rembrandt for some of his strong effects of chiaroscuro. As a forerunner of French romanticism, Michel is still much respected in France but is almost forgotten elsewhere.

chapter 6

Romantic Revolt in England: The Pre-Raphaelites

The Pre-Raphaelite Ideal

Romanticism as a state of mind, an emotional attitude toward life, is peculiar to no single period. Romanticism as an organized revolt to express and propagandize an attitude is peculiar to the nineteenth century. Of all the forms this revolt assumed, Pre-Raphaelitism was the most idealistic, but it was also self-defeating.

Pre-Raphaelitism was a confusion of ingredients including revolt against the times, adulation of the Middle Ages, noble aesthetic aspirations, religious yearning, sententious moralizing, morbid sentimentality, historical delusions, faulty archeology, and debilitating literary preoccupations. This is a damning list, yet the Pre-Raphaelites had a unique importance in the conservative and placid world of English art. As the only group dedicated to rebellion against the status quo, they injected a leavening influence that has affected English painting and writing ever since, even when the Pre-Raphaelites are not recognized as its source.

Of all romantics, the Pre-Raphaelites were the ones whose obsession with the past rose most specifically from their horror of the present. England in the second half of the nineteenth century was omnipotently the center of the Industrial Revolution, swelling with wealth and wholeheartedly dedicated to materialism. The great Victorian age was under way with all its complacency and adventurousness, its practical idealism and social abuses, its elegance and vulgarity, its stolid virtue and its virtuous aberrations. The Queen had been crowned in 1837; when she would die sixty-four years later in the first year of the twentieth century, very few of her subjects would be able to remember clearly a time when she had not been at the head of a country

devoted to materialism as a way of life. The Pre-Raphaelites questioned this way of life, and although the reform they proposed now seems misled—an effort to revive the past rather than to construct the future—they at least exposed the problem and proposed a solution of sorts.

Fundamentally the question was whether the human spirit could flourish when life was dominated by commerce, whether the soul could blossom in an air contaminated by the smoke of factories. The Pre-Raphaelites' answer was that it could not, an answer that they saw tangibly obvious in the sordidness of industrial slums, in the dreary reaches of respectable bourgeois life given over to the pursuit of money and animal comforts, in the ugliness of the objects the new machines were turning out, and in the artificiality of the fine arts, which seemed starved of nourishment. But unfortunately they sought to answer the question by running away from it, by returning to the surface forms of past glories rather than searching out new ones. Thus they were defeated before they began, and ended by proving nothing definitely except that it is difficult to go very far forward by walking backward. In terms of twentieth-century criticism, their shortcomings are pathetically apparent and their virtues have become unfashionable, for their art is devoid of the kinds of abstract formal and structural values that are taken for granted today as the starting point for critical evaluations. The only element that can save them, their expressive intensity, is obscured by a factor intolerable to the contemporary aesthetic, their literary sentimentalism.

As a group, the Pre-Raphaelites were close in age to the older French impressionists such as Manet, Pissarro, and Degas, yet they might have been painting in another century. Indeed they tried to do so, and the century they had in mind was the fifteenth, in Italy, as well as the even more remote ones of Dante and the Arthurian legends. They tried to return to the craftsmanship and (as they imagined them) the spiritual values of the late Middle Ages and the early Renaissance. If they were aware that the German Nazarenes had tried and failed to do the same thing, they did not profit from the warning. Actually they depended much less than the Nazarenes on direct reference to the past; in their enthusiasm they were true products of their own time.

The enthusiasm and the high ideals, the im-

practicality and the failure of Pre-Raphaelitism were symbolized when several of the Brotherhood set out to decorate the library of the Oxford Union in 1857. Emulating, they believed, the fifteenth-century Italians who covered the walls of Florentine churches with frescoes, they set about doing so in the library, convinced that an aesthetic resurrection was at hand. The circumstances seemed ideal, since the building itself was an imitation of a medieval one, and the Pre-Raphaelites were banded together as fellow craftsmen unified by moral principle rather than as effete painters ambitious for conventional success in an age of industry and commerce. But their paint was hardly on the walls before it began to chip, flake, and peel. Their fresco technique was as unsound as their social theorizing, a disaster from enthusiastic beginning to humiliating finish.

Rossetti

In spite of its social theorizing, Pre-Raphaelitism was a variety of escapism, having less to do with objections to the industrialized world than with a feeling of revulsion for the world on any terms, a neurotic denial of life, a yearning for a never-never land where the soul was freed from the rebuffs and responsibilities of daily living. The leader of the movement, Dante Gabriel Rossetti (1828–1882), was especially subject to the old romantic delusion that confuses emotional indulgence with spiritual nourishment. But in his poems and his swooning visionary paintings he was the most expressive member of the Brotherhood, because he was the most personal and most emotional interpreter of an ideal to which, in the end, only personal emotionalism could give a reason for being.

Rossetti was the center of the founding members—in 1848—of the secret Brotherhood, which immediately became not a secret at all. The two other most important founding members were John Everett Millais (1829–1896) and William Holman Hunt (1827–1910). Hunt's portrait of Rossetti [88, p. 78], with its enormously enlarged eyes, seems to try to force onto a not exceptional face the exceptional quality of inward vision. This same forcing is characteristic of Rossetti's own paintings; he failed to develop his precocious minor talent. He was only twenty-one when he con-

88 William Holman Hunt. *Dante Gabriel Rossetti.* Copy of a portrait dated 1853. Oil on canvas, 11 × 8½″ (28 × 22 cm). Private collection, England.

ceived his best painting—or, at least the one that has worn best over the years, *Ecce Ancilla Domini (The Annunciation)* [89].

By the least demanding academic standard this is a faulty work; the Virgin's left shoulder seems to disappear within the wall against which she crouches; the foreshortening of the right thigh is not at all convincing, and if there is a body within the drapery that stretches from neck to ankles of the Angel Gabriel it is curiously meager in volume. Nevertheless, the mood of the picture, established by the neurotic intensity of the Virgin, is altogether convincing. Medieval and Renaissance paintings of the Annunciation conventionally showed the Virgin in an attitude of surprise as the Angel delivers his announcement that she is "full of grace"—miraculously pregnant—but the announcement was always received, even so, with queenly grace or maidenly humility. Rossetti shows us instead a brooding girl who recoils from the fate in store for her and seems, with her clouded eyes, only half to comprehend the role that she must accept. Unconventional in its effect even today, *Ecce Ancilla Domini* was so harshly criticized when Rossetti exhibited it at the Portland Gallery in London that he thereafter forswore public displays of his work.

Rossetti came closest to fulfillment when dealing with the subject that was his true obsession: the vision of a woman who was personified for him first by his wife, Elizabeth Siddal, then by Jane Burden, who became the wife of his friend William Morris. His marriage with Elizabeth Siddal was filled with quarrels and irritations, but he loved to look at her and to draw her. When he fell in love with Mrs. Morris years later, he believed that he had always been in love with her since the Pre-Raphailites had first seen her in the audience at a theater matinée. They were working on the Oxford Union Library murals at that time and asked her to pose for them; Rossetti's drawing illustrated here [90] is probably the first he made of her. Elizabeth Siddal and Jane Burden bore some resemblance to one another, and every woman Rossetti painted, even when he used other models, resembled the two of them. He was in love with a facial type that enchanted him. Jane Burden Morris most triumphantly embodied it, with her great thick masses of undulating hair,

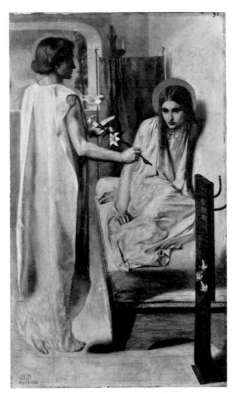

89 Dante Gabriel Rossetti. *Ecce Ancilla Domini (The Annunciation).* 1849–1850. Oil on canvas, 28½ × 16½″ (72 × 42 cm). Tate Gallery, London.

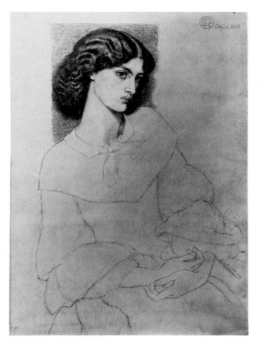

90 Dante Gabriel Rossetti. *Jane Burden.* 1858. Crayon, 17 × 13″ (43 × 33 cm). National Gallery of Ireland, Dublin.

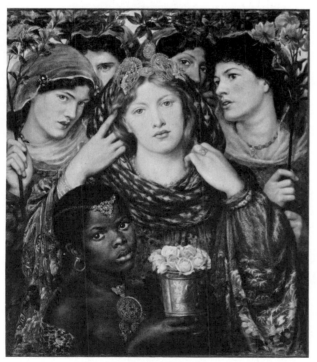

91 Dante Gabriel Rossetti. *The Beloved (The Bride).* 1865–1866. Oil on canvas, 32½ × 30″ (83 × 76 cm). Tate Gallery, London.

her tremendous brooding eyes, her heavy, rather swollen neck, and her small, full, exaggeratedly curling mouth. When Rossetti is fully given over to the adoration of this type he is at his best.

The fascination Jane Burden's face held for the Pre-Raphaelites must have been in part that it recalled the facial types in pictures by certain early Renaissance masters they admired, such as Fra Filippo Lippi, Verrocchio, and Botticelli. Botticelli was virtually rediscovered by the Pre-Raphaelites; the inward gaze, the long neck, the strongly defined jaw, and the sinuous convolutions of hair in Botticelli's *Venus* [2] have their counterparts in pictures like *The Beloved* (sometimes called *The Bride*) [91], although the linear rhythms so electric in Botticelli have become flaccid in Rossetti. Botticelli's vital grace is reduced to anemic languor. It would be pleasant to be able to say that as Rossetti's obsession continued his perceptions deepened and his vision took new and more profound form; instead, he followed a course of repetitious elaboration. *The Beloved* even offers the type in triplicate, swathed in the complications of arts-and-crafts fabric and jewels with which Rossetti loved to bedeck his enchantresses. Even his knights are Mrs. Morris in other costumes.

William Morris and the Arts and Crafts

William Morris (1834–1896) had an importance beyond his position as the husband of Rossetti's Jane Burden. He was originally trained as an architect; as a poet he still has a respectable reputation; as a painter he worked in a manner close to Rossetti's; but as the founder of the Arts and Crafts Movement he made as enduring a contribution as any connected with Pre-Raphaelitism. In 1851 England held the epoch-making fair called the Great Exhibition of the Works of Industry of All Nations, when some of the most preposterous objects ever created by man were displayed in one of the most beautiful and important structures of the century. The Crystal Palace was a sudden, brilliant, glittering architectural sport, one of the first modern buildings, a prophecy of buildings that would not be built for another century. It was created by force of circumstance.

The problem was to erect a structure large enough to house the tens of thousands of ex-

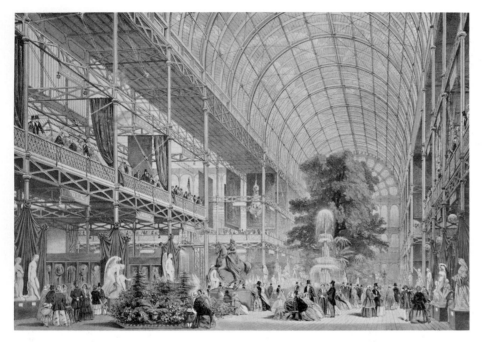

92 Joseph Paxton. Transept of the Crystal Palace, London. Color lithograph by J. Nash, 13½ × 19⅛'' (34 × 49 cm). From *Dickenson's Comprehensive Pictures of the Great Exhibition,* 1854.

hibits of the fair and to construct it quickly and not too expensively. A greenhouse designer, Joseph Paxton, created an open web of cast-iron girders, wrought-iron trusses, and jointed iron pipes of standard measurements, then covered this thin, light skeleton with a skin of glass. The Crystal Palace, built in Hyde Park around great living trees [92] became, on the interior, a fantasy. Paxton's solution to the architectural problem was utterly direct and practical, yet the final effect was fairylike, enchanted. The Crystal Palace was a sensation, but its architectural implications were missed. It was regarded as a wonderful and fantastic novelty rather than as the demonstration of a new aesthetic in architecture, which it was.

Among other things, the Crystal Palace was the world's first prefabricated building. The iron units were cast in foundries all over England, their lengths being determined by the largest practical size in which it was possible to manufacture the glass panes that would sheathe the skeleton cage. These panes also were manufactured in many places, and the business of assembling the huge structure from the multiplication of a few unit parts was rapid and simple. After the exhibition, the building was dismantled and re-erected in Kensington, where it served as a museum and concert hall until, as late as 1936, it was destroyed by fire.

The Crystal Palace was potentially the source of the "functional" architecture of the twentieth century, but to English eyes in 1851 it was not, strictly speaking, architecture at all. The old Houses of Parliament that had burned (and supplied Turner with a subject for painting) were at just this time being replaced by a new structure in the Gothic style. This was *real* architecture—meaning that it drew first from the past, then forced past forms into some kind of workable arrangement with the contemporary world. In the case of the Houses of Parliament there was more justification than usual for such an idea, since the older structure had not been completely destroyed and the remaining genuinely medieval parts were to be incorporated into the new building. Also, the old structure had for a long time been synonymous with the solid tradition of English government, and the new one must be a symbolic monument as well as a usable structure. The building, as finally completed, was an impressive massing of elements—the masterpiece, certainly, of neo-Gothic architecture and as good a defense as could be offered for the use of Gothic forms in a century to which they were foreign.

The Pre-Raphaelites, as has already been pointed out, also sought inspiration in Gothic (and early Renaissance) art. Like everybody else, they failed to recognize the Crystal Palace

as revolutionary architecture. They were more clear-sighted in recognizing the low state of the flood of objects being created by machines, and even in handmade objects. Designers and craftsmen had reached the nadir of their art, and the illustrated catalogue of furniture and bric-a-brac exhibited by all nations in the Crystal Palace (with England as the chief offender) has become a standard chamber of the most hilarious horrors in the history of design. Such objects as the "Irish" chair, with its two arms in the form of Irish wolfhounds, one rising, one reclining [93]; the "rich and costly bedstead," marking the initial appearance in the English language of the adjective *costly* as one of aesthetic description [94]; the baby's bassinet made from papier-mâché, which seems to be balanced on a large brooch [95]; and such fantasies as ornamental razors [96]—these were part of the aesthetic Grand Guignol that had just inspired the formation of the Pre-Raphaelite Brotherhood.

93–96 Four items from *The Art Journal Illustrated Catalogue of the Great Exhibition, 1851.*

93 "Irish" chair.

94 Bedstead.

95 Baby's bassinet.

96 Ornamental razor.

Morris' Arts and Crafts Movement shared the general Pre-Raphaelite fault of retreat rather than advance: he tried to return to the purity of hand craftsmanship in the face of the machine. The modern style in decoration, when it finally evolved, was to be based on virtues inherent in the machine rather than on a return to virtues the machine seemed to have perverted. But the Arts and Crafts Movement at least called attention to this perversion and created objects where design and usability were more important than vulgar elaborations. Morris tried to revive the crafts of hand weaving, cabinetmaking, metalwork, stained glass, even the hand-printed and illuminated manuscript. But a new society demanding thousands upon thousands of repetitions of an object could not be supplied by hand craftsmanship, and Morris was able to shed only a little light in the general darkness. In the end his contribution was less in the objects he designed and made than in his stirring of an awareness that design could be a quality inherent in the material and the making of an object as opposed to design as used in the objects we have just seen, where motifs drawn from everywhere were murderously debauched and plastered at random over any salable object.*

Like the other Pre-Raphaelites, Morris saw the Middle Ages and the early Renaissance as a paradise where every object was beautiful. His vision of it in paintings, such as *Queen Guinevere* [97], filled with the kind of fabric and furniture he designed, does seem a little crowded. The same arty clutter characterizes such Morris interiors as have survived. But because the Arts and Crafts movement respected the materials it worked with, it held the seed of a true revival. It remained for this seed to be fertilized later by designers who accepted the present instead of holding to Morris' nostalgic veneration of the past. In 1862 Morris founded his own firm, spe-

*The Pre-Raphaelites were not alone in their recognition of the low state of design. Even the compiler of the illustrated catalogue for the exhibition seems to have suspected that some of the objects were a little overelaborate. And it would be chastening for anyone who enjoys laughing at the Crystal Palace exhibits to compare them with a similar quantity of furniture and bric-a-brac by modern manufacturers. These twentieth-century items would draw upon a different set of motifs—streamlined ones and so on—but many of them would be just as bad and unusable as, and much more shoddy than, their Victorian counterparts.

97 William Morris. *Queen Guinevere*. 1858. Oil on canvas, 28¼ × 19¾″ (72 × 50 cm). Tate Gallery, London.

cializing in handcrafts for the decoration of churches. Here, where his medievalism was most appropriate and where handcraft could supply the market, he made his great success.

Rossetti's Followers

Rossetti exerted enough influence to make what might be called Rossetti-ism a subdivision within the Pre-Raphaelite movement. The most immediate of his followers was Edward Burne-Jones (1833–1898), one of several painters who, like Morris, joined the founding brothers in a second wave. He was one of Morris' most enthusiastic workers in stained glass and tapestry, and the two-dimensional disciplines imposed by these techniques affected his style in painting. The ornamental flatness of *The Prioress' Tale* [98] reflects his solid professionalism as a designer. The long panel, a favorite shape

98 Edward Burne-Jones. *The Prioress' Tale.*
1869–1898. Watercolor, 40½ × 25″ (103 ×
64 cm). Delaware Art Museum, Wilmington.

with Burne-Jones, comes of course from
stained-glass windows, and Burne-Jones' rich
color is more like dyed wools than painted can-
vas. Even more than Rossetti he was unabashed
in lifting elements wholesale from the painters
and craftsmen who invented them so long be-
fore. But he was also a better workman than
Rossetti.

Like so much Pre-Raphaelite work, *The Prior-
ess' Tale* is a curious amalgam, combining a
Chaucerian subject with Italianate forms, two
vigorous if not very compatible sources of in-
spiration watered down with precious aestheti-
cism. The composition was originally designed
in 1859 for a cabinet belonging to William Mor-
ris, and the work was done in Morris' house at
17 Red Lion Square, a residence that served as a
manifesto by demonstration of his and the Pre-
Raphaelites' theories. Ten years later Burne-
Jones began the watercolor replica illustrated
here. Nearly thirty years after that he picked it

up again and completed it, in 1898, the year of
his death, and sent it to Paris, where it was ex-
hibited in the Exposition of 1900. (The back-
ground was altered from the cabinet panel, a
city scene replacing a landscape.) In her
Memorial of her husband, Lady Burne-Jones
wrote that while he was painting the poppies in
the foreground of the picture someone re-
marked upon the importance of the first lines in
a composition. "Yes," said Burne-Jones, "they
come straight from the heart. You see how the
flowers come at intervals like those in a tune."
He sang, pointing to the poppies one after the
other, "La, La, La, La." Like other romantics, the
Pre-Raphaelites were fond of such analogies
between the arts. Architecture was "frozen
music" and so on. The American lady who later
acquired *The Prioress' Tale* saw Burne-Jones at
work on it in his studio shortly before his death,
and reported that he had looked as if he "were
seeing beyond this earth."

Although much of his work is nearly as dated
as these mawkish aestheticisms, Burne-Jones
saves himself again and again for anyone willing
to look at his pictures without taking the stand
that all Pre-Raphaelite painting is ludicrous
per se. Having been introduced to Botticelli's
art by Rossetti, Burne-Jones went on to add such
formidable and hard-bitten masters as Signorelli
and Mantegna to those he studied. He studied
them intelligently and profitably. In *The Golden
Stairs* [526] he constructed a picture with more
decision, variety, and subtlety than Rossetti ever
commanded. The rhythmic grouping, here
clustered, there open, with its movement here
quickening, there slowing, is nicely adjusted
along the major curve running from top to bot-
tom of the long panel.

Among painters not at all connected with the
movement some Rossetti influence is apparent
for half a century. Even so popular and conven-
tional a man as Lawrence Alma-Tadema
(1836–1912) was affected. In *A Reading from
Homer* [99, p. 84] the young lady in the uncom-
fortable position on the marble bench (Alma-
Tadema was famous for his rendition of mar-
ble) is at least a cousin to Jane Burden. George
Frederick Watts (1817–1904) was an acquaint-
ance of Burne-Jones, and in his familiar *Hope*
[100, p. 84] he draws upon him and through
him upon Rossetti. Watts shared the anti-
materialist idealism professed by the Pre-
Raphaelites and frequently, as in *Hope*, gave it a
touching expression, although he was an un-

99 Lawrence Alma-Tadema. *A Reading from Homer.* c. 1885. Oil on canvas, 3' × 6'⅜'' (.91 × 1.84 m). Philadelphia Museum of Art (George W. Elkins Collection).

even painter who never quite found himself except for a moment in occasional pictures like this one. Toward the end of the century, Aubrey Beardsley (1872–1898) picked up Rossetti's neurotic types and the Pre-Raphaelite arts-and-crafts decor and incorporated them into the fin-de-siècle preciousness [101] that was the most audacious revolt of the English intelligentsia against the now-obese smugness of the Victorian age on the point of decline.

Hunt, Millais, and Ruskin

Precocity was characteristic of the Pre-Raphaelites. Perhaps only very young persons could be at once so idealistic and so misled. Rossetti was only twenty when the "secret brotherhood" was founded in 1848; William Holman Hunt and John Everett Millais were respectively twenty-one and nineteen. And the group found its public defender in the writer and critic John Ruskin (1819–1900), who, although nine years older than Rossetti, had established his reputation as a critic in his early twenties. At sixteen he had discovered Turner (who figures in the next chapter), understanding the aspects of Turner's

100 George Frederick Watts. *Hope.* 1886. Copy of original of 1885. Oil on canvas, 4'7½'' × 3'7¼'' (1.41 × 1.1 m). Tate Gallery, London.

a sharp-focus photographer. Actually, Ruskin had offered this advice to beginners only; otherwise it is obviously altogether opposed to his understanding of Turner, and he certainly understood that the selection of detail in early Italian painting was more important than the imitation of nature. But Hunt, especially, "rejected nothing, selected nothing, and scorned nothing" in his moralistic charades.

Hunt based his art on the idea that a *tableau vivant* should be set up and then reproduced with excruciating complication. At its worst, his sententious, sentimental moralizing produced pictures like *The Awakening Conscience* [102], where a kept woman is shown rising from her paramour's lap as she experiences a sudden moral revelation. The sinful pair have been singing at the piano. Hunt even had a specific song in mind, Thomas Moore's "The Light of Other Days," and explained that "the woman is recalling the memory of her childish home, and breaking away from the gilded cage with a startled holy resolve, while her shallow companion sings on, ignorantly intensifying her repentant purpose." As an added fillip Hunt designed a frame to go with the picture, decorating it with

101 Aubrey Beardsley. *The Mysterious Rose Garden,* from *The Yellow Book,* Vol. IV, January 1895.

art that were not apparent to conventional critics or, when apparent, were puzzling or offensive to academic taste. Five years before the founding of the Pre-Raphaelite Brotherhood, Ruskin had published the first volume of his *Modern Painters,* a series that began as an interpretation and defense of Turner. In celebration of its appearance (Ruskin was twenty-four) his father bought *The Slave Ship* [114] for him.

Ruskin loved medieval and early Renaissance Italy as passionately as the Pre-Raphaelites did. Unlike them, he recognized the dangers of medievalism, prophesying that if the painters' interest in the early artists led them into imitation of the past they would "come to nothing." His advice to painters to "Go to nature, rejecting nothing, selecting nothing, and scorning nothing" was misinterpreted as meaning that the painter should become as nearly as possible

102 William Holman Hunt. *The Awakening Conscience.* 1855. Oil on canvas, $29\frac{3}{4} \times 21\frac{5}{8}''$ (76×60 cm). Tate Gallery, London.

marigolds, the symbol of sorrow, and ringing bells, the traditional symbol of warning.

But to choose this particular picture as an example of Hunt's work, offering as it does every opportunity for a field day at his expense, is not quite fair. By a cruel reversal, *The Awakening Conscience* has become an extreme example of exactly the kind of painting the Pre-Raphaelites objected to in its artificiality and its unimaginative presentation of a narrative subject. Hunt comes off much better in *The Hireling Shepherd* [Plate 5, p. 87], on the face of it a pastoral allegory where Ruskin's "Go to nature, rejecting nothing, selecting nothing, and scorning nothing" has produced a splendid, jewel-like surface in which every blade of grass, each petal of each blossom, each hair in each lock of hair, is executed with amazing precision. As usual with Hunt, *The Hireling Shepherd* is a moralistic sermon, but we may forget, in enjoying his sheer technical brilliance, that he is preaching at us. The shepherd is neglecting his flock to indulge in unworthy dalliance, and the

Death's Head moth in his raised hand is a symbol of the vanity of life's pleasures or perhaps even a comment on the biblical wages of sin.

Millais also followed the doctrine of acutely imitative detail, but more thoughtfully than Hunt. It is true that in Millais' *Christ in the House of His Parents* [103] there are too many shavings on the floor, too many sheep in the pen, too many folds in the garments, too many nicks and cracks in the table, too many microscopically executed incidents everywhere distracting from the main point. Probably this is because the main point was foreign to the experience of the painter in the nineteenth century. The picture shows the child Christ prophetically wounded in the hands, but the nominally mystical subject becomes not much more than another piece of storytelling in a picturesque genre setting. The void left by the absence of mystical conviction must be filled with little things like shavings. But Millais has compensated as far as he can by an expert unification of the picture space into areas broad and simple

103 John Everett Millais. *Christ in the House of His Parents (The Carpenter's Shop)*. 1849–1850. Oil on canvas, 2'10'' × 4'7'' (.86 × 1.4 cm). Tate Gallery, London.

Plate 5 William Holman Hunt. *The Hireling Shepherd.* 1851. Oil on canvas, 30 × 42½″ (76 × 108 cm). City Art Gallery, Manchester.

Plate 6 Joseph Mallord William Turner. *Interior at Petworth.* c. 1835 – 1837. Oil on canvas, 2′11¾″ × 4′ (.91 × 1.22 m). Tate Gallery, London.

Plate 7 Albert Bierstadt. *Merced River, Yosemite Valley.* 1866. Oil on canvas, 3′ × 4′2″ (.91 × 1.27 m). Metropolitan Museum of Art, New York (gift of the sons of William Paton, 1909).

Plate 8 Fitz Hugh Lane. *Ships and an Approaching Storm off Owl's Head, Maine.* 1860. Oil on canvas, 24 × 39⅝″ (61 × 101 cm). Collection Governor and Mrs. John D. Rockefeller IV.

104 John Everett Millais. *James Wyatt and His Granddaughter Mary.* 1849. Oil on panel, 13⅞ × 17¾″ (35 × 45 cm). Private collection, England.

enough to hold all these incidental accessories within compositional bounds, and he has tinted these areas in rich decorative colors. The picture is admirable in every way except the way that is most important. It is too easy to see in each of the figures a model posed in the studio, impossible to feel that any of them is a participant in a mystical event. The extreme naturalism was consciously adopted in an effort to represent the scene without the sentimental trumpery of the day, a sound idea that, if backed up by unquestioning faith rather than by the self-consciousness of an adopted theory, might have given the picture the force and conviction it lacks. But as the picture stands, it reveals Millais for what he was, a prodigious technician applying his skill to a subject foreign to his emotional experience. The literalness that is now bothersome because it serves no expressive end offended the public of the time because it seemed irreverent, and the picture's subtitle, *The Carpenter's Shop*, was given it in derision.

But technical skill at Millais level could not fail to appeal to a public who regarded a painter first of all as a performer. And his own background of prosperous respectability and his temperamental affinity for graceful society

made him an outlander in the Pre-Raphaelite camp. Millais was by nature neither a bohemian nor a dissenter; popular success was inevitable for him, and he not only achieved it but finally became president of the Royal Academy. His defection was a mortal blow to the Brotherhood. Popular success was badly out of key with their dedication to revolt against the times; it violated the fundamental concept of the Pre-Raphaelite as being isolated from the vulgarities of the contemporary world. Just as the French romantics established the bohemian concept of the artist still current in Paris—the starveling genius in a Left-Bank studio, leading a life half carefree and half tragic—so the Pre-Raphaelites initiated the bohemian tradition in Bloomsbury and Soho, where the artist may defy convention as a matter of principle, or of convenience, or of habit.

As his success increased, Millais' work became increasingly shallow, but when he is at his best Millais is the most satisfying of the Pre-Raphaelites because he is the least pretentious. Occasionally he fulfills cleanly and brilliantly his full potential as a superb technician and an agreeable if not profound artist. The delight of a picture like his double portrait of *James Wyatt and His Granddaughter Mary* [104] is its completeness and its consistency within its limiting boundaries. Without straining to give more than he has to offer, Millais records sympathetically the appearance of two people in their habitat. Since each of the multitude of objects represented in the picture is meaningful through its association with the sitters, the mass of detail is pleasurable to explore, in contrast with the cluttered paraphernalia of *The Awakening Conscience* or the neatly arranged stage props and costumes of *Christ in the House of His Parents*. This is a comparison in one direction. In another, for instance with another family portrait, Degas' *Bellelli Family* [277], *James Wyatt and His Granddaughter Mary* does not come off so well. But painting offers many different kinds of pleasure, and it would be wearing if all painters were giants.

As a declared revolt, Pre-Raphaelitism lagged behind the romantic rebellion in France—coinciding, in fact, with a counter-revolution, realism. But the Pre-Raphaelites had been preceded in England by a spontaneous and indigenous romanticism in landscape painting, as we will now see.

chapter 7

Romantic Landscape in England and America

English Romantic Landscape: Constable

When Delacroix was electrified by the technique of *The Hay Wain* [105] in the Salon of 1824, he established its author, John Constable (1776–1837) as a patriarch in the family tree of modern art, with descendants first in Delacroix's colorism, then in that of the French impressionists via Delacroix, and through them to a dozen branches of color theory and manipulation in the twentieth century. But if Delacroix was also sensitive to the special Englishness of *The Hay Wain,* it left no mark on him. Constable is the purest representative and to a large extent the originator of a school of landscape painting characterized by a kind of domestic intimacy, a rich and cultivated gentleness, a warm and living and vibrant yet comfortable and not very analytical response to nature. His world of fields and forest, of small bridges and secluded glens, of open heaths and distant buildings is so peaceful as to resemble a garden plot in comparison with the American wilderness that was attracting American artists at the same time. And any touch of melancholy in Constable is so gentle as to be a happiness in comparison with the dark brooding ruined buildings, deformed trees, and menacing peaks in German landscapes. The people who inhabit Constable's England are thoroughly identified with its low hills, its trees, its cottages, which seem always to have been a part of it as much as its rocks and grasses. Its cathedrals, like the one on the horizon in Constable's *Stoke-by-Nayland* [106], aspire less to heaven than to peace on earth, and the clouds that move and swell through the same picture are not threatening but are a part of the fertility of drenched fields, the source of full streams and clear brooks.

This kind of Englishness, richly solid and lyrically sensitive without too heavy a metaphysical burden, received its literary expression in the En-

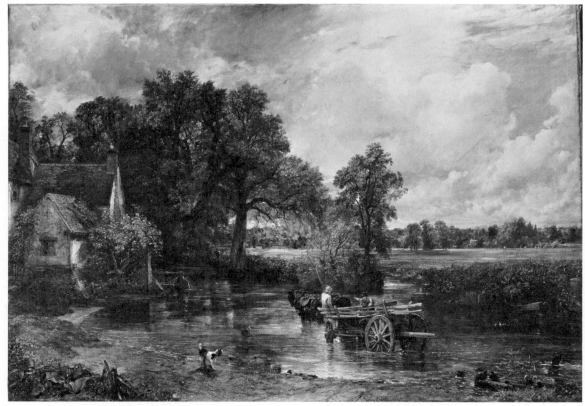

105 John Constable. *The Hay Wain*. 1821. Oil on canvas 4′2½″ × 6′1″ (1.28 × 1.65 m). National Gallery, London (reproduced by courtesy of the Trustees).

106 John Constable. *Stoke-by-Nayland*. 1836. Oil on canvas, 4′1½″ × 5′6¾″ (1.26 × 1.69 m). Art Institute of Chicago (W. W. Kimball Collection).

glish nature poets and its pictorial one in dozens of painters of picturesque landscape above whom Constable rises as a major artist surrounded by a crowd of minor attractive ones. He rises in fact as a major landscapist of any time or place, quite aside from his historical importance as a colorist.

Constable elaborated pictures like *The Hay Wain* and *Stoke-by-Nayland* from sketches made on the spot, usually very small and signed and dated on the back, which are not only notations of form and color but also of his immediate response to the subject. From these he developed the finished paintings methodically. But he was always intent, as Delacroix learned to be, upon retaining the effect of spontaneity that establishes the strongest communication between the painter and the observer. His method was brilliantly consistent. *Old Chain Pier, Brighton* [107, p. 92], which was carried only into an intermediate stage of completion, reveals this consistency.

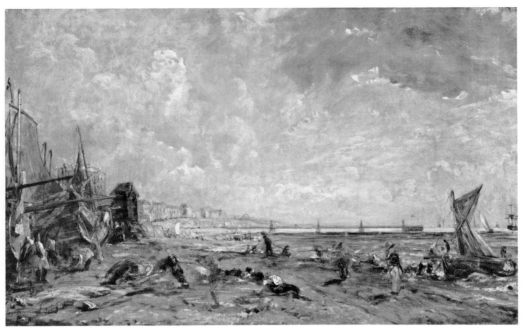

107 John Constable. *Old Chain Pier, Brighton*. Date unknown. Oil on canvas, 23½″ × 38½″ (60 × 98 cm). Philadelphia Museum of Art (W. P. Wilstach Collection).

A sketch made on the spot has been enlarged and modified in whatever way seemed compositionally best, its outlines being sketched in lightly with pencil. Some of these pencil lines should be apparent in the illustrated detail [108]. The ground of the canvas itself is a warm tawny color. The major color notes have been struck in with a liberal use of paint; here and there a touch is applied with the palette knife. Constable is "working the whole canvas at once"—bringing it everywhere to the same degree of completion before he goes on to the next stage in any of the parts. As a result, the picture as it is offers remarkable satisfactions, aside from its interest as a demonstration of method. It is unified by the consistency of the degree of suggestion with which its various parts are struck in, with the exception of the sail at the extreme right, which has been pushed a little further than the rest of the picture. If one part is more brilliantly struck in than another, it is the sky with its pure white clouds and its occasional spot of celestial blue. For Constable the sky with its moving clouds was the focal point of any landscape, structurally as well as expressively. In *Stoke-by-Nayland* as a typical fine example, sky, trees, and the forms of the earth are united as movements of form and light, and the

108 Detail of Figure 107.

sky is at once their origin and their climax. He made innumerable quick, sketchy studies of clouds of all types, fascinated less by their types than by their dynamism, as shifting, changing, building, and disappearing evidence of invisible forces. In their totality they are not so much nature studies as they are abstractions of those forces.

It would be easy to go on from this point to exaggerate Constable's emphasis on such abstract elements in his completed paintings. They are present and they are important; they account for the difference between Constable and the average painter of taste, skill, discretion, and sensitive response to nature. But they do not dominate the pictures. They serve always as vehicles for the romantic interpretation of specific aspects of nature, remaining subservient to it—in his own words, "all is made subservient to the one object in view, the embodying of a pure apprehension of natural effect." It was to capture the "natural effect" that he applied his color with the free brush and the pure tones that captivated Delacroix.

Turner

Constable, encouraged by Benjamin West among others, began late as an artist, developed slowly, and spent the last years of his life in a state of morbid depression. Otherwise he might have developed in the direction that finally brought his contemporary, Joseph Mallord William Turner (1775–1851) to the point where his vision of nature was finally reduced—or purified, or elevated—to the point of pure abstraction in which the elements of air, water, and fire virtually consume the representational forms making up a scene. Nominally the subject of *Snowstorm* [115] is a material object—a steamboat—upon a body of water, surrounded by air and revealed by light. Actually the canvas is a tempest of forms and colors that in themselves are emotionally expressive. They very nearly, if not quite, obliterate the pictorial subject to speak entirely for themselves.

Turner's progress from romantic realism toward romantic abstraction can be followed through a few pictures painted at intervals of roughly a dozen years. The early *Falls of the Rhine at Schaffhausen* [109], painted in 1806, thirty-six years before *Snowstorm,* is the conventional sort of subject picturesque-romantic painters are fond of doing. It is potentially more Turneresque than some others, simply because the falls suggest the release of natural forces (an idea that preoccupies Turner later on), but on the whole this picture remains, rainbow and all, less an expressive one than a topographical souvenir with some romantic exaggerations. It is one of the best pictures of its kind to be

109 J. M. W. Turner. *Falls of the Rhine at Schaffhausen.* c. 1806. Oil on canvas, 4'10½" × 7'10" (1.49 × 2.39 m). Museum of Fine Arts, Boston (Special Picture Fund).

found anywhere, but it is of a fairly obvious kind. The carts, human figures, animals, barrels and bundles stretched across the lower foreground have the sort of tourist interest that is basic to the average picturesque landscape. Still, no average picture of this type would have expressed so dramatically the wild rush of water against the crags that thrust back into it.

Turner had an early success and was a prolific artist, but he found his way to completely individual expression rather slowly. His early *Dido Building Carthage* [110] is one of his large compositions close to the manner of Claude Lorrain, the seventeenth-century French classical landscapist, but Turner's semiclassical synthesis of architecture and landscape is much more than a mere skillful derivation. His first interest in the picture is in the drama of light. Turner's light is not light as the impressionists were to discover it, not a vibrant opalescent shimmer, but light as the element of fire, the fire of the sun. In *Dido Building Carthage* the sun blazes through the sky and burns a path down the center of the picture, consuming the stone bridge in the distance and impregnating the water with its brilliance.

Yet there is a contradiction here between the serenity of the picture's component forms—its temples and its trees—and the bursting energy of the sky. Turner did not hesitate long in making his choice between fire and marble. In *Ulysses Deriding Polyphemus* [111, 112], the sun at the horizon is an explosion of live coals spraying out across fantastic and agitated forms. Turner's romantic vision of the world as a cosmic union or struggle between the elements, dominated by fire and water, is finding its way to expression as it could not do in either *Falls of the Rhine* with its imposition of factual reference, no matter how grandiose, or in the forms of classicism, no matter how monumental.

In at least one actual event, however, Turner found a subject as good for his purpose as any invented one. He witnessed the great conflagration that destroyed the Houses of Parliament in London in 1834 and recorded it in a combination of remembered fact and expressive invention [113, p. 96]. The sky is a furnace; it is filled with leaping ragged areas of orange and yellow sprinkled with the vermilion flecks of floating cinders. Billows of purple smoke rise into the incandescent air; fragments of disintegrating

110 J. M. W. Turner. *Dido Building Carthage.* 1815. Oil on canvas, 5'1½'' × 7'5½'' (1.54 × 2.27 m). National Gallery, London (reproduced by courtesy of the Trustees).

111 J. M. W. Turner. *Ulysses Deriding Polyphemus.* 1829. Oil on canvas, 4'3'' × 6'7'' (1.3 × 2.1 m). National Gallery, London (reproduced by courtesy of the Trustees).

112 Detail of Figure 111.

architecture merge with it, and in the background the towers of Westminster Abbey glow as if molten. The water of the Thames is a flood of brass; boats filled with spectators lie upon it as diaphanous as shadows. The crowds on the bank are gauzy and unreal, the stone bridge melts away into the distant violence. The gas jets of the lamps surmounting its buttresses are as pale as evening lights against the sunlike intensity of the holocaust. Here Turner has reached a statement of his major theme; the dissolution of material reality into a universe where the elements are fused into one another in a way suggestive of primeval chaos. Water fuses with air, air and water fuse with fire, while earth, stone, and metal dissolve into all of them.

To express this fusion in terms of paint, Turner adopted an increasingly free technique where form was suggested by broader and broader areas of color, sometimes scrubbed in a film over the canvas, sometimes applied with heavy impasto, this latter especially in the passages where light appears most purely and most fiercely in its maximum concentration as fire. In a way this is impressionism, and Turner is often thought of as a proto-impressionist. He was all but unknown in France, but nearly twenty years after his death he was "discovered" by two of the impressionists, Monet and Pissarro, who were taking refuge in England during the German occupation of Paris in 1870. But it is difficult to say just how much direct influence Turner had on their subsequent development of impressionism as a technique for representing light; by hearsay their own statements on the question are contradictory. In the long run the question is not a very important one, since on important scores the connection is tenuous. For the impressionists, light was an optical phenomenon; for Turner, it was a cosmic force. The impressionists' light is part of a happy everyday world; Turner's is a manifestation of romantic mystery. Turner broke the surface of his painting into scrubs, films, dashes, and gobbets of color, and so did the impressionists. But for Turner color was first of all abstract and expressive; for the impressionists it was first of all descriptive of visual reality. We may make an exception of Monet's very late works, but the difference between Turner and impressionism is still the difference between *The Slave Ship* [114, p. 96] and *Red Boats at Argenteuil* [268], the difference between the visionary and the commonplace, even when the commonplace is

113 J. M. W. Turner. *The Burning of the Houses of Parliament.* c. 1835. Oil on canvas, 3′1¼″ × 4′1½″ (.92 × 1.23 m). Philadelphia Museum of Art (John H. McFadden Collection).

as beautiful as the impressionists discovered it could be. In other words, the impressionists were unaffected by Turner as far as any expressive factors were concerned, and as technical processes Turner's explosions of color have only incidental connections with impressionism's investigation of the spectrum.

With *The Slave Ship* Turner's development toward a final abstract statement of romantic emotionalism was nearly complete. The title of the picture still clings to literary associations not inherent in the painting as an independent work of art, and it is with a kind of disappointment that we discover the narrative incident in the foreground right, where a shackled leg disappears into the water, surrounded by devouring fish. This bit of storytelling seems an afterthought, a concession to popular standards in a picture that was not only complete without it but is reduced from grandeur to melodrama by its inclusion. But in *Snowstorm* [115] the majestic and terrible power of the elements, hinted at a third of a century before in the picturesque

114 J. M. W. Turner. *The Slave Ship.* 1840. Oil on canvas, 2′11¾″ × 4′ (.91 × 1.22 m). Museum of Fine Arts, Boston (Henry Lillie Pierce Fund).

115 J. M. W. Turner. *Snowstorm: Steamboat off a Harbor's Mouth.* 1842. Oil on canvas, 3 × 4' (.91 × 1.22 m). Tate Gallery, London.

Falls of the Rhine, is at last expressed without the distractions of incidental trivia. A few blurred forms at the vortex of the composition, the ship and its mast, are a reminder that grandeur and mystery are human concepts, that if the universe is vast and violent beyond our comprehension, it is given meaning only because, existing within it, we have contemplated it with romantic imagination.

Turner was a mild eccentric who, in spite of his active public life as an eminent painter, managed to keep his personal life virtually secret. He never married, but maintained a long relationship with a common-law wife that became known only after his death. From 1829, when he was fifty-four, until 1837, when the Earl of Egremont died, Turner was a regular visitor at the Earl's seat, Petworth. His paintings of the interiors at Petworth are surely among the strangest interiors ever conceived. Like Turner's world of nature, the rooms often seem consumed not by fire but by incandescent atmosphere [Plate 6, p. 87]; when human beings (or pets) are discernible in the near-abstract paintings, they glow orange and red like live coals. Yet there is no air of violence or destruction; rather, the rooms seem to have been employed as subject matter not in any specific interpretative way, but as raw material for half-visionary exercises in pure colorism. For some Turner students, the handful of Petworth pictures is the summation of his genius.

The Hudson River School

If we try to explain the differences between national schools of landscape painting, the character of local topography is only a secondary explanation—in most cases. It is true that the lovely island that they lived on has always inspired English poets, and it also inspired Constable—but under no circumstances can it explain Turner. The great exception to the rule occurred in mid-nineteenth-century America, when topography and what can only be called a national mood, the spirit of the times, were equally inspirational in the birth of a new school of landscape painting—an art where Americanism was a positive essence flowing from native springs even while allied technically to the great world of painting in Europe.

The paintings of the so-called Hudson River School are as meticulously polished, sometimes to the point of niggling detail, as Caspar David Friedrich's landscapes, but there the similarity ends. Where Friedrich's mood was nostalgic and often gloomy, even ominous, the Americans' is full of youthful optimism. Friedrich's *Two Men Looking at the Moon* [32] are surrounded by sinister forms, even if they seem to have come to terms with a threatening world. But the two men in Asher B. Durand's *Kindred Spirits* [116, p. 98] are inspired by communion with a Nature that nourishes their souls. Friedrich's *Mountain Peaks* [117, p. 98] holds the observer within a menacing chasm pressing inward on either side and blocked off in the distance by harsh cliffs and cruel pinnacles, while the American peaks in Albert Bierstadt's *Merced River, Yosemite Valley* [Plate 7, p. 88], equally cliffed and pinnacled, rise gloriously into light as golden as that of any imagined Hellas. But Bierstadt's elysium of crags, water, trees, and rough earth is not an imagined one; the essential characteristic of these American landscapes is their reality, the fact that they are scenes within a glorious land that was opening, unfolding to yield an inexhaustible sequence of new beauties to delight, amaze, and enrich an expanding nation.* The tiny figures that spot

*Even when painting imaginary landscapes the Hudson River men were more likely to concoct one from the elements of a familiar world than to try to reassemble a lost one. *Merced River, Yosemite Valley* was synthesized in the studio from sketches made on the spot eight years earlier when Bierstadt accompanied government surveyors in the Rockies.

Merced River, Yosemite Valley here and there—standing on a ledge of rock, moving across the shining water in a small boat—are not crushed by the immensity of the forms around them. They enter this vastness as strangers but not as intruders; their place within it may be temporary, but they are neither lost nor threatened. They are in the presence of a sublime grandeur and they breathe its air. It is a new conception of wilderness, indifferent to human presence yet benign. It is a wilderness that never entirely yields to domestication; even at its most placid, as in Thomas Doughty's *In the Catskills* [118] it is a world infiltrated, but not transformed, by its discoverers.

The range of the Hudson River School is indicated by these three examples, from the philosophical or poetic intimacy of *Kindred Spirits* and *In the Catskills* to a passion for natural forms of supernatural grandeur, as in *Merced River, Yosemite Valley*. And it should already be apparent that "Hudson River" is an inaccurate blanket designation for a school spreading from one side of the continent to the other. Actually, "school" is also a loose term here except for the early days, when the painters knew one another and worked closely together. Unified by neither place nor time over the two generations when they flourished (roughly between 1820 and 1880), these American landscapists shared the greater bond of optimism, enthusiasm, and belief in some wondrous spirit in the American wilderness that endowed humanity with a portion of its ineffable sublimity.

Durand (1796–1886) and Doughty (1793–1856) belong to the first Hudson River generation,* and the quietness of their pictures illustrated here is typical of the general temper, while Bierstadt (1830–1902) belongs to the second;† his glorification of the West exemplifies the taste for wilder and more dramatic scenes that affected the character of the school. But there is no sharp dividing line, and both generations ranged from the intimate to the vast. Frederic Edwin Church (1826–1900), whose *Niagara Falls from the American Side* made him the leading painter of the second Hudson River generation, was so intent on

* Some others: Charles Codman, Alvin Fisher, Henry Inman, and Robert W. Weir.

† Some others: John W. Casilear, John F. Kensett, Worthington Whittredge, Jasper F. Cropsey, and Thomas Moran.

116 Asher B. Durand. *Kindred Spirits*. 1849. Oil on canvas, 46 × 36″ (117 × 92 cm). New York Public Library (Astor, Lenox, and Tilden Foundations).

117 Caspar David Friedrich. *Mountain Peaks*. 1826. Oil on panel, 4′3½″ × 5′5¾″ (1.31 × 1.67 m). Nationalgalerie, West Berlin.

painting the other great sights of the world that he traveled north to Labrador and south to Ecuador making sketches that, back home, became the raw material for imaginatively synthesized paintings of icebergs on one hand [119] and on the other vast panoramas of the Andes filled with tropical storms, rainbows, and volcanic eruptions. Church represents the gamut of the school, having begun as a student and follower of its founder, Thomas Cole.

118 Thomas Doughty. *In the Catskills.* 1836. Oil on canvas, 31½ × 42¼″ (80 × 107 cm). Addison Gallery of American Art, Andover, Mass.

119 Frederic Edwin Church. *The Icebergs.* 1861. Oil on canvas, 5′4½″ × 9′4⅜″ (1.63 × 2.84 m). Dallas Museum of Fine Arts (anonymous gift).

Thomas Cole

Before it coalesced under the leadership of Thomas Cole (1801–1848), the Hudson River School's discovery of American landscape had been anticipated by kindred spirits that included Doughty, whose *In the Catskills* we have just seen, and Washington Allston with an occasional painting like his *American Scenery* [39]. It was Cole, however, who formulated the principles that the early group was to observe— each painter in his own way. Basically, Cole believed and taught that the infinite details of a landscape, no matter how vast, could be assembled into a unit that expressed the spiritual or philosophical heart of the scene—a communication between God and man.

The principle extended to imaginary landscapes and, in Cole's case, didactic allegories. Two scenes [120, 121; p. 100] from the four making up his *Voyage of Life* series will give an idea of the bizarre mixture of moralizing, mysticism, melodrama, and naïve platitude that he grafted onto ideal landscapes with curious effect.

In *Youth,* the hero of the allegory sails forth from a verdant shore where a fantastic palm tree, introduced into an otherwise fairly normal landscape, recalls certain picturizations of the Garden of Eden. Youth's guardian angel standing by the river bank and relinquishing him to the perils of life's voyage increases the resemblance of this episode to an Expulsion. In the preceding (and first) picture of the series, the angel was at the helm of the boat as the infant hero sailed onto the River of Life as it springs from its mysterious source in a cavern. Now in charge of the tiller, Youth sails forward toward his vision of a fantastical domed and minareted concoction that rises like soap bubbles in the sky above distant mountains. The river is placid, and now flows between the banks of wooded fields where leaves, tree trunks, and ferns glitter like enamel and jewels. But in *Manhood* the water darkens and grows turbulent; it boils in rapids through canyons and gorges; the trees are blasted where they have survived at all; storms sweep through the sky and the murky gloom is inhabited by the demons of temptation. (Barely visible in the upper center of the picture, they are demons of lust, intemperance, and suicide.) But far above, in a spot of light, the guardian angel continues to watch, as the man holds his hands in prayer. In the final scene the little boat has completed its hazardous passage

120 Thomas Cole. *The Voyage of Life: Youth.* 1840. Oil on canvas, 4'4'' × 6'6'' (1.32 × 1.98 m). Munson-Williams-Proctor Institute, Utica, N.Y.

121 Thomas Cole. *The Voyage of Life: Manhood.* 1840. Oil on canvas, 4'4'' × 6'6'' (1.32 × 1.98 m). Munson-Williams-Proctor Institute, Utica, N.Y.

122 Thomas Cole. *The Oxbow of the Connecticut River.* 1836. Oil on canvas, 4'3½'' × 6'4'' (1.31 × 1.93 m). Metropolitan Museum of Art, New York (gift of Mrs. Russell Sage, 1908).

and sails into the ocean of immortality with its now-aged passenger still intact.

In the light of today's taste, these pictures must be accepted as the creations of an extraordinarily naïve spirit if they are not to appear pretentious. In that case, naïveté was remarkably widespread when Cole exhibited them after their completion in 1840.* Half a million people saw the pictures, and prints of them were sold by the thousands. The pictures themselves were commissioned by a wealthy banker, Sam Ward. Cole was enormously successful; *The Voyage of Life* was only one of many commissions of its kind, and his fellow artists in both painting and literature admired him (with a few exceptions) as much as did the public and his moneyed patrons. Durand's *Kindred Spirits* was painted in memory of Cole the year after his death; the kindred spirits represented in it are Cole and the American nature poet William Cullen Bryant. Bryant's poetry, like Cole's *Voyage of Life,* is at an awkward age, but it may not be

* At the Art Union, formed to eliminate the dealer and thus increase the painter's percentage of the price of a picture. Public membership was by subscription. Members received prints and, by lottery, original paintings. Nearly 19,000 people all over the country finally joined. Oliver W. Larkin in his classic *Art and Life in America* has deftly characterized the Art Union as "joining the aesthetic with the acquisitive, and national pride with national zest for a bargain."

long before their moral idealism in both cases becomes more conspicuous than their threadbareness and triteness.

But even today the two pictures we have just seen are remarkable for the consistency with which two contrasting moods are presented. Compositionally *Youth* and *Manhood* are carefully studied to make their points even if the points are obvious and labored. Cole held theories about the psychological effects of colors, believing that they corresponded to musical tones in their differences. The extremely literal detail in both pictures is more noticeable than the effort to combine these details in shapes and colors expressive in themselves. *Youth* is composed in horizontals and verticals, *Manhood* in whirls of dark around a vortex of light. Given a "modern" execution, either scheme could be abstracted into an arrangement of shape and color that might be regarded respectfully by critics who are unable to make concessions to the pictures as Cole conceived them. It is just possible that during a trip to Germany Cole became acquainted with Friedrich's pictures; there are obvious parallels between some passages in pictures like *Youth* and some in the German romantic's painting. It is certain that Cole knew and was influenced by the art of the seventeenth-century Italian romantic Salvator Rosa in the darkly turbulent *Manhood.*

From the distance of a century and a half that has made us suspicious of moralistic art, it is easy to patronize *The Voyage of Life,* but this condescension cannot be extended to Cole's pure landscapes. During the rise of abstraction with its intellectualized code of aesthetics—beginning early in this century—the Hudson River School, and Cole in particular, fell low in critical favor; it was not until the 1950s that the school began its resurgence and paintings like Cole's *The Oxbow of the Connecticut River* [122] were again perceived as something better than detailed topographical renderings. *The Oxbow* is a profoundly dramatic picture, broadly conceived in deep space; its minute detail is so beautifully articulated into large movements that the picture is first seen, inevitably, as a whole with its great sweeping forms, the wide swing of the Connecticut River through the valley, the passage of clouds, the rise of hills across the stretch of meadows. It is only secondarily—but with further delight—that the intricate tooling of forms within forms, glittering in the sun, is discovered as one may discover through a

magnifying glass unsuspected complications on the surface of a leaf or a bit of tree bark, or with binoculars the infinite detail of meadows and hills reaching back into the distance, brought suddenly close as if they could be touched.

Cole was born in England. When his family migrated to America in 1818 he was only seventeen but had already worked as a textile designer and an engraver. In America he designed wallpaper and studied wood engraving; the meticulousness of this technique stayed with him as a painter and made his pictures the most sharply detailed of the Hudson River School. When he was twenty-two Cole entered the Pennsylvania Academy of the Fine Arts in Philadelphia, the nation's first art school. He studied there for two years and then went to New York, where his landscapes were an immediate success.

Cole's father had emigrated to America at the urging of the precocious teenager, who held the double vision of the new world as a virgin wilderness and a land of opportunity. Thomas was not disappointed on either score. Although he never penetrated far beyond the Catskills, these small mountains were still wild enough in comparison with England, where the land he knew was either thoroughly domesticated or beginning to suffer the blights of industrialization. In 1829, already a success in the land of opportunity at the age of twenty-eight, Cole returned for a tour of England and Europe that lasted two years. He made a second trip in 1841–1842. His birth date is within a year or two of Delacroix's, yet he seems to have been unaffected by the excitement of what was then modern art in France—Delacroix's conflict with the establishment, symptomatic of the romantic restlessness that was evident in the rest of European art.

If he had made his second trip about ten years later, in the 1850s instead of early in the 1840s, Cole could easily have come under the influence of the Pre-Raphaelites, who shared with him a passion for explicit realistic detail in the service of romantic expression, although he might have felt uneasy about the neurotic tinge that infected their work. As it was, this English-born artist, with his peculiar combination of naïveté and something approaching genius, became one of the most American of artists. Among other attributes that make him so, he was a seminal figure in a specifically American aspect of landscape painting that has been un-

derstood only in recent years—luminism. The term cannot apply to all of Cole's painting—not, for instance, to *The Voyage of Life,* with its artificial illumination—but *The Oxbow* exemplifies the luminist ideal.

Luminism

The unifying element in *The Oxbow* is not so much the interrelationship of natural forms as the way these forms receive the light that plays upon them, the permeation of light everywhere—on each leaf, on the expanse of water, in the sky. This is not the soft, flickering light of Constable's world, nor is it the shattering light of Turner's. Nor is it, exactly, a natural light; it is more nearly supernatural in its revelation of precise details that the eye would not naturally perceive.

The term *luminism* has been coined to designate this landscape style, peculiar to American painting in the nineteenth century, that came about through the various artists' response to a common impulse without benefit of theory. Luminism was never a school with a set of defined principles; these principles were first formulated in retrospect by John I. H. Baur (of the Whitney Museum of American Art) when he coined the term in 1954 and called luminism "a polished and meticulous realism in which there is no sign of brushwork and no trace of impressionism, the atmospheric effects being achieved by infinitely careful gradations of tone, by the most exact study of the relative clarity of near and far objects, and by a precise rendering of the variations in texture and color produced by direct or reflected rays."

Luminist landscapes are usually peaceful, impregnated with an absolute quiet in which no leaf trembles and each wavelet on a beach is held in suspension, where a boulder or a pebble, the one as sharply defined as the other, shares an equal role in the miracle of nature, God's handiwork revealed through the ineffable agency of light. Even when storms arise, as in *Approaching Storm near Newport* [123] by Martin Johnson Heade (1819–1904), one of luminism's first masters, or *Ships and an Approaching Storm off Owl's Head, Maine* [Plate 8, p. 88] by another, Fitz Hugh Lane (1804–1865), the scenes remain transfixed in a preternatural hush; there is no threat, and our contemplation of nature and objects in light is

123 Martin Johnson Heade. *Approaching Storm near Newport.* c. 1860. Oil on canvas, 2'4'' × 4'10¼'' (.71 × 1.48 m). Museum of Fine Arts, Boston (M. and M. Karolik Collection).

undisturbed. Both pictures exemplify dramatically the difference between luminism and impressionism, which was also based on the study of light: in luminism, time is arrested, while impressionism captures the record of a fleeting moment. (As examples, Monet's *Terrace at Sainte Adresse* [Plate 15, p. 220] and his *Spring Trees by a Lake* [269].) The transitory character of impressionist vision is indicated by such frequently met titles as *Snow Effect, Rain Effect,* and so on. In neither the Heade nor the Lane that we have just seen would *Storm Effect,* with its association of quick notation, be appropriate to either the mood or the technique of the pictures.

Second-generation painters of the Hudson River School, such as Bierstadt with his panoramas of the Rockies, can also be called luminists, although their grander subjects and somewhat operatic presentation reduce the quality of enchanted suspension in time that is basic to early luminism. Church worked at first in Cole's manner but later, even in his most exotic and tempestuous subjects, retained the preoccupation with detail that characterizes luminism.*

The importance of luminism in the history of art is that its recognition in the twentieth century revealed, for the first time, that mid-nineteenth-century American art was not merely a provincial cousin to European art—as it had been habitually considered—but had its own history and its own reasons for being that were quite foreign to European developments. The painters of a nation that could still be called the New World discovered in luminism their own form of expression that was as American as the literature of the period in the work of such authors as Melville, Hawthorne, and Thoreau. In 1980, twenty-six years after Baur's coinage of the term, luminism came fully into its own with a landmark exhibition, "American Light," at the National Gallery of Art in Washington.

* Luminism is also exemplified by certain American genre painters, notably George Caleb Bingham [191, 192] and William Sidney Mount [189].

chapter 8

Ingres

The Pedant

In 1824, the year of Delacroix's romantic blast with *Massacre at Chios,* the classical school was without a leader. David was both a very old man and in exile; Gros was floundering and compromising. Both Gérard and Guérin were alive, but neither had the qualifications for leadership. But that year a self-exiled student of David returned from Italy. He had been working on a large religious picture, *The Vow of Louis XIII* [129], a commission for the cathedral in his provincial home city of Montauban. He brought *The Vow of Louis XIII* with him for exhibition in the Salon, much concerned as to its reception, since he had been in and out of academic favor for a long time and had no idea whether he would be attacked again or received as the prodigal son. There had been a hint that he might be in the Academy's good graces; to his surprise he had been elected its corresponding member in Florence a few months earlier.

The Vow of Louis XIII was a success. The Salon that year centered around it and the scandalous *Massacre at Chios.* Jean August Dominique Ingres (1780–1867) became the new leader of classicism, and for the rest of their lives he and Delacroix were identified as official opponents in the classic–romantic imbroglio. At times the conflict came down to personal terms—at least on Ingres' part. Eighteen years older than Delacroix, he was an old man before he ever offered his hand to his romantic adversary. Delacroix recognized Ingres' virtues; Ingres never conceded any to Delacroix, perhaps because in his heart he felt ill equipped for the struggle he had entered into and was jealous of the ease and flourish with which Delacroix seemed to lead his life. Ingres was a pedestrian personality, stubborn and plodding; Delacroix was spectacular and aristocratic in contrast to Ingres' humble ori-

gin and bourgeois ambition. Delacroix painted brilliantly and theorized ever more brilliantly. Ingres' pronouncements were stuffy. From all he wrote and said, it is possible to cull only here and there a phrase not embarrassing in obviousness and pedantry. He was a poor talker.

But he was a great painter. His own art did not prove the validity of the dogmas he defended; it showed only that no dogma, not even one self-imposed, could stifle a creative spirit so powerful that it demanded expression on any terms. As the official leader of classical painting Ingres had to fight not only Delacroix but also a second and even more formidable adversary—the romantic painter within himself. Unlike Gros, who recognized a similar conflict and subjugated his personal expression to classical doctrine, Ingres seems never to have realized where the problem lay. He was shocked and puzzled when classical painters found his work unclassical. He failed to see that romanticism goes deeper than the surface of strong light and shade, swirling action, broken color, and asymmetrical composition, none of which he used. He also failed to see that classicism goes deeper than controlled outline, flat color, tight surface, and symmetrical balance, all of which he continued to use obediently. His attitude toward the Academy remained that of a dogged student intent upon making good marks to win

first prize, even when he was the Academy's leader and spokesman.

Ingres was a great painter in spite of himself. Just how this happened is best explained by examining a group of typical pictures in chronological order.

The Student

At seventeen Ingres came to Paris and entered David's studio. His grandfathers had been a tailor and a wigmaker; his father was a carver of sculptural ornaments. At fourteen the boy was playing the violin in an orchestra to make a little money * Later he won prizes in drawing, and in Paris under David he continued to win them. He became David's favorite student—for a while. David painted his portrait, as affectionate, engaging, and informal a little picture as the great disciplinarian ever allowed himself to do. By 1800 Ingres was assisting David in important work. He painted, for instance, the classical standing lamp that is a conspicuous part of the portrait of *Madame Récamier* [13]. But about this time an unexplained rift developed between Ingres and David. It was never mended.

Ingres had done well in preliminary competitions for the *Prix de Rome* and now, in 1801, he won it. The full subject of his competition picture was *The Envoys of Agamemnon, Sent to Achilles to Urge Him to Fight, Find Him in His Tent with Patroclus Singing of the Feats of Heroes* [124]. As an exercise in the design of male nudes, ranging from the too-muscular giant at the right to the too-lissome youths at the left, † the picture has all the artificiality, the precision, and the respect for recipe of a typical *Prix* winner. It also holds some prophecy of Ingres' future work, the germs of his originality. This originality began to appear during the next few years, to the distress of his sponsors.

The state of France's finances in 1801 was so precarious that, although Ingres had won the *Prix,* no money could be found to send him to Rome. In the five years before the money was available, the state gave him a studio and an al-

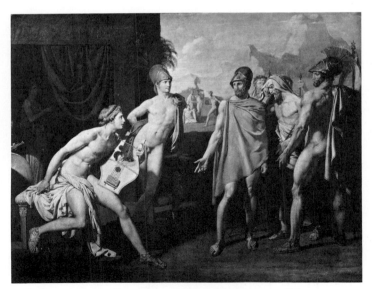

124 Jean Auguste Dominique Ingres. *The Envoys of Agamemnon.* 1801. Oil on canvas, 3'7¼'' × 5'1'' (1.1 × 1.55 m). École des Beaux-Arts, Paris.

* He continued to play the violin all his life, as a diversion and a solace; hence the phrase *violon d'Ingres,* by which the French mean any cherished and sustaining hobby.

† All identifiable according to the story in the *Iliad,* which Ingres studied carefully.

lowance-in-disguise in the form of occasional commissions. Ingres also did a number of portraits on his own and exhibited in the Salon. But bizarre elements began to appear in his work—bizarre, that is, by the standard of conformity expected of a *Prix de Rome* man—culminating in his portrait of *Madame Rivière* [125], exhibited with several others in the Salon of 1806.

Madame Rivière is a masterpiece of linear design. Present everywhere, its pattern is most apparent in the folds of the gauzy scarf and the large shawl flowing through the lower half of the picture. Here sinuous, there suddenly straightening, here moving slowly, next breaking into swirls or ripples, the lines defining folds and hems have their own beauty as abstract rhythmic patterns more important than their function as description. For the first time Ingres was called Gothic, an epithet that was to haunt him for life.

Gothic was a term of opprobrium in the classical vocabulary because it summarized the qualities antithetical to *classic,* and the classicists had never admitted the possibility of more than one standard of beauty. In late Gothic sculpture and painting, drapery was represented in exaggerated bunchings and knottings, the opposite of classical simplicity, in patterns of nervous intensity the opposite of classical repose. The intensity is not reflected in Ingres' particular and very personal use of line in the *Madame Rivière,* a graceful and seductive picture. It shares with Gothic art an interest in the edges and contours of bunched forms, but these are organized into a different, more flowing kind of pattern as a way of drawing form and composing a picture. Each line is a delight to follow individually, full of its own sensitivity, invention, and variety, yet no line exists independently. Each one mutually supports and is supported by every other one. The overall pictorial structure is an integration of broad general movements within which the individual lines are intertwined. A major current flows in a long curve from the bottom of the picture along the hand and up the arm, then along the shoulders where it merges with a quieter, horizontal, stabilizing pattern running from one side of the frame to the other. Such "currents" may be picked up anywhere in the picture; each one merges or divides along its course to flow into or serve as origin for others.

Consciously or not, Ingres violated the classical dogma of accurate or idealized proportion

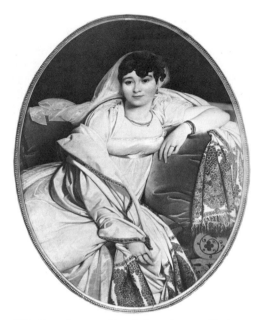

125 Jean Auguste Dominique Ingres. *Madame Rivière.* c. 1805. Oil on canvas; oval, 45⅝ × 35½'' (116 × 90 cm). Louvre, Paris.

to create this rhythmic structure. It is true that if the lady should stand up, her arms hanging at her sides would be of grotesquely different lengths. The right one is elongated and the left one, resting on the pillow, is shortened. These distortions were dictated while the abstract pattern was being evolved from a series of natural forms. The long even curve of the right arm establishes the main direction of the linear currents eddying around it; the left one reverses these currents, checks them and brings us into quieter areas (the pillow and the bodice) that serve to relieve and accentuate the more active areas surrounding them. Except to a dogmatist the distortion would be neither noticeable nor disturbing. It is even less noticeable that the figure of Madame Rivière exists ambiguously from the waist down. The linear currents are so fascinating in themselves that it makes no difference that the disposition of the clothing describes only a token relationship between the forms of the body and the couch upon which they lie. But the academicians were outraged, especially because these unexpected heresies against academic convention were made by a young man to whom they had already awarded the *Prix de Rome*—for which the necessary funds had at last been found.

The Expatriate

With *Madame Rivière* and his other Salon pictures of 1806 labeled "Gothic," "bizarre," and "revolutionary," Ingres left for Rome hurt and confused. He was twenty-six; Girodet had not yet painted *The Entombment of Atala,* David was working on *Le Sacre,* Géricault was only fifteen, and Delacroix was a child of eight.

For the next fourteen years Ingres stayed in Rome and then spent four years in Florence, with a brief excursion to Paris in between. He was thus an expatriate while romanticism announced itself tentatively in *Atala,* made its first sensation with the *Raft of the Medusa,* and found its great man with the exhibition of *Dante and Vergil* in 1822.

Ingres was more than content to stay away. He was as enchanted with Rome as he was disenchanted with Paris. Rather than return, he broke his engagement to a young woman named Anne-Marie Julie Forestier, and after another abortive engagement to the daughter of a Danish archeologist he proposed by letter to Madeleine Chappell, a cousin of one of his friends in Rome. He had never seen Madeleine, who was in her thirties. She came to Rome and they met, romantically, at the tomb of Nero. The marriage was a success.

During the years in Rome between his arrival and his marriage, the "eccentricities" of Ingres' style had become more and more pronounced, which means that he had continued to develop as an original painter in spite of what he regarded as his loyal adherence to conventional classical disciplines. His *Bather of Valpinçon* [126], painted in 1808, could be Ingres' masterpiece if one picture had to be chosen from many eligible ones. It presents the typical Ingres paradox of classical derivations combined with extremely personal and, now, even sensuous responses. Nominally, *The Bather of Valpinçon* has the closest classical associations, since the pose of the figure, with the cloth twisted about one arm, is borrowed from a figure of a nereid on a Roman sarcophagus. But there all resemblance to classical sculpture ends, and although the picture is smoothly painted, with precisely defined contours, these neoclassical elements are superficial. Again, line is the picture, this time not in the complicated patterns of the *Madame Rivière* but in a reduction of the drawing of the nude body to a few subtle, almost eventless contours, suddenly

126 Jean Auguste Dominique Ingres. *The Bather of Valpinçon.* 1808. Oil on canvas, 4'8⅝'' × 3'2¼'' (1.44 × .97 m). Louvre, Paris.

contrasted with the bunched convolutions of the cloth and the turban, all played against the long straight folds of the curtain at the left, briefly echoed at the upper right. Like the contours, the modeling of the body is reduced to an ultimate simplicity and is correspondingly subtle. And a new—and thoroughly un-Davidian—element appears in the painter's sensuous response to the warmth and softness of the naked flesh.

The first series of Roman paintings reaches its climax three years later (1811) in *Jupiter and Thetis* [Plate 9, p. 185]. Ingres' *Prix de Rome* picture had shown Achilles and his beloved friend Patroclus being called to Agamemnon's support by his ambassadors. *Jupiter and Thetis* illustrates a climactic episode later in the same story. It is certainly the most bizarre of all Ingres' paintings. The curious distortion of the woman's throat, the indescribable quality of her arms, flowering into tiny hands, the fantastic complications of the drapery falling from her body and disposed in utterly illogical folds and

rills, the figure of Jupiter with its gigantic, soft torso and its diminutive face encircled by a black wreath of hair and beard—all these, with all the other curious and meticulous details, pushed just to the point of the grotesque, even to the edge of the repellent, are saved in the end by the assurance of their design and, above all, by the sensation they convey that they are distilled from secret inner experience [127].

Actually, the picture follows explicitly Homer's account of how Thetis, a sea nymph, begged Jupiter to grant victory to the Trojans, to avenge an insult to her son Achilles. The request is granted in spite of the fact that in granting it, Jupiter must incur the wrath of Juno. The god had once renounced his secret love for Thetis and yielded her to Achilles' father.

In his copy of a French version of the *Iliad,* Ingres marked a passage that especially interested him; a paraphrase may give some idea of how closely he captured the essence of the episode:

Thetis arose from the waves of the sea, and at the break of day rose through the immensity of the sky to Olympus. There she found him whose eye sees all the universe, the son of Saturn, seated far from the other gods on the highest summit of the mountain. She appeared before him and, with one hand upon his knees and lifting the other to his chin, she implored the monarch. But the god who commands the clouds answered nothing; he remained long in silence. Then this god of thunder let escape from his breast a profound sigh, and said, "I promise you the satisfaction of your desires, and in pledge I accord you the sign of my sacred head." Thus he spoke, and knit his black brows; the divine hair stirred upon the immortal head, and vast Olympus trembled, and Thetis, from the height of dazzling Olympus, threw herself again into the depths of the sea.

Yet, in spite of Ingres' close adherence to the text, *Jupiter and Thetis* is not a literary picture, not a mere illustration. It is complete in itself, legitimately and independently a pictorial expression. Even with no literary reference as a guide, the observer cannot but understand the drama of the moment, the nymph's hesitant temerity as she touches the face of the god, the power of the god himself, and the tension as he weighs whatever secrets must determine his response.

Jupiter and Thetis was the last of the paintings Ingres sent back to Paris under the regulation requiring an annual work from a *Prix de Rome* winner, and he kept a special affection for it all

127 Jean Auguste Dominique Ingres. *Jupiter and Thetis,* detail (see Plate 9, p. 185).

his life. It is the most personal of his major works, impregnated as it is with the element that most intimately characterizes Ingres' art, an element regarded dubiously by many people attempting to evaluate him: an obsessive sexuality that defies the mask of classical idealization. Basic to Ingres' conception of his subjects (in all likelihood unconsciously so on Ingres' part), sexuality is present as if by subterfuge. Where an open and virile masculine sensuousness would not be questionable, there is a suggestion of secret sensual revery. A psychiatrist might find it natural that *Jupiter and Thetis* and others of Ingres' early Roman pictures with the same quality were painted while the artist's personal life was disturbed by his two abortive engagements and the curious circumstances of his courtship of Madeleine Chappell, and

equally natural that after his happy marriage in 1813 his painting took a "healthier" direction. But these same pictures can be defended as Ingres' finest work. According to one theory, all creative art is a kind of purification for the artist, and if *Jupiter and Thetis* is abstracted from Ingres' personal emotional confusions, then it is a very "modern" picture of a kind frequent in the twentieth century, where the creative act becomes a kind of release and a private confessional for the artist, and the resulting work of art is only incidentally intended for the public, which is free to make of it what it will.

The Troubadour

In Rome Ingres found in Raphael a new idol among the old masters, and for him the early-sixteenth-century Italian replaced all other official academic deities. Ingres' nature inclined toward gentle grace, which Raphael offered; at the same time Raphael was acceptable to an avowed classicist because his derivations from classical antiquity were quite direct. But

128 Jean Auguste Dominique Ingres. *Paolo Malatesta and Francesca da Rimini.* c. 1814. Oil on panel, 13¾ × 11″ (35 × 28 cm). Musée Condé, Chantilly.

Raphael's influence on Ingres was not altogether for the best and is an element in a not very happy footnote to his total work: his troubadour pictures.

Troubadour painting was a school within a school, and although it flourished under painters who had been trained by David, classical subjects were abandoned for historical anecdotes of the Middle Ages and the Renaissance. Ingres, their contemporary, painted troubadour subjects when these men were having their first success, combining this kind of picture with the ones we have just seen. His troubadour subjects included a *Betrothal of Raphael,* painted in 1812, no doubt more than coincidentally the year of his own second betrothal, and *Raphael and La Fornarina.* These were the only two pictures Ingres completed in a projected series covering the life of his new idol. He repeated the second subject many times, finally with a variation as late as 1860, of which he wrote "I hope it will cause all the others to be forgotten." He also made repeated versions of *Paolo Malatesta and Francesca da Rimini* [128]. Other subjects were *Henry IV Playing with His Children while the Spanish Ambassador Is Being Admitted, King Philip of Spain Investing the Marshal of Berwick with the Golden Fleece, The Death of Leonardo da Vinci in the Arms of Francis I,* and *Aretino in the Studio of Tintoretto.* These labored storytelling pictures seem a waste of Ingres' meticulous technique. Except for the two Raphael subjects and the *Paolo and Francesca* they hardly suggest his linear beauties.

It was specifically the vogue for troubadour painting that inspired David's complaint in 1808 that the direction he had set for the fine arts was too severe to please for very long in France. "In ten years the study of the antique will be abandoned," he said. "I hear the antique praised on every side but when I try to find it applied, I discover that it never is. All these gods, all the heroes, will be replaced by chevaliers, by troubadours singing beneath the windows of their lady-loves, at the foot of medieval towers." The invasion of Olympus by troubadours was another of the many indications that the romantic spirit was inherent in the thought and feeling of the early nineteenth century. The troubadour subject was natural to romanticism and was much used in romantic treatments by romantic painters and dramatists, and troubadour pictures were also among the ancestors of the

acres of history pictures covering Salon walls later on. As far as Ingres was concerned, the subjects offered him nothing, nor did he have anything to bring them. And there is much of their dryness in the important but essentially dull *Vow of Louis XIII.*

The Prodigal

But whatever its faults, *The Vow of Louis XIII* [129] was a success with everyone. After its triumphant exhibition in the Salon of 1824, the classicists, relieved to have found a new leader, welcomed the *Vow* as his inaugural address, and the romantics, including Delacroix, were glad to see the end of Davidian formula. The classicists' approval was an about-face; they had consistently attacked Ingres' Salon pictures. Cries of "Gothic" had resounded again in 1819. By some extraordinary feats of critical gymnastics invoking as a bad example the Italian primitive master Cimabue, the academicians had managed to make the same objections to the simplicity of Ingres' Roman painting that they had made to the complications of *Madame Rivière.**

The Vow of Louis XIII was acceptable to the academicians because it was a thoroughly derivative picture. Ingres received a commission for it in the first place on the strength of a painting of *Christ Delivering the Keys to St. Peter,* which he had completed in 1820 for the Church of Trinità dei Monti in Rome, a lamentable picture, a pasting together to the point of plagiarism of elements from Raphael. *The Vow of Louis XIII,* while it remains a greatly respected work today, is really not much better on that score, although the pasted-together ensemble is more agreeable. But for the academicians this fault was a virtue. They were willing to accept the renegade who had returned to the fold with a large imitation of a certified Old Master. They forgave the original excesses of his youth.

Delighted to return, Ingres remained in Paris for ten years. He received one official award after another and was named President of the École des Beaux-Arts, the official school. He taught the academic recipes to as many as a hundred students at a time, enforcing classical

* Specifically, the objections centered on a reclining nude, the *Grande Odalisque* [156], now in the Louvre.

129 Jean Auguste Dominique Ingres. *The Vow of Louis XIII,* upper portion; width 8'6'' (2.59 m). 1824. Oil on canvas, 13'9¾'' × 8'7⅛'' (4.21 × 2.62 m). Cathedral, Montauban.

dogma relentlessly (teaching beauty as one teaches arithmetic, Delacroix said), and he was even successful now and then in reducing his own art to dry conformity. His major commission of the period, the *Apotheosis of Homer* [130], is an exquisitely studied demonstration of the classical rules, the picture every *Prix de Rome* contestant would have painted if he could have.

But the accord between Ingres and the world of academic success was not quite as warm as it appeared. He had grown increasingly irascible, and when another large religious picture, *The Martyrdom of St. Symphorien* [131], received a bad reception in the Salon of 1834, Ingres asked to be transferred back to Rome as Director of the Academy there. He was given the appointment and left again for Italy in much the same frame of mind as before. He refused all commissions, forbade henceforth the showing of any of his pictures in the Salon, and painted—among others—two pictures in which the spirit of his early Roman work is recalled with renewed and extraordinary intensity.

In both of these a languorous sexuality is expressed in forms of gemlike precision, a contrast that comes close to being jolting in one of

130 Jean Auguste Dominique Ingres. *The Apotheosis of Homer*. 1827. Oil on canvas, 12'8'' × 16'10¾'' (3.86 × 5.15 m). Louvre, Paris.

131 Jean Auguste Dominique Ingres. *The Martyrdom of St. Symphorien* (reduced replica with minor variations from original for Cathedral of Autun, 1834). 1865. Oil on canvas, 14⅓ × 12¼'' (36 × 31 cm). John G. Johnson Collection, Philadephia.

them, the vividly tinted *Odalisque with the Slave* [132, p. 112]. The other, *Stratonice* [133, p. 112] repeats the subject with which David had won the *Prix de Rome* long before [5] and in spirit recalls Ingres' own *Jupiter and Thetis.* Within an elaborate Greek interior, where every mosaic, every vein of marble, every smallest detail of carved ornament, every implausible fold of drapery, is rendered with the microscopic intensity of a revelation, a dream, or a vision, the figures in the drama of repressed passion are transfixed in attitudes of extreme artificiality. Like *Jupiter and Thetis, Stratonice* is saved from mawkishness or absurdity by qualities that may be sensed but are not easy to explain. They have to do with the consistency of the vision, where each of the multitude of details is conceived in harmony with all the others, and conception is totally integrated with execution. It is possible to be puzzled by this conception or to be unsympathetic to it, but it is impossible not to feel that every form, every line, and every relationship of the painted images are expressions of emotional convictions passionately held by the artist who created them.

Ingres completed these two pictures, after interruptions, about 1840. He was sixty years old. The following year, in bad health, he re-

turned to Paris. The prodigal's second home-coming was triumphant with official receptions and awards. He began work on two mural commissions, *The Golden Age* and *The Age of Iron*. The first was never finished and the second was only sketched in. The fragments are not impressive. Possibly Ingres might have reached some conclusions to the struggle between sensuous forms, academic doctrine, and elaborated allegory that tears them apart, but in their present state they are like battlegrounds abandoned in fatigue.

In 1849 Madeleine Chappell died. The marriage that had begun with such an extraordinary courtship had been an ideal one, and Ingres was inconsolable until three years later when he yielded to the urging of friends and remarried, at seventy-one. In 1855 he was induced to relent in his determination never to exhibit again in the Salon, and like Delacroix in that year he had a gallery to himself for a retrospective collection. There were further honors at

132 Jean Auguste Dominique Ingres. *Odalisque with the Slave*. 1842. Oil on canvas, 28 × 39⅜'' (71 × 100 cm). Walters Art Gallery, Baltimore.

133 Jean Auguste Dominique Ingres. *Stratonice* (variation on version of 1840). 1866. Oil on canvas, 24 × 36¼'' (61 × 92 cm). Musée Fabre, Montpellier.

home—he was even named a senator in 1862—and his renown became international with honorary membership in the academies of other countries. When he died in 1867 at eighty-six he had outlived Delacroix, although classicism had not.

Two pictures from these last years enjoy somewhat inflated reputations. In 1820 Ingres had begun work on a standing female nude, *La Source* [134]. Now, thirty-six years later, he completed it with the help of pupils. The figure with its softened contours and cottony flesh is a superior academic studio piece, but it is a very poor second to the two great Roman nudes, the *Bather of Valpinçon* and the *Grande Odalisque*. The face, a symmetrical mask on the classical formula, has grown vapid. By most standards, *La Source* is a fine picture, but not by the standard of Ingres at his greatest.

In 1862 (according to the date on the picture) or 1863 (according to a letter in which he mentions it) Ingres completed *The Turkish Bath* [135], a recombination of figures from several pictures painted in different periods. The Bather of Valpinçon, now playing a mandolin, dominates a confused arrangement of some

134 Jean Auguste Dominique Ingres. *La Source*. 1820–1856. Oil on canvas, 5'4½'' × 2'8¼'' (1.64 × .82 m). Louvre, Paris.

twenty-five naked and ill-assorted harem women, ranging downward from the Bather's undiminished loveliness to the almost comical vulgarity of the squirming masses of flesh in the background. One conspicuous head, just behind the upraised arm of the reclining figure in the right foreground, with its cheek against the ear of the adjoining figure, is wedged into the composition in such a way that it would be physically impossible for a body to exist normally attached to it. *The Turkish Bath* had a difficult history, explaining some of its defects. Ingres completed it about 1852 as a rectangular composition, then reworked it several times, once after it had been returned by a purchaser, and finally changed its shape to the present cir-

135 Jean Auguste Dominique Ingres. *The Turkish Bath*. c. 1852–1863. Oil on canvas, diameter 42½'' (108 cm). Louvre, Paris.

cular one, with necessary additions and subtractions. He was eighty-three by the time he made this final revision.

Portraits and Drawings

As a portraitist Ingres was so prolific and worked so frequently at his highest level that it is difficult to eliminate dozens of superb pictures in order to select a representative few. The early "Gothic" portrait of *Madame Rivière* has already been considered. In comparison with it, the portrait of his friend the painter *François Marius Granet* [136] is more restrained, not only because the subject is a man but also because Ingres has come under new influences. He never repeated the complexity of linear flow that marked *Madame Rivière,* either because of the criticisms of it or because in Italy he discovered the portraits of the Italian Renaissance and was attracted by their greater simplicity—or, of course, because of both. In the portrait of Granet, the head surmounts a generally pyramidal mass and is lifted above the distant horizon in order to play its lines and shapes against an eventless passage of sky. The strongest value contrasts, the white collar and

136 Jean Auguste Dominique Ingres. *François Marius Granet.* c. 1807. Oil on canvas, 28¾ × 24″ (73 × 61 cm). Musée Granet, Aix-en-Provence.

the dark hair, frame the face as a further assurance that it will remain the undisputed focal point of the composition. The architectural landscape background is full of interest, but since it is reduced to small scale in the distance it emphasizes the largeness of the figure.

These are all standard Renaissance devices worn threadbare in the work of any number of painters who used them in very much the way Ingres did; they are not difficult to employ skillfully. Ingres' *Granet* is a masterpiece because over this conventional framework he builds his own linear pattern, combining the sinuosities of the edges of the open cape and its thrown-back collar with the contrasting solidity of its general silhouette, contrasting equally the unqualified rectangularities of the book, the bit of wall, and the buildings in the background with the irregular shapes of the white collar, the head, and the locks of hair patterned against the forehead. All the forms have more mass, more solidity, and are more naturalistic than those of the *Madame Rivière,* but they are still drawn in linear arabesques that have their own abstract beauty. And in both portraits the sensuousness of Ingres' response to human beauty warms and illuminates these images presented with such precision and control.

The background of the *Granet* is a specific reference to place. It shows the Villa Medici, the Renaissance palace acquired by the French Academy as its Roman base. With its gardens, its fantasy of a façade, its sculpture, its great halls, its towering position on the most beautiful of Roman hills, looking across the most spectacular panorama of the city, the Villa Medici was a paradise for the *Prix de Rome* winners, who lived and painted there (and still do). Like Ingres, Granet was a *Prix de Rome* man. (For a while he enjoyed a success in Paris, although his work is forgotten today—which is a mercy.) Ingres' portrait of him hangs in the municipal museum in his home city of Aix-en-Provence. A few feet away *Jupiter and Thetis* covers the end wall of the gallery, a combination evoking Ingres' young manhood in Rome.

The general formula of the *Granet* served Ingres for many of his finest early portraits. In later ones, such as that of the young *Comtesse d'Haussonville* [137], done in 1845, he shows greater dependence on accessory details for their inherent interest as objects, more complication for the sake of stunning naturalistic rendering (in the stuff of the dress, for instance) at

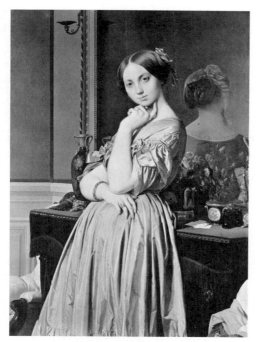

137 Jean Auguste Dominique Ingres. *The Comtesse d'Haussonville*. 1845. Oil on canvas, 4'5½'' × 3'1¼'' (1.36 × .92 m). Frick Collection, New York (copyright).

imposed her personality upon the painter, where ordinarily when Ingres painted a portrait it was the other way around.

The great exception among all Ingres portraits is the one of *Louis-François Bertin* [139, p. 116], founder and director of *Le Journal des Débats*. Here it is obvious that Ingres was seeking something beyond a satisfactory "likeness" or an elegant effigy. The selection of pose, the tension in the position of the hands on the knees as the man leans forward slightly, the elimination of accessory detail, the sharp, decisive patterning of the hair (which in a preliminary drawing is shown to have been, actually, rather limp and characterless) all contribute to the impression of shrewdness and energy that would not have been present in a simple transcription of the subject's appearance sitting patiently for the artist.

A drawing by Ingres is of such delicacy that it is brutalized in even the best reproduction. He drew constantly and made innumerable preliminary studies for his paintings. The Musée Ingres in his native city of Montauban is the great treasurehouse of these studies, but hundreds of Ingres drawings are in museums and collec-

the expense of linear invention. Toward the end this tendency dominated the painter to the point that a portrait is in danger of holding more interest as a contemporary record of an interior and a lady's toilette than as a transmutation of fact into art. But Ingres never entirely succeeded in his effort to be anything but himself. Ingres the academician never quite managed to stifle Ingres the original artist.

Ingres had one great limitation as a portrait painter, if one demands that a portrait be not only a fine painting but an interpretation of character. In his average portrait whatever we learn of the sitter's character we must infer by association. Sometimes these associations are strong. The early (1812) portrait of the *Comtesse de Tournon* [138] presents one vivid individual among Ingres' gallery of somewhat repetitious and superficially explored personalities. Yet even in this case we may feel that the old Countess was a person of such sprightly character and such characterizing features that some reflection of her individuality was inevitable in anything like an accurate reproduction of her appearance. Here the sitter seems to have

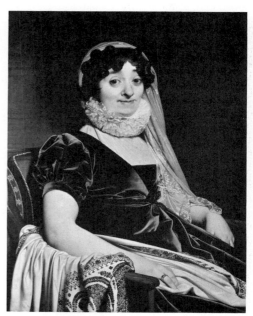

138 Jean Auguste Dominique Ingres. *The Comtesse de Tournon*. 1812. Oil on canvas, 36⅝ × 28¾'' (93 × 73 cm). Collection Henry P. McIlhenny, Philadelphia.

tions elsewhere. These include especially the small portrait sketches in pencil made sometimes as preliminary studies, sometimes as souvenirs given in affection or to ingratiate himself with the aristocrats who came through Rome in steady streams. One of these is the *Comte Turpin de Crissé* [140], with the head typically modeled in more detail than the figure, which is sketched in with absolute assurance but with only an occasional light indication of shadow to enhance the form, which is otherwise revealed entirely by line. Ingres frequently catches a stronger suggestion of personality in these drawings than he tries for in more carefully studied paintings. Jaunty elegance, alert, sophisticated intelligence, social aplomb, and even a hint of amused cynicism are presented in the features and the pose as Ingres has transcribed them quickly here with the model before him. If Ingres seldom reflects his sitter's individuality with equal acuity in his paintings, it is because his immediate response to a subject, which was instinctively perceptive, was not ordinarily increased and deepened by further reflection; rather it was lessened by further study of the portrait as a problem in design. If this is a limitation it must be accepted as one playing its own part, not necessarily negative, in Ingres' creation of some of the most extraordinarily effective portraits in the European tradition.

In his portraits Ingres is a great stylist; so is he, of course, in his subject pictures. But he must remain only a stylist, nothing more, even in such pictures as *Jupiter and Thetis,* unless his characterizing element of hidden and even unconscious personal emotional expression is recognized. Baudelaire, who was so perceptive of the universal significance of the conceptions released through Delacroix's romantic forms, searched uneasily in the art of Ingres for meanings he seems to have suspected were concealed beneath the polished surface and fettered within the implacable contours of Ingres' style. He never convinced himself that these meanings were there. But the twentieth century, with its exploration of the hidden impulses of creation, has revealed Ingres as an intense, intimate, and even secret artist of the most personal kind beneath his stylizations and pedantry.

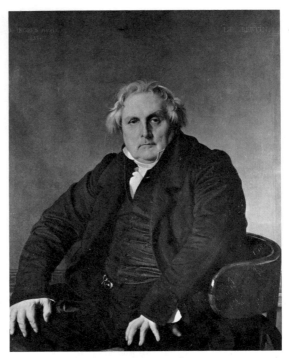

139 Jean Auguste Dominique Ingres. *Louis-François Bertin.* 1832. Oil on canvas, 46 × 35½″ (117 × 90 cm). Louvre, Paris.

140 Jean Auguste Dominique Ingres. *Comte Turpin de Crissé.* Probably 1818. Pencil, 11⅝ × 8⅞″ (30 × 23 cm). Metropolitan Museum of Art, New York (bequest of Walter C. Baker, 1972).

part two

Realism and Impressionism

chapter 9

Three Realists: Goya, Daumier, and Courbet

Idealism and Disillusion

For all their differences, the classicists and the romantics held one conviction in common, and it was a basic one: they thought of life and the world as a mystery that could be explored to discover the reason for our existence. Neither doubted the assumption that we are here for a reason and that our being is justified and meaningful. For both, nature—all the different facets of life, of the world—was what Delacroix called a vocabulary, which could be used to study the mystery's solution. Classic or romantic, the idealist assumes that within all the conflicts and contradictions, all the ambiguities and confusions of life, somewhere there is a harmony, a discoverable truth, by which we can understand the fact that we exist. The forces around and within us, all apparently working at odds against one another, must certainly be not accidental, as they appear to be, but animated toward meaningful order; must certainly be some part of a universal plan within which we move for some purpose toward some reward, some profound satisfaction of the human yearning to be more than an organism that is born, suffers, and dies.

The classicist sought to clarify the mystery by intellectualizing human experience. The romantic sought its heart in the more ambiguous area of the "soul" and was willing to cultivate even life's suffering in the conviction that emotional experience holds the answer everyone seeks. But in the end—and this is the important point—both classicist and romantic were idealists, refusing to accept the world at its face value, rejecting it in the end, forcing the experience of life into their respective and equally arbitrary molds in spite of repeated evidence that they could never get more than a part of it to fit.

By the middle of the nineteenth century, twenty-five years after David's death and a decade before Delacroix's and Ingres', painters were becoming

disillusioned with idealism in either form and were turning to realism, which in several forms was to dominate painting until near the end of the century. Meanwhile, the movement had been anticipated by one of the most unillusioned painters who ever lived, the Spaniard Francisco José de Goya y Lucientes (1746–1828).

Goya: His World

Goya was a contemporary of David almost to the exact years, having been born two years earlier than the master of classicism and dying three years after him. Yet as a young man he discarded the classicism of his teachers, and he was never affected by the type of romanticism that developed in France. In his very old age Goya visited Paris and is said to have admired the work of the young Delacroix. But he could have told himself that the vehemence of his own work—its emotional color and its dramatic force—not only exceeded that of this Frenchman who was fifty-three years younger but that his, Goya's, art was born from a fervent experience of life that gave it a vitality alongside which Delacroix's romanticism was a theoretical demonstration.

Because of his fire and his dramatic force, Goya is often called a romantic painter. Because he deals so frequently with horrors and with the fantastic, he may appear to be a painter of the world of imaginative emotionalism inhabited by one type of romantic. But Goya was a realist because he saw the world without illusion. No other painter has seen it more naked of saving grace, either of reason or of sentiment, of intellect or of soul. Even when his visions are most monstrous, even when he is most outraged by what he sees and records it most violently, Goya is a realist in the basic sense; he sees the world around him for what it is and he accepts its existence as unalterable fact. The world Goya saw was not a world he could condone; but neither did he hope to change it or to discover hidden within it the classicist's order or the romantic's yearning conviction of some ultimate, if undecipherable, meaning.

The circumstances surrounding Goya in his daily life as a Spaniard offered no nourishment for idealism of any kind. While David was synthesizing an art in praise of Reason, stimulated by the French philosophers who had deified it,

Goya was working at the court of Spain, surrounded by a group of human monsters who have never been surpassed for stupidity, viciousness, ignorance, greed, and corruption, in a country intellectually all but inert, with a populace brutalized by poverty, bigotry, and oppression. The national characteristics of Spain at that moment included a catalogue of all evil and misery, and Goya's observation of the world gave him no reason to believe that the eighteenth-century philosopher's dream of Reason had produced anything more than monsters. He said as much in a print showing a student asleep over his books while the air around him is filled with screech owls and bats [141]. The print has been given various interpretations, but any interpretation must accept its premise of the triumph of nightmare. This incapacity to think our way toward reasonable and humane

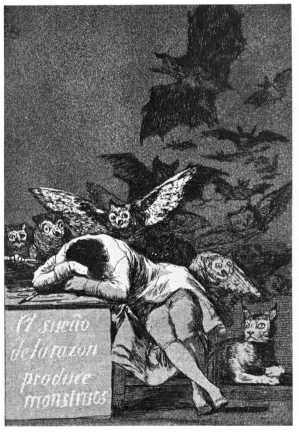

141 Francisco Goya. *The Sleep of Reason Produces Monsters.* 1797–1798. Etching and aquatint, $8\frac{3}{8} \times 5\frac{7}{8}''$ (21 × 15 cm). Philadelphia Museum of Art (SmithKline Corporation Collection).

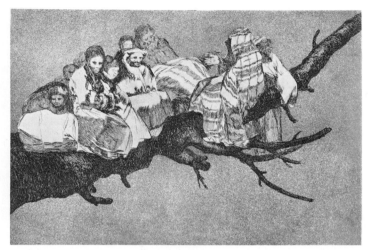

142 Francisco Goya. *Ridiculous Folly,* from the *Disparates.* 1813–1820. Etching and aquatint, 9½ × 13¾'' (24 × 35 cm). Philadelphia Museum of Art (gift of Mr. and Mrs. R. Sturgis Ingersoll).

existence is parabled in another print [142] in which a philosopher or teacher mouths by rote the phrases of learning to an audience deaf, dumb, and blind to thought of any kind, the whole scene taking place upon a branch so rotten that it will presently drop everyone into an abyss of which they are not even aware.

The wonder is that from such a world a man like Goya managed to emerge at all. To his common origin he owed his physical vigor and, for that matter, his intellectual vigor, which might have been stultified and corrupted if he had grown up in the world he entered later. To this world, the world of his patrons, the court and the circle surrounding it, he owed his living, the opportunity to paint, and thus eventually his fame, but he never conceded a point in his contempt for it. Goya was incapable of the kind of flattery exercised by David when he painted Napoleon's disintegrating empress as a mere slip of a girl in *Le Sacre*. Fortunately, flattery was never required of him. His portraits of the royal family are explicitly of contemptible, mediocre, or at best pathetic characters. That these portraits were accepted and that he was commissioned to repeat them is proof enough that the sitters were as stupid as he painted them to be, so satisfied with themselves that they admired their own images without seeing the ghastly revelation beneath the painted reflections.

The Family of Charles IV [143] shows a group of pompous freaks, swathed in velvets and silks and dripping with jewels. It has been nicknamed once and for all "the grocer and his family who have just won the Grand Lottery," a witticism hard on grocers and their families but

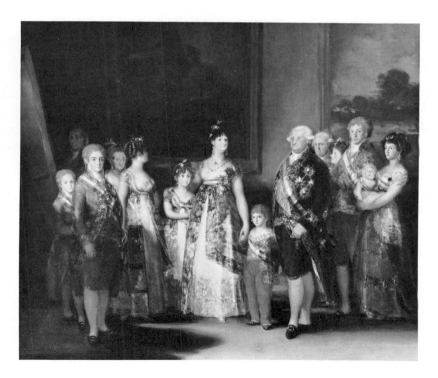

143 Francisco Goya. *The Family of Charles IV.* 1800. Oil on canvas, 9'2'' × 11' (2.79 × 3.35 m). Prado, Madrid.

charitable to the King of Spain and his. The monarch stands in the foreground on the right, his chest and belly ablaze with decorations. A glance is enough to substantiate the story that during the day he would ask his minister, a villain named Manuel Godoy, how things were going and without waiting for an answer would consider his obligations as ruler of a nation completed for another twenty-four hours. His grotesque queen stands in the center, embracing her daughter and holding the hand of her son awkwardly enough to suggest that these maternal gestures were unfamiliar ones for her. These children are presumed to have been fathered by the same Manuel Godoy, whose duties at court extended beyond the usual ministerial ones. This queen, Maria Luisa of Parma, also granted her favors to an occasional servant. There have been more vicious women in history, but they were women of greater intelligence and hence capable of greater inventiveness than this one. To the left foreground is Ferdinand, heir to the throne, who is a blank. Behind him is the face of a witch, the King's sister. Only the young couple at the extreme right seem normal. Goya has sympathetically concealed the spinal deformity with which this one of the King's children was born, translating it into a posture twisted because she carries her child in her arms. Her husband is also a human being. But the children on each side of the Queen are devoid of innocence. The hard-faced little boy is like his father—not the King—and the girl is already an echo of her mother. Behind this collection, almost obscured in deep shadow, at the far left, Goya is at work on the picture.

In Goya's art his contempt for the people around him widens to become a horror of humanity in general. In his portraits of children he comes closest to relenting; yet even here, as in the *Don Manuel Osorio de Zuñiga* [144], he may see purity and innocence as nothing but fodder for corruption. From the shadows behind the utterly charming image of the little boy gleam the eyes of cats in wait to devour the fragile bird. Goya's young women are creatures of fire and beauty, but without tenderness, and he is fond of playing them in front of figures of frightful old hags. On the surface this contrast reminds us that youth and beauty are transient, but it is even more emphatically a statement that the human spirit is not only subject to corruption but apparently, to Goya's way of think-

144 Francisco Goya. *Don Manuel Osorio de Zuñiga.* c. 1787. Oil on canvas, 4'2'' × 3'4'' (1.27 × 1.02 m). Metropolitan Museum of Art, New York (Jules S. Bache Collection, 1949).

ing, impotent to withstand it. *Que Tal?* [145] tells us that time does not ripen humanity into wisdom, but rots and withers it into foolishness and evil.

For Goya, evil is the ultimate reality, violation and degradation the universal fate. He never condones these truths, holding them to be self-evident, but he hardly protests against them. He states vehemently that they are abominable, but he never suggests the possibility of amelioration or correction. *And Nothing Can Be Done about It* [146] is the title of another of his prints, one from a series making up as horrifying a record of cruelty as has ever been set down in any medium: Goya's *Disasters of War.*

Between 1808 and 1814 Goya witnessed the Napoleonic invasions of Spain, the guerrilla warfare that followed them, the famine of 1812 that was one result of them, and the return of the Inquisition under Ferdinand VII. Even granting the difference between French and Spanish viewpoints on the subject of Napoleon,

145 Francisco Goya. *Que Tal?* c. 1801. Oil on canvas, 5'11¼'' × 4'1½'' (1.81 × 1.23 m). Musée des Beaux-Arts, Lille.

146 Francisco Goya. *Y no hai remedio (And Nothing Can Be Done about It),* from *The Disasters of War.* 1810–1820. Etching and aquatint, 15½ × 16⅝'' (39 × 42 cm). Philadelphia Museum of Art (SmithKline Corporation Collection).

we must recognize that the contrast between the treatment of the Napoleonic legend in French painting and Goya's observation of terrible fact is a legitimate, if extreme, example of the difference between romantic and classical idealism and realism. There is no glory in Goya's war, no grandeur in victory or grand emotion in defeat; there are only rape, slaughter, and mutilation. His subject is human bestiality. The victims get second billing to the rapists, butchers, and mutilators; we are appalled by the perpetrators but not led to great compassion for the victims, whose agony, no matter how frightful, we must accept as a human condition beyond correction. Gros' *Pesthouse at Jaffa* is by comparison an Elysium.

In such a world reality becomes nightmare, and Goya the realist created some of the most fantastic visions in the history of art. *The Disasters of War* are realistic in fact and in representation, lamentable as it may be that the world offers material for this realism. The set of prints called the *Caprichos* are fantasies, yet their comments on greed, superstition, stupidity, bigotry, avarice, and indifference are comments on our nature as social beings with responsibilities for which we are accountable, a fundamental concept in realistic art. The *Caprichos* are social comment made in terms of the grotesque, the monstrous, and the hallucinatory. In some of Goya's work the hallucination passes beyond such comment and becomes a symbolical damnation of humanity, as in the ghastly *Saturn Devouring One of His Sons* [147, p. 124]. These morbidities are Goya's answer to the romantic dream of noble passions, and instead of the classicists' Olympians, he shows a terrifying *Colossus* [148, p. 124] dwarfing the world, a magnificent and brutish figure who dominates the universe yet looks upon it without comprehension.

Goya: His Isolation

Some of the most trenchant observations of human vanity and corruption have been made by painters or writers who have moved freely within a specific world, and have been accepted as part of it by its denizens, while within themselves they have remained separated from it by an unusual isolating circumstance. They remain free to observe with the objectivity of an outsider, yet with intimate access to their material.

Goya was such a man. As the official painter of the court he was intimately associated with the aristocratic world. His mistress was the Duchess of Alba, supposed to have been the most beautiful woman in Spain and by all accounts so entrancing that she was forgiven much that would have been held against a plainer woman. This was a real love affair, and in spite of the Duchess' high station, it was not so much a part of Goya's participation in the world of wealth and position as it was a continuation of his youth as a hard-working and hard-living painter in Madrid's world of brawls and the bullring. Goya himself was an amateur bullfighter and, by legend, a good one. Later he did a series of etchings, the *Tauromachia,* on this sport or art. Here, as in his paintings of the life of the city, its strollers, its beggars, its people of the streets, he is established historically as a realist finding material in the life around him and commenting on it in contemporary terms, without reference to picturesque places or customs. If the city life he painted has an exotic flavor for us, it did not for him.

148 Francisco Goya. *The Colossus.* c. 1818. Etching and aquatint, scraped; 11⅜ × 8⅛″ (29 × 21 cm). Metropolitan Museum of Art, New York (Harris Brisbane Dick Fund, 1935).

147 Francisco Goya. *Saturn Devouring One of His Sons.* c. 1821. Fresco detached on canvas, 4′9½″ × 2′8⅛″ (1.46 × .83 m). Prado, Madrid.

Goya's withdrawal from this life—from life in general, for that matter—a spiritual withdrawal that left him a figure moving actively among people yet observing them from seclusion, was the result of a desperate illness in 1792 that left him totally deaf at forty-six. Whatever elements in his temperament had predisposed him to the contemplation of human folly were now exaggerated; the isolation of deafness also coincided with his rise in official favor and his increasing contact with the world of the court.*

* Goya had become a court painter under Charles III in 1786 and was raised to *pintor de cámara* in 1789 by Charles IV, at about which time he seems to have studied the liberal ideas of the French encyclopedists, who were popular with Spanish intellectuals. This period of relative optimism was terminated by his illness in 1792 with convalescence and deafness in 1793. He became President of Spain's Royal Academy in 1795 and First Painter to the King in 1799.

149 Francisco Goya. *Portrait of His Wife, Josefa Bayeu.* c. 1798. Oil on canvas, 32 × 22″ (81 × 56 cm). Prado, Madrid.

The first years of deafness and isolation produced the *Caprichos,* a set of eighty aquatints* first announced to the public in 1797 and published two years later. *The Sleep of Reason Produces Monsters* [141] was its first plate and its theme. In the *Caprichos* unreasonable beings

* Aquatint is a method of acid-biting a metal plate in such a way that the effect of a graded wash is approximated, thus allowing nuances of light and shade not possible in ordinary etching. It is usually combined with etching, as in Goya's work. The process was developed as a secret one by Jean-Baptiste Le Prince (1734–1781) and had become public property only shortly before Goya used it, having been revealed in a technical manual, *Encyclopédie Méthodique,* in 1791. Aquatint was particularly valuable to Goya since its wide range from deep shadow to brilliant light was adaptable to the nightmarish illumination of the spectral regions he was creating

defeat themselves and torture one another with every cruelty, indignity, and foolishness; the pattern of Goya's pessimism is set, and from this time on, circumstances continue to increase his paradoxical combination of vehemence and detachment. In 1802 the Duchess of Alba died. Goya was fifty-six years old. He witnessed the Napoleonic invasions and the uprisings in Madrid before the death of his wife ten years after that of his duchess. He had been married for thirty-six years to Josefa Bayeu, the sister of a painter with whom he had an early association, a devoted, loyal woman who bore him twenty children, some of whom lived; he painted a very sympathetic portrait of her [149].

Goya was now so cut off from human contact and so embittered that he left Madrid to go into seclusion in his country house, *La Quinta del Sordo* (Deaf Man's Villa). With its walls lined with frescoes that Goya painted over the following years (including *Saturn Devouring One of His Sons,* now transferred to the Prado), the country villa became a compartment of hell transplanted into the Spanish countryside.

At sixty-eight, Goya was still a man of astounding vigor. He etched the *Tauromachia,* a set of forty large plates telling the history of the bullfight and its heroes, and by 1819, at seventy-three, he had produced another set of twenty-two etchings and aquatints, the *Disparates,* and completed *The Disasters of War,* although for political reasons these latter were not published until 1863, long after his death.

The *Disparates* are the most fantastic of Goya's prints and in many ways the most philosophical; they are grotesque allegories whose interpretations Goya leaves up to the observer. Interpretation is not always possible in precise terms, but as the summation of all Goya's previous work the meaning of the *Disparates* is clear enough, and horrifying; Goya's deepest and bitterest experience is translated into fantasies of horror, outrage, and despair. On first publication they were given the innocuous title *Proverbios* by the puzzled and no doubt frightened Academy. The title is apt, in that a proverb expresses some fundamental and enduring idea concerning the world disguised as humor or grotesquerie, but not apt in that proverbs grow out of the experience of a people, and the *Disparates* are Goya's own. The word really means, approximately, *Fantastic Blunders.*

In 1824 Goya went into voluntary exile in France. Settled in Bordeaux, his eyesight failing

150 Francisco Goya. *El Famoso Americano, Mariano Ceballos,* from *Tauromachia.* 1825. Lithograph, 12¼ × 15¾'' (32 × 40 cm). Philadelphia Museum of Art (John D. McIlhenny Fund).

and his vigor at last waning, he began working in the new medium of lithography* and produced four large stones continuing the *Tauromachia,* of an almost orgiastic vitality [150]. He died in Bordeaux in 1828, at eighty-two.

Goya: His Innovations

The first influences on Goya as a painter were at odds with one another, and he was at odds with

*Lithography, a process of drawing on prepared stone and then printing from it, was invented about 1796 in Munich by Aloys Senefelder, who published an account of his invention in 1818. Lithography is the most direct of all the art-printing processes, imposing a minimum of technical barrier between the artist's hand and the completed print. The artist draws on smooth stone just as he would do on paper; the drawing may be transferred repeatedly to paper with very little change in character. Lithographic darks are even richer than those of aquatint, and every nuance between black and white is possible. The fine-grained texture of the stone gives lithography its particular individuality, although in modern variations of the technique surfaces other than stone are often used.

both of them. For a century Spain had been dependent on imported artists, and Goya was first subjected to the borrowed rococo forms of various Italian masters, the kind of painting that inspired David's revolt, and then to the art of Raphael Mengs (1728–1779), an influential German neoclassical painter of exceptional dryness, with whom he worked for a while. Goya rejected classicism on sight, but after Mengs and Francisco Bayeu used their influence to get him a place with the Royal Tapestry Works in Madrid in 1776, he produced a series of vivacious decorative paintings that easily hold their own alongside those of the eighteenth-century Italians whose tradition they follow. But even while Goya was painting within the rococo tradition of lightness and charm, sinister implications are at play beneath the artificial gaiety. The jolly girls who toss the puppet in a blanket in *El Pelele* [151] are young witches. If their victim is only a puppet, it is because they are still novices. Later they will substitute human carrion for the rag doll; this holiday in a park is only a rehearsal for a witches' sabbath.

Portrait commissions came Goya's way readily. His earliest portraits are rich technical dis-

151 Francisco Goya. *El Pelele (The Manikin)*. 1791. Oil on canvas, 8′9″ × 5′3″ (2.67 × 1.6 m). Prado, Madrid.

plays with the models posed rather stiffly, a bit overweighted sometimes with incidental elaborations of costume, partly of course because the dress of the period so dictated, as in the portrait of the *Marquesa de San Andrés* [152]. The subject is not deeply explored as a personality; we make our own deductions from the lively objectivity of Goya's re-creation of the lady's features, but we are not told much about her. She regards us with an alert and tolerant glance, yet as far as Goya's characterization of her as an individual is concerned, she might be any one of hundreds like her. But a few years later Goya stands the *Marquesa de La Solana* [153] before us as a complete individual. Her homely features are presented without idealization, but never for a moment does Goya regard any detail of them, or of her costume, as incidental portions of a still life that happens to be composed of a human being dressed in a certain way. Every element in the portrait of the

152 Francisco Goya. *The Marquesa de San Andrés*. 1785–1790. Oil on canvas, 33 × 22″ (84 × 56 cm). Private collection.

153 Francisco Goya. *The Marquesa de la Solana*. 1791–1795. Oil on canvas, 5′11¼″ × 4′ (1.81 × 1.22 m). Louvre, Paris.

154 Francisco Goya. *Nude Maja.* c. 1797–1798. Oil on canvas, 3′1⅜″ × 6′2¾″ (.95 × 1.9 m). Prado, Madrid.

Marquesa de La Solana contributes to the creation of a total personality, subtly projected. The earlier *Marquesa de San Andrés* is a catalogue of accessories, and the fact that styles in dress have changed between the two portraits is only a superficial explanation of their difference. In the later one the lace of the skirt and shawl could have been played up as arresting details; instead they are all but eliminated in the reduction of the composition to large simplified areas of blacks and grays, within which the pinkish tones of the face and the bow of ribbon perched above it take on an extraordinary life. The portrait is a play between the face and the ribbon bow; the reality of the face, its rather stubborn strength, is emphasized by its existence within the contrastingly airy and delicate frame of the shawl and the climax of the fashionable absurdity of the bow. Larger than the face and brighter in color, elegant and dainty where the face is plain and coarse-featured, the bow is the first thing one sees in the picture. But it immediately loses its battle for attention to the face beneath it, a face that appears to accommodate the incompatible accessories surrounding it as a concession to the necessities of mode but goes on about its own more important business without giving them further thought.

156 Jean Auguste Dominique Ingres. *Grande Odalisque*. 1814. Oil on canvas, 2′11⅞″ × 5′3¾″ (.91 × 1.62 m). Louvre, Paris.

This superb portrait was probably done just before Goya's climactic illness. As pure painting, it reflects his discovery of Velázquez in the royal collections, now accessible to him. It is also a prelude to his experiments in the use of color and the representation of form that were in full stride by 1800, the year of the portrait of the royal family. Historically these experiments are as important as Delacroix's later ones, although their effect on other painters was delayed by Goya's comparative isolation in Spain.

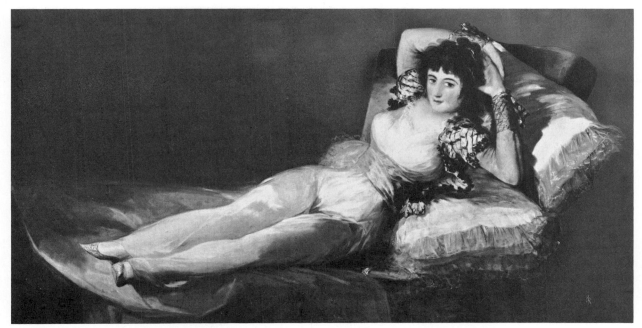

155 Francisco Goya. *Clothed Maja.* c. 1797–1798. Oil on canvas, 3′1¾″ × 6′2¾″ (.95 × 1.9 m). Prado Madrid.

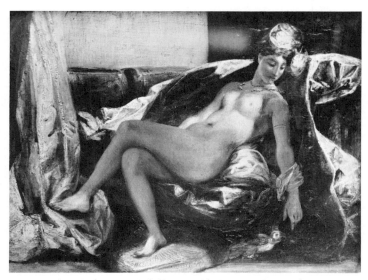

157 Eugène Delacroix. *Odalisque with Parrot.* 1827. Oil on canvas, 9½ × 12½″ (24 × 32 cm). Musée des Beaux-Arts, Lyon.

Goya was dissatisfied with the light, quick touch of his early paintings and their clear, fresh, attractive but rather obvious decorative colors. As Delacroix was to do, he fumed against the painting methods that made a painting only a kind of tinted drawing. His experi-

ments were not in the same direction as Delacroix's were to be, but he was working away from the same dissatisfactions when he complained "Always lines, never bodies! Where does one see lines in nature? I see only forms, forms that are lighted and forms that are not, planes that are near and planes that are far, projections, and hollows. I see no lines or details, I don't count each hair on the head of a passerby, or the buttons on his coat. There is no reason why my brush should see more than I do."

Goya's great Spanish predecessor, Velázquez, could have said the same thing; of all painters he made the closest identification between brush and eye. But similar means served different ends. Goya was hunting a way of painting that would present an image with the immediacy of instant vision. This, of course, is visual realism—not the search for an ideal and not the imitation of nature in detail, but the capturing in paint of the impact of life as we meet it head-on. We see first in breadth, in masses; we receive a total impression that carries with it a certain emotional impact. Later we may examine things more closely, may relish the beauty of a line, the complexity of a part within the whole, may perceive individual hairs on a head or buttons on a coat down to the way they are sewed on. Such details may offer a great deal of

interest or aesthetic pleasure, but to Goya's way of thinking they obscured the point, which was to capture the quality of the whole, to record it in such a way that its immediate vividness, as it impressed him, was expressed with truth at maximum intensity. Since a picture cannot be painted in the space of a glance, his problem was to discover a way of painting an image that would retain this immediate intensity. Of course this can always be done to some extent in a quick sketch. But that, again, was beside the point, since a sketch is only suggestive, and dependent for its effect on its very incompleteness. Along with immediacy and intensity Goya wanted the decision and the completeness that distinguish a work of art from a fragment of nature.

To work out some of the problems involved in training his brush not to "see more" than he did, Goya set himself an exercise that produced two of his most celebrated paintings, the paired *Nude Maja* [154, p.128] and *Clothed Maja* [155, p. 129].* It was inevitable that legends should accumulate around such a startling pair of pictures, which look like anything but analytical studies in technique, and inevitable too that these legends should attach themselves to the Duchess of Alba. The most popular story is that the Duchess posed for the *Nude Maja* during the Duke's absence and that the *Clothed Maja* was dashed off quickly when the lovers received word of the Duke's imminent return, an anecdote false in every factual and psychological detail except that the features of the girl in the *Majas* are close to those of the Duchess in Goya's several portraits of her. But since Goya used these features as a type for the spirited, vixenish young beauties who populate his work, the resemblance offers no support whatsoever to the ridiculous anecdote.

Maja and its masculine equivalent *majo* are untranslatable. Dictionaries give *fop* or *dandy* for *majo; gallant* is close. *Coquette* might do for *maja,* but not very well. The words carry associations of youth, good looks or prettiness, city pleasures, flirtatious display, fancy dress without high fashion, and common rather than aristocratic origin, with probabilities of flexible morality. As part of an international movement of dandyism at the end of the eighteenth century, these Spaniards had their counterparts in England in the macaronis, and in France in the *merveilleuses,* who adopted eccentric modes of dress. The clothing worn by *majos* and *majas* eventually became the national dress of Spain.

The *Majas* were painted about 1800, the year David painted *Madame Récamier* [13], a perfect contrast to the *Clothed Maja,* opposing the fashionable grace and artificiality of the neoclassical portrait with the bold vitality of Goya's realism. The *Nude Maja* and Ingres' *Grande Odalisque* [156, p. 128]—the comparison is legitimate in spite of the disparity of dates—are in even more extreme and clarifying contrast. With Delacroix's *Odalisque with Parrot* [157, p. 129] the classical–romantic–realistic comparison is complete. In their different ways, the Frenchmen poeticized a nude model to accord with an arbitrary standard. Goya painted—magnificently—simply a naked girl, audacious, almost insolently matter-of-fact in her nakedness. If the figure is unidealized, if the nakedness is piquant because the image seems so literal, this same literalness saves it from lasciviousness. It is too frank to be suggestive. As is always pointed out, its clothed companion piece with its gauzy, clinging, half-concealing, half-revealing gown comes closer to being the suggestive one of the pair.

Technically the innovation in the *Majas* has to do with reducing the image to its essential planes, which are painted in bold, flat areas instead of being fused in subtle modulations from one to another. This does not mean a simpler, easier way of painting. Goya's boldness takes as much calculation as Ingres' subtlety; the forms and colors that seem so direct and uncomplicated are disposed in relationships as firmly integrated with one another as in any other form of picture-making. Delacroix's problem—"All precautions have to be taken to make the execution swift and decisive" in order not to lose "the extraordinary impression accompanying the conception"—is also Goya's, with the difference (in the case of the *Majas*) that where Delacroix is concerned with recording inner, emotional impressions through exotic images, Goya presents us with what appears to be an image of striking external reality. The important words here are *what appears to be,* because Goya is not merely reproducing the object he sees, camera-fashion. He is preserving his own vision of reality in such a way that we see it and respond to it as he did, not as we might respond to the actual object if we saw it ourselves. If Goya had sought out new means of representation only in order to reproduce visual fact, the search would have been pointless. The point was to discover a new way of representation which, preserving his own vision of the world,

would be for him the best possible vehicle of expression.

The *Majas* occupy a special place in Goya's work as demonstrations, in addition to being arresting paintings in themselves. Expressively, however, they are excelled by other paintings where Goya's realism is an interpretative vehicle more than a technical process. One example is the portrait of *The Toreador José Romero* [158]. As pure painting the picture is opulent in texture and color, with the rich red lining of the cape curving up to the shoulder, the blue-green of the wide sash, the ruddy flesh tints, the blacks of the hair and the vest, and the pulsating lights everywhere on silks, velvets, and gilt embroidery. Against this brilliance Goya plays the reserved, even pensive, face of the young man. The hands, held so quietly, have an almost feminine delicacy, remindful of the precision, the refinements, the nuances and the observance of

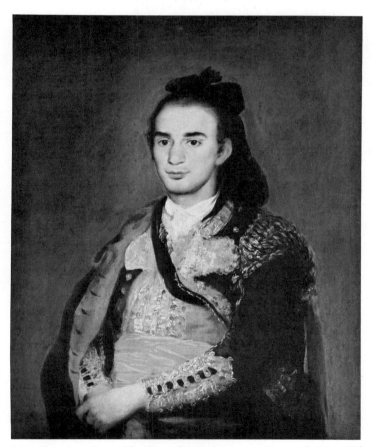

158 Francisco Goya. *The Toreador José Romero*. Date unknown. Oil on canvas, 36 × 29½″ (91 × 75 cm). Philadelphia Museum of Art (Mr. and Mrs. Carroll S. Tyson, Jr., Collection).

ritual that differentiate the bullring from the slaughterhouse.

The difference between the *Majas* and a portrait like this one is the difference between an exercise in which the interest of the subject is incidental to its presentation and an interpretation in which presentation serves expression. Goya's genius here and in other portraits lies in his revelation of the character of the sitter in what appears to be an altogether objective statement of the features. Like many other painters, Goya achieves this revelation by controlling the objective reality through selection and modification of pose and details. Where an unimaginative portraitist would have posed his bullfighter in an attitude of theatrical braggadocio suggestive of the usual connotations of the bullring, Goya cut through this overlay of convention and habit and produced, instead, a painting that not only characterizes the sitter but also extends its comment into the area of philosophical speculation. Yet all this is achieved through the devices of surface realism, without symbolical clues or idealistic references. It was to this end that Goya found it necessary to discover his way of painting in which "my brush should not see more than I do." And, once discovered, this way of painting served him not only as a painter of the familiar world but also as a painter of scenes of horror, fantasy, and violence, to which the quality of "immediate vision" brings an appalling reality.

On May 2, 1808, citizens of Madrid rioted against French soldiery, and on the following day the captured rioters as well as citizens arrested without proof of guilt were taken into the countryside near the city and shot. Goya recorded both events in a pair of pictures in 1814, six years after the events. If the picture of the executions of May 3 [159, p. 132] had no other virtues, it would still demonstrate that Goya's way of seeing and painting "only forms, forms that are lighted and forms that are not, planes that are near and planes that are far, projections, and hollows" gives to the subject, painted long after the event, the quality of an event that happens as we look at it. The victims, and the barren mound behind them, stand out against a dark sky in an explosion of light and blood. One man spreads his raised arms in defiance against the executioners. Another, a priest, prays; another seems only half comprehending; others clutch at themselves in terror or hide their faces in despair. Ranged in front of them,

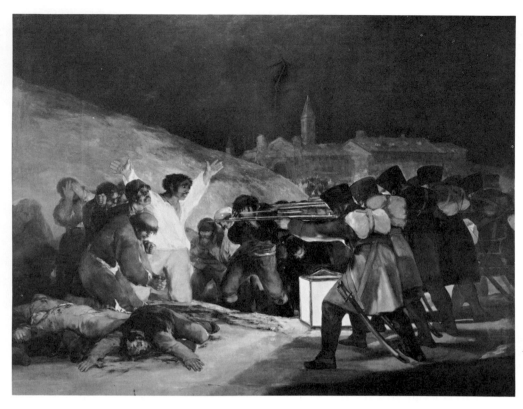

159 Francisco Goya. *The Executions of May 3, 1808.* 1814–1815. Oil on canvas, 8'9'' × 13'4'' (2.67 × 4.06 m). Prado, Madrid.

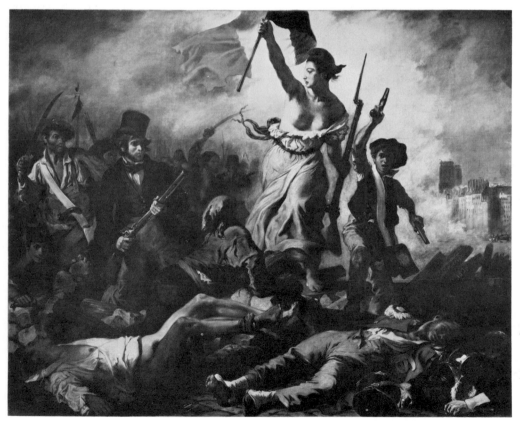

160 Eugène Delacroix. *Liberty Leading the People.* 1830. Oil on canvas, 8'6'' × 10'10'' (2.59 × 3.3 m). Louvre, Paris.

the uniformed soldiers, rifles firing, are like automatons. Their faces are not shown, their stances are identical, they are painted in dull grays and browns. This depersonalization accentuates the humanity of the victims, and especially it makes the central defiant figure a symbol of the individual's revolt against the forces of organized oppression, even though, in Goya's world, he is impotent before them.

Not much later, Delacroix was to commemorate a similar popular uprising in Paris, which took place in 1830, with his *Liberty Leading the People* [160]. As a romantic idealist he gives us a flurry and surge of drapery around an allegorical female figure leading other figures who thus, inevitably, lose their human identity and become allegorical symbols also. Or, if we try to regard them as human beings, they are at best actors in a costumed pageant. Goya's central figure of the man with arms spread wide may be, as we have just said, something like a symbol of humanity's unquenchable passion for liberty, but if Goya had such an idea in mind he delivered it in terms of the facts of this world, not in a vision of an artificial one. Both pictures can be compared with *The Oath of the Horatii* [Plate 1, p. 53] as a third treatment of the same general theme: the individual's sacrifice of self to an ideal of freedom and justice. Of the three, Goya's alone meets the world on its own terms. David's by this standard (which, of course, is not the standard to which David aspires) is chilly and abstract; Delacroix's is a bit highflown. In both of them life serves as material for art, which then becomes important for its own sake, relegating life to second place. In Goya the raw material of life is ordered and intensified by an art that reveals, but never takes precedence over, the world in which we live. This is why Goya is first a realist, although he is as dramatic as any romantic, as fantastic as any visionary. His art became a mine for later movements whose aims might even be at loggerheads with one another—impressionism in the nineteenth century, and expressionism, even surrealism, in the twentieth. Goya demonstrates again that the arbitrary boundaries of one ism or another are never wide enough to encompass the totality of a great artist's work.

This is especially true of another artist who by classification must be called a realist, a man who knew the world as well as Goya did, who painted it as literally yet more intimately, who was as aware of human foibles and vanities as Goya was, and suffered more from them—yet who found life good where Goya found it ultimately base: the Frenchman Honoré Daumier.

Daumier: Realism and Bourgeois Culture

Daumier (1808–1879) was born in Marseille the year of the riots in Madrid and the executions of May 3. By 1830, the year of the uprisings celebrated by Delacroix's *Liberty Leading the People,* he was working at his first job in Paris as cartoonist for a publication called *La Caricature.* During the next forty years he produced more than four thousand popular cartoons, by which he made his living, as well as innumerable drawings and sketches and several hundred paintings. Daumier was the noblest realist of them all; he was one of the finest painters of any school in nineteenth-century France; and he was buried in a pauper's grave at the age of seventy-one.

Just as romanticism had been the natural expression of the turbulence of the first half of the nineteenth century in France, so realism replaced it just as naturally as an expression of the second half. Daumier lived in the era of the Bourgeois Triumphant, the practical matter-of-fact, cautious, comfort-loving citizen, scornful of theory if it did not serve a tangible, profitable end (hence no classicist) and suspicious of passion if it threatened personal security (and hence not a romantic)—the little man of great common sense.

If this world sounds like an infertile one for the artist, that is only because we forget what an artist is: if truly creative, artists absorb the gross experience of their time and distill from it its essential meaning. In France, around the middle years of the century, creative talents in all the arts ceased to yearn toward ancient Greece and Rome, returned from the long jaunt to the Orient, and began to examine things as they found them at home. They discovered in the prosaic world infinite material and, above all, infinite variety. They discovered that a peasant woman was a better subject for them than Ceres, that a respectable bourgeois housewife offered possibilities not even hinted at by Venus, and even that a common prostitute could be painted or written about more rewardingly than a harem full of odalisques. A street in Paris was discovered to be more dra-

matic than an Arabian lion hunt. And if a woman choosing a hat in a millinery shop was involved in making a decision less strenuous than the ones made by the Horatii or the Sabines, nevertheless her dilemma had its own legitimacy and could be the subject of a work of art commenting on human life.

Nor need such a comment be trivial. It had, among other advantages, the great one of being a comment made at first hand, as if made on the spot instead of being trumped up in the studio. To make such comments at full force, painters invented new techniques that horrified the Academy and eventually destroyed it as a potent force in French art. Artists discovered in realism the most flexible of all approaches to expression. Freed from the restrictions and recipes of classicism, no longer goaded by the romantic obligation to theatricalize, they discovered that the world around them offered everything, that at last the individual was freed to interpret the world independently instead of echoing established formula. Classicism had shrunk like a dried pea; romanticism had swollen until it burst; realism offered the world of every day as the painter's lodestone.

Realism served painters of all temperaments. Within the world at hand those of classical temperament could find images of universal truths. The romantically inclined could find the passion they yearned for. The cynic, the sentimentalist, the social theorist, the objectivist, the wit might create their own images from the raw material of a single subject that in itself might be the most commonplace fragment of the world, familiar to everybody. Thus in its very flexibility, realism became more demanding than either classicism or romanticism had been: without the established devices of a David or a Delacroix to follow, the realists were exposed as whatever they were, big or little of spirit, imaginative or pedestrian in perception of the world.

Daumier is the French counterpart of Goya in his contempt for hypocrisy, falsehood, and injustice. If he is a lesser master, it is because he was never allowed to reach full stature as a painter. Goya's *Caprichos* were withdrawn a few days after they were published, and he escaped punishment by the tribunal of the Inquisition for the temerity of his subjects only because he had had the greater temerity to dedicate them to Charles IV (who could have found everything he stood for attacked in them)

and to seek, successfully, the King's protection. But Daumier, on the other hand, was imprisoned for a published caricature of his king, and his serious work was curtailed in 1835 under severe restrictions of the freedom of the press. Hobbled by poverty, without a market for his kind of painting, he was unable to paint at all until he was forty, and then he painted in obscurity with neither the time nor the money (or, for that matter, the reason) to do the ambitious pictures that force artists' growth and prove their mettle. But Daumier was a great painter, and certainly one of the two or three finest draftsmen of his century. And if compassionate observation of human frailty and human nobility is a standard of comparison, then Daumier surpasses Goya, and only Rembrandt, in the seventeenth century, can keep him company.

Daumier, unlike Rembrandt, made his most profound statements by means of the most commonplace subjects, usually the city streets and the ordinary people in them. Instead of inventing allegories, fantasies, and nightmares as Goya did to reveal human nature, Daumier observed the attitudes men and women—and children—assumed and the expressions on their faces and reproduced their essence, while seeming only to sketch them casually, candid-camera fashion, as they went about the routine of their daily affairs.

Daumier: Social and Political Comment

As a boy Daumier had lessons from an academic master who assigned him the usual exercises in drawing from plaster casts. Later he studied briefly at the Academy in Paris, where the rigid classical disciplines were surely unsympathetic to his temperament and his vision of life. Essentially he was a self-taught artist who learned to draw by observation; he never dissected a body, but he knew more about the way a body moves, the way muscles and fat are disposed upon the skeleton, than any painter who made a fetish of classical anatomy. *The Battle of Schools* [161] is a caricature comment on the revolt of the realistic painter against academic idealism. A dirty little fellow in peasant clothes, armed with a thick heavy brush, faces a skinny academician, posed in the attitude of David's Romulus from *The Sabines* and armed with a palette and a mahl stick (an accessory to the

161 Honoré Daumier. *The Battle of Schools.* From *Le Charivari*, 1855. Lithograph.

162 Honoré Daumier. *Boy Running.* Date unknown. Crayon and wash, 6 × 9″ (15 × 23 cm). National Gallery of Art, Washington, D.C. (Rosenwald Collection).

creation of the slick finish of academic painting). The reason this burlesque of the beautiful body of David's classical athlete is so funny is that its comic exaggerations of a skinny naked man are so true, so logical. These shrunken hams and knobby joints and pipestem legs are

at least as brilliant a variation on the human form as are the idealized Davidian forms they caricature, and they are based on a more supple familiarity with anatomical fact.

Daumier learned to draw as a caricaturist, and in his transition from caricature to serious painting he held to the strict economy of statement that is caricature's essence. In a few bent lines and an area or two of wash he could capture the physical mass, the action, and the inner nature of his subject, whether a group of people waiting at a station or a frightened boy running [162]. In this way, too, he resembles Rembrandt, who was Daumier's true drawing master as nearly as he ever had one.

Daumier is the only important painter of the nineteenth century in France whose development was entirely independent of the Academy and the Salon: he neither received their favors nor needed to battle their opposition. This was because he did not regard himself as a painter with a career to make and a reputation to establish. He was a professional artist with a living to earn, and he earned it by working against deadlines for periodicals.

Such work could have been a prostitution of his genius if he had curried favor by yielding to popular standards. Instead, Daumier created a new standard that lifted the cartoon of social

and political comment to the level of serious art. Even when his cartoons are most humorous they are never entirely trivial. When he draws a funny face, it is also the face of a specific character produced by a way of life acting upon a temperament. In it we recognize an individual of a social type within a complicated social system.

The favorite target of Daumier's benign exposures was the lower middle class, uncomfortable in its dutiful pretensions to gentility. He shows its members exhausted and puzzled at Salon exhibitions [163], drenched in their Sunday best by sudden downpours on an excursion to Versailles [164], harassed by squawling brats who nullify the order and comfort of their flats, reduced to a thousand indignities by the frictions and irritations of living with their fellows who never quite recognize in them the superiorities they aspire to within themselves. Behind in their rent, they have humiliating encounters with the landlord on the stairs. Their bus doesn't wait for them. Friends yawn at their funny stories; their collars are always too tight or too loose; and they realize one day that they and their mates look terrible in their bathing suits. But their lives are also full of sudden small domestic felicities. A middle-aged couple resting under a tree remember their youth as they watch birds nesting [165]. Young parents glow

164 Honoré Daumier. *Grandes Eaux à Versailles.* From *Le Charivari,* 1844. Lithograph, 9⅛ × 7¼" (23 × 18 cm).

165 Honoré Daumier. *Turtledoves—Just the Way We Were,* from *Tout ce qu'on voudra.* 1848. Lithograph, 10½ × 9" (27 × 23 cm). Philadelphia Museum of Art.

163 Honoré Daumier. *Before Moreau's Picture at the Salon.* From *Le Charivari,* 1864. Lithograph, 9½ × 8¼" (24 × 21 cm). Private collection.

with pride at their little boy, although he is an absurd replica of his pompous father. Friends exchange intellectual platitudes about the Salon success of the year, impressed with one another's acumen.

Daumier's cartoons are based upon the assumption, never questioned, that life is good, whatever indignities, absurdities, and brutalizations it may inflict upon us. This was also Rembrandt's assumption, except that Rembrandt could not go as far as to admit the absurdities. That Daumier admits them, even cherishes them, explains the attraction held for him by a favorite subject, Don Quixote [166]. The addlepated old man, mounted on his bony nag of a charger, his own bony silhouette topped off by the tin basin he imagines to be a knightly helmet, rides forth toward one imagined chivalric adventure after another, followed by his fat, stolid, uncomprehending and loyal lackey, Sancho Panza, who pulls his master out

of one mudpuddle or dungheap after another, where the old man's adventures always end. The story of Don Quixote is nominally a satire on the romantic foolishness of chivalric fiction, but it is also an undercover affirmation of the invincibility of the spirit; after each humiliating fall the old man pulls himself together and dodders forth toward a new one, his illusions intact. The paunchy bourgeois who gets caught in the rain, who misses his bus, who goes through a terrible world sustained by a blind, unreasoning conviction of his own importance—to Daumier, this paunchy bourgeois is noble in his absurdity if he remains an honest man.

But when Daumier is confronted with corruption, stupidity, hypocrisy, or chicanery in high places, his tolerance vanishes. *The Witnesses* [167, p. 138] could serve as well today as an indictment of warmongers as it did in 1872. In fact it has done so, in hundreds of descend-

166 Honoré Daumier. *Don Quixote and Sancho Panza*. Date unknown. Oil on canvas, 22¼ × 33¼″ (57 × 84 cm). Private collection.

167 Honoré Daumier. *The Witnesses.* 1872. Lithograph, 10 × 8¾″ (25 × 22 cm). Metropolitan Museum of Art, New York.

168 Honoré Daumier. *Le Ventre Législatif.* 1834. Lithograph, 11 × 17″ (28 × 43 cm). Philadelphia Museum of Art (gift of Carl Zigrosser).

ants, ever since. The politicians ranged in tiers in *Le Ventre Législatif (The Legislative Belly)* [168]—usually more politely translated as *The Legislative Body,* at the expense of Daumier's point—are individually identifiable as Louis Philippe's henchmen, but even without this reference the caricatures stand as murderous revelations of the mentality of corrupt politicians anywhere, any time.

The year of *Le Ventre Législatif,* Daumier published the great lithograph *Rue Transnonain, April 15, 1834* [169]. At the time of its publication the title was enough to explain the scene where a family lies murdered in the disorder of a bedroom—a father in nightshirt and nightcap, lying on the body of his child, with the body of a woman in the shadows at the left and the head of an old man projecting into the picture at the right. The Rue Transnonain was a street in Paris inhabited by workers who were suspected of participation in the disorders of the Republican Revolt of 1834. When it was fired on from an apartment house, the civil guard broke in and shot the inhabitants, innocent or guilty.

David, as he did in *Marat* [8], would have idealized the figures in the scene as far as possible,

certainly substituting a beautiful body for that of the stocky, ungainly father. The rumpled nightshirt would have fallen into folds of classical purity. Delacroix would have chosen a different moment, perhaps the tumultuous entrance of the guard into the room, a swirl of figures, a sort of *Sardanapalus* [83] or a *Chios* [80] in a new

locale. Either artist might have produced a fine picture. But Daumier rejects these dramas to bring us into the room, in all its commonplaceness. He shows us the grossness of the father, the intimate disorder of the bed, the woman's body sprawled and ugly, the more pathetic because it is mercilessly real.

170 Honoré Daumier. *After the Trial.* Date unknown. Watercolor, 11 × 14¼″ (28 × 37 cm). Private collection.

Daumier: His Faith

Daumier turned out his lithographic cartoons for popular consumption in journals on the average of three a week, with occasional individual stones, such as *Rue Transnonain,* for general sale. In the humorous cartoons having to do with the daily scene, the faith Daumier lived by is only implied in the affectionate quality of his raillery. More searching comments would have been inappropriate (and, for that matter, impossible) since no man can produce three major works every seven days.

But in his paintings, which were noticed by only a few people during his lifetime, he speaks at full strength to say that, in spite of the Rues Transnonain, Legislative Bellies, and the skeletons of those killed by war and starvation, humankind is good. This is Daumier's faith. The mere fact that he held it does not make him a greater or lesser artist than a pessimist like Goya. Optimism and pessimism are not aesthetic qualities. Nor, of course, is it "good" or virtuous to believe that humanity is "good." Pollyannaism is likely to be more dangerous than skepticism, sentimentalism more vicious than cynicism. But Daumier is neither a Pollyanna nor a sentimentalist, and his conviction that life is ultimately good must be recognized if his painting is to be understood as anything

more than a representation of people going about the routine of their daily affairs.

In his paintings Daumier seldom accuses, preferring to affirm the triumph of good rather than to expose the evils standing in its way. True, there are the numerous savage representations of lawyers [170, p. 139], who for Daumier, familiar with the venal courts of the period, were a compound of arrogance, pomposity, and corruption, feeding on the ills and confusions of society. But for all their trenchancy, these pictures are exceptions. We need only compare the *Third-Class Carriage* [171], with its young peasant mother and children accompanied by the old grandmother, with any young beauty and old hag of Goya's to understand that, where Goya believes life a process of physical and moral corruption, Daumier finds it ultimately incorruptible—by its very force of growth and continuation, if by nothing else.

Yet, magnificent as they are, Daumier's pictures of peasants, of people close to the soil, are not his most individual or his most subtle achievements. His peasants are still related to "nature's nobleman," not too much changed from the "noble savage" conceived in the eighteenth century. And while Daumier was working, the painter Millet (to be seen shortly) was also discovering the peasant in similar interpretations. Daumier's individual achievement rests, finally, in his discovery of human nobility in a more obscure quarter: that vast middle ground between tillers of the soil at one end and personages of high position at the other, within the dreary reaches of undistinguished city streets where ordinary people live out their lives in rented cells. Daumier's man is the little man of good will whom he first discovered by satirizing him, the good bourgeois who for all his confusions is neither vicious nor a fool in the long run. In *The Print Collector* [172], Daumier declares his faith in this man as a rational creature.

The Print Collector is painted in a few scrubs of color dominated by grays and browns. It shows a man of no particular distinction or individuality, although he exists vividly, looking through a portfolio of prints in a small shop. His figure is reduced nearly to silhouette; this simplification is extreme, but an additional line of detail would be superfluous. The man is all there—the body beneath the clothes, the spirit within the body. The clothes tell us of a position in the world—not a position of any conse-

171 Honoré Daumier. *Third-Class Carriage.* c. 1862. Oil on canvas, 25¾ × 35½″ (65 × 90 cm). Metropolitan Museum of Art, New York (H. O. Havemeyer Collection, 1929).

172 Honoré Daumier. *The Print Collector.* Date unknown. Oil on canvas, 13⅜ × 10¼″ (34 × 26 cm). Philadelphia Museum of Art (W. P. Wilstach Collection).

quence; the body tells us other facts—age, and that this is a city man, for instance. We do not need to deduce these various facts. We are presented with them complete, in the total impression of the man's reality, as we might understand them at a glance, without deduction or

specification, if he passed us on the street. We can say flatly that this is a middle-class man who collects prints as a hobby; beyond that, we may ponder the idea that print-collecting is not a necessary animal function, such as feeding and sleeping; and that, hence, it is proof that this is a human being possessed like other human beings of the thing that separates him from the animals, called intellect, soul, consciousness, ego, or any of dozens of other names. We may even point to various means Daumier has used to say this. We can make a symbol, for instance, of the way the figure emerges from mysterious shadows into even more mysterious lights. But in the end we cannot altogether explain how Daumier says that this man shares with us a miracle so good that none of our frailties is of any importance when balanced against the fact of our existence.

Daumier's basic premise of goodness alleviates the melancholy of his second one: that within the crowds and conformity of the city the individual is psychologically isolated. Daumier is the first painter to express this phenomenon of modern life. He represents his print collector alone—literally alone in the picture, although the crowds passing on the street, the proprietor of the shop, and other customers are certainly nearby. And each of the people in the *First-Class Carriage* [173] is alone in his or her own world, even while crowded side by side with other passengers. In some of Daumier's pictures individuals establish a tenuous bridge between themselves. An artist shows his prints to a collector; two men ponder a game of chess, warmed by an illusion of intimacy through recognition of the identity of their mutual isolation; prisoners sing together [174]. These moments of intimacy are poignant because they are rare. In *The Drama* [175] Daumier shows us

173 Honoré Daumier. *First-Class Carriage.* 1864. Wash drawing, 8 × 11¾″ (20 × 30 cm). Walters Art Gallery, Baltimore.

174 Honoré Daumier. *Prison Choir.* Date unknown. Oil on canvas, 19¾ × 24″ (50 × 61 cm). Walters Art Gallery, Baltimore.

175 Honoré Daumier. *The Drama.* Date unknown. Oil on canvas, 38 × 35″ (97 × 89 cm). Neue Pinakothek, Munich.

an audience carried away by a performance on the stage, each person unconscious of the shouldering and pressing of the other people around, absorbed in an illusion created by shoddy scenery and wild posturings, an illusion more real than contact with fellow beings will be when the performance is over and they leave the theater with the crowd.

Daumier: His Life

A few facts of Daumier's life are pertinent here. He showed precocious talent as a child, but his family, which had moved from his birthplace of Marseille to Paris, was unsympathetic to the idea of art as a career or unable to support him during years of study and a struggle for recognition, with the result that he entered painting by the back door of journalism. At twenty-two he was doing political cartoons for *La Caricature,* and it was for one of these that he was imprisoned for six months, when he was twenty-three. This was in 1832; the cartoon was *Gargantua,* showing Louis Philippe swallowing bags of gold extracted from the people.

Daumier's drawing at this period was rather solidly modeled within closed outlines, as can still be seen in *Le Ventre Législatif* and *Rue Transnonain.* His history as a draftsman is one of steady change toward a more broken, open, nervous, expressive line, with greater and greater economy of modeling, as evident in *Boy Running.*

In 1835 *La Caricature* was replaced by *Le Charivari,* on which Daumier worked for the rest of his professional life.* The realistic novelist Honoré Balzac was also a member of its staff and commented that "this boy has some Michelangelo under his skin." Baudelaire was one of the very few others who recognized in Daumier something more than a skilled commercial cartoonist.

In 1877 Daumier's eyes failed after forty years of overwork. Corot, a saint among painters, had given him a small country cottage some years before, and Daumier retired there on a state pension awarded him by the Third Republic.

* A *charivari* is a mock serenade of discordant noises, made by beating on pots and pans, howling, and yelling, beneath the windows of someone who has given displeasure—a good name for a critical journal.

The pension was more than deserved: under the various regimes since 1830 Daumier had been unyieldingly and courageously a republican propagandist.

When Daumier died two years after his retirement the store of paintings in his little house was purchased by a syndicate from his widow for almost nothing. When they were put on the market years later, along with numerous forgeries that still cause confusion, they were worth a fortune. The paintings date from 1848, when Daumier presented an allegorical figure of the Republic in a competition for mural decorations in the Hôtel de Ville—which, of course, he did not win. His first exhibition was arranged in 1878, just before his retirement, when he was seventy years old. Thus it happened that the school of realism, where in retrospect Daumier is a major figure, had been born, had fought its battles, and had given way to a new variant called impressionism before these realistic masterpieces were known.

In the meanwhile realism's battles had been fought, not expertly but with the greatest of pleasure, under the leadership of a painter who fell half by accident into that position, a man a decade younger than Daumier, who died the year before Daumier's tardy exhibition and who had left France some years before that— Gustave Courbet.

Courbet: His Theories versus His Practice

The theories of realism as advanced by Courbet (1819–1877) were not very complicated. Neither were they always very clear, since Courbet was not much of an analytical thinker. When it was necessary for him to formulate a written statement, he did so with the help of friends who were better at words than he was, which explains why what Courbet said about painting and what he did in painting never quite agree. With the best intentions in the world, his friends were likely to clarify his half-formed theories—in directions expedient to purposes immediately at hand—with less regard for Courbet's painting than for their own convictions.

"Show me an angel and I will paint one" is the bluntest of Courbet's pronouncements. He held that "painting is an essentially concrete art, and can consist only of the representation of

things both real and existing"—a limitation that would have ruled out all classical history paintings, all romantic invention, and most of the work of the old masters most admired by Courbet himself.

Nor is Courbet's own painting as objective as such pronouncements imply it should be. Although he stated that he wanted to "translate the customs, the ideas, and the look" of his own time into pictures, he added that he wanted to do so "according to my own understanding" of them. This means that while he referred directly to the world around him for his material, instead of to an imagined antiquity or a romantic Orient, he interpreted what he saw rather than merely transcribed it. And if he did not paint angels, if he painted only what he could see, what Courbet chose to see was usually dramatic rather than prosaic. Even when a subject was nominally prosaic, he observed it more romantically than would be expected from a painter tagged "realist" and dedicated to the annihilation of the romantic ideal. His realism was conscious, but his romanticism was inborn.

It must be remembered, too that we see Courbet's innovations in reverse perspective. We look at them from this side, across an intervening century during which realism went far beyond Courbet in the direction he set. From this distance he seems as romantic as he does realistic, but in the Salons of his own time his realism was extreme.

176 Gustave Courbet. *Young Bather*. 1866. Oil on canvas, 4'3¼" × 3'2¼" (1.3 × .97 m). Metropolitan Museum of Art, New York (bequest of Mrs. H. O. Havemeyer, 1929.

But these considerations are historical. Historically it is important that Courbet was called a realist, an anti-idealist. Beyond that, beyond realism or idealism or any other ism, Courbet is a painter, in the purest sense of the word *painter*. His paint simply as paint, as a rich oily substance applied to canvas, is magnificent.

His *Young Bather* [176] is typical of many Courbets that strike us first with the mincing artificiality of the pose. The fact that in combination with this artificiality the model is painted with a high degree of realism may even make the picture a bit ludicrous; standards in feminine beauty have changed, and we see only an overweight young woman posing with unconvincing daintiness against a too-obviously trumped-up landscape background. The branch the model holds in her left hand is retouched with a few leaves, but it is still a studio prop not very convincingly related to the tree it is supposed to grow from. Such inconsistencies conceal the revolutionary character of the *Young Bather,* although nothing can conceal the magnificence of its painting.

In *Woman with a Parrot* [177], also painted late in Courbet's career at a time when he was

177 Gustave Courbet. *Woman with a Parrot.* 1866. Oil on canvas, 4'3 × 6'5" (1.3 × 1.96 m). Metropolitan Museum of Art, New York (bequest of Mrs. H. O. Havemeyer, 1929, the H. O Havemeyer Collection).

178 Gustave Courbet. *A Spanish Woman.* 1855. Oil on canvas, 32 × 25¾" (81 × 65 cm). John G. Johnson Collection, Philadelphia.

dark locks. This is Courbet's realism. The dark shadows, the rich lights, the color that swells and recedes from black to brilliance are moody and dramatic. It is a mood Courbet repeats again and again with complete independence of his subject.

In his landscapes [179] Courbet goes to nature instead of fabricating a vision, but if he begins with real rocks, real streams, real trees, and real deer with their russet pelts, he ends by investing nature with a romantically heightened richness, where grottoes of foliage sink into greenish-black shadows and come forward into vitreous lights, where slabs of rock disappear from the warm sun into cool, heavy water, a nature as sensuous as flesh.

And always there is the paint, its own fat oiliness a part of the expressiveness of the painted objects. Courbet frequently applied paint with his palette knife, the thin flexible blade that is ordinarily used to mix colors on the palette. He would strike in the side of a rock with the flat of the knife, or with its tip he would flick in a sparkle of light. He painted whole pictures in this way, a technique familiar enough today, but with him an innovation.

Courbet was a natural painter. His only instruction was brief and under poor masters. He was the son of a farmer—a wealthy one—near the provincial city of Ornans, not a locality of-

having a period of fashionable success and his disciples were accusing him of compromising with conventional standards of prettiness, his innate romanticism is given full play. As an avowed realist Courbet may have painted the model very much as she looked, posed in the studio. Nevertheless, the pose is theatrical and the whole affair several steps removed from what one would expect to encounter in the course of daily events, even if it is less so than an angel with wings. The picture is full of artificialities that contradict its realism, but all contradictions are meaningless in the face of the sumptuousness of the paint, applied with such richness as to make the flesh and the gleaming torrent of chestnut hair almost tangible.

Ultimately, it is in this tangibility of the image that Courbet's realism lies. In *Two Girls on the Banks of the Seine* [Plate 10, p. 186], one of the most luscious paintings of the century, the weight of languid flesh is all but palpable against the cool moisture of grass and leaves; the heavy cloth and airy lace have their own existence. In the portrait of *A Spanish Woman* [178] the hand concealed in the heavy hair exists as certainly as the visible portions of the figure, because the tangibility of the whole carries with it the feel of the palm pressed into the

179 Gustave Courbet. *The Grotto.* c. 1860–1864. Oil on canvas, 25¼ × 31⅛" (64 × 79 cm). Baltimore Museum of Art (Cone Collection).

fering much opportunity for the discovery and development of a painter's talent. When he went to Paris, Courbet found his teachers on the walls of the Louvre, especially in the paintings of such seventeenth-century masters as Zurbarán, with their heavy shadows and full, rounded forms.

In effect self-trained, Courbet nevertheless had a picture accepted in the Salon of 1844, one he had painted two years earlier when he was only twenty-three. The picture, a self-portrait with a black dog, was not much noticed. He exhibited six canvases in 1848, an exceptional year, a year of revolution, when, without a jury, the Salon was thrown open to all comers.

The following year this excessive democracy was corrected; but in one of the efforts to liberalize the Salon that occurred sporadically during the century, the new government ruled that the jury be composed of painters chosen by election rather than appointed from the academic clique. This liberal jury awarded Courbet a medal for a painting called *After Dinner at Ornans,* a picture of ordinary people sitting around a table in a simple interior. Although no longer very interesting in itself, *After Dinner at Ornans* is historically important as Courbet's initial declaration that common people engaged in ordinary activities should be accepted as subjects for significant painting. Deliberately violating the academic code requiring small size for genre subjects, Courbet painted *After Dinner at Ornans* at the large scale conventionally reserved for the Academy's highest category, history paintings. That any jury, even the most liberal one, should have awarded a major medal to *After Dinner at Ornans* is an indication of the restlessness of French artists under the Academy's domination. Courbet also had another of his numerous self-portraits in this Salon, a romantically conceived painting in heavy chiaroscuro, called *The Man with the Leather Belt* [180]. Courbet was handsome, and until he became grossly fat he never tired of painting himself, always in the most admiring way, a self-adulation that would be more bothersome if it were less naïve.

His early success did not last long in official circles. The Salon juries subsequent to the unusually liberal one of 1849 bitterly resented the fluke that had given a medal to this offensive intruder, and from that time on Courbet was mercilessly attacked by the Salon and reviled by conventional critics. One wonders what they

180 Gustave Courbet. *The Man with the Leather Belt.* c. 1844. Oil on canvas, 39½ × 32½'' (100 × 83 cm). Louvre, Paris.

might have said about Daumier (who was ten times the realist Courbet was), if he had offered the irritations to the aestheticians and the competition to the established painters that Courbet did. For Courbet became a real threat. While Daumier was painting in obscurity, Courbet was seeking recognition through a declaration of war just as the romantics had done before him, choosing the usual battlefield, the Salon, for his conquest. He was a threat to the intellectual lethargy of the average critic, who had no intention of examining new ideas when the old ones were so easy to repeat year after year, and he was a potential competitor to the conventional painters who had staked out a market in the gigantic salesroom that the Salon had become.

Courbet: His Socialism

When Courbet won his medal he had no theories about realism. He was painting only what it appealed to him to paint. Both *After Dinner at Ornans* and *The Man with the Leather Belt* deny his later contention that the artist "does not have the right to enlarge upon" nature, that he "trifles with it at the risk of denaturing the beautiful which exists in the most diverse forms of

reality." He claimed that "Beauty as given by nature is superior to all the conventions of the artist." But of course it isn't, and in these early paintings as well as in most of his later ones the conventions of the artist serve Courbet well, not so much in the depiction of his "visible and tangible world" as in the expression of some poetic mystery existing beneath it. Even *Two Girls on the Banks of the Seine,* which takes art out of the studio and puts it on a familiar river bank— reflecting the kind of life enjoyed by the new middle class with its gardens, its walks in the country, and its Sunday excursions—ends not as a representation of two young bourgeois women on the banks of the Seine but as a sensuous evocation.

However, in certain pictures Courbet's departure from conventional subject matter and his relatively realistic treatment of it (relative in comparison with the derivative idealism making up the work of the rank and file of his contemporaries) offered some basis for the attacks that were made upon him. His trouble with the Salon began the year following his medal. Under Salon regulations any painter who had won a medal could exhibit thereafter without submitting his work to the jury. The jury of 1850, back to normal abuses, suffered from its immediate predecessor's liberality. Courbet took advantage of his position as a previous medal winner to exhibit nine pictures, includ-

ing an immediate but infinitely superior descendant of *After Dinner at Ornans,* a large demonstration piece called *A Burial at Ornans* [181], showing a group of peasants and bourgeois around an open grave in the harsh countryside near his native city.

A Burial at Ornans is an impressive picture, huge, sober, richly and conscientiously painted, a prodigious technical demonstration without fireworks. It is irreproachable as a demonstration of the academic virtues of sound draftsmanship, and it is more than adequate as a composition. But the attacks on it were virulent. Without much question the objections were quite arbitrary, being inspired more by Courbet's personal presumptuousness than by the inherent nature of the painting. Courbet had observed the simple people around the grave most sympathetically, but for the picture to have been labeled "socialistic" for this reason seems fantastic. Nevertheless this happened, and *Stonebreakers* in the same Salon, showing a laborer and a ragged boy at this work, was given the same tag. Both subjects were unusual, and in both pictures common people were represented without the sentimentality or condescension that would have made them acceptable to Salon taste. Compared with the prettified subjects alongside them on the walls of the exhibition, Courbet's peasants seemed like brutes, and the painter's normally sympathetic attitude

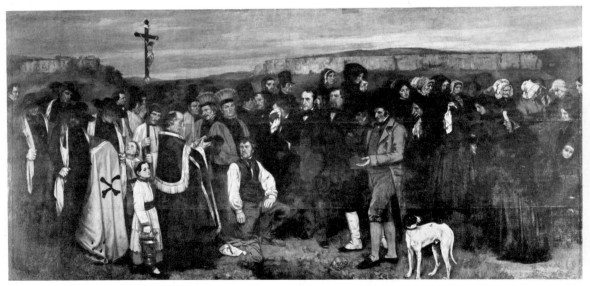

181 Gustave Courbet. *A Burial at Ornans.* 1849. Oil on canvas, 10′3″ × 20′10″ (3.12 × 6.35 m). Louvre, Paris.

toward them was found both aesthetically disturbing and socially and politically offensive.

Courbet enjoyed the furor, especially since he soon found admirers outside the Salon. Because the aestheticians attacked his paintings as socialism, the socialists countered by defending them as art. This confusion of values was unfortunate for Courbet. Under the influence of the socialist philosopher Pierre Joseph Proudhon, with whom he formed a friendship, Courbet began to take himself seriously as a political thinker. Labeled a socialist, he said that he was "not only socialist, but furthermore democratic and republican, in a word a partisan of all revolution and above all a realist, a sincere friend of the true truth." Such a statement sounds good at first, but it begins to fall apart when examined. Émile Zola, the realist novelist and one of the great liberal spirits of the century, recognized Courbet's inadequacy as a social philosopher and said, "Oh, poor Master, Proudhon's book has left you with a case of democratic indigestion." Proudhon's book was the formulation of a theory of the social function of art that he set down in 1865, his *Du principe de l'art et de sa destination sociale.* Courbet boasted that *A Burial at Ornans* was the burial of romanticism, echoing Gros' remark that *Massacre at Chios* was the massacre of painting. He made an effort to bind his art to political theory, but the truth is that he was too much of a painter and not enough of a theorist to conceive a painting in anything but the shallowest of theoretical terms. In celebration of the appearance of his friend's book, Courbet painted a portrait of Proudhon with his two little daughters [182]. The socialist philosopher sits in a very posey pose, with books and manuscript nearby, painted with acutely naturalistic precision. Courbet's "democratic indigestion" is paralleled in the images of this picture, where he forces his realist theory into a literal application and produces the most artificial painting of his career.

Courbet enjoyed being in the public eye, where he remained dramatically in successive Salons. At the 1853 Salon, Napoleon III did him the service of threatening to slash one of his paintings with a whip. Fortunately Courbet was wealthy enough not to have to depend upon selling his pictures to the Salon public, and when he did sell he sold for good prices to collectors with special tastes. His chief patron was Alfred Bruyas of Montpellier, but the Comte de Morny, a powerful dignitary of the Second Empire, was also his patron in secret. Courbet used to visit Bruyas in Montpellier, and has recorded one visit in a picture of staggering arrogance, *The Encounter,* which came to be called *Bonjour Monsieur Courbet* [183], showing the painter setting out for a day's work, posed to

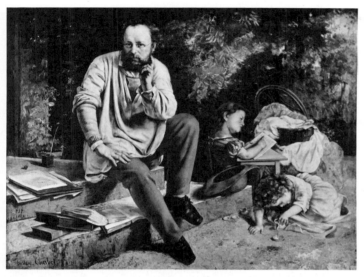

182 Gustave Courbet. *Proudhon and His Daughters.* 1865. Oil on canvas, 5'6'' × 6'6'' (1.68 × 1.98 m). Petit Palais, Paris

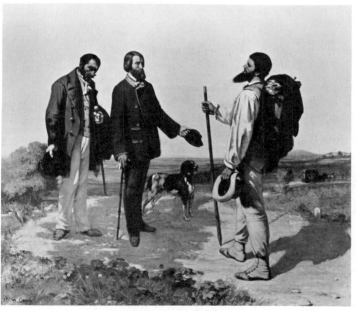

183 Gustave Courbet. *The Encounter (Bonjour Monsieur Courbet).* 1854. Oil on canvas, 4'2⅜'' × 4'10⅛'' (1.29 × 1.49 m). Musée Fabre, Montpellier.

display his handsome bearded profile at its best, while Bruyas and a manservant address him with the subservient humility appropriate to vassals before their lord. Bruyas was not the kind of man shown here—but Courbet was.

Courbet: «The Studio»

At midcentury the Paris cafés were becoming more and more the meeting places for discussion and exchange of ideas between artists, as the younger ones began more and more to abandon the studios of official painters to seek out the men who were in revolt against the academic system. Courbet's special cafés were the Brasserie des Martyrs and the Andler Keller, where he was surrounded by admiring students. In spite of his egotism Courbet was interested in helping young painters. He visited their studios, was patient with their requests for aid, and seems generally to have given them the stimulus they could not find in the hidebound instruction of the official schools.

Finally in 1861 there was a minor revolt within the sacred walls, and a group of students from the Academy petitioned Courbet to teach them. In a public letter, written with the help of his literary friend Castagnary, Courbet told them that he could not consent to enter into a student–teacher relationship because each artist must be creatively independent to be of any significance. But he took advantage of the opportunity to make a statement of faith, and he did consent to the setting up of a studio to give informal criticism to the students, who would be working largely on their own. The studio was not a great success, but it produced one noteworthy sketch showing the class at work with a bull on the model stand instead of the usual nude. (The bull actually had been brought into the studio.) This was in line with the idea that realism should abandon all artificialities and deal with the coarse reality of simple things, but there is also something artificial about a bull on a model stand.

Courbet's preeminence as a rebel and martyr had been established a few years before the stu-

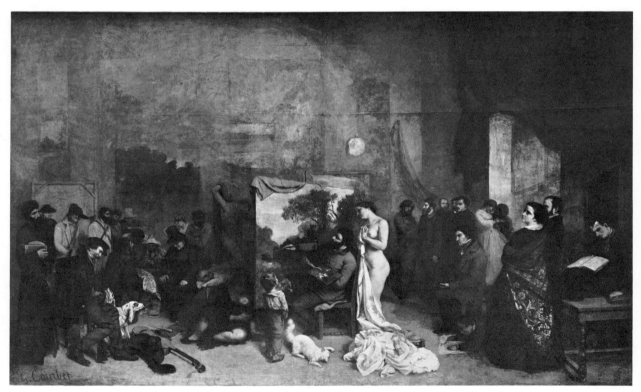

184 Gustave Courbet. *The Studio: A Real Allegory of the Last Seven Years of My Life.* 1855. Oil on canvas, 11′9¾″ × 19′6⅝″ (3.6 × 5.96 m). Louvre, Paris.

dent petition. As the informally proclaimed leader of the realists, he had set about the production of a painting that would be his manifesto, standing in a corresponding position to *The Horatii* and *The Sabines* for classicism, and to *Raft of the Medusa* and *Massacre at Chios* for romanticism. The full title of the tremendous picture was *The Studio: A Real Allegory of the Last Seven Years of My Life* [184]. The title, and the conception of the picture, were presumptuous; Courbet never questioned for a moment that the general public would be as interested in the man Courbet as in the theory of realism, and this egocentricity is carried out literally in the composition. The artist is centered dramatically, at work on a landscape, flanked on one side by proletarian types and on the other by various friends and well-wishers. In detail the allegory runs something like this:

At left, a poacher and his dog (the Hunt, a frequent subject of Courbet's) seem to look with some suspicion at a sombrero, a guitar, and a dagger (Romantic Poetry—also elements in certain very early paintings by Courbet). A death's head lies upon a copy of the periodical *Le Journal des Débats* (the Press, and perhaps a comment on censorship or the sterility of critical journalism). A lay figure, or artist's manikin, hangs attached to a stake (either a symbol of academic art or a reference to paintings of the Crucifixion, or both). A vine-grower (Labor) is surrounded by figures representing types who, in Courbet's half-jelled social philosophy, prey upon the people: a Jewish secondhand dealer (Commerce), a buffoon (the Theater), a priest, and a prostitute.

So much for the left. At right: in the foreground, a man and woman who represent knowledgeable art lovers; a couple embracing near the window (Love? Possibly the free love of socialist liberation); the poet and friendly critic Baudelaire, reading a book and representing the Art of Poetry.* The critic Champfleury represents Prose; Proudhon himself, who probably suggested this allegorical mishmash, represents Social Philosophy, a man named Promayet Music, and one Max Buchon Realistic Poetry. Finally, the enlightened collector and

friend Bruyas symbolizes the Maecenas upon whose patronage the arts have always depended.

As for the nude model standing behind the painter, she may represent Courbet's realistic muse, but she also fulfills the unwritten law that every demonstration piece of this kind intended for Salon exhibition must include a nude, to show the painter's mastery, and some still life; here the magnificently painted yards of cloth she holds and the objects upon it where it tumbles onto the floor. As for the admiring small boy and the cat, their allegorical function is tenuous if it exists at all.

The absurdities of this rigmarole are so extreme that it would be unfair to enumerate them if Courbet's painting, as usual, did not make up for everything else. As a manifesto of realism the picture is as curious as it is as an allegory. Separate passages are only as realistic as Courbet usually was, which means that they are romantically presented. And when we add to this the unrealism of the arrangement, *The Studio* becomes a manifesto indeed—but not the one Courbet had in mind, proclaiming as it does the victory of his persistently romantic vision over his professed goal.

Courbet: The Pavilion of Realism

Courbet planned to exhibit *The Studio* along with a second showing of his first sensation, *A Burial at Ornans,* at the Exposition Universelle of 1855, one of the series of world's fairs staged in France at intervals during the century. For this Exposition the conditions of the Salon were modified. It was made international for the first time, with an international jury. The French entries were to summarize the preeminence of France in the arts, and in these special circumstances the *hors concours* ruling permitting medalists to exhibit without submitting to the jury was abrogated. Several of Courbet's entries were accepted, but *The Studio* and *A Burial at Ornans* were rejected by a jury that must have felt great elation in returning the *Burial* this time, in retaliation for Courbet's having inflicted it on an impotent jury in 1850.

The rejection of *The Studio* was especially disconcerting to Courbet, since Ingres, who had not entered a picture in the Salon for twenty years, had been induced to carry the banner for classicism with forty canvases, a retrospective of

* Baudelaire's friendly connection with Courbet did not last long. Later he referred to "the mob of vulgar artists and literary men whose shortsighted intelligence takes shelter behind the vague and obscure word Realism."

his career, while "modern art" was represented by Delacroix with about the same number.

To compete with these impressive displays of idealism, Courbet decided to exhibit his rejected paintings, with others, in a special building constructed at his own expense, which he called the Pavilion of Realism. David had made a small fortune through private exhibition of *The Sabines,* and so had Géricault with the *Raft of the Medusa.* Courbet's Pavilion of Realism was a fiasco, but its unhappy entrepreneur might have taken some comfort if he could have read an entry in the journal of one distinguished visitor. "I went to see Courbet's exhibition," Delacroix wrote. "There alone for nearly an hour. I discovered a masterpiece in his rejected picture. I couldn't tear myself away from it. They have refused, there, one of the most extraordinary works of our time."

And of course Delacroix was right. *The Studio* is an extraordinary picture and a fine one. Its pretentious allegorical nonsense is not important. When all is said and done, Courbet remains here, as in all his work, a pure painter in spite of his theorizing and his politicking. The art of David is richer after we know it as a demonstration of a theory of art and a statement of social dedication. The more we know about Delacroix's aesthetics and his technical processes the more we find in his pictures. But with Courbet it is the reverse. His professed realism and his professed socialism are worse than no help at all in enjoying his art; they would actually stand in the way if we had to consider them, but fortunately we do not.

Courbet's World

Courbet, a painter born, had neither Delacroix's intellect nor David's shrewdness. But beyond either of these men he had a capacity for responding to the everyday world, a talent of such strength that when his brush was in his hand his theories about art and society dropped away and left him purely and simply in the only capacity in which he was without question great and sure of his ground.

Courbet's world was a place where the literal reality of things—peasants at a funeral, deer in the green depths of a woods, a snowy field, the sea, baskets of flowers, two girls lying on the grassy banks of a river—is identical with his unanalytical response to them. This response is not a complicated one but it is always present. He responds to the human warmth of simple people, to the cool secrecy of the woods and the rich waxy pelts of the deer, to the breadth of the sea or a river and the heavy sheen of its water or the tumbling foam of waves, to the opulence of healthy flesh and the heaviness of a coil of hair, to cloths and laces. In front of his paintings we need no theory, aesthetic or political, to derive the fullest satisfactions they have to offer. We are reminded of the wisest thing Courbet ever said: "There can be no schools; there are only painters."

Courbet's career, and his life, ended in a footnote beginning with the promise of glory and ending in exile. His Salon medal had coincided almost exactly with the election of Louis Napoleon as first president of the Second Republic, and the twenty years of his reign (as Napoleon III after 1852) were the great years of Courbet's life as a painter. In March 1871, after the humiliating defeat of the Franco-Prussian War, the population of Paris rose against the government, and for a while it appeared that in the ensuing Commune Courbet was to be what David had been just after the Revolution. Suddenly his overpublicized socialism was not a liability but a political asset, and he was elected to the body of representatives of the people, made president of an assembly of artists, and put at the head of a commission to safeguard the Louvre and other national art treasures. As David had done almost a hundred years before, he abolished the Academy's schools and did away with Salon medals.

But these "reforms" lasted no time at all. The Commune ended in May, and reprisals began. Courbet was sentenced to prison and after several months there he was removed to a nursing home. He was an aging man now, ill and—for the first time—defeated. During the rioting of the Commune a national monument, the Colonne Vendôme, had been wrecked. It was—and is—a giant column designed after the model of ancient Roman commemorative columns, a neoclassical tribute to Napoleon. Courbet, the anticlassicist, had once said that it should be torn down. Whether or not he had anything to do with its destruction is not certain, but he was ordered to pay the costs of its repair and re-erection. Even for Courbet, who was still a wealthy man, this was impossible. He managed to escape to Switzerland, where he died six years later.

chapter 10

The Realism of Daily Life

The Persistence of Realism

When the story of nineteenth-century art is told in terms of its heroes and villains, its aesthetic conflicts, its various movements rising and falling one after another, and the careers of its innovators, we are likely to forget that for each hero, villain, or innovator there were dozens or hundreds of excellent painters who were not particularly concerned with art wars so long as they were able to make their own way professionally in spite of the hubbub. And although the nineteenth century was the most tempestuous as far as these wars were concerned, it also produced probably the largest number of fine secondary talents. From around 1800 to about 1870 it seemed that every practicing artist as well as a number of amateurs drew and painted with the skill of masters. No matter that the academies too often tried to impose their dogmas on artists at large; they also demanded of their students a standard of technical discipline so high that an ill-drawn or ill-painted picture is rare among the thousands that have survived their times. Two landmark exhibitions, *The Romantic Movement* and *The Age of Neo-Classicism,* held in London under the auspices of the Council of Europe in 1959 and 1972 respectively, brought together some two thousand paintings, sculptures, and drawings that not only did a great deal to break down the division between romantic and neoclassical idealism (some artists were represented in both exhibitions) but were also revelations of the high quality of work by nineteenth-century artists who have been underestimated in the shadow of more dramatic figures.

From the two exhibitions could have been culled a third with some such title as "Realism in the Age of Idealism," consisting of paintings in which the main interest was in subject matter of the contemporary everyday world

familiar to everybody and appealing to a wide public for exactly that reason. Before the age of photography there was a kind of magic to the painter's ability to reproduce in two small dimensions the entire three-dimensional visual world, and for most people the pleasure of recognition was more accessible than the inspiration provided by the moral dilemmas of the Horatii or the passions of an Oriental potentate. Realism was a persistent force in nineteenth-century painting long before Courbet brought it into the arena of the Salon.

The taste for unpretentious realistic representations of the amenities of bourgeois life was international. In London, a scene of young children in a playground on Hampstead Heath [185] must have been particularly refreshing in contrast with the weighty official paintings of Sir Joshua Reynolds; in Berlin, one could join by proxy the strollers in the Lustgarten admiring a huge granite bowl that had just been erected there, causing a sensation [186]; in Copenhagen, there was the intimacy of an interior where we meet two brothers of the artist as students [187], astonishingly forecasting for us today the poignantly evocative interiors by the great impressionist Edgar Degas. The painters of these three pictures are Jacques-Laurent Agasse

186 Johann Erdmann Hummel. *The Granite Bowl in the Lustgarten, Berlin.* 1832. Oil on canvas, 25¾ × 34¾″ (66 × 89 cm). National-galerie, West Berlin.

187 Wilhelm Bendz. *Interior, Amaliegade.* Date unknown. Oil on canvas, 12⅝ × 18¾″ (33 × 48 cm). Hirschsprung Collection, Copenhagen.

(1767–1849), who was born at Geneva of a family of Scottish origin and worked briefly in David's studio in Paris but spent his life after 1800 in London; Johann Erdmann Hummel (1769–1852), who taught perspective and optics in Berlin; and Wilhelm Bendz (1804–1832), who was trained at the Royal Academy in Copenhagen and was beginning a successful career as a painter of portraits and interiors when he died at twenty-eight in Italy.

185 Jacques-Laurent Agasse. *The Playground.* 1830. Oil on canvas, 17⅜ × 14″ (45 × 36 cm). Musée d'Art et d'Histoire, Geneva.

These are obscure names in the history of art except for specialists, and there is not much chance that they will ever become celebrated ones. But the paintings, once encountered, are not easy to forget. They can stand here as representative of a widespread and persistent form of realism that found its historically conspicuous expressions elsewhere.

The American Scene: Bingham

While Turner was painting in England and the Hudson River men were revealing a new American spirit through American landscape, other painters were making explicit records of aspects of the American scene that were unique to it. Before the middle of the century John James Audubon (1785–1851) had made his magnificent collection *Birds of America,* where ornithological record was combined with unwavering brilliance of draftsmanship and design. George Catlin (1796–1872) had lived with American Indian tribes in order to paint some three hundred portraits of them and nearly two hundred scenes from their daily life, a corpus of pictorial anthropology that ranged from hasty notations of little aesthetic interest to arresting works of art like the portrait *Buffalo Bull's Back Fat (Head Chief, Blood Tribe)* [188]. William Sid-

189 William Sidney Mount. *Eel Spearing at Setauket, Long Island.* 1845. Oil on canvas, 29 × 36″ (74 × 91 cm). New York State Historical Association, Cooperstown.

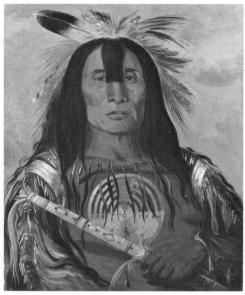

188 George Catlin. *Buffalo Bull's Back Fat, Head Chief, Blood Tribe.* 1832. Oil on canvas, 28¾ × 23¾″ (74 × 61 cm). National Museum of American Art, Smithsonian Institution, Washington, D.C.

ney Mount (1807–1868) discovered that American genre subjects could be just as picturesque and just as salable as European ones. In between anecdotal and frequently sentimental scenes he painted the first pictures that invested American blacks with a natural dignity. And in some landscapes, such as the famous *Eel Spearing at Setauket, Long Island* [189], his mastery of selective detail revealed in a steady, unifying light made him one of the most impressive American luminists. And Eastman Johnson (1824–1906), in addition to outdoor scenes of remarkable, almost impressionistic freshness, painted American interiors that at their best could justify the invention of a new term, indoor luminism [190, p. 154]. But it remained for a man named George Caleb Bingham (1811-1879) to bring to scenes of American life the indigenous feeling that the Hudson River painters brought to American landscape.

Bingham was born in Virginia; while he was a child the family moved to Missouri. He was first a cabinetmaker's apprentice, then a student of law, then a student of theology before he discovered that he was a painter. There is some doubt as to exactly what his earliest training was. Possibly he studied for a while with a painter named Chester Harding. But when he

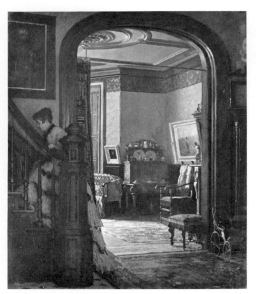

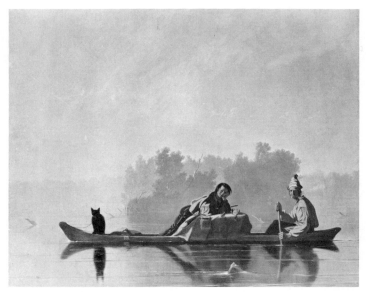

190 Eastman Johnson. *Not at Home.* c. 1872–1880. Oil on canvas, 26½ × 22¼″ (67 × 57 cm). Brooklyn Museum.

191 George Caleb Bingham. *Fur Traders Descending the Missouri.* c. 1845. Oil on canvas, 29 × 36½″ (74 × 93 cm). Metropolitan Museum of Art, New York (Morris K. Jessup Fund, 1933).

set himself up as a portraitist in St. Louis he was essentially self-trained. Later he studied briefly at the Pennsylvania Academy of the Fine Arts, but his style retained always a flavor of the primitivism associated with the early American tradition. He was by no means a primitive painter, but the flavor is there. Much of it was lost after he studied for three years in Düsseldorf, but fortunately he did not go there until he was forty-six. In his best work he is a purely American artist of the first half of the century, although he painted for another twenty years after his return from Europe.

Bingham the painter has been compared with Mark Twain the writer. His pictures of life in the country or the towns and small cities of the Middle West draw their subject matter, and their cast of characters, from the same sources Mark Twain used in *Tom Sawyer* and *Huckleberry Finn*. A similarity, too, is the fact that both men were popular as inventors of pure narrative and humor and came into tardy recognition for the deeper content underlying their engaging surfaces. On the face of it, *Huckleberry Finn* is an adventure story spiced with rustic humor and picturesque locale. At the same level, Bingham's *Fur Traders Descending the Missouri* [191] is a genre painting. But the story of Huck's journey down the Mississippi is also poetic and philosophical; so, too, are the evocations of

Bingham's representation of a man, a boy, and a pet fox in a dugout canoe.

The quiet surfaces of water and sky, the shadowy island in the distance, the spareness and gentleness with which these meager elements are selected and arranged into a picture go far beyond objective record of picturesque fact. In a special way *Fur Traders Descending the Missouri* is another statement of the relationship of man to a primal and benevolent wilderness, the theme of the Hudson River painters. But as it is treated here, the theme is at once more idyllic and more down-to-earth, at once more subtle and less artificial. In spite of its subject drawn from contemporary life, in spite of local picturesque details realistically shown, the picture is almost classical in its elimination of unnecessary incidentals to create a timeless image. This may be exaggerating a point, and it is entirely improbable that Bingham thought of his picture in this way, but the point is there, and it does a great deal to account for the serenity of a picture that could be transformed into mere record or mere narrative by a few additions and complications. The figures of the youth and the rough old man, the great stretch of river and sky, are not symbolical—it would be a mistake to try to make symbols of them—but if the simplicity of *Fur Traders Descending the Missouri* is compared with the highflown trumpery of

Cole's *Voyage of Life* there are certain overlappings of meaning. Cole presents his allegory in specific and didactic, and hence rigidly limited, terms. Bingham, without moralizing or allegorizing, opens up a much wider area of reflection. This does not have to mean that one picture is "better" or "worse" than the other, but it does mean that where Cole was ambitious to make a grand statement, he ended with a small one, while Bingham did the reverse: in what appears to be the simple presentation of an unpretentious subject we discover wide extensions of meaning. The two pictures, incidentally, were painted within a few years of one another, *The Voyage of Life* in 1840, *Fur Traders* about 1845.

Fur Traders Descending the Missouri is exceptional even in Bingham's work for its gentleness. But again and again he takes scenes from the life of the expanding American frontier and reveals the vitality of the epoch. His genius lay in his ability to reveal a kind of grandeur through the trivia that made it up. In *The Wood Boat* [192] he does not pretend that the boatmen who transported wood down the river were grand and noble men, although they may have been happy and roughly healthy ones. But Bingham creates forms of monumental character and disposes them in logical, monumental relationships to one another in such a way that the sum of picturesque details is more than its parts. Bingham's "classicism"—it is important to keep the word in quotation marks—may be compared to that of Poussin in *Et in Arcadia Ego* [386]: Poussin is a seventeenth-century intellectual synthesizing a philosophical dream of classical antiquity while Bingham is a nineteenth-century provincial recording the life around him. Yet in their integration of human and landscape forms into a monumental whole, the two painters have gone about the creation of a picture in much the same way. Bingham's relationship to three other seventeenth-century French painters, the brothers Le Nain, is even closer. Like him, they painted genre subjects and combined realism, monumentality, and a primitive flavor in pictures that rise above the temporary and specific nature of their subjects.

Bingham's pictures were tremendously popular and were sold by the thousands in engraved reproductions. His "election series" was aimed at the popular market, and these pictures [193] are full of roistering narrative incident. Here it is a bit of a strain to find the "grandeur" behind the scenes, although Bingham's most enthusiastic admirers are able to do so. Grandeur aside, the election series gives vital expression to the vigor and enthusiasm of their period. Bingham shows in them that if he can compose a quiet scene of a man, a boy, and a fox in a dugout canoe with sensitive economy, he can also manipulate dozens of figures on a

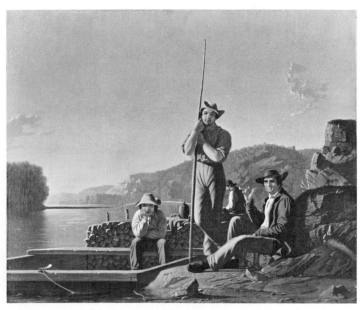

192 George Caleb Bingham. *The Wood Boat*. 1850. Oil on canvas, 24¾ × 29⅝″ (63 × 75 cm). St. Louis Art Museum.

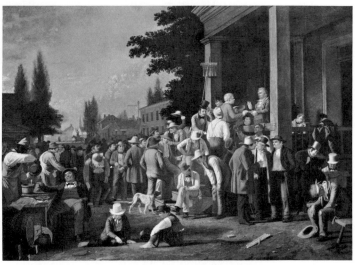

193 George Caleb Bingham. *The County Election*. 1851–1852. Oil on canvas, 2′11½″ × 4′3¾″ (90 × 1.24 m). St. Louis Art Museum.

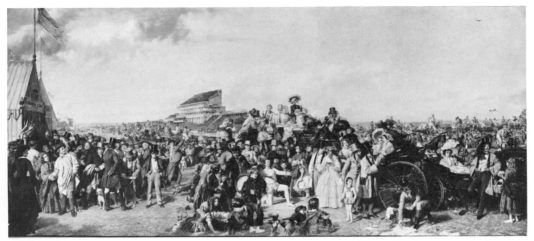

194 William Powell Frith. *Derby Day.* 1856–1858. Oil on canvas, 3'4'' × 7'4'' (1.02 × 2.24 m). Tate Gallery, London.

crowded stage—a considerable technical feat in itself, but it is given point by the fact that the arrangements are not only physically logical but characteristically expressive as well. Each of his characters is conceived not only as a physical mass but as a consistent personality, and the interplay of personalities is as clear as their relationship in space. The shortcoming is that the personality types are so obvious as to be trite, too true to type to be real or very interesting. In the election pictures Bingham is like a stage designer and director. He constructs a set and then fills it with expressive action. But his actors are not always talented.

Bingham was the last American painter of major stature to develop relatively free of European influence. Obviously, the word *relatively* is an important one. In a civilization that began as an adjunct to Europe's it would be impossible to find a purely native tradition in colonials and their descendants. But because he was so isolated from the more sophisticated American centers, because he had to discover so many things for himself in his relative separation from European developments, and because he used what he discovered to interpret subject matter unique to his world, Bingham is emphatically an American artist. The generation of painters that followed him in the second half of the century were less so, partly because it became easier for Americans to study in Europe, but largely because America itself had conquered its frontiers by that time and the conditions, and the spirit, that produced Bingham were fading.

195 Detail of Figure 194.

Popular Realism in England

The kind of realism that the public liked most reached its zenith of popularity and technical polish in Victorian England, where the national

bent for literary or storytelling pictures was allowed full play. Nominally, the Royal Academy, like its model in France, declared allegiance to elevated subject matter, but where the French code relegated genre painting to a kind of aesthetic ghetto, the English were happy to read highminded sentiments into anecdotal pictures of daily life and to settle for lively contemporary narrative instead of historical drama. The apogee of this kind of painting, not only in Victorian England but possibly anytime anywhere, was reached by a painter who still commands respect, William Powell Frith (1819–1909). The nature of Frith's subject matter is revealed by a random list of a few of his picture titles: *A Village Pastor; The Railway Station; Boswell's Dinner Party; The Wedding of the Prince of Wales,* which was a command picture for the Queen; *English Merrymaking One Hundred Years Ago; Life at the Sea Side; Breakfast Time; New Ear Rings;* and above all *Derby Day* [194, 195], for which Frith received about $75,000 for the engraving rights alone. His pictures were so admired that on exhibition they had to be protected from the crowds by special railings.

Rossetti and his loyal followers admitted Frith's technical prowess, but they loathed him for his "low and common" subjects. (Frith's influence on Millais was strong enough to account in large part for this member of the Brotherhood's fall from grace—as well as his subsequent roaring success.) Frith in turn held the Pre-Raphaelites in contempt for their idealistic and hyperaesthetic preoccupations. Frith

painted the *Private View at the Royal Academy, 1881* [196] to satirize "aesthetic" fashions in dress, he said, and the "folly of listening to self-elected critics in matters of taste." On the left is "a family of pure aesthetes absorbed in affected study of the pictures." Near them "in homely contrast" stands Anthony Trollope. To the right is Oscar Wilde, "a well-known apostle of the beautiful, with a herd of eager worshippers surrounding him." Other characters appearing in the picture include Gladstone, Browning, Huxley, Du Maurier, Ellen Terry, Lily Langtry, and Frith himself.

Whatever his limitations as an aesthetician may have been, Frith did paint with zest. *Derby Day* has a natural liveliness in its exploration of a commonplace subject, a quality always admired in the art of the impressionists to which it is unfavorably compared. But of course it has no suggestion of the subtlety, the originality, and the interpretative overtones of Degas' comparable subject, *A Carriage at the Races* [282].

Frith was awarded all academic honors as well as public esteem. Professionally he was the English parallel of the French academicians who at this time, as we will see, were engaged in vicious persecution of the impressionist rebels. Frith had no more sympathy with impressionism than he had had with the Pre-Raphaelites, but on the whole he seems to have been a man of good will. He scoffed, but he did not persecute—perhaps because, unlike the French academicians, he did not feel threatened by the innovators.

196 William Powell Frith. *Private View at the Royal Academy, 1881.* 1881. Oil on canvas, 3′4½″ × 6′5″ (1.03 × 1.96 m). Private collection, England.

chapter 11

French Realism Out-of-Doors

The State of Landscape in France

While the partisans of Ingres, Delacroix, and Courbet were carrying on their three-cornered debate in the studios in Paris, something new was happening in the countryside near the capital. Easels were beginning to sprout among the woods, in the fields, and along the banks of rivers. For the first time, French painters were taking natural landscape seriously.

Landscape painting as the more-or-less accurate reflection of a specific scene from nature hardly existed (in France) before the second quarter of the nineteenth century. There were souvenir paintings of famous views, and occasional exceptions, such as David's view of the Luxembourg Gardens painted from the window of the room in which he was imprisoned, but there was not a French landscape tradition as landscape is generally thought of today, having to do with trees, streams, hills, clouds, and other components of nature in their natural combinations. A literary gentleman-collector named Deperthes, in the eighteenth century, summed up the French attitude toward landscape pretty well when he defined it as "the art of composing sites after choosing the most beautiful and the most noble elements offered by nature." Deperthes warned that "If the study of nature is indispensable, it should be considered nothing more than a secondary means in a type of painting which, if it is to be properly accomplished, demands above all the inventive skill and the purity of taste which alone can give order to the inspirations of genius."

The countryside in its uncorrected state was not very highly thought of. It was accidental, unorganized, and impure. Gardens were formal; the obvious thing to do with a tree was to line it up with other trees and trim the whole row into a common shape. In the studio the painter worked in much the

same way, without the uniformity but with just as much artificiality in the creation of ideal shapes from natural ones. Landscape was synthesized from harmonized trees, perfected hills, well-disciplined streams, and generic clouds. The landscape painter's job was to organize these elements into compositions of purity, nobility, serenity, and perfect proportion. This was classicism, of course. Classical landscape was idealized; it was structural; it was heroic—a fitting counterpart to the figures of gods and heroes created in much the same way.

Such landscape may fall easily into the familiar traps of the classical style: monotony, sterility, and decorative formula. But it need not do so. The finest classical landscapist was certainly the Academy's seventeenth-century god, Nicolas Poussin (1594–1665). His *Gathering of the Ashes of Phocion* [197] is an extremely complicated picture, but from its complication all confusion, agitation, and uncertainty have been removed. Each of its elements—and there must be hundreds of them—is conceived less as a tree, or a branch, or a wall, or a figure, or a building than as an abstract form that must be adjusted to take its place in balance with all the other forms in the composition.

The satisfactions to be found in *Gathering of the Ashes of Phocion* have nothing to do with the pleasures to be found in nature. Neither may much interest be looked for in its nominal subject. Phocion was an Athenian general who was unjustly convicted and executed for treason, and the picture shows his wife and an attendant gathering his ashes after his cremation. But the painter is not interested in telling the story or making a parable. The subject is of incidental, less than incidental, importance. The picture's title may be *Gathering of the Ashes of Phocion* but its real subject is Order. The satisfaction to be derived from it comes from the contemplation of this order in its perfection, its serenity, its abstract clarity from which all confusion, accident, and impurity has been distilled.

But we have already seen that for the romantic soul perfect order was not enough. Or, rather, it was the wrong thing. The romantic responded to nature in its untrammeled aspects, seeing trees, streams, flowers, birds, clouds, the wind, the rain, and the simple people living close to these things as manifestations of the vague, universal mystery toward which the romantic spirit yearns for emotional fulfill-

197 Nicolas Poussin. *Gathering of the Ashes of Phocion*. 1648. Oil on canvas, 3'9'' × 5'10'' (1.14 × 1.78 m). Collection the Earl of Derby, Prescot, Lancashire.

198 Jacob van Ruisdael. *The Cemetery*. c. 1660. Oil on canvas, 4′8″ × 6′2¼″ (1.42 × 1.89 m). Detroit Institute of Arts.

ment. When this yearning was most intense it demanded turbulent aspects of nature to satisfy it, even menacing ones. "Arise, ye desired storms!" was a familiar romantic cry. Nothing could be too big or too disorderly—crags in disarray, wild valleys, tempests, cataclysms—or too exotic.

This emotionalized landscape, too, was conjured up in the studio, and it too had a tradition as old as that of classical landscape. As a single example, *The Cemetery* [198] by Jacob van Ruisdael (1628–1682) is filled with storm clouds, a rainbow, shattered trees, unruly water, a ruined abbey, with mysterious dark recesses and sudden spectral lights. And it is, of course, as carefully and as artificially a concocted landscape as is *Gathering of the Ashes of Phocion*.

The new French landscapists who fled the studios for the countryside were thoroughly sympathetic to the classical idea that landscape painting involved problems of composition, a balanced disposition of the forms within the picture space. They were even more sympathetic to the idea that nature was full of emotional connotations which it was the painter's privilege to reveal. But they subjugated both these ideas to a third: they believed that any

fragment of nature as it existed, even the most familiar and commonplace bit of field, river bank, or forest, was a legitimate subject for a work of art that could be intellectually satisfying without classical artificialities and emotionally expressive without recourse to the usual romantic stimulants.

We have seen that there was some precedent for this way of feeling in England. English painters were already at work from something like the same point of view, and in seventeenth-century Holland there had been similar development along with romantic examples, such as the one we have just seen.* The French drew

* As for the Hollanders, it is conventional to point out that the bourgeois origin of their seventeenth-century school of realistic landscape corresponds to the bourgeois origin of the French painting about to be discussed here. This is true, with the difference that the Dutch landscapes were part of a movement in painting stimulated by the Dutch love of things the good burghers proudly treasured—their houses full of possessions, their countryside, and themselves. This was less true in nineteenth-century France. As a broad statement of the difference: the Dutch landscapes are records of fact, while the French ones are records of responses to fact.

freely from both sources without imitating either. The important point historically is that these were French painters introducing a concept of nature altogether radical to the tradition of French landscape, a concept that was to become the dominant one during the next seventy years when French artists were setting new directions for the art of all the Western world.

Barbizon: Rousseau, Dupré, Diaz

One of the centers for the painters who began to flee Paris to discover nature was Barbizon, a picturesque village on the edge of the Forest of Fontainebleau not far from Paris. The Forest of Fontainebleau is one of those neat, gracious woods never for a moment to be confused with a wilderness and seldom suggesting anything more savage than Hyde Park. But it afforded vistas where the traces of rational humanity were as inconspicuous as they are allowed to be anywhere in France. And near the forest there were fields, peasants, and peasant cottages, which interested some of the painters, as well as chickens, ducks, and cattle, which held an unreasonable fascination for others. The Barbizon painters were not formally organized into a "movement," but the name of the village has attached itself to a dozen or so landscapists and painters of peasants or animals, several of whom spent a great deal of time there. Others made occasional visits and still others worked elsewhere but in the same spirit.

The spirit is best classified as romantic–realistic. As realists the Barbizon painters made direct reference to nature and worked directly in its presence with respectful attention to the actual disposition of its forms. It is difficult to make this sound like much of an innovation today, when everyone's idea of a landscape painter is an artist at an easel set out in the open air, but an innovation it was. Even Courbet ordinarily fabricated his landscapes indoors (as he shows himself doing in *The Studio*), although he made sketches for them out-of-doors (as he shows himself setting out to do in *Bonjour Monsieur Courbet*). His advice to young painters was to work from nature "even if from a dunghill." The Barbizon painters had been working from nature for years, being somewhat older than Courbet. And being much more temperate they were not interested in dunghills. As romantic-realists they were interested not only in the look of nature but in discovering its "moods," the "spirit" of trees and fields and skies, "the oak wrestling with the rock," one of them said. But the mood was always discovered within the subject; the subject was never violated to serve the mood. Even when the final picture was to be painted in the studio, as it usually was, painters subjected themselves to the discipline of preliminary study out-of-doors, working closely within the bounds of the subject's physical identity.

These Barbizon painters were hard at work between 1830 and 1840. At first the going was difficult, upstream against the opposition of the Academy. For a while they were castigated as vulgar, but eventually most of them were accepted in the Salons and even won medals. On the whole they were quiet, unobtrusive people, and since landscape was a secondary art their deviations from the academic norm were less offensive than they would have been in the usual demonstration paintings. By the 1850s these artists were beginning to have successes they continued to enjoy during the rest of their lifetimes while the Academy found its whipping boy in Courbet. By the end of the century, after their deaths, their vogue was tremendous, and they became stars of the international salesrooms, being collected with particular avidity in America.

In retrospect we see that it was the misfortune of the Barbizon painters to have laid so excellent a foundation for so exceptional a generation of painters—the impressionists who followed them—that their own work has suffered by comparison. By the 1920s their paintings were being pushed to less conspicuous places on museum walls. By 1950 they had become more than anything else a storage problem, with a few examples given exhibition space as historical fillers. Today critical evaluation of the school is more sympathetic, but still in flux. Three typical Barbizon painters will do very well here to introduce the school: Théodore Rousseau (1812–1867), Jules Dupré (1811–1889), and Narcisse Virgile Diaz de la Peña (1807–1876). A fourth, Constant Troyon (1810–1865) made such a success in the Salon that he is taken up later in the chapter that discusses the state of that institution at midcentury.

Of the three, Rousseau is the most rewarding after continued acquaintance. He combines a sense of the monumentality of landscape with a passion for its individual forms amounting to

nature worship. He is so impressed with nature as a force that every irregularity in the growth of a tree, every blade of green that springs from the earth, every cloud that scuds busily across the sky has for him its own vigorous life as part of a purposeful scheme full of growth and activity. He sees no need to inject romantic folderol into nature because to conceal or change any part of the natural miracle would be only to weaken it. He sees no need to put it into classical order because he feels a more powerful order behind the growth of things, the turn of the seasons, the rising or setting of the sun [199]. He painted images of this cycle of omnipotent force as humans have always painted images of their gods, but he did not have to fabricate an image because it was everywhere for him to see. Mystery, revery, and philosophical explanation are only incidental to his perception of the miracle around him. The miracle was tangible, self-explanatory. He accepted it at face value and gloried in it. He was a great bearded fellow (untrimmed beards were cultivated by the Barbizon painters along with other aspects of nature in its pure state) and the suave academicians enjoyed regarding him as an oaf. But during the 1850s he attained the general popularity of the school, and Salon success as well. He was not a commuting landscapist; he spent most of his life at Barbizon, where he was happiest, and died there at fifty-five.

Rousseau's pantheism, for that is what it amounted to, was a kind of poetry, but it is doubtful whether the public who admired his landscapes were aware of this quality beneath the literal "picture of something" painted with a high degree of the objective accuracy they spontaneously respected. Poetry of a more obvious kind was cultivated by Jules Dupré [200]. He was closer to the romantic tradition than Rousseau was. (Delacroix spoke kindly of him.) He had a great enthusiasm for the English landscapists, who were also romantics who found poetry in simple aspects of the countryside with its contented farmers, shepherds, and flocks. Dupré's mood, however, is more introspective than the cheerful English one. Individually his paintings are often effective in their hint of romantic pathos within the heart of nature, but he is repetitious, and after a while one suspects that his mood was continued as his trademark where it became a good thing on the market.

Narcisse Diaz is even more conventionally romantic. In fact he falls outside the realistic half of the romantic-realist classification suitable to the school as a whole. His pictures are frankly concoctions, his most typical ones being of small, secluded clearings in the forest from which the observer looks through the broken silhouettes of leaves and branches as if from a shadowed room or a grotto, at patches of light sky or open fields beyond [201]. Occasionally

199 Théodore Rousseau. *Under the Birches, Evening.* 1842–1843. Oil on panel, 16⅝ × 25⅜″ (42 × 64 cm). Toledo Museum of Art (gift of Arthur J. Secor).

200 Jules Dupré. *The Hay Wagon*. Date unknown. Oil on canvas, 14¼ × 18⅛'' (36 × 46 cm). Metropolitan Museum of Art, New York (bequest of Catherine Lorillard Wolfe, 1887).

201 Narcisse Virgile Diaz de la Peña. *Forest Path*. Date unknown. Oil on canvas, 28 × 23¾'' (71 × 60 cm). John G. Johnson Collection, Philadelphia.

these leafy cubicles are inhabited by human beings, by ideal figures such as nymphs in white robes, or even by mythological characters. It is a pleasant formula, although Diaz forced it a little.

Daubigny

The truest poet of the group was neither Dupré nor Diaz, but Charles-François Daubigny (1817–1878), who discovered poetry within his subjects instead of grafting it onto them. It is a simple poetry, as direct as it is sensitive; there is never anything dramatic or high-flown about it. Daubigny's love of nature is at the opposite pole from Rousseau's fervent adoration of it. He contemplates quiet skies; gentle rivers; level, eventless fields, in calm light. Rousseau clutched with obsessed intensity upon every natural detail: the leaf was as important as the tree; he was reluctant to forego the joy of representing each blade of grass in a field. His problem was to capture the monumentality of the whole through the enumeration of an infinite number of parts.

Daubigny, instead, begins with the acceptance of wholeness. There is a kind of wisdom in the breadth of his vision, its calmness, its perception of the unity of natural objects which rises above their complication. His landscape is intimate and domesticated. Farm cottages rest in his countryside as naturally and as peacefully as the shrubs and trees that have grown there; so do the small stone bridges of France and the boats on the full, quiet streams [202, p. 164]. Alone among the Barbizon painters Daubigny worked entirely out-of-doors, even adopting a little canopied rowboat as a floating studio in order to paint the banks of the river across a placid stretch of water. He loved the cool river light impregnating fresh moist air, the gentle sobriety of farmyards and quiet fields in early morning or evening light. These observations, made and recorded in the open air, place Daubigny historically as the most important of the Barbizon painters; of them all, he made the most valuable contribution to the next generation, to an extent that is only beginning to be fully recognized.

As a mine for imitators, the landscape tradition of the Barbizon painters has yielded some of the most inane pictures ever turned out by commercial hacks. Their work has been deformed into countless pretty picturesque views

of the kind used on scenic calendars, pasted on wastebaskets, and cut up for jigsaw puzzles. The resemblances of these superficial imitations are close enough to the originals to have clouded our perception of the unobtrusive virtues of the Barbizon school.

Millet

The history of art is full of drastic re-evaluations, especially in our time which is so full of shifts and upheavals and variety in points of view. Painters are especially vulnerable during the century after their death, and the reputation of Jean-François Millet (1814–1875) tobogganed from a point high enough to make his descent very swift. Two generations ago sepia reproductions of three of his pictures, *The Sower* [203], *The Gleaners* [204], and *The Angelus* [205] hung in every classroom and Sunday school. They are typical of Millet's most ambitious work with their peasant figures generalized into large, semisculpturesque forms dominating the foreground of a deep landscape, thrown into grander-than-life eminence against the sky, meant to be symbolic of our universal union with the earth. But Millet's noble poor seem a little self-conscious of their symbolic importance, a little too cleaned up to smack convincingly of the soil of which they are supposed to be an emanation. That this should be so today is striking evidence of how taste can reverse itself,

since the objections to Millet during his lifetime, objections that were violent, were on the opposite score. "This is the painting of men who don't change their linen, who want to intrude themselves upon gentlemen; this art offends me and disgusts me." The speaker was a

204 Jean-François Millet. *The Gleaners.* 1857.
Oil on canvas, 33 × 44″ (84 × 112 cm). Louvre,
Paris.

205 Jean-François Millet. *The Angelus.* 1857–
1859. Oil on canvas, 21¾ × 26″ (55 × 66 cm).
Louvre, Paris.

snob,* but it is still rather sad that Millet should
have suffered so during his lifetime on one
score and should have been discarded later on
for the opposite reason.

The generations between Millet's death and
his fall from favor admired him as a painter who
had achieved the ultimate statement of the no-
bility of the simple man, that idea begun so long
ago and adapted to such a variety of expres-
sions. The most successful example of Millet's
variety was *The Sower,* which he repeated many
times. The peasant is recognizable as one of
Michelangelo's naked titans, descended from
the Sistine ceiling, put into rough clothes, and
given a bag of grain—a disconcerting blunder
of miscasting. But if this initial hurdle is cleared,
we see that the figure has considerable power,
its gesture is a wide, generous one, harmonious
with its amplitude and its symbolism.

The Sower symbolizes the turn of the seasons,
the cycle of growth, fruition, and return to the
soil. It may suffer in comparison with Daumier,

* The same Count de Nieuwerkerke, Director of
Fine Arts, who refused to look at Delacroix's St.
Sulpice murals.

but today we are discovering that we condescended too easily to Millet. There are dozens of Millets, such as *The Bleaching Tub* [206], to rebuke us. Here the breadth and solidity of the forms, without derivative reference, and the drama of the light are uncloyed by sentimental values. The abstract values of painting—formal relationships for their own sake—are at least as important here as are representational ones, and the representation is uncluttered by the anecdotal overlay that mars Millet's most popular work. And in an occasional atypical picture, *The Quarriers* [207] for example, Millet is suddenly released from the efforted and naïve solemnity he too often imposed upon himself and paints instead with assurance and fervor in forms of dramatic strength remindful of Daumier at his best.

Millet's failures came when he overreached himself and were inherent in his personality. He was the son of a farmer—but not, like Courbet, of a prosperous one—and was only well enough educated to envy the condition of being a gentleman without having the means to turn himself into one. Nor had he the perception to recognize that it was not important for

207 Jean-François Millet. *The Quarriers*. 1846–1847. Oil on canvas, 29 × 23½″ (74 × 60 cm). Toledo Museum of Art (gift of Arthur J. Secor).

him to be one. He became stiff and forbidding, belonging nowhere. Young painters found him difficult to approach, although certainly he must have been hungry for the appreciation they were ready to offer. Although his pictures were accepted by the Salon after his debut in 1847 with a classical subject, his tepid successes did not counteract the sting of harsh criticisms. He avoided Paris (no doubt because he could not afford to live there in the manner he thought befitting), and he and Rousseau were the only two of the Barbizon group to settle in the village permanently. Altogether he had a difficult life. He was an honest man whose art was essentially traditional but was called radical, a sober realist whose sobriety has been misread as sentimentalism. With all these factors engaged in critical re-evaluations of his art, Millet in the late twentieth century is probably more firmly established on the basis of his virtues than at any time since his death in 1875.

206 Jean-François Millet. *The Bleaching Tub*. c. 1861. Oil on canvas, 17¼ × 13″ (44 × 33 cm). Louvre, Paris.

chapter 12

Corot

Corot's Popular Success

The best of the Barbizon painters are excellent men who would be difficult to include in a list of the great masters of painting. Their associate Jean-Baptiste Camille Corot (1796–1875) would be difficult to omit. Since he is not a classifiable painter, Corot is grouped with the Barbizon school because he did some work out-of-doors, had certain affinities with the Barbizon spirit in some of his work, and knew and was sympathetic to the Barbizon group. He belonged to an older generation, having been born in the eighteenth century, two years before Delacroix and only seven years after the Revolution. He painted just as he pleased, propounding no set of theories in opposition to others, making no belligerent pronouncements, living the eighty years of his life so quietly and painting so modestly that it is always a surprise to discover how much influence he exerted. As an isolated instance, he was on the liberal Salon jury of 1849, the one that awarded the medal to the unknown Courbet for his *After Dinner at Ornans* to the embarrassment of subsequent juries. He was fifty years old before his own father, a prosperous merchant, realized that there was a serious painter in the family. In that year Corot was awarded the Legion of Honor, and for the first time his father stopped saying apologetically that "Camille amuses himself with painting" and said "Well, since they have decorated Camille, he must have talent," as neat a statement as could be invented to summarize the bourgeois attitude toward aesthetic achievement.

At nineteen Corot was working in the family's business, his father having refused to give him the money to study art. Later he was given the allowance that had been allotted to a poor relation who had died, and he lived thus until his pictures began to sell, which they did when he was well along in

middle age. There seems to have been no serious conflict within the family. If there were conflicts or upheavals of any kind in Corot's life, they left no mark on his work. He never married and seems never to have been in love.

The pictures that began to sell so tardily were not his best ones. But they are still the ones best known and much loved by a wide public; they are also the ones connecting him most closely with the Barbizon school. Bad prints of his *Souvenir de Mortefontaine* [208], typical of the manner that brought him into popularity and kept him there for decades, used to hang on every other living-room wall. Fluffy trees, some grasses and shrubs flecked here and there with bits of light, a quiet body of clear water, a mild sky, and a few small, graceful figures are combined and recombined in these pictures, painted as if seen through a cool haze. They are minor lyrics of great sweetness and tenderness, overfamiliar, and weak and obvious in comparison with Corot's best work. But they are lovely pictures and need not be rejected just because they give pleasure to so many people.

Popular success came to Corot during the 1850s. The Emperor purchased one of his poetic landscapes, *Souvenir de Marcoussis,* from the banner Salon of 1855, not as official patronage but because he liked it. Dealers were quick to add snob value to a product that had already begun to find purchasers on the strength of its popular attraction. For the rest of his life Corot could sell as many of these pictures as he was willing to paint—more, in fact, and his pictures were forged by the hundreds. There is a story that when one poverty-stricken forger was suspected and forced to go to Corot with the picture he was offering as an original, Corot signed the forgery for him. This should not be true, but it is not out of character. Corot gave money to many artists, good or bad, who needed it. It has already been mentioned that he deeded a country cottage to the aging and destitute Daumier.

Corot could have made a fortune if he had wanted to. He did make a great deal of money, which he did not need. His tastes were simple and he had been perfectly happy on his allowance. In the meanwhile, along with the pictures that were clamored for, he continued to paint the kind he liked best himself.

Corot and the Tradition of Landscape

Long before he hit upon his popular style, Corot was painting landscapes of an opposite solidity and definition. They are the first en-

208 Jean-Baptiste Camille Corot. *Souvenir de Mortefontaine.* 1864. Oil on canvas, 25¼ × 34½'' (64 × 88 cm). Louvre, Paris.

209 Jean-Baptiste Camille Corot. *The Bridge at Narni.* 1826–1827. Oil on canvas, 26¾ × 37¼'' (68 × 95 cm). National Gallery of Canada, Ottawa.

210 Jean-Baptiste Camille Corot. *View of Rome: The Bridge and the Castle of Sant' Angelo with the Cupola of St. Peter's.* 1826–1827. Oil on paper, mounted on canvas; 8⅝ × 15'' (22 × 38 cm). Fine Arts Museums of San Francisco (Collis Potter Huntington Memorial Collection).

tirely legitimate descendants of Poussin's classical tradition after two centuries of great admiration and partial understanding. They are also among the forerunners of the modern movement, making Corot a bridge between tradition and revolution.

Corot's connection with Poussin [197, 386] is most apparent in early pictures, such as *The Bridge at Narni* [209], where he takes an actual scene but idealizes it along Poussinesque lines.

The connection is less apparent but goes deeper in pictures where he holds himself more closely to the actual appearance of the subject yet invests it with Poussin's monumental calm. As examples, his views of Rome (Rome especially, although he did similar cityscapes elsewhere) respect objective fact with deceptive literalness. Buildings and hills are disposed approximately as they actually exist [210, 211; p. 211], not juggled about at will, yet their for-

211 Jean-Baptiste Camille Corot. *View of the Farnese Gardens*. 1826. Oil on paper, mounted on canvas; 9½ × 15¾″ (24 × 40 cm). Phillips Collection, Washington, D.C.

mal relationships are as satisfying as those in a Poussin where all the forms are invented and arbitrarily combined.*

How did Corot manage to impose this perfect order on forms that in reality were combined by chance? Rome is a magnificent welter of structures and gardens, punctuated at random with some superbly organized vistas, but Corot did not choose these readymade compositions as subjects. Overall, Rome is a hodgepodge of streets and buildings that have grown partly without plan and partly according to a series of plans that interrupt and compete with one another. Corot takes views of this welter and brings them into classical order without appearing to violate photographic reality.

As an explanation of how he went about doing this, his own statement "Form and value—there are the essentials" tells everything and nothing. Form and value are part of the jargon of any tenth-rate painter. Corot's words tell us nothing we cannot see for ourselves, that like every painter working from nature he begins with the raw material presented by the forms

* For purposes of completeness it has to be pointed out that Poussin's tradition as observed by Corot includes reference to the art of Poussin's contemporary Claude Lorrain. But this is an unnecessary detour for getting to the main point. Lorrain's poetic devices may be echoed in *The Bridge at Narni* and are obvious in Corot's late, soft style. But Lorrain would never have painted as Corot does in the views of Rome. It is possible to imagine Poussin doing so.

and values as they exist, and makes his own adjustments of their relationships to achieve his own variation on the theme of the visible world. Thousands of painters do this, with varying degrees of technical skill. Some of the worst are more highly developed technicians than Corot was. But very few of them enlarge or clarify our experience. Certain of Corot's adjustments are apparent to anyone. He avoids strong value contrasts, sticking to the middle range of half tones. He mutes color similarly. If it were possible to superimpose a photograph of the scene over one of his paintings, his variations from actual proportions and dispositions would not be extreme. But slight or great, they put the subject into order.

In this respect, it may be illuminating to compare Corot's transmutation of a specific scene, a view of the Church of Santa Maria della Salute seen from across the Grand Canal in Venice [212], with the same subject as treated by one of the most commonplace spirits among nineteenth-century painters, the academician J. L. E. Meissonier [213]. One of the most successful painters of the day, Meissonier is the subject of more detailed comments later on in this book. He was a painter without technical limitations and equally without depth or sensitivity. The painting under consideration here is a muddle of gondolas, mooring masts, lanterns, water, and architecture, all painted with bright facility and a high degree of representational accuracy. From detail to detail Meissonier's collection of

212 Jean-Baptiste Camille Corot. *View of the Quay of the Schiavoni*. 1834. Oil on canvas, 12½ × 18″ (32 × 46 cm). National Gallery of Victoria, Melbourne (Felton Bequest, 1925).

213 Jean-Louis Ernest Meissonier. *View of Venice*. 1888. Oil on canvas. Louvre, Paris.

factual statements may be read with considerable interest by anyone with an affection for Venice, as a kind of snapshot reminder of that enchanted city, but beyond this limited function the picture does not exist. It is a parasite on its subject: it neither intensifies nor clarifies our sentiment or our understanding. At best, it merely engages our attention momentarily because the representational trickery of brush and paint is so deft. It is an immediately attractive and then almost as immediately a wearisome picture. It badgers us with irrelevant details; it nags at us to admire the flashy skill with which they are represented. Oddly enough, for all its detailed accuracy it is only superficially a true picture of the scene. Looking across the Canal toward Santa Maria della Salute one is conscious of the openness of sky, the flatness of water, the isolation of beautiful monuments within these expanses. The haphazard and accidental minutiae of the city are lost within this bigger scheme.

It is with this big scheme that Corot has concerned himself, not only by the selection of a more distant point of view but also by the arbitrary selection and placement of such elements as packing cases, barrels, and human figures, as well as moored boats, to balance and harmonize the architectural elements whose placement is predetermined. The resultant composition is more nostalgically a reminder of Venice than Meissonier's snapshot can ever be, even though it contains conspicuous elements, such as Oriental figures and sailing vessels, that none of us has ever seen there. But this evocative power is the least important aspect of Corot's achievement. Because he is an original spirit where Meissonier was a commonplace one, Corot sees Venice through a personality that invests it with the serenity and harmony of his own vision and thus enlarges our own vision of it. And quite aside from the fact that this is a picture of a certain city, it is a painting in which the disposition of forms would be deeply satisfying even if the subject were as completely an invented one as *Gathering of the Ashes of Phocion.*

It is possible to discover in a general way how Corot's apparent objectivity has transcended itself, although his own comments on the quality of his objectivity are of no help at all. "I paint a woman's breast exactly as I would paint an ordinary bottle of milk," he said. No description could be more inaccurate than this one, with its crassness and its implied denial of any selective response to visible reality. He could better have said "I paint an ordinary bottle of milk as if it were a woman's breast," for every object he paints is part of a world elevated by the contemplation of this one with sentiment and dignity.

Like Poussin's, Corot's world is a quiet one where contemplation offers greater pleasures than action. Like Poussin's it is a world regarded from a distance, yet from this distance it is a world of extraordinary clarity. This clarity may be close to magical, as it is in the transformation of *Village Church, Rosny* [214] from commonplaceness or pretty picturesqueness into enchantment. The eye, freed from its limitations, sees details in faraway objects. But these details are never prolix. Like everything else they are selected and adjusted into harmony and balance. Corot's world is simpler than Poussin's, more intimate because it is less complex. And where Poussin's world is created serene within a kind of crystal vacuum, Corot's has become serene surrounded by the breath of life. The peaceful innocence so characteristic of Corot's world is emphasized by the suggestion of naïveté, almost of awkwardness, in the draftsmanship of certain details, notably the human figures. This occurs frequently in Corot's paintings and is a larger factor in setting the character of his world than is generally recognized.

Apparently Corot never formulated a specific problem for himself, never worked toward the

214 Jean-Baptiste Camille Corot. *Village Church, Rosny.* 1844. Oil on canvas, 21½ × 31½'' (55 × 80 cm). Private collection.

crystallization of any aesthetic theory. To say that he "felt his way" toward expression is misleading if it suggests fumbling. But it will do very well to describe his way of creating pictures, if by "feeling his way" we mean the development of acute sensitivities to form and value and color relationships that must be brought into balance by a sense of their rightness without dependence on rule. When the composition of a picture is systematic (*The Oath of the Horatii,* or *Raft of the Medusa),* it is possible to define the relationship of each part to the whole without fear of misreading the painter's scheme. But when the composition is "felt," there is always the danger that an effort to anlayze it by hindsight may yield conclusions that would surprise the painter who organized it in the first place.

Nevertheless, what can we find in a small Corot called *Mur, Côtes du Nord* [215], where he was free to dispose the forms compositionally in any way he chose, not being bound by the predisposition of forms existing as the buildings of a city? We might say that of the five little figures, the one to the left in the background group echoes the attitude of the corresponding one in the foreground pair, thus tying the groups together. Or reading the figures as a foreground group of two and a background group of three, we may enjoy the variety of this balance. On the other hand, the standing figure may be separated from the rest and we may find that the picture is composed as a kind of double seesaw with the mound of earth, center, as a pivot. One plank of the seesaw would stretch diagonally into the depth of the picture from foreground left to middle ground right, balanced at either end by paired figures. The second plank on the same pivot would cross the first at right angles, balanced at either end by the standing figure and the pyramidal block centered above and behind the heads of the foreground figures.

Whether the picture is analyzed from any of these beginnings or from any one of a half a dozen other possible ones, everything in it falls reasonably into place. Yet the composition was probably not schematic in Corot's mind. *The Oath of the Horatii* and *Raft of the Medusa* are both variations on accepted schemes, the *Horatii* with icy brilliance, the *Raft* with respectable competence. But Corot could not bring himself to borrow even the elementary skeleton of an established compositional formula. "It is better to be nothing than to be the echo of other paintings," he wrote in his notebook. His quietness makes his originality inconspicuous, yet Corot was as original as any of the noisier revolutionaries who made great stirs in his lifetime.

215 Jean-Baptiste Camille Corot. *Mur, Côtes du Nord.* 1850–1855. Oil on canvas, 13 × 21⅞″ (33 × 56 cm). John G. Johnson Collection, Philadelphia.

Portraits and Figure Studies

During his lifetime Corot's portraits and figure studies were all but ignored; today they have become the most sought-after of all his work. Usually these are of young women, only now and then of men or children. There are well above three hundred of them, of which Corot exhibited only two, and they are the most personal work of an unusually personal artist. Like his landscapes, they are a firm bridge between tradition and contemporary painting. This is a general statement and is most important as a general one, but it may be brought down to specific terms by comparisons of Corot's *Woman with the Pearl* [216] with Leonardo da Vinci's *Mona Lisa* [217] and of his *Interrupted Reading* [218] with Picasso's *Lady with a Fan* [219].

The similarity between *Woman with the Pearl* and the *Mona Lisa* is too close to be accidental

and, of course, Corot was familiar with the Renaissance masterpiece in the Louvre. Originally he followed it even more closely; he first painted the hair in an arrangement like Mona Lisa's and then modified it. The strands can still be seen as raised pigment in *Woman with the Pearl* although Corot has painted them out in giving his model a different coiffure. But for all its frank use of the earlier picture as a prototype, *Woman with the Pearl* is not an Italianate imitation but an original work of art. While French academic painters were imitating the surfaces of Renaissance painting, mistaking stylistic plagiarism for philosophical union with the masters (even Ingres was guilty sometimes), Corot brushed superficialities to one side and understood the formal construction upon which the Renaissance statement was based. Like *Mona Lisa*, *Woman with the Pearl* is a massing of volumes building from the hands, placed parallel to the picture plane, into the

216 Jean-Baptiste Camille Corot. *Woman with the Pearl.* c. 1868–1870. Oil on canvas, 27½ × 21¼″ (70 × 54 cm). Louvre, Paris.

217 Leonardo da Vinci. *Mona Lisa (La Gioconda).* c. 1505. Oil on wood panel, 38¼ × 21″ (97 × 53 cm). Louvre, Paris.

218 Jean-Baptiste Camille Corot. *Interrupted Reading.*
1865–1870. Oil on canvas, 36½ × 25¾'' (93 × 65 cm)
Art Institute of Chicago (Potter Palmer Collection).

219 Pablo Picasso. *Lady with a Fan.* 1905. Oil on canvas,
39¾ × 32'' (101 × 81 cm). National Gallery of Art, Washing-
ton, D.C. (Harriman Collection).

masses of the torso, turned slightly away into
the picture space, and returning as the head re-
turns toward a full frontal view. These major
volumes and the movement from one to an-
other are enriched by the minor ones that com-
pose them. Corot understands this formal struc-
ture but utilizes it for individual expression, just
as an architect might understand the construc-
tion of Renaissance buildings with their arches
and vaults and the nobility of their volumes
but would make contemporary use of the con-
cept without rebuilding a Renaissance palace.
Woman with the Pearl has the tenderness and
the intimacy of Corot's finest landscapes; it has
also their structural subtlety of form and color
which invests an apparently casual subject with
a truly classical repose. Such trivial and appar-
ently realistic details as the folds of a sleeve, a
loosely fastened bodice, a fall of hair are parts
of an image so firmly integrated that trivialities
are transmuted into ideal monumentality.
Corot's achievement in paintings like this one

was to bring into harmony the apparently in-
compatible elements of intimacy and nobility,
of sensitive vision and formal abstraction.

It is this formal abstraction that allies him to
modern painting. Even more than *Woman with
the Pearl, Interrupted Reading* seems casual in
its pose. The pose, also, is more original and
more complicated in its building up of mutually
supporting and balancing volumes. The similar-
ity to Picasso's *Lady with a Fan* is probably co-
incidental, but it is not very important whether
the composition of the modern picture, con-
sciously or not, stems from Corot's. What is
important is that the masterful abstract con-
struction, which in Corot is concealed beneath
a deceptive appearance of inconsequential
ease, is emphasized in Picasso, where the pose
is frankly an artificial one. In Picasso's design
the abstractions of pictorial composition are
exposed for their own interest, demanding at
least equal attention with whatever emotional
or evocative character the painting may also

have. In other words, Corot's painting is traditional in that its abstractions are concealed from the lay observer even though they account for much of the painting's appeal to us; Picasso's is "modern" because these abstractions are brought to the surface and attention is called to them in order to make the most of the intellectual pleasure such abstractions afford.

This is the fundamental revolution in modern painting, and as this story goes on we will see that eventually the result is a reversal of values: in traditional painting, abstract values must be sought beneath the immediate representational and emotional or evocative ones. In modern painting, emotional and philosophical values may be deciphered within abstractions that seem at first not to offer them. But this is a parenthetical jump into the twentieth century, which the reader may feel free to forget for the moment. In the meanwhile, it is enough to re-

member that Corot is a formal painter as well as an artist of tender sensibility.

His *Mother and Child on Beach* [220] demonstrates both aspects with particular emphasis. The protective gesture of the young mother, which could easily have turned mawkish, is as dignified as it is gentle. The figure is designed in unusually large and simple volumes, with a broad and powerful movement initiated by the arclike fold at the bottom of the skirt, continuing in the emphatic one running along the right side up to the waist, then continuing along the back to terminate in the oval of the head. The broad sweep of this circling movement dips suddenly and flows along the long arms to terminate when it finds its goal, the figure of the child, which is painted as a solid, static pyramid, an effective brake on a movement so strong that it demands this decisive termination if it is not to carry us outside the picture. This strong static

220 Jean-Baptiste Camille Corot. *Mother and Child on Beach*. 1868-1870. Oil on canvas, 14⅞ × 18⅛″ (38 × 46 cm). John G. Johnson Collection, Philadelphia.

221 Jean-Baptiste Camille Corot. *Young Greek Girl.* 1868–1870. Oil on canvas, 32⅝ × 21¼″ (83 × 54 cm). Private collection.

ancholy and a hint of languor, a mood that would pall and would certainly degenerate into trifling affectation if it were not stated in forms of such logical decision, revealed in steady, moderate light, constructed in colors dominated by the subtlest grays, grayed blues, creamy yellows, and occasional accents of rich reds. It is an art of nuances—nuances of form, of color, of mood. If the pictures have a quality of simplicity it is because these nuances are perfectly controlled to fuse form, color, and mood into a harmony so unified that it appears to have been arrived at all of a piece. One of the masterpieces is *Young Greek Girl* [221], a portrait of Emma Dobigny, a favorite model of Corot's. The Greek costume is only an accessory. Corot's "Albanian Girls," "Jewesses of Algiers," "Oriental Women," "Judiths," and "Gypsies" have nothing to do with the passionate drama of romanticism, nor do his occasional nude bacchantes have anything to do with revelries of the flesh.

Corot's figures are most at home costumed, and indoors. Although he frequently fabricates a landscape behind them, they remain surrounded by the quiet air, the peaceful seclusion, the intimate protection, of a simple and familiar interior. In one series of figure studies he represents models in his studio, showing a corner of the room, and his easel [Plate 11, p. 186]. Corot's natural habitat is the secluded room, the quiet landscape, or the city in moments when its monuments and rivers and the spaces of its streets and squares are at rest. Yet Corot was an active man. He served on Salon juries; he traveled; he had a great success; he knew and was admired by the most conspicuous of his contemporary painters. But by the evidence of his art, which surely may be trusted, the world of activity did not impinge upon the world of contemplation in which he lived. Corot's world is exceptional in that this privacy is untouched by the morbidity or bitterness of so many worlds where people live alone.

Corot once compared Delacroix to an eagle and himself to a lark. He was satisfied, he said, with his "own little music." From anyone else the comparison would sound specious, and even from Corot it is misleading. His art is more robust and more profound than the comparison implies. It is an art where reverence for simplicity is combined with mastery of civilized nuance. These are not the virtues of "little music" or of little painting.

element on the left is reflected on the right by the two parallel horizontal bands of light cloth at the bottom of the picture and the triangular fold of cloth of the skirt just above them; this in turn is incorporated within the general movement of the forms first described.

It is difficult to avoid enumerating dozens of Corot's figure pictures in discussing them, since each one offers new delights and new variations on his theme. Yet this theme should seem limited, since again and again he presents us with a picture where the mood is one of placid, inconsequential revery, touched by the faintest mel-

chapter 13

The Salon at Midcentury

The Academy and the Salon

By every implication in this story so far, the Academy has been cast in the role of villain. This is type-casting, and like all type-casting it is the result of one magnificent performance. In the decades just after the middle of the century, following the relatively mild persecution of Courbet, the Academy seemed determined to annihilate all French painters of genius, offering its awards, both honorary and financial, to a clique that included some of the most desperately mediocre talents ever to have made their mark in the history of art.

The Academy's motives, like the motives of other villains, seemed to itself virtuous and high-minded. Its position seemed impregnable. But its defeat, after some spectacular battles, was sufficiently ignoble to satisfy its bitterest enemies. The very word *academic* has come to mean stuffy, trite, reactionary. An introduction to this chastened institution and the painters who received its favors is in order if we are to understand why it is still so beleaguered by historians of modern art, and why it rejected and reviled painters who have become recognized as the great ones of the time, and also why there have been tentative efforts, recently, to rediscover a degree of virtue in academic art.

The Academy was founded in 1648 under the patronage of Louis XIV as the Royal Academy of Painting and Sculpture. It was soon dominated by a painter named Charles Lebrun (1619–1690), whose skillful and flatulent *Louis XIV Offering Thanks* [222] is a good example of the style to which he was addicted. Lebrun was an excellent painter, in the sense that he could be depended upon to turn out a good, workmanlike job on any assignment that could be executed according to the rules. But when we have said that, we

222 Charles Lebrun. *Louis XIV Offering Thanks.* Date unknown. Oil on canvas, 15'9⅛'' × 8'7⅞'' (4.85 × 2.65 m). Musée des Beaux-Arts, Lyon.

have come close to defining an industrious hack. And indeed Lebrun was frequently nothing more than that. *Louis XIV Offering Thanks* is far from his best or his worst picture, and it can stand very well as a typical example of the kind of picture known unflatteringly as an "academic machine."

An academic machine is a technical exercise demonstrating the painter's degree of skill in manipulating the standard techniques of drawing, painting, and arranging a picture according to established formulas. And it should be said now that an academic machine is an academic

machine, whether the industrious hack is following Lebrun's formula or one of Picasso's. Contemporary exhibitions are full of pictures not only as meretricious as the worst of Lebrun's but fabricated on much less demanding patterns.

Because he was a pedant rather than a creative artist, Lebrun set the French Academy off in the wrong direction from the beginning. This could have doomed it to wither away into impotence, except that the Academy was maintained in a position of great power by circumstances having nothing to do with the creative genius or the creative shortcomings of the men who controlled it. The head of the Academy, in the service of the king, with fat commissions to dole out to the faithful, could dictate his own recipe as the credo of art—and those painters who were not willing to conform to his recipe could go elsewhere and do the best they could at keeping body and soul together.

The moving spirit behind the formation of the Academy was neither Louis XIV nor Lebrun, but the king's minister of finance, Colbert, who recognized Lebrun's special fitness for the job at hand and selected him for it. Colbert was one of those statesmen, appearing here and there in history, who have recognized the value of art as an instrument of national propaganda and have so employed it. Believing that a government is measured by the yardstick of the monuments created under it, Colbert conceived of the Academy as a caucus of architects, painters, and sculptors with authority to determine an appropriate national character for the arts.

The great French painter of the century was a man twenty-five years older than Lebrun, Nicolas Poussin, whose *Gathering of the Ashes of Phocion* [197] we have already seen. Poussin was fifty-four years old when the Academy was founded and had left France for the second time because he could not tolerate the intrigues of the established artists and could not prostitute himself to the grandiose projects for which Lebrun was soon to become the ideal director. Poussin spent most of his life in Italy, where he was free to paint as he pleased, nourished by the monuments of classical antiquity in his creation of an art of serenity, of contemplation, of order and balance and depth.

Poussin would have been the natural leader of the Academy if its second and more admirable function had not gone begging. For in addition to regulating the character of the arts, the

Academy was supposed to perpetuate all that was best in their great tradition. In truth, Colbert and Lebrun probably thought of these two functions as identical. But they could not be, because they were based on the premise that great art can be produced by formula, and it cannot. No formula can make a great artist out of a mediocre one, and any formula will restrict the expression of certain painters, usually those with something new to say. The Academy patronized only such talents as were content to work within the formula it approved. This is all very well as far as it goes, since there was plenty of work to be done by artists of conscience and discretion well-trained in their craft. This training the Academy could supply. But as a corollary, it is also true that the Academy often rejected artists of genius, since by definition genius transcends formula by extraordinary powers of invention.

The artist without official standing could of course subsist on private patronage, as Poussin largely did, and during the eighteenth century the Academy's stranglehold was weakened by a class made up of individuals of wealth and cultivation in the arts, capable of recognizing original talents, who supported whatever painters pleased them, in or out of academic favor. But academic strictures remained effective in the official schools, where arbitrary standards were perpetuated and talent was disciplined into conventional channels by the prospect of material rewards for the docile student. These were the schools David cried out against, in the name of art, justice, and youth, when he annihilated the Academy at the time of the Revolution.

But the new Academy under David's influence (not directly under him, for he consistently refused to accept official directorship of the school) was more vicious than it had been before. The worst aspect of the situation was that the Revolution shifted the market for paintings from a small, aristocratic, knowledgeable group of patrons to a large, common, aesthetically ignorant public. The Salon became a gigantic salesroom to serve the bourgeoisie, who in their eagerness for the acquisition of "culture" accepted the academic stamp of approval as a guarantee of art.

The Salon was a cruel weapon. Its jury of admission held the power of professional life or death for the painter still in search of a public. The beginner who tried to bring work to attention elsewhere was in the position of a merchant opening a store with merchandise stamped "defective" by government officials. Pictures poured in for submission to the Salon in such quantities [223] that as many as four

223 Félicien Myrbach-Rheinfeld. *Candidates for Admission to the Paris Salon.* (Basement of the Palais d'Industrie). Pencil drawing, probably for an illustrated journal. Metropolitan Museum of Art, New York (Harris Brisbane Dick Fund, 1947).

224 François Heim. *Charles X Distributing Awards, Salon of 1824, in the Grand Salon of the Louvre.* 1827. Oil on canvas, 5'8'' × 8'5'' (1.73 × 2.57 m). Louvre, Paris.

thousand might be rejected from a single exhibition, in spite of the fact that in the largest Salons as many as five thousand might be hung, crowded on vast walls, frame to frame, from eye level to ceiling. The pictures in poor locations might be next to invisible but at least they had received the stamp of approval—literally the Salon stamp on the back—while rejected pictures might be returned to the artist indelibly stamped with the *R* for *refusé,* thus rendered unsalable. A purchaser might take an option on a picture, subject to its passing the jury, or might refuse to accept one already purchased because it failed to do so. The annual presentations of awards were state events of solemnity and importance [224].

Although the system originated in France, it flourished vigorously, if less tempestuously, throughout Europe. England's Royal Academy was, and is, particularly respectable and its private receptions [196] were, and are, particularly fashionable. But in France the Salon became also a public battleground, with the academicians entrenched in fortified positions assaulted by rebel forces. Once they had battled their way in (as the romantic painters did) the rebels had

a way of turning respectable themselves, joining ranks with the traditional painters to oppose the next wave of dissenters. During the nineteenth century, revolts followed one another so rapidly that a group of painters would hardly be established in a strategic position before it was attacked from the rear by another. The French public enjoyed the battles and took sides, mostly for the conservatives. Throngs of people crowded the exhibitions, and the Salon prize-winners were discussed vehemently.

Fledgling painters hoped that from the colossal grab bag their work would somehow emerge as the season's success, or, lacking that, even as the season's scandal—as the *Raft of the Medusa, Massacre at Chios,* and *A Burial at Ornans* had done. But these pictures were exceptions. Most of the entries fell obediently within conventional categories or failed to pass the jury. There would be the moralistic allegories; there would be the hundreds of history pictures celebrating great events in pompous terms; there would be the cute children, the sentimental anecdotes, the picturesque landscapes; and always there would be the armies of nudes—nymphs, Venuses, and bathers caught

by surprise. There would be the imitations of every picture that had ever made a Salon success, warmed over and hopefully served up again. There would be the sound, craftsmanlike, first-rate work of second-rate men, and, here and there within the interminable stretches of bad, mediocre, and respectable painting would be a work of art. Almost a quarter of a million pictures were exhibited in Salons during the nineteenth century in France alone.

The painter's problem was how to compete for attention in such a field. Startling eccentricity, by which painters may strain for attention today, was ruled out in the first place, if not by the painter's lack of imagination, then by the fact that the jury was unlikely to accept an unconventional work. Sheer technical excellence was not much help either, since the overall technical level of Salon pictures was very high. It is appalling to look over old Salon catalogues and see the hundreds of painters whose technical mastery seems equaled only by their aesthetic and spiritual idiocy. (Where are all these paintings now? Those in museums have sunk by degrees to the basements; the rest, if not destroyed, are in those even more mysterious limbos where unwanted paintings await an improbable resurrection.)

Subject—what the picture was "about," the story it told—took on exaggerated importance as one way of differentiating between pictures all cast in the same technical mold. Or a painter with the time, energy, and means to devote to the production of an unsalable picture might stand out by means of another device: size. The Salon system produced the phenomenon of the demonstration piece painted for exhibition only, so large that it could not be lost in the crowd (the *Raft of the Medusa* was of course one of these). But unless it was purchased by the state, a painter could do nothing with a demonstration picture after the Salon closed except roll it up and store it away in the hope that the state would eventually acquire it. This is what actually happened when the pictures were manifestos of new movements and were preserved, either by the painter or by perceptive collectors, until time had proved the importance of the movement. Courbet's mammoth *The Studio,* for instance, remained in his possession until his death, and was sold as part of the contents of his studio in 1881. After resale to another private collector, it was finally purchased for the Louvre in 1920, sixty-five years

after Courbet painted it, with funds collected by public subscription.

The idea upon which the Salon system was supposed to be based was sound: the Salon was supposed to offer an annual exhibition of the best work by established painters and a proving ground for new talent. Jurors would have had to be superhuman to perform their task with complete effectiveness, but they were much less than that. If a generality is ever safe, it is safe to say that for several decades beginning around 1850 the men controlling the Academy and the Salon were all but blind aesthetically, and all but sadistic in their persecution of any painter who fell out of line with their goose step. This was bad enough, but their unpardonable crime was that they debauched public taste under the pretense—or, more generously, under the illusion—that they were elevating it in their systematic program to reduce the art of painting to sterile repetitions of exhausted formulas. Yet in spite of everything, these decades were one of the most vigorous, original, and productive periods in the history of painting—a tribute to the vitality of French creative genius, which has always emerged victorious in its constant struggle with equally French suspicion of change.

The Salon of 1855

The Salon of 1855 was a climactic one and has already been mentioned in connection with Delacroix, who was given a large retrospective as one section of it, with Ingres, who relented after twenty years of abstention from Salon exhibition to accept a similar honor, and with Courbet, who was rejected and built his Pavilion of Realism to get a showing for *The Studio.* It was the biggest Salon ever held and was made international as part of the great Exposition Universelle of that year. We will use it here to examine the nature of Salon art, since its awards went to painters whose work is an international summary of popular/official taste at the time and for the rest of the century.

Ingres was induced to exhibit by hints that the government had him in mind for special honors when the awards were announced, but these honors did not materialize. He received the Salon's highest award, a Grand Medal of Honor, but so did nine other painters, including his enemy Delacroix. The report of the jury to Emperor Napoleon III carefully listed the

winners alphabetically with no comment, although in classifications other than the fine arts the various juries gave reasons for their decisions. Apparently the competition among manufacturers or engineers, who sent in tens of thousands of exhibits to the Exposition Universelle, was less touchy and personal than the rivalry among painters and sculptors.

225 Edwin Landseer. *A Distinguished Member of the Humane Society.* c. 1838. Oil on canvas, 3'8'' × 4'8½'' (1.12 × 1.44 m). Tate Gallery, London.

226 Edwin Landseer. *Blackcock.* c. 1874. Oil on canvas, 19¾ × 26'' (50 × 66 cm). Collection Henry P. McIlhenny, Philadelphia.

Of the ten Grand Medals of Honor in painting, three went to eminent foreigners: Peter von Cornelius (Prussia), Sir Edwin Landseer (United Kingdom), and Hendrik Leys (Belgium).

Cornelius (1783–1867) was an inevitable choice. In his twenties he had gone to Italy as a member of the hyperaesthetic medievalist group, the Nazarenes, but returned under royal patronage in 1819 to Munich, where he made a conscientious but heavy-handed effort to revive the art of monumental fresco, with Michelangelo as his model. He was a didactic (not a natural) romantic, so opposed to realism as a contradiction of noble ideals that he refused to draw from nature, including models. When he received his Salon award in 1855 he was Director of the Academy of Munich, a corresponding member for his country to the Institute of France, and a conventional and skilled painter of portraits and scenes from religious history. The medal was a bow to France's neighbor to the east.

Landseer (1802–1873) received a medal as a similar gesture across the English Channel. A comparative youngster of fifty-three (Cornelius was seventy-two at this time, Ingres seventy-five), he was already the dean of English painters because no other man in the history of art managed to paint animals so much as if they were human beings. With its coy title, *A Distinguished Member of the Humane Society* [225] is typical of Landseer's pictorial manipulation of the pathetic fallacy. Landseer could paint a stag and invest it with all the dignity of an eminent conservative clubman. He also painted pictures that, like *Blackcock* [226], keep appearing as a rebuke to his wasted talent. *Blackcock* is a harmony in grays, tans, and whites, with a dash of bright blood on the snow. It is as richly painted as a Courbet, and it treats birds as birds, not as simpering human beings. Landseer was an expert draftsman, and his drawings are beginning to interest collectors again. From the great mass of his work it would be possible to cull a small group of fine paintings.

The Belgian Leys (1815–1869) was even younger but even better connected; he was a painter of history pictures, genre subjects imitating those by his country's seventeenth-century masters [227, p. 184], portraits, and official decorative pictures of the usual kind. There is nothing wrong with his work except that it is parasitic; its merit depends upon its approximation of its models.

These three awards, however, were more concerned with international courtesy than with the art of painting. The awards to Frenchmen give a more accurate idea of Salon taste.

Grand Medals of Honor, 1855

Although some of the award winners in 1855 now seem too bad to have been true, we can fairly use this year as an example because the awards were made with particular care to summarize France's preeminence in the arts. The sprinkling of good pictures among them shows that the jury was more perceptive than in many other years, and the inclusion of a few former heretics shows an effort toward open-mindedness. Even Courbet had some paintings accepted; it was the rejection of *The Studio* and, for exhibition a second time, *A Burial at Ornans* that caused the excitement and in retrospect leaves the jury open to charges of bias. The 1855 jury was a good one as juries went.

Among the seven Frenchmen receiving the Grand Medal of Honor, the star was neither Ingres nor Delacroix but a terrible little man of inflated reputation—Jean-Louis Ernest Meissonier (1815–1891), whose view of Venice [213] has already been compared with one by Corot. At twenty-five Meissonier won his first Salon medal in the lower brackets, and a year later

228 Jean-Louis Ernest Meissonier. *La Rixe (The Brawl)*. 1855. Oil on canvas, $17\frac{1}{4} \times 22''$ (44×56 cm). Collection H. M. Queen Elizabeth II. Reproduced by permission of the Lord Chamberlain.

(1841) he was awarded a higher one. After two years he went up another notch, and he repeated this success five years later. Then in the 1855 exhibition came his Grand Medal of Honor for a picture called *La Rixe (The Brawl)* [228], which was such a success that Napoleon III selected it from all others for purchase and

Plate 9 Jean Auguste Dominique Ingres. *Jupiter and Thetis*. 1811. Oil on canvas, 10′10″ × 8′5″ (3.3 × 2.57 m). Musée Granet, Aix-en-Provence.

Plate 10 Gustave Courbet. *Two Girls on the Banks of the Seine.* 1856. Oil on canvas, 5'6½" × 6'9⅛" (1.69 × 2.06 m). Petit Palais, Paris.

Plate 11 Jean Baptiste Camille Corot. *The Artist's Studio.* 1855 – 1860. Oil on canvas, 24⅜ × 15¾" (62 × 40 cm). National Gallery of Art, Washington, D.C. (Widener Collection).

Plate 12 Jean Léon Gérôme. *Prayer in the Mosque.* 1860 (?). Oil on canvas, 35 × 29½" (89 × 75 cm). Metropolitan Museum of Art, New York (bequest of Catherine Lorillard Wolfe, 1887).

presentation to Queen Victoria as a souvenir of the English sovereign's visit to the Exposition. By now Meissonier was forty years old; he lived to be seventy-six and continued to accumulate honors until new ones had to be invented for him. He was the first French painter to receive the Grand Cross of the Legion of Honor, among other things. There was no question in his mind, and there seemed to be little in the minds of many rational people, that he was the Leonardo da Vinci, the Michelangelo, of modern times. One American millionaire, A. T. Stewart, bought a Meissonier by cable, sight unseen, for $76,000, an amount that would translate into the highest amounts paid for Picassos during his lifetime. In his later years he cultivated a tremendous white beard that dropped to his waist. He was fond of patterning it carefully in a series of points and posing in a black velvet robe with a jeweled belt. In this costume and with his prize beard cascading down the velvet he would assume an expression of fiercely profound and melancholy thought, as one who has transcended the intellectual limitations of mortal man, and thus he would have himself photographed or painted.

It is maddening to remember that while this mean-spirited, cantankerous, and vindictive little man was adulated, great painters were without money for paints and brushes. The typical Meissonier is a dry, pinched, painstaking illustration of some event from military history, usually Napoleonic, or an anecdote enacted by models in costume, frequently the costume of seventeenth-century musketeers. *La Rixe* is an example of this formula, and it is one of his best works, probably his best in this genre category.

Meissonier offered the new picture-buying public exactly what it wanted. In the first place, his pictures told stories; they were easy to "understand." And the little figures enacting these stories were laboriously and accurately detailed. The public demanded that painting be something which had quite obviously been difficult to do, like a cathedral built from toothpicks. Not only did Meissonier put every tiniest highlight on every button, but it was even possible to identify a soldier's regiment from some of these buttons. What Meissonier lacked in imagination (which is to say, everything) he would have made up in meticulous execution, if such a void could have been filled by a device so meaningless.

It was not until after 1855, about 1859, that Meissonier began his series of Napoleonic subjects. His *1814* [229], showing Napoleon in the

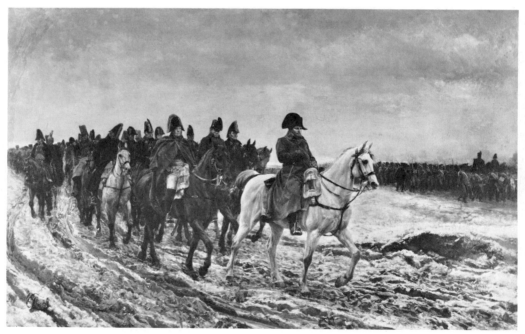

229 Jean-Louis Ernest Meissonier. *1814.* 1864. Oil on canvas, 19¼ × 29½″ (49 × 75 cm). Louvre, Paris.

final days of the debacle of empire, is a good example and today the best known of his many pictures of Napoleonic victories and defeats. It is an achievement of a kind to do what Meissonier did: to take the history of military campaigns where men died in blood, or of starvation and exposure, to take events that were flung across a continent, that marked the rise and the collapse of an empire and changed the direction of history in the Western world, to take triumphs and cataclysms full of glory, terror, and anguish, to take all this and reduce it to nothing more than a well-organized collection of lead soldiers, accurately uniformed. Meissonier has left accounts of his efforts to create the effect of snow by spraying miniature models with borax or sugar, accounts so naïve in their enthusiasm for imitation that they would be touching if this man had not been mistaken for a genius. Nothing he ever painted suggests for a moment that he conceived of art as anything beyond a display of manual skill, or of his subjects as anything more than pegs upon which to hang his display. In his *1814,* it might be granted that the infinite details have been neatly packed into their container (which is less than twenty inches high), and that the picture suggests, however faintly, some mood of sadness and regret. But these are inadequate virtues in the circumstances. The defeated Emperor's air of dejection might just as well be that of a man who has committed an embarrassing faux pas at an important social gathering and has been sent home in bad weather with an unusually large escort. Whatever else we can read into *1814,* whatever it says of grandeur and collapse, we must read into it for ourselves by our knowledge and associations with the pictured event. The painting is, in short, completely a parasite on what it is about. In that capacity, it is perfect.

For this very reason this kind of painting pleased—and on the same terms much of it still does, for that matter. But it has nothing do with art for all that it has to do with craftsmanship, nothing to do with expression for all its detailed illustration, nothing to do with the human spirit or with the enlargement or intensification or clarification of human experience. Even as a technical exercise it is unoriginal; its superiority to the rank and file of Salon pictures is only one of degree, not of kind. Meissonier says nothing. Behind his preoccupation with representing scenes from Napoleonic history lies the confused thinking that can attribute greatness to a painting on the strength of the greatness of the pictured event. But greatness does not rub off in this way. Meissonier manages to reduce some of the most important, dramatic, and harrowing events in history to the expressive level of a well-shined shoe. The polish is admirable, but in the long run not very important.

These unfriendly comments are based, of course, on the idea that great art, or even good art, is a form of significant expression. From that point of view Meissonier is easy to deride. But as a superbly professional miniaturist, nothing more, he is unbeatable. Henry James called him, in fact, "the prince of miniaturists," and Meissonier had other contemporary admirers, including Ruskin—which is surprising until we remember Ruskin's primary aesthetic principle involving the detailed imitation of nature. It is more difficult to reconcile Degas' having found Meissonier acceptable, although he could have had no sympathy with his pretentiousness.*

After Meissonier, whose art was so spectacularly pointless, the remaining Grand Medal winners, now forgotten, are a little dull. This is too bad in the case of Alexandre-Gabriel Decamps (1803–1860), a painter for whom one would like to find a generous word. His work retains a certain vigor and some force of color. In *Oriental Night Scene* [230], as a typical example, reds and yellows are bright and rich against a ground of browns and blacks. Although a younger man than either Ingres or Delacroix, like them Decamps was given a room to himself for the exhibition of fifty pictures, and his work was discussed by the critics as if he were of their caliber.

Decamps tried his hand at a variety of pictorial work, including some political cartoons that might look better if they did not have to stand comparison with Daumier's, which were appearing at the same time. One painting, *The Experts* [231], showing some monkeys at work judging a picture, indicates that Decamps was not entirely fooled by the Salon system. But al-

*Like all painters of skill without imagination, Meissonier was at his best when he was at his least pretentious. He did some very pleasant exercises where his photographic eye and his well-trained hand combined to reproduce nicely selected bits of typical French countryside. As literal objective mementos of a scene, these can be most attractive, and if Meissonier had painted nothing else he might have been remembered as a sound landscape painter of the second rank, limited but never bothersome.

230 Alexandre-Gabriel Decamps. *Oriental Night Scene.* c. 1840. Oil on canvas, 23¾ × 20¼" (60 × 51 cm). John G. Johnson Collection, Philadelphia.

231 Alexandre-Gabriel Decamps. *The Experts.* 1837. Oil on canvas, 18¼ × 25¼" (46 × 64 cm). Metropolitan Museum of Art, New York (H. O. Havemeyer Collection, bequest of Mrs. H. O. Havemeyer, 1929).

though one would like to do so, it is difficult to find Decamps very interesting today. He is a respectable painter but not a very stimulating one. Meissonier has a morbid fascination, but Decamps is too good to be interesting as a bad painter. As a matter of fact he was one of the earliest Orientalists. He traveled in Asia Minor before Delacroix went to Morocco. But he was content to illustrate rather than to interpret, and as an Orientalist he remains a genre painter whose subjects are taken from Turkish and Arabian locales. This is why the majority of the critics in 1855 preferred him to Delacroix. He was easier.

The other Grand Medal winners may be considered briefly:

Émile Jean Horace Vernet (1789–1863) was the son and grandson of two other Vernets, painters of some distinction. The talent was running thin by the third generation but was still adequate for the manufacture of history and military subjects by the standard recipes. Vernet was a happy, popular, successful man whose family tradition certainly helped bring him his medal.

François Joseph Heim (1787–1865) was a classical painter of the most academic kind. From his *Prix de Rome* in 1807 to his Grand Medal of Honor in 1855 his career could be used as an example to prove that slow, steady, and conventional wins the race. His *Scene from Jewish History* [232, p. 190], is an exercise in Davidian style consistent enough to look for a moment like something more. Then one sees that it is nothing but an assemblage of polished but meaningless parts, an exercise indeed. It is the kind of picture that, if torn to pieces, might yield many fragments suggesting that the total might have been a neoclassical painting of the best kind, for in the fragments the Davidian disciplines are apparent, and one is free to believe that surely so much sound craftsmanship must have served some expressive purpose. Heim also painted the interior panorama of *Charles X Distributing Awards to Artists at the End of the Exhibition of 1824* illustrated in the early pages of this chapter [224]. Here he comes off better in a picture adapted to his talents, the detailed representation of an event where factual record is an end in itself.

Finally, Louis Pierre Henriquel-Dupont (1797–1892), was an engraver. He has some genuine

232 François Joseph Heim. *Scene from Jewish History*. 1824. Oil on canvas, 12'10¼'' × 15⅛'' (3.92 × 4.6 m). Louvre, Paris.

historical importance since, after studying with Guérin as a very young man and then with an equally classical engraver, Bervic, he revolted against classical technique to develop a freer, more vigorous one. Thus in his small way he is a counterpart of Delacroix, the difference being that Delacroix was a creative artist as well as a technical innovator.

If we omit Ingres and Delacroix as great painters and Meissonier as an offensive one, this is a good sound list of accomplished wielders of the brush, boring rather than vicious. Its main fault is not its inclusions but its omissions. As a list of the living French painters supreme in their fields in 1855 it will not do. The most conspicuous absentees are Courbet, Daumier, and Corot. No jury can be held accountable for time's re-evaluations, and nearly a century and a half has elapsed since 1855. But it should not have taken a crystal ball to see that Courbet was a better painter than, say, the genial and suave Vernet. And if Daumier was painting virtually in secret, it was because the Salon standard was so inimical to his genius that he did not find a public.

Salon awards were graduated downward from the Grand Medal of Honor through Medals First, Second, and Third Class, with the usual sop of Honorable Mentions at the bottom. In the long list of winners in these lower classes more names have endured and some became even more conspicuous in the Salon than the Grand Medalists above. Yet all the winners of the Grand Medal of Honor are at least hazily familiar names to anyone who has spent much time with the history of painting, while among the other awards, even the Medals First Class, there are utter strangers even to the specialist. Occasionally someone investigates these men, hoping to discover and revive a neglected painter of merit. So far no one has struck gold, but critics now realize that the blanket dismissal of Salon art is an exaggeration. In the first place, to ignore it is to ignore the historical context in which the rebels were painting, and, as well, the contribution that academic painting made to the development of such painters as Renoir among the impressionists (who always acknowledged his debt to his academic master Gleyre) or Géricault among the romantics.

Medals First Class, 1855

Corot was recognized in the second rank of awards with a Medal First Class, and one went to Théodore Rousseau (who in 1867 was even to win a Medal of Honor). The jury's report lists forty-eight Medals First Class, thirty-two of them to French painters, seven to painters of the United Kingdom, and the rest scattered around other European countries. Among the other First Medalists, several are still familiar names:

Rosa Bonheur (1822–1899) still has a following, especially in America, where her *Horse Fair* [233] is perpetually admired. She was a child prodigy and exhibited in the Salon when only nineteen. By 1848, when she was twenty-six, she had already won a Medal First Class. In 1853 she came conspicuously into public favor with *The Horse Fair,* which was very large to have been painted by a woman but would have attracted attention even if it had been painted by a man. There was nothing feminine about Rosa Bonheur's painting, and there were many unfeminine aspects to her deportment. Like the lady romantic George Sand, Rosa Bonheur affected men's clothes upon occasion. She was an admirer of Sand, and lived her own life freely with some of the same romantic flair. She knew everyone. She painted animals with great knowledge and sympathy, but never made

Landseer's mistake of trying to turn her animals into noble human beings. She painted with a heavy, rich pigment and might have found a source for this in Géricault. Toward the end of her life, which coincided with the end of the century, she tried to bring her work into line with that of the impressionists, who were the modern painters of her old age. She did not succeed, but her attempt indicates an admirable open-mindedness and a continuation of the determinedly "unfeminine" vigor that was her most individual characteristic among women painters. She was very popular in England, no doubt because animal paintings were held in such esteem there, but she well deserved her Greek Cross of the Legion of Honor from Queen Victoria. She was the first woman to receive it.

Alexandre Cabanel (1823–1889) was another *Prix de Rome* winner whose life was a succession of triumphs. Later he twice won the Grand Medal of Honor, in 1865 and 1867. He was an extremely fashionable painter. Since one of his paintings [254] is considered later in some detail, this is enough about him here.

Léon Cogniet (1794–1880), was also a *Prix de Rome* man, five years older than Delacroix and like Delacroix a student of Guérin. Unlike Delacroix, he remained a loyal follower in

233 Rosa Bonheur. *The Horse Fair.* 1853–1855. Oil on canvas, 8'1¼'' × 16'7½'' (2.44 × 5.07 m). Metropolitan Museum of Art, New York (gift of Cornelius Vanderbilt, 1887).

Guérin's classical manner. Since this manner was already watered down in Guérin's work, its further dilution in Cogniet's leaves very little substance. Cogniet was a weak colorist and a routine composer. He was one of those painters who never advance beyond the state of favorite pupil. Like others of this type, he spent his life as a teacher of rules just as he had learned them. Meissonier studied under him; so did Rosa Bonheur.

Hippolyte Jean Flandrin (1809–1864) was a disciple of Ingres. Ingres once threatened to resign from the Academy when the Salon jury refused one of Flandrin's paintings. Occasionally, Flandrin approximated Ingres' quality, and he left one study of a male nude [234] of an arresting sensuousness that has made it a great favorite in the Louvre. But in searching for a style of his own by following a series of enthusiasms Flandrin failed to develop very far in any of them. And the one in which he developed farthest, a modified troubadourism, was not the most fortunate choice he could have made.

Federigo de Madrazo (1815–1894), a Spaniard, dominated Spanish official art as a history and portrait painter. He was a brilliant success and the favorite of Spanish aristocrats, was much

honored officially in France also, and painted in a bright, flashy manner.

Karl Ernest Rodolphe Heinrich Salem Lehmann (1814–1882) is less impressive than his name. Born in Kiel, a naturalized Frenchman, a pupil first of his father and then of Ingres, he followed the classical formulas with such dryness and so obsessively that even his contemporaries found him limited in this way. Nevertheless he won Medals First Class in 1840 and 1848 as well as in 1855. He founded a prize to encourage the defense of the academic tradition. Possibly it is still awarded.

Joseph Nicolas Robert-Fleury (1797–1890) was a student of Girodet and Gros. Following at a safe distance behind the romantic vanguard, he capitalized on its successes whenever they could be made palatable to bourgeois taste. His career was a succession of official honors and sinecures culminating in the directorship of the Academy's School of Fine Arts and then the directorship of the Academy in Rome.

With Constant Troyon (1810–1865) we come to a curious phenomenon: the cow in nineteenth-century painting. Before his discovery of this animal's potential as an art object, Troyon

234 Hippolyte Jean Flandrin. *Study of Male Nude.* 1855. Oil on canvas, 3'2½'' × 4'3¾'' (.98 × 1.24 m). Louvre, Paris.

had already put behind him a successful career as a painter of landscape in the Barbizon spirit and, as was mentioned earlier, is ordinarily grouped with that school. At twenty-three Troyon made his debut in the Salon; at twenty-nine he was awarded a Medal Third Class and at thirty a Medal Second Class. At thirty-one he had a real Salon success with a picture of Tobias and the Angel in a landscape, which was praised by the perceptive and sophisticated critic Théophile Gautier and at the same time admired by the public. In 1846 Troyon reached the award of Medal First Class. The following year he visited Belgium, where he discovered the works of two seventeenth-century painters, Albert Cuyp and Paul Potter, whose landscapes were backgrounds for various domestic animals, especially cows. From that time on, cows and—to a lesser degree—sheep precccupied Troyon. He painted them standing in pools, grazing in meadows, entering the fold, leaving the fold, and sometimes just doing nothing at all. He was the best (he was an excellent painter) of a considerable group of artists dedicated to the cow. They found a ready market for their work. The cow in the living room became a familiar item. The success of these pictures may have been a result of increasing urbanization, a bourgeois nostalgia for the countryside as cities became more crowded, more complicated, more mechanized. Critics praised Troyon's mastery of the anatomy of the cow with as much seriousness as they praised other painters' mastery of the nude. Whatever the explanation for his fascination with the cow, and if we forgive him some inevitable repetitiousness, Troyon was skillful in disposing these creatures pleasantly in landscapes of grassy charm under skies of agreeable tints [235]. His Medal First Class of 1855 was his third; he won a fourth in 1859. He seems to have been a generous and agreeable man, with much of the placidity characteristic of his favorite subject.

Finally, among the First Medalists whose names are still familiar, there was Franz Xavier Winterhalter (1806–1873), a German by birth but a cosmopolitan by nature and experience. A portraitist, he traveled from court to court all over Europe. There was hardly a king or queen or person of great title whom he did not paint at one time or another. It is easy to see why he was so sought after. His women have a melting loveliness and his men an aristocratic male elegance leading to the conclusion that European nobility of the mid-nineteenth century was a special race of unparalleled physical beauty. Winterhalter was one of those portraitists, most frequent

235 Constant Troyon. *The Pasture*. c. 1852. Oil on canvas, 25¼'' × 35½'' (64 × 90 cm). Metropolitan Museum of Art, New York (bequest of Collis P. Huntington, 1925).

236 Franz Xavier Winterhalter. *Prince Albert of Saxe-Coburg-Gotha.* c. 1867 (replica of original of c. 1846). Oil on canvas, 7'10" × 5'1" (2.39 × 1.55 m). National Portrait Gallery, London.

in England, with a knack for retaining a likeness while beautifying the subject. His portraits still have great appeal in their decorative and triumphantly superficial way [236]. Like many other painters who do not have much to say but do not pretend to be saying more than they can, Winterhalter is an enjoyable painter when accepted on his own premises.

One eminent painter, Thomas Couture (1815–1879), was awarded a Medal First Class but refused it, indignant because it was not a Grand Medal of Honor. A pupil of Gros, then of Delaroche, Couture was a *Prix de Rome* winner and made a successful Salon debut at twenty-three with a picture entitled *Young Venetian after an Orgy.* He was only thirty-two in 1847 when he won a Medal First Class with his *Romans of the Decadence* [243], another post-orgy scene that is such a perfect example of the academic concoction at its typical best that it is

generally used today as an illustration when a single specimen must stand alone to typify the breed. Couture was a painter of great talent and a vast intolerance. We will see more of him and his *Romans of the Decadence* shortly.

Medals Second Class, 1855

In the longer list of Medals Second Class there are fewer names of importance. Two are somewhat younger men. Jean Léon Gérôme (1824–1904) lived into the twentieth century, as did Adolphe William Bouguereau (1825–1905). Just now the reputations of both these painters are on the rise, although it is difficult to see Gérôme's virtues when we remember his imposition of the vicious tyranny of the academic formula in the latter half of the century, with its sterility, dogma, hypocrisy, and above all its sel-

237 Jean Léon Gérôme. *Pygmalion and Galatea.* Date unknown. Oil on canvas, 35 × 27" (89 × 69 cm). Metropolitan Museum of Art, New York (gift of Louis C. Raegner).

fishness and its blindness in the face of new developments.

Gérôme was a painter who pushed the slick painting surface to its limit, and he was as handy as Meissonier with highlights on buttons. According to some accounts he was also nearly as odious a personality. But he was more of an artist. He was just as fascinated with technical display in details but he was more selective in their use. He had a sense of color—for Meissonier, one color was just about as good as another—and among the multitude of his paintings (for like other successful Salon painters he was extremely productive for an insatiable market) from time to time a work of surprising attraction occurs.

The slick, tight surface typical of so much academic painting harks back to David's, as in *The Horatii*. Gérôme, in his *Pygmalion and Galatea* [237], a wonderful and terrible picture, is

238 Honoré Daumier. *Pygmalion,* from *Histoire Ancienne.* 1842. Lithograph, 9 × 7½'' (23 × 19 cm). Philadelphia Museum of Art (gift of Carl Zigrosser).

painting a classical subject with a high polish, but we are a long way from the master of the Revolution and even further from Ingres. Neither the vigorous anatomical naturalism of *The Horatii* nor the sensuous idealization of a nude by Ingres has left a mark on this descendant, although the figures have been drawn with acute naturalism and then prettified. *Pygmalion* is a consummately obvious and vulgar picture.

The story is that of the young sculptor Pygmalion. Having done a marble statue of Galatea, he falls in love with his own work, which is brought to life by Venus, who has observed the young man's plight. Gérôme's statue-woman is painted in rosy flesh pinks in the upper parts where life has suffused it and fades out gradually to pure marble white at the feet, where the process of vivification has hardly begun. Salon audiences found this tour de force ravishing, but time has not been gentle with the picture. Its pretensions and affectations are mercilessly revealed and even the nude girl, once captivating, looks a little comical since fashions in feminine loveliness have changed. It is extraordinary that a public with access to Daumier's hilarious burlesque of the same subject [238] could ever take Gérôme seriously again, but they continued to do so.

Salon painters were sometimes pseudo-classical, sometimes pseudo-romantic, but always genuinely opportunistic. Orientalism had long ceased to be innovative and was popular in all kinds of treatments. Gérôme painted Oriental subjects without any expression of their mystery, their turbulence, or even essentially of their exoticism, in paradoxical combination with his tight pseudo-neo-Davidian style. He was a master at the rendition of the silks, brasses, jewels, and other rich stuffs and objects of the Near East. Usually he used them as knick-knacks to trick out some foolish anecdote, some trivial little story for the Salon public to read, but occasionally, as in *Prayer in the Mosque* [Plate 12, p. 186] he seems to become another painter and his trivia coalesce into a picture that rises above them.

Prayer in the Mosque is more than a straight reproduction of an inherently interesting subject. The colors are beautifully modulated, juxtaposed in combinations of unexpected distinction; the figures are skillfully disposed within the space, the monotony of their long stretch back into deep perspective being broken here and there most judiciously; the airy columns of

the mosque have an abstract interest beyond their interest as exotic architecture. Even when we admit that these volumes are inherent in the structure and not an invention of the artist, it is still true that Gérôme has made the most of them.

Like Gérôme, Bouguereau went on from his Medal Second Class in 1855 to the Grand Medal of Honor and the whole category of official awards. The birth and death dates of these two academicians coincided within a year, and each was a resounding commercial success on both sides of the Atlantic. Bouguereau's name has become synonymous with the application of technical prowess to any salable subject. Whether he was painting high-class barroom nudes or holy pictures, he was breathtakingly adept at assuming appropriate masks to conceal the repetitious sterility of his conception. Whether painting nymphs and satyrs or *Youth and Cupid* [239] to titillate bourgeois sexuality or madonnas appealing to associative religious ideas in much the same way, Bouguereau was such a skillful performer that the buying public saw no inconsistency in the work of a man who alternated between the roles of lecher and mystic. And indeed there is no inconsistency here, since in neither role was Bouguereau an expressive artist: he was a salesman with an infallible eye for the market. But he was a technician of such prowess, in a style soft and slick at the same time, that anyone who is at all interested in painting can hardly fail to respond to one by Bouguereau as a performance, no matter what he may think of it as a work of art. No matter how clearly one sees that *The Thank Offering* [240] is sentimentalized to the point of nausea, its technical aplomb remains staggering.

The wonder of a painting by Bouguereau is that it is so completely, so absolutely, all of a piece. Not a single element is out of harmony with the whole; there is not a flaw in the totality of the union between conception and execution. This, of course, is a requirement for any great work of art. The trouble with Bouguereau's perfection is that the conception and the execution are perfectly false. Yet this is perfection of a kind, even if it is a perverse kind, and Bouguereau is proof that the art of painting is so various and so complex that even "bad" pictures can be fascinating when considered as part of the whole record of our own nature.

A Medal Third Class also went to Théodore Chassériau (1819–1856), who had begun as a student of Ingres and then had been attracted by the colorism and exoticism of Delacroix. He managed to fuse some of the sinuous grace of his first master with the warmth and light of romanticism; before his relatively early death he had developed a hybrid style of decorative attraction, displayed especially in murals.

239 Adolphe William Bouguereau. *Youth and Cupid.* 1877. Oil on canvas, 6'3½'' × 2'11'' (1.92 × 89 cm). Louvre, Paris.

240 Adolphe William Bouguereau. *The Thank Offering*. 1867. Oil on canvas, 4′10″ × 3′6¼″ (1.47 × 1.07 m). Philadelphia Museum of Art (W. P. Wilstach Collection).

The Salon Public

What, in summary, do all these pictures reveal as to the taste of the bourgeoisie, the new public of picture buyers? First of all, that a painting must in some way be ostentatious. It must pretend to a kind of profundity or sensibility, and it must do so without violating the veneer of proprieties that passed for morality. If a specific moral lesson can be incorporated or implied, so much the better, but it must be a moral lesson flattering to bourgeois convention. These components of a picture must be immediately apparent on the picture's surface; they must not be reached via some philosophical bridge. This ordinarily means that the picture must tell a story of some kind. It may not exist simply as a painting; it must be a picture *of* something. That is why the Salon painter was a narrator first and a painter second.

Whether or not conscious of doing so, the Salon painter sought to flatter the public, continually, by implication, assuring them of their sensitivity, their cultivation, their intellect, their nobility of soul, their moral probity. The more this flattery was rewarded—by purchases—the more intense it became, and the more intense it became, the more it was rewarded by further purchases, in a vicious downward spiral. It must be remembered too that as the Salons became bigger and bigger the public was educated to lower and lower standards. Thousands of pictures were exhibited in each Salon, and there simply never are thousands of great painters alive at any one time, especially in any one country, even when the country is France. But all these thousands of pictures received the official stamp as great art. In these circumstances it is not surprising that by the 1860s, when the impressionists appeared, the public was offended by pictures painted in a revolutionary technique, pictures whose virtues ran counter to all the Salon vices that for so long had been mistaken for virtues of an elevated kind.

But to this summary of a depressing situation the reminder should be added that Delacroix, Ingres, and Corot were also alive and successful (Courbet, as well, was successful in his special way) and a generation of painters just then clearing their teens was assimilating the various contributions made by these giants of the first half of the century: Ingres' exquisite control and his respect for tradition; Delacroix's revolution of color and his insistence that the painter is independent of formula; Courbet's rejection of the ideal and the faraway in favor of the everyday world around us; and Corot's demonstration that the painter's private world could be explored to yield images of universal meaning. The young men who were to be known eventually as the impressionists were ready to build from these contributions, assimilating them without imitating the forms they had taken in the art of the great men of the first half of the century. The battle against academic dogma was a bitter one, and literally it very nearly cost some of the young impressionists their lives. But before the end of the century their victory was decisive.

chapter 14

Manet

The Salon des Refusés

The year 1863 is the sharpest dividing line in the history of painting since the French Revolution. It is the year of the Salon des Refusés—the Salon of the Rejected Painters. It centered around a painter named Edouard Manet (1832–1883).

It had been almost exactly a century since David had been admitted as a student of the Royal Academy. Now, within a decade, the leaders of classicism, romanticism, and realism disappeared, as if the decks were being cleared for a new generation of painters ready to make use of everything that had been discovered during a hundred years of revolution and counter-revolutions. Ingres and Delacroix died; so did Rousseau; Courbet was in exile. The conflicts between one ism and another no longer seemed important to a generation that respected Ingres for certain virtues, Delacroix for others, Courbet for yet others, without feeling that the theories these men had defended were mutually exclusive. All three were admired and followed; so was Goya; so were the eighteenth-century court painters whose artificiality Goya and David had rejected. The art of the Venetian Renaissance was studied with new excitement. The young painters were learning from everything and imitating nobody.

But the academicians had learned nothing, and were still imitating themselves. In 1863 the Salon jury finally overstepped all bounds in its spite and favoritism; the trading of votes, the reactionary prejudices, were this time too flagrant to be tolerated. More than four thousand paintings were rejected by a jury that seems to have been dominated by a forgotten pedant named Signol, a teacher at the École des Beaux-Arts. The rejected painters and their supporters stirred up so much agitation that the Emperor stepped into the

fracas. To judge from the kind of picture he was accustomed to buying for himself and as gifts for distinguished visitors, his taste in painting was in accord with the jury's. But as a politician in a country where art was a part of national life, Napoleon III could not ignore a group of artists and intellectuals that was growing as large as the Academy and its hangers-on—and making more noise. The revolt of the students who had petitioned Courbet to open a studio had occurred only two years before, in 1861. And in 1862 a commission had been appointed to look into the organization and policies of the Academy's school in Paris, its branch in Rome, and its Salon regulations. Ignoring these straws in the wind, the jury of 1863 kept on course and now found itself in rough weather. The Count de Nieuwerkerke, who seemed triply invulnerable as Director General of Museums, Superintendent of Fine Arts, and titular president of the jury, was summoned by the Emperor and ordered to give the rejected pictures a showing.

The official announcement of this unpleasantness was mild, stated not as a rebuke to the jury but only as a decision of the Emperor's to authorize a second Salon made up of paintings rejected from the regular one, in order to give the public a chance to judge for itself the legitimacy of the complaints that had reached him. This was sensational enough. By implication it was an official admission that academic judgment was not infallible. By implication-once-removed it was even more heretical: it made way for the premise that there is no single standard, no single formula by which the excellence of a painting may be calculated.

Having thus laid themselves open to public trial, the academicians set about gathering their forces to ensure the failure of the Salon des Refusés. Meanwhile the rejected painters were in a quandary. Under the terms of the Emperor's order, they had two weeks in which to withdraw their pictures if they wanted to. At the end of that time the remaining pictures would be hung in other rooms near the Salon proper in the Palace of Industry, a vast structure built for the 1855 Exposition where the Salons were now being held. A few years before, a painter named Bonvin had arranged in his studio a small show of rejected works by various painters. This miniature preliminary Salon des Refusés had met with a scandalous reception, although some painters, including Courbet (whose own exhibition of rejected pictures in the Pavilion of Realism had been a failure), had spoken up for it. With this precedent the painters' dilemma was whether to risk a similar reception, whether to lay themselves open to the vindictiveness of future Salon juries, whether to exhibit in the humiliating role of a rejected painter against the odds that the exhibition would be a popular success, or whether to play safe by withdrawing. In the end most of the painters decided to risk it.

The exhibition was both a success and a failure. Throngs crowded into it, but not many people came to "judge for themselves the legitimacy of the complaints." Eager for the relaxation of a good laugh after the annual cultural exercise of the Salon proper, the public made the most of a double opportunity to demonstrate artistic perception, first by the usual appreciation of the accepted works, then by the derision—always so easy and so reassuring to the derider—of the rejected ones. The popular critics had a field day at the expense of the rejected painters, although an occasional picture was singled out for sympathetic comment even in the conventional press. The minority support was fervent; a painter-writer named Zacharie Astruc even founded a paper, issued every day during the run of the Salon, to defend the good pictures among the rejected, especially Manet's.

All in all, in terms of the moment, the Salon des Refusés was not a great success. It did not immediately impair academic prestige with the general public. But the public's easy scorn, the critical diatribes in the press, even the persecutions that the Academy continued to inflict on painters of originality are not of importance in comparison with the fact that after 1863 the mortal illness of the academic organization was apparent to any good diagnostician. No matter that it grew increasingly vicious during its invalidism, its ultimate death as a dominant force in French painting was certain and the nature of its malady was recognized.

The Salon des Refusés established roots for the idea that every painter has the right to paint as he pleases and to be judged as an individual by other individuals, instead of painting according to the rules of a school whose officials have the power to grant or deny him the right to be seen. Delacroix and Courbet had fought for this idea, but they had been immune to the Salon's weapon of rejection, Delacroix by his mysterious influential connections and Courbet through the fluke of his early medal. The Salon

des Refusés was a mass exhibition of painters who would ordinarily have been helpless against the aesthetic censorship of the Salon system. Painters were achieving their own equivalent of freedom of speech.

The Salon des Refusés was no collection of masterpieces, and it must have included some really appalling pictures among the hundreds that had been legitimately turned down by the jury as inadequate attempts to meet academic standards. If the two exhibitions could be reassembled side by side today, they would probably look much alike, except that the technical polish of the officially accepted pictures would be higher overall than that of the rejected ones, and the rejected ones would be studded here and there with early works of men who have become recognized as the masters of the last half of the century. The most conspicuous of these paintings would be three by Manet: *Young Man in the Costume of a Majo* and *Mlle. V. in the Costume of an Espada,* both of which would have to be borrowed from the Metropolitan Museum of Art, and *Le Déjeuner sur l'Herbe,* which is in the Louvre.

The « Le Déjeuner » Scandal

It was *Le Déjeuner sur l'Herbe* that everyone came to see and laugh at or rail against. The Emperor himself made it a four-star attraction by calling it immodest, and the critics attacked it in downright scurrilous terms. Manet suffered deeply from these attacks because the last thing he wanted was notoriety through a succés de scandale. Well-to-do, suave, cultivated, worldly, and socially conventional, Manet coveted a conventional success and to the end of his life he sought it in the Salon.

Two years before the Salon des Refusés he had seemed on the way to what he wanted. That year, at twenty-nine, he had submitted two pictures, one of them a portrait of his parents and the other a *Spanish Guitar Player* [241]. The pictures were not only accepted but attracted so much favorable attention that the *Spanish Guitar Player* was taken down and rehung in a better spot. Manet received an honorable mention (a puny award but a beginning) and by the time the Salon closed he had established himself as a young painter who would be watched.

Manet's technique in both pictures, especially the *Spanish Guitar Player,* was open to the

241 Edouard Manet. *The Spanish Guitar Player.* 1860. Oil on canvas, 4'10'' × 3'9'' (1.47 × 1.14 m). Metropolitan Museum of Art, New York (gift of William Church Osborn, 1949).

same objections that were to be made later when his work was howled down. The public, who spontaneously enjoyed the pictures, would then no doubt have joined in the attack. The public is never very conscious of technical aberrations so long as the end result is a recognizable image of a subject it enjoys. It enjoyed Manet's portrait of his parents because portraits of an artist's parents appeal to the admirable moral sentiment of filial devotion. And the *Spanish Guitar Player* had the attraction of a picturesque subject, even though Manet had not presented it in a picturesque way. Throughout the history of Manet's lifelong struggle with the Salon, the public followed the critics' cue to damn on technical grounds pictures that it would just as quickly have followed a cue to praise.

Just two months before the 1863 Salon, which was to result in the Salon des Refusés, Manet made a tactical error by exhibiting fourteen pictures in the gallery of a dealer named Martinet. For some reason the critics were hostile and suspicious. They prophesied that when the Salon opened Manet would fail to repeat his

first success, if he got into the Salon at all. While this should not have affected a normal jury, it is easy to believe that the reactionary jury of 1863 was already looking forward to rejecting the paintings of a young artist who had been cocky enough to exhibit so conspicuously to the public just before the Salon's pronouncements for the year. The easy thing to do was to annihilate the upstart, and the jury annihilated Manet. It is probable that Delacroix had had something to do with Manet's good fortune in his first Salon, but in 1863 Delacroix was too ill to participate in the judging

If the jury hoped for a chance to reject him, Manet made it easy for them with *Le Déjeuner sur l'Herbe.* The other two pictures that fell under the ax with it, *Young Man in the Costume of a Majo* and *Mlle. V. in the Costume of an Espada,* were not too different from the successful *Spanish Guitar Player,* but *Le Déjeuner sur l'Herbe* is a startling picture even today. [242]. In an ordinary bit of woods, a matter-

of-fact young woman has inexplicably removed her clothing while a pair of fully dressed young men lounge indifferently nearby and another young woman, draped in a chemise, bathes in a pool just beyond. The picture was listed in the catalogue as *Le Bain (The Bath),* but immediately acquired the title by which it is still known. None of the possible translations—"Breakfast on the Grass" or "Luncheon on the Grass," which are equally used, or "Picnic," which never is—seems quite satisfactory. The subject is an adaptation in contemporary dress of the venerable tradition of demonstration pictures showing figures in a landscape, a synthesis of nudes, nature, and still life as an exhibition of skill. But Manet's painting differs from other such pictures in having not the thinnest disguise of allegory or idealization. It is extremely direct, to the point of brashness, and purely a demonstration of painting, without anecdotal or moralistic veneer of any kind. The dissociation between painter and subject is just about as

242 Edouard Manet. *Le Déjeuner sur l'Herbe.* 1863. Oil on canvas, 7'3¾" × 8'10⅜" (2.15 × 2.7 m). Louvre, Paris.

complete as is possible. To the confused and offended jury, who had never seen anything like it, the directness seemed not only brash but insolent. The total divorce from moral pretensions, being incomprehensible to people accustomed to reading moral platitudes into painting, seemed immoral in itself.

The public and critical damnation of *Le Déjeuner* seems altogether indefensible in retrospect, but we might be generous and pause for a moment to try to see the picture as it looked to a startled art lover in 1863. Toward the end of the twentieth century this demands as great an effort as would have been required in another direction in the middle of the nineteenth. As a reminder of what the public expected and had been educated to think of as the proper thing in art, an examination of Thomas Couture's *The Romans of the Decadence* [243] is chastening. The picture had been the Salon sensation of 1847 and subsequently was accepted as a masterpiece that would, quite naturally in the normal course of events, take its place among the great masterpieces of the past. Manet himself had chosen Couture as his teacher and had worked with him off and on for five years. Remembering that it is always easier to scoff at pictures in their declining years than to dis-

cover in them reasons for the virtues formerly ascribed to them, let us be patient with *The Romans of the Decadence*.

It is a compendium of popular demands. For one thing, it is cultural. Something cultural is implied by the title, which flatteringly assumes that the observer is familiar with Roman history. (And what in the world could be cultural about the subject of *Le Déjeuner*?) Moralistically the subject is treated on a high plane; one is invited to disapprove of the decadence of these people, who orgiastically defile a noble hall filled with statues of their sturdier forefathers. (Are we asked by Manet to disapprove of the action of his young woman who has disrobed so casually? No; he seems to accept it as the most natural thing in the world.) And *The Romans of the Decadence* is an impeccable piece of painting by a standard requiring careful drawing, complicated elaborations, and studio poses accurately rendered (whereas, once the critics had pointed it out, it was obvious that *Le Déjeuner* was painted in a way devoid of subtleties, refinements, and difficult detail; this scoundrelly artist must have turned it out in an hour or so, like a sign painter).

It is easy to see now that the culture in *The Romans of the Decadence* is specious; that its

243 Thomas Couture. *The Romans of the Decadence.* 1847. Oil on canvas, 15′1″ × 25′4″ (4.6 × 7.72 m). Louvre, Paris.

moral tone, while sincere on Couture's part, is shaky, allowing one to disapprove of the decadents while relishing vicariously their languishing indulgences; that while it obviously took hours and days and weeks to execute, it is technically static—that is, a repetitious studio exercise—where *Le Déjeuner* is inventive, explorative, and far from "easy" or careless although the difficulties overcome by the painter are less apparent to the untrained eye.

They were not apparent at all to a public accustomed to taking for granted that in a picture of *Le Déjeuner's* dimensions the artist's job was to show how closely he could approximate the perfections of the academic formula. Not picturesque, not historical, and not anecdotal, *Le Déjeuner* seemed unexplainable except as a work of an incompetent or a madman or, worst of all, a prankster. The popular critics were no help to the public, since they made no effort to understand what Manet was doing.

«*Le Déjeuner*»: Technical Innovations

And exactly what was Manet doing?

At this time he had seen very little of Goya's painting, yet he was pushing to their conclusion the same problems of representation Goya had set himself, quite as if Goya had served him as an intermediate step in the solution. Manet is more systematic and more objective than Goya, but like him Manet wants to capture the immediacy of instant vision. Like him, Manet does so by reducing the image to essential planes painted in bold, flat areas. He goes beyond Goya in the elimination of the transitional areas where planes merge from light into shadow through a series of half tones, those areas that are neither light nor shadow but somewhere in between the two as the form curves away from the source of illumination. The nude in *Le Déjeuner* is all but devoid of transitional tones, and the shadows are reduced to a minimum. It is as if the lights had spread, consuming all intermediate values and compressing the shadows into areas so small and concentrated that they may even be reduced to a mere dark line along one side of the form. This is most dramatically apparent if the head of this nude [244] is compared with one of the heads from Courbet's *Two Girls on the Banks of the Seine* [245]. Courbet capitalizes on modulated half tones to give his image weight and mood; Manet eliminates them to reveal the image as the eye might receive it in one brilliant flash of light. Manet may have been influenced by effects in early photographs where the primitive emulsion, incapable of registering half tones, reduced in-

244 Edouard Manet. Detail of Figure 242.

245 Gustave Courbet. *Two Girls on the Banks of the Seine*, detail (see Pl. 10, p. 186).

finite gradations to similar broad uninterrupted areas of light and sharp concentrations of dark. It would be appropriate for Manet, the most implacably objective of painters, to find a point of departure in the absolute objectivity of images produced by the operation of physical laws.

In addition to its effectiveness as formal description with a vivid immediacy, this quick, summary modeling offered advantages in the use of color. The broad light areas of Manet's forms could be painted in colors at full intensity over their whole breadth, whereas in conventional modeling the color would have had to be debased by darkening and graying where it began to turn into the intermediate tones between light and shadow. At the same time Manet frequently exaggerated the blackish and grayish tones in the shadows themselves. Reduced to such small areas, blacks and grays served to emphasize the broad expanses of color in the lights, allowing them to sing out above the darks. In comparison with the dulled tints of conventional painting or even with the bright, but broken, color of Delacroix, Manet's broad areas and large spots of color, flatly applied, seemed barbarous. Conventional painters were also deeply offended because Manet painted his forms in flat silhouettes of color and then brushed his shadows into them while they were wet. The usual way was to define the darks first and then progress into the lights, which might be painted over them. There are technical advantages to this conventional method that need not be gone into here, but it is worth mentioning that this minor deviation from standard technique was attacked as a serious heresy, in the general condemnation of everything Manet did or did not do.

Le Déjeuner sur l'Herbe is not a perfect picture. The figures are poorly integrated with their setting; they have the air of having been cut out of another picture and pasted onto this landscape where by lucky coincidence they almost fit—and in a way this is what actually happened. Manet made studies from nature for the landscape but painted the models in the studio without reference to natural light. Also he has left a bothersome ambiguity in the transition between the foreground and the middle ground where the second young woman bathes. The trees around her, and the rowboat just discernible at the right, where it is drawn up to the bank of the stream, are miniature

ones, or else the bathing girl is a giantess. It is impossible to establish a logical relationship between the receding vista of woods in the left third of the picture and the vista behind the bather. But if the picture does not hang together in all its parts, its major individual parts are superb. In the nude figure and the tumbled still life of fruit, bread, and discarded clothing Manet is already painting at full power in the manner that will shortly reach full integration in another painting.

«Le Déjeuner»: Borrowed Elements

Le Déjeuner was not attacked for shortcomings such as these but for its major virtues as a technical innovation, and for the "immorality" of the subject. Defending him against this latter charge, Manet's supporters pointed out that he was following the tradition of an old master, the Venetian painter Giorgione, who about 1500 had also combined nude female and clothed male figures in a landscape, and that the picture, hanging in the Louvre, shocked no one. This superficial parallel is still regarded as a defense that should have routed the opposition, but actually it is not much to the point. Giorgione's *Concert Champêtre* [246]* is a harmony of sensuous textures—flesh, velvet, satin, hair, grass, crystal, stone, and foliage. It evokes a world of idyllic dream; neither the luxuriously costumed adolescent males nor the golden-fleshed females can be compared in spirit with Manet's young boulevardiers or the well-known model who posed for the nude. This rebuttal was made at the time and is perfectly legitimate. *Le Déjeuner*'s defenders further pointed out that Manet's group of three figures was taken from a trio of river gods appearing in the lower right corner of a composition by Raphael, a *Judgment of Paris* [247]. But this also is a poor defense. Raphael's figures are allegorical nudes. It is true that the Academy had honored other paintings on the basis of even more tenuous connections with its Renaissance deity, but that is still no defense of *Le Déjeuner,* if it needs defense.

But of course it does not need defense of this kind. Manet was not trying to emulate either

* The authorship of the picture is questioned by most historians. If not by Giorgione, it is by a painter close to him.

246 Giorgione(?). *Concert Champêtre.* c. 1510. Oil on canvas, $3'7\frac{1}{4}'' \times 4'6\frac{3}{8}''$ (1.1 × 1.38 m). Louvre, Paris.

247 Marcantonio Raimondi, after Raphael. *The Judgment of Paris.* c. 1513–1534. Engraving, $11\frac{1}{2} \times 17\frac{1}{4}''$ (29 × 44 cm). Pennsylvania Academy of the Fine Arts, Philadelphia (John S. Phillips Collection).

Giorgione or Raphael. He frequently borrowed compositions. This was not plagiarism any more than it was plagiarism when Ingres borrowed the pose of the *Bather of Valpinçon* from some Roman sculptor or the composition of *Stratonice* from a Greek vase painting. Manet's

borrowings are closer to home—he was especially indebted to Goya—but in the end his borrowing was more superficial than, say, David's when he so meticulously incorporated classical details in his paintings. Manet neither made references to his sources nor made any attempt to conceal them. The superficial debt of *The Balcony* [248, p. 206] to Goya's *Majas on a Balcony* [249, p. 206] could hardly be more apparent, but neither could the fundamental difference between the two paintings. In the Goya, two of his typical spirited young vixens are combined with sinister caped and hatted male figures in the background, ominous, half-revealed, the omnipresence of evil behind the bright façade of daily life as Goya shows it again and again. In Manet's adaptation these figures are replaced by a solid, respectable bourgeois as one of a triple portrait group.

Must all this borrowing be apologized for? After all, most painters who borrow so directly from others are damned as eclectic or with that even more damning word *derivative*. There are all varieties of eclecticism, but at their typical worst eclectic painters borrow from others in the hope that something of the meaning will come along with the borrowed forms. Manet is in no way an eclectic painter, and no pardon is

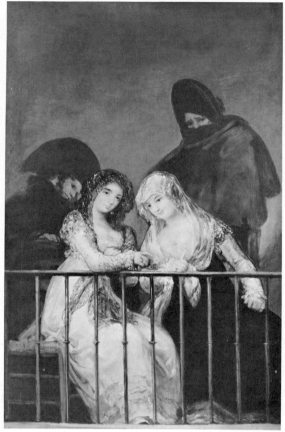

248 Edouard Manet. *The Balcony*. 1869. Oil on canvas, 5'7¾" × 4'1¼" (1.72 × 1.25 m). Louvre, Paris.

249 Francisco Goya. *Majas on a Balcony*. c. 1810–1815. Oil on canvas, 6'4¾" × 4'1½" (1.95 × 1.26 m). Metropolitan Museum of Art, New York (bequest of Mrs. H. O. Havemeyer, 1929).

necessary because no offense is committed. He is no more an eclectic painter than Shakespeare was an inferior dramatist when he made use of borrowed plots.

Manet's borrowing, however, has nothing to do with new interpretation or enlargement of the subject. He is, in fact, not much interested in subject; a subject merely supplies him with forms to be painted. In *Le Déjeuner* he is not interested in the fact that some young people are having a picnic in unconventional circumstances. He is interested in a way of doing the picture, the means of representation rather than what is represented. *Le Déjeuner*'s relationship to Giorgione's *Concert Champêtre* or Raphael's *Judgment of Paris* need not be apologized for nor need it be used as a defense. *Le Déjeuner* need only be regarded as an effort to discover

technical means to make the most direct translation of pure visual experience into the language of paint.

«*Olympia*»

If there is any question as to whether *Le Déjeuner sur l'Herbe* is entirely successful, or only a near-masterpiece occupying the position of a landmark, there is no question at all in the case of a picture Manet was painting the year of the Salon des Refusés but did not exhibit until two years later, his indisputable masterpiece, *Olympia* [Plate 13, p. 219].

Le Déjeuner is startling; *Olympia* is breathtaking. *Le Déjeuner* is puzzling, here and there contradictory; *Olympia* is of the utmost clarity,

brilliantly consistent in each detail, each brush stroke, each color. A young courtesan, unabashed in her nakedness, regards us with the same clinical detachment with which Manet has observed and represented her. The hard little body, the short legs, the sturdy trunk, the broad face are those of a woman of the people, but Manet makes no comment, either sentimental or sociological. He does not dramatize. The drama is in the paint—in the abrupt collision of the flat, pinkish-cream light areas of the flesh with the equally flat grayish or blackish shadows; in the expanse of white sheet where nothing seems to happen yet where the painted surface is alive; in the quick, summary notations of embroidered ornaments, of the ribbon at the neck, the bracelet; in the explosion of the bouquet of flowers.

Like *Le Déjeuner, Olympia* has a traditional counterpart in Venetian painting (and a closer one than Giorgione's *Concert Champêtre*), Titian's portrait of a Venetian courtesan, called *The Venus of Urbino* [250]. The parallels are direct: the general disposition of the nude figure on the white-sheeted couch, the screen or curtain in the background to the left, the two serving women in the depth to the right in the Titian and the single serving woman in the corresponding foreground position in the Manet, the

little white dog in the Titian, the black cat in the Manet. But, again, the transformation is complete, from the sensuous harmonies of the Venetian painting to the flat objectivity of the Manet

Olympia is entirely a studio product, with none of *Le Déjeuner's* disturbing ambiguity in the grafting of studio figures onto a landscape, and, above all, without the inconsistent foreground-background relationships. Manet's flash-of-light vision is better adapted to the revelation of objects at close range than to the exploration of deep space. The closing up of the space occupied by the serving women in the Titian—by pulling the single serving woman of *Olympia* into the same plane with the rest of the subject—makes possible the unity of this vision. Manet has finally achieved the objectivity implied in Courbet's defenses of realism.

It should be obvious by now that if the term *classicism* is elastic, and *romanticism* more so, the term *realism* is most elastic of all, including the widest range of responses in the transcription of the visible world. Some critics, especially in France, differentiate objective realism like Manet's with the term *naturalism,* leaving the term realism free to designate realistic painting that presents ideas, especially those having to do with social theories, as Courbet

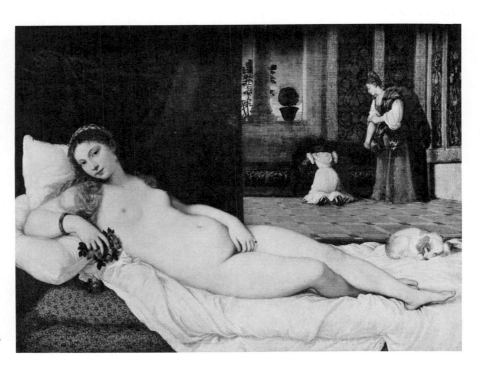

250 Titian. *Venus of Urbino.* 1538. Oil on canvas, 25⅝ × 46⅞″ (65 × 119 cm). Uffizi, Florence.

thought his did. Courbet's friend Castagnary, who helped him formulate some of his pronouncements, also wrote "Courbet and Proudhon have committed an aesthetic error. Art has nothing to do with the imposition of ideas," and he was using the term *naturalism* as early as the year of the Salon des Refusés. Moral values are incorporated into realism; naturalism is amoral. The realist interprets what he sees; the naturalist merely paints the spectacle of life around him, its vice and ugliness, its beauty and sweetness, not preferring one to the other and commenting on neither. The realist may try to find fundamental truths in commonplace objects, but the naturalist deals with the moment only, even at its most ephemeral.

The aesthetic satisfactions to be found in naturalism, then, must not be looked for in the subject. Being uninterpreted, the subject is only second best to actuality, and, furthermore, the naturalistic painter may choose to represent subjects aesthetically unpleasing in themselves. Aesthetic satisfaction must be found only in the way the picture is done, since it cannot be found elsewhere. The idea of "art for art's sake" is born, an idea leading eventually to the argument that, since subject is not important, it must be eliminated altogether and a painting must be nothing but lines, shapes, and colors. This is one of the arguments of contemporary abstract painters. Since it can be traced back directly to Manet's "art for art's sake," it makes Manet the first modern artist in a quite specific way. And it gives additional importance to the year 1863 as a dividing line.

Yet, at the risk of confusing the point and at the same time committing a heresy, we must admit that *Olympia* as a subject has an interest aside from the major one of art for art's sake. Granted that Manet does not interpret or moralize or tell a story or make a comment of any kind; granted that his own interest in the subject was incidental to his interest in painting it a certain way; granted that the fascination of this way is in itself enough to hold one in front of the picture—granted all this, it is still true that *Olympia* is not only a representation of reality but a revelation of it. Actuality is not transcribed so much as intensified through Manet's vision of it. For more than a hundred years now the young courtesan has regarded us with her special combination of assurance, insolence, and indifference. She still does so as if her glance and ours had just met; she holds us eternally

upon the point, upon the moment, of recognition. With *Olympia* we finally reach the pole opposite classicism: the classicist sought to create images in which eternal and universal values are summarized; Manet creates images in which the moment, with whatever implications it may hold for the individual, is crystallized.

Manet before «Le Déjeuner»

How did Manet arrive at *Le Déjeuner* and *Olympia*?

He had entered Couture's studio in 1850 at the age of eighteen, after a time spent at sea and two failures to pass entrance examinations for the naval school. Before this his parents, both of them from wealthy families, had accepted the boy's choice of a naval career as an alternative to law, which was their own ambition for him.

The influence of Couture on Manet must not be discounted. Couture was a harsh and narrow man, but he was no mean painter as far as brush and color are concerned. *The Romans of the Decadence* is an academic exercise and its faults are easy to enumerate mercilessly, but in many small canvases—*Little Gilles* [251], for instance—where he is just painting, Couture is almost as pure a painter as Manet. The color

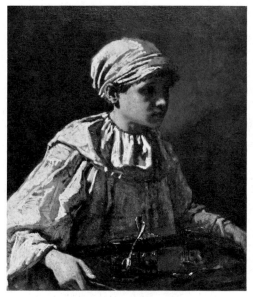

251 Thomas Couture. *Little Gilles.* 1876. Oil on canvas, 25¾ × 21½'' (65 × 55 cm). Philadelphia Museum of Art (William L. Elkins Collection).

in *Little Gilles* is rich, subdued and creamy; the broad tonalities of lights and darks even suggest an origin for Manet's representational processes as already described. Couture was an excellent teacher for Manet, who was able to take advantage of the good that was offered while remaining immune to the trumpery and bombast of the master's "important" work.

Manet was a realist from the start, and his student days under Couture—1850 to 1855 or 1856—coincided with the emergence of Courbet, but Manet never studied under anyone but Couture in spite of quarrels and insults in Couture's studio. Manet objected to the artificiality of the studio poses, the tight rendering that was mandatory in student work, all the academic rules and conventions. He drew and painted with such freedom that Couture told him once, "You will never be more than the Daumier of your time," which was his way of saying that Manet might pass at the level of this popular cartoonist who had a certain vulgar

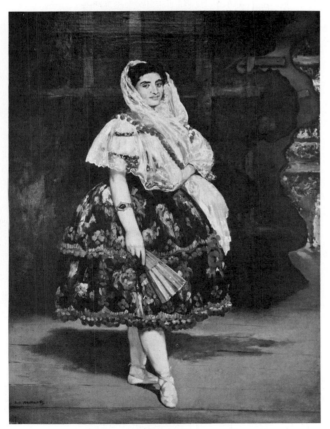

252 Edouard Manet. *Lola de Valence.* 1862. Oil on canvas, 4′1½″ × 3′¼″ (1.23 × .92 m). Louvre, Paris.

flair but was, of course, no artist. What Couture thought of Courbet and his followers he summed up in a painting called *The Realist,* showing a painter in rough country clothes using a monumental classical head as a stool to sit on while sketching a butchered pig.

Manet's special friend in Couture's studio was Antonin Proust, who entered it at the same time. Proust was another youth of intelligence and social position, equally eager for conventional success. Both young men admired Delacroix, who had become a legendary hero to student painters. They called on him at one time when Manet wanted to make a copy of his *Dante and Vergil in Hell,* which was then hanging in the Luxembourg Museum. Delacroix received the two young men and granted permission to copy, but his manner was so chilly and formal beneath its elegant courtesy that Manet did not follow up an association that would have been much more to his taste than the assemblies around Courbet at the Brasserie des Martyrs.

Delacroix might have remembered the visit when he spoke up for the first picture Manet sent to the Salon jury, *The Absinthe Drinker,* in 1859, of which Couture had said that the only absinthe drinker must have been the man who painted it. The jury agreed with Couture and rejected it over the head of Delacroix.

But two years later Manet made his surprising Salon success with the portrait of his parents and especially the *Spanish Guitar Player.* His interest in Spanish subjects was increased by a group of Spanish dancers who were making a great success in Paris. He painted most of them individually and in groups on the stage.

The Spanish pictures were among those the critics found most offensive of the fourteen Manet exhibited with such a disastrous reception at Martinet's just before the 1863 Salon. A portrait of the leading dancer, *Lola de Valence* [252], was especially detested; it was described as a "bizarre confusion of red, blue, yellow, and black." One critic said it was as if Goya had "gone native in the middle of the Mexican pampas, smearing his canvases with crushed cochineal bugs"—these insects being the source of a brilliant magenta dye. Manet was much influenced just at this time by the colors of Spanish painting; he adopted the typical Spanish neutral gray or blackish backgrounds with spots of color played against them. The color is fairly bright when it is accented in this way, but it is hard to see a "bizarre confusion" today in *Lola*

de Valence, even though Manet retouched the picture, brightening its color, after the exhibition. There are vivid passages, but only the soupy browns and obvious tints of the standard Salon product could have made them seem so outrageously raw. Many painters even imitated the darkened tones of paintings by the old masters, disfigured by coats of dirt and varnish. Today Manet's color has suffered from similar disfigurement. In the late 1950s the Metropolitan Museum of Art cleaned *Woman with a Parrot* [253], transforming it from a pleasant, rather quiet picture into a brilliant one; the long robe, which for years had appeared to be a somewhat innocuous light tan, was revealed as a fresh luminous pink with almost white lights, combined with the woman's russet hair in which the ribbon is a bright blue accent.

The «Olympia» Scandal

With the exhibition of *Lola de Valence* and the other pictures at Martinet's and their bad critical reception, the damage was done, and when Manet submitted *Le Déjeuner* to the Salon of 1863, the events already described occurred. After the scandal of the Salon des Refusés the Emperor continued his half-hearted efforts to liberalize academic practices. If he did not put his heart into it, it was because as a good bourgeois himself Napoleon III actually approved of the Academy and liked its typical product.

During the Salon's long history its juries had been elected in various ways. For a while after the Revolution of 1848, election was by the votes of all painters who had exhibited the preceding year, a fairly satisfactory system although it carried with it the risk of inbreeding. But before long this system was tightened, and the jury was nominated in part by previous medal winners and in part by the Academy itself. Considering that the majority of the medal winners were academicians, it is easy to see how this system produced the situation of 1863. Jury membership had again become static and the academic caucus seemed again impregnable.

Now the Emperor made a tepid reform by which the Academy's direct nominations were reduced to one quarter of the jury members, the remaining three quarters to be elected by vote of painters—but again only painters who were also medal winners. But it was a reform of sorts, and combined with a new caution in-

stilled by the narrow escapes of 1863, it produced a liberal jury that included Corot. In 1864 there was a petition to continue the Salon des Refusés. It was not granted, but a room was set aside for the exhibition of some rejected pictures. They attracted little attention because more pictures had been admitted to the Salon, including Manet's. He exhibited a *Christ with Angels* and a *Bull Fight.* The criticism of the latter was so violent that he destroyed it, except for a fragment.

Then in 1865 came the exhibition of *Olympia,* with a *Christ Insulted by the Soldiers* in the same Salon. It would be repetitious to go into much detail of the vituperative attacks to which they were subjected. The critics surpassed their record of 1863 in viciousness but not often in originality. The same objections were made to Manet's "coarseness" and to the "immorality" of

253 Edouard Manet. *Woman with a Parrot.* 1866. Oil on canvas, $6'7\frac{7}{8}'' \times 4'2\frac{5}{8}''$ (1.85 × 1.29 m). Metropolitan Museum of Art, New York (gift of Erwin Davis).

the *Olympia*. It was compared, among other things, to "high" game, and the crowds surrounding it to morbid sensation-hunters looking at corpses in the morgue. Every indecency and corruption was read into it, nor was Manet himself spared inferences that his private character was of much the same order. Yet from the 1863 Salon the Emperor had purchased a *Birth of Venus* [254] by the academician Cabanel, as audaciously erotic a nude as had ever been put on public exhibition. The critics admitted that this studio Venus was "wanton" but were able to discover refinements in Cabanel's painting to counteract its lasciviousness. These were the same critics who called *Olympia* a dirty picture.

To escape the furor Manet went to Spain. It was his first trip to that country, whose art had so influenced him. He was disappointed, not in the paintings of Velázquez and Goya, which he now saw at their best, but in the life and the aspect of the cities and people. He had expected something more picturesque, more colorful, more like the painting and the dancing that up to then had been his Spanish experience. We have the anomaly of a trip to Spain ending his Spanish period, because after that Manet turned more and more to life around him in Paris for the subject matter of his paintings.

Manet and Zola

Upon his return from Spain, at the border, Manet received an indication of what he might continue to expect at home. The French customs inspector, seeing the name Manet on the luggage, called his family in to take a look at the eccentric artist who had painted the scandalous pictures everyone was talking about. Manet suffered intensely from this kind of notoriety, which was to continue with only temporary abatements for the rest of his life, and he never developed a defense against it. The Spanish trip was in 1865; in 1866 the Salon refused *The Fifer,* now in the Louvre. The next year there was another of the great world's fairs. Not invited to exhibit, Manet erected his own pavilion (as Courbet had done for the exposition of 1855 and as he did also this year). More scandals, more jeers. *The Execution of Maximilian,* painted for this exhibition, was withdrawn at the last minute because of the touchy political situation. The next year, 1868, Manet was finally accepted again by the Salon with two pictures, both very badly hung, *Woman with a Parrot* and a portrait of Émile Zola.

Émile Zola, of course, was to emerge as one of the dominant figures of his generation with a

254 Alexandre Cabanel. *Birth of Venus.* 1863. Oil on canvas, 2'7½" × 4'5" (.8 × 1.35 m). Pennsylvania Academy of the Fine Arts, Philadelphia (Gibson Bequest).

great block of sociological novels, a dozen crusades, and the climax of the Dreyfus case where his exposures shook the foundation of the French government. The Dreyfus case is an abomination in the history of injustice, countered only by the fact that the same nation produced a Zola to correct it. (His open letter headlined *J'accuse,* which appeared in the newspaper *L'Aurore,* brought the Dreyfus affair to international attention and polarized France.) In Manet's portrait Zola is only twenty-eight years old. He was just emerging from obscurity and had not long since emerged from poverty.

In his capacity as a critic of the arts, which is the one that concerns us here, Zola's perception did not equal his courage. He defended Manet and some of the other painters we will see, but without a clear understanding of what they were about aesthetically. Nevertheless he defended them with the conviction that they were achieving something good and were having to achieve it while suffering injustices from established hacks and pedants. The year Manet's *Fifer* was rejected, Zola wrote a series of articles on the organization of the Salon system for a paper called *L'Événement,* including an article in defense of Manet. "A place in the Louvre is reserved for Manet," he wrote. "It is impossible, impossible I say, that he will not have his day of triumph, that he will not obliterate the timid mediocrities surrounding him." Furious objections poured into the offices of *L'Événement* (not from everybody—some readers thought Zola was joking), and Zola, who had asked special permission to write the series of articles, lost his post as art critic of the journal. The following year he published a monograph on Manet and Manet did his portrait.

Zola is shown seated at his desk surrounded by references to the new movement in painting [255]. A photograph of *Olympia* is on the wall. Behind it, and half covered by it, is Velázquez' *Bacchus.* The third picture in the group is a Japanese print. On the table, just behind the quill pen, the monograph on Manet does double duty as a reference to the connection between the painter and writer and as Manet's signature.

The Japanese print is a rather special reference. These prints, today so familiar, were just becoming generally known among artists in Europe, some of the first ones having been discovered among other packing in barrels of imported porcelains. In Japan the print was a vig-

255 Edouard Manet. *Émile Zola.* 1868. Oil on canvas, 4'9½" × 3'7½" (1.46 × 1.1 m). Louvre, Paris.

orous popular art form not taken very seriously by the effete aestheticians and decadent painters when prints first flourished there. After developing in a tightly closed civilization, the prints when they finally reached Europe much later bore some surprising resemblances to the painting that was beginning to develop with Manet and the impressionists. The subjects were taken from the daily world of entertainment, the theater, the transient world of actors and courtesans, teahouses, views famous with tourists, landmarks. These subjects were in opposition to the formalized art of the "fine" painters but at the same time they were not presented in an unimaginatively realistic way; they were highly stylized and sophisticated. Manet was doing much the same thing. He painted dancers, singers, people in a public garden listening to music, the courtesan Olympia. But these subjects from the transient world were not approached emotionally, any more than

were the subjects of the Japanese prints. Technically the Western painter and the Japanese printmaker were quite different, the Japanese print being conceived in conventionalized linear patterns having little to do with the look of actuality and *Olympia*, for example, having everything to do with one vision of it. Yet when the critic Castagnary called *Olympia* "a playing card," he referred to its composition of flat, well-defined areas of color and he could as appropriately have compared it to a Japanese print for the same reason. European artists now began to draw upon the Japanese print for compositional ideas, and in the portrait of Zola the arrangement of the background into nicely balanced rectangular areas—the pictures, the screen, the resultant rectangular areas of wall—is one reflection of Japanese-print composition [256].

Manet and His Contemporaries

A group of painters, literary men, and dilettantes now began to gather around Manet, some of them his own age, most of them a little younger. The difference was only a few years—ten or less—but psychologically the younger painters were separated from him by a generation. *Le Déjeuner* and *Olympia* had already made Manet a name and a martyr; the younger men were just beginning their careers, and although they were meeting the same reception as Manet, his conspicuousness made him their spokesman and the symbol of their revolt. He bore the brunt of the attacks on this group of "modern" artists, who were soon to become known as the impressionists. During their formative years the Café Guerbois was their center, replacing Courbet's Brasserie des Martyrs as the winnowing place for new ideas.

Manet did not pontificate as Courbet tended to do, nor did he ever identify himself wholeheartedly with the group around him. His cultivated manners gave an impression of greater warmth and participation than he was offering; even more than Delacroix, he barricaded himself from intimate contacts with all but a few people. The only members of the new group who knew him well were the ones whose personal backgrounds offered the same amenities as his own; the only bond that held him to the bohemian world of the struggling impressionists at the Café Guerbois was one of which he would gladly have rid himself: his rejection and vilification by the world he had failed to conquer. During all this time, up into the 1870s, he had sold fewer than half a dozen pictures. Sales were not vitally important to him except as a form of recognition, although even his substantial means, which he inherited, were beginning to feel some strain. He was married (after a liaison of some years) to his piano teacher and lived quietly.

One of the more sedate members on the fringe of the impressionist group was Henri Fantin-Latour (1836–1904), a painter acceptable

256 Torii Kiyonaga. *Shigeyuki Executing Calligraphy*. 1783. Woodcut, $14\frac{3}{4} \times 9\frac{5}{8}''$ (37 × 24 cm). Philadelphia Museum of Art (gift of Mrs. John D. Rockefeller).

257 Henri Fantin-Latour. *A Studio in the Batignolles Quarter.* 1870. Oil on canvas, 5′8½″ × 6′10″ (1.74 × 2.08 m) Louvre, Paris.

to the Salon and its public but sympathetic to the innovators. One of his recent successes had been a group portrait of Delacroix surrounded by friends called *Hommage à Delacroix.* He now decided to repeat this documentary idea in a portrait of Manet in his studio, thus loyally identifying himself with the rebels in paying homage to their leader—although he left the "homage" out of the title, calling the picture *A Studio in the Batignolles Quarter* [257], where Manet then had his work place.

Manet is at his easel. Seated next to him is Astruc, the painter and writer who had been one of his most vigorous supporters during the Salon des Refusés and had maintained an association with the impressionists. Zola stands at Astruc's side. The young man whose head seems framed by the picture behind him on the wall is the painter Renoir; the tall one at the right is the painter Bazille; behind Bazille, as if crowded in as an afterthought, appears the shadowy face of Claude Monet. These are important men and we will have a great deal to say

258 Henri Fantin-Latour. *Still Life.* 1866. Oil on canvas, 23¼ × 28¾″ (59 × 73 cm). National Gallery of Art, Washington, D.C. (Chester Dale Collection).

259 Edouard Manet. *Le Bon Bock*. 1873. Oil on canvas, 37 × 32⅝″ (94 × 83 cm). Philadelphia Museum of Art (Mr. and Mrs. Carroll S. Tyson, Jr., Collection).

about them. Standing behind Manet is a German painter of less consequence named Otto Scholderer who worked largely in London but made several stays in Paris and, of course, knew Fantin well. He painted still life, some landscape, and some charming figures, bridging romanticism and impressionism, but need not be considered further. The eighth portrait is of Edmond Maître, an amateur musician and a great and loyal friend of the group.*

* Fantin-Latour is not easy to classify as a painter. Reduced in size and printed in black and white as they are here, his portraits might be photographs. At full scale this quality is tempered by the presence of the brush, with which Fantin had a delicate touch. His still-life painting [258] is only a shade less photographic. The arrangements of the painted objects are decorative like other popular still life, but more subtly adjusted into balances of form and color. Fantin's success in the Salon and other salesrooms was inevi-

Late Pictures and Last Days

Suddenly one of Manet's pictures made a Salon success. He had become interested in the seventeenth-century Dutch painter Franz Hals, whose free brushwork resembled Manet's own. Hals' subjects included genre ones of a convivial nature; Manet now painted a fat man enjoying a pipe and a glass of beer, *Le Bon Bock* [259], and the public loved it. No objection could be made to the violence of the color this time. It was all grays and browns and normal flesh tones, with one flash of white in the cuff of a sleeve, the most typically Manet detail in the picture. Elsewhere the painting is as dextrous as usual but more conventional in tonality. The face is still conceived in well-defined planes individualized by the strokes of the brush, but there are more planes, hence the forms are represented in more detail. Confronted with a kind of subject it had always liked, painted in a more conventional technique, the Salon public was delighted.

Manet's friends were less pleased. The success of *Le Bon Bock* was based on the very values they—and Manet—had rejected as false. *Le Bon Bock* was a success not because it was a fine painting but because it was a picture of a jolly fat man enjoying a pipe and a beer. But no one need have felt any concern. The next year two of Manet's three submissions were rejected, and the accepted one, *The Railroad Station,* received the usual scandalous press. The story continued in the same way. Manet was refused for another Exposition Universelle in 1878. Two years before his death, his old friend from Couture's studio, Antonin Proust, was appointed Minister of Fine Arts. He forced Manet's election to the Legion of Honor with a medal in the Salon. But Manet was now suffering from locomotor ataxia and was too ill to enjoy this tardy and dubious award. He died in 1883, and when seven years later *Olympia* was purchased

table since he so completely fulfilled the first requirement: conformist subject matter represented with detailed accuracy. Occasionally he would execute a painting with the dash of Manet or the more broken technique of the impressionists, but in general he adhered to surface respect for conventional academic disciplines. However, he was without academic pretensions, even in the allegorical and literary or musical subjects that form a third, rather less distinguished, group within his work.

260 Edouard Manet. *Boating.* 1874. Oil on canvas, 3'2¼" × 4'3¼" (.97 × 1.3 m). Metropolitan Museum of Art, New York (bequest of Mrs. H. O. Havemeyer, 1929, the H. O. Havemeyer Collection).

by subscription and offered to the Louvre,* it was accepted only reluctantly and under duress, although developments in painting had by then affirmed its indisputable preeminence as a landmark in the history of art.

During Manet's lifetime, impressionism was being developed by his fellow painters as an art of the out-of-doors, full of the shimmer of light in the open air painted in a high-keyed palette of pure tints eliminating the grays and blacks that were such an important factor in Manet's color. Manet had resisted the appeal of impres-

sionism and outdoor painting, but after 1874 he accepted it more and more. His conversion began when he watched Monet paint at Argenteuil, on the Seine, one of the impressionists' favorite spots. His color began to freshen, to lighten, his brush stroke increased in vivacity. Even so, he remained a man of the boulevards and the studios. Pure landscape did not much appeal to him; when he painted the out-of-doors he populated it with his city folk, out of town for the day. But it was a great change. The couple enjoying themselves in *Boating* [260], the naturalness and relaxation of their attitudes, the informality of the composition suggesting that the subject has been caught snapshot fashion—all these are a long way from the couples in *Le Déjeuner,* its studied arrangement,

* Strictly speaking, to the Luxembourg Museum, the Louvre's waiting room. A painter must have been dead ten years before his work can hang in the Louvre.

the artificiality of its combination of figures and landscape. The couple in *Boating* exist in the full open air permeated by sunlight.

The sparkle and informality that are imposed on the outdoor painter when he wants to capture effects of light and air began to show also in Manet's studio subjects. *Skating* [261], if it had been painted a few years earlier, would have been flatter, more static, its lights broader, its darks more concentrated and emphatic, its whole surface more tightly knit. Instead, it vibrates everywhere with nervous, energetic, restless life, modeled as it is in hundreds of quick suggestive strokes which are at least as important as strokes of color as they are as definitions of form [262]. Color becomes brighter and purer, the suggestion of form even more cursory, although it remains decisive. An eye may now be nothing but an irregular star of paint; a lip or a nose or an ear may be made up of a brush of color spotted with an accent of light, another of dark. It is the kind of painting that can degenerate into the shallowest kind of tour de force. In Manet it never does. The por-

261 Edouard Manet. *Skating.* 1877. Oil on canvas, 36 × 28″ (93 × 72 cm). Fogg Art Museum, Harvard University, Cambridge, Mass. (Maurice Wertheim bequest).

262 Detail of Figure 261.

trait of *George Moore* [263] pushes technical showmanship just to the edge of artificiality, simultaneously transcribing the features of this talented but rather irritating young man as a work-of-art-for-art's-sake and as a witty revelation of an exceptional character.* The two aspects of the picture are inseparably present in one another.

Manet's last major work, and very nearly his last one of any kind, was *The Bar at the Folies-Bergère* [Plate 14, p. 219], painted in 1881 (although dated 1882), when his illness had progressed so far that it was only with the greatest physical difficulty that he could paint at all. Yet this is a large picture and it approaches *Olympia* in its certainty, in the drama of its paint, in its arresting presence. And by a perfectly logical tour de force it manages to hark back to the early style of *Olympia* in certain passages, while pushing to its limit in other passages the evanescent, shimmering, impressionist manner of Manet's last years.

The immediate foreground is the counter of a bar, with bottles, a compote of fruit, and a glass vase holding two roses, all painted as if Manet wanted to demonstrate finally that no one could excel him as a painter of still life. The barmaid stands behind the counter, leaning forward slightly toward an invisible customer. The silhouette is bold, of an extraordinary symmetry relieved by small interruptions and variations, climaxed in the geometrical oval of the head with its heavy cap of hair. The face, which is not Olympia's in features, recalls Olympia's as a passage of flat tone given its third dimension by the brushing in of a few small, sudden concentrations of dark.

The rest of the picture—the entire background—is a mirror. The uncompromisingly defined figure of the barmaid, as reflected from the back, is now amorphous, softened; the unseen customer appears facing her, a few halftone blurs; farther back the dress circle is half defined, half suggested, in merging and intermingling shapes that coalesce here and there into a gesture, an attitude, a hat, a gloved hand holding opera glasses.

* The young Irishman and professional show-off had come to Paris to study under Cabanel but soon abandoned the idea of a career as a painter. As an extremely superficial art critic and a deft novelist he drew upon French models for a career as an English man of letters.

263 Edouard Manet. *George Moore.* 1879. Pastel. 32 × 25¾" (81 × 65 cm). Metropolitan Museum of Art, New York (gift of Mrs. Ralph J. Hines, 1955).

Yet, if *The Bar at the Folies-Bergère* summarizes so much of Manet's accomplishment, it is also inventive in a new way. The complexity of its composition, the structural geometry of the insistent horizontals running in bands across the picture, the strong central triangle of the figure with the secondary geometrical forms included within it—all these are new in Manet. *The Bar at the Folies-Bergère* is a swan song only by its coincidental date with Manet's last illness and his death. He was painting with as much inventiveness and curiosity and independence as he ever had done. And no man has ever painted with more.

Immediately after Manet's death his pictures began to sell at rising prices. The press discovered that he was a great painter. Before a year had gone by a memorial show was prepared. It was held in the galleries of the École des Beaux-Arts—the fortress of the Academy.

Plate 13 Edouard Manet. *Olympia*. 1863. Oil on canvas, 4′3¼″ × 6′2 ¾″ (1.3 × 1.9m). Louvre, Paris.

Plate 14 Edouard Manet. *The Bar at the Folies-Bergère*. 1881. Oil on canvas, 3′1¾″ × 4′2″ (.95 × 1.27 m). Courtauld Institute Galleries, London.

Plate 15 Claude Monet. *Terrace at Sainte-Adresse.* 1866. Oil on canvas, 3′2⅜″ × 4′3⅛″ (.98 × 1.3 m). Metropolitan Museum of Art, New York (purchased with special contributions and purchase funds given or bequeathed by friends of the Museum, 1967).

Plate 16 Claude Monet. *Rouen Cathedral: Tour d'Albane, Early Morning.* 1894. Oil on canvas, 41¾ × 29″ (106 × 74 cm). Museum of Fine Arts, Boston (Arthur Gordon Tompkins Residuary Fund).

chapter 15

Impressionism Out-of-Doors

The Impressionist Declaration

In 1874 a group of artists with their core at the Café Guerbois organized a society to exhibit their work at their own expense. Such an idea had been in the air for some time, without any unanimity of opinion, but now these painters saw no other way to bring their work properly before the public.

Some of the prospective exhibitors wanted to invite the friendlier older painters to show with them, for the prestige this would lend the unknowns—such men as Corot and the grand old revolutionary Courbet, who was still alive although in exile. (It was just as well that they decided against doing so, for even Corot, that man of good will, referred to them later as "that gang.") Other members wanted everyone in the group to pledge never to send to the Salon; still others, who were beginning to have an occasional picture accepted there, thought this idea bad. Manet, their great man, refused to have any part of the exhibition. So did Fantin-Latour. Even some of the painters who decided to come in did so reluctantly, still convinced that the Salon was the real field of conquest.

When the first exhibition was finally organized, it was partly a commercial venture and partly a declaration of aesthetic war. Commercially the members hoped to increase the number of private collectors who were beginning to buy their work. They were spurred on by the fact that just at this time the adventurous dealer Durand-Ruel, who had taken on some of them, was going through a financial crisis and was forced to stop all purchases until he could get his affairs in order. Aesthetically, the group was dedicated to the idea that threadbare formulas—or arbitrary formulas of any kind—could not be forced on a painter without stifling him creatively. They demanded the right to paint as they pleased, and what they pleased, as the only means of fulfilling their creative potentials.

After considerable confusion, including quarrels and hurt feelings, an exhibition was assembled and hung in the studio of the photographer Nadar, another habitué of the Café Guerbois. Nadar has his own importance in the history of photography, and a cartoon by Daumier shows him in a balloon "elevating photography to the level of a fine art"; he was a pioneer in aerial views.

The thirty exhibitors were an odd combination including half a dozen names that were to be among the greatest of the century, an equal number of sound masters of the second rank, a friendly amateur or two, one popular Salon painter, and a few ghosts who would have disappeared altogether if their names had not been preserved on this historic list.* For so mixed a group no single title seemed descriptive enough, so a noncommittal name was settled on after great effort to find something more specific: *Societé anonyme des artistes peintres, sculpteurs, graveurs, etc.*

But the name did not last; an appropriate descriptive one invented itself. The exhibit of 165 pictures had hardly opened before the painters were dubbed "impressionists," a name considered as hilarious as the painting that supplied the cue for it—*Impression, Sunrise* by Claude Monet. Although the nickname was derisive, it cut through the obscuring surfaces of personal styles to the unifying element in the most original of the pictures. The impressionists accepted the new label and soon changed the name of their organization to *Peintres impressionistes.*

Altogether the impressionists held eight exhibitions before they disbanded, the first in 1874 and the last in 1886, with many changes of membership during these years. By 1886 the group was full of dissensions and many of the members had grown dissatisfied with impressionism and had departed from it.

By that time, in any case, the organization had served its purpose. It had won its battle for the attention of dealers and collectors in spite of the continued insults of the Academy and its entourage of philistines and mossbacks. Resistance

died hard in these circles. As late as 1893, when a great collection of impressionist paintings was willed to the Louvre, it was subjected to the kind of criticism accorded *Le Déjeuner sur l'Herbe* thirty years before in the Salon des Refusés and was accepted only in part.* Gérôme, now seventy, described the pictures as "filth" that only "a great moral slackening" could make acceptable to the government. But this was the last senile gasp of the old guard, and although Gérôme and Bouguereau were still coveted by one kind of collector, so were Renoir and Degas by others. Americans were buying so extensively that when *Olympia* was purchased by subscription and offered to the Louvre in 1890, one of the reasons was that the subscribers feared France would lose it as other masterpieces had already been lost to the United States.

The Nature of Impressionism

Just what is impressionism? The word *impression* had been used in art criticism off and on before Monet attached it to his picture of a sunrise. Its connotations were not flattering. The writer Théophile Gautier expressed regrets that Daubigny was satisfied to give his "impression" of a landscape and "neglect" details, although of course Daubigny was deliberately eliminating details in poeticizing his images. "Impression" suggested incompleteness, a superficial vision of the subject. When the impressionists made an honest word of it and sought a definition, one suggestion was "painting in terms of tone rather than in terms of the object itself." Any definition must be based on this idea, the idea that the impressionist does not analyze form but only receives the light reflected from that form onto the retina of the eye and seeks to reproduce the effect of that light, rather than

* For the record, in alphabetical order, they were: Astruc, Attendu, Béliard, Boudin, Bracquemond, Brandon, Bureau, Cals, Cézanne, Colin, Degas, Desbras, Guillaumin, Latouche, Lepic, Lépine, Levert, Meyer, de Molins, Monet, Morisot, Mulot-Durivage, de Nittis, A. Ottin, L. A. Ottin, Pissarro, Renoir, Robert, Rouart, and Sisley.

* This was the Caillebotte collection. Gustave Caillebotte was a naval architect of considerable wealth, a quiet man who discovered the impressionists before they became popular on the market and bought their pictures not as investments but because he liked them. (Many canny Americans bought impressionists early because Durand-Ruel, having been right about the Barbizon painters before their prices went up, might be right again.) Caillebotte was an amateur painter himself, made friends with the impressionists, exhibited in the second group show and

264 (left) Francisco Goya. *Dr. Peral.* c. 1800–1810. Oil on panel, $37\frac{3}{8} \times 25\frac{7}{8}''$ (95 × 66 cm). National Gallery, London (reproduced by courtesy of the Trustees).

265 (above) Detail of Figure 264.

the form of the object reflecting it. For instance, if a bush in the distance seen in a certain light reaches the eye only as a green blur, the impressionist paints it as a green blur, even if it happens that the bush is so familiar that its exact form could be reproduced from memory. Monet, the purest of the impressionists if we accept this definition, once said that he wished he had been born blind and could have gained his sight so that he could paint without knowing what the objects before him were, since this would allow him to see them purely in terms of light. Never having seen a bush, he would not

know that the distant green blur was a bush and would reproduce it in a matching green blur of paint without having to forget his detailed acquaintance with it as a form.

This pushes to its ultimate Goya's idea of training his brush not to see more than his eye did. But there is the great difference that Goya wanted to train his brush to reproduce forms— "forms that are lighted and forms that are not, planes that are near and planes that are far, projections, and hollows." In his portrait of *Dr. Peral* [264] form is solidly represented, but a close detail of part of the face [265] shows how he has

four successive ones, threw his fine house on the river open to the young painters, and continued to buy their pictures during their most desperate times. He made a point of buying the kinds of pictures not salable on the regular market—the very large ones and the ones painted to solve special problems. He did this to help the painters, but as a result he also acquired some of their most important work. The Caillebotte paintings that were finally accepted (the rejected ones included some fine Cézannes) are at the heart of the Louvre's impressionist collection.

Another friend of the impressionists was Victor Chocquet, a minor government official, the rarest and most perspicacious type of art collector. With very little money to spare, he was ready to make sacrifices elsewhere to own and enjoy the pictures he liked. As a very young man he bought watercolors by Delacroix. Like Caillebotte he discovered the impressionists for himself. Among the pictures sold by Chocquet's widow in 1899 were thirty-one Cézannes, eleven Renoirs, eleven Monets, and five Manets, all of the very highest quality.

eliminated the "lines and details" to which he objected in classical painting. The bridge of the nose, for instance, is not defined by a line, although to the classical draftsman lines represent the divisions between forms. The pupil of the eye is not a circular dark spot but a dark irregular area, which was all Goya allowed his brush to see since his own eye could perceive only that much from the distance at which he was painting. But Goya never goes so far as to sacrifice form to this kind of vision.

Further back, Velázquez in the seventeenth century was something of an impressionist in "painting by the tones." The reflection in the mirror in his *Venus and Cupid* [266, 267] is an extreme example. Velázquez has reproduced only the light reflected from the cloudy mirror as his eye received it from a certain distance. That light happens to carry with it the lights and darks composing the reflected face. All lines, all details have been eliminated in this process of double reflection from the model's face to the painter's retina. Less dramatically, the other forms in the picture are painted in the same way. A host of other examples could be culled from the past to show that the impressionist idea was not altogether new, even if it had not been set up as a theory and a technique until the nineteenth century, with special departures of its own that made it revolutionary.

The quality of instant vision, the subject revealed in a momentary aspect, takes on more importance in impressionism than it ever had before. *Olympia* is seen as if in a sudden flash of light, but the model is posed, the composition studied. The pure impressionists will paint as if they had caught the subject unawares, in a chance gesture. And in painting colored light—light colored because it is reflected from the varicolored objects making up the world—the impressionists will shatter the surface of their canvas into thousands of fragmented tints. Both of these innovations imply loss of form—loss of compositional form and loss of solidity in individual forms. Several members of the impressionist group will discover that this is impressionism's soft spot, and we will see them abandoning typical impressionist procedures to remedy it.

But whatever its definition, impressionism as a school of painting is the climactic expression of the nineteenth century. It gathers together the contributions of the conflicting schools of the first half and fuses them into a way of paint-

266 Diego Velázquez. *Venus and Cupid.* 1651. Oil on canvas, 4'1¼" × 5'9¾" (1.23 × 1.77 m). National Gallery, London (reproduced by courtesy of the Trustees).

267 Detail of Figure 266.

ing from which, in turn, the art of the twentieth century develops, partly as a continuation of impressionism, partly as a reaction against it.

The Impressionist Inheritance

From Delacroix the impressionists inherited discoveries in the theory of color upon which they enlarged. His technique of applying color in individual strokes, which he called *flochetage,* was extended to such a point that the surface of some impressionist painting became a rough texture of dots and dabs of paint. Delacroix found greens within reds, blues and purples in the shadows of yellow. He abandoned the idea that a red object, for instance, was red all over. Any other color might exist within the red area, either because the laws of physics produced it by reflection ("Color is a merging of reflections," he said) or simply because the painter wanted it there in order to enhance or reduce the intensity of the colors stroked on nearby. From this starting point, the impressionists began to use their eyes like prisms, turning white light into all its components of the spectrum, red, orange, yellow, green, blue, and violet.

From Courbet the impressionists inherited the inexhaustible mine of the everyday world. Some of them in their first days knew him in his last ones at the Brasserie des Martyrs. The Barbizon painters amplified Courbet's legacy, revealing landscape as a subject independent of romantic fervor or classical formality. They opened a door through which the impressionists rushed pell-mell into the open air, where they discovered their studios in fields, along river banks, and, for that matter, in the city streets.

These legacies seemed to contradict one another and all of them contradicted the art of Ingres. But the impressionists found compatibilities beneath what appeared antitheses. Technically the impressionists learned from all these sources and dozens of others—the English landscapists, the Japanese print, the art of Venice and of the French court, the new process of photography, perhaps too the scientific researches into the nature of light and color by such men as Chevreul, Helmholtz, Maxwell, and Rood. In this respect no other movement in the history of art has been quite so flexible as impressionism.

Monet

Impressionism as a technique devoted to capturing effects of light out-of-doors is exemplified most purely in the painting of Claude Monet (1840–1926), who forced it to its limits, and then beyond.

Monet was the son of a grocer; his parents refused to support him in a career as an artist, offering to buy him out of his military service if he would abandon the idea. This he refused to do, and by the time he was sixteen he had a local reputation as a caricaturist in his home city of Le Havre. His interest in landscape was stimulated by painters who came to Le Havre to paint the port or the beaches, particularly by Eugène Boudin (who will be seen later). In Paris Monet identified himself with the impressionists although he had had an occasional Salon acceptance, with a mild success in 1866. His poverty was desperate; malnutrition contributed to the death of his wife; he had to write begging letters to friends and was sometimes without money to buy paints. As late as 1888 Manet was helping him financially. (The similarity of their names sometimes caused confusion in exhibitions—to Manet's indignation.) But after 1890, at fifty, Monet was prosperous.

Monet's development can be summarized in a handful of pictures that must stand for many hundreds: he was an insatiable worker. *Red Boats at Argenteuil* [268, p. 226], painted in 1875, is a fully developed impressionist landscape of the period of the first group exhibition. The stretch of water is shot through with strokes of blue in many different shades. The reflections of boats and shore are struck into it freely, in bright tints of greens and pinks. On its sunny side, the largest of the boats is yellow in the highest lights, shot with lavender near the water, yet a bright rosy color overall; on its shadow side the hull is a strong violet-blue, made up of dark blues, grape colors, violet-reds, and a touch or two of vermilion. No colors are pulled together; each stroke (at close range, that is) tells individually. The boat is decorated with a stripe running around it near the gunwale. On the shadow side this stripe cuts through the purple-blue as a brilliant emerald green; on the sunny side it is bright yellow. The small clouds are flicks and dabs of pure white. On the grassy bank half a dozen greens are freely juxtaposed and intermingled, some yellowish, some bluish.

268 Claude Monet. *Red Boats at Argenteuil.* 1875. Oil on canvas, 23⅜ × 31⅝″ (60 × 81 cm). Fogg Art Museum, Harvard University, Cambridge, Mass. (Maurice Wertheim bequest).

From a little distance these different tints and colors within single areas tend to disappear as individual strokes. The eye "mixes" them and in doing so creates colors with more vibration, more sparkle, than would have been possible if the various reds or greens or blues or pinks had been mixed on the palette and applied in large areas in the conventional way or pulled together by "blending" on the canvas. In this state of impressionism form has not disappeared, although light, shattering against it, is already permeating and softening its surface, obscuring its details.

In black and white, the sunlit side of the red boat is all but indistinguishable from the water around it. In color, however, the contrast is quite strong. The values—the lightness or darkness of the colors—are so nearly identical that in black and white the contrast disappears. This is not merely an accident of photographic translation; it is a result of the fact that Monet is painting in terms of color as light rather than in terms of form as revealed by light and shade. As a contrast to make this point, *Red Boats at Ar-*

genteuil can be compared with the *Terrace at Sainte-Adresse* [Plate 15, p. 220] painted nine years earlier, which is still conceived in light and shadow. The forms are decisive, everywhere defined, although in color this picture is equally bright, equally sunny. The only areas where form tends to disappear are those clumps and sprays of flowers, painted in spots of red, green, and yellow with almost no shadow. Elsewhere the forms exist solidly in the light that strikes across their surfaces to reveal them. In *Red Boats at Argenteuil,* light is already beginning not so much to reveal the objects as to be revealed by them. Light permeates them, they fuse with it; forms do not interrupt light, as they do in the *Terrace at Sainte-Adresse,* but are caught up in it.

Monet's preoccupation with reducing all visual experience to terms of pure light became an obsession. When his young wife died he was horrified to find himself analyzing the nacreous tints of her skin in the early morning light. As he continued to paint, wishing he could have been "born blind in order to gain his sight and be

able to paint objects without knowing what they were," as he began more and more to develop the ability to see light and nothing but light, light became like a corrosive substance eating away the objects bathed in it. *Spring Trees by a Lake* [269] is all but formless. Within the twinkling strokes of blue, blue-green, pure green, yellow-green, and yellow covering most of the canvas, we barely recognize, by occasional vertical strokes of purplish and reddish tints, the trunks of a few trees. The extreme of this progressive dematerialization of matter is reached in "effects" of certain hazy and foggy atmospheres where the canvas dissolves into mist and material forms become mists within mists.

Between the *Terrace at Sainte-Adresse* and his late pictures Monet changed from a painter responding to nature into one fascinated by an abstract problem. In the early pictures the attraction of subject is great; in the *Terrace at Sainte-Adresse,* half the observer's pleasure is

his feeling of participation in a world of sun, air, flowers, and water. There is a keen and delightful sense of the fresh, strong breeze, the presence of the sparkling sea. There is also the more abstract pleasure offered by the certainty, the vigor, and the invention of the painting just as painting. In the later pictures this is the whole pleasure. It must be, for the objects from which we might have gained the sense of participation in the scene have become devoured by a technical process.

Monet invented a name for what he was trying to achieve: *instantaneity.* In 1891 he exhibited, at Durand-Ruel's, a series of fifteen paintings of haystacks in the different lights of different times of day, analyzing the color–light relationships in various stages between half lights of early morning and evening and the full blaze of midday. This faintly pedantic exhibition was a great success. Monet then set out on an even more elaborate analysis and painted some

269 Claude Monet. *Spring Trees by a Lake.* 1888. Oil on canvas, 29 × 36″ (74 × 91 cm). Philadelphia Museum of Art (William L. Elkins Collection).

forty pictures of Rouen Cathedral [Plate 16, p. 220] on gray days, bright days, in early light, late light, full light, light at different seasons of the year. These exercises are interesting, but they emphatically isolate the limitation of Monet's method. The monumental gray form of the cathedral is ground into a pulp of blues, oranges, pinks, and lavenders. The geometrical complications of its buttresses, windows, spires, and tracery become tottering masses of tinted fluff; they lean and waver in random placements on the canvas. A cathedral, with its mass, its organization, its logical formality, is a poor choice for dematerialization in close-range painting when it is supposed to be existing within full light. Theoretically we should be able to forget that this is a cathedral which appears to be going to pieces; practically it is difficult to do so.

But the Rouen pictures were followed by another series, this time of a perfect subject. In the garden of his house in Giverny, which Monet had bought with the proceeds from his first successful sale, there was a pool with water lilies that he had painted from time to time. Now in the 1890s he discovered in the surface of the pool, and the leaves and blossoms floating upon it, a subject with enough material to last him for the rest of his life. The shimmering, shifting translucence of the water, the delicate, all but translucent petals of the blossoms, the flat shiny pads of leaves floating or half submerged in water close to the same color, with the light glancing off surfaces or striking through them onto surfaces below, repeating

and reflecting on every hand the whites and the rainbow tints—these were inexhaustible in their combinations and recombinations. Now Monet's canvases became the surfaces of pools, fragmented areas where water, light, air, and the delicate substance of blossoms all partook of one another, echoed one another, and crossed one another's boundaries until there was no differentiation between them.

The water-lily paintings supplied the motif for Monet's last work, a series of large decorative panels [270, 271]. In these hugely expanded

271 Detail of Figure 270.

270 Claude Monet. *Water Lilies.* c. 1925 (?). Oil on canvas, 6'6¾" × 18'5½" (2 × 5.63 m). Formerly Museum of Modern Art, New York (destroyed by fire).

canvases, with large brush strokes, the forms of nature are difficult to distinguish. If the paintings are regarded as representations of lilies and water with ripples and glancing reflections of light, they never become more than great inchoate masses of opalescent color arbitrarily cut off on four sides by a frame. But if they are regarded as abstract arrangements of color applied in directed strokes, they gradually coalesce. One movement of strokes across the canvas is revealed as a check or a buttress to another; a system beginning in one section and seeming to vanish will reappear elsewhere. The colors are woven and built into a structure that is its own reason for being. The "systems" in these paintings are free inventions, felt rather than calculated, and the danger is to exaggerate their precision or to find within them a logic that does not exist. But it is safe to say that Monet, from his impressionist beginning when he painted spontaneous approximations of visual effects of light and atmosphere, gradually transformed his art into one of abstract surfaces where relationships of form and color exist for themselves in spite of the vestigial remains of a subject. It is on this basis that Monet now seems to have anticipated a school of contemporary American abstraction. Jackson Pollock (1912–1956) painted by dripping, flicking, dribbling, or pouring semiliquid colors onto a canvas or panel laid on the floor [272]. The pattern of different colors, densely intermingled or freely splattered, exists without even secondary reference to the visual forms of nature. It exists for itself as color, as line, as a complex within which movements, systems, rhythms are overlaid and intertwined. The same thing can be said about Monet's late water-lily pictures, if their starting point of light playing over the forms of nature is ignored. Thus Monet becomes a bridge between the naturalism of early impressionist painting and total abstraction. "Abstract impressionism" would be an appropriate term to describe Pollock's sparkling interweaving of dots, splashes, and ropelike lines of color, and the term is sometimes used as a variant of "abstract expressionism."

Monet's landscapes and the late semiabstract paintings into which they merged are his historically important work. They obscure his portraits and figure studies, most of which were done between 1860 and the early 1870s. (He did many of his young first wife.) In any case, he had no great interest in human beings as personalities to be interpreted; he painted them from much the same point of view as he painted landscape—as elements of nature in light. In the gentle *Woman in a Garden, Springtime* [273, p. 230] the woman is more like a blossoming shrub than a person.

272 Jackson Pollock. *Autumn Rhythm.* 1950. Oil on canvas, 8'0" × 17'3" (2.67 × 5.26 m). Metropolitan Museum of Art, New York (George A. Hearn Fund, 1957).

273 Claude Monet. *Woman in a Garden, Springtime.* c. 1875. Oil on canvas, 19⅝ × 25¾″ (50 × 65 cm). Walters Art Gallery, Baltimore.

Sisley and Pissarro

The two other "pure" impressionists in the group were Alfred Sisley (1839–1899) and Camille Pissarro (1830–1903). Their experiments were less venturesome, within narrower boundaries, than Monet's. Hence they always fall into second place with brief consideration in books of this kind, which is too bad but inevitable.

A painter's merit cannot be gauged by the number of lines of type required to comment on it, and to comment at any length on Sisley would involve repetition of much that already has been said about Corot and Monet. His fresh and quiet art [274] has affinities with both.

Sisley resigned himself early to poverty, obscurity, and official rejections, and although he exhibited in the first impressionist show and three others, he spent very little time in Paris and finally retired to the village of Moret, where he could exist at minimum expense surrounded by subject matter that appealed to

274 Alfred Sisley. *Bridge at Villeneuve.* Date unknown. Oil on canvas, 21½ × 29″ (55 × 74 cm). John G. Johnson Collection, Philadelphia.

him—a quiet countryside and a village with old buildings, bridges, and river banks. Sisley's parents were English and he spent some time in that country. Of all French painters he comes closest to the special lyrical response to nature found in English painters and even more in English poets. Corot was his idol, and his painting has Corot's serenity beneath the more vibrant impressionist surface. Once he had discovered the impressionist palette and the technique—which he never forced—his manner changed very little over the years, yet his work is not repetitious. Each picture is remarkably complete in its effect, where much impressionism seems fragmentary. Without Monet's passion for experiment, which kept the pictures pouring forth, and without a market to set a demand, which he would have worked to supply, Sisley painted with great deliberation, allowing the fullest expression of his sensibilities. He did not live to see the triumph of impressionism extend as far as his own work, but immediately upon his death his paintings began to fetch high prices. During his lifetime he sold them for twenty-five or thirty francs each.

Pissarro's impressionism has much of the sobriety of Sisley's but is less reflective. He was the oldest member of the group, being two years older even than Manet. Born in the Virgin Islands, he came to Paris the year of the great exposition of 1855. Everyone who knew Pissarro seems to have left some account of him, and by all these accounts his life and his character were a catalogue of virtues—loyalty to his friends, wisdom as the father of a large family, courage in adversity, and patience, tolerance, honesty, and industry in all circumstances.

Although Pissarro was intent upon capturing transient effects just as Monet was, he never abandoned the relative discipline of early impressionism, and for a while late in his career he joined the "neoimpressionists," who tried to solidify impressionism by systematizing its free prismatic shattering of light into a scientific application of color in minutely calculated dots [377]. Pissarro soon abandoned this extreme, but that he was attracted to it at all shows his cautiousness in the use of impressionist effects. While Monet was pushing further into exploration of effects of light and air at the expense of form, Pissarro was retreating. *Peasant Girl with a Straw Hat* [275] is an effort to retain the atmospheric vibration of impressionism while at the same time imposing the discipline of well-defined contours on forms monumentally arranged in space.

Even when he was sharing with Monet the excitement of the impressionist discoveries, Pissarro retained his respect for the material fact of the subjects he was painting. When he painted trees and fields they remain trees and fields rather than becoming a multitude of small elements reflecting light. In no circumstances could he have shared Monet's wish to be ignorant of the objects he saw. Of all the impressionists he is the one most closely allied to the Barbizon spirit with its love of fields, copses, and peasant huts as part of a simple life with a nobility of its own—with Corot's in its personal, reflective mood, and with Monet's in its preoccupation with effects of light and atmosphere at different times of day and in various weathers

275 Camille Pissarro. *Peasant Girl with a Straw Hat.* 1881. Oil on canvas, 28⅞ × 23½″ (73 × 60 cm). National Gallery of Art, Washington, D.C. (Ailsa Mellon Bruce Collection, 1970).

276 Camille Pissarro. *Place du Théâtre Français, Pluie.* 1898. Oil on canvas, 29 × 36'' (74 × 91 cm). Minneapolis Institute of Arts (William Hood Dunwoody Fund).

By comparison, his cityscapes are vivacious [276]. He reduces crowds, carriages, and individual figures to the merest suggestion, in scattered dots and his typical "commas" of paint, but he never allows his city buildings to decompose as Monet's cathedrals did. Pissarro is a careful painter (Monet seems careless at times). He was the only one of the impressionists to exhibit in all eight of the group shows, and during the constant squabbles he was the unofficial moderator.

More than any other member of the group, Pissarro encouraged younger men. At least three painters who were notoriously suspicious and thorny to deal with—Degas, Cézanne, and Gauguin—always retained a deep affection for him. Like Monet's and Sisley's, his financial situation was often desperate and at best difficult, but finally, at the age of sixty-two, he had the satisfaction of seeing his reputation established, not spectacularly but soundly enough, in a large retrospective exhibition organized by Durand-

Ruel. It was a gratifyingly happy ending to an admirable career.

Midway during the careers of Monet, Sisley, and Pissarro, pure impressionism was abandoned by two painters who felt limited by the transient effects it imposed. One of these men, Renoir, brought impressionism directly into the tradition of the old masters by subjecting it to their disciplines. The other, Cézanne, subjected it to new disciplines, making it the point of departure for the most radical redirection of the art of painting in some six centuries.

A third, Degas, had never accepted impressionism on Monet's terms in the first place, and was its great traditionalist even while he was one of its most startling innovators. It was never necessary for Degas to revert to traditionalism as Renoir was to do, since he had been a traditionalist from the beginning. His innovations, eccentric at first glance, are as a matter of fact brilliantly logical extensions of traditional principles—principles rather than formulas.

chapter 16

The Bellelli Family

Edgar Degas (1834–1917) was the aristocrat of the impressionists, not only
by birth but as well in his intellectuality and reserve, his personal detach-
ment in observing a commonplace world to record it intimately. Of all the
impressionists he is the most subtle, disguised as the most direct; the most
reflective, disguised as the most noncommittal; the most acute, disguised as
the most casual. He is their finest draftsman and composer; he is one of the
finest draftsmen and composers of any period. He was the only impression-
ist to recognize that the momentary effect (with Degas, a moment may be
split to its ultimate fraction) can be used for complete revelation of individ-
ual character. He was, in fact, the only impressionist interested in exploring
individuals as psychological entities. The personalities he thus recorded
exist with a completeness, a reality, that puts their portraits among the great
ones of any age. Sometimes these personalities are people Degas knew,
sometimes they are nobodies—a milliner's assistant at work, a clerk, a pros-
titute, a vagrant. But no matter who they are, they are revealed in the most
significant nuances of their inner being; and at the same time they are
equally revealed in their relationship to the social order.

This doubly acute perception is apparent in Degas' work from the begin-
ning. In 1856 he was only twenty-two years old. The Salon des Refusés was
still an inconceivable event seven years in the future; Manet was just leaving
Couture's studio; Pissarro was getting settled in Paris; Monet was a local boy
in Le Havre doing caricatures. Degas was in Naples visiting his aunt, the
Baroness Bellelli. He made sketches of her, of her husband, and of their
daughters, his young cousins Giovanna and Giuliana Bellelli. During the
next three or four years of subsequent visits to Florence, where his relatives

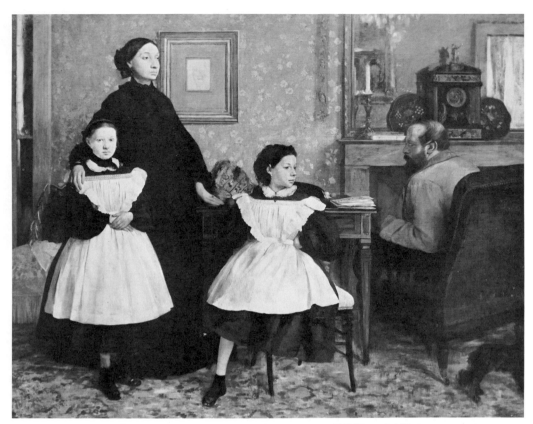

277 Edgar Degas. *The Bellelli Family.* 1859. Oil on canvas, 6'6¾" × 8'3½" (2 × 2.53 m). Louvre, Paris.

were then living, he made other sketches and began to organize them into a group portrait. By about 1859 he had completed the most extraordinary of all family portraits, a study of individual personalities and their interrelationships, both discreet and total, expressed through pictorial composition [277].

The family was a disturbed one, and the primary fact of the father's emotional separation from the mother and daughters is established by his unconventional placement, seated as he is with his back partly turned toward us and his face in shadow. Compositionally this isolation is defined by the strong line of the table leg that is continued by the line of the side of the fireplace—only slightly interrupted by a few papers on the corner of the table—and on up to the top of the picture by the frame of the large mirror over the mantelpiece. Thus the right-hand third of the picture, containing the father's portrait, is cut off by a compositionally heretical but expressively brilliant device. In addition, this area is filled with small shapes, further dif-

ferentiating it from the left two thirds where the shapes are stronger and more simple.

In contrast with the bent, indecisive attitude and silhouette of the husband, the wife stands with decision and dignity. The wide hoop skirt and the narrow shoulders form a pyramid, the stablest of all geometrical forms. Surmounting this dark silhouetted triangle and framed by her dark hair, the face of the Baroness with its calm, sadness, and strength, is the focal point of a composition in which we are led from one formal and psychological relationship to another, yet always back to this one crucial focus of meaning.

The mother's arm rests on the shoulder of Giovanna, the daughter who was most like her mother and closest to her. Degas includes the smaller triangle of the figure of the little girl within the larger one of the mother's to establish this similarity and this closeness. The other daughter, Giuliana, was more volatile and more divided in her allegiance to her parents. For her Degas chooses an unconventional pose, one leg

drawn up beneath her as she sits on the corner of a chair, one hand on her hip (Giovanna's hands are placidly folded) and her face turned from her mother and sister in the general direction of her father, although she does not quite meet his glance. Giuliana thus unites the two halves of the composition structurally, tied at once to the mother and the sister by the identity of her costume and by the lines following or echoing lines in the mother-Giovanna group, and yet also tied to the father. This was Giuliana's relationship to the family: divided between its parts, although in the end (as here) she was closest to her mother and sister.

In its other elements the composition is unified by the repeated horizontals and verticals of the picture on the wall, the table, the door frame, the bell pull, and, for that matter, by any line or mass one wants to pick out. The rather rigid skeletal structure is relieved by the broken pattern of the rug and the sprinkling of flowers on the wallpaper.

A multiple portrait, demanding a division of attention among several individuals and yet a unity of the picture overall, is as taxing an assignment as a painter has to cope with. *The Bellelli Family* is a masterpiece from half a dozen points of view, technically and expressively. Here in his first major picture Degas demonstrated his extraordinary combination of acute sensibility to the most personal, most private inner life of the individuals he observes and his peculiar objectivity that allows him to stand outside these perceptions and present them in the most clinical, analytical way.

Degas' Impressionism

Degas is one of those painters whose art is best discussed chronologically.

His father,* a banker, had planned a career in law for his son, but this study was abandoned in 1855. This was the year of the Exposition Universelle, and Degas was much excited by Courbet's Pavilion of Realism. He was also an admirer of Delacroix. But Ingres was his great man, and the exposition gave him a chance to meet the old painter. M. Valpinçon, a friend of Degas' father, owned *The Turkish Bather* (now called the *Bather of Valpinçon* [126]) but had

* Auguste de Gas. The son changed the surname to the less aristocratic form in 1870.

refused to lend it to the Ingres retrospective planned for that year's vast Salon. Degas induced Valpinçon to change his mind and Valpinçon told Ingres of this. Degas and Valpinçon were invited to Ingres' studio, where Degas was given the advice to "draw lines, young man, many lines." Degas was entering the Academy's school, but as it turned out he spent most of his time studying privately under Lamothe, one of Ingres' pupils, since at that time Ingres was accepting no students.

Degas had been a precocious natural draftsman, and his first student work makes one wonder what was left for him to learn under instruction, but he drew lines, perhaps many lines, under Lamothe. Although his allegiance to Ingres never wavered, his idea was not to emulate the classical style but to capitalize on the discipline and the structural knowledge of the human body upon which it was supposed to be based. Unlike the ordinary student who imitated only the surfaces of the classical style, Degas ignored surfaces and went beneath them to the legitimate fundamentals that had been all but forgotten. He observed them from his earliest work to his last. An early drapery study [278]

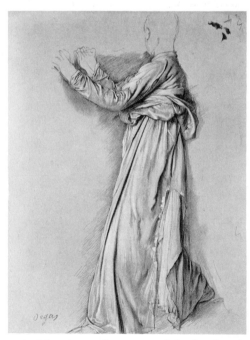

278 Edgar Degas. Drapery study for *Semiramis*. 1861. Black pencil and chalk on blue paper, 11⅝ × 7⅞″ (30 × 20 cm). Louvre, Paris.

and the somewhat later, wonderfully certain, wonderfully controlled *Lady on Horseback* [279] are, respectively, an academic preliminary drawing for a large composition and a drawing in the tradition of Ingres, although neither could be confused with its prototype. *Lady on Horseback* is instinct with life as well as elegance. So, of course, is a drawing by Ingres, but there is a fullness and warmth in Degas' drawing as opposed to the cooler sparkle of his idol's. The still-later drawing for a portrait of Manet [280] is more relaxed, more inventive, yet equally disciplined. Ingres is still present, but in addition to greater warmth there is also a record and an interpretation of personality that in Ingres stopped at whatever immediately apparent suggestions were offered by the subject's face and costume. As a mature artist Degas never merely draws. He uses his crayon to probe, to explore, to discover. In a study, *Two Café Singers* [281], the transformation of classical discipline is complete; it operates now with a freedom (and

280 Edgar Degas. Studies of Manet. c. 1864–1865. Pencil on pink paper, 16 × 11″ (41 × 28 cm). Louvre, Paris.

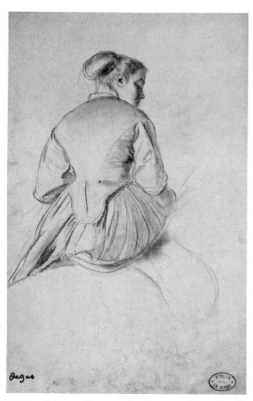

279 Edgar Degas. *Lady on Horseback.* 1860–1865. Pencil, 12½ × 8″ (32 × 20 cm). Louvre, Paris.

281 Edgar Degas. *Two Café Singers.* 1878–1880. Pastel and charcoal, 17½ × 23″ (44 × 58 cm). Collection Mrs. John Wintersteen, Haverford, Pa.

in the service of a subject) that would have horrified Ingres but could never have developed in the art of Degas without the foundation of classical experience. There is not a detail, not so much as the upward bend of a singer's thumb, that is extraneous to the whole; there is not a touch of the crayon dependent on less than perfect mastery.

Degas had met Fantin-Latour and Manet, and now he began to sit in on some of the discussions that were developing at the *Café Guerbois*. By the latter 1860s he had discovered his material: the life of the city as he saw it in the drawing room, in the studio, in the shops, even in the brothel; on the boulevard, at the racetrack, in the cafés, the theater, the opera—all the places where people congregated and could be studied in a thousand expressive attitudes, attitudes spontaneously and unconsciously assumed, combined later from sketches or memory into compositions that seemed equally spontaneously and accidentally put together. In *A Carriage at the Races* [282], carriages and horses are chopped off as if by chance, and in the background a few horses and riders, trees and low buildings are scattered as if at random, while a couple of women, a sleeping boy, a

man, and a dog are caught in momentary and casual attitudes as if unaware of the painter. The pose-not-posed, caught as if by good fortune at its most expressive moment, becomes Degas' major preoccupation, including the combination of these individual poses in eccentric compositions where the impression is what Degas wants it to be—that of an arbitrarily selected fragment. But if one tries to extend the fragment, one realizes quickly that it is not a fragment at all, but an entity complete and satisfying in itself.

Actually, as Degas himself said, no art was ever less spontaneous than his. His "snapshot" compositions are the result of reflection, study, and calculation. The portrait of Diego Martelli [283, p. 238] is a direct descendant of Manet's of Zola [255]. But Zola sits formally for his portrait; Martelli only pauses long enough for the artist to sum up a composition in a quick glance—or seems to. The elements are the same—the man, the desk, the papers on it, the furniture of the room, rectangular prints or pictures patterning a wall. Like Manet, Degas draws upon the Japanese print for his composition, using in addition to the rectangular divisions of the *Zola* the bird's-eye view, the tilted perspective found in

282 Edgar Degas. *A Carriage at the Races.* 1873. Oil on canvas, 14³⁄₈ × 22″ (37 × 56 cm). Museum of Fine Arts, Boston (Arthur Gordon Tompkins Fund).

some of the prints. All of this is impressionism in effect until the solidity, the balance, the contemplative sobriety of the picture is understood as classical.

Degas loathed the word *impressionist* with its connotation of the accidental and the incomplete, and he fought against it until he managed to get it dropped from the announcements of the fourth group exhibition of 1879, when it was replaced by the word *independent*. He was not interested in the paraphernalia of outdoor impressionism, the countryside and atmospheric effects. City streets offered him as much fresh air as he wanted; the racetrack was open country enough. Theaters and intimate interiors offered the kind of light and air he liked to paint. He needed artificial life, he said, and not for a moment would he have considered yielding to impressionist seductions to paint at Argenteuil, as Manet finally did. Degas insisted that painting was an art of convention. To imitate nature from the model was bad enough; to imitate all its accidents out-of-doors was unthinkable. He painted from brief notes and sketches, preferring to observe carefully and then depend upon memory. When he used a model he habitually followed a practice that had been used occasionally by some other painters: he let the model move about the studio while he observed the movement of bones and muscles, constructing his figure from this knowledge rather than by imitating the aspect of a single pose with its necessary loss of spontaneity.

Degas' Classicism

The essentially classical nature of Degas' art and his great originality in the use of classical principles are summarized in one of his most carefully studied paintings, *Foyer de la Danse* [284], painted in 1872. By a device approaching tour de force but familiar to the artists of classical antiquity, Degas combined a momentary scene of action with what would seem to be its impossible opposite, the imposition of classically static order. At the right of the composition are clustered the ballet master, the rehearsal violinist, and several dancers. The ballet master has just tapped on the floor with his stick, and on this signal the violinist has lowered his bow. The dancer whom he has been rehearsing pauses, motionless, in the middle of a step,

283 Edgar Degas. *Diego Martelli.* 1879. Oil on canvas, 43½ × 39¾″ (111 × 101 cm). National Gallery of Scotland, Edinburgh.

awaiting the master's comment or correction. Other dancers glance in her direction.

Thus, although the figures are caught in instantaneous attitudes, these attitudes are legitimately static ones between moments of action, allowing Degas to compose the various figures in classically static fashion without congealing them in Davidian posturings. The same device was used in the sculpture of antiquity. As an example, the famous *Discus Thrower* is shown just as his arm reaches the high point of the throw, at the very moment before it descends, thus allowing the sculptor to represent, legitimately motionless, a moment in a series of violent movements.

Foyer de la Danse is as nicely balanced as any classical exercise, with a variation on the seesaw principle. But the balance is not by weight, as is usual, but by a play of weight against interest. By weight the group of figures on the right, with ballet master, violinist, and dancers densely clustered, is too heavy for the single figure of the dancer on the left. But by interest, isolated as she is and the object of attention from every

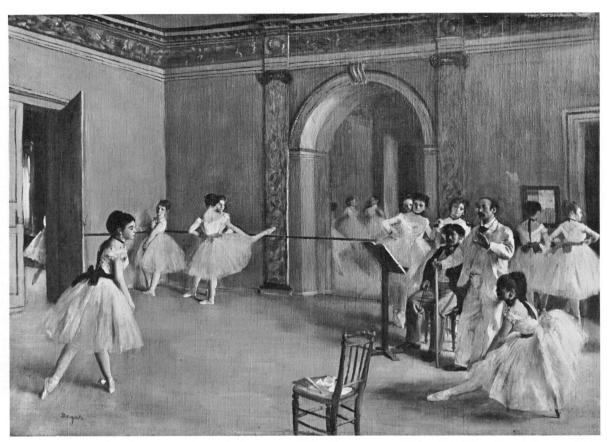

284 Edgar Degas. *Foyer de la Danse*. 1872. Oil on canvas, 12½ × 18″ (32 × 46 cm). Louvre, Paris.

side, she counters their weight. This kind of balance is sometimes called "occult" balance; no one has ever used it with more skill than Degas, and obviously its attraction for him is the possibility it offers of combining balance with what seems to be random placement.

In painting, classical principles dictate a "closed" composition, complete within itself, and the scene usually takes place in a boxlike space. This is true of *Foyer de la Danse*. Degas varies the restriction by turning the "box" so we see it at an angle, not only from the side but also from above, but the space itself remains clearly defined. The back wall and the side wall to the left are actually seen. The wall outside the picture to the right is defined by the fact that light flows into the room from its window. In the immediate foreground a chair is set in such a way that its back parallels the side walls, and hence its side near us identifies a plane corresponding to a fourth wall between us and the dancers. The function of the chair, then, is to

define space, yet it seems to be the most casually disposed object in the whole painting. Upon this skeleton an analysis of the picture's composition could be elaborated at length to include every object in it, since not the smallest detail is accidental. The final unifying element is light, light as it flows upon and defines the objects disposed in space. This, of course, is the opposite of the light of typically impressionist painting that consumes the objects it touches.

Foyer de la Danse was completed just before Degas made a trip to New Orleans, where his mother had been born. Degas went to visit her family and his two brothers, the younger René and the elder Achille, who had entered the family's cotton-brokerage firm there. Degas repeated the compositional idea of the *Foyer* picture in *The Cotton Exchange at New Orleans* [285, p. 240], where he defined space similarly, including a chair in the left foreground, with his uncle Michel Musson testing a sample of cotton while sitting in an adjacent chair.

285 Edgar Degas. *The Cotton Exchange at New Orleans.* 1873. Oil on canvas, 28³/₃₂ × 35³/₃₂'' (72 × 90 cm). Musée des Beaux-Arts, Pau.

Degas' Humanity

Degas did several portraits of his relatives on this trip, and that of his brother René's wife [Plate 17, p. 269] is one of the most exceptional among all his work. A special bond of affection had always existed between Degas and his younger brother, and now this was extended to his brother's wife, for René de Gas had married his blind cousin, Estelle Musson. The blind eyes turned to the light, the placement of the figure in the left half of the canvas with the rest of the space behind it nearly vacant, the quietness of the pose suggesting resignation, the delicacy of the colors—rose, gray, and silvery white—all have something to do with the mood of tenderness, loneliness, and affectionate sympathy pervading the picture. The composition seems to be a spontaneous one and is, of course, not a complicated one. If we cannot analyze precisely how the mood is created, we nevertheless cannot fail to be touched by it and to feel Degas' exceptional response to this sitter.

The portrait is an especially intimate expression of a quality for which Degas usually receives small credit. Because he defended his prejudices with a sharp tongue, anecdotes about his witticisms and his eccentricities have obscured the tenderness that was also a part of his nature. Because he never married and because he did some unflattering nudes of women—his famous "keyhole" compositions—he acquired a reputation as a woman-hater. He also did a less well-known series of brothel scenes [286] in which the inmates are shown as ugly lumps of degraded female flesh.* But these scenes can hardly be called comments on women in general; they might better be called protests against the violation of the human spirit. The model for Degas' *Self-Portrait in a Soft Hat* [287] was no misogynist; the face is as gentle as it is skeptical. It is the face of a man who, when he painted his aged father listening to a friend's music [288], contemplated one of the most poignant aspects of human life with deep understanding and consummate tact.

* These are monotypes, paintings or drawings done on a nonabsorbent surface and then transferred while still wet to papers under pressure. Degas is the only major nineteenth-century artist to have done important work in this medium.

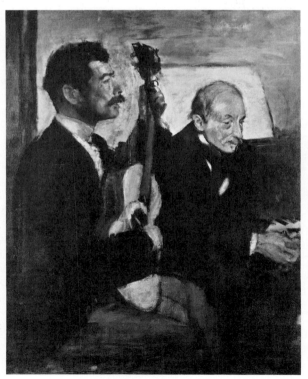

286 Edgar Degas. *Two Women*. c. 1879. Monotype, black ink on tan paper; $8\frac{7}{8} \times 11\frac{1}{8}''$ (23 × 28 cm). Museum of Fine Arts, Boston (Bigelow Collection).

287 Edgar Degas. *Self-Portrait in a Soft Hat*. 1857–1858 Oil on paper applied to canvas, $10\frac{1}{4} \times 7\frac{1}{2}''$ (26 × 19 cm) Sterling and Francine Clark Art Institute, Williamstown, Mass.

288 Edgar Degas. *Degas' Father Listening to Lorenzo Pagans Singing*. c. 1869–1872. Oil on canvas, $31\frac{1}{2} \times 24\frac{3}{4}''$ (80 × 63 cm). Museum of Fine Arts, Boston (bequest of John T. Spaulding).

Degas and the Impressionists

Shortly after Degas returned from New Orleans, plans for the impressionists' first group show got under way at their open forum, the Café Guerbois. Degas was a constant irritation to the other members during its organization. He had always held himself aloof from most of them, but now he was full of ideas that met with no one else's approval. Above all he was eager to avoid any implications that this was another Salon des Refusés, and he confused things by insisting that as many popular painters be included as could be induced to enter. He ended by drawing in more painters than anyone else, which was helpful since it decreased each one's share of the expense (most of the group were always in financial trouble). No matter how much they admired his work, many members disliked Degas—and he seems to have given them plenty of reason. He was witty and frequently he turned his wit against them. He could seem a snob when someone failed to interest him; unlike Manet he did not trouble to hide his feelings beneath a gloss of manners. He always showed himself at his worst in public, concealing his generosities from everyone and reserving his affection for a very few people, most of whom were not at all connected with his professional life.

Why was Degas interested in exhibiting with the impressionists? The answer redounds to his great credit. He had nothing to gain professionally from the association; he even had much to lose. He had been accepted in the Salon for six years running, 1865 to 1870 inclusive—apparently not submitting the following years—and had had compliments from influential quarters. To exhibit with so dubious a group as the unknowns of the Café Guerbois could only block a continuation of this mild but promising success. Degas did not need the vaguely possible financial benefits that the other members hoped against hope might develop in the form of sales. He was wealthy and he even objected to selling his pictures, although he gave away many. He might have been expected to be suspicious and disdainful of the whole thing just as Manet was, yet Degas was one of the most industrious workers in organizing the exhibition and calling it to general attention.

The fact is that Degas believed in the group and in the group show because he believed in the new painting. His relationship to impres-

sionism was a curious one; we have already seen how many of its premises he rejected. But he did share with the other impressionists the conviction that the subject from contemporary life, presented with the quality of immediacy, was the proper field for painting in his time. It was a time so complex that artists could no longer hope to achieve the expression of an ideal universal order conceivable in antiquity and reflected in the art of antiquity. Nor in such a time could such a thing as universal knowledge be imagined, as the Renaissance had imagined it and given it form, for science had begun to make specialists of everyone and nobody understood more than a fraction of the surrounding world. The romantics had recognized both impossibilities in the world as it is and had escaped into a never-never land of emotional stimulants. But as a man of the world fascinated by the world, Degas rejected these romantic escapes.

Denied classical serenity, Renaissance wisdom, and romantic escape, we must be content with those small and commonplace fragments of the infinitely complex world that are within the scope of our comprehension. The function of the artist, then, by Degas' idea, is to take these fragments and treat them in such a way that they afford full play to the sensibilities of anyone whose imagination can reach beyond their commonplaceness into the infinite realm of personality and association. No other painter, not even Daumier, shared the intensity of Degas' interest in the commonplace as material for painting, his fascination with the exact description of the way people stood, sat, moved, existed in their daily round. But if the impressionists did not share Degas' intensity, they shared his interest in the everyday world according to their own more casual ways of seeing it. And for that reason Degas knew he was one of them.

After 1886, date of the last impressionist group show (he exhibited in all but the next-to-last), Degas saw few people and exhibited rarely, working in his studio as a recluse. There was a steady demand for his work. He had never liked to sell his pictures, but it now became necessary for him to do so: he had sacrificed most of his fortune in 1876 to extricate his brother from difficulties following speculations in American stocks. The exact circumstances are not known since Degas was extremely reticent about all details of his personal life.

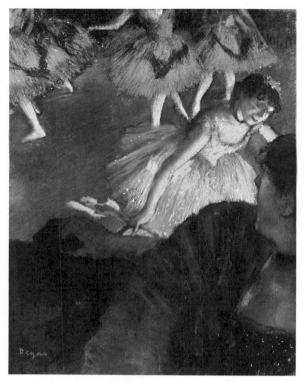

289 Edgar Degas. *Ballerina and Lady with Fan.* 1885. Pastel, 30 × 26″ (76 × 66 cm). John G. Johnson Collection, Philadelphia.

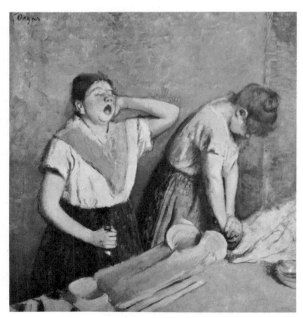

290 Edgar Degas. *Two Women Ironing.* 1882. Oil on canvas, 31 × 28¾″ (79 × 73 cm). Louvre, Paris.

The ballet pictures that account for so much of his popularity today were produced in great numbers after the middle 1870s. His interest in the ballet was not that of a balletomane: the ballet happened to provide in one package all the elements with which he was working—indoor or artificial light, frequently unusual in source, as from footlights; eccentric angles of vision, as from a box above the stage; accessory elements of unexpected shapes, supplied by such things as bits of stage scenery, props, the rails of the orchestra pit or the curve of a box seat [289]. Above all, here were the human figures of balletmasters, wardrobe mistresses, mothers waiting for or upon their daughters, figure after figure to be caught in momentary attitudes full of variety, especially the dancers themselves with their bony, sinewy bodies and curious stances. Sometimes Degas seems to be interested in contrasting the glamor of the ballet with the unglamorous, rather plain girls who learn to go through curious contortions to present glamorous illusions. But ordinarily his interest in dancers is not much different from his interest in, for instance, the two laundresses [290], one ironing, one yawning, whose occupational attitudes equally fascinated him.

Degas gradually abandoned oil paints and limited himself to pastel, for which he had always had a predilection. He was essentially a draftsman and always found the texture of oil unsympathetic. The "lines, many lines" Ingres had advised him to draw as a student had remained the basis of his art as a painter. Line came increasingly to mean for him a boundary reduced to minimum complexity for maximum description.

Pastel is ordinarily associated with filmy, airy effects because it must be applied delicately over a textured surface and not touched again if it is to retain its life. Rubbing or drawing over it deadens it. But by means of some special fixatif the composition of which is unknown, Degas could work over his pastels without losing their grainy quality, and alone among those who have used the medium he gave it all the strength, depth, and solidity of oil. In place of its usual chalky tints he achieved a full-bodied brilliance. It was the perfect medium for him. He was drawing and, at once, painting. Toward the end of his life his sight failed, and his pastels became broader and broader in drawing. For the first time, forms tended to diffuse into something like impressionistic effects, but a

lifetime of studying the construction of the human body, and its movement, had taught him where the essential hollow or bulge in a contour told most about bone, muscle, and fat. His last drawings, done when he was going blind, are still miracles of draftsmanship [291].

In the art of Degas, tradition and innovation are so fused that they exist in identity with one another. A hundred examples could be given to continue the illustration of this point: one, *Nude Arranging Her Hair* [292], a pastel, is closely allied to the *Bather of Valpinçon* [126]. Ingres' harem beauty has become a bourgeoise, her seraglio a boudoir in a Paris flat of which we see a corner with a somewhat blowzy chair. The beautifully patterned turban is gone; so are the svelte, lovely contours of the odalisque's body. Degas' young woman ducks her head to work vigorously at the nape of her neck with a comb. Her shoulders bunch together as she raises her arms, the lines from elbows down either side, along back and buttocks, along

breast, chest, and hips, describe a series of muscular contractions and relaxations, taut here, inert there, rounded in this place, hollowed out in another, stretched across the projections of bones or resting weightily upon them. In the bourgeois century, Ingres' revery of sensuous delight has given way to Degas' factual statement of bourgeois actuality.

Technically, the enameled precision of Ingres and the direct vigor of Degas may seem to contradict one another; basically they are allied. Degas' active linear contours defining forms modeled in vibrant light and Ingres' dulcet ones enclosing forms across which light flows like a caress are arrived at from the same tradition, which each painter reverences and observes and, each in his own way, enlarges. If Ingres depends upon the tradition of the Renaissance, so does Degas depend upon it and upon Ingres.

Degas was also a sculptor, doing occasional pieces from time to time until, in his last years,

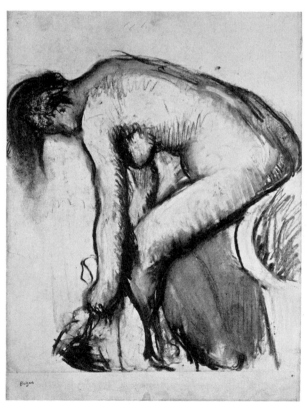

291 Edgar Degas. *After the Bath: Woman Drying Her Feet.* c. 1890. Charcoal and pastel, 22⅜ × 16″ (57 × 41 cm). Art Institute of Chicago (gift of Mrs. Potter Palmer).

292 Edgar Degas. *Nude Arranging Her Hair.* c. 1885. Pastel, 21¾ × 20½″ (55 × 52 cm). Private collection.

293 Edgar Degas. *Woman Rubbing Her Back with a Sponge.* c. 1900. Bronze, height 18″ (46 cm). Philadelphia Museum of Art (bequest of Curt Valentine).

294 Edgar Degas. *Little Dancer of Fourteen Years.* 1880–1881. Bronze with cloth accessories, height 39″ (99 cm). Metropolitan Museum of Art, New York (bequest of Mrs. H. O. Havemeyer, 1929.)

his sight nearly gone, he did many. What his eyes could no longer see to draw, his hands could feel to model. Theoretically there is such a thing as impressionist sculpture; actually, Degas is the only sculptor who is impressionist in anything like a pure definition. Like his paintings, his small sculptures wonderfully embody momentary aspects of unidealized figures [293], rejecting all incidentals and nonessentials to capture the essence of visible reality. Essentially these are sketches in wax, not conceived as bronzes. Similarly, his single large piece is in effect not so much sculpture as a masterpiece of

draftsmanship in three dimensions. The bony little figure of the "ballet rat" [294], the suggested textures of hose, bodice, hair, and flesh, the vivid reality of her stance, make possible the extraordinary features of a real tarlatan skirt and a real satin hair ribbon. Astonishing at first, they take their place after a moment or two as integral harmonious parts of the reality of the figure as a whole. The only trouble is that as time has passed, the cloth has grown limp, soiled, and dusty. The reality of these real accessories is less real, in the end, than the reality of the bronze image.

chapter 17

Renoir

Degas and Renoir

Degas is not convinced of life's goodness, although he never for a moment questions its fascination. Whether he is painting with as much sympathy for his subject as he does in the portrait of Estelle Musson or with the detached observation apparent in his treatment of the less attractive women in a café on the Boulevard Montmartre [298], he never stands in judgment, never makes a moral evaluation, never commits himself to a comment on the philosophical justification of our existence in the world. If in the end the flavor of his art is pessimistic, it is not because Degas ever points out a pessimistic conclusion, but because he lets the decision go by default. The average person "interpreting" art expects to find a positive statement of faith, an affirmation of hope that each individual existence in the world serves some ultimate good. Degas neither confirms nor refutes such an idea.

Degas' attitude toward the world—a fascination with its fragments, a refusal to comment on its wholeness—is summarized in his attitude toward women. Few painters have been more preoccupied with representing them; no painter has portrayed them more acutely as personalities. None has been more sensitive to their psychological nuances or recorded these perceptions more intimately. But Degas seems hardly conscious of women as mothers, sweethearts, or sirens. Even in *The Bellelli Family* his perception of the relationship between mother and daughters is remarkable for its analysis of human relationships rather than for sentiment. Similarly, woman's body fascinates him but only as a structural entity, not as a symbol of beauty or an object of desire. His late drawings of women climbing in and out of bathtubs, drying themselves, scratching themselves, caught in every awkward and unlovely attitude that presupposes the absence of an observer—these so-

called "keyhole" subjects, in which he actually was at his most objective, along with pictures of prostitutes and nondescript women as in, again, *Café, Boulevard Montmartre,* account for the persistent accusation of mysogyny.

In all these respects Degas' opposite is Auguste Renoir (1841–1919), probably the best loved of the impressionists today.

Renoir is a joyous painter, so convinced of life's goodness, which seems apparent to him on every hand, that he feels no need to philosophize or moralize about it. If he does not comment it is only because he does not find it necessary to ponder "the meaning of life." He finds life so wonderful that simply to participate in it gives meaning to existence. He never reports on life's specific fragments, as Degas does, because life in its wholeness is present for him in every woman he paints. Where Degas individualizes women Renoir generalizes woman as a symbol. Even when he paints a portrait we are conscious of womanhood first and only incidentally of the specific individual represented. And when he is not painting a portrait he repeats over and over again a facial and physical type that he adopted early and was content to vary only slightly as his art matured, not because he needed a convenient formula but because woman as a generic concept was lovelier to him than any individual set of features could ever be.

As a broad distinction: Degas' world is the world of intellect, Renoir's the world of the senses.

Renoir and the Mystique of Woman

Woman is a principle so pervading Renoir's universe that everything he paints is accessory to her. Children and flowers are corollaries to his concept of woman as a kind of earth- or life-symbol who blossoms and comes to fruition. Fields, streams, trees, and skies are echoes of her fertility. When Monet painted a woman out-of-doors, she became identified with the sward, the bushes, with nature around her, because she shared with other natural objects the faculty of reflecting light. But when Renoir paints a woman out-of-doors the relationship with nature is reversed. Instead of absorbing her, the impressionist shimmer and vibration is like an emanation from her, an emanation of the life she represents, animating all nature.

The mystique of woman is a constant in French art, and through Renoir impressionism makes its contribution to this tradition. The near-mystical veneration of woman in French art and life combines the simultaneous recognitions of her most direct attractions and her most profound significance. She is a creature of unusual sensibilities in human relationships, a reminder that no matter how complicated man may have made himself as a civilized being, he continues to exist only through the operation of a natural force he cannot explain but which woman embodies. This concept has given woman an extraordinary position in French life and thought. Among its many different early expressions was the medieval veneration of the Virgin coexisting with the code of chivalric love by which the knight served his lady.

Woman was never more pervasive in French life than during the eighteenth century at a court dominated by women and given over to the pursuit of lovemaking. In spite of all the dimpled affectations of eighteenth-century court art in spite of all the furbelows and ruffles and ribbons and fantasies of dress and manners, in spite of all the viciousness and indulgence of a sociologically indefensible way of life among the aristocracy—in spite of all this, the mystique of woman was never altogether obscured by the cultivation of woman as an object of pleasure, and the art of the eighteenth-century court painters was given over to her celebration. Renoir's contact with this art was early and direct.

As a boy (his father was a tailor from Limoges, poor and with a large family) Renoir was apprenticed to a decorator of fine porcelain. He copied onto cups and plates flowers and other motifs from the eighteenth-century court painter Boucher.* Their fresh pinks and blues,

* François Boucher (1703–1770) was also an early influence on David; some of his mannerisms are reflected in *Mars Vanquished by Minerva* [18]. But with David's shift to classicism Boucher became one of the painters he most abominated. Boucher's candified tints, his prettified girls, his great puffs and swirls of shining satins and taffetas, his hothouse flowers, his feminine elaborations are the quintessence of rococo style, suggesting perfumes, powders, erotic refinements. The surface of his painting is slick and shiny, his nudes sometimes seem almost rubbery. He is not much liked today but he is a delightful painter if he is regarded as a great stylist. Renoir was as much influenced by an earlier painter, Antoine Watteau (1684–1721), although less obviously.

their vivacity, their prettiness (a word of which Renoir was never afraid) always remained a part of Renoir's painting. Of Boucher's *Bath of Diana* [295] he once said that he kept going back to it again and again, "as one returns to one's first love."

Boucher's painting was full of the stylish artificialities and the titillations demanded by his patrons at the court and in the demimonde. It has won for itself the unflattering designation "boudoir painting." Renoir revivified the tradition by leaving the boudoir for the out-of-doors, abandoning Boucher's artificial paraphernalia for natural banks of grass and flowers. Instead of Baths of Diana he paints healthy young women bathing in country streams. Above all, he abandoned coy suggestion for a straightforward, full-blossomed sexuality that would have reduced his buxom nudes to biological specimens if he had not been so completely and naturally within a tradition wholly French—the tradition that combines the frankest delight in sexuality with the most unquestioning reverence for woman's fundamental significance as the source of all warmth and life in the world.

Renoir entered the studio of a painter named Gleyre* in 1862. As a student and then as a young painter with no resources and no patrons he kept himself alive doing occasional porcelain painting and some hack commercial work, including the decoration of window blinds. Monet was having the same struggle and the two men were good friends. For a few years Renoir groped about, imitating photographs briefly and working for a while in the manner of Delacroix. He later destroyed these pseudo-romantic productions, and the earliest Renoirs we have, from around the middle 1860s, show how much he learned from Courbet. *Bather with Griffon* [296], painted in 1870 and exhibited in the Salon that year, belongs to this early

* Marc Gabriel Charles Gleyre (1808–1874) was a Swiss who settled in Paris as a successful painter of history and genre. He made a Salon sensation in 1840, another in 1843. When Delaroche quit teaching, Gleyre took over his studio, and altogether he trained some five or six hundred students, among them Gérôme and, as well as Renoir, the other young future impressionists Monet, Sisley, and Bazille. Gleyre was a sound painter and had the respect of these young men although they had no ambition to follow him. He in turn recognized and respected the unusual talents of Monet and Renoir. He deserves a kind word in any history of nineteenth-century painting.

295 François Boucher. *Bath of Diana*. 1742. Oil on canvas, 22½ × 28¾″ (57 × 73 cm). Louvre, Paris.

group, which seem like preparatory work if they are thought of in context with Renoir's later career. But independently *Bather with Griffon* can hold its own in the company of great paintings of the nude in any time. If it lacks anything, it is the full individuality of style that marks a work of art as completely the artist's own.

Half a dozen influences are rather obviously at work here. There is the wonderful rich paint of Courbet, Courbet's feeling for the texture of young flesh expressed in pigment of an opulence that is in itself part of the expression of form. Renoir lightened this richness with the more delicate coloration, the pinks and blues of rococo painting, and lightened Courbet's spirit also by such details as the enchantingly feminine heap of discarded garments and the little dog lying on them. These are painted with a freshness and delicacy that make Courbet seem ponderous. The pose is a classical one, and significant as an indication of Renoir's early attraction to the stability of traditional forms to which he will hark back later when his art is more reflective. There are of course numberless Venuses of antiquity in variations of this pose, the first one probably having been Praxiteles' *Aphrodite of Cnidus* and the best known the *Venus de Medici* [297].

But, of course, there is not the faintest suggestion of neoclassical mannerism in Renoir's

use of a classical pose: *Bather with Griffon* is a realist painting from a living model. Everywhere it makes superb use of the academic technical disciplines, capitalizing on their sound virtues as Renoir learned them from Gleyre, ignoring the shallow uses to which they were ordinarily put. All these elements temper one another—classicism, realism, academicism, eighteenth-century sensibility—and all of them are bound together by Renoir's strongly personal response to the idea of womanhood.

After these early paintings, Renoir's development falls into four periods, during which he discovers and practices impressionism, then rejects it, and finally returns to it with variations.

Renoir and Impressionism

By 1870 Renoir was beginning to explore, with Monet, effects of light and air and ways of representing them with broken color. By the time of

296 Auguste Renoir. *Bather with Griffon*. 1870. Oil on canvas, 6'1½'' × 3'9¼'' (1.84 × 1.15 m). Museu de Arte, São Paulo.

297 *Venus de' Medici*. Roman copy or variation of Praxiteles' *Aphrodite of Cnidus*. Marble, life size. Uffizi, Florence.

298 Edgar Degas. *Café, Boulevard Montmartre.* 1877. Pastel over monotype, $16\frac{1}{2} \times 23\frac{1}{2}''$ (42 × 60 cm). Louvre, Paris.

the first group exhibition his impressionist manner was fully developed, and he continued working impressionistically until 1882. The dappled light, the diffused forms, the young grace, the air of courtship, typical of his work in this period, are consummated in the *Moulin de la Galette* [Plate 18, p. 269], an ambitious showpiece he painted for the third impressionist exhibition of 1877. The *Moulin de la Galette** has something of impressionism's momentary revelation of the subject and much of pure impressionism's haze of light fused with atmosphere. Yet Renoir is yielding only reluctantly to this cultivation of transient effects and shortly he will become thoroughly dissatisfied with them. Most of his figures are caught in repose. Like Degas in *Foyer de la Danse* [284], Renoir continues to feel the need for classical stability in his compositions; it finds its way into pictures of the early period almost as if without his will. His figures never quite lose their formal identity within the quivering luminosity surrounding them.

During this first tremendously productive period, Renoir painted portraits, figures, pure

*A *galette* is a kind of cake; the *Moulin de la Galette* was a popular, inexpensive dancehall and restaurant in Montmartre but later developed into a less savory spot than the one Renoir painted.

landscape, landscape with figures, still life, and street scenes. A comparison of *Moulin de la Galette* with *Café, Boulevard Montmartre* [298] demonstrates that Renoir and Degas lived in Paris as if in two different cities. For Renoir Paris was a city of light, happiness, air, movement, warmth, a city in blossom. For Degas it was a collection of human beings in haphazard juxtaposition, stratified in a system of social levels. Although the dancers in the *Moulin de la Galette* include portraits of several of Renoir's friends, they remain generic young females and their generic young male suitors, idolaters of the female principle. Only once, at the end of this delightful period, Renoir departs momentarily from the generic conceptions that are the rule in his work. In *Luncheon of the Boating Party* [299] the members are more definitely individualized by physical feature, even if not particularly so by psychological differences. Among them, at the left, holding a small dog, is the young woman who was soon to become Renoir's wife.

Renoir had by now found some patrons. An influential one was the publisher Charpentier, in whose garden he had occasionally painted. Renoir was beginning to find portrait commissions too, and in order to further these Madame Charpentier commissioned him to do a portrait of herself and her two little girls [300]. It was

299 Auguste Renoir. *Luncheon of the Boating Party.* 1881. Oil on canvas, 4'3'' × 5'8'' (1.3 × 1.73 m). Phillips Collection, Washington, D.C.

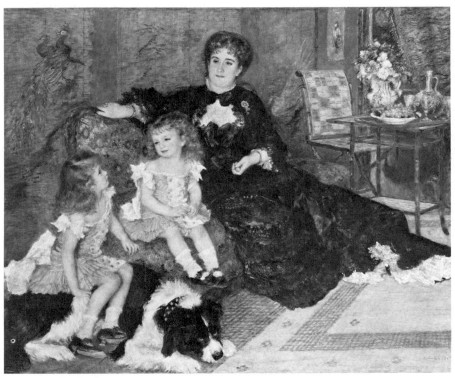

300 Auguste Renoir. *Madame Charpentier and Her Children.* 1878. Oil on canvas, 5'1½'' × 6'2⅞'' (1.54 × 1.9 m). Metropolitan Museum of Art (Wolfe Fund, 1907).

submitted to the Salon of 1879 and because (in part, at least) of the social prominence of the sitter it received a good position and was a success. (Renoir never shared the attitude of aggressive hostility toward the Salon and was glad to show there when he could get accepted.) He set about deliberately in the portrait of Madame Charpentier to paint a picture that would please conventional taste without prostituting his talent. He did not regard it as a lowering of standards or a denial of principles to modify his impressionist manner to accord more closely with Salon standards. The result was a fine portrait even if it is not Renoir's most exciting work. Its limitations, however, are apparent if it is compared with Degas'. portrait of the Baroness Bellelli and her two little girls [277]. It is one of the rare instances where Renoir by his own standards falls short of Degas by his.

With plenty of commissions coming his way by the end of the 1870s, when he was forty years old, Renoir had reached the point at which most painters would have industriously followed up their successes. But Renoir was full of dissatisfactions with the kind of painting he was doing. The direction of these dissatisfactions is apparent in the departures made in *Luncheon of the Boating Party* from the *Moulin de la Galette,* a nearly identical subject. *Luncheon of the Boating Party* is more sharply defined in its forms, more conventional (if no more successful and not quite so interesting) in its compositional balance. Renoir was ready to abandon the light touch of impressionism just when collectors were beginning to be attracted to it. A trip to Italy in 1882 verified his suspicions of impressionism and put an end to his impressionist period.

Return to Tradition

Restless, unsure of his direction, beginning to feel that in seeking effects of light he had forgotten "how either to paint or to draw," that in working directly from nature he had forgotten how to compose, that in impressionism a painter descended to monotony, Renoir had refused to exhibit with the group in their shows of 1879, 1880, and 1881. The Italian pilgrimage of 1882 had a definite goal: the Vatican frescoes of Raphael. They had been an academic shrine ever since Ingres had proclaimed Raphael's godhead. And they did not disappoint Renoir.

In their breadth and amplitude and definition, their "simplicity and grandeur," he said, they confirmed his dissatisfactions with impressionism. He saw too the Pompeiian paintings that had given such impetus to the classical revival a hundred years before, that had "removed the cataracts" from the eyes of David when he went to Rome as a young painter trained in the eighteenth-century tradition. And by chance Renoir also stumbled across a book now well known to painters but then obscure, a late-fourteenth-century handbook on the craft of painting by Cennino Cennini, a follower of Giotto, who described in great detail the technique of egg tempera painting, a technique demanding the clearest, the most concise definition of form, allowing for no suggestion, dictating implacably closed contours. Renoir had always admired Ingres' line, and now in the light of these Italian revelations he discovered new virtues in Ingres' meticulously controlled surface as well.

Renoir determined to subject himself to a period of discipline, to learn again how to draw, paint, and compose. *Dance at Bougival* [301], painted on his return from Italy, has a new solidity and definition in the two dancing figures, although the seated ones in the background are similar to those in the *Moulin de la Galette* in their softer, airier form. Renoir was equally determined, as a matter of practical business, to make a success in the Salon instead of directing himself toward the handful of art lovers who were "capable of liking a painting without Salon approval."* And he would do it this time without compromising, not even to the extent he had done in *Madame Charpentier and Her Children.*

The disciplinary problems he set himself were to be solved in a painting of bathers in a landscape [Plate 19, p. 270] on which he worked for three years, from 1884 to 1887, when it was exhibited at Petit's, a commercial gallery, with

* Renoir exhibited at the Salon for the last time in 1890 after abstaining for seven years, but his determination to make a Salon success is indicative of the whole reorientation of his way of thinking and painting. The need for Salon recognition passed when, about 1883, he reached a financial agreement with Durand-Ruel assuring him of an adequate income, and in 1892 Durand-Ruel held such a successful exhibition of his work that thereafter Renoir had no money troubles.

great success. Even most of the impressionists admired it, because Renoir's suspicions of impressionism as a blind alley had come to be shared by others of them (not by Monet) who were hunting their own ways out of its mists. In fact, the year before the *Bathers* was exhibited,

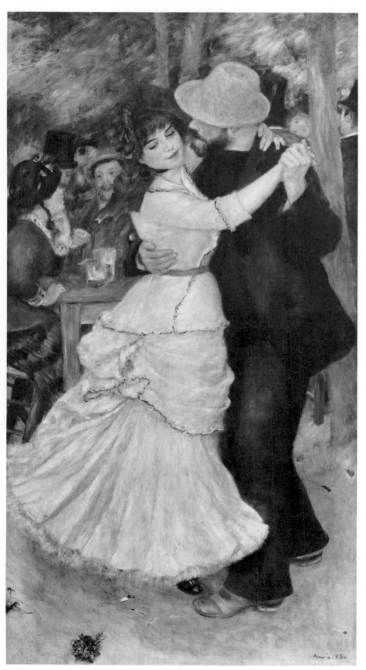

301 Auguste Renoir. *Dance at Bougival.* 1883. Oil on canvas, 5'10¾'' × 3'2½'' (1.8 × .98 m). Museum of Fine Arts, Boston.

the last group show had been held (1886), and of the major impressionists only Degas and Pissarro had participated.

The *Bathers* is a wonderful and in many ways a most inconsistent painting. It is obviously a demonstration piece, even an exercise, but the appreciation of its very sound brilliance in this capacity in no way hampers the simultaneous enjoyment of its lightness, its gaiety, and its charm. For all its Italian inspiration, Renoir's "tight" or "dry" or "harsh" period, as it is variously called, is not Italianate. The *Bathers* is closer to Boucher than it is to Raphael. These firm, pink nudes with their pouting lips, short noses, tapered hands and feet, and swelling curves have not changed much from the type of Diana and her attendant nymph, although the taffetas, the pearls, and the ornamental park where Diana bathed have given way to simple linen, a pin or two in the hair, and an ordinary bit of countryside. The lineage of these bathing girls goes even further back; Renoir adapted his composition from a seventeenth-century French bas-relief by the sculptor François Girardon on the Fountain of Diana in the gardens of Versailles [302, p. 254].

The playful sportiveness—splashing of water and so on—of Renoir's bathing figures is belied by their static and studied design. There is a contradiction, too, between the tight modeling within unsparingly precise outlines and the impressionistic opalescent shimmer of the background. Yet these contradictions do not matter. Renoir achieved an improbable combination of virtues: the picture is fresh, appealing, and intimate; it is also calculated and formal.

To explain the harmonious coexistence of these contradictory elements might be possible, but it is unnecessary if we accept something Renoir once said: "These days, they try to explain everything, but if a picture could be explained it wouldn't be art."* In the *Bathers* one element after another can be isolated for explanation—the echo of Ingres' line, the impressionistic vibration in the background, the eighteenth-century succulence of the nudes, the reference to Girardon who composed within a

* Renoir is not the only painter who has felt this way. Among many others, Picasso said the same thing when he was asked to analyze the symbolism of his *Guernica* and replied that if he had wanted to put it into words he would not have painted a picture, he would have written a book.

302 François Girardon. Late seventeenth-century cast of bas-relief from Fountain of Diana. North Terrace, Versailles.

certain tradition, the vestigial realism of the figure to the lower right. Yet, in the end, there is no necessity to explain why this great picture is not a mere studio concoction, if we admit that a total painting may be more than the sum of its parts, except one part which cannot be isolated, "the passion of the painter which carries everything else before it." These are Renoir's words, and in no painter's art are they more important than in his own.

Fulfillment

For Renoir, living and painting were indivisible. There is a steady correspondence between the changes in his way of painting and the progressive states of his maturity and experience as a human being. His impressionist pictures with their lovely girls, their happiness, their subjects of courtship, identify his own young manhood. The shift to new disciplines in painting coincides with his acceptance of new personal responsibilities, marriage and fatherhood. But he soon relented from the severities of his reaction against the "irresponsibility" of impressionism. By the end of the 1880s he was working toward a new manner, coincident with the period in his own life when the business of settling down had been achieved, when he had established an adequate security for himself and his family,

303 Auguste Renoir. *Nude.* c. 1888. Oil on canvas, 22 ×18¼″ (56 × 46 cm). Philadelphia Museum of Art (Louis E. Stern Collection).

and was discovering the quiet and rewarding fulfillments of middle age.

His effort in this period is to combine formal values in painting with such virtues of impressionism as can be dissected away from its shortcomings. He frees his brush once more; his touch quickens; he allows color-as-light to flood back into his pictures, but it is an obedient light respectful of the forms it illuminates. From the Renaissance Venetians Renoir had learned that free painting, full form, and luscious color could coexist with formal order, and he went to work to establish all these elements in his personal style. At first glance the pictures of this third period look like a reversion to impressionism; at second, the color is fuller and richer; the forms, even though the edges are no longer liney, remain solid. Beneath the renewed sweetness there is a more reflective sturdiness, beneath the surface informality an increased order. It is impressionism chastened by tradition, ordered by contemplation, dignified by maturity.

With the lesson of the *Bathers* behind him, Renoir returned to simple, intimate subjects, painting again his personal response to them without sacrificing what he had regained through formal discipline. Instead of the synthetic poses of the *Bathers* he paints the natural attitude of a young girl pulling on her stocking [303] but studies it as a composition of sculpturesque volumes. In the following years there are so many fine pictures that a selection at random could hardly fail to give a good example. Among them, *Two Girls at the Piano* [304] affords a double comparison with the *Bathers* and the *Moulin de la Galette.* In all three pictures Renoir employs one of his favorite motifs, consisting of a pair of figures, one seated in the foreground and the other, usually standing, behind her in an encircling attitude.

In the *Moulin de la Galette* these two figures are conspicuous in the center foreground. A girl in a light striped dress sits on a bench with one arm over its side; behind her a girl in a darker dress stands with her hand on the first girl's shoulder, leaning forward. The grouping is extremely pleasant, the effect is there, but there are ambiguities to the forms. It is not easy to follow the volumes and they are a bit cottony. In the *Bathers* the two figures on the bank in the left half of the picture are in comparable, although far from identical, relationship. The one in back holds a cape or towel across her shoulders in such a way that it forms a kind of terminating enclosure for the interrelated masses of the two bodies. There is no ambiguity to the forms; every volume is defined in space and in its exact relationship to other volumes. In *Two Girls at the Piano* the figure relationship of the two girls in the *Moulin de la Galette* is restudied to give it the formality of the *Bathers.* The formality is disguised; it is animated by the vivacious charm of the early masterpiece, but the formality is there, and it makes of *Two Girls at the Piano* something more than a charming picture, just as it is also something more than a formal exercise. It is an impressionist delight if savored only for its color and its subject. But if regarded more abstractly as a series of interrelated volumes, it builds almost sculpturally into interrelated masses. The sense of weightiness, of solid form, and the reduction of the various elements in the picture to semigeometrical

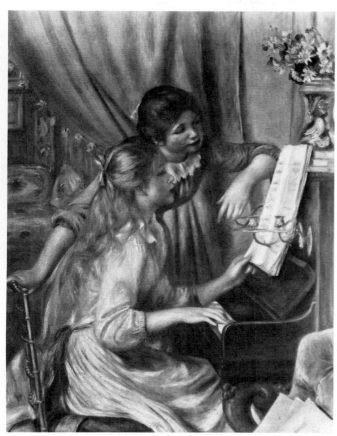

304 Auguste Renoir. *Two Girls at the Piano.* 1892. Oil on canvas, 45½ × 34½″ (116 × 88 cm). Louvre, Paris.

equivalents increase the generic quality of the figures. The swelling volumes, pulsing with color, are Renoir's symbols of the burgeoning generative forces of nature.

Last Pictures

In Renoir's final period this expression surges into full undisguised statement. From the point of view of the usual painting of the female nude, the *Bather* [305] painted in 1917 or 1918, shortly before Renoir's death at the age of seventy-eight, is grotesque. The swollen belly, the massive thighs, the great heavy feet, the billowing construction of flesh drenched in the color of strawberries and oranges against the acid greens of the tumultuous background—these are strong fare. By one standard of comparison Renoir has exaggerated his former virtues beyond the point of tolerance and to the point of absurdity; by another, he has reached the only logical conclusion to the basic conception that he stated nearly fifty years earlier in *Bather with Griffon* [296]. The heavy, rolling, glowing masses of the late paintings may be grotesque as human female figures, but they are magnificent as abstract expressions where color and form in themselves have finally become fully identified with the omnipotent and indestructible fertility of nature.

It is typical of most painters who work over a very long period of time that their late work is painted most loosely, with greatest freedom. This was true of Renoir, and the natural tendency was exaggerated by a physical malady that appeared as early as 1881 and had begun to cripple him by 1890.* In his old age rheumatism had so paralyzed him that he had to paint in a wheelchair with his brush strapped to his hand. When a foolish visitor asked him how he managed to paint such beautiful pictures under such difficulties, Renoir rebuked him with "One does not paint with one's hands." This was not altogether apt if it is taken to mean that Renoir had never considered sheer manipulation of paint of any importance, for he loved the texture of oil as much as Courbet did, and could apply it just as sensuously. But it is true that Renoir was one of those artists who paint from the heart, to such a degree that the work of the

* At this time Renoir left Paris to spend the rest of his life in Cagnes, in the South of France.

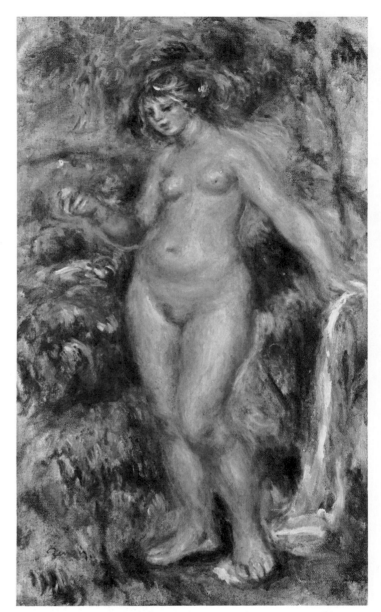

305 Auguste Renoir. *Bather*. 1917–1918. Oil on canvas, $20\frac{1}{4} \times 12''$ (51×30 cm). Philadelphia Museum of Art (Louise and Walter Arensberg Collection).

hand and the expression of the heart were identical. From time to time there is a critical flurry during which Renoir's "sentimentality" is discovered with disapproval. But it never takes long for such flurries to subside. In the wonderfully balanced art of Renoir, sentiment is chastened by formal order and formal order is warmed by sentiment.

chapter 18

Impressionism's Precursors and Individualists

Boudin and Jongkind

Several dozen painters' names could be catalogued as indirect contributors to the development of impressionism, and several hundred respectable ones discovered it after the end of the century and made it standard exhibition fare in Europe and America. Leaving most of them to the encyclopedia, we still must mention some fine and important painters who were second only to the men who have emerged as impressionism's giants.

Eugène Louis Boudin (1824–1898) was older than the rest of the group. His sixteen years' seniority put him in something of a fatherly position to Monet when he met that penniless and precocious youth in Le Havre, which was Boudin's native city as well as Monet's. It was Boudin who first interested Monet in landscape, to which for some reason the youngster had adopted a scornful attitude, and they worked together on landscape subjects.

The typical Boudin is a long and placid strip of beach, usually at Trouville, with ladies and gentlemen ranged in front of the sea's horizon beneath a wide, high, and deep expanse of sky, usually seraphic, occasionally threatening [306]. A figure may be indicated in three or four touches of paint in different colors—a white skirt, a red shawl, a blue umbrella—accented with bits of dark for heads and feet. But Boudin also did pure landscapes, not always involving water and beaches He was interested in representing different weathers; these effects, and his cursory notations of form, made him a precursor of impressionism before he exhibited in the first impressionist show. He shared the impressionists' later triumphs and was also awarded a Salon medal in 1889 and the Legion of Honor in 1892. Not strictly speaking an impressionist, Boudin was acceptable on much the same terms as the Barbizon men, whose paintings by then were established commodi-

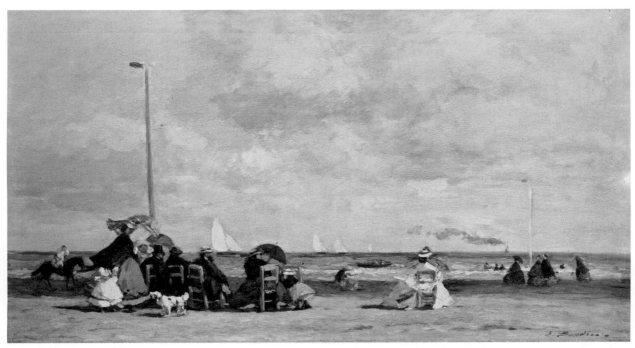

306 Eugène Boudin. *Beach at Trouville*. 1864–1865. Oil on panel, 10¼ × 18⅞″ (26 × 48 cm). National Gallery of Art, Washington, D.C. (Ailsa Mellon Bruce Collection).

307 Johann Barthold Jongkind. *Drawbridge*. Date unknown. Oil on canvas, 18½ × 21¾″ (47 × 55 cm). Philadelphia Museum of Art (Robert Stockton Johnston Mitcheson Collection, given in his memory by Lucie Washington Mitcheson).

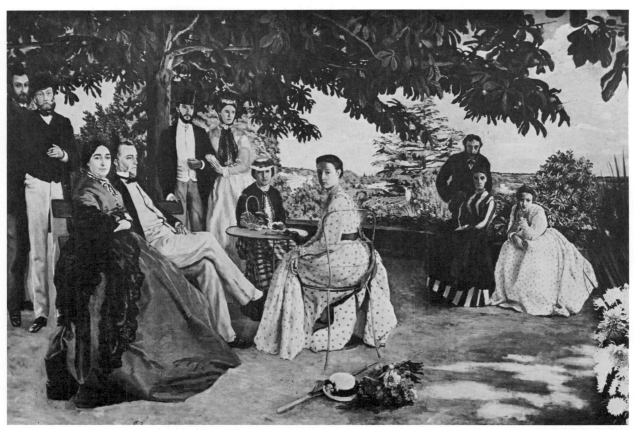

308 Frédéric Bazille. *The Artist's Family.* 1868 (retouched 1869). Oil on canvas, 5'3¾'' ×7'7'' (1.54 × 2.31 m). Louvre, Paris.

ties. He is a delightful painter, more and more sought by collectors.

Johann Barthold Jongkind (1819–1891), a Dutchman, spent his mature life in France. For a while he joined the Barbizon painters, but for the most part he worked independently. He had a strong influence on Monet, and on Sisley and Pissarro, because he investigated transitory effects of light and painted with a quick, vibrant brush. This is his closest connection with impressionism, but an equally important aspect of his art not frequently enough mentioned is that Jongkind was a romantic landscapist [307] in the spirit (if not the technical tradition) of earlier Dutchmen, especially Ruisdael [198].

Bazille

Frédéric Bazille (1841–1870) was a close friend of Monet and Renoir in Gleyre's studio and a popular member of the circle at the Café Guerbois. He was a tall, handsome young man with money and talent who was still finding himself as a painter when he was killed during the battle of Beaune-la-Rolande in the Franco-Prussian War of 1870. He was born the same year as Renoir, and in looking at the few pictures he painted before his life was cut so short, one must remember that if Renoir had been killed at this time, of the pictures illustrated in this book only *Bather with Griffon* would have been painted. Even Monet's impressionism was in its early stages, and the first group show was not held until four years later.

The characterizing feature of Bazille's work is a painstaking disposition of the elements of a nominally informal subject. A group portrait of his family on a terrace [308], a picture more than eight feet long, which was exhibited in the Salon of 1868, is filled with a curious, stiff, unnatural stillness that extends even to the leaves on the trees in the distance. It is anything but impressionistic. The yet more curious *Summer*

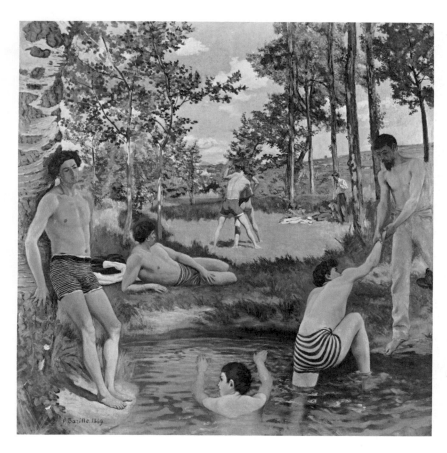

309 Frédéric Bazille. *Summer Scene, Bathers*. 1869. Oil on canvas, 5'1⅝" × 5'2" (1.58 × 1.59 m). Fogg Art Museum, Harvard University, Cambridge, Mass. (gift of M. and Mme. F. Meynier de Salinelles).

Scene, Bathers [309], painted in 1869 and exhibited in the Salon of 1870, shows a further imposition of rigid pattern, now geometrical, on a scene filled with casual attitudes—or, at least, attitudes transfixed from casualness into Bazille's odd rigidity. Compositionally the picture is closer to "neoimpressionism," a movement we will discuss shortly, than to impressionism, and it is difficult to avoid pointless conjectures as to the course impressionism might have taken if Bazille had lived beyond the first period of what surely would have been an exceptional creative life.

A third painting, freer in technique, has poignant associative interest. This interior of *The Artist's Studio* [310] shows a group of young friends. Renoir is seated at the extreme left. Just above him, on the stair, is Zola. Manet stands in front of a painting on an easel. Behind him is Monet, and standing at the side of the easel is Bazille himself. Manet painted this figure, or at least Bazille's head. At the far right their musician friend Edmond Maître is at the piano.

Morisot

Berthe Morisot (1841–1895) was a granddaughter of the painter Fragonard* and the sister-in-law of Manet, but her interest in painting was not the result of this connection. Manet painted her frequently; she is the seated figure in *The Balcony* [248]. Berthe Morisot is a charming painter, and a sound one, too, making her own variation on Manet's broad style, although she first painted as a pupil of Corot and at times is a little influenced by Degas. Early in her career she appeared in the Salon, but she forswore Salon exhibition as a declaration of

* Jean Honoré Fragonard (1732–1806) was the last in the three-generation trio of eighteenth-century painters—Watteau, Boucher, and Fragonard—and the most facile. In line with the taste of the day, his style was feminine, coquettish, fanciful. As a successful painter he threw a commission to an unknown youngster named David. In lion-and-mouse fashion, David returned this favor by protecting Fragonard after the Revolution.

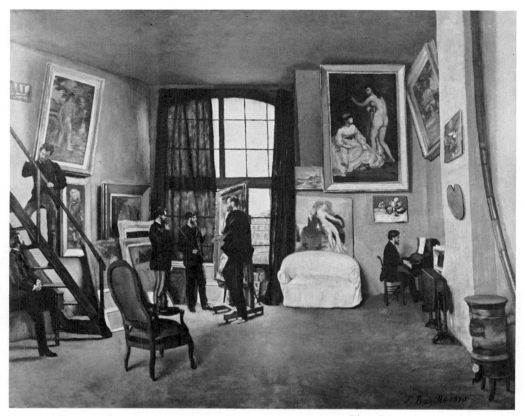

310 Frédéric Bazille. *The Artist's Studio.* 1870. Oil on canvas, 38⅞ × 47″ (99 × 119 cm). Louvre, Paris.

311 Berthe Morisot. *Woman at Her Toilet.* c. 1875. Oil on canvas, 23¾ × 31¾″ (60 × 81 cm). Art Institute of Chicago (Stickney Collection).

faith in the impressionist cause. This faith was enduring; she continued to paint impressionistically after Renoir and others had abandoned the cause. She exhibited in all but one of the group shows and did more than her share of the hard work involved in organizing and maintaining an association of frequently difficult temperaments. Her sister Edma also painted for a while, but quit to become a wife and mother. Berthe successfully combined matrimony, motherhood, and a career.

Berthe Morisot's delightful *In the Dining Room* [Plate 20, p. 270], with its sensitivity, flourish, and style is one of impressionism's most entrancing pictures. It is customary to say about any woman painter, as if it were the ultimate compliment, that she paints with almost the vigor of a man. But the beauty of Berthe Morisot's art is its femininity, which in her case is not to be confused with weakness, indecision, or an only partial achievement of a masculine standard. One would not want to "strengthen" *Woman at Her Toilet* [311] any more than one

would want to endow its lovely model with the muscles of a wrestler.

Berthe Morisot was an extremely engaging correspondent. Her letters are full of illuminating comments on Manet. As a random sample, speaking of *The Balcony,* she said that Manet's paintings make "the impression of a wild or even slightly green fruit," a very neat characterization of the exotic and somewhat astringent quality of that picture in comparison with the Salon paintings of 1869 among which it appeared.

Berthe Morisot was rather jealous of another woman painter of talent who studied under Manet and followed his manner closely. This was Eva Gonzalès, the only painter Manet ever permitted to name him as teacher. She was a proficient technician, although obvious in her echo of Manet. She did not exhibit in the group shows, probably because Manet did not.

The impressionist movement produced three exceptional women painters. The third was an American, Mary Cassatt.

Cassatt

Mary Cassatt (1845–1927) was an extraordinary young woman, the daughter of a wealthy Pennsylvania family, who against her parents' wishes went to Paris to continue the study of painting, which she had begun at the Pennsylvania Academy of the Fine Arts in Philadelphia. In Paris, enrolled in the studio of an established conventional painter, she found herself drawn to the art of the impressionists, and in 1879 and thereafter she exhibited with them. She was a hard worker and a stern self-disciplinarian. She was closer to Degas than to any other of the impressionists (efforts to establish a romantic liaison between the two, in the interest of fictionalized biography, have been fruitless) and shared his interest in capturing casual gestures as if unobserved by the model, as in *Woman Arranging Her Veil* [312]. But Mary Cassatt was not an imitator of Degas or of anybody else. She developed her own distinctive style of precisely defined form, which she combined with impressionist informality of subject and composition [313].

Mothers and children were favorite subjects of Mary Cassatt; she never married, and it would be easy to read into this fact something of frustration and compensation, except that the other facts of her life would not bear out such a con-

312 Mary Cassatt. *Woman Arranging Her Veil.* c. 1890. Pastel, 25½ × 21½'' (65 × 55 cm). Philadelphia Museum of Art (bequest of Lisa Norris Elkins).

clusion. She was a vigorous woman, and lady, with a great many friends, and was apparently quite happy in her career as a painter without the impedimenta of a husband and children. Although she was a friend of the impressionists during their difficult days, she never for a moment participated in anything suggesting bohemianism. Her personal life on both sides of the Atlantic remained that of a sensible, cultivated, level-headed, and privileged gentlewoman, which makes her enthusiastic participation in the "scandalous" movement of impressionism all the more admirable.

Mary Cassatt is an important figure in the history of the development of American taste because she introduced her wealthy American friends to the new art and urged them to collect it. The pictures bought by the Havemeyer family especially, now in the Metropolitan Museum of Art, are the American equivalent of the Caillebotte collection in the Louvre.

313 Mary Cassatt. *The Bath*. 1891. Oil on canvas, 39 × 26″ (99 ×66 cm). Art Institute of Chicago (Robert A. Waller Fund).

Mary Cassatt's most individual creative efforts were not her paintings, which were always respectable and frequently superior even by the demanding standard of the company they kept, but her prints, which were something more. For the other impressionists, prints were an adjunct to painting, forms of drawing although in media somewhat more complicated than the ones ordinarily used. For Mary Cassatt, as for all first-rate printmakers, there was an excitement in meeting the technical demands of the print and capitalizing on them to produce works of art where the medium and the expression were interdependent. Under the inspiration of Japa-

nese block prints she brought a new crispness, definition, and economy to etching in combination with its related techniques, drypoint and aquatint. Prints like *The Letter* [314] capitalize on the interest in daily household activities shared by the Japanese printmakers and the impressionists and combine Japanese interest in flat pattern with Western drawing. The demanding techniques of fine printmaking were attractive to this extraordinary woman, who seems to have mistrusted effects of spontaneity as cultivated by the majority of her impressionist colleagues. Mary Cassatt combined militant support of the impressionist cause with her own resolute individuality within its ranks.

Impressionism: Its Unity

Considering the wide range of personal styles among the impressionists, and the wide range, too, of their expressive goals, what accounts for the commonality they present in retrospect?

314 Mary Cassatt. *The Letter*. 1891. Etching and aquatint, 13⅝ × 9″ (35 × 22 cm). Philadelphia Museum of Art (Louis E. Stern Collection).

They were united in their conviction that the world around them in its most casual aspects offered the most fascinating material for painters; that the accidental relationships between people strolling in the streets were more interesting, richer in their variety, than the formulas for studio compositions. This, of course, became a declared principle, consciously observed. But there was something more, something less obvious but, if anything, more basic: their dispassionate, objective response to form in visual terms, a quick, spontaneous response that leaves its imprint even on those artists who, like Degas and Cassatt, discipline this response most firmly. Whether it is a matter of landscape, urban scenes in the street or in cafés and theaters, or domestic interiors or portraits; whether the artist's individual style presents the subject as brilliantly shattered as Monet's or as concisely bounded as Cassatt's; whether the artist's sympathies are those of a nature lover, a scientist, or a psychologist—the imprint of the immediate response to form in purely visual terms remains indelibly imprinted on the completed painting. *Impressionism* as the term is ordinarily used is most strongly associated with the translation of light into its broken components on canvas, but in its fullest meaning the term goes beyond this eye-and-hand technical duet. The impressionists—at least in France—identified their immediate objective response to visual form with their deeper, subjective response to life, and although they never formulated this relationship as a doctrine, and perhaps were not always conscious of it, it is the relationship that unifies the impressionists and makes of impressionism a profound art rather than reportage on the contemporary scene.

Impressionism in England: Whistler

The Pre-Raphaelite movement was well under way when the Salon des Refusés took place in 1863. One of the most detested pictures in that exhibition was *The White Girl* [315] by a young American, James Abbott McNeill Whistler (1834–1903), who, having been dismissed from West Point (he failed chemistry), had come to Paris to study under Gleyre. In Paris he knew Courbet, Manet, Monet, Degas, and Fantin-Latour. *The White Girl,* which he preferred to call *Symphony in White No. 1,* is one of the fine

315 James Abbott McNeill Whistler. *The White Girl.* 1862. Oil on canvas, 7'1½'' × 3'7'' (2.17 × 1.09 m). National Gallery of Art, Washington, D.C. (H. W. Littemore Collection).

pictures of nascent impressionism, and there is no good explanation as to why Whistler at this point abandoned Paris. It was not that he was wounded by the reception of *The White Girl* or because he feared a good fight. For the rest of

his life he was one of the liveliest scrappers in the London arena.

Without adopting Pre-Raphaelitism he became a fixture in the Pre-Raphaelite aesthetic circle and that of the younger men, like Oscar Wilde, who carried Pre-Raphaelite aestheticism on into the 1890s with even more precious and immensely more sophisticated variations. Whistler knew the poet Swinburne and the novelist and critic George Moore; he became a great dandy and a famous wit, a bright figure among the creative talents and their admiring circle who continued the Pre-Raphaelite revolt against Victorian materialism and stuffiness.

As an impressionist, Whistler never adopted the broken strokes and the sunlit effects developed by his former French associates. He worked instead more and more in a muted palette of grays and blacks, softly blended, painting the misty tonalities of evening or gray days, sometimes flecked or splashed with red or golden lights, with strong reference to Japanese prints or Oriental ink-wash drawings with their simplification and their subtle, colorless gradations. Ruskin, who had understood Turner's art when he was a young man, was unable to accept Whistler s now that he was an aging professor. He was so infuriated by Whistler's *Falling Rocket, Nocturne in Black and Gold,* a picture which might have delighted Turner, that he wrote "I have seen, and heard, much of cockney impudence before now; but never expected to hear a coxcomb ask two hundred guineas for flinging a pot of paint in the public's face." Whistler sued Ruskin for libel, as much for the sport of it as for any other reason, and after a well-publicized trial was awarded damages of one farthing. Poor Ruskin suffered a mental

316 James Abbott McNeill Whistler. *Arrangement in Gray and Black No. 1 (The Artist's Mother).* 1871. Oil on canvas, 4′9″ × 5′4½″ (1.45 × 1.64 m). Louvre, Paris.

breakdown the following year (1878) and for the remaining miserable twenty-two years of his life was removed from the critical scene while Whistler continued to send up his rockets.

Because he wrote well and because he talked so wittily that his bon mots were repeated everywhere, Whistler had great influence among intellectuals and cultivated amateurs. His central idea was that of art for art's sake—the belief that abstract values in painting, such as form and color, should exist for themselves, not as accessories to the imitation of nature or, especially, to storytelling. He called his pictures "symphonies," "arrangements," "harmonies," or "nocturnes" in an effort to induce the public to see a painting as a painting, not as a picture of something. The picture still popularly called *Whistler's Mother* he insisted on calling *Arrangement in Gray and Black* [316, p. 265] because "that is what it is. To me it is interesting as a picture of my mother; but what can or ought the public to care about the identity of the portrait? The imitator is a poor kind of creature. If the man who paints only the tree, or flower, or other surface he sees before him were an artist, the king of artists would be the photographer."

If this idea sounds elementary today, one reason is that Whistler helped to establish it as a basic tenet in modern art. His rejection of imitative effects allies him more closely with modern abstract painters than with the impressionists. In the meanwhile, the English public continued to respond to nonabstract sentimental anecdotes. *The Doctor* [317] is a standard example.

Unhappily, Whistler's own painting sometimes falls a little flat in the light of his theories. It seldom goes far beyond the level of tasteful arrangements of objects that remain semiphotographically represented, even though they may be in a focus so soft that they virtually disappear. The exquisiteness and daintiness of Japanese screen painting rather than the force of the finest Japanese prints influenced him in pictures like the portrait of *Miss Cicely Alexander* [318]. To the fragile charm of the picture there can, of course, be no objection. The disappointment is only that Whistler's pictures never have the importance that a more thoroughgoing application of his theories could have given them. He paints more like a tactful follower of someone else's theories than an adventurous creative artist in his own right.

317 Luke Fildes. *The Doctor*. 1891. Oil on canvas, 5'5½" × 7'11¼" (1.66 × 2.42 m). Tate Gallery, London.

318 James Abbott McNeill Whistler. *Miss Cicely Alexander: Harmony in Gray and Green.* 1872. Oil on canvas, 6'2¾'' × 3'2½'' (1.9 × .98 m). Tate Gallery, London.

This is less true of his etchings, where he brought a new sensitivity to the medium. Beginning conventionally— which at that time meant beginning with the attitude that an etching is not much more than a drawing done on a copper plate in such a way that it can be printed many times over—Whistler eventually developed a manner dependent upon the treatment of the plate itself. With a few lines indicating the subject he would wipe the plate elaborately to produce infinitely subtle tonalities and gradations. Since the plate had to be inked and wiped for each impression, each impression was, in effect, an original work.

Whistler was a great battler against philistinism, but at the same time he gave ample support by his style of life to the philistine's conception of the artist as an undependable fellow who may be very sensitive and all that, but is not likely to be very sound.

His personality supported the idea. In public he cultivated affectations of dress and manner, and in private he was a difficult man, demanding a worshipfulness from his friends and students that they finally tired of giving. One of these was Walter Richard Sickert (1860–1942), who studied under Whistler until the inevitable rupture and was then self-taught. After a while virtually nothing of Whistler remained in Sickert's work. He became a solid, downright painter, as English as boiled mutton. He borrowed heavily from Degas for subject matter and composition, yet retained his earthiness in contrast to Degas' civilized mastery. It was not through Whistler, but through Sickert, a quarter of a century after it had shaken France, that impressionism was imported to England and given a national flavor.

Sickert founded an association of painters called the Camden Town Group, in 1911, to "advance" British painting, but the group was neither impressionist nor, in 1911, very advanced. A partial explanation for England's indifference to impressionism may be that so many of impressionism's most attractive elements had been anticipated, in different form, by Constable. Also, impressionist effects of light seemed pallid after Turner's blazing canvases; for that matter, English watercolor supplied the fresh tonalities offered in oil by impressionism. These factors were sufficient to take the edge off the excitement of impressionist innovations. And as for portraiture, the British tradition was not only inviolable but it, too, offered enough

319 Giovanni Fattori. *La Rotonda di Palmieri*. 1866. Oil on canvas, 4⅞ × 13⅞" (12.4 × 35.6 cm). Galleria d'Arte Moderna, Florence.

of the light touch of Renoir (through Gainesborough and his tradition) and even the breadth of Manet (through Reynolds and his) to make investigation of what the Frenchmen were doing seem a little pointless.

Italy: The Macchiaioli

While its battles were being fought and won in Paris, impressionism remained all but totally a French affair. After the victory, other national impressionist schools proliferated on the French model, especially in America. The exception was Italy, where a group of painters called the Macchiaioli anticipated something similar to impressionist theory and practice as early as 1850, with a culminating exhibition held in Florence in 1861, thirteen years before the impressionists organized their first exhibition in Paris.

Like the impressionists, the Macchiaioli were a vanguard group in revolt against the stultification of official painting, which, because comatose, was even more depressing in Italy than in France. Like the impressionists too, they developed their ideas in lively discussions in a café; their Guerbois was the Caffé Michelangelo in Florence. And in a way similar to the impressionists' they thought that their immediate responses to the visual world could best be rendered in *macchie* (splashes) of colors. The major difference occurred here, for the Macchiaioli employed contrasts of dark and light colors instead of the high-keyed prismatic

palette with which the impressionists played vibrant fields of light across their canvases.

A comparison of *La Rotonda di Palmieri* [319] by Giovanni Fattori (1825–1908) with a Boudin we have already seen [306] should give, even in black and white, an idea as to why Boudin's art is protoimpressionist while that of the Macchiaioli, in spite of theories similar to those the impressionists were to advance later, offered no extensions in the direction impressionism was to explore. Fattori's very attractive picture is a static patchwork of somewhat heavy, modified colors rather than a fracturing and refusion of pure tints. It is best enjoyed if accepted for its decorative charm rather than regarded as a protoimpressionist failure, which is the way it tends to be seen by historians.

The Macchiaioli found an early spokesman and patron in Diego Martelli, whose portrait by Degas we have seen [283]. But in Martelli they also found their nemesis. Having discovered the French during their early triumphs and scandals, Martelli lectured in Italy on Manet, Renoir, Degas, Pissarro, and Cézanne. Confronted with this formidable array of new masters, the Italians abandoned whatever direction their own ideas might have taken them and adopted impressionism wholeheartedly.

Their work is so largely concentrated in Italian collections that the Macchiaioli are seldom seen elsewhere, which is unfortunate, since they are painters of great charm in the isolated historical enclave that they occupy. Other members of the group were Telemaco Signorini, Silvestro Lega, and Adriano Cecioni.

Plate 17 Edgar Degas. *Estelle Musson (Mme. René de Gas).* 1872 –1873. Oil on canvas, 24⅛ × 19¾″ (61 × 91 cm). National Gallery of Art, Washington, D.C. (Chester Dale Collection).

Plate 18 Auguste Renoir. *La Moulin de la Galette.* 1876. Oil on canvas, 4′3½″ × 5′9″ (1.31 × 1.75 m). Louvre, Paris.

Plate 19 Auguste Renoir. *The Bathers (Les Baigneuses)*. 1887. Oil on canvas, 3'10⅜" × 5'7¼" (1.18 × 1.71 m). Philadelphia Museum of Art (Mr. and Mrs. Carroll S. Tyson Collection).

Plate 20 Berthe Morisot. *In the Dining Room*. 1886. Oil on canvas, 24⅛ × 19¾" (61 × 50 cm). National Gallery of Art, Washington, D.C. (Chester Dale Collection).

chapter 19

The Situation in Germany

Feuerbach and Böcklin

In Germany after 1850, academic classicism reached the end of its road in the work of Anselm Feuerbach, while German romanticism put forth its most showy bloom with Arnold Böcklin. Both men were immediate contemporaries of the founding brothers of the Pre-Raphaelites; the birth dates of Rossetti, Hunt, Millais, Feuerbach, and Böcklin are crowded into the same three years—1827, 1828, 1829—which means that all of them were beginning their careers as the century made the turn into its second half.

Feuerbach (1829–1880) is a kind of German Ingres, struggling against the current to perpetuate the academic classical tradition. He studied at the Düsseldorf and Munich academies that paralleled the École des Beaux-Arts; he also studied in Paris under Couture, Manet's teacher. Like Ingres and then Couture, he persisted in his allegiance to the classical subject with derivations from the Italian Renaissance. He had something of Ingres' feeling for line and much of the formal solidity and tonal harmony of Couture at his best. He was a sensitive and austere artist when he was not smothering his personal genius under excessive conformity to tired formulas. He was not altogether a success, being overshadowed by Böcklin's effulgent romanticism as well as by newer developments in vigorous realism that were fermenting at the same time in Germany, in line with Courbet's realism in France. Nor is he much remembered outside Germany today, in spite of such achievements as the portrait *Nanna* [320, p. 272], with its impressive reserve and beautiful pattern, or *Orpheus and Eurydice* [321, p. 272].

The latter picture especially shows why Feuerbach's reputation has grown steadily in Germany until today he is one of the most revered of German nineteenth-century masters, while at the same time his influence on German

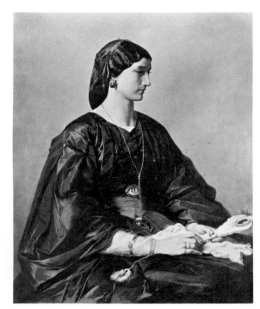

320 Anselm Feuerbach. *Nanna*. 1861. Oil on canvas, 46¾ × 38¼″ (119 × 97 cm). Staatsgalerie, Stuttgart.

painting has been negligible. The sensitivity and restraint of *Orpheus and Eurydice,* the elegance and clarity and control imposed upon a subject of intensely emotional nature, are foreign to the German tradition of fervent and mysterious statement. Feuerbach was a truly classical artist. As such he is isolated within the Germanic tradition, which has combined such disparate ideals as passionate emotionalism and literal realism but has never absorbed much of the classical ideal that demands the transmutation of passion and reality into images of abstract and logical beauty. German aestheticians helped formulate that ideal but Germany's great creative painters have never followed it. Artistically, Feuerbach remains a foreigner, although a respected one, in his own country. Spiritually he is closest to the long classical traditions of Italy and France, but in those countries he is overshadowed because he neither initiated a school nor made a sufficiently conspicuous contribution to the one he followed. He is a painter of exceptional quality who seems destined to perpetual obscurity because his painting never followed an exceptional direction.

Feuerbach's romantic contemporary, Böcklin (1827–1901), on the other hand, was a great success. Generally regarded as a master during his own lifetime, he was virulently attacked by

critics at the beginning of the twentieth century, to such an extent that his merits, which exist, were obscured by his shortcomings, which can be disastrous. It takes much patience and tolerance not to pass by some of Böcklin's most serious work as gross, obvious, or even laughable. But the pendulum has swung faster for Böcklin than for most painters, and recently he has become an interesting figure historically, since critics have recognized his influence on contemporary fantastic painting, notably surreal-

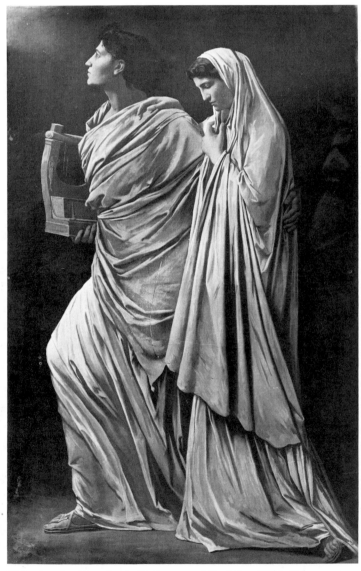

321 Anselm Feuerbach. *Orpheus and Euridice.* 1869. Oil on canvas, 6′4¾″ × 4′3¾″ (1.95 × 1.24 m). Kunsthistorisches Museum, Vienna.

ism. Just now, Böcklin's work must be regarded with a kind of double vision. Much of it looks trite, pretentious, ludicrously ponderous in its effort to create a world of fantasy in concrete terms. But that effort is important. The only way to approach Böcklin today is to clear the field by admitting first how "bad" some of his pictures are in order to reach a more sympathetic understanding of how "good" they almost are.

Böcklin's work divides easily into a few categories. First there are his sentimental classical landscapes filled with ideal allegorical figures. One of the standard examples is *Spring* [322], a picture that suffers from having too much of a perfectly good thing, a redundance of obvious symbols—maidens, young lovers, gamboling cupids, budding trees, blossoming sward, fluffy clouds. It is typical of Böcklin to belabor his point. In *Spring* he is like a guide who takes us by the hand and insists on explaining each detail of a subject with which we are already too familiar. Except that it is obvious and insistent, *Spring* is a respectably composed picture, with passages ranging from poetic subtlety (as the

hill covered with mingled foliage and architecture) to the most hackneyed symbolism. Böcklin wanted to capture the innocence of vision that was Runge's primary concern; this is one of several factors in his art allying him directly with the traditions of early German romanticism. Innocence of this kind escapes Böcklin (although he is naïve, which is not quite the same thing), but in the swarm of pictures he produced in this classical-sentimental-lyrical-romantic manner, an occasional one rings true enough to rebuke us. In *Sappho* [323], for instance, the lyrical mood is more effective for being simpler. *Sappho* is in an almost literal sense a less wordy picture than *Spring*. A single figure gleams magically in the dark of a forest; the expression of private revery is increased because her back is turned toward us; there is no story, no direct allegory, no symbolism already too familiar. The mood created is, in short, created pictorially, Hence *Sappho* is more satisfying than *Spring* with its conducted tour of literary clichés. Pictures in this classification make up the bulk of Böcklin's early work and

322 Arnold Böcklin. *Spring*. c. 1870. Oil on canvas, 28¼ × 22¾″ (72 × 58 cm). Schack Gallery, Munich.

323 Arnold Böcklin. *Sappho*. Before 1890. Oil on canvas, 37¼ × 29″ (95 × 74 cm). John G. Johnson Collection, Philadelphia.

they continue to appear throughout his life, with variations.

A second group of pictures shows tritons, nereids, mermaids, sirens, nature gods, evil hobgoblins, and other fantastic creatures related to Germanic legends. These appear thick and fast during the 1870s, and of course parallel Wagner's operatic use of the same material at the same time. (Wagner was fourteen years older than Böcklin.) Böcklin intersperses these Teutonic creatures with centaurs and other classical monsters, using them in the same Germanic spirit of ominous mystery and violence.

Böcklin shared coincidentally with the Pre-Raphaelites the idea that extraordinary subject matter could best be represented in realistic images, an idea that cropped up several times during the century. William Blake, with his "spirits and visions delineated in stronger lineaments than the perishing and mortal eye can see," was one expression of it. So were Friedrich and Runge, with their explicit detail in the service of mysterious and nostalgic recollec-

tion. The Nazarenes and the pre-Raphaelites "discovered" that religious subject matter had been effectively presented in realistic detail by medieval artists. Böcklin differs from the painters in this list because he was not interested in sharply detailed realism so much as in full-bodied, matter-of-fact presentation of his fantasies, as if they had been set up in the studio and then painted without imaginative variation. When his "magic realism" fails to come off it is for the reason that his most fantastic subjects seem, in the end, heavyhanded and literal. This is true, at any rate, of the pictures showing nereids, tritons, hobgoblins, and the like. One cannot help wishing sometimes that his playful water creatures would get back into their clothes and return to the beer hall where their roistering properly belongs.

Finally, there is the third group, Böcklin's dreamlike landscape inventions, like the well-known *Island of the Dead* [324]. These are quite directly the continuation of Friedrich's ruined Gothic choirs, graveyards, and threatening for-

324 Arnold Böcklin. *Island of the Dead.* 1880. Oil on panel, 2′5″ × 4′ (74 × 1.22 m). Metropolitan Museum of Art, New York (Reisinger Fund, 1926).

325 Hans Thoma. *Woodland Meadow.* 1876. Oil on panel, 19 × 14½″ (48 × 37 cm) Kuntshalle, Hamburg.

ests and crags. At twenty, Böcklin was painting in imitation of Friedrich's subjects, if not his technique, in pictures with such titles as *Landscape with Ruined City* and *Forest in the Moonlight.* He soon abandoned such direct references to the early romantics, but fantasies of the general type of the *Island of the Dead* crop up in his work regularly, then appear frequently in the last two decades of his life.

The three categories of Böcklin's work overlap and intermingle, but in a general way they represent chronological stages of his art—from sentimental-lyrical classicism to subjects from Germanic mythology and monstrous visions to imaginary landscapes like the *Island of the Dead,* at once serene and sinister. And in these landscapes, at last, magic and realism come close to fusion. Rocks, trees, tombs or shrines, sky, water, and lonely figures are combined in

theatrical arrangements that, if they fall short of magical transformation, at least take us into a foreign land.

Later German Realism

Chronology is always confusing. (Fortunately it is not always important.) It is particularly so in the latter half of the nineteenth century because of the time lag between developments in France and corresponding ones elsewhere in Europe, with further lags in America. Feuerbach was the great German academic classicist and Böcklin the culminating romantic, but it is also true that Böcklin was born the same year as Courbet. This means that Courbet's revolt against idealism, either classic or romantic, was also contemporary with the Pre-Raphaelite movement in England. And since one art revolution followed another so rapidly in France, it means further that while Böcklin was painting, the Salon des Refusés came and went, the impressionists held their exhibitions and disbanded, and men we have yet to see, such as Cézanne, Seurat, Gauguin, and van Gogh, were at work. We tend to think of these great innovators as a younger generation, following painters like Böcklin. In fact, Seurat and van Gogh died ten years before Böcklin did, Gauguin the same year as he, and Cézanne only five years after.

Realism in one form or another had always been a major element in German painting. Realism in the sense of Courbet's return to the earthiness of nature found a German protagonist in Hans Thoma (1839–1924), a man ten years younger than Courbet and for a while his student. Like Courbet's, Thoma's realism must be qualified by the term "romantic-realism." But he painted so unevenly and in such a variety of manners that a representative collection of his work would look like a group show by several painters of varying talents. He ranged from the fresh literalness of pictures like *Woodland Meadow* [325] through other landscapes concerned with the monumentality of natural forms to such romantically evocative creations as *Recollection of a Town in Umbria* [326, p. 276]. The unifying factor in his work is the response to nature that took so many forms in the nineteenth century, as, indeed, it took several different ones in his own painting. He differs from earlier German landscapists in that his scenes, even at their most imaginative level,

326 Hans Thoma. *Recollection of a Town in Umbria.* Date unknown. Oil on cardboard, 20½ × 28″ (52 × 71 cm). Neue Pinakothek, Munich.

carry no burden of metaphysical pondering. It is this difference that finally makes a realist of him. It should be mentioned too that Thoma also turned his hand to heroic and religious themes, at which he was uniformly unsuccessful. As a portrait painter, when his sitters are close friends or members of his family he frequently delineates his subjects with a sympathetic, straightforward clarity that can be most engaging.

Courbet's "show me an angel and I will paint one" was turned into an even flatter statement, "I paint only what I see, and only from nature," by Wilhelm Leibl (1844–1900), who observed his dictum to the letter. Like Courbet he chose peasants as subjects; unlike Courbet, he observed realistically without romantic overtones. *The Poachers* [327] shows that Leibl was a strong draftsman and a vigorous painter. It shows little

else except the configuration of the faces of two Bavarian peasants. It is, however, only part of a larger picture [328] that Leibl worked on for four years and then divided into several parts because he was dissatisfied with the composition. Leibl was the true leader of the new realism in Germany; he worked in conscious opposition to Feuerbach's classicism, Böcklin's romanticism, and the individualistic art of a third and unclassifiable contemporary, Hans von Marées (1837–1887).

Although he died before 1900, Marées is more closely related to twentieth-century painting than to that of his own century. He was disturbed by the bourgeois realism of Thoma and Leibl, which seemed to him commonplace and transient. Yet he felt also that Feuerbach's traditionalism was threadbare. Without passing through the experience of impressionism,

Marées felt something like the same dissatisfactions that were very soon to lead Renoir to abandon impressionism's effects for a new study of form. Marées is even more closely comparable to Cézanne. The two men, born within two years of one another and working away from the same dissatisfactions, were unknown to one another, not only as individuals but as artists. Marées appears farther on in this book [486]; he is mentioned here to place him in chronological context.

Menzel

Just why impressionism failed to gain a foothold in Germany is a question that tempts an answer by speculation and hindsight; perhaps the chronic political enmity between the two countries, exacerbated by the Franco-Prussian War, contributed to Germany's rejection of a French aesthetic revolution that burgeoned after that war ended in 1871. Whether or not this idea is defensible, the career of Adolf von Menzel

(1815–1905) is a miniature history of such interchange as there was between the leading French and German painters in the latter nineteenth century.

Menzel held in Germany a position that it is impossible to imagine existing in France during the impressionist years. He was regarded as both Germany's living old master and its leading modernist. This was at the height of his success. Much earlier, as a young man during the 1840s, he had painted a series of pictures in a fresh, spontaneous manner with direct observations of effects of light that prefigured early French impressionist work thirty years in the future. He abandoned this direction, however—or, rather, smothered it under anecdotal detail—in crowded street scenes somewhat in the spirit of Frith's *Derby Day* and large paintings where historical figures such as Frederick the Great were pictured in equally anecdotal circumstances.

Menzel's international reputation was such that a large exhibition of his painting was held in Paris in 1885. Manet made the cryptic remark

327 Wilhelm Leibl. *The Poachers*. 1882–1886. Oil on canvas, 21¾ × 16½'' (55 × 42 cm). Nationalgalerie, West Berlin.

328 Wilhelm Leibl. *The Poachers,* as it appeared before division into parts.

that Menzel was a "great artist but his paintings are bad." Degas, alone among the impressionists, had good words to say for Menzel. But Menzel in turn had nothing good to say of impressionism, which he rejected except for some grudging comments on the vigor of Manet's brushwork.

Menzel was a largely self-taught artist who achieved the distinction of a professorship at the Berlin Academy. In his early years he had to support himself as an essentially commercial artist, and the journalistic emphasis of those years seems to have become ingrained, manifesting itself in the reportage of his street scenes and historical reconstructions. Like so many other nineteenth-century German artists, Menzel the painter is difficult to see outside his home ground, where his paintings are concentrated in public collections. But Menzel the draftsman is increasingly well represented in American collections, and it is as a draftsman that his reputation is now strongest. As an example, his drawing of a man drinking [329], with two separate sketches of the man's right hand and the glass, and a third sketch of the glass—a preparatory study for a single figure in a large multifigure painting—has the vigor, the certainty and freedom, and above all the direct observation that show him at his best and ally him with both Manet and Degas.

Of course it is not necessary that all late-nineteenth-century painters conform to the impressionist model to be acceptable. In Philadelphia, as we are about to see, Thomas Eakins, possibly his country's greatest artist, painted as if unaware of impressionism and the more radical movements that succeeded it during his lifetime. But Menzel came so close to the impressionist periphery without being caught up by its current and contributed so little to the realist tradition he chose to follow that it is difficult to evaluate him except as an impressionist manqué.

329 Adolf von Menzel. *A Man Drinking.* 1888. Pencil, 7¾ × 4⅞" (20 × 12 cm). Collection Ingrid and Julius Held, Williamstown, Mass.

chapter 20

American Realism after 1870

Duveneck, Chase, and Sargent

After the middle of the century, American painters, now thoroughly decolonialized, went more often to Paris than London to study, and also to the several academies in Germany, especially the one at Munich. As expatriates and impressionists, Whistler and Cassatt were exceptions. The rule was that American students came home to continue the European academic tradition. America's art schools were modeled as closely as possible after those in Europe, where impressionism was outlawed, with the result that while America produced quantities of well-trained painters among its talented students, impressionism was a generation late in taking root.* Three Americans who studied abroad and were influential at home may stand for dozens of their colleagues and students: Duveneck, who worked in the Middle West, Chase, who worked in the East, and Sargent, who worked on both sides of the Atlantic.

Frank Duveneck (1848–1919), a Kentuckian by birth, went to Munich when he was twenty-two and came under the influence of Leibl. After a

* Ten American impressionists formed an association to exhibit their work in 1898, when "impressionism" was synonymous with modernism in this country. For our purposes, the fact that Childe Hassam (1859–1935), to choose one of them as an example, painted American subjects instead of Parisian boulevards or meadows bordering the Seine is a small difference between him and the French impressionists whose technique he employed very well. Aesthetically his pictures are no better and no worse for having been painted a generation after impressionism's victory, but historically they are footnotes.

The other painters in the association of ten were Frank W. Benson, Joseph R. De Camp, Thomas W. Dewing, Willard L. Metcalf, Robert Reid, Edward Simmons, Edmund C. Tarbell, John H. Twachtman, and J. Alden Weir.

dazzling student career he divided his time between Cincinnati and Munich, with schools in both places that produced a whole Duveneck group. He was a dashing brushman and could strike in a head or a figure with impressive style and assurance [330]. The general tonality of the Munich school was very dark; Duveneck's hallmark was a combination of somber color with slashing, vibrant manipulation of paint. When he is at his best the combination is extraordinarily effective. But he was so facile a painter that his brush often ran away with him in superficial display. Unfortunately, most of his students imitated his facility but missed the depth and power that still make Duveneck's best pictures stand out in the galleries of such American museums as have continued to exhibit them in spite of his eclipse.

William Merritt Chase (1849–1916) was born in Indiana and studied in Munich, where he knew Duveneck. His early work has the same dark Munich tonality as Duveneck's, but he was more investigative than his friend and brightened his work under the influence of Velázquez and Hals. These were painters who also influenced Manet, whose work Chase's often resembles in a cautious way. When he follows Manet, Chase is not a revolutionary but an intelligent and gifted painter working after the revolution was won and its innovations accepted.

330 Frank Duveneck. *Georg von Hoesslin.* 1878–1879. Oil on canvas, 16 × 13¾″ (41 × 35 cm). Detroit Institute of Arts.

331 William Merritt Chase. *A Friendly Call.* 1895. Oil on canvas, 2′6¼″ × 4′1¼″ (.77 × 1.23 m). National Gallery of Art, Washington, D.C. (gift of Chester Dale).

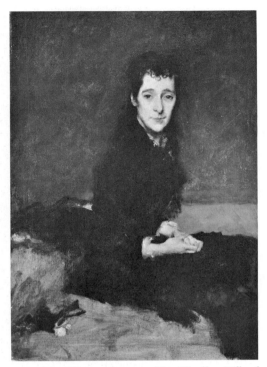

332 John Singer Sargent. *Mrs. Charles Gifford Dyer.* 1880. Oil on canvas, 24½ × 17¼″ (62 × 44 cm). Art Institute of Chicago (Friends of American Art Collection).

333 John Singer Sargent. *Simplon Pass: A Lesson.* 1911. Watercolor, 15 × 18¼″ (38 × 46 cm). Museum of Fine Arts, Boston (Charles Henry Hayden Fund).

The dreadful epithet "eclectic" dogs Chase in all accounts of his work and is impossible to avoid, since in addition to Hals and Velázquez and Duveneck he included among his masters-by-proxy his friend Whistler, the eighteenth-century French master of still life Chardin, Sargent, the American impressionist Twachtman, the brilliant but shallow Spanish stylist Fortuny, and finally the French impressionists. Chase's saving grace was his zest for art and his consequent influence as a teacher. Shuttling back and forth between Europe and America he brought back from each trip discoveries that were perhaps routine in Europe but came as revelations to his students at the Chase School in New York, then the New York School of Art, and for thirteen years the Pennsylvania Academy of the Fine Arts in Philadelphia. The list of his students includes the names of painters (such as Marsden Hartley [495] and Georgia O'Keeffe) who became the first modern masters of American art. And his own work, when it is at its freshest and most zestful, more than atones for its obvious derivations. As an example, *A Friendly Call* [331] can be broken down into elements from Fortuny, Japanese prints, and French impressionism, but the blend is delightful.

John Singer Sargent (1856–1925) was the most consummate virtuoso America produced, but in the final balance he became less an American than an international portrait painter with his headquarters in London and branch offices in Boston and New York. He studied in Paris under Carolus Duran, one of the soundest of the academic professors. To the ultimate degree Sargent had the English society portrait painter's knack for catching a likeness while at the same time flattering his sitter. Those who posed for Sargent could be certain in advance that in the completed picture they would be perfectly recognizable yet transformed into aristocrats no matter who they really were. It is true that Sargent painted some of the shallowest portraits of an era that was rich in them. He knew that he was often the victim of his own facility, and he often appears to fling his paint onto the canvas almost contemptuously. But his work is too easily damned. If all his commercial showpieces could be done away with, a large number of pictures would still remain where his facility is put into the service of perception [332]. And in his watercolors and drawings even those critics who habitually reject his portraits are willing to accept his technical brilliance as

an end in itself. In addition, the watercolors are, of all Sargent's work, most likely to be more than technical displays. When he grew sick of portrait painting for fashionable customers he would escape for a few days into watercolor painting for himself, recording his response to informal subject matter in pictures that are as appealing in their intimacy as they are fascinating in their virtuosity [333, p. 281].

Homer and the End of an Epoch

The two painters who emerge as the ones most closely integrated with the American scene, painting it in an American spirit in the second half of the century, are Winslow Homer and Thomas Eakins. Contemporaries of the French impressionists, both men were realists of the highest order. They shared with the impressionists a preoccupation with country scenes or bourgeois life, but instead of training their own sensitivities to accord with a European vision, they remained Americans who explored their own country and, more important, the character of their fellow Americans. The fact that Homer and Eakins painted American people engaged in typically American activities is relatively unimportant. What is important is that they explored beneath American surfaces to discover and express the psychological nuances that differentiated America from Europe. Bingham had done this also, but with subject matter so picturesquely and uniquely American that less subtle perceptions were involved. To some extent Homer capitalizes on subject matter comparable to Bingham's but Eakins painted an American world from which the frontier had vanished. Homer was only eight years older than Eakins, but he is something of a transition between Bingham, the painter of frontiers, and Eakins, the painter of a matured nation.

Winslow Homer (1836–1910) made only a moderate success in the picture market; the big prices during his long life went to more conventional work than his. Yet today it takes a moment to see where his unconventionality lay. It lay in the same quarter as that of the early

334 Winslow Homer. *Gloucester Farm.* 1874. Oil on canvas, 20¾ × 30⅛″ (53 × 77 cm). Philadelphia Museum of Art (John H. McFadden, Jr., Fund).

impressionists. Homer's first important pictures, notably *Gloucester Farm* [334], have the same interest in natural outdoor light, represented with much the same sparkle and economy, as Monet's early work (for instance, *The Terrace at Sainte-Adresse* [Plate 15, p. 220]) or Boudin's. But the resemblance is coincidental; there is no real probability that Homer knew the work of either of these two men at that time.

Gloucester Farm has the formal dignity and, to a surpassing degree, the clarity of the group of pictures to which it belongs: Homer's scenes of rural life in New York and New England painted from around 1867 on into the first years of the 1880s. As genre pictures, these intimate masterpieces had sufficient attractions to make them salable in the lower price brackets, but as "serious" paintings they were thought to lack polish, just as the impressionists were thought "crude" at the same time in France. It is, of course, precisely their lack of polish—or what was thought of as polish—that lifts pictures like *Gloucester Farm* from the rank and file of nineteenth-century genre painting, that makes them not only pictures of great pastoral charm but masterly formal compositions as well. It is apparent enough, now, that Homer has eliminated all finicky detail to create a pattern of formal masses revealed in consistent light, that he has chosen the most ordinary genre elements but has simplified them and disposed them in harmonious balance, that no touch of the brush is careless, that each stroke is as thoughtfully considered and as carefully applied as in any painting of a conventionally polished kind. But this control was not apparent to a public habituated to enjoying illusionistic details in a multitude of incidental objects factually described.

While his pictures sold at low prices, Homer continued to make ends meet by commercial work, such as book and magazine illustration. His earliest work was of this nature; he had covered the Civil War as a pictorial reporter for *Harper's Weekly,* and his first oil painting, *Prisoners from the Front* [335], records the experience *Prisoners from the Front* is a surprisingly satisfactory painting in these circumstances, but in comparison with the pictures that now began to follow it, like *Gloucester Farm,* it is still pictorial journalism.

Homer went to England in 1881 and stayed there during 1882 as well, working in watercolor, in which he followed the tight and rather dry manner that was popular with English watercolorists just then. Upon his return he abandoned his rural pastorals, settling in Prout's Neck, Maine, and shifting his attention to the life of fishermen on the Grand Banks, which he described in a series of etchings and oils. The gentle slopes and quiet barns and peaceful country people of *Gloucester Farm* were replaced by more dramatic elements, such as raging seas, rocky shores, and the strong men and women who struggled against them. Subjects

335 Winslow Homer. *Prisoners from the Front.* 1866. Oil on canvas, 24 × 38'' (61 × 97 cm). Metropolitan Museum of Art, New York (gift of Mrs. Frank B. Porter, 1922).

336 Winslow Homer. *The Life Line.* 1884. Oil on canvas, 28¾ × 41⅝'' (73 × 106 cm). Philadelphia Museum of Art (George W. Elkins Collection).

337 Winslow Homer. *The Hunter.* 1891. Oil on canvas, 2'4¼'' × 4' (.72 × 1.22 m). Philadelphia Museum of Art (William L. Elkins Collection).

like *The Life Line* [336], one of several pictures showing wrecks or rescues at sea, had enough narrative appeal to increase Homer's popularity. He adapted his early, gentler style to a vigorously masculine one where the violence of nature, and man's hazardous life in contact with it, are expressed in a technique as harmonious to the subject as his earlier manner was harmonious to the scenes of farm life. But Homer was still at his best when anecdotal elements were least conspicuous, as in *The Hunter* [337],

where relationship to nature becomes a philosophical subject rather than a narrative one. It is symbolical enough—although, of course, Homer never intended it to be—that the figure in *The Hunter* dominates the horizon, while in the wilderness of the Hudson River painters man was a tiny figure infiltrating a natural vastness. The frontiers are conquered; the giant trees of the Hudson River landscapes are felled, and *The Hunter* places his foot on this one almost as if it were a fallen enemy. He is no

338 Winslow Homer. *Ship Unfurling Sails.* Date unknown. Watercolor, 10¾ × 14½″ (27 × 37 cm). Philadelphia Museum of Art (gift of Dr. and Mrs. George Woodward).

longer an intruder in a benign wilderness, but its benevolent conqueror

In the Maine pictures, Homer is the last of the Americans to paint in immediate contact with the raw life of a new country.* And in his own very late work he grew further and further away from his preoccupation with the solemnities and the powerful forces of nature. He made frequent trips to the West Indies, and eventually the shining palms, the glittering clear water, the sun-drenched sails of these islands asserted themselves over the dour coasts and the sturdy folk of the North. To paint them, Homer freed himself from the conventional niceties of his early watercolor style to work in broad, fluid areas of scintillating transparency [338], suggesting in a few essential notes the choppy or undulant surface of a bay, the degree of tension in a sail receiving the wind or hanging limp or furled, the lay of a boat in the water, and always the pure brilliance of sun in clear air—all of these captured in a momentary aspect, as if set down in a fraction of a second. Thus, having begun, in pictures like *Gloucester Farm,* as an independent parallel to the earliest develop-

* At least, he is the last to treat this life as more than a pure genre record. Painters like Frederic Remington (1861–1909), with his cowboy pictures, continued to illustrate locally picturesque aspects of American life, often with great liveliness.

ments in French impressionism, Homer produced at the end of his career some of the purest impressionistic work of his time.

Thomas Eakins

Thomas Eakins (1844–1916) may well be the greatest American painter. He is certainly one of the finest painters of his century, Americanism aside.

Eakins went to Paris at twenty-two to study under, of all people, Gérôme, at the École des Beaux-Arts. (He also studied with Bonnat there.) This was in 1866. The Salon des Refusés had taken place only three years earlier, and *Olympia* [Plate 13, p. 219] had been exhibited only the year before Eakins' arrival. Manet's art was the scandal of Paris, but nothing Eakins ever painted shows that he was affected by the twin explosions of *Le Déjeuner sur l'Herbe* [242] and *Olympia.* It is not difficult to understand why this particular young painter was indifferent to Manet's art although he was intelligent, questioning, and thoughtful.

Eakins' passion was anatomy. For him, the human body was the most beautiful thing in the world—not the body as an object of desire, or as a set of proportions, but as a construction of bone and muscle. He had already spent two years dissecting cadavers at the Jefferson Medical College in Philadelphia "to increase my knowledge of how beautiful objects are put together" so that he might "be able to imitate them." Manet's experiments with the technique of capturing the quality of instant vision could be of no interest to Eakins, who found the human body beautiful because its structure and its movements were "means and end reciprocally adapted to each other." Manet's broad planes of light sacrificed the complete statement of a structure that Eakins found glorious. He was not interested in the quality of instant vision, but in a total reality where every part of the body served and depended upon every other one. This did not mean the imitation of every hair on the head, every pore in the skin, or for that matter even every small muscle, but it did mean an expression of every part of the body as a working part of a perfectly integrated structure. His academic drawing *Masked Seated Nude* [339, p. 286] introduces no muscles not actually visible beneath the model's fleshy padding, and may even omit a few that were, but its

339 Thomas Eakins. *Masked Seated Nude.* c. 1866. Charcoal on paper, 24 × 18″ (61 × 46 cm). Philadelphia Museum of Art (gift of Mrs. Thomas Eakins and Miss Mary A. Williams).

less in the face of reality so beautiful. He found that idealization—to which he held no objection when it was an "understood" idealization—was seldom based on "a thorough understanding of what is idealized." Without this understanding, idealization was merely "distortion, and distortions are ugliness." The classic and romantic idealizations current in Paris seemed to him nothing more than such distortions. He saw no point in copying casts, a routine exercise in art schools, even those from the sculpture of the best Greek period, because nature itself was at hand for study. He worshiped the Parthenon figures, but these figures were "undoubtedly modeled from life," he thought, and he saw no reason to refer to them for models when nature was "just as varied and just as beautiful in our day as she was in the time of Phidias." "The Greeks did not study the antique." Why paint gladiators in ancient Rome when there was a boxing club around the corner? When he returned to his native Philadelphia he became the first painter to find subjects in the world of sport. The young boxer in *Salutat* [340] with his lean, hard legs, his power-

extraordinary reality comes from Eakins' knowledge of the structural function of each concealed bone, the disposition of each tensed or relaxed muscle upon the skeletal framework in any specific attitude. It is a body one can imagine shifting itself into another position. Nominally, the pose is static; actually, structure and movement were so identified in Eakins' conception of the body that movement is present even in a quiet body, if by nothing more than an immediate potential. The body in *Masked Seated Nude* is alive; every bone and muscle is performing its required function in maintaining the body in the position it has assumed. Eakins never drew a living model as if it were a corpse, a statue, or a pattern of light and shade falling on an inert object. Because he studied anatomy at a medical school and analyzed the body so carefully, he is sometimes called a scientific realist, and even he called himself one. But of course he was not. His scientific knowledge of anatomy was a means to the end of expression, just as the structure of the body is a means to the end of movement.

But he was scientist enough to have no use for the formulas of ideal beauty, either romantic or classical. Idealization seemed to him point-

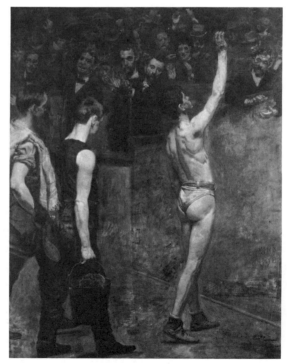

340 Thomas Eakins. *Salutat.* 1898. Oil on canvas, 4′2″ × 3′4″ (1.27 × 1.02 m). Addison Gallery of American Art, Andover, Mass.

fully bunched shoulders, his long arms, is built for his profession and will do better in the ring than one of David's idealized warriors could do. His body is beautiful not because its abstract proportions are harmonious (they are not, particularly) or because it can be defined by lines abstractly beautiful in themselves, like those of Ingres' nudes. It is beautiful because it is a normal human body, an example of that miraculously self-contained mobile structure in good condition. In Paris, Eakins had found that he learned more by watching his fellow students when they stripped and wrestled in the studio than he did by drawing from posed models.

But of course the miracle of the human body is only a part of the miracle of a human being. Eakins' statements about his fidelity to the imitation of nature seem to deny the other part of the miracle, which is human consciousness, yet in the long run that is what Eakins is most concerned with; otherwise he might better have spent his time painting animals, whose bodies are equally miraculous as self-contained mobile structures, and even more various and dramatic than human ones. Music was a large part of

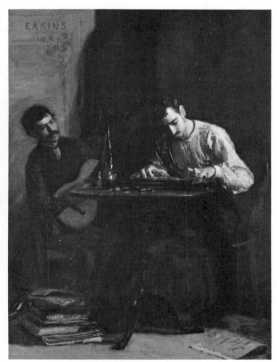

341 Thomas Eakins. *Musicians Rehearsing.* c. 1883. Oil on canvas, 16 × 12″ (41 × 30 cm). Philadelphia Museum of Art (John D. McIlhenny Collection).

Eakins' life, particularly music as an intimate communion between friends, and the man who painted *Musicians Rehearsing* [341] was not a scientific anatomist but a man who was sensitive to the ultimate mystery in human life for which words like *soul* and *spirit* have been coined. In this picture Eakins is akin to another realist, the Daumier who painted *The Print Collector* [172], or to Degas, who painted his father listening to a friend's singing [288]. In its subjectivity, *Musicians Rehearsing* is at one pole of Eakins' work, with the objectivity of *Salutat* at the opposite one. Most of his pictures lie in the intermediate area where imitation of visible realities and revelation of inner ones are balanced in a way uniquely his own.

In this area dozens of portraits could be cited. The one of *Mrs. William D. Frishmuth* [342, p. 288], a collector of musical instruments who is shown seated among them, would be hard to surpass, either as an example of Eakins at his painterly best or as one of his typically forceful, direct, and acute revelations of personality. As a piece of objective realism the head [343] is superb beyond virtuosity. The set of the lidded eyes in their sockets, the bony projection of the irregular nose with its fleshy tip, the sag of the aging face on its strong foundation of bone, the firmness of the mouth, held decisively by a habitual contraction of the muscles, the swirl of thin soft hair away from the rather flat temples and the slightly bulging forehead— all of these features, logically integrated and existing as a magnificently solid volume in space, are presented with a tangibility approaching illusion. But the vivid emanation of character comes from something more than this masterly reproduction of a set of features extraordinary in themselves. Some of Eakins' means toward the revelation of this personality are obvious; they consist largely of the centuries-old devices of selection and accent. What Eakins has eliminated as incidental and unrevealing we cannot say, but we can see the sharp stroke that emphasizes the angle of the eyebrow at one side, the sudden emphatic shadow of the nostril, the exaggeration and breaking of the highlights in the eyes, glistening in the collapsing flesh around them. The delicacy of the pearls and the neckerchief accentuates the ruggedness of the head; the pose of the whole figure describes a monumental respectability, surmounted by the determined, reflective intelligence of the face.

342 Thomas Eakins. *Mrs. William D. Frishmuth.* 1900. Oil on canvas, 8'1 × 6'1½'' (2.46 × 1.84 m). Philadelphia Museum of Art (gift of Mrs. Thomas Eakins and Miss Mary A. Williams).

343 Detail of Figure 342.

344 (left) Detail of Figure 342.

345 Detail of Figure 342.

The slight conceit of the right hand [344] resting on the piano with one finger pressing a single key, as if sounding a note, saves the pose from usualness. But counteracting any suggestion of affectation, the other hand [345] rests palm downward with massive placidity upon the strings of a viola, as if quieting them. The face and hands are the three lightest spots in the picture—not an unusual device, but exaggerated here. They are exceptionally small and exceptionally conspicuous among the shadows, which are punctuated here and there with duller lights of polished wood and subdued metallic glints. The picture, which is very large, is dark in tonality, the dress black in the surrounding dark warm browns, with occasional russet tones in the instruments. The most conspicuous spot of color is the cool clear blue of the neckerchief; it serves as a final accent to the powerful head, making doubly sure its position as the climax of the picture.

It would be possible to go on from here and argue that in the guise of an objective image Eakins has made comments upon profound and universal truths, but this would be to distort his art away from a sphere in which it is complete. His genius as a portrait painter lay in his ability to create—or, rather, to perceive and then to reveal—the psychological entity of an individual, without recourse to any but the most objective means. Any philosophical speculations stirred by the portrait of Mrs. Frishmuth must come from the observer as they might be stirred by an acquaintance with the rich personality of Mrs. Frishmuth herself, the personality Eakins has perceived, revealed, and immortal-

346 Thomas Eakins. *Miss Van Buren.* c. 1889–1891. Oil on canvas, 45 × 32″ (114 × 81 cm). Phillips Collection, Washington, D.C.

347 John Singer Sargent. *Mrs. Swinton.* 1896–1897. Oil on canvas, 7′6″ × 4′1″ (2.29 × 1.24 m). Art Institute of Chicago.

ized. If a single word could describe the quality of his portraits the word would be *honesty*—honesty in the representation of externals, and honesty of characterization. It is easy to see why some of his portraits were refused after they had been commissioned, why some others were accepted only to be burned. Sitters who hoped to emerge as dukes or duchesses were mistaken when they chose Eakins to paint their portraits. Yet when Sargent, the most expert flatterer of this kind, came to Philadelphia and was being lionized, Eakins was the man he asked to meet. His fashionable hostess had never heard of the local painter. A comparison of Eakins' *Miss Van Buren* [346, p. 289] with a typical "society portrait" explains why Sargent [347, p. 289], who admired the one but painted the other, made his famous remark, in self-disgust, that portraiture was "a pimp's profession." It is a remark that no portrait by Eakins could ever have inspired.

Like the French impressionists, Eakins painted the urban bourgeoisie on their holidays in the countryside, strolling, fishing, boating, lying in the shade, yet it would be impossible to mistake one of his pictures in this group for a French painting, just as it would be impossible to mistake the Schuylkill River at Philadelphia for the Seine. *Mending the Net* [348, 349] is a sturdier, more factual, more direct picture than its delicious French counterparts composed of color dissolved in atmosphere. Eakins' light is just as wonderfully the light of outdoors, but it is seen with a steadier eye and is painted with a firmer and more deliberate brush. Monet's boats riding at anchor at Argenteuil, Renoir's tender young people in dappled shadows, even Pissarro's sparkling fields, are feminine and evanescent (although no less delightful) by the standard of Eakins' clear skies, firm earth, heavy water, and steady light. Nor does Eakins yield to the casual, almost haphazard composition of so much impressionism; the intervals of grouping in the line of figures against the sky along the riverbank in *Mending the Net* is beautifully calculated to achieve an expression of naturalness without any loss of pictorial unity. In this particular combination of virtues—apparent spontaneity with exquisite calculation—Eakins when he is at his best is comparable to the great compositional master of impressionism, Degas, although he has no interest in Degas' brilliant innovations of the "snapshot" compositions with their eccentric angles, their objects bi-

348 Thomas Eakins. *Mending the Net*. 1881. Oil on canvas, 32¼ × 45¼" (82 × 115 cm). Philadelphia Museum of Art (gift of Mrs. Thomas Eakins and Miss Mary A. Williams).

349 Detail of Figure 348.

350 Thomas Eakins. *The Agnew Clinic.* 1889. Oil on canvas, 6'2½'' × 10'10½'' (1.15 × 3.31 m). University of Pennsylvania, Philadelphia.

sected by the margins of the picture, and their figures captured in unexpected attitudes.

Eakins was interested in the relationship between photography and vision, and sometimes used photographs for reference, not as a matter of convenience but as a stimulus in solving problems of vision and representation. He was not in search of a formula; he painted sometimes in broad, simplified forms, sometimes with detailed precision, as he did in *Max Schmitt in the Single Shell* [Plate 21, p. 303], an extreme example but one of his finest paintings, emulating the detailed clarity of a deep sharp-focus lens capable of registering minute details with equal precision from foreground to horizon. Each twig of the trees on the river bank is shown as if at close range in miniature; this definition extends beyond the distant bridge to include a small boat and even its puff of smoke. Max Schmitt, in the scull, turning toward us as if we were holding a camera, appears to be waiting for the click of its shutter. But like Corot, who, with less complication, also represented distant details with similar telescopic clarity, Eakins has adjusted colors and values as a creative painter, not as a photographer with an exceptionally good camera. He has massed his details in acute concentrations; they seem all the more wonderfully precise because they are played between the broad flat stretch of water and the even flatter expanse of

sky. The effect is like that of a clear day in early spring when the world seems to emerge in magically revealing light after the obscurities of winter, when the eye is sharpened to a new sensitivity to everything it sees, as if privileged for a few hours to find new experience in familiar objects. The picture is full of the enchantment of such an experience; the oddly shaped clouds, white and scintillating in the bright sky, are a half-fantastic element further removing the scene from literalness, even though the existence of exactly such clouds at exactly such spots is conceivable as a fact of nature. No other picture of Eakins' demonstrates more absolutely his fidelity to "imitation" and, at the same time, his manipulation of intimate detail into an expressive unity that explores beneath realistic surfaces. For precisely this reason, and in spite of the fact that it is not dedicated to the poeticization of nature, *Max Schmitt in the Single Shell* is a consummate and perhaps the final expression of that special fascination with infinite detail in all-revealing light that began with the early Hudson River School and is now called luminism in American landscape painting.

The Agnew and Gross Clinics

A limitation inherent in realism, the one that seemed its insuperable defect to the idealists, is that it is ill adapted to the synthesis of monumental compositions. The impact of a *Mrs. Frishmuth* or a *Max Schmitt* or a *Mending the Net* depends upon our feeling that the scene existed in toto before the eyes of the painter. If we stop to think about it, common sense tells us that the parts were assembled on the canvas, in the studio. There is no reason to believe that Mrs. Frishmuth sat patiently while Eakins busied himself for days painting the musical instruments surrounding her, and it is obvious that in *Max Schmitt* the clouds, the light, the puff of smoke, and the man in the single shell did not remain supernaturally transfixed during the hours and days that Eakins worked on them. But this fact does not intrude itself between the image and the observer; we believe in the total simultaneous existence of all the parts. But in certain kinds of subjects, and beyond a certain point of complication, this belief becomes strained, as it does in *The Agnew Clinic* [350]. *The Agnew Clinic* represents a medical arena where the doctor lectures during the course of

an operation. In addition to twenty-seven visible spectators, Eakins shows two doctors, two assistants, a nurse, and the patient under anesthesia. He makes no effort to dramatize the scene, unless the rather obtrusive variety of attitudes assumed by the spectators can be called dramatizing in a small way. The operation itself and the people performing it are described as noncommittally as a factual report, down to such details as the instrument table and even the stenciled *University Hospital* on the operation cloth beneath the patient. The report is adequately organized and is quite lucid in its separate parts, but it remains an enumeration of facts rather than a response to them.

This odd dryness, the downright stubborn objectivity, might have been the result of the unfavorable reception fourteen years earlier of a similar picture, *The Gross Clinic* [351]. Here the head of the doctor is dramatized not only by its pose and its facial expression but by its position as the climactic point of the foreground group and its isolation against the shadowed background where the figures of the spectators are barely visible in the gloom. There is some disharmony between this dramatization and the reportorial character of the assistant figures; the artificiality of the pose of the woman at the left (the patient's mother) is also obtrusive. But on the whole it is an impressive picture whether or not it is altogether a consistent one, and a near miss, at least, in solving the problem Eakins set himself, which was the reconciliation of monumental treatment through realistic means.

The Gross Clinic had a dramatically unfavorable reception, being rejected for exhibition in Philadelphia's Centennial Exhibition of 1876, a rejection comparable to Courbet's earlier one in Paris, and for much the same reason: its realism seemed brutal. It remains a startling picture today, especially in the detail of Doctor Gross' hand holding the scalpel. The fingers glisten with blood fresh from the incision in the patient's thigh. Eakins finally arranged to have the picture hung among the medical exhibits of the Centennial. This and subsequent discouragements may have led him to the uncompromisingly flat statement in *The Agnew Clinic,* as opposed to the interpretative effort, in *The Gross Clinic,* to show the scientist as a towering intellectual figure beyond the limitations of ordinary men.

But it is not so much that Eakins was out of his depth in these two pictures as that he was

351 Thomas Eakins. *The Gross Clinic.* 1875. Oil on canvas, 8′ × 6′6″ (2.44 × 1.98 m). Jefferson Medical College, Thomas Jefferson University, Philadelphia.

out of his field. His field was the perception and the revelation of character, a field common to all centuries of painters, and he holds his own in that field without apologies in any quarter. And in a field special to his own half-century, the observation of urban man in conjunction with nature, he was unique in capturing the quality of this aspect of life as it was expressed in his own country.

Postscript: The Ash Can School

At the very end of the nineteenth century in America there appeared a group of young men who painted into and as far as the middle of the twentieth, but who are best considered as part of the century that produced realism and impressionism. These were the painters of the Ash Can School, a name given them in derision (by just whom, there is some question) because

352 John Sloan. *Greenwich Village Backyards*. 1914. Oil on canvas, 26 × 32″ (66 × 81 cm). Whitney Museum of American Art, New York (purchase).

353 John Sloan. *The Wake of the Ferry*. 1907. Oil on canvas, 26 × 32″ (66 × 81 cm). Phillips Collection, Washington, D.C.

they were devoted to blatantly commonplace subjects in protest against the gentility of fashionable painting. As a group they were a short generation younger than Duveneck, Chase, Sargent, and Eakins, having been born in the 1860s

and early 1870s. Coming at the end of a century studded by revolutions, the story of their own revolt is anticlimactic, especially since the essence of their heresies had been proclaimed long before by the realists and had been superseded by new ones. But this was in Europe. In their American context, the members of the Ash Can School were a lively and even an adventurous band.

The most potent influences on the Ash Can School were Manet, Daumier, and other French painters related to them, men who finished their careers and died during the boyhood of the five Americans who were to form the original group: Robert Henri (1865–1929), George Luks (1867–1933), John Sloan (1871–1951), William Glackens (1870–1938), and Everett Shinn (1876–1953). Duveneck influenced some members of the group; they painted with a very free brush, which some of them were likely to exaggerate into coarse, even slipshod, technique. The everyday subject matter of the impressionists and the social comment of one form of realism were also somewhat coarsened in their adaptation to the Ash Can enthusiasm for the hurly-burly of the American city along its main stem, in its back streets, and in its honky-tonks, bars, cheap restaurants, and rented bedrooms.

The group was formed in Philadelphia in the 1890s, led by Robert Henri. They called themselves the Philadelphia Realists. Henri's importance is hardly hinted at by his painting, which was as facile as Sargent's but less elegant. Henri preferred common people to aristocrats. His great importance was as a teacher who stimulated more adventurous originality in his students than he demonstrated in his own work. His book *The Art Spirit* is still inspiring to many beginners.

John Sloan comes close to being a one-man summary of the Ash Can School, which changed its base to New York (and its name to New York Realists) around 1900 and took on its typical character *Greenwich Village Backyards* [352] shows the kind of subject that soon generated the nickname Ash Can. But *The Wake of the Ferry* [353] shows that at their best the Ash Can painters could go beyond the cheerful journalistic vigor of their descriptions of the city to discover, as Daumier did, the existence of the individual as a sentient unit isolated within the mass of the metropolis. Sloan was also an early practitioner of the humorous cartoon of social satire,

as in *"Professor—Please Play 'The Rosary'"* [354], an indigenously American kind of humor which, expanded and polished, was to become *"The New Yorker* cartoon."

As for the other three, William Glackens began as an illustrator on the *Philadelphia Press* and continued as a successful cartoonist in New York. After painting in the typical Ash Can manner for a while, he renounced his birthright during an extended residence in France and returned, in effect, as a Franco-American impressionist. Everett Shinn followed a similar early gambit. Then, under the influence of Degas, he did theater subjects and finally turned to theatrical decoration, where his talent for rather thin and florid ornament was most at home. George Luks was by a couple of years the oldest and by all odds the gustiest member of the group. He painted, with great appetite, subjects from New York's East Side [355], from coal mines, and also from city life in general.

Luks became a small cause célèbre in American painting when the National Academy re-jected one of his paintings, offended by his "vulgarity," that word so familiar to realists in France. Three more painters joined the Ash Can group of five to form "The Eight" around Luks as active dissenters from academic doctrine. The new trio were Arthur B. Davies (1862–1928), whose wispily elongated figures in rhythmic combinations inspired by Blake were an odd combination with the low-living characters of the Ash Can family gallery; Ernest Lawson (1873–1939), whose purely impressionist work was later affected by Cézanne; and Maurice Prendergast (1859–1924), who developed a decorative patchwork style evolved from impressionism [Plate 22, p. 303]. Of all these artists, including the original group, Prendergast, whose art once seemed the most fragile, has been the most enduring. Now that the raucous demonstrations of the Ash Can School with which he was so discrepantly allied have faded in the distance, the solid artistry with which he applied his delicate sensitivity has become impressively apparent.

354 John Sloan. *"Professor—Please Play 'The Rosary,'"* 1913. Charcoal, $18\frac{1}{4} \times 16\frac{5}{8}''$ (46 × 42 cm). Addison Gallery of American Art, Andover, Mass.

355 George Luks. *The Spielers.* 1905. Oil on canvas, $36 \times 26''$ (91 × 66 cm). Addison Gallery of American Art, Andover, Mass.

356 George Bellows. *A Stag at Sharkey's.* 1916. Lithograph, 18¾ × 24″ (48 × 61 cm). Philadelphia Museum of Art (gift of Mr. and Mrs. George Sharp Munson).

A somewhat younger man, George Bellows (1882–1925), became a disciple of Ash Can principles in the early 1900s (he was a student of Henri) and produced, among other fight and sporting scenes, the painting and the lithograph [356] of *A Stag at Sharkey's,* which is as well known, probably, as any American picture within ten years either side of it. Bellows was still a very young man when it began to be evident that the Ash Can School had run its course. No other school of painting that at first looked

* Except one, the regional school of the 1930s in America, led by Thomas Benton, Grant Wood, and John Steuart Curry.

so new became old-fashioned more quickly;* the exhibitions of European avant-garde painting so enthusiastically sponsored by the Ash Can painters themselves made them out of date.

Bellows' Americanism was conscious and determined; he even feared European travel as a possible corruption. This kind of Chinese Wall self-consciousness has plagued some other American painters since Bellows and has been a point of departure for some critics who have failed to see that the Americanism of Allston, Bingham, Homer, Eakins, and any other painters who can be grouped with them was an inborn Americanism, not a rejection of foreign influences.

chapter 21

Sculpture after Canova

Rude and Carpeaux

Sculpture during the nineteenth century ran a lagging second to painting, at least as far as inventive vitality was concerned. Quantities of sculptures were produced, but between Canova early in the century and a genius named Rodin at its end, there was no sculptor to supplant Canova as an international figure, and none to jolt the establishment with evidence that a new art movement was entering the lists with a Delacroix, a Courbet, or a Manet carrying the banner.

In contrast with painters, who flourished in groups, the few sculptors who rise above the humdrum mass are isolated figures. One of these is François Rude (1784–1855), best known for his *Departure of the Volunteers of 1792,* which has acquired the more popular name of *La Marseillaise* [357]. The statesman Thiers—Delacroix's behind-the-scenes patron—commissioned the enormous sculpture to decorate one of the piers of the Arc de Triomphe, a monument to Napoleon's victories that was standing unfinished twenty years after Waterloo. The sculpture is something of a hybrid, combining the romantic fervor of the tempestuous flying Genius of Liberty, or the Motherland, with neoclassically nude or armored volunteers who respond to her exhortations. By temperament Rude was a realist, and there is as well a realism to the nudes that helped account for the shock *La Marseillaise* created at the time. Idealized nudity of warriors in a classical subject such as David's *Sabines* was all very well, but to represent Frenchmen going into a recent battle naked or garbed in classical armor seemed both indecent and ridiculous. In a lesser sculpture these objections might still seem valid, but they are reduced to carping by the vital energy, the rushing movement, of Rude's masterpiece.

296

Rude's synthesis of romanticism and realism is marked again in *The Imperial Eagle Watching over the Dead Napoleon* [358], commissioned in 1845, a late manifestation of the romanticization of the Napoleonic legend that produced so many protoromantic paintings (by Gros and others) during his lifetime. Upon a bier designed for a demigod Rude placed the realistic corpse of an unimpressive little man, harmonizing the disparity by forceful modeling that made an indissoluble unit of bier, bird, and corpse. In spite of this aesthetic solution the realism of the corpse shocked the former commandant of the Imperial Guard on the island of Elba, who had commissioned the memorial, and he rejected it for a second, more romantic version in which the eagle lies dead at Napoleon's feet as the Emperor awakens to immortality.

Rude found only one worthy follower before Rodin's emergence. This was Jean-Baptiste Carpeaux (1827–1875), who studied under both Rude and the established academicians and managed to satisfy the latter while following the former. His sculpture on the façade of the Paris Opéra, *The Dance* [359, p. 298], is as conspicuous a public sculpture as Rude's *La Marseillaise,* and as worthy of its eminence. The rhythms of *The Dance* are appropriately more fluid and graceful than those of Rude's heroic subject; the forms are harmoniously interwoven with a surface vivacity often called the sculptural parallel to the free brushwork of romantic painting.

357 François Rude. *Departure of the Volunteers of 1792 (La Marseillaise).* 1833–1836. Stone, 42 × 26′ (12.8 × 7.93 m). Arc de Triomphe de l'Étoile, Paris.

358 François Rude. *The Imperial Eagle Watching over the Dead Napoleon.* 1845. Bronze, 11⅜ × 21″ (29 × 54 cm). Musée des Beaux-Arts, Dijon.

359 Jean-Baptiste Carpeaux. *The Dance.* 1865–1869. Limestone. 15′ × 8′6″ (4.57 × 2.59 m). Opéra, Paris.

Rodin

Against this meager background appeared Auguste Rodin (1840–1917), the century's great sculptor and the only one who can stand with its array of great painters. More poetic than Rude, whom he admired, more profound than Carpeaux, with whom he studied modeling, inspired by Donatello and Michelangelo on a late trip to Italy, learning from everywhere, even from impressionism (the least likely source for a sculptor), Rodin can neither be called eclectic nor classified as classicist, romantic, realist, or anything else. He is a summary of universal goals in sculpture, with consequent overlappings, recombinations, and frequent excesses, from one work to the next. The one thing he never is is pure neoclassicist,

although his marbles are sometimes as smoothly carved as Canova's.

Rodin shared the impressionists' fascination with the revealing gesture, the unposed expressive posture of a person caught unawares, but did not share their interest in daily life with its surface objectivity. Technically he is an impressionist when he models to capitalize on the play of light over forms that are realized by suggestion rather than by detailed statement, broken surfaces that reveal incompletely defined forms as if seen in flickering illumination. Puristic standards in sculpture may deny the legitimacy of this surface treatment, which confuses the visual illusionism of painting with the tactile existence of sculptural mass, but Rodin, who set his own standards and observed his own disciplines, employed it to the limits of its technical possibilities.

Beneath his impressionistic surface, Rodin is sometimes a dramatic realist, sometimes a quasisymbolist, almost always an aggressive masculine romantic with a powerful sexual drive. He was not infallible. The erotic mysticism of pieces like *The Hand of God* [360] begins to

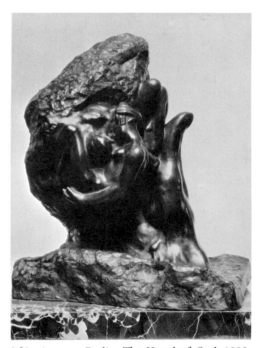

360 Auguste Rodin. *The Hand of God.* 1902. Bronze, 26¾ × 22″ (68 × 56 cm). Philadelphia Museum of Art (gift of Jules Mastbaum).

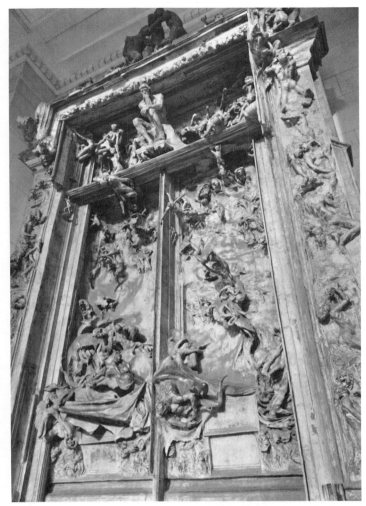

361 Auguste Rodin. *The Gates of Hell.* 1880. Bronze, 18 × 12′ (5.49 × 2.74 m). Philadelphia Museum of Art (gift of the estate of Jules Mastbaum).

The bumpy, sketchy, gouged, and roughened surfaces of impressionism were so cultivated by Rodin that he seems often to have tortured his clay, punching and kneading it beyond reason. "Sculpture is quite simply the art of depression and protuberance," he once said. "There is no getting away from that." This is certainly a limited definition that would eliminate a large percentage of the world's great sculpture, but for Rodin this violent manipulation had an expressive reason for being. A great part of the effectiveness of Rodin's sculpture comes from the plastic drama of the modeling, where the sculptor's fingers are "seen" at work. It is often objected that this is a perversion of the noble material of bronze, to ask it to be nothing more than a kind of preservative for figures conceived as clay with all clay's yielding plasticity. If this were so, it would be a fundamental flaw in the majority of Rodin's bronzes. Actually, it is this very plasticity that accounts for a powerful emotional impact, as if the forms had been captured alive.

In marble, Rodin's technical impressionism takes another direction. Transitions from one portion of realistic form to others are smoothed and softened until they seem to be partially obscured by mists, as in *The Kiss* [362, p. 300]. But Rodin is also acutely realistic on occasion; he spent three years in litigation to disprove the charges that an early work, *The Age of Bronze,* was not a work of sculpture at all but an actual cast from a living model. It was not, but in its reproduction of an exceptionally perfect male model it might almost as well have been.

The single monument that can stand as the summary of Rodin's genius is not the *Gates of Hell* but the *Burghers of Calais* [363, p. 300], which commemorates the heroism of six citizens who in 1347 appeared before Edward III of England pleading that their city be spared and offering their lives in return. Here a subject that could tempt any artist to melodrama is presented with noble reserve; the individual citizens are portraits characterizing a range in age and temperament unified by the ideal of heroic self-sacrifice; technically the rough, gouged depressions and protuberances of the sackcloth robes are made the most of without being pushed to the point where they detract from the more realistic modeling of the heads.

The burghers are living presences; their common humanity is not smothered by their heroism, which makes the heroism all the more

seem, nowadays, embarrassingly pretentious. And his *Gates of Hell,* which was to have been the Sistine Ceiling of sculpture but was never carried beyond the stage of preliminary studies [361] and a few completed figures, is rather a hodgepodge whether it is regarded as philosophy or as sculpture. The familiar *Thinker,* one of the completed figures, known everywhere from numerous casts, can be found in the upper central portion of the *Gates,* where he broods over the fate and folly of humanity just as Michelangelo's prophet Jeremiah, from which the *Thinker's* pose is borrowed, broods from the height of the Sistine Ceiling upon the passing spectacle below.

impressive. Realistic observation, romantic passion, classical restraint, and impressionistic rendering—an impossibly contradictory combination on the face of it—are blended with such unobtrusive perfection that one is unaware of the sculpture as a synthesis. It stands as a work of art that needs no classification except that it is a Rodin.

Rodin would have made an excellent painter; his drawings are in some ways more satisfying than most of his sculpture. His typical manner involved a free, loose, linear description of contours, with washes of color that were allowed to run and spread beyond these contours, or might be entirely independent of them, as they are in *Imploration* [464]. Here the two bodies are drawn against a tawny color that merges with a background of russets, blues, pale greens, and grays that have no descriptive function. Rodin drew quickly, sometimes allowing his pencil to follow the contours as he watched the model rather than the pencil. He achieved surprising descriptions of fleshy masses with an absolute minimum of means. His subjects were erotic more often than not but are saved by Rodin's obvious conviction of the identity between physical love and spiritual fulfillment.

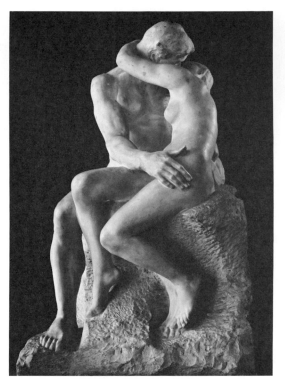

362 Auguste Rodin. *The Kiss.* 1886. Marble. Over life size. Musée Rodin, Paris.

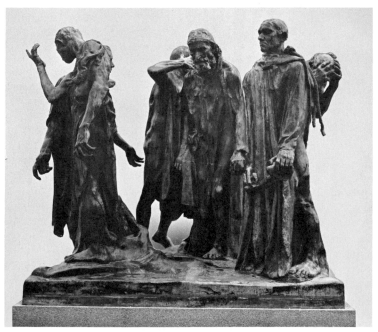

363 Auguste Rodin. *The Burghers of Calais.* 1884–1886. Bronze, 7'1'' × 8'2⅛'' × 6'6'' (2.16 × 2.49 × 1.9 m). Hirshhorn Museum and Sculpture Garden, Smithsonian Institution, Washington, D.C.

chapter 22

Fin-de-Siècle

The Mood

As the nineteenth century drew to a close a pervasive mood compounded of ennui, preciosity, exaggerated aestheticism, a taste for high fashion in decoration and the exploration of low life in the demimonde manifested itself in the arts. This fin-de-siècle mood, by its very nature, which was self-indulgent rather than aggressive, was never strong enough to dominate the life of its decade or to crystallize in a self-contained art movement, but it affected the work of artists and writers whose major alliances lay elsewhere. It is a persistent component of an international scene with centers in London, Paris, Vienna and, during the comparatively innocent "gay nineties," New York.

In England the fin-de-siècle mood, having been anticipated by the aesthetic posturing of the Pre-Raphaelites (at least by Dante Gabriel Rossetti's), was consummated with a strong flavor of the perverse by such direct descendants as Aubrey Beardsley, whom we have already seen [101] and in the literature (and manners) of Oscar Wilde, whose coterie of admirers so offended the honest William Frith during a private view at the Royal Academy [196]. It was in Wilde's circle in England, in fact, that the fin-de-siècle aesthetic came closest to what might be called its purest expression.

In France, which in this case means Paris, the fin-de-siècle decade was particularly enjoyable as the opening years of what the French call their *belle époque,* the era of elegance and gaiety preceding World War I. A caustic record of his milieu in the 1890s was left by a painter who by patrician birth had entrée to the most fashionable circles in Paris but for peculiar reasons chose instead to be an observer of the demimonde, where high and low life met—Henri de Toulouse-Lautrec.

Toulouse-Lautrec

As impressionism began to be absorbed into the historical continuum of painting and other isms began to develop from it, the list of painters whose art was impressionist or closely allied to impressionism a generation after the adventures of the original group could be extended indefinitely. Among this generation Henri de Toulouse-Lautrec (1864–1901) made his own special departure.

Lautrec's life has been used as the subject of so many biographies—some accurate, some unpardonably falsified—and his art has become so familiar in debased forms through commercial adaptations that it has become difficult to regard his paintings as works of art in themselves. They have become illustrative adjuncts to the story of his life and the fascination of the personalities he used as subject matter. These personalities are, in truth, fascinating enough. His greatest single source of material was the dance hall and cabaret called the Moulin Rouge, a phenomenon of the end of the century in Paris without a parallel today, a place where intellectuals, performers, human curiosities, and the flotsam of bohemia intermingled. But he also painted other cabarets and the related world of the theater, cafés, restaurants, and brothels. He painted dancers, singers, prostitutes, circus performers, performing animals, actors, sportsmen, and his acquaintances and friends—who ranged from noblemen to derelicts. And he was himself, of course, the most bizarre of all the creatures in the world he recorded.

Henri-Marie Raymond de Toulouse-Lautrec Monfa was descended from one of the finest houses in France. His family tree includes the names of kings and queens of both France and England. If he had not been crippled—as a child he broke both legs in two falls that left him a grotesque dwarfish caricature of a man—he might have continued his family's tradition of hunting, riding, and provincial high living at the family seat at Albi. With these facts as a beginning, there is always a temptation to reduce any consideration of Lautrec to a series of biographies, first his own and then those of people like two of his favorite models, the dancers Louise Weber, known as La Goulue (The Glutton) and the nameless woman who chose for herself the name Jane Avril. Lautrec's art, as he records such people in the life of the half-world they inhabited, is partly journalism, partly an informal sociological record through the incisive presentation of specialized modes and manners, and partly, by whatever extension the observer wants to make for himself, a moral lesson. *The Salon in the Rue des Moulins* [364],

364 Henri de Toulouse-Lautrec. *The Salon in the Rue des Moulins.* 1894. Oil on canvas, $3'7\frac{7}{8}'' \times 4'4\frac{1}{2}''$ (1.11 × 1.32 m). Musée Toulouse-Lautrec, Albi.

Plate 21 Thomas Eakins. *Max Schmitt in the Single Shell.* 1871. Oil on canvas, 32¼ × 46¼″ (82 × 117 cm). Metropolitan Museum of Art, New York (Alfred N. Punnet Fund and Gift of George D. Pratt).

Plate 22 Maurice Prendergast. *Afternoon, Pincian Hill, Rome.* 1898. Pencil and watercolor, 21 × 27″ (53 × 69 cm). Phillips Collection, Washington, D.C.

Plate 23 Henri de Toulouse-Lautrec. *At the Moulin Rouge.* 1892. Oil on canvas, 3'11½" × 4'7⅜" (1.21 × 1.41 m). Art Institute of Chicago (Helen Birch Bartlett Memorial Collection).

Plate 24 Gustave Klimt. *Hope II.* 1907–1908. Oil and gold on canvas, 43⅜" (110 cm) square. Museum of Modern Art, New York (Anonymous donor and Mr. and Mrs. Ronald Lauder Fund).

365 Henri de Toulouse-Lautrec. *Jane Avril Leaving the Moulin Rouge.* 1892. Gouache on cardboard, 33¼ × 25″ (84 × 64 cm). Wadsworth Atheneum, Hartford, Conn. (bequest of George A. Gay).

which shows the reception room of a brothel frequented by Lautrec, is a flatly objective report on the surface, but by extension it reflects vice in its highest commercial brackets (for this was a fashionable and expensive house) as an activity so exhausted of excitement that it reduces to pointlessness one of the most profound aspects of life. In the end Lautrec's unillusioned observation is at least as effective as Degas' horror in the presence of degradation in his monotypes of brothel scenes [286].

Whatever agonies of the spirit Lautrec suffered, he never allowed himself an intimate comment on a subject, much less a tender one. He comes closest to confessing an affectionate response in his numerous paintings and drawings of Jane Avril. By the time she reached the

Moulin Rouge, Jane Avril had behind her a career as a child prostitute and then a courtesan who rose in her profession as she passed from protector to protector. She was untrained and unconventional as a dancer, improvising in a way described by contemporaries as invested with a kind of controlled tension that threatened at any moment to explode but never did: she acquired the nickname La Melinite (Dynamite). Lautrec might in any case have been fascinated by her worn, bony, chalk-white viperine face, but she was apparently a woman of high intelligence and alert perceptions in spite of her lack of education. Lautrec's most affecting picture of her shows her leaving the Moulin Rouge, an isolated figure, withdrawn and pensive, in the hectic ambience of Montmartre at night [365].

Even more than Degas, who was his model and his god, Lautrec is first a draftsman and second a painter. As Ingres told Degas to do, Lautrec draws "lines, many lines," but they are lines of his own kind, lines that coil and strike like serpents, jab and gash like knives, or when appropriate sag like the pouches of tired flesh they define, as in the devastating portrait of Oscar Wilde [366, p. 306]. Line satisfied Lautrec; he developed very few paintings to the point where his first, direct lay-in of drawing is entirely obscured.

Lautrec's debt to Degas is most conspicuous in his composition. One of his few highly finished paintings, *At the Moulin Rouge* [Plate 23, p. 304], is an example, with its tilted perspective and the segmentation of some of the objects. It shows part of the promenade that surrounded the dance floor; at the left, the railing between the promenade and dance floor cuts across the picture, separating the observer from the group of men and women at the table. Whether or not Lautrec had such an effect in mind, the effect of this separation is to put the observer at a vantage point where he watches but is not watched; it is the so-called keyhole vision (not altogether a savory way of putting it) of much of Degas' late work. Like Goya, Lautrec was a painter who "moved freely within a certain world and was accepted as part of it by its denizens, yet within himself remained separated from it by an isolating circumstance, remaining free to observe with the objectivity of an outsider, yet with intimate access to his material." Like Goya with his deafness, Lautrec with his deformity was thus isolated, and without pushing the analogy too

366 Henri de Toulouse-Lautrec. *Oscar Wilde.* 1895. Watercolor, 23⅝ × 19¾″ (60 × 50 cm). Private collection.

367 Henri de Toulouse-Lautrec. *Two Women Dancing.* 1894. Gouache on cardboard, 23¾ × 15¾″ (60 × 40 cm). Private collection.

far it is still safe to say that the railing between the observer and the rest of the picture helps to identify us with Lautrec's "view," psychological and physical, of the subject.

It is redundant to insist that the composition of *At the Moulin Rouge* is not haphazard but brilliantly planned; in this case there is a special circumstance that should prove how definitely Lautrec planned it and how imperatively the haphazard, snapshot quality is calculated as the psychological basis of the picture. Originally the canvas ended without the last portion on the right side that now includes the most "haphazard" and the most telling element: the weirdly illuminated face of the woman at the extreme right edge. In order to introduce this figure Lautrec added to the canvas at the right side (and also at the bottom). If these portions are covered up we still have a fine picture, a group portrait of several of Lautrec's friends (all are identifiable) gathered around a table, but we no longer have the picture that has the

strongest claims as Lautrec's masterpiece, combining his eccentric individualism with analytical control.

In color, too, the additional figure transforms the scheme from something skillful to something masterful. If the composition of *At the Moulin Rouge* owes a great deal to Degas, the color is Lautrec's own. It is dominated by the strong chemical green of the shadows on the woman's face, eerily covering the forehead, nose, and upper lip, and the violently orange hair of the woman seated at the table nearby. These two colors clash and vibrate against one another within a scheme of smaller areas of sharp colors lashed by accents of black and purple. These are the colors of Lautrec's world, a world of artificial stimulations, of dreadful ennui, a world shrill, strident, divided between avidity and indifference. Renoir's eternal values have no place in it. Instead of Renoir's young girls in meadows we have *Two Women Dancing* [367]; instead of Monet's twinkling foliage

or his ponds rippled by fresh breezes, the torpid atmosphere of shuttered rooms, the stale air of dance halls whipped into turbulence by the petticoats of dancers, gaslight instead of sunlight. When Lautrec paints a portrait out-of-doors in the small gardens of his friends in Montmartre, his sitter has the pallid air of a night creature unaccustomed to daylight. Degas, being witty at the expense of his impressionist friends who went into the country to paint streams and meadows, said that the smell of fresh air made him sick. With something closer to truth, Lautrec could have said that the air of the dance hall and the brothel was a palliative for the pains that racked his dwarfed and twisted legs. Bohemia was not his natural habitat. In the background of *At the Moulin Rouge* he shows himself moving through the world

he adopted as an expedient; he is the stunted figure played against the enormous height of his companion (a cousin and his most loyal friend, Tapié de Celeyran) behind the group at the table.

In the relationship of his life to his work, the surprising thing about Lautrec is that, in spite of the alcoholism and the spectacular dissipations which are too well covered by his biographers, he was tremendously productive. In spite of his personal tragedy, with whatever neuroses it might have been expected to engender, he paints with sanity, vigor, and the clearest, sharpest perception of the life around him. His detachment is never self-pitying; his comments on viciousness are never vicious, scornful, or envious; and his painting of depraved subjects is no more depraved than it is self-righteous. Conditioned by his subjects, we are more aware of the seamy world in which he moved as an artist than we are of the other world in which he moved with equal freedom and which was the world from which he observed the one he painted: the world of intellectuals and aristocrats.

If Lautrec does not reach the stature of a great painter outside his century, it may be because the world he painted limited his range of comment, but within the boundaries thus set, his art is complete. In addition, he was a technical innovator in the medium of lithography and he virtually created the poster as a work of art.

Essentially his contribution to color lithography was to close the gap between the completed print and our sense of the presence of the artist. In painting, the artist's presence is felt because we are separated from him by a minimum of technical barrier; we stand in front of his picture as he stood in front of it, the paint we see is the paint he applied. But in a print we must jump the gap created by the intervening process of actual printing, between the artist's work on the lithographic stone or the etching plate and the transfer of his work to paper. Lautrec closed this gap and at the same time widened the technical range of lithography by treating the stone with a new informality. He would speckle its surface with ink by flipping the ink-soaked bristles of a stiff brush above it or dab the surface in any way he chose [368]. He would combine lithographic crayon with lithographic wash in a deliberate exaggeration of textures. In short, he combined and invented variations on conventional lithographic tech-

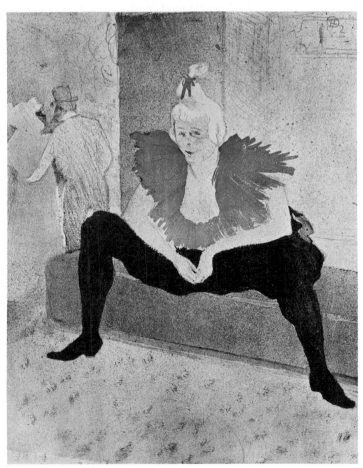

368 Henri de Toulouse-Lautrec. *Seated Female Clown (Mlle. Cha-U-Kao),* from *Elles.* 1896. Lithograph, 20½ × 15¾″ (52 × 40 cm). Philadelphia Museum of Art (Lisa Norris Elkins Fund).

niques in order to give them variety; his imagination freed lithography much as the technique of impressionism released painting from formula. Always the closest of the print media to the intimacy of drawing, lithography in color now approached the immediacy of painting. The artist's hand became more apparent. In addition to the psychological value for the observer, this liberation widened lithography's expressive potential for the artist in ways that have been carried further ever since Lautrec pointed the way.

In the art of poster design [369] Lautrec recognized factors now accepted as so basic that it is hardly necessary to point them out. First, a poster must make its total impact immediately if it is to be effective in its primary function, since it is an announcement, not an object for contemplation. Second, since pictorial images are to be combined with type, their design must be harmonious with the flatness and boldness of type or lettering. Both of these considerations call for simplification and virtually demand the reduction of design to two dimensions. Although tentative efforts had been made in "art" posters, Lautrec pushed these ideas to their conclusion and in applying them remained an artist as well as a designer of publicity. His posters "took possession of the street," a contemporary said, but they are also works of art.

Lautrec's posters bear multiple relationships to the Japanese print. In the first place, these prints were ready-made ancestors as examples of patterning in areas of flat color bounded by lines ornamental in themselves. In the second, they combined, frequently, printed legends with pictorial images [256], although the ornamental character and the indecipherability of the Japanese legends obscured this fact from Western designers. Also, the Japanese prints of actors were related to the nineteenth-century theatrical poster in that they familiarized people with the physiognomy of popular performers of the day even if they were not posted as advertisements. The difference was that the Japanese prints were designed to give continued pleasure on extended contemplation of their subtleties of line and color areas, while Lautrec's posters had to be absorbed at a glance if they were to attract the attention of busy passers-by. Lautrec met this requirement first; yet he also designed his posters to reward continued acquaintance, even if not to the extent of their Oriental prototypes.

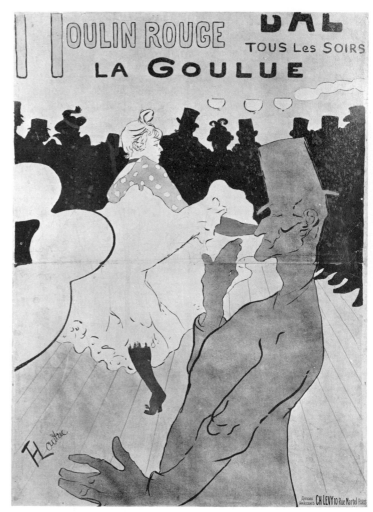

369 Henri de Toulouse-Lautrec. *La Goulue at the Moulin Rouge.* 1891. Lithograph, 5′5″ × 3′10″ (1.65 × 1.17 m). Philadelphia Museum of Art (gift of Mr. and Mrs. R. Sturgis Ingersoll).

Art Nouveau: Klimt

The final decade of the nineteenth century saw the birth, life, and temporary demise (pending its resurrection in the 1960s) of a style of decoration called Art Nouveau—the New Art. Art Nouveau was an effort to create new expressive rhythms in a unified style based on the lines of natural forms, particularly the stems, blossoms, and tendrils of trailing or climbing plants. Its theory was applied in the design of architectural ornament and art-crafts, from which Art Nouveau spilled over into painting. The bulbous forms at the left side of *La Goulue at the Moulin Rouge,* presumably cigarette or cigar

smoke, are art-nouveau-derived, and there are frequent reflections of art-nouveau line (at its best it was given the name "whiplash" line) in Lautrec's drawings. Art Nouveau permeates Aubrey Beardsley's style and is the direct source of elements in paintings of the period that we have yet to see—Munch's *Anxiety* [466], with the wavering lines in the background, van Gogh's *La Berceuse* [417], with its flowered background, and a number of paintings by Gauguin with their patterned flowing lines of water and plants and, specifically, the background of his *Self-Portrait with Halo* [423].

Until its resurrection in 1960, Art Nouveau suffered the contumely always visited upon once-fashionable but outdated styles. Even in its own day it had its detractors, who called it "noodle [or spaghetti] style" *(style nouille)* in France, "eel style" *(paling stijl)* in Belgium, and "tapeworm style" *(Bandwurmstil)* in Germany— all references to the tendency of the style's sinuous lines to relax and grow flaccid.

More respectfully, Art Nouveau was called *modernismo* in Spain, *stile Liberty* in Italy (after

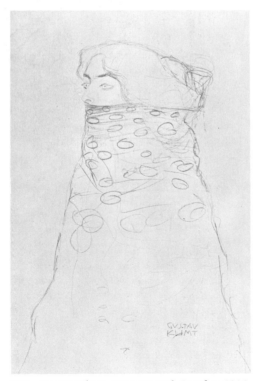

370 Gustav Klimt. *Woman with Scarf* c. 1915. Red pencil, $22\frac{1}{8} \times 14\frac{5}{8}''$ (56 × 37 cm). Museum of Modern Art, New York (W. Alton Jones Foundation Fund).

Arthur Liberty's shop in London, which popularized the style in fabrics), and *Jugendstil* (Youth Style) in most German-speaking countries. In Vienna it was called *Sezessionsstil* after the Secession group of architects, artists, and decorators who banded together to promote modern art and organize exhibitions of their own work in opposition to, of course, the academic conservatives. In the work of Gustav Klimt (1862–1918), one of the original members of the group, the fin-de-siècle mood in Vienna as formalized by Art Nouveau received one of its most unified expressions.

Klimt's paintings [Plate 24, p. 304] are elaborately decorative, and come as close to being an art-craft related to ceramics and textiles as pictures can come. His figures are clothed in robes that, rather than hanging on bodies, are presented as flat areas in which their luxuriant patterns, often spotted with gold, can be displayed undisturbed by folds. An air of neurotic, languid, sexual yearning breathes what life there is into these brilliant exercises in decoration, but they need little more than this brilliance to carry them.

Klimt's drawings are another matter. His curling lines, rather than imitating the rhythms of flowing water, twisting vines, and the other bits of nature from which Art Nouveau patterns were conventionalized, have their own quality of living growth. Delicate and exuberant, they impart their life to Klimt's favorite subject, portrayals of fashionable types [370]. In addition, time has given these drawings poignant associations as records of fin-de-siècle elegance that reached its height in a city that has never recovered from the disaster of war.

Schiele

Klimt found his single important follower in another Viennese, Egon Schiele (1890–1918), who managed to compress within the last years of his short life (he died of influenza at twenty-eight) a body of work that in its extraordinary intensity has not only made him a cult figure in the field of drawing but has also brought him an increasingly firm position as one of the most powerful expressionists of the twentieth century. Schiele learned one thing only from Klimt— the expressive power of line—but that was enough to release something close to genius in his phenomenal talent. As a draftsman he can

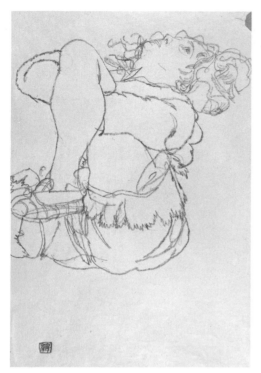

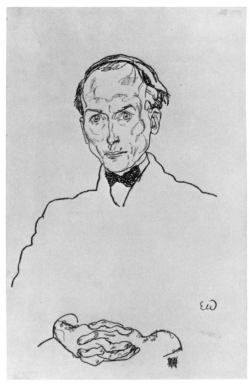

371 Egon Schiele. *Woman with Slipper.* 1917. Charcoal, 18⅛ × 11¾″ (46 × 30 cm). Museum of Modern Art, New York (gift of Dr. and Mrs. Otto Kallir).

372 Egon Schiele. *Dr. Ernst Wagner.* 1918. Chalk, 18⅜ × 11½″ (47 × 30 cm). Collection Ingrid and Julius Held, Williamstown, Mass.

stand with such masters as Daumier and Degas, although he put his powers to a different end from either. With neither Daumier's humanity nor Degas' cool objectivity, he had their capacity to summarize the mass, the weight, the flexibility and energy of the human body in lines that never faltered. More than either, he described the body in terms of its contours, in linear images, frequently erotic, of men and women alone or intertwined [371].

In 1912, when he was twenty-two, Schiele served twenty-four days of imprisonment in the small community of Neulengbach on charges of pornography that seem to have been trumped up. But it is true that in his early work, especially in a series of nude self-portraits, he may have cultivated an image as the bad boy of the Viennese avant garde. This exhibitionism soon gave way to a serious—and staggeringly brilliant—application of his erotic bent, which in its turn was gradually absorbed into quieter, more contemplative images.

In what must be referred to, tragically, as his late work, Schiele showed signs of abandoning the exploration of his own libido for the more difficult exploration of normal personalities in portrait drawings [372] that can stand with any, and in their perception of character are unexcelled, or unequaled, by those of any artist so young. It may be safe to call Schiele a genius on the assumption that what he left is only the first period, the introduction, to a life in art that with maturity could hardly have failed to place him with the giants.

The Postimpressionists

Lautrec died in 1901. If he can be regarded as the last of the impressionists, thus rounding out the century, it must be remembered that, in the meanwhile, impressionism had already been transformed and the direction of the art of the twentieth century had been set by four men whose innovations were not assimilated by the nineteenth century in which they lived. These men were Georges Seurat, Vincent van Gogh, Paul Cézanne, and Paul Gauguin.

part three

Transition

chapter 23

Postimpressionism: Its Classicists

The Explorers

By the end of the nineteenth century, impressionism had run its course, although Renoir, Degas, and Monet continued to work well into the twentieth. But even while impressionism was still fighting for final recognition, new directions were being followed by several men whose art was to determine the course of painting in the first generation of the new century. Fanning out from impressionism, they explored independently. More than any other painters in the history of art, they developed their theories in isolation, and in contradiction to one another. They are grouped under the catch-all designation of *postimpressionists,* a term meaning nothing except that these artists departed from impressionism to find new ways of painting. The ways they found were too various to be covered by a more descriptive designation; at least so far, no better collective term has been found to describe the work of Paul Cézanne, Georges Seurat, Paul Gauguin, and Vincent van Gogh (all of whom, incidentally, died before Renoir, Degas, and Monet—even by as much as thirty-five years, to take the extreme limits between the death of Seurat, who died very young, and Monet, who died very old). The point is made at such length only to remind the reader once more that chapters in a book follow one another between neater boundary lines than do the birth and death dates of painters or, especially in our time, the genesis and development of new expressions in art. The trauma that led from impressionism into the plethora of isms we group under the term *modern art* was experienced by and expressed by the painters we call postimpressionists.

Neoimpressionism: Seurat

While Renoir was painting his *Bathers* in reaction against the formlessness of impressionism, a younger man named Georges Seurat (1859–1891) was attacking the same problem in a different way. With excruciating patience he was applying tiny dots of color to sixty-seven square feet of canvas which, when the dots finally covered it, would be the painting that divides impressionism from the twentieth century, *Sunday Afternoon on the Island of La Grande Jatte* [Plate 25, p. 337], which shows the strolling crowd in a public park on an island in the Seine near Paris. Both Renoir and Seurat were intent on pulling together again the disintegrating forms of impressionism, redefining their boundaries and solidifying the masses that had become ambiguous in their fusion with light and air. Renoir did so by retreating from impressionism; Seurat did so by plunging into it and putting it in order like a fanatic housewife tidying up a bachelor's apartment. By a more dignified comparison, he was like a catalyst dropped into the frothy impressionist mixture, suddenly transforming it to geometrical crystals.

By any comparison, Seurat was the most systematic painter who ever lived, and of all painters who have tried to work on scientific principles he is the only one of major importance whose art suggests the laboratory as much as it does the studio. Since he was systematic in the extreme, his work is easy to reduce to a recipe. But like any recipe for painting, this one is deceptive since it is full of hidden variables dependent on the skill and the sensibilities of the artist. Seurat's recipe may produce a work of art as it did when Seurat used it, or a pointless exercise as it usually did in the hands of his followers. But the recipe remains:

First: Simplify all natural forms to silhouettes in accord with their basic geometrical equivalents, modifying them as necessary in accord with the taste of the artist to increase their effectiveness as pure design. Seurat's taste was for the most exquisite precision of contour; even before he added the element of geometrical reduction, this taste is evident in his academic student drawings [373], which allied him to the tradition of Ingres. He worked in the Academy's school under Lehmann, a disciple of Ingres, and he studied drawings by Ingres even while he was studying Delacroix's color. But he was unaffected by Delacroix's spirit, and it should be-

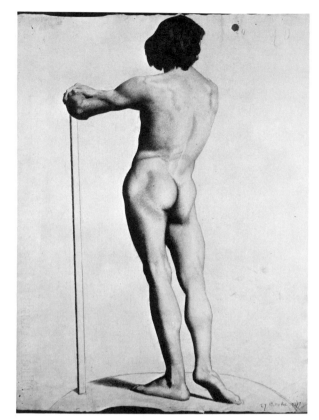

373 Georges Seurat. *Male Nude.* 1877. Charcoal, 25 × 19″ (64 × 48 cm). Private collection.

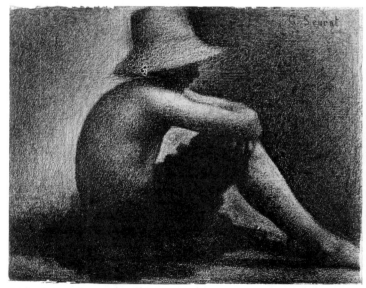

374 Georges Seurat. *Seated Boy with Straw Hat.* 1882. Conté, 9½ × 12¼″ (24 × 31 cm). Yale University Art Gallery, New Haven, Conn. (Everett V. Meeks Fund). Study for Figure 378.

come apparent as his work is followed here that Seurat is well within the classical tradition—its purity, its balance, and even in the specifically classical-academic characteristic of insistence upon formula. Drawings in his fully developed style [374] have their own kind of formal idealization, even though Seurat insisted always upon the contemporary, everyday subjects of impressionism as opposed to the idealism of conventional classical themes.

Second: Assemble these silhouettes into a composition (previously determined in its general expressive disposition), further modifying the individual forms and adjusting their interrelationship until they are perfectly integrated with one another and the space around them. The subject of this composition will observe the impressionists' allegiance to the world at hand, but its expressiveness will be achieved by the application of psychological values of line and color that impressionism sacrificed to "effects" of light and atmosphere and the accidental dispositions of form in nature.

Third: Paint this composition in the technique called divisionism or pointillism, in accord with theories of color held by the artist.*

It is in the second stage, the creation of the composition, that Seurat returns most obviously to French classical standards. The infinite adjustment of the parts of *La Grande Jatte* into a perfected, static interrelationship is in the tradition of Poussin. But the highly simplified forms are not Poussinesque; in their creation and their combination Seurat is equally in the tradition of the ubiquitous Japanese print, with its ornamental flatness. Of course these two traditions are contradictory, Poussin's being a tradition of composition of three-dimensional forms in three-dimensional space. *La Grande Jatte* can be read thus, or it can be read simply across its surface, just as its forms can be read as silhouettes or as geometrical solids. As a composition of solid forms in classical depth the picture is more subtle, more complex, and finally more rewarding, but it is also a wonderfully effective composition if it is regarded as an enormous flat ornamental screen. This spatial ambivalence, offspring of the union between the Euro-

pean painters' admiration for Japanese print design and their own ingrained Western tradition, is present in a great deal of painting during these years. And although Seurat certainly knew the prints at first hand, their influence also entered his art in a roundabout way, through the art of Puvis de Chavannes.

Pierre Cécile Puvis de Chavannes (1824–1898) occupies a curious position in French painting. A little younger than Courbet, a little older than Manet, he was unaffected by the realist-impressionist movement and is habitually thought of as one of the successful academic painters. Actually Puvis de Chavannes had a series of early rejections from the Salon and later on, when he was firmly established and served on Salon juries, he irritated the other members by the freedom of his judgments, and at the end of the century he was greatly respected by the generation represented by Seurat. Puvis often seems both sentimental and stuffy to contemporary taste; his allegories are obvious and his subject pictures have a tiresome synthetic sweetness. But as a mural designer, as he essentially was, he simplified and flattened his forms into compositions of a decorative clarity and nicety unique in his generation.* We see more and more that he was an important influence on modern painting, not only through Seurat but, even more surprisingly, through Gauguin.

Seurat so admired a painting by Puvis, *The Poor Fisherman* [375, p. 316], that he made a free copy of it shortly before he began work on *La Grande Jatte*. Whatever else *The Poor Fisherman* may be—sentimental, prettified, and ambiguous in its compromise between conventionalization and photographic realism—compositionally it is a harmonious combination of simplified forms disciplined into delicate but decisive balance. Upon this kind of composition Seurat imposed further disciplines, always in the direction of increased abstraction, as in the severely beautiful *Bridge at Courbevoie* [376, p. 316], distilled to the geometrical essence of the subject's elements. In *La Grande Jatte,* Seurat's problem was to achieve equal clarity and repose in the manipulation of active elements in far more complicated relationships.

* To make a fine distinction, *divisionism* would be the breaking up of color into its component parts, *pointillism* its application in dots of uniform size. *Chromoluminarism* is another term sometimes met, meaning the same things.

* His numerous murals include *The Sacred Wood,* in the Sorbonne in Paris, the celebrated series of the life of Ste. Geneviève in the Panthéon nearby, and some late, not entirely successful allegories for the staircase of the Public Library in Boston.

375 Pierre Puvis de Chavannes. *The Poor Fisherman*. 1881. Oil on canvas, 4'11⅞'' × 6'3'' (1.52 × 1.91 m). Louvre, Paris.

Once the composition was established, the execution of the painting in the dot-by-dot technique of pointillism remained as a chore before which most painters would have blanched, and which demanded even of Seurat an obsessive concentration. Pointillism, as it is usually called, or divisionism as the neoimpressionists preferred to call it, is a dead end in the maze of color theories branching out from Delacroix's rediscovery of reds in greens, purples in yellows, of vibrations and countervibrations between the color elements of a painting that led, in one direction, to the even more broken color of impressionism. The work of the scientists who investigated the physical laws of light and color was known to the impressionists and probably influenced them to some degree in a most informal way. But there is nothing informal in the art of Seurat; he studied these theories and applied them methodically.

Where Monet would paint a large green area of foliage with many shades of green and occa-

376 Georges Seurat. *The Bridge at Courbevoie*. 1886. Oil on canvas, 18 × 21½'' (46 × 55 cm). Courtauld Institute Galleries, London.

sional flecks of pure yellow or pure blue, allowing these tints and colors to be more or less blended by the eye, Seurat attempted to analyze the exact proportions of the components of a tint, to separate them into the colors of the spectrum, and then to apply them with scientific precision so that their optical blending would produce not only the tint but also the degree of vibration he wanted. The surface of his canvas becomes a kind of "molecular dance" in contradiction to the absolute precision of the forms within which these myriads and myriads and myriads of dots spin and quiver. In his preliminary black-and-white studies for a picture, Seurat approximated the effect of pointillist color by drawing, in his own way, on charcoal paper with black wax crayon [374]. Charcoal paper has a fine but conspicuous grain that allows flecks of white to show through the black, to a degree dependent on the pressure of the crayon. The crayon is always pure black; grays are produced by the interspeckling of the paper's grain, just as tones and colors in the completed painting are produced by the interspeckling of calculated quantities of the component colors.

There is an essential objection to pointillist technique, which was made at the time and is still legitimate in spite of the fact that Seurat's stature among recent painters makes a statement of this objection heretical. But there is no point in pretending that it is possible to look at a painting by Seurat without being first of all conscious of the novelty of its technique. One must somehow manage to cross the barrier of agonizingly meticulous and desperately sincere application of an elementary scientific principle before one is free to enjoy a work of art. Access to Seurat's studio is still through his laboratory, and one is required to watch him at work there before one is allowed to see the pictures.

But once this privilege is granted, the pictures are worth the wait. According to his own aesthetic, which he once formulated in a didactic outline, Seurat left no room for intuition in the creation of a work of art. But it is impossible to look at *La Grande Jatte* and believe that it was produced entirely by rule. If it observes rules more rigorously than painting had ever done before, these rules are still subject to the sensibilities of the artist who applied them. And for that matter, there is not very much in Seurat's rules that was new. As if it should come as a revelation, Seurat propounded a set of general

principles that had been observed for centuries. Some of them were truisms that could have been picked up en route during study in any sound academic painter's studio, such as the rule that dark tones and cold colors suggest sadness, that gaiety is suggested by luminous tones and warm colors. Since the Renaissance, and perhaps earlier than that, Seurat's principles had been familiar to any thoughtful painter. In reading accounts by his followers one is amazed at the long-faced reverence with which Seurat's restatement of a pedant's primer seems to have been greeted. Only the theory of optical color was new, or newish.

Seurat was also interested in discovering a scientific basis for pictorial composition, and he investigated among others a famous mathematical formula called the "golden section." Also called the "divine proportion" or "gate of harmony," it was formulated by the architect and engineer Vitruvius in the first century B.C. and revived in the Renaissance. In 1509 it was published in a book by a Bolognese monk, Luca Pacioli, illustrated by Leonardo da Vinci, who had made his own investigations of the mathematical bases of harmony. It was picked up again in the twentieth century by certain cubists and adopted as a name for their group, the Section d'Or. Applied as a test to many a great painting or building or art object, the "golden section" fits perfectly. Applied in the same way to some of the worst pictures or buildings or objects ever painted or built or manufactured, it works just as well. Used as a formula for creation, it may yield results similar to those more effectively arrived at by a combination of general principles and intuition. Analogies may be made: in music, for instance, it is possible to create a fugue that is technically impeccable, by rule, yet an offense to the ear. In cookery it is possible to follow a recipe closely and produce a dish that is just edible where a master chef would produce a delight from what would seem to be the same preparation of the same ingredients. The point of insisting on all these objections to Seurat's fascination with formula, objections that may sound uncharitable, is only to insist that *La Grande Jatte* as a work of art rises above its demonstration of codified rules. Seurat was a very young man who was investigating the whole process of creative effort, beginning with its mechanics. One can imagine him, had he lived, passing through a crisis similar to Renoir's, from the other direction. Where

Renoir—rightly—mistrusted the spontaneous, unstudied effects of impressionism and recognized the need for self-discipline, so Seurat might have—rightly—relaxed his obsession with "scientific" calculation as the way to expression, putting his faith first in impulse and second in discipline, as Renoir did after his period of reorientation.

As it was, Seurat produced a cycle of paintings demonstrating, systematically, the different principles of his aesthetic before his death at the age of thirty-two. *La Grande Jatte,* the first of the cycle, was exhibited in 1886 in the eighth and last impressionist group show. The group was breaking up; this was the first exhibition in four years, and neither Renoir nor Monet participated. The great problem was what to do about *La Grande Jatte* and the other neoimpressionist paintings—including those of Pissarro, who was involved just then in his brief excursion into this field [377], and those of his son Lucien, who was exhibiting for the first time, and those of Paul Signac, whose name is second only to Seurat's in neoimpressionism. Finally all these pictures were segregated in a room by themselves. The term *neoimpressionism* was coined in this year as a gesture on the part of Seurat and Signac. In spite of their departures from impressionist technique they thus acknowledged their debt to the men who had first explored the translation of prismatic light into pigment. But since the impressionist ideal was to capture the transient moment and the neoimpressionist hope was to capture the essential quality of a scene and transfix it, the exhibition of 1886 must have been an oddly contradictory one. And it demonstrated that pure impressionism had served its purpose and reached its end, as the founding members dropped away to solve special problems while new recruits, like Seurat, used impressionism as a foundation for new structures.

The Salon des Indépendants

The importance of the impressionist exhibitions had been reduced, also, because a new and more inclusive organization had been formed to allow any painter who wanted to do so to exhibit. This had occurred in 1884, two years before the last impressionist show and the exhibition of *La Grande Jatte.* Several hundred artists rejected from the Salon of that year had

377 Camille Pissarro. *River—Early Morning.* 1888. Oil on canvas, 18¼ × 21⅞" (46 × 34 cm). John G. Johnson Collection, Philadelphia.

come together to form an organization to hold no-jury exhibitions, calling themselves the Société des Artistes Indépendants (the same name the impressionist group had used for a while). Seurat was one of the leaders in the organization of the Indépendants, and the first exhibition was dominated by his *Une Baignade* [378]. *Une Baignade* is obviously a forerunner of *La Grande Jatte*; it differs in that Seurat has not yet adopted the pointillist technique. It is a large, quiet picture, rather subdued in color, serenely balanced, but without the combination of formal severity and vibrant surface that would fully individualize Seurat in *La Grande Jatte.* Seurat, along with Pissarro and Signac, also exhibited in Brussels with a new group called Les Vingt, which was devoted to the struggle for the recognition of new art movements in that country. Similar organizations soon appeared both in Europe and in America.

It was while Seurat was helping to arrange another Salon des Indépendants in 1891 that he contracted pneumonia. It is frequently assumed that he was weakened by the days and nights of laborious effort required to execute his large, carefully dotted paintings. He had not quite finished his picture for the Salon des Indépendants

378 Georges Seurat. *Une Baignade.* 1883–1884. Oil on canvas, 6'7'' × 9'10½'' (2.01 × 3.01 m). National Gallery, London (reproduced by courtesy of the Trustees).

of 1891 when he died. *The Circus* [379, p. 320] is an odd picture, with its thin, rather stringy forms and its immobility, which denies the theoretically lively action of its subject. In planning it, Seurat formulated a set of problems contrasting at every point with those he had solved in *La Grande Jatte*: artificial light instead of daylight, an indoor setting in sharply limited space instead of an outdoor one in deeper space, a subject of action instead of repose. But if *La Grande Jatte* seems to demonstrate the legitimacy of Seurat's theories, *The Circus* demonstrates their limitations.

Theoretically, *The Circus* should be a successful picture. The lines swirl in a way that is theoretically correct to express action. The silhouettes, as in the rider's skirt and the hat of the clown in the foreground, are full of theoretically expressive upward movements that should express gaiety ("Gaiety of line is given by lines above the horizontal"). The color is dominated by oranges, reds, and yellows, the "warm dominants" expressive of action and cheerfulness in Seurat's codification of rules.

But sometimes it is necessary to look at a picture not in the light of what the artist intended to do, or how successful the result should have been in view of the way he did it, but quite subjectively as to whether or not the picture speaks for itself. In *The Circus* the means are justified by theory, but there is a real question as to whether the end has been achieved, a legitimate question in spite of our knowledge that the picture is not quite complete. The truth is that as a demonstration *The Circus* is interesting, but as a work of art it remains a demonstration. Almost detail by detail it can be paired with Lautrec's picture of the *Circus Fernando* [380, p. 320], even to the ringmaster's whip, the dancing clown, the scattered audience, in a comparison disastrous to Seurat's contention that picture-making can be reduced to a science. Lautrec has observed the same general principles—active line, vivacious shapes, cheerful color—in a picture full of life not because it was painted in ignorance of method or theory, for of course it was not, but because method and theory, already mastered, were taken for granted as part of the act of creation. In Seurat's picture, method as an application of theory *is* the act of creation, or is meant to be, and this time it has not been enough.

Not only as Seurat's last work but also as his least successful demonstration, *The Circus* leaves one wondering what lesson Seurat would have learned from it and what new explorations he might have made. For with *La Grande Jatte* as a beginning and *The Circus* as a conclusion, Seurat had completed a series of five demonstrations of his systematic aesthetic. *La Parade* [381], following *La Grande Jatte* and painted in 1887–1888, attacks the problem of representing figures out-of-doors illuminated by artificial light. (The row of lotus-like shapes along the top of the composition is a line of flaring gas jets.) The depth of *La Grande Jatte*'s landscape is eliminated by flat walls and screens, reduced in pattern to an abstraction of overlapping rectangles. The figures, instead of being disposed in a variety of attitudes within space, are ranged flatly and repetitiously across a plane close to the observer.

Following *La Parade,* Seurat set himself the problem of a third and last static subject, this

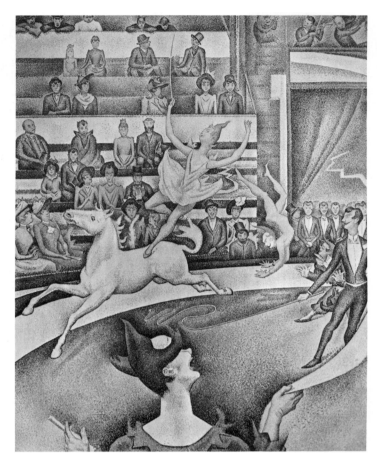

379 Georges Seurat. *The Circus.* 1891. Oil on canvas, 5'10⅞'' × 4'10¼'' (1.79 × 1.48 m). Louvre, Paris.

380 Henri de Toulouse-Lautrec. *In the Circus Fernando: The Ringmaster.* 1888. Oil on canvas, 3'3½'' × 5'3½'' (1 × 1.61 m). Art Institute of Chicago (Joseph Winterbotham Collection).

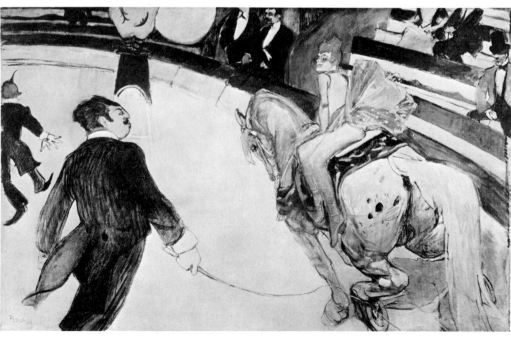

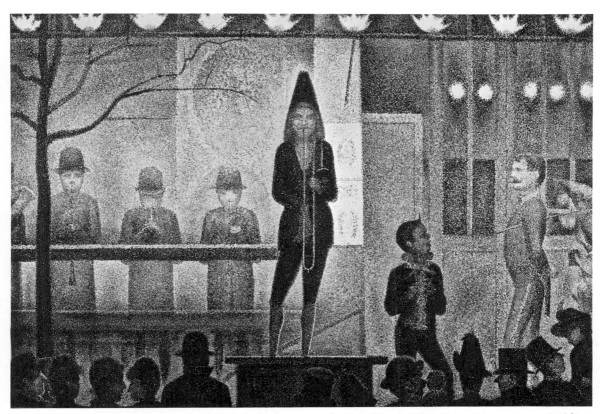

381 Georges Seurat. *La Parade (Invitation to the Side-Show)*. 1887–1888. Oil on canvas, 3'3¼'' × 4'11'' (.99 × 1.5 m). Metropolitan Museum of Art, New York (bequest of Stephen C. Clark, 1960).

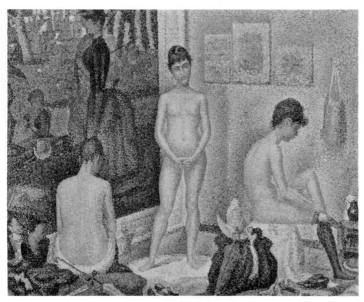

382 Georges Seurat. *Les Poseuses* (second version). 1888. Oil on canvas, 15½ × 19½'' (39 × 50 cm). Private collection.

time with the variation of his first indoor setting, and in natural light, *Les Poseuses (The Models)*. (Along one wall, a portion of *La Grande Jatte* was incorporated into the composition.) *Les Poseuses* is the most delicately colored, the most minutely executed, of all Seurat's pictures, exquisite to the point of thinness and dryness. His friends objected to this quality in it, attributing the picture's look of anemia to the extreme smallness of the dots. Seurat must have agreed. In any case, he followed the disappointing large version with a small one [382], where the tiny dots of paint are harmoniously scaled to the picture area, thus transforming an arid and flavorless picture into one of gemlike precision.

Le Chahut [383, p. 322] was the first of Seurat's kinetic subjects, arranged in shallow space, a preliminary to the kinetic variation of *The Circus*. Although the series of five pictures would certainly have been extended to include, for instance, a kinetic subject in natural light out-of-doors, they are a unit just as they stand. They are an impressive life work, yet surely they are

383 Georges Seurat. Study for *Le Chahut.* 1889. Oil on canvas, 21⅞ × 18⅜'' (56 × 47 cm). Albright-Knox Art Gallery, Buffalo, N.Y.

384 Georges Seurat. *La Poudreuse (Madeleine Knobloch).* 1889. Oil on canvas, 37½ × 31¼'' (95 × 79 cm). Courtauld Institute Galleries, London.

only an introduction, a preface, to a main text that was never written.

Seurat left a single portrait, of Madeleine Knobloch, his mistress, called *La Poudreuse* [384]. Seurat's liaison, and the child of it, whom he acknowledged, were unknown even to most of his closest friends until after his death. In *La Poudreuse* he originally painted his own portrait in the frame now filled by a small bouquet; it has been revealed by X-ray photography. Seurat's family acknowledged Madeleine Knobloch and divided the contents of his studio with her. Since Seurat had sold or given away almost nothing, this meant virtually his entire output. But no one was very interested in acquiring pictures in an eccentric technique most of which were, in any case, too large to hang except as collection pieces. They had been the subject of the usual scandals, so repetitious since the Salon des Refusés. Even ten years after Seurat's death his pictures were considered practically worthless, and *La Grande Jatte* was sold in 1900 for only nine hundred francs. Less than fifty years later a syndicate offered a million dollars for its return to France.

Other Neoimpressionists

Neoimpressionism attracted a large number of followers, as might be expected of a manner offering so explicit a formula. Seurat was disturbed by the size of the number, since none of them had the scientific perseverance that was prerequisite to neoimpressionism if it was to be more than formula painting. Nor did many of them have the creative sensibility that was also necessary, although Seurat denied it. After Seurat's death his leadership was taken over by Paul Signac (1863–1935). Signac was four years younger but had had as much to do with the origins of neoimpressionism as had Seurat himself. Signac, in fact, had converted Seurat to the work of the impressionists, objecting to the "dull" colors of *Une Baignade* when it was exhibited in the first Salon des Indépendants. The two men had met at the formation of the Société des Indépendants, and Signac remained one of its hardest-working members and was its president for twenty-six years after 1908.

Signac was an attractive man, vigorous, enthusiastic, and as outgoing as Seurat was secre-

tive. These qualities are reflected in his painting. He keeps bursting out of the strait jacket of neoimpressionist precision to indulge himself in the joy of painting. He executed some pen-and-ink drawings in a rather painful dot technique which was practiced by several other members of the group, including occasionally Seurat, but he was more at home with a dashing form of divisionism in which broad strokes of color are patterned freely rather than methodically and in watercolors where vivaciously sketched lines and spots of color sparkle against white paper [385]. His book *From Eugène Delacroix to Neo-Impressionism,* published in 1899, is the classic doctrinaire reference on the school.

Among other followers, two are more distinguishable than most: Henri Edmond Cross (1856–1910), one of the founders of the Société, was more interested in emotional expression than in scientific theory and sought it by using the purest, brightest colors of any of the neo-impressionists, to the point even of using them arbitrarily without regard to the actual color of the objects painted. He thus anticipated, as will become apparent later, the work of the fauvist painters, including Matisse. And Maximilien Luce (1858–1941) painted some sensitive pictures remindful of Pissarro. Like Pissarro he abandoned neoimpressionism to revert to the fresher, more intimate effects of impressionism itself.

Cézanne: His Revolution

By age and by association, Paul Cézanne (1839–1906) was one of the impressionists. He was five years younger than Degas, a year older than Monet, two years older than Renoir. He was a

385 Paul Signac. *The Port of St. Tropez.* 1916. Watercolor, 13¼ × 16⅛'' (34 × 41 cm). Brooklyn Museum (anonymous gift)

solitary man, but insofar as he had friends at all, he found them among his impressionist contemporaries. He exhibited in the first and third of the group shows, and when he was in Paris he frequented the Café Guerbois during the days when it was an impressionist center.* When Cézanne died at sixty-seven, Monet, Renoir, and Degas were still working. Yet by the time Renoir was setting himself to the task of painting the *Bathers* and Seurat *La Grande Jatte,* Cézanne had already developed a way of painting as solid as Renoir's was ever to be, and more revolutionary than Seurat's. He said that he wanted "to make of impressionism something solid and durable like the art of the museums." It is a statement of intention that would have been appropriate from either Renoir or Seurat, but Cézanne's solution of the problem was so revolutionary that it takes him out of the impressionist generation except in the strictest chronological sense. Seurat was twenty years younger than Cézanne, yet without dates to guide us it would be easy to believe that the art of Seurat was a transitional step between impressionism and Cézanne. Chronology aside, Cézanne is a twentieth-century painter; that is why he is placed at this point in this book, instead of having been discussed with his impressionist friends and contemporaries or before the younger Seurat.

Cézanne was the most revolutionary painter since the dawn of the Renaissance, which is what the critic Clive Bell meant in 1920 when he said "If the greatest name in European painting is not Cézanne, it is Giotto." Cézanne recognized something of the same kind when he said "I am the primitive of the way I have discovered." Together these two statements mean that European art was given a new direction in the early fourteenth century when a painter named Giotto di Bondone abandoned stylized medieval formulas of representation and turned to nature as his model; that for nearly six hundred years painters followed this direction, varying and perfecting Giotto's innovation, until Cézanne appeared and gave the first redirection since Giotto; and that like Giotto's achievement, Cézanne's is only a beginning, which will be

varied and perfected by many generations of painters who will follow him.

No person in his right mind with more than a nodding acquaintance with the art of Cézanne approaches an explanation of it without the assumption that anything like a total and specific explanation is impossible. In the art of any great painter there is always a residue of the inexplicable after the historians and aestheticians have done their best with him. Cézanne's case is extreme. He himself complained that he had never "realized"—that is, completed, brought to concrete existence on canvas—his theories, what he had hoped to achieve. Even if we discount his statement in view of his temperament (which combined self-doubt with perseverance and allowed dissatisfaction with his own work to coexist with his conviction of its greatness) it is still true that he never managed to clarify his theories into an explainable formula. In this respect he is the opposite of Seurat. Where Seurat was certain of his formula and had only to submit himself industriously to its application, for Cézanne every brush stroke was a hazardous step and an experiment that might wreck the whole structure on the canvas. It is a mistake, often made, to analyze a painting by Cézanne as if it were a perfect and complete demonstration. And if a satisfactory analysis of one Cézanne is finally reached, it is not of much help in analyzing the next one, since Cézanne is full of variations and contradictions from picture to picture. When he said "I am the primitive of the way I have discovered," he recognized not only the revolutionary nature of his art but also his feeling that he had gone but a short distance, and awkwardly, in the direction he set.

As a point of departure for any explanation of his art, two of Cézanne's own comments are more helpful than any others. These comments have become hackneyed for the good reason that no one has been able to invent more succinct ones to suggest the nature of the problems Cézanne set himself and the character their solution imposed on his painting. The twin statements are "I want to do Poussin over again, after nature" and "I want to make of impressionism something solid and durable like the art of the museums."

To "do Poussin over again, after nature" sounds easier on first hearing than it does after a little thought. To do Poussin over again after nature would be to combine somehow the two

* By 1877 the Guerbois had lost its importance as an impressionist meeting place, and the Café de la Nouvelle Athènes partially replaced it. The Nouvelle Athènes, however, became a center for literary intellectuals with only a scattering of painters.

opposites, Poussin's classical order and nature's immediacy. The catch is that neither must be sacrificed to the other, nor may they be mutually watered down to a compromise. How is it possible to be at once artificial and natural? To be at once orderly, like the world Poussin invented, and full of accidentals, like the world of nature? Synthetic on one hand, imitative on the other? For instance, could the problem be solved by repainting Poussin's *Gathering of the Ashes of Phocion* [197], charging its crystalline vacuum with effects of light and air? The suggestion is manifestly absurd since the resultant hybrid would sacrifice what Cézanne wanted from Poussin, the clarity of his order, and would not carry with it what he wanted from impressionism, its immediate contact with the reality of nature. Or, to reverse the combination, perhaps a natural landscape could be observed and modified with an eye to discovering within it the clarity and order achieved by Poussin in his invention of "unnatural" landscapes. This is an improvement. Corot, in fact, had already done this in pictures like the views of Rome [210, 211], which have been discussed.

Corot is a firm link in the tradition of Poussin, and his landscapes of the early period do combine an actual, existing scene with Poussinesque harmony of a sort. But these pictures are cityscapes; their architectural forms are half ready-made for classical disposition, and when Corot painted pure landscape rather than cityscape, his sense of order was lessened—even if we forget his late, fuzzy pictures, where it was even sacrificed.

Doing Poussin over again after nature did not mean, to Cézanne, adjusting the monumental forms of a great city into closer harmonies. It meant the imposition of order onto nature without any loss of nature's vibrance, its quality of life and growth—in short, its naturalness, so dear to the impressionists that they had once been willing to sacrifice everything else to it. For this quality of life, of reality, Corot had substituted a kind of enchanted revery in pictures that were perfection in their way. But it was not the way Cézanne was seeking.

Thus to do Poussin over again after nature becomes a convenient phrase describing a problem but offering no hint of a solution. To perfect an interrelationship of forms in space, as Poussin did, yet to express the reality of their existence in nature, which is haphazard: this, Cézanne thought, must somehow be possible.

Cézanne: Color as Form

To so "make of impressionism something solid and durable like the art of the museums" is "Poussin after nature" turned around, if you wish, but an additional factor is implied—the special use of color made by the impressionists. In breaking their colors and applying the varying tints in individual strokes side by side, the impressionists conceived of color as a manifestation of light, and specific kinds of light. To begin with, Cézanne discards the idea of capturing transient effects. In the world he paints there is no time of day—no noon, no early morning or evening. There are no gray days, foggy days, no "effects" of season or weather. His forms exist in a universal light that impregnates and reveals, but it is not a light in the sense of directed rays from a single source, not even the sun. It is not light as an optical phenomenon to be investigated and experimented with. It is a uniform and enduring light, steady, strong, and clear, not a light that flows over objects and not a light that consumes them. It is a light integral to the canvas; it is "painted in" with every stroke of color.

Conceiving of light in this way, Cézanne had no interest in the broken color of impressionism as a kind of optical trick to capture its shimmer in air. But the idea that impressionism's strokes of varying color could be identified with the expression of form did interest him. He began to model objects in a series of planes, each plane represented by a change of color. A round apple would be transformed into a roundish object of many facetlike planes which might change from yellow to orange, from orange to red, from red to purple, as one stroke succeeded another. In choosing these colors from facet to facet Cézanne observed—to some degree—the theory of advancing and receding color, which can be explained briefly:

A spot of yellow on a piece of blue paper appears to be in front of the blue, since yellow is optically an advancing color, blue a receding one. But a spot of blue on a sheet of yellow will look more like something seen through a hole in the paper than like something laid on top of it, for the same reason. This is because, in general, warm colors, such as yellow and orange, advance; in general cool colors, such as blue and blue-green or blue-purple, recede. But dozens of other considerations affect this generality, such as the texture of the colors, their

relative intensities, their relative areas, and the effect on them of adjacent colors. And part of the problem of modeling in "plastic color" is the problem of the local color of the objects themselves, how to paint a green pear green, a red apple red, a white cloth white, yet to observe within the green, the red, and the white the color changes that will express the form. The word *express* is used instead of *describe* because the form can be "described" in black and white or with conventional use of color.

To reduce the idea of plastic color to these simple terms is immediately misleading, suggesting as it does that the objects in a picture by Cézanne are modeled on a formula that should be specifically recognizable in the painting itself. But this is almost never so. It is easy to imagine Seurat reducing the theory of plastic color to a series of equations and then following the equations faithfully in a studio demonstration. For Cézanne this would have made the whole thing pointless. He was not a studio theorist; he insisted that the painter's first allegiance was to his subject, that he must work in the presence of his subject. For Cézanne, constant allegiance and reference to the subject supplied both discipline and nourishment for the process of creation. If he was painting a landscape he set up his easel out-of-doors, like an impressionist, not to capture the landscape's effect, as the impressionist did, but to absorb its essence. For a painter to work in his studio from sketches or from memory was to weaken his communion with the subject; to have worked entirely from theory would have been to sacrifice this communication altogether. When circumstances forced Cézanne to abandon this principle, he chafed; at work on a large composition of nude bathers he is supposed to have complained that it was impossible to find a group of models willing to pose thus outdoors, on the spot. He was exaggerating when he fretted in this way, for he did customarily synthesize figure groups from preliminary drawings and paintings made from models. But he never synthesized a pure landscape; and in all his painting the theories of form and color, which we have imagined Seurat applying within the neat boundaries of a formula, were given an additional complication by the facts of nature as Cézanne observed and respected them. There are many photographs of localities painted by Cézanne, taken from spots as close as possible to those where he must have stationed himself at work. The surprising thing about these photographs in comparison with Cézanne's paintings is always his close adherence to the subject where one expects deviation from it.

Cézanne: Geometrical Form

The various elements of Cézanne's art are so completely integrated with one another that it is difficult to separate them for explanation one at a time. It is like taking a loaf of bread and trying to explain from it what flour is, and milk, and salt—above all, what yeast is, as the essential transforming element. So far, we have spoken of his effort to find within nature an order comparable to the classical ideal, and of his idea that color and the expression of form could be inseparably identified with one another. If we arbitrarily separate two more elements from their matrix, we should then be able to go ahead and make a summary of Cézanne's development from beginning to end without too many interruptions for qualifying comments. The first of these elements is his conception of geometry as the basis of all form, the second his distortion of form for purposes of structural composition on a geometrical basis.

As for the first, his idea that all forms in nature could be reduced to geometrical ones, such as cylinders, cubes, spheres, and cones, was not new in itself. A frequent exercise in the studios showed beginners how the human body could be simplified into a series of boxlike or cylindrical shapes—one for the chest, one for the pelvis, long ones for the thighs, jointed to others for the leg from the knee down, all this as an aid in establishing the general relationship of the parts of the body to one another before going into details of musculature and the like. And many artists, especially in the seventeenth century, concocted geometrical figures as novelties. But Cézanne's reduction of natural forms to their geometrical equivalents has nothing to do with simplification as a convenience or a stunt. It is at once structural and expressive. Expressively it capitalizes on the psychological association between simple, basic shapes and the basic facts of existence. A love and respect for simple things, a sense that they have a nobility connected with fundamental truth, is a constant in French thought and art. Cézanne's *Card Players* [Plate 26, p. 337], where one man stands like a column and the men at

the table have the solidity and dignity of natural objects—of hills or boulders—is an expression of this sense, conveyed by the solid geometrical forms disposed with architectural stability. This "architectonic" quality is close to a literal reflection of architecture. The three men, bending over their cards, approximate in space the volume of a great dome. Compositionally the picture has a direct relationship to a *Card Players* by the seventeenth-century Italian Caravaggio; in spirit it has a less obvious but more basic one to Poussin's *Et in Arcadia Ego* [386]. Cézanne's *Card Players* shows that "Poussin over again after nature" need not refer to landscape alone: in a commonplace subject, and without loss of contact with the everyday world, Cézanne has achieved classical dignity.

Dignity permeates every object Cézanne paints, whether it is a human figure, a factory chimney, a discarded millwheel, a sugar bowl, a piece of fruit, or "a mere crumpled tablecloth," which "may take on the majesty of a mountain," as Sir Charles Holmes said. In *The Card Players* Cézanne does what Millet would have liked to do but seldom managed, hampered as he was by the persistent virus of sentimentalism endemic in nineteenth-century realism. Of simple people Cézanne made abstract forms expressing the dignity of human existence.

Cézanne: Distortion and Composition

In addition to being almost symbolically expressive, the reduction of forms to geometrical equivalents was a compositional device for Cézanne. After admonishing a friend and follower (Émile Bernard) to see everything in nature in terms of geometrical solids, Cézanne went on to say that these solids should then be put into such perspective that planes and sides of objects were directed toward a central point. This element in Cézanne's composition is readily apparent in, again, *The Card Players* and is basic to the analysis of any of Cézanne's compositions where the objects are unified by a force that could be a mutual orientation toward a selected point, or perhaps several interrelated ones.

386 Nicolas Poussin. *Et in Arcadia Ego.* 1638–1639. Oil on canvas, 33½ × 47⅝'' (85 × 121 cm). Louvre, Paris.

Although the orientation of the planes in a composition toward some selected point is a clue, Cézanne's composition is a much more complicated affair than, say, the problem of disposing several characters on a stage, directing them to stand facing a central character. By such an approach, still-life painting would be only a matter of arranging selected objects harmoniously and then reproducing their appearance with whatever slight modifications the painter wants to make. And this was, of course, the very definition of most still-life painting until Cézanne revolutionized it. Fantin-Latour's still life of 1866 [258] shows that a selection of attractive objects nicely combined in a "set-up" can yield a beautiful picture even when the painter's reproduction of it is more photographic than interpretative.

A closer kinship with Cézanne is found in the realistic still-life paintings of Chardin,* an eighteenth-century artist who is Cézanne's natural forebear in the tradition of French "love and respect for simple things," which both painters express by revealing the dignity of unexceptional objects. In Chardin the degree of verisimilitude is high. The departures from visual fact in *The White Tablecloth* [387] are modifications, not distortions. Tone and color are subtly adjusted, meaningless details are eliminated to reveal the element of abstract formal organization beneath the apparently photographic representation. The weight, solidity, and texture of the objects are emphasized and their geometrical form is made the most of, yet not exaggerated. For most painters of still life, sensitive realism like Chardin's offers sufficient range for expression. For Cézanne it did not. "I do not want to reproduce nature," he said, "I want to re-create it."

This re-creation in terms of the orientation of the planes, lines, and volumes of objects involved departures from visual fact extreme enough to go beyond modification and become distortion. By realistic standards, the table in *The White Sugar Bowl* [388] is askew, the folds of the cloth do not "read," there are dark outlines here and there that can have no photographic justification. As a specific example, the

*Jean-Baptiste-Siméon Chardin (1699–1779) shifted the emphasis in still-life painting from technical display to formal organization. However, during his lifetime his work was more appreciated for its imitative than for its creative elements.

387 Jean-Baptiste-Siméon Chardin. *The White Tablecloth.* 1737. Oil on canvas, $3'2\frac{7}{8}'' \times 4'3\frac{3}{4}''$ (.99 × 1.24 m). Art Institute of Chicago (Mr. and Mrs. L. L. Coburn Memorial Collection).

upper edge of the piece of fruit at the far right center is defined against a thick dark line (in the original, a purplish black) unjustifiable on any score connected with the imitation of the object. Such a line around part of any of the objects in the Chardin would be a shocking disfigurement because it would violate the literalness upon which the picture is based. But such lines, and similar variations from literalness, occur throughout the Cézanne, along with other departures, such as the tilted tabletop with its splayed boundaries.

The effect of the dark line is to pull that part of the table plane which is behind the piece of fruit closer to the plane of the fruit itself. It also modifies the spherical volume of the fruit, tending to flatten it a little. In other words, Cézanne has stopped regarding a table top as a plane and a piece of fruit as a solid to be imitated in such a way that their relationship in his picture must approximate their relationship as parts of the "set-up" from which he is working. He now regards them as a plane and a volume to be adjusted at will to the demands of pictorial organization. Abstract values have superseded realistic ones. If he wants to pull two planes closer together than they are in nature, he does so; if he wants to flatten a solid, he does so; if he wants to tilt a plane, as the table top, he does so, as part of an arrangement of planes and solids

that could not exist literally in nature, but can and does exist wonderfully in painting. If he wants to vary the shape of an object in any way, he does so: the lemon in the extreme lower right corner of *The White Sugar Bowl* would be grossly misshapen if it were introduced into a Chardin or any other realistic still life. It is flattened along its bottom edge and slightly tilted—very slightly, but importantly—along its horizontal axis upward from right to left. Without knowing exactly what kind of explanation Cézanne himself would have made, it seems apparent that the flattening gives the form a base, stabilizing it at a point in the composition where a less static form would be distracting. And the upward right-to-left tilting or warping of the form as a whole engages it into the general movement of the composition, which is upward in the same direction. If this movement is followed across the picture, it is countered by the pear farthest to the left, which leans against the upward thrust.

Every element in the picture could be incorporated into any one of several discoverable movements across and into the composition. In the original, color is one of the balancing and coordinating factors as well as the primary one establishing the forms. If there is a single "central point toward which the planes and sides of objects are directed," it might be the apple nestled among other pieces of fruit and lying directly in front of the sugar bowl. We would then have two compositional systems incorporated into a single one—the upward right-to-left movement with its countermovement, and then the grouping of planes and volumes around the planes and volume of the "central" apple. Other schemes could certainly be discovered within these two. But in the long run it may be a mistake to attempt a formal analysis. It is enough to experience, without analyzing, the magnificent combination of stability and vivid life which is the end effect of the painting when it can be seen in the original, and is suggested even in a photograph.

The importance of Cézanne's distortion of objects as a basic redirection of the art of painting can hardly be exaggerated. It is here that he becomes for his disciples the most important name since Giotto. For he proclaims the painter's right to "re-create" nature, to ignore the laws of representation formulated and used by painters over many centuries, to express the essence of his subject as he feels and understands it, and to violate the literal appearance of nature in any way he thinks is necessary to achieve this expression. This is the essence of modern art.

388 Paul Cézanne. *The White Sugar Bowl.* c. 1890–1894. Oil on canvas, 20⅛ × 24⅜'' (51 × 62 cm). Collection Henry P. McIlhenny, Philadelphia.

Cézanne: The Student

Cézanne was born in 1839 in the provincial city of Aix-en-Provence. His father, who had been a hat manufacturer before he became a banker, had accumulated a comfortable fortune. An important fact in Cézanne's boyhood and early youth was his friendship with a bright and ambitious youngster just his own age who also lived in Aix—Émile Zola. They were best friends, and for a while, as young men, they imagined themselves making their careers together in Paris, Zola at his writing, Cézanne at his painting. But as it turned out, while Zola was becoming famous Cézanne was working in obscurity or exhibiting with scandalous receptions. Zola at first championed Cézanne as he championed Manet. But his faith in Cézanne wavered; it has already been noted that Zola's perceptions, when it came to painting, were not always equal to his crusading spirit.

Finally the friendship broke permanently, in 1886, when Zola published his novel *L'Oeuvre*, the story of a painter who worked against the current of popular taste and understanding. The hero is recognizable as a composite of Cézanne, Manet (who could not object, having died three years before), and the typical concept of the artist as a bohemian renegade from society. Cézanne was deeply wounded. In a sad and polite letter he thanked Zola for the copy of the book he had sent, but he never spoke to him again.

Altogether, 1886 was a climactic year in Cézanne's life. He finally married a former model named Hortense Fiquet, after a liaison of some seventeen years which had produced a son who was now entering adolescence, and in the fall, Cézanne's father died and left him a fortune. Combined with the break with Zola and the sobering approach of late middle age, these were definitive events, although his relationship with Hortense had ceased to mean much. She spent most of her time in Paris with their son. Cézanne stayed on in Aix with his aged mother, seeing very few people, not even his old impressionist friends who used occasionally to visit him. Almost a recluse, moody and difficult, he painted for the next twenty years with no other thought than to reach a conclusion of the problems he had set himself. This was the fourth and last of the periods into which Cézanne's work falls.

Cézanne's first period is one of hesitancy, confusion, and groping. At twenty he was study-

389 Paul Cézanne. Study after Houdon's *L'Écorché*. 1888–1895. Graphite, $10\frac{3}{4} \times 8\frac{1}{4}''$ (27 × 21 cm). Metropolitan Museum of Art, New York (Maria De Witt Jesup Fund, 1951, from Museum of Modern Art, Lillie P. Bliss Collection).

ing law in Aix in accordance with his father's wishes, but in accordance with his own he was also working in the local art school. On the side he was trying to fumble through the study of painting by himself, working in a strong but dark and oppressive manner suggested by seventeenth-century Italian and Spanish painting, which he knew largely in reproductions. In 1861 his father allowed him to abandon his half-hearted efforts to go through with the study of law, and he went to Paris to join Zola and prepare for entrance to the Academy's school. He worked in the Académie Suisse, an odd studio opened by a one-time model named Suisse, where models but no instructors were supplied. Delacroix had worked there at one time, and Courbet. Cézanne met Monet there, and Pissarro. Like everyone who came into contact

390 Paul Cézanne. *Uncle Dominic (The Man in a Blue Cap).* 1865–1866. Oil on canvas, 31⅜ × 25¼″ (80 × 64 cm). Metropolitan Museum of Art, New York (Wolfe Fund, 1951, from Museum of Modern Art, Lillie P. Bliss Collection).

with Pissarro, Cézanne revered him, and continued to do so all his life, referring to him as the "humble and colossal" Pissarro.

Such drawings as have remained from Cézanne's early days as a student are strong, rather blocky, with a concentration on massive, simplified forms within the slightly bulging contours of the baroque manner Cézanne admired at that time. (Thirty years later, he was still drawing from casts as a formal exercise [389].) They were far from the academic tradition, and Cézanne's application for admission to the École des Beaux-Arts was rejected. He returned to Aix and tried to work in his father's bank for a while, but before long he was back in Paris.

He admired the painting of Delacroix for its swirling forms [78], Courbet's for its weight and solidity [178], and he also admired many academic painters, especially Couture [243]. His interest in baroque painters with their strong chiaroscuro continued. It was a hodgepodge of enthusiasms, and Cézanne never managed to harmonize them during this first, or "romantic" period, which lasted up to 1872. He frequently used Courbet's palette-knife technique [179], exaggerating it until the strokes defining the broad planes were modeled almost as if in clay. This is apparent in *The Man in a Blue Cap* [390], also called *Uncle Dominic.* By hindsight or coincidence this breaking up into planes forecasts Cézanne's later expression of planes in color sequences, but as to color itself *The Man in the Blue Cap* is not related to this idea. It is done in tans, browns, creamy tones, and grays, punctuated by the bright blue-green of the cap, the dash of red in the scarf at the neck, and rather ruddy flesh tones. Other pictures of the period may be almost without color, in dark browns and blacks, with monochromatic lights, like the awkward but powerful portrait of *The Artist's Father* [391, p. 332]. The still lifes are also thickly painted, rather heavy in form, sometimes almost ponderous. There are many emotionalized subjects, sometimes allegorical, often suggesting his own frustrations and confusions. There are religious subjects, including some "copies" which are very free adaptations of well-known baroque paintings. In this manner there is the odd and rather disturbing *Washing of a Corpse* [392, p. 332], which at first glance seems to be a Pietà.

During these years Cézanne met Hortense Fiquet—in 1869; a son was born in 1872. Cézanne was in and out of Paris, where he never really felt at home. He spent the time of the Franco-Prussian War and the Commune in Aix and in the village of l'Estaque, near Marseilles, avoiding the draft, and in 1872 he worked with Pissarro at Pontoise. Under this benign influence he entered his second, or impressionist, period.

Cézanne: The Impressionist

Cézanne's impressionist period runs from 1872 to 1877. By 1878 he had discovered what Renoir was to discover five years later; he was the first of the impressionists to turn away from transient effects in landscapes, if indeed he can be said ever to have accepted them. His great

link with impressionism was Pissarro, who himself kept a fairly tight rein on impressionism's tendency to dissolve form into tinted veils. Later, Cézanne objected even to Pissarro's impressionism, saying that if Pissarro had kept on as he had started, he would have been the greatest of them all. But Cézanne felt that, instead, Pissarro had succumbed to the common failing.

The two men worked side by side at Auvers, where Cézanne painted *The House of the Hanged Man* [393], which has become the standard example of his impressionist period. It was exhibited in the first group show, to which Cézanne was admitted upon Pissarro's insistence in spite of general objections. Manet even gave as a reason for not exhibiting that he could not afford to commit himself alongside Cézanne, who was thought of as a little freakish even by those other members who sensed his strength. And Cézanne gave them plenty of reason for feeling so. He was rough in manner, sometimes surly, always unsure of himself, and defensively contemptuous of fine manners. In a rare excursion into satire he did a take-off on Manet's *Olympia* [394], including in the background a top-hatted dandy as a jibe at Manet.

When the impressionist exhibition opened, Cézanne's pictures were the most ferociously attacked of all. (It goes without saying that all this time, and for a long time after, Cézanne was regularly rejected from the Salon.) Yet, as an impressionist painting, *The House of the Hanged Man* is much more concerned with formal definition, much less with light effects,

391 Paul Cézanne. *The Artist's Father.* 1860–1863. Oil on canvas, 5'5½" × 3'9" (1.66 × 1.14 m). Private collection.

392 Paul Cézanne. *Washing of a Corpse.* 1867–1869. Oil on canvas, 19¼ × 31½" (49 × 80 cm). Private collection.

393 Paul Cézanne. *The House of the Hanged Man.* 1873–1874. Oil on canvas, 22¼ × 26¾″ (57 × 70 cm). Louvre, Paris.

394 Paul Cézanne. *Olympia.* 1875–1877. Watercolor and crayon, 9¾ × 10½″ (25 × 27 cm). Philadelphia Museum of Art (Louis E. Stern Collection).

than the average. It is impressionistic in the purification and heightening of color; impressionism had released Cézanne from his heavy browns and blacks and had taught him to apply his paint more sensitively, in smaller strokes. These elements finally led to his thinking in terms of planes and volumes modeled in color.

Cézanne: Realization

The third period, in which Cézanne abandons impressionism and matures as an original artist, runs from 1878 to 1887, coinciding with the traumas of his marriage, his father's death, and the break with Zola. By now Cézanne had abandoned Paris except for an occasional short visit. From time to time he saw Renoir, Monet, Pissarro, and Zola, but in his preoccupation with new problems he began to withdraw from his friends. After the group show of 1878 he did not exhibit again with them. If Zola had been able to understand the work of his friend at this time he might not have said, as he did about 1880, that the misfortune of the impressionists

was that no artist had achieved "powerfully and definitely" the possibilities inherent in the new painting. "They are all forerunners," he said of the impressionists. "The man of genius has not arisen."

The man of genius had arisen and was at work in the steady light of the South, solidifying the shifting, quivering effects of impressionism into something solid like the art of the museums, and reconciling Poussin's classicism with nature. The transformation of Cézanne's art in this "constructive" or "classical" period is revealed by even a superficial comparison of *The House of the Hanged Man* with a *View of Gardanne* [395]—a small town not far from Aix—where the houses rising on the steep slope are abstracted into a configuration of interlocking planes. If such a subject, like Corot's, seems half ready-made, with its blocky houses mounting up to the climax of the steepled church, it is largely because Cézanne's statement is so clear. In the hands of most painters the picturesqueness of the jumbled houses almost on top of one another would have been exaggerated by playing up the interest and variety of the very confusions Cézanne eliminates when he paints planes, not walls, and volumes, not houses, and disposes them in a painting where the interest must be in created abstractions, not in imitated picturesqueness. This is what Cézanne means by "motif" instead of subject. *View of Gardanne* is a fine semiabstract pictorial structure; it would not make the best possible travel poster.

In subjects less obviously adaptable to logical disposition, the sense of organization in Cézanne's transmutation of the forms is just as great even if the means are less apparent. In landscapes like *L'Estaque and the Gulf of Marseilles* [396] all the elements dearest to the impressionists—water, sky, foliage, a scattering of small architectural forms—begin to coalesce in new perspective, a perspective expressed by color instead of vanishing points. In talking about his pictures to his friends, Cézanne used to point to passages where he was dissatisfied because the color remained merely color, not simultaneously color and perspective. By definition, perspective is "the science of representing, on a plane surface, natural objects as they appear to the eye," with vanishing points and linear systems that create an illusion of distance. But Cézanne abandons the idea of perspective as line. "Color is perspective." He is not interested in an illusion of distance or an illusion of

395 Paul Cézanne. *View of Gardanne.* 1885–1886. Oil on canvas, 31½ × 25¼'' (80 × 64 cm). Metropolitan Museum of Art, New York (gift of Dr. and Mrs. Franz H. Hirschland).

form. In his landscapes there is a new compactness, a deliberate limiting of space. The distance from foreground to background across trees and fields, buildings, and the gulf and on to the hills on the other side in *L'Estaque and the Gulf of Marseilles* (as in his other landscapes now) is contracted toward the observer. Instead of emphasizing the recession of plane after plane into expanding distance, Cézanne draws each plane forward, compressing space and thus increasing the sense of ordered unity.

When he is not painting out-of-doors he is working at the same kind of problem in still life, in front of the apples and pears that rotted during the weeks, the artificial flowers, and the ginger jar, the plate, and the few vases that appear in picture after picture. Objects assume new patterns of planes and volumes in arbitrary

396 Paul Cézanne. *L'Estaque and the Gulf of Marseilles.* 1882–1885. Oil on canvas, 25¼ × 31½'' (64 × 80 cm). Philadelphia Museum of Art (Mr. and Mrs. Carroll S. Tyson, Jr., Collection).

397 Paul Cézanne. *Still Life with Commode.* c. 1885. Oil on canvas, 25⅜ × 31½'' (65 × 81 cm). Fogg Art Museum, Harvard University, Cambridge, Mass. (Maurice Wertheim bequest).

flattenings and tiltings, new balances and new rhythms [397]. Heads and bodies, in portraits and figure studies, are subject to similar distortions. Yet for all their revolutionary character, the paintings are first of all alive as expressions, whatever their surface of technical theory. Cézanne never loses himself in theory, a danger of which he was always conscious. Far from pure theoretical demonstrations, his landscapes are still filled with the life of growth; and portraits,

398 Paul Cézanne. *Madame Cézanne.* c. 1885. Oil on canvas, 18⅛ × 15″ (46 × 38 cm). Philadelphia Museum of Art (Samuel S. White, 3rd, and Vera White Collection).

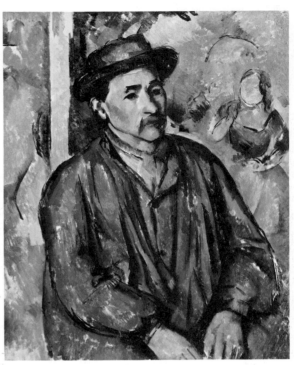

399 Paul Cézanne. *Peasant in a Blue Smock.* 1895–1897. Oil on canvas, 32⅛ × 25½″ (82 × 65 cm). Kimbell Art Museum, Fort Worth, Tex.

even while organized as monumental structures, are still personalities, even pictures of mood [398, 399].

Cézanne: Fulfillment

In the final period, the twenty years from 1886 until his death, Cézanne pushed toward a conclusion, generally in the direction of increased abstraction. To indicate the extent of this development, two views of Mont Sainte-Victoire, near Aix, may be compared. The first [400] was painted just at the dividing line of the third and fourth periods; the second [Plate 27, p. 338] is no earlier than 1904, two years before his death.

The low peak of Sainte-Victoire, rising above the countryside and familiar to Cézanne all his life, visible from his studio window, preoccupied him in painting after painting. It must have become for him something of a symbol of what he wanted to express: the grandeur, the life, the power, yet the eternal order and stability of nature. In the earlier of the two pictures we are

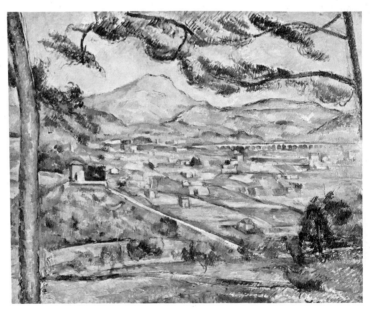

400 Paul Cézanne. *Mont Sainte-Victoire.* 1886–1887. Oil on canvas, 23½ × 28½″ (60 × 72 cm). Phillips Collection, Washington, D.C.

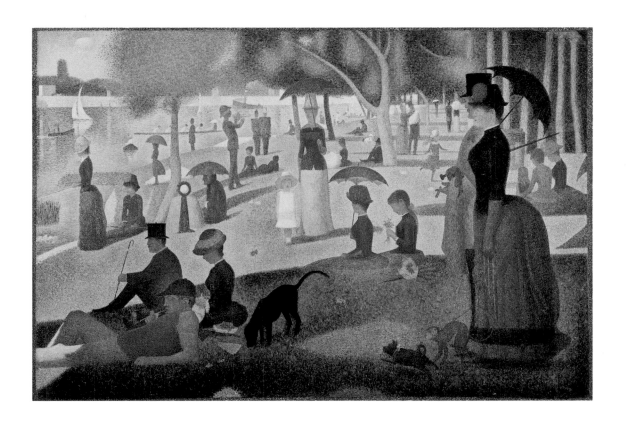

Plate 25 Georges Seurat. *Sunday Afternoon on the Island of La Grande Jatte.* 1884 – 1886. Oil on canvas, 6′9″ × 10′3⁄8″ (2.06 × 3.06 m). Art Institute of Chicago (Helen Birch Bartlett Memorial Collection).

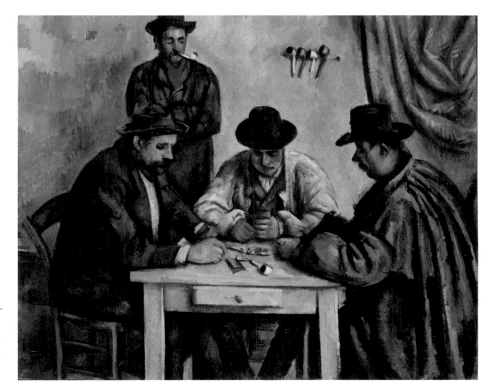

Plate 26 Paul Cézanne. *The Card Players.* 1890 – 1892. Oil on canvas, 25¾ × 32″ (65 × 81 cm). Metropolitan Museum of Art, New York (gift of Stephen C. Clark).

Plate 27 Paul Cézanne. *Mont Sainte-Victoire.* 1904 – 1906. Oil on canvas, 27⅞ × 36⅛″ (73 × 92 cm). Philadelphia Museum of Art (George W. Elkins Collection).

Plate 28 Vincent van Gogh. *L'Arlésienne (Madame Ginoux).* 1887. Oil on canvas, 24 × 17″ (61 × 43 cm). Metropolitan Museum of Art (Samuel A. Lewisohn bequest).

comparing, the peak is seen across a valley where a viaduct, roads, fields, and houses are disposed around it. We are led to its mass across a complexity of smaller volumes ordered, among other ways, by the fanning out of roads and the divisions between fields. Partly because of coincidental reasons, such as the bordering trees and the pattern of foliage against the sky, the terrain rising to a central mountain and bearing many small architectural forms, this picture is especially close to Poussin, specifically to *Gathering of the Ashes of Phocion* [197]. But for all its grandeur and vitality, the scene is also intimate in its sense of enclosure, of peace and order.

In contrast, the very late painting is more severe, yet it is electric in its sharp, vividly colored planes. The forms now approach complete abstraction. Occasionally a house may still be dis-tinguished as a house, or a clump of trees may tell as itself, but for the most part from plane to plane, which means from color to color, the forms exist as color-planes only. The mass of the mountain itself remains recognizable, yet it is broken into echoes and continuations of the planes that build toward it, and these planes are further continued into the sky. The compression of space is extreme. Fields, mountain, and sky are concentrated into the shallowest depth compatible with the interlocking crystallization of vivid blue, green, and orange planes.

Again and again Cézanne explored Mont Sainte-Victoire as a motif. Somewhere between these two versions, in its degree of abstraction, is a view of the mountain as seen across the gash of a quarry [401]. The flat clifflike sides of orange stone impose a different order upon the composition; the peak is given a sharper eleva-

401 Paul Cézanne. *Mont Sainte-Victoire As Seen from Bibemus Quarry.* c. 1898–1900. Oil on canvas, 25½ × 32″ (65 × 81 cm). Baltimore Museum of Art (Cone Collection)

402 Paul Cézanne. *Mont Sainte-Victoire.* 1885–1887. Watercolor, 15⅛ × 19½″ (39 × 50 cm). Fogg Art Museum, Harvard University, Cambridge, Mass. (gift of Henry P. McIlhenny).

tion in harmony with the uncompromising upward rise of the quarry walls with their vertical divisions. As a final comparison, the sharp upward movement of this version contrasts with the lower forms, the gentler movement, of a watercolor painted, again, just at the turn of the third into the fourth period [402].

Cézanne's watercolors are of extraordinary delicacy. They never suggest the heaviness and occasional fumbling that it is possible to find in some of his oils. (Other oils are painted nearly as thinly and transparently as watercolor.) The forms are indicated with a few lines lightly touched onto the paper with pencil, then these are supplemented with a minimum of planelike washes in small areas of prismatic blue, pink, green, and violet, very pale but clear and bright.

Cézanne: «The Great Bathers»

It was after 1885 that Cézanne painted the synthesized figure studies, such as *The Card Players* which we have already seen, one of five variations on the subject, and *The Great Bathers,* the climax of a long series of compositions of bathers in landscape.

The theme of bathers in a landscape had interested Cézanne in different ways as far back as his very early "romantic" period. *The Great Bathers* [403] painted near the end of his life is a curious picture, an arresting one certainly, and for most people not a very agreeable one. Cézanne's distortion in still life and landscape is nowadays acceptable to even casual observers; it is slight in comparison with the extreme distortion seen constantly in modern painting,

familiar to everyone because it is reproduced on every hand. After the more jolting experience of Picasso's rupture and rending of natural form, the person with no formal knowledge of art accepts Cézanne's trees and mountains and apples and pears without questioning their relatively mild departures from visual fact. But it is not so easy for the layman to accept the distortion of the human body with its strong associations dependent upon a standard of normal physical beauty. The female nudes in *The Great Bathers* may be no more distorted than the cloth, the bowl, and the fruit in *The White Sugar Bowl* [388] (which belongs to the same period)

but they are more disturbing because they violate a standard of beauty that is held with an emotional tenacity not at all comparable to the average person's respect for the shape of an apple or a pear.

These comments are obvious enough and would be altogether pointless except that there is a legitimate question as to whether the stock problem of nudes in a landscape is an entirely sympathetic one for Cézanne's purposes. For Renoir, yes; his bathers remain delicious creatures as well as the components of a painting [Plate 19, p. 270]. They are also expressive of the theme uniting Renoir's total work: the beauty of

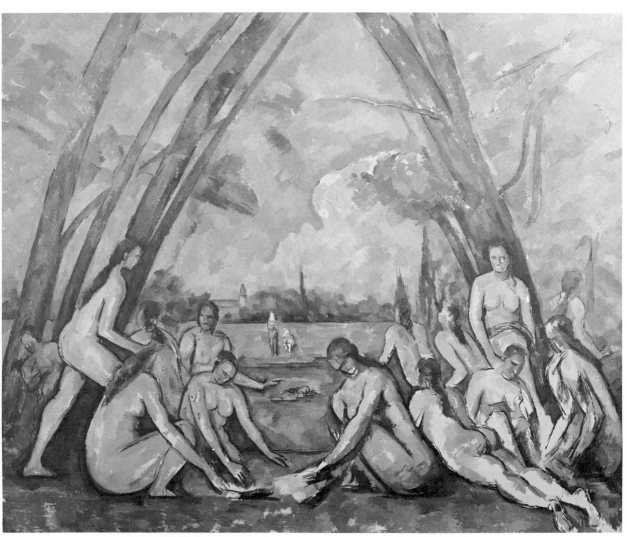

403 Paul Cézanne. *The Great Bathers.* 1898–1905. Oil on canvas, 6'10'' × 8'3'' (2.08 × 2.51 m). Philadelphia Museum of Art (W. P. Wilstach Collection).

the world as he knew and loved it and found it symbolized in women. But there is no reason why the female nude should serve Cézanne as a motif; there are even reasons why it should not, since it is known that he was embarrassed in the presence of a nude female model, suspicious and fearful of women in general. The simple, straightforward men who were his models for *The Card Players* [Plate 26, p. 337] are compatible, as motifs, with the closeness to simple values that we have called basic in Cézanne's art, with its expression of the dignity of everyday, ordinary things. From this point of view, *The Great Bathers*—Cézanne's most ambitious effort as a monumental structure—may be far down the list expressively, since its motif is so artificial, so far removed from the painter's own emotional experience. At the same time, this very removal clarifies the painting as a pure formal abstraction. Historically, *The Great Bathers* is a landmark in the development of abstract painting, the summit of Cézanne's art. Its importance in the genesis of twentieth-century painting will become apparent later in comparison with, for instance, Picasso's *Les Demoiselles d'Avignon* [510]. By itself *The Great Bathers* may be less rewarding than most Cézannes. But in context with his total work, as a planned climax and summary, it is an important document in the history of art.

At least three of the several formal systems that are fused into the construction of the picture are apparent without much searching. First, of course, there is the powerful arched form established so emphatically by the tree trunks and echoed by at least a portion of each figure. Second, a countersystem reverses this upward thrust by a downward one climaxing where the arms of the central figures reach toward a central spot. This countersystem, also, is reflected in some portion of each figure. Finally, there is a movement into compositional depth, most apparent in the figure at the lower right lying on its stomach and facing into the picture. There are also the strong stabilizing horizontals of horizons and banks running across the center and lower portions of the composition. The picture is not finished; parts of the canvas are not covered. But the unity and the deliberation and the consistency of the picture as it stands, the integration of every smallest part into the structural whole, are so satisfying that there is no sense of loss in our knowledge that the structural process could

have continued into further complications and refinements.

In the last decade of his life, Cézanne began to be well known. By 1900, except in the usual backwater of academic intelligence, his power and the importance of his revolution were recognized beyond the specialized circle of a very few dealers, painters, and critics. In 1895 the dealer Ambroise Vollard exhibited a large number of Cézanne's paintings, reintroducing him to Paris after a lapse of close to twenty years. Vollard was only thirty years old at this time and had opened his firm only two years before. Not very certain of his own taste, he wisely accepted advice from good sources, especially from Pissarro and Degas. Pissarro, always Cézanne's good angel, brought him to Vollard's attention. It was the beginning of Vollard's career as a dealer in avant-garde painting, and Cézanne painted his portrait in 1899. The public was appalled by the 1895 exhibition, the conservative painters and critics were outraged, but Cézanne was immediately established as a master in the minds of the former impressionists and among the canny collectors who were beginning to gather around adventurous dealers. It did not take long for the baying of the academic hounds to recede into the distance as a meaningless racket. Within a few years, independent critics had become at least as influential as official ones, and exhibitions held by independent dealers were even more influential than the official Salon as arbiters of taste—finally to the point of abusing their prestige, in some cases, as badly as the Salon had ever done. And the Salon, considerably chastened, liberalized its standards to meet the competition of the more exciting exhibitions that had grown up all around it.

Cézanne died in 1906, at sixty-seven, after a collapse brought on by exposure when he was caught in a sudden storm while painting out-of-doors. In the autumn Salon of 1907 he was given a large retrospective. As a summary of a painter's development, a retrospective exhibition is associated with the idea of a winding up, a completion, a capping-off, a termination. In Cézanne's case it is impossible to make this association. His retrospective was not the terminal point of a career so much as it was a summary of a new concept of form in painting that had been brought, in the art of one man, from its genesis in impressionism to a point of departure for the generations of a new century.

chapter 24

Postimpressionism: Its Romantics

The Nature of Expressionism

Seurat and Cézanne were painters within the classical tradition by its most inclusive definition: they believed that the chaotic material of human experience could be clarified and universalized, and that the means of effecting this transmutation could be discovered through the analysis of form and structure. The fact that their forms were so innovational—especially Cézanne's—makes them no less classical. It simply demonstrates that the classical spirit need not depend for expression on images of gods and heroes foreign to the modern world but may assume forms as original as those of gods and heroes had been when the classical Greeks invented them so long ago. The art of Seurat and Cézanne led the way for the abstract geometrical schools of the twentieth century, such as cubism, which completed the transformation of the gods and heroes into the simplest Euclidean rectangles.

But paralleling this "classical" development, the romantic spirit was forcing its own new expressions, this time with pain and violence exceptional even for romanticism. The art and the lives of Vincent van Gogh and Paul Gauguin were spectacular climaxes in the romantic tradition (which has a way of expressing itself in climaxes); their painting led in turn to the romantic art of the twentieth century, which was expressionism and its variants.

Expressionism in painting is the free distortion of form and color for the expression of inner sensations or emotions. All expressive art is a transfiguration of form to some degree, but expressionism is especially concerned with intense, personal emotions and frequently has connotations of pathos, violence, morbidity, or tragedy. Distortion in itself is not necessarily expressionistic. Cézanne's distortions are not, because they are primarily structural,

and only indirectly a vehicle for the transmission of his feelings. And these feelings in any case are not transmitted in intimate, emotionalized terms.

The expressionist opens his heart and soul and releases his deepest feelings through images intended to embrace the observer and make him a partner rather than an audience, a participant or, at least, a sympathizer within the picture's emotional world. Less intimately, the expressionist may interpret the world for the observer by distortions revealing its essence in emotional terms peculiar to the painter. Expressionism is romanticism extended—further intensified.

Expressionism is a recent term and applies specifically to modern art, but as a general term it can apply here and there as far back as one cares to go in the history of art. In the late sixteenth century, when El Greco twisted and elongated his forms and tied them together in near-hysterical patterns of swirls, angles, and lights, he anticipated the devices of expressionism, although the word was not to exist until three centuries later. And when Daumier, in one of the great drawings of the nineteenth century [404] abandoned his usual economical, realistically descriptive draftsmanship for a tangle of agitated lines to describe a clown standing on a chair, waving his arms and shouting, he was drawing expressionistically. In the arms, recognizable form even disappears. Descriptively, the arm on the left is entirely illegible as an arm, but expressively it climaxes a pathetic and goaded figure in which Daumier makes one of his rare pessimistic statements about life, agreeing with Macbeth that it is "a tale told by an idiot, full of sound and fury, signifying nothing."

Van Gogh: «The Starry Night»

Modern expressionism stems directly from the tragic Dutchman Vincent van Gogh (1853–1890), a man a little older than Seurat, who died a year before Seurat did. Both stemming from impressionism, these contemporaries could hardly be more unlike—Seurat with his calculation, his method, his deliberation, van Gogh with his passion, his shattering vehemence. Instead of *La Grande Jatte* [Plate 25, p. 337], so cool, so defined, so self-contained, van Gogh gives us *The Starry Night* [405], where a whirling

404 Honoré Daumier. *Clown.* c. 1868. Charcoal and watercolor, $14\frac{3}{8} \times 10''$ (37 × 25 cm). Metropolitan Museum of Art, New York (Rogers Fund, 1927).

force catapults across the sky and writhes upward from the earth, where planets burst with their own energy and all the universe surges and pulsates in a release of intolerable vitality.

Like all the most affecting expressionist creations, *The Starry Night* seems to have welled forth onto the canvas spontaneously, as if the creative act were a compulsive physical one beyond the artist's power to restrain. "Inspiration" as a kind of frenzied enchantment visited upon a painter, a paroxysm calling forth images only half-willed, is a justifiable concept in van Gogh's case if it is ever justifiable at all. *The Starry Night* implies that it was executed in a fever of creation, as if it had to be set down somehow on canvas in an instant, as if a pause

405 Vincent van Gogh. *The Starry Night.* 1889. Oil on canvas, 29 × 36¼″ (74 × 92 cm). Museum of Modern Art, New York (Lillie P. Bliss bequest).

for calculation would check the gush, the momentum, of a brush guided by a mysterious spiritual force rather than by knowledge and experience. And to a certain extent this was so. Van Gogh's letters tell of days when his painting went well, when he would work into the night without stopping to eat. In some instances the paint is squeezed onto the canvas straight from the tube, as if to reduce to a minimum the obstructions between conception and execution. Yet all this is misleading. His letters also speak of his studies for a picture that obsesses him, a picture of a starry night. There is a full preliminary drawing.

If *The Starry Night* seems to burst, to explode, to race, it does not run away. It is built on a great rushing movement from left to right; this movement courses upward through the landscape, into the hills and on into the sky, and floods into the picture like a swollen river in the galaxy beginning at the border on the upper left. But this movement curls back on itself in the center of the picture, then rushes forward again at a reduced pace, and finally curls back once more to join other rhythms instead of running out of the picture. In the rest of the sky, the moon and stars are whirlpools meshing with these major movements. The cypresses rise abruptly and lean slightly in the opposite direction as a brake; their own motion, spiraling upward, is another check to the horizontal lunge of earth and sky; a church steeple cuts

less conspicuously across the sweep of a hill on the horizon, to the same effect. The moon, largest of the whirlpools of light, is itself a force that sucks the current back into the picture at a point where it would otherwise rush beyond the frame and be lost.

All of this is calculation, not in Seurat's sense certainly, but it is a scheme consciously observed. *The Starry Night* may have been painted at white heat and even with passages of improvisation. Something like "inspiration" was present and accounts for the extraordinary immediacy of the picture, but this inspiration flowed from a reservoir of study and experience even if it was released by the passionate absorption of the moment. But in the end, it is this moment that tells. Confronted by *The Starry Night* we are brought into van Gogh's presence more intimately than other painters ever quite bring us into theirs. It is a bitter kind of poetic justice that today thousands of people find van Gogh an accessible and sympathetic personality, while during his life, craving love and offering it everywhere, he was able to form only a handful of friendships, half of them disastrous.

Van Gogh: Early Days and Works

Indeed van Gogh must be a much easier man to read about than he was to be around. Small, ugly, and intense, without charm or wit, intelligent but narrow, socially awkward, ill dressed as a point of honor, tortured by religious confusions, yearning for affection but egotistical and stubborn, eager to please but resentful of criticism, he was one of those people who hold noble ideals too nobly, who offer their love as an embarrassing gift, whom one would like to like but whose presence is a burden. He seemed incapable of enjoying himself or of giving pleasure; in all the letters he wrote—and he wrote beautifully—there is no indication he ever took anything casually for a moment.

The men of van Gogh's family were traditionally clergymen, but two uncles had a prosperous gallery in The Hague, which they sold to the international art dealer Goupil. Through this connection young Vincent, at sixteen, obtained a place with Goupil, first in The Hague, then in London, and finally in the main branch of the firm in Paris. But he failed. Never suave, always opinionated, no friend of the rich, who buy pictures, he ended by irritating so many customers

that he was dismissed. Turning to religion, he failed at the theological seminary. When he sought to sacrifice himself in service as a combination evangelist and social worker among miners in a desperately depressed and gloomy area, he failed. He subjected himself to all the hardships of his poverty-stricken parishioners— their miserable quarters, their abominable diet. He slept on a hard board and a straw mattress when he could have had a comfortable bed. The miners laughed at him; their children hooted at him in the streets. Twice in love, he was twice rejected—once by his landlady's daughter in London, once by a cousin. Rejected by the women he wanted to love, rejected by the people he wanted to help, van Gogh attempted to fulfill himself on both scores by living with and caring for a prostitute he picked up on the street, ugly, stupid, and pregnant. This idyll, which could have been inspired by Dostoevski, endured for twenty months.

It was not until 1880, when he was twenty-seven years old, that van Gogh decided to be a painter. He entered this new life not as one enters a profession but as one accepts a spiritual calling, in foreknowledge of self-sacrifice.

His will, his compulsion, to paint as a direct expression of self, as a psychological need quite aside from professional ambitions or the will to fame, no matter what suffering would be involved, sets van Gogh apart from the impressionists, who had fought stubbornly in the face of every discouragement but had always been professional painters, careerists. Delacroix had established the idea of the painter's right to paint as he pleased, to enter into a pitched battle against entrenched manners of painting; Courbet had continued to fight, more as an individual than as a member of an organized school with a leader and henchmen; the impressionists had further abandoned the pre-nineteenth-century idea of the painter as a craftsman with a product to sell in satisfaction of a demand, and finally were to succeed in creating a demand by bringing public taste into line with their standards. They seemed to have culminated the idea established by Delacroix. And to all these painters, of course, art was certainly a release and an emotional satisfaction, as creation must be to any artist. But they were professionals. With van Gogh the balance swings to the other side. Although he yearned for attention, although he exhibited when he could and finally managed to sell one painting, he was not

406 Vincent van Gogh. *The Potato Eaters*. 1885. Oil on canvas, 32 × 45″ (81 × 114 cm). National Museum Vincent van Gogh, Amsterdam.

first of all a man making his way in a profession. He was a man intent on saving his soul, in creating his very being, by painting pictures.*

Van Gogh had begun to draw at the time of his failure as an evangelist among the miners, and had attended classes for a while at the academy in Brussels. He took up serious study as an over-age beginner in the academic art school at The Hague, but did not stay long. He had a

* The single picture van Gogh sold, if we don't count the ones he traded for paints, was *Red Vineyards,* which was exhibited six months before his death in a group show organized by Les Vingt, the Brussels group with whom Seurat also exhibited. Van Gogh had exhibited in the Paris Indépendants shows, as anyone could do, and had organized two exhibitions in Paris restaurants, one in Le Tambourin, which was frequented by writers and painters, one in a huge low-priced restaurant called La Fourche. This was his public exhibition record during his lifetime. The year following his death he was given a retrospective at the Indépendants. This was in 1891. In 1935 when the Museum of Modern Art held the first big van Gogh show in New York it established the attendance record, to that date, for exhibitions of the work of a single painter living or dead.

cousin there, Anton Mauve, one of the most popular painters of the day. Mauve was a painter of sentimentalized humanitarian subjects in the degenerating tradition of the Barbizon school. The association was a short one, ending as so many of van Gogh's associations did, in a quarrel. This was also the time of his association with the prostitute Sien, which had become intolerable. Van Gogh left to paint on his own in the town of Neunen, where his father was now pastor. He puzzled and frightened the townsfolk; the pastor forbade them to pose for his son.

The work from this period—from his first efforts in 1880 until the beginning of 1886—is a continuation of the obsessive humanitarianism that had led Vincent into evangelical work, and it has the same excess of gloomy fervor that had led to his failure. His subjects are poor people, squalid streets or farms, miners and peasants broken by poverty and toil, the inmates of almshouses. He draws in crayon or charcoal, and in his paintings his colors are as depressing as his subjects. His first large, ambitious composition, of which there are three versions, was *The Potato Eaters* [406], painted in the dismal browns

and greenish blacks of the period. "I have tried to make it clear how these people eating their potatoes under the lamplight, have dug the earth with these very hands they put in the dish. . . . I am not at all anxious for everyone to like or admire it at once."

His taste in painting generally was also involved more with humanitarian ideas than with aesthetic values. He admired Millet, and another French painter of peasants, l'Hermitte, and the Hollander Josef Israels, although he objected when these men idealized their subjects, as they usually did. He also admired Daumier and Rembrandt, again largely for their subject matter. He read such English authors as George Eliot and Dickens, who wrote of the poor and the oppressed. The American writer Harriet Beecher Stowe was another favorite; *Uncle Tom's Cabin,* with its pathetic slaves, stirred him deeply. He read the sociological realistic novels of Zola. But he also read the aesthetic Goncourt brothers. He hardly knew of the impressionist painters at this time.

Early in 1886 van Gogh suddenly left Holland for Paris. It seems to have been an abrupt decision. It was certainly an important one. He had gone to Antwerp and had studied for a while at the academy there, but found it dull and restricting. Academic training was intolerable to him because it seemed divorced from the earthy and simple values he was interested in. But he was a clumsy draftsman and he knew it, and he felt the need of stimulation and excitement from other painters. If he could not tolerate the school in Antwerp, neither could he go back to working on his own in a backward rural community. His brother Theo was directing a small gallery in Paris, a branch of Goupil's. Vincent wrote him that he would be in the Louvre at a certain hour, and asked Theo to meet him there.

Later Theo was to recognize his brother's power as an artist, but at this time Vincent was only the family problem, a maladjusted and difficult man whose drawing was nothing more than an emotional stopgap, who was reaching his middle thirties and could not hold a job, who had shown that he was impractical and unstable and would have to be either supported or abandoned to the most desperate circumstances of life, to vagabondage, starvation, the almshouse. The story of Vincent and Theo from now on is a poignant one. Their letters, up to Vincent's last unfinished one written just before his suicide, read like a fine novel and have furnished the material for several poor ones. In his letters Vincent reveals the gentleness and above all the clarity of thought that were so rare when he spoke and not at all apparent in his actions. His torment is equally revealed, and Theo's patience and love. But in their day-to-day relationships when they were together, Vincent remained a problem—stubborn, hypersensitive, and eccentric. Theo's heart must have sunk when he read Vincent's letter telling of his decision to come to Paris, but he took his brother into his flat, supported him from his own limited income, and set about helping him find his way toward a solution of his problems.

Theo's gallery handled work by all the major impressionists as well as the standard Salon masters who sold much better. Theo himself, like any good dealer, was always hunting new talent and had scouted the impressionist group shows with more sympathy than most dealers risked. Vincent's arrival coincided with the final impressionist exhibition, when only a few of the original group were exhibiting and a special room had been given over to the neoimpressionists, including Seurat with *La Grande Jatte.*

The impressionists' happy, brightly tinted art did not immediately affect Vincent. He entered the studio of Cormon, a conventional painter who gave his students sound training in the imitation of the model. Here, a grown man among youngsters, Vincent labored industriously, correcting his drawings until he had erased holes in the paper, irritating everyone, the class freak. Just how he managed to get accepted in a class limited to thirty students, with a waiting list, is a question. Theo's position as a dealer probably helped. Lautrec was among the students and Vincent came to his studio from time to time, but he was an oddball in the effervescent company and after standing hopefully on the sidelines for a while he would disappear. Lautrec did a sketch of him at a café table; it shows a thin, bearded man leaning forward intently.

The stimulation and the new ideas Vincent had come to Paris to find came not from the young men at Cormon's studio but from the patriarch of the impressionists, Pissarro, reappearing yet again in his constant role of saint. As he had done with Cézanne, Pissarro now induced Vincent to abandon his gloomy palette and turgid shadows for the bright, high-keyed colorism of the impressionists. But the transformation was more than a technical one; the spirit

407 Vincent van Gogh. *The Miners*. 1880. Pen, lightly colored; 17¼ × 21½″ (44 × 55 cm). Rijksmuseum Kröller-Müller, Otterlo, Netherlands.

of Vincent's art was equally changed. One of his earliest existing drawings [407], done at about the time of his decision to work seriously at art, shows, as he described it in a letter to Theo, ". . . miners, men and women, going to the shaft in the morning through the snow, by a path along a hedge of thorns, shadows that pass, dimly visible in the twilight. In the background the large constructions of the mine, and the heaps of clinkers, stand out vaguely against the sky. . . do you think the idea good?" Good or bad, the idea was typical of his preoccupation at that time with the hard lot of common people, full of cold, gloom, and miserable hardship. But now when he paints *The Huth Factory at Clichy* [408] he has stopped seeing and thinking in terms of oppressed workers, blackened chimneys, belching smoke, piles of cinders and slag, and sees instead a blue sky, red roofs, a foreground of slashing yellows and greens, all singing in the open air.

From the broken strokes of impressionism and the uniform dots of pointillism (Vincent

408 Vincent van Gogh. *The Huth Factory at Clichy*. 1887. Oil on canvas, 21¼ × 28¾″ (54 × 73 cm). St. Louis Art Museum (gift of Mrs. Mark Steinberg).

409 Vincent van Gogh. *Harvest—The Plain of La Crau.* 1888. Reed pen and ink, 9½ × 12½″ (24 × 32 cm). Collection Mr. and Mrs. Paul Mellon, Upperville, Va.

410 Vincent van Gogh. *Three Pairs of Shoes.* 1887. Oil on canvas, 19 × 27¾″ (50 × 71 cm). Fogg Art Museum, Harvard University, Cambridge, Mass. (Maurice Wertheim bequest).

had made a brief sally in this latter direction) he developed a way of painting in short, choppy strokes of bright color, like elongations of the pointillist dots, which later were to bend and writhe and to be reflected also in drawings [409]. Suddenly he is an artist, suddenly his own man. The contrast between *Three Pairs of Shoes* [410] and *Père Tanguy* [411], painted the same year, is complete. The old shoes are vigorously painted, but the color and the implied humanitarianism are still on the dull and rather heavy-handed level that is so bothersome in *The Potato Eaters* [406]. But Père Tanguy suddenly lives, as no other of Vincent's images had lived until then, and Vincent himself suddenly lives as a fulfilled painter.

Julien Tanguy, affectionately called Père Tanguy, was a color grinder who as a traveling paint salesman had met most of the impressionists during their most difficult days before 1870.

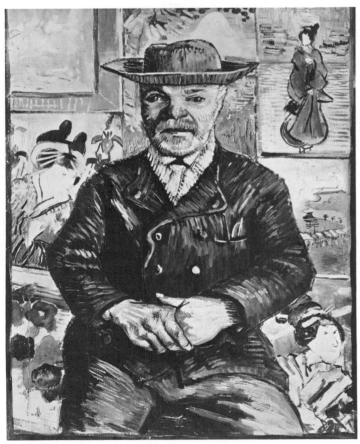

411 Vincent van Gogh. *Père Tanguy.* c. 1887. Oil on canvas. 25¾ × 19¾″ (65 × 51 cm). Collection Stavros S. Niarchos.

When he opened his own small shop of artists' materials in Montmartre he began "buying" their paintings, which usually meant accepting them in exchange for supplies. He also kept their work on hand for chance sales, and thus grew into a collector and art dealer. He was particularly fond of Cézanne; during the years of Cézanne's obscurity as a voluntary exile in Aix, his paintings could be seen only at Père Tanguy's. There were times when Monet and Sisley would have been without materials to paint with if it had not been for this fatherly man. Madame Tanguy did not share his confidence or his interest in those painters who, like van Gogh, used a great deal of paint but were totally unsalable.

Psychologically, Vincent's portrait of Tanguy is a complicated picture in spite of the directness and solidity of the image. Tanguy as a personality, with his combination of naïveté and grandeur, is shown at once as a real person individualized by his bright eyes, his alert face, his simple coat and scarf and hat, and as a monumental abstraction with some of the quality of sculpture. There are few portraits where the play of personality between painter and subject is so apparent. Here, as he was to continue to do, Vincent paints his own psychological presence into the picture. The colors are vivid, with the strong dark-blue mass of the coat in the center surrounded by emerald greens and bright orange-yellows. Everywhere except in the blue coat, the painting is shot through with spots and lines of vermilion. There are lines of vermilion in the shadow on the left side of the face; purely arbitrary lines of vermilion separate the figure from the background, running from the neck on either side down along the shoulder and continuing to the bottom edge of the canvas. As Manet did in his portrait of Zola [255], van Gogh places his subject against a background of references, in this case Japanese prints. But where Manet painted a realistic image of great elegance and of great objectivity, every stroke of Vincent's brush is determined more by his reaction to the subject than by its appearance. From now on the painter who began as so dreary a colorist uses color of an intensity, both optical and expressive, beyond any use of it until this time.

Has Vincent benefited from his labors in Cormon's studio? Perhaps. In the drawing of the head and the hands of Père Tanguy there is a certainty and definition that may have been

strengthened by the disciplines he inflicted on himself, but if it is examined academically the drawing fails everywhere, even where Vincent did not deliberately violate academic principles for expressive necessity. In the hands, the fingers of the hand on our right could not physically pass behind the others as they are supposed to do. As for Père Tanguy's right arm, from wrist to elbow, it does not exist within the sleeve, and the thigh below it is ambiguous. But these are foolish points, not to be thought of twice. Whether or not van Gogh could ever have become an academic draftsman is beside the point, since he has now discovered where his power of expression lies, and he knows that it is not compatible with either academic regulation or impressionist vision. It is possible to think of pure impressionism as the ultimate imitative realism where the eye becomes only a lens (it was once said of Monet that he was "only an eye—but what an eye!"). And the world Vincent must transmute into images is accessible to no lens. It is an inner world of his own. While he thought of himself as the logical descendant of impressionism, actually he rejected all impressionism's values to explore this tormented inner world instead of impressionism's joyous everyday one.

In February 1888, Vincent van Gogh left Paris for Arles, in the South of France, where this exploration was to begin in earnest.

Van Gogh: Arles, Saint-Rémy, and Auvers

The events of van Gogh's life between his departure from Paris in early 1888 until his suicide in July 1890 are well enough known to have established him in the popular mind as the archetype of the Mad Genius. Not mad, he was an unstable personality who in the last two years of his life was subject to epileptoid seizures. Not quite a genius, he was a painter who in his last two years produced a life work of extremest originality, combining theory with a high degree of personal emotionalism. Because the events of his life are dramatic enough to be disproportionately intrusive in a discussion of his painting, they must be summarized first:

Vincent left Paris in a fit of despondency to which many factors contributed. He was irritated with the squabbling and bickering that, he found, was the form usually taken by the stimu-

lating discussions he had hoped for among painters. Not only was he dependent on his brother Theo; he also felt that he was in his way—as he was. And in any case, Paris in February is not a cheerful city for the low-income bracket. For a painter who had suddenly discovered color it was gray, its studios drear. By temperament Vincent was restless. He had lived his life feeling that what he was hunting was just around the corner. This time he thought it lay in the brilliant sun and the simpler life of a small Provençal city. And this time it did.

Theo gave him an allowance and he set himself up in Arles. For this man of thirty-five it was like a youth's first discovery of the world on his own. Before long he was working so hard that he had several fainting spells. Or perhaps these were the first indication of the malady that was about to make itself apparent. It was also just the time of the arrival in Arles of the painter Paul Gauguin.

Gauguin was a fantastic and to van Gogh a glamorous personality, with barbarous and brutal good looks the ugly little man must have envied, and an established reputation among avant-garde painters. The men had met in Paris but did not know one another very well in spite of Vincent's strong attraction toward Gauguin. Gauguin was somewhat older, and there is a hint of adolescent hero worship in van Gogh's feeling for him. He urged Gauguin to visit him in Arles; Gauguin finally consented. As far as their painting was concerned there was an important mutual influence. As far as their life together was concerned there were tensions beyond endurance, at least beyond Vincent's, and in an incident that apparently will never be clarified in its details there was a violent quarrel, after which Vincent went to his room, cut off an ear, wrapped it up, and delivered it to one of the girls in a brothel that he had frequented with Gauguin. This was during the last weeks of 1888. Shortly before, he had painted a self-portrait as a present for Gauguin [412]; the words *à mon ami Paul* are still faintly discernible along the upper left border. The Arles experience had begun with the happiest period of van Gogh's life; but the face in the self-portrait for Gauguin is already the face of a man pushed to the limits of endurance, and the remainder of Vincent's life was torment beyond anything he had endured before.

During the first five months of 1889 he remained in Arles, with intermittent periods in

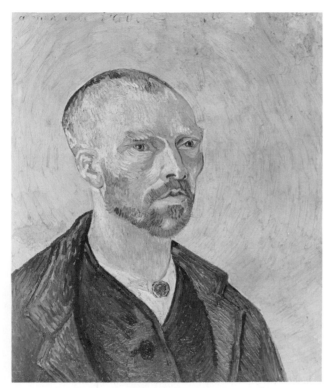

412 Vincent van Gogh. *Self-Portrait*. 1888. Oil on canvas, 24⅛ × 20¼" (62 × 52 cm). Fogg Art Museum, Harvard University, Cambridge, Mass. (Maurice Wertheim bequest).

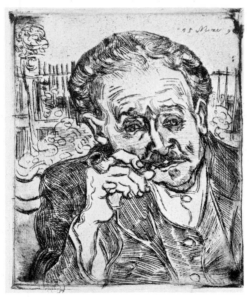

413 Vincent van Gogh. *Dr. Gachet*. 1890. Etching, 7⅛ × 6" (18 × 15 cm). Philadelphia Museum of Art (purchase, John D. McIlhenny Fund).

the hospital as his seizures recurred. He suffered hallucinations, and his irrational behavior got him into trouble with the townspeople, as had happened elsewhere. Then for a year—May 1889 to May 1890—he was an inmate of the asylum at Saint-Rémy, nearby, where he had comparative freedom and could receive immediate treatment—of a kind—during seizures. He worked passionately. *The Starry Night* was painted at Saint-Rémy.

In 1890 the seizures seemed to have relented and he was thought well enough to return to the North. He went to Auvers, not far from Paris, where Pissarro lived and had worked with Cézanne. Pissarro would have taken Vincent into his own house but his wife, understandably, objected. The immediate reason for the choice of Auvers was the presence there of Dr. Paul Gachet [413],* a physician who had special qualifications for this special case since he was a friend of Pissarro and Cézanne and some of the other impressionists—whom he had frequently treated without a fee—and was as interested in art as he was in medicine.

In Auvers Vincent experienced no further seizures. He made occasional short visits to Paris, saw Lautrec there once more, and went to the Salon and exhibitions, but he could not take much of Paris at a time. In Auvers he painted constantly. Dr. Gachet was a miracle of encouragement. But Vincent feared a recurrence of the dreadful experiences in Arles and Saint-Rémy. His consciousness of the burden his life imposed on his brother was extreme, exaggerated now because Theo had married and had just had a son.

* Dr. Paul Gachet (1828–1909) was himself an amateur painter of creditable skill with a special fondness for engraving and etching. Cézanne did his only plates with Gachet, and van Gogh now etched the doctor's portrait. His acquaintance with painters went back to an early one with Courbet. Like Choquet and Caillebotte he discovered the impressionists for himself and collected them along with a lot of "dark pictures" that Vincent objected to in his house. His collection is now in the Louvre. He struck Vincent as being "at least" as eccentric as he himself was, and there was justification for this impression. Among the free-thinking doctor's several unusual schemes was one for a "mutual autopsy" association by which painters would leave their brains for analysis after their deaths. He had been something of a nuisance to the young impressionists but they were also genuinely fond of him.

Vincent had come to Auvers in May. Near the end of July he began a letter to Theo in which two sentences are particularly revealing of the nature of his art and his relationship to it:

Really, we can speak only through our paintings.

In my own work I am risking my life, and half my reason has been lost in it.

He did not finish the letter. It was not a "suicide note," although parts of it are a summation of his relationship with Theo and have about them an air of finality. But when he stopped the letter in the middle and went out with his paintbox and his canvas he might have gone out to paint. The revolver with which he shot himself was never identified. He might have borrowed it on the way from a peasant, with the excuse that he would use it to shoot at the crows that were a nuisance in the field. He shot himself below the heart, but managed to walk back to the inn where he was staying. Contrary to the circumstances as usually taken for granted, he did not shoot himself during an attack or in anticipation of one, and during the two days before he died he was lucid. Theo had been reached, and Vincent died in his arms.

Van Gogh: Later Work

The bulk of van Gogh's life work, the paintings that poured out during the two years and five months between his arrival in Arles and his sui-

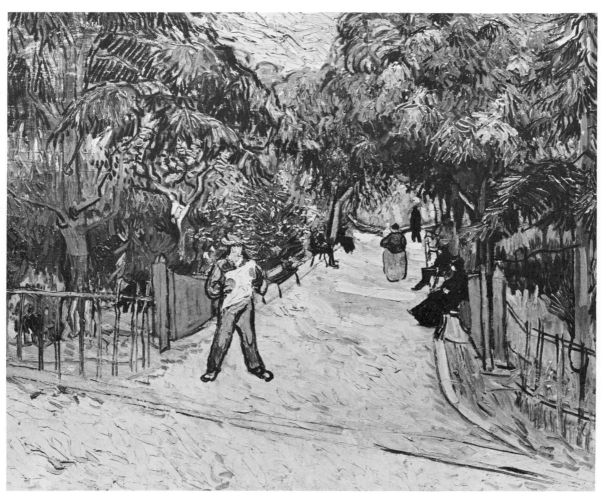

414 Vincent van Gogh. *Entrance to the Public Gardens at Arles.* 1888. Oil on canvas, $28\frac{1}{2} \times 35\frac{3}{8}''$ (72 × 90 cm). Phillips Collection, Washington, D.C.

415 Vincent van Gogh. *Sunflowers*. 1888. Oil on canvas, 36¼ × 29″ (92 × 74 cm). Philadelphia Museum of Art (Mr. and Mrs. Carroll S. Tyson, Jr., Collection).

shapes and images as they developed in Arles, are superficially cheerful. And some of the pictures are genuinely happy ones unless the pathetic associations of the painter's life are grafted onto them. But most of them take on a disquieting introspective intensity or restlessness if they are regarded as something more than spots of color on a wall.

In *Entrance to the Public Gardens at Arles* [414], a twisting and writhing motion is only half repressed in the tree trunks, and it continues into foliage and breaks through in the patch of sky, painted in a flat color yet in angular, motionful strokes. In the pictures of flowers, especially the great heavy sunflowers of Arles [415], there is the same duality. The series of sunflowers are his most popular pictures, the brightest in color, the most obviously ornamental and, being flowers, of course the most "cheerful" and nice to have around. The decorative quality was intentional. Vincent wrote from Arles in a letter to Émile Bernard that he was thinking of "decorating my studio with half a dozen paintings of sunflowers, a decoration in which chrome yellow, crude or broken, shall blaze forth against various backgrounds of blue, ranging from the very palest emerald up to royal blue and framed with thin strips of wood painted orange. The sort of effect of Gothic stained glass windows." The modeling of the flowers' great coarse central cushions of stamens was done in actual relief, the pigment being built up close to a quarter of an inch in some places, and textured like the rough mass of the stamens themselves. Individual petals are also defined by relief, each one existing as a mass of paint with its edge standing out prominently in front of the petals behind it. The sunflower pictures are large ones, the monstrous blossoms being painted at full size. They have a savage vehemence that is reduced to bright prettiness in the small color prints that are so popular.

An extreme flatness as far as modeling in light and shade is concerned, or even as far as the breaking of color is concerned, is characteristic of the Arles pictures in general, but their surfaces are heavily textured. The background of *L'Arlésienne* [Plate 28, p. 338] is a solid yellow, the brilliant yellow that obsesses Vincent now, broken only by the texture of the broad, thick application. Purple, its complementary, is played against it in the dress, and within the clash of the two colors the figure is transfixed. It

cide in Auvers, must be more familiar to a wider public today than the work of any other single painter. At least this is true in the United States. There are individual paintings, such as *Whistler's Mother* and the *Mona Lisa, The Blue Boy* and a Corot or two, that are better known, but in Vincent's case it is not a matter of one or two paintings. Half his work must have been reproduced in tens of thousands of color prints, offered in portfolios as inducements to subscribe to newspapers, framed up assembly-line fashion for sale in department stores and gift shops. To a vast audience on the fringe of "appreciation" he is synonymous with modern art—to which, actually, he is an excellent introduction.

This does not sound like a tragic art. Tragic art does not appeal to tens of thousands of people as a living-room decoration. The brilliance of the color, the decorative attraction of the

is a composition in silhouettes, the double influence of the Japanese print and of Gauguin, who was now visiting Vincent and working with him. But even while he was painting in the dark tones of the early period, van Gogh had come upon Japanese objects and had been fascinated by their color. In Paris he knew Japanese prints well, as we see in the background in the portrait of Père Tanguy (where the color in the prints is exaggerated into brilliance, rather than reproduced in the softer tints of the originals), and he wrote about his trip to Arles that as he approached on the train he was so excited that he could almost believe it was Japan he was coming to. As a descendant of the Japanese print, *L'Arlésienne* has the obvious inherited characteristics of simplified silhouette and flat color, but the sinuous line of the Japanese silhouette has been replaced by a sharpened, forceful, more angular one, and the conventionalized charm has given way to a hypnotic intensity.

Madame Ginoux, a neighbor who posed in regional costume for *L'Arlésienne,* was one of several friendly people who solved for a while van Gogh's perpetual model problem. The most obliging of these were the postman Roulin and his wife. He painted five portraits of Roulin, one of them [416] showing his uniform in a strong blue against a pale blue background, with the beard in short, straight, springing strokes of brownish and yellowish tints flecked with bits of bright blue and red. The figure is more three-dimensionally modeled than that of *L'Arlésienne,* but in the remarkable portrait of Madame Roulin called *La Berceuse* [417] the flatness is again extreme. The picture began with a sentimental idea. It was to recall lullabies to lonely men, Vincent said, and he compared its colors to common chromolithographs. He said from time to time that he wanted to make "naïve" and primitive images like those in popular almanacs or calendars that appealed to uncultivated people—another manifestation of his repeated efforts to identify himself with simple folk in whose lives he imagined that love and honesty and understanding existed in a natural state.

But it is typical of him that the intention he states in literary terms is seldom apparent in the completed picture—in most cases, fortunately not. Whether or not he began sentimentally he did not in the end paint sentimentally in *La Berceuse,* and it certainly does not suggest a chromo. Madame Roulin sits in an attitude rem-

416 Vincent van Gogh. *The Postman Roulin.* 1888. Oil on canvas, 32 × 25½″ (81 × 65 cm). Museum of Fine Arts, Boston (gift of Robert Treat Paine 2nd).

iniscent of Père Tanguy's, but slightly turned, and the figure is built in comparably simplified, half-primitive forms. The hands hold a rope that would be attached to a cradle, a usual means of rocking one. The lower part of the background is a solid red, against the complementary green of the skirt. The black blouse and the face are played against a background of wallpaper transformed into a dreamlike pattern of flowers, some pink ones being semirealistic alongside others that are geometrized. All are connected by odd loops and swirls, punctuated by diamond shapes, these derived from stems and leaves. The rest of the area is filled with black rings, each with a dot of vermilion in its center. The chair is defined by heavy black outlines. The resultant combination of naïveté, violence, and dream makes *La Berceuse* one of van

417 Vincent van Gogh. *La Berceuse (Madame Roulin)*. 1889. Oil on canvas, 36¼ × 28¼″ (92 × 72 cm). Museum of Fine Arts, Boston (bequest of John T. Spaulding).

painted the portrait *La Berceuse* of the motherly Madame Roulin in such a way, he said, that when these sailors saw it in their cabin they would feel "the old sense of cradling come over them."

After the crisis of his first attacks, his break with Gauguin, and finally his transfer to the asylum at Saint-Rémy, Vincent's paintings take on the swirling, tempestuous form and the more mystical expression of which *The Starry Night* is a climactic example. But they are interspersed with milder expressions, such as *The Road Menders at Arles* [418, p. 358]. Its warm tones and the everyday subject modify and even for a moment conceal the compulsive writhing of the great trees whose roots must plunge into the earth with the same voracious energy that forces the trunks and branches upward. And in one exceptional moment the fields around Saint-Rémy are painted in the rain [419, p. 358] and the violence fades into poetic melancholy, the twisting lines give way to a pattern of straight ones slanting across the surface of a composition recalling Japanese prints where rain over quiet landscapes was represented in the same way—an abstract linear design superimposed over natural forms.

Then after Saint-Rémy, during the scant three months in Auvers, the twistings and knottings begin to relax. Their violence is not so much tempered as habitual, much of their true force is lost. The arabesque of lines goes limp. Movement, instead of charging through the picture, is slowed and diffused. The electric presence of the *Public Gardens at Arles* becomes a light, agreeable decorativeness in *Stairway at Auvers* [420, p. 359]. There is a sense of deflation in the Auvers pictures. In color, in pattern, they share the qualities that make Vincent van Gogh one of the most popular painters in the world, but they have lost the spiritual intensity that makes him a great one.

Gauguin: Early Days and Arles

As a matter of chronological tying together, it may be pointed out here that at the time of van Gogh's death Manet had been dead only seven years, and the other impressionists were at the height of their powers. Monet was fifty years old (van Gogh died at thirty-seven) and had another thirty-six years of life ahead of him. Cézanne was not to begin *The Great Bathers* until eight

Gogh's great canvases but it certainly does not recall a lullaby.

In van Gogh's attachment to the Roulins, psychiatrists who are interested in postmortem analyses might find a substitute-parent relationship. Roulin, who was not a mail carrier but worked at loading and unloading mail from the trains, was a tremendous man, six and a half feet tall. Vincent wrote Theo that Roulin was "not quite old enough to be like a father" to him, but that he had a "silent gravity and tenderness . . . such as an old soldier might have for a young one." Thus he offered Vincent an outlet for both the dependent filial affection and the hero worship he was so eager to bestow. In another letter Vincent refers to sailors as "children and martyrs," a phrase in which there are strong elements of a psychological self-portrait, and he

418 Vincent van Gogh. *The Road Menders at Arles.* 1889. Oil on canvas, 29 × 36¼″ (74 × 92 cm). Cleveland Museum of Art (gift of Hanna Fund).

419 Vincent van Gogh. *Rain.* 1889. Oil on canvas, 28⅞ × 36⅜″ (73 × 92 cm). Collection Henry P. McIlhenny, Philadelphia.

420 Vincent van Gogh. *Stairway at Auvers*. 1890. Oil on canvas, 20 × 28″ (51 × 71 cm). St. Louis Art Museum.

years later. Seurat died the year after van Gogh. Picasso was a boy of nine.

Paul Gauguin (1848–1903) was five years older than van Gogh and outlived him by thirteen years. His life was as exraordinary in its circumstances as Vincent's was, but the circumstances, which included greater poverty and privation since he had no brother to support him, were more of his own making than Vincent's had been. Like Vincent's, his life has been a mine for biographers. Its central mystery is why he chose to paint.

In Vincent's case the compulsion is explicable. Anyone can accept the idea that painting is an emotional release for a man who fits in nowhere else. Since Vincent's time the idea has even been so abused that art schools are filled with students whose only qualification as potential artists consists of a demonstrated lack of qualification for being anything else. But Gauguin was a vigorous, rather brutally handsome, worldly, and self-confident man who entered a stock brokerage firm at twenty-three and did very well at his job. After a couple of years he was a successful bank agent; he married well and was soon a father. He began to draw and paint a little for relaxation, as many respectable businessmen have done without disrupting their lives. In 1876 (he was twenty-eight now) he had a painting in the Salon and was buying impressionist pictures. He owned work by Manet, Renoir, Monet, Sisley, and Pissarro, and even Cézanne, among others. Then the ubiquitous Pissarro appeared in person—this time not in a role Gauguin's family would have called that of a saint but rather that of a diabolic tempter, as things turned out. The two men painted together, and Gauguin exhibited in the

impressionist group show of 1879 and the successive ones up through the final one in 1886. By that year he had given himself over entirely to painting as a career and was living by such hand-to-mouth jobs as pasting signs on billboards. He had expected to eke out a living as a painter, perhaps had even expected to be a successful one without too long an apprenticeship. Pissarro objected to his "commercialism" when Gauguin worried about selling, but it was not easy for a man who had been well-to-do to see his money drain away, to accept hardships that turned out to be more severe even than he had expected as part of the anticipated satisfactions of a creative life. His wife, a Danish woman, was forced at last to return to her family with Gauguin's children, a temporary measure that became permanent.

Gauguin was a sport from the romantic tradition of bohemianism, the concept of the artist as a free soul beyond the conventions of society, sacrificing such bourgeois ideals as security and respectability to the precarious but stimulating life of the studios. Gaiety and self-indulgence and moral license, which were incidental to bohemianism in its origins as a way of life dedicated to creative effort, finally became ends in themselves and created the phenomenon of the painter who does not paint, the writer who does not write, the thinker who does not think but who makes the most of the bohemian's exemption from social responsibility. Gauguin has been seen by some biographers as a man attracted by the bohemian way of life, a man who remained a Parisian bohemian even when he fled the life of the studios to paint in the South Seas. And he did indeed have many of the qualities associated with parasitic bohemianism. He was vain, selfish, an ardent and indulgent sensualist. He loved flattery but was niggardly in recognizing the achievements of his colleagues. He was jealous of his innovations and quick to resent their adaptation by other painters. He dramatized himself, was something of an exhibitionist. The figure he cut as a personality was important to him, and he cultivated it not only by scandalizing the bourgeoisie, as all bohemians enjoy doing, but by creating a legend of himself among other painters. He never hesitated to sacrifice other people to this legend or to his self-love.

But the difference between Gauguin and the armies of picayune neurotics who answer to the same description is that he made a painter of

himself. If he had expected an easy success he soon discovered that he was not going to have one, and he continued to paint even when it became apparent that if he had sacrificed other people he was also going to have to sacrifice himself. He continued to paint in the face of every privation, every discouragement, in the face of humiliation, of ill health, ultimately in the face of death. If he was guilty of play-acting, these facts were very real.

From the beginning, exotic places and primitive peoples were a part of Gauguin's life, and in the end he sought a final identification with them. When he was a child his parents emigrated to Peru. Later as a recruit in the merchant marine he knew Rio de Janeiro. When he began painting seriously he hunted out spots where he could find or could imagine he found a primitive naturalness, including parts of Brittany and the island of Martinique, these before he made his visit to van Gogh in Arles. (On the way to Martinique he worked for a while as a digger on the Panama Canal.) The experience of Martinique was a determining one; after his return to France he was more than ever restless for exotic places, more than ever dependent upon them for the kind of stimulation that bohemian Paris could no longer give him.

After impressionist beginnings, Gauguin had theorized a great deal about what he wanted to do, and shortly before his visit to van Gogh he had set out to summarize his new ideas in a canvas called *The Vision of the Sermon (Jacob and the Angel)* [421], painted in the Breton village of Pont-Aven, where he had established himself as one of the colony of artists attracted by picturesqueness and inexpensive living. It shows a group of Breton women in regional costume witnessing the struggle of Jacob and the Angel in a field painted a solid bright red. In their simple and superstitious faith the women think of the struggle in factual terms, seeing it literally as a struggle between a man and an angel. But for the observer outside the picture—and outside the limitations of simplicity and superstition—the supernatural quality is established by the unreality of the red field. The regional bonnets are designed in almost flat silhouettes to make the most of their decorative shapes. A small cow, entirely (and deliberately) out of scale appears in the upper left quarter. The trunk of a tree cuts in a strong diagonal across the picture and separates the biblical struggle from its peasant spectators.

421 Paul Gauguin. *The Vision of the Sermon (Jacob and the Angel).* 1888. Oil on canvas, 29¼ × 36⅝″ (74 × 93 cm). National Gallery of Scotland, Edinburgh.

The technical theories Gauguin applies here include the use of pure color, the reduction of all forms to their essential outlines, and the elimination of modeling within those outlines as far as possible, especially modeling by shadows. Also he insists on the painter's right to effect an entirely arbitrary arrangement of nature, although in this particular composition one does not have to look far to see that this arbitrary arrangement is closely related to the composition of Degas, which depended on arrangements the reverse of arbitrary, those discoverable in the accidental relationships of the everyday world.

Those are the technical means. The Gauguinesque spirit of the picture is in its searching out of exotic forms (the costumes of the women) in combination with what he called the "rustic and superstitious simplicity" of the subject. When he went to Arles, Gauguin took these ideas with him.

He arrived in Arles on the twentieth of October 1888, expecting to stay for perhaps a year. The faithful Theo had supplied money for the trip, with enough extra for first expenses, and hoped to sell enough of Gauguin's canvases to keep him in funds thereafter. Vincent was excited beyond measure. He redecorated his room in anticipation of the great visit, and after Gauguin's arrival he found their discussions "terribly electric." But Gauguin wrote to a friend that he found everything in Arles "cheap and pretty" and admitted that in these electric arguments he would say "Corporal, you're

right!" to avoid having to discuss questions with a man who seemed to like everything he detested (including the Barbizon painters) and to understand nothing that he liked (including Ingres and Degas). He found very little material that interested him, thought of leaving, changed his mind—for practical reasons, one may suspect, since Theo was virtually pensioning him as a companion for Vincent—was bored and restless. From the dark southern beauty of the Arlésiennes and their somber costumes [422] he managed to extract material for a composition suggestive of mystery and superstition, much in line with *The Vision of the Sermon* but not with the life and spirit of Arles.

On the whole, the visit that was such a traumatic experience for van Gogh—ending in the quarrel, the amputation of the ear, the first seizure—was a fiasco for Gauguin. Many years later he wrote that he owed something to Vincent in the "consolidation of my previous pictorial ideas." He also congratulated himself that he had been "useful" to Vincent, and acknowledged a debt to this friend who had shown him that there were people even unhappier than himself. But he had come to Arles reluctantly and now he left it with relief. His stories about exactly what happened there are contradictory, reflecting rather more credit on himself in later versions than in his first accounts.

422 Paul Gauguin. *Old Women of Arles.* 1888. Oil on canvas, 28¾ × 36″ (73 × 91 cm). Art Institute of Chicago (Mr. and Mrs. L. L. Coburn Memorial Collection).

Gauguin: Pont-Aven and Le Pouldu

So Gauguin returned to Brittany, first to Pont-Aven, moving later to the similar village of Le Pouldu when Pont-Aven became tourist-ridden as such picturesque unspoiled spots always must. In 1889 and part of 1891 he was the center of a group of painters who gave the name *synthetism* to the manner of heightened color, flattened form, and heavy boundary lines he had been developing. Synthetism was a loosely formed aspect of or a secondary name for sym-

bolism, a movement more literary than pictorial with a strong flavor of the exotic and the mysterious in reaction against realism. As far as Gauguin was concerned, though, he was following his own course and the words people attached to his art were of no concern to him except that he was flattered by the attention. He did not take synthetism very seriously, and satirized it in a self-portrait as a synthetist saint with a halo [423]. But while it is a tongue-in-cheek performance, the picture in its increased abstraction unwittingly hints at a direction another generation will follow under Gauguin's influence.

His serious work continued in the direction of *The Vision of the Sermon.* In *The Yellow Christ* he showed a medieval yellow wooden statue from the chapel of a small town near Pont-Aven, placing it out-of-doors and surrounding it with peasant worshipers. He was still attracted to the heavy forms of primitive and early arts, in this case those of the rough Romanesque sculpture and architecture of the region. He had even offered his *Vision of the Sermon* to the local priest, wanting to see it hung in the small church where he hoped the picture would harmonize with the ancient, rugged, and simple forms of the architecture. But the gift was refused because the priest suspected a hoax. Gauguin and the artists who gathered around him in Brittany were not remarkable for their seriousness and reverence in affairs of this kind, but this time the gift had been offered in all sincerity.

Although it seems contradictory to the flatness and unbroken color of synthetism, Gauguin was also studying Cézanne at this time, and his portrait of *Marie Lagadu* [424, p. 364] is evidence. Cézanne's faceted planes are suggested, but everywhere the forms are more neatly contained than Cézanne's, more ornamental and more graceful. Gauguin sensed Cézanne's monumentality—and was to draw upon it—but he did not explore Cézanne's compositional premise of formal distortion in abstract spatial relationships. The woman is posed in front of a Cézanne still life, but instead of copying it Gauguin has tightened the forms in accord with his own taste.

His basic theme continued to preoccupy Gauguin: the undercurrent of superstitious fear beneath the simplicity of primitive people, the menacing whisper of the unknown permeating lives apparently simple and natural. In Le Pouldu he yearned more and more for the fara-

423 Paul Gauguin. *Self-Portrait with Halo.* 1889. Oil on panel, 31¼ × 20¼″ (79 × 51 cm). National Gallery of Art, Washington, D.C. (Chester Dale Collection).

way, the bizarre. Now, to find authentically exotic material in situ, Gauguin decided to flee civilization. An exhibition of his work was organized, and with the help of every friend with enough money to buy paintings or enough influence to attract attention to them, enough purchasers were found (including Degas) to put him in funds for a voyage to Tahiti. He left in April 1891.

Gauguin: Tahiti and Last Years

From Gauguin's experiences in Tahiti it is possible to isolate certain facts to describe an elysium. He scorns the mean provinciality of the French colonial settlements and moves into the interior. The natives are beautiful people, the men like gods of the earth, the women like its flowers. He occupies a simple wooden hut in the midst of lovely country, surrounded by exotic birds, fruit, and foliage. He takes a young girl as his native wife; later she bears him a son. He paints all day, happily naked. He learns the native tongue, explores native myths.

The rest of the picture is less halcyon. He grows old rapidly; he spits "a litre of blood" daily for weeks at a time; he develops a persistent rash or eczema; lesions will not heal, and remain open sores; a foot broken in a brawl fails to mend properly and agonizes and immobilizes him; he runs out of funds and the money promised from France never arrives; he must beg a few francs here and there, receiving some now and then from his wife in Denmark; his daughter, at twenty, dies in Denmark, and for a man who has seen so little of her he takes it very hard and writes such a bitter letter to his wife that he never hears from her again; he humiliates himself and works for six francs a day doing hack jobs for the colonial government he detests; during periods of absolute penury he lives off boiled rice; during others, off dry bread and water; when even the Chinese storekeeper cannot give him further credit he is without bread and lives off a few mangoes; he attempts suicide with arsenic but vomits it up and has only a great agony instead; he writes abusive letters to government officials and as a result of one of them he is sentenced to a fine and three months in jail. He enters an appeal, which would have taken him to another island for a hearing, but before he leaves he suffers two slight strokes. He is helpless in his hut,

424 Paul Gauguin. *Marie Lagadu.* 1890. Oil on canvas, 25⅝ × 21½″ (65 × 55 cm). Art Institute of Chicago (Joseph Winterbotham Collection).

abandoned except for occasional visits from natives. His sight fails. One leg is suppurating. He dies alone.

This hell was divided into two periods on either side of a return to France. Chronologically the periods are: the first Tahitian one, from his departure from Paris in the spring of 1891 to his return landing at Marseilles (with four francs in his pocket) in August 1893; he remained in France until February 1895; then he returned to Tahiti, stayed there until moving to the Marquesas Islands in November 1901, where he remained until his death.

The interlude of a year and a half in France is bizarre enough in itself. The object of the trip was to collect money due him and to try for more with an exhibition of the paintings he brought back. The exhibition was a scandal and a mild success; Degas liked it. Real financial help came from an unexpected source. An uncle died and left Gauguin an inheritance. He

spent it rapidly, with the assistance of a companion he picked up somewhere in Montmartre, a mulatto with an Oriental cast to her features who called herself Anna the Javanese. Whatever her other attractions, Anna was a spectacular accessory to Gauguin the Exotic, who now disported himself in a long blue frock coat like a minstrel's, with large pearl buttons, a blue vest embroidered in bright colors, buff trousers, a gray hat with a blue ribbon, and a fancy walking stick he had carved for himself with barbaric figures and inlaid with a pearl. This outfit was adopted on a return trip to Pont-Aven but also made its appearance in Paris. Combined with Anna and a pet monkey, it was spectacular enough and could certainly be described as inviting attention, yet when it and Anna received more attention than Gauguin liked from a

group of sailors, he got into a brawl with them and it was at this time that his foot, or ankle, was broken by a blow from a wooden shoe. These events took place in the little resort of Concarneau near Pont-Aven, and Gauguin had to be taken home on a stretcher (according to some versions) or trundled in a wheelbarrow (according to other credible ones). As the script for a comedy these grotesque incidents would be hilarious. When one remembers that they happened in earnest, they are appalling. Anna capped the affair by abandoning Gauguin on his bed of pain and going to Paris, where she stripped the studio of all objects of value and disappeared.

The wonder is that from the misery, the confusion, the distraction of Gauguin's life in the islands an art of any order could come. Yet it did. And in spite of his reiterations that he was a "true savage" and in spite of the fact that he was painting in a native hut instead of a mansard studio, his paintings are always sophisticated, in effect the paintings of a Parisian who has gathered material on primitive location. He may have lived with the natives, may have taken a native wife, may have learned their langauge and their myths, but he was no primitive. He spent the end of his life in a tremendous natural reference library, acquiring a new vocabulary of motifs—dark-skinned figures, native cloths, bananas and palms and curious plants with fantastic blossoms.

Synthetism would have been an apt word if it had been coined to describe Gauguin's pictures like *Ia Orana Maria* [425], one of the earliest from the first Tahitian period. The picture is completely synthetic—divorcing the word for the moment from its associations of shoddiness. The words of the title are the equivalent of *Ave Maria* or *We Hail Thee, Mary.* A native woman and her son on her shoulder are haloed like the Virgin and Child. Two women stand in attitudes of reverence or prayer while an angel behind them points to the Tahitian Madonna. Nothing could be more artificial, much less connected with the life of the natives. It is the *Vision of the Sermon* in a new locale, except that where the Breton picture was tentative, the Tahitian one is assured in its use of rich colors and the disposition of ornamental forms into a tapestry-like unity. As a final curiosity and a final divorce from his immediate material except as studio props, Gauguin has turned to yet another source for the attitudes of the two adoring

425 Paul Gauguin. *Ia Orana Maria.* 1891. Oil on canvas, 44¾ × 34½″ (114 × 88 cm). Metropolitan Museum of Art, New York (bequest of Samuel A. Lewisohn, 1951).

women. They are transposed directly from a bas-relief from a Javanese temple, known to Gauguin from a photograph which in all likelihood he had purchased at the Paris World's Fair two years before. A picture that refers to a photograph of a Javanese temple, purchased in Paris and carried to the South Seas, that incorporates Javanese figures with Tahitian models into a Christian subject treated as a decorative composition to be taken back to Paris and sold in a commercial gallery for money to free the painter from the degrading commercial forces of civilization is certainly a synthesis of some kind.

Ia Orana Maria is a richly decorative painting using an exotic vocabulary, but it would be forcing the point to pretend that it explores beneath the surface of native life. Gauguin uses Tahitian material in a way closer to its inherent character in a picture painted the following year, *Manao Tupapau* [Plate 29, p. 371], usually translated as "The spirit of the dead watching," although according to Gauguin's own notes it may mean either "she thinks of the spirit of the dead" or "the spirit of the dead remembers her." The theme was suggested to him when he returned late one night to discover his Tahitian wife lying on their bed waiting for him, terrified by the dark. He explained the picture in unusual detail in a letter to his wife in Denmark, telling what he wanted to express and how he went about expressing it. Instead of describing fright in a "literary way" by posing the model in the pantomimic gestures of anecdotal painting, he tried to relay the sensation by a "somber, sad, frightening" color harmony that would "sound" to the eye like a tolling death bell. Since the Polynesians believed that phosphorescence is the spirits of the dead, he painted in the background some fantastic flowers resembling sparks. Instead of making the ghost (appearing like an idol on the left) a wild and menacing figure, he made it "like a small, harmless woman, because the girl can only see the spirit of the dead linked with the dead person, a human being like herself." At other times he made further notes on the symbolism of *Manao Tupapau,* comparing the spirit of the living soul and the spirit of the dead to day and night, and—in line with the popular nineteenth-century taste for such things—making a musical analogy to the "undulating horizontal lines" and the "harmonies of orange and blue brought together by yellows and purples."

426 Paul Gauguin. *The Moon and the Earth (Hina Te Fatou).* 1893. Oil on burlap, 45 × 24½″ (114 × 62 cm). Museum of Modern Art, New York (Lillie P. Bliss Collection).

During the first years in Tahiti Gauguin evolved his typical heavy-legged, narrow-hipped, square-shouldered female figure type not at all reflective of the rounded sensuous bodies of the Tahitian women but appropriate to his idea of savage monumentality and a fit

participant in his allegories of the union of primitive people with earth, sky, and the mystical forces behind nature. The woman in *The Moon and the Earth (Hina Te Fatou)* [426] is a moon goddess, but a far cry from the classical Diana and a far cry from Ingres' *La Source* [134] (the spring in the background suggests the comparison) and a far cry too from Degas' nudes. But Degas, the worshiper of Ingres, bought *Hina Te Fatou,* and it can take its place in the long line of pictures where painters have summarized their art in images of the female nude. With Gauguin this summary is a compound of sophistication and primitivism, of affectation and decision, above all a reversal of the impressionist idea that the world must be met on its own terms and interpreted through

its own appearance. Instead, Gauguin rejects the world; the painter's assignment becomes the exploration of universal mysteries through symbols rather than the observation of temporary fact through fragments of tangible reality. This is Gauguin's importance—no matter what affectations and insincerities and limitations may hobble him in the expression of so ambitious an idea.

In the last terrible years of his life, after his return to the islands following the grotesque exhibitionism of the interlude in Paris and Pont-Aven, Gauguin's art contradicts the picture of him as a harassed and decaying man. It takes on a reserve, a decisiveness, and a removed calm. As in *Poèmes Barbares* [427], of 1896, the gestures of his figures become hieratic and formalized. The idol and the figure are no longer part of a world of superstitious fear but exist together in a world of barbaric mysteries. In the very large and complicated picture with the cumbersome and literarily pretentious title *Whence Come We? What Are We? Whither Go We?* [428, p. 368], a painted tapestry of figures, idols, and landscape neither cumbersome nor pretentious, there is an air of finality beyond that of any other of his compositions. This may be because the picture is conceived first and last as a studio summary; it is to Gauguin what *The Studio* is to Courbet [184], *La Grande Jatte* to Seurat [Plate 25, p. 337]. It is also a tribute to Puvis de Chavannes, whose painting Gauguin had admired and even copied. Gauguin protested too much when he wrote of *Whence Come We?* that "By God, it is not a canvas made like Puvis de Chavannes, studies from nature, then preparatory cartoons, etc. It is all boldly done, directly with the brush, on a sack-cloth full of knots and rough spots. . . ." This may be true enough, but compositionally it is a cousin of Puvis' *The Sacred Grove* [429, p. 368]. There are the same strong horizontals and verticals, the same shining water at the left, cut by a dark slanting tree in the Puvis and a slanting dark reflection in the Gauguin, the same rounding off of the corners, especially noticeable in the upper right but also noticeable in the figures at lower right and lower left. The conspicuous female figure leaning on one arm at the lower left of the Gauguin reverses a similar figure in the lower right of the Puvis. But Gauguin need not have protested. The picture is his own, and if it is directly connected with a tradition, then it places him securely within a great one.

427 Paul Gauguin. *Poèmes Barbares.* 1896. Oil on canvas, 25⅜ × 18¾″ (65 × 48 cm). Fogg Art Museum, Harvard University, Cambridge, Mass. (Maurice Wertheim bequest).

428 Paul Gauguin. *Whence Come We? What Are We? Whither Go We?.* 1897. Oil on canvas, 5'7" × 14'9" (1.7 × 4.5 m). Museum of Fine Arts, Boston (Tompkins Collection, Arthur Gordon Tompkins Residuary Fund).

429 Pierre Puvis de Chavannes. *The Sacred Grove.* After 1883. Oil on canvas, 3'1½" × 6'10⅞" (93 × 2.11 m). Art Institute of Chicago (Potter Palmer Collection).

The Nabis

Gauguin's influence on a new generation of painters was felt at close quarters in the work of a group of converts twenty years younger than he, who abandoned the principles of the Académie Julian—virtually a preparatory class for the Academy's school—and even of the École des Beaux-Arts, in order to follow his ideas of composing in flat, unmodeled areas as

developed at Pont-Aven. By the time Gauguin left for his first stay in Tahiti his influence was apparent in the work of these young "Nabis." The word comes from a Hebrew one meaning "prophets," not altogether an apt description for a group of painters who made their own adaptations of other men's innovations but were not particularly innovative themselves.

The spokesmen for the group were the painters Paul Seruzier (1863–1927), who first dis-

covered Gauguin for the rest of them, and Maurice Denis (1870–1943), whose statement that "a picture—before being a horse, a nude, or an anecdote—is essentially a flat surface covered with colors assembled in a certain order" was the heart of the Nabi credo. He was not yet twenty years old when he wrote this, and the Nabis abandoned the principle shortly, or at least they grew less insistent about it. But it is still one of the most frequently quoted passages in art criticism and theory. There is nothing complicated about it; it is a succinct statement of the decorative principle in painting and goes no further, which is the reason the Nabis outgrew it. They outgrew it rather quickly, although Gauguin insisted on calling them, resentfully, his "followers" long after they had gone their own several ways.

The two most enduring painters of the group proved to be Pierre Bonnard (1867–1947) and Édouard Vuillard (1868–1940). Vuillard's manner in *Woman Sweeping* [430] exemplifies the patterns of the first Nabi work now modified by a kind of interior impressionism suggesting the warmth and seclusion of small rooms where comfortable and affectionate lives are lived without excitement or the necessity of

it, a quality that led to the coining of the term *intimism* as an offshoot of the Nabi aesthetic. A somewhat linear effect is retained here and there, rather surprisingly combined with a soft-focus effect in the foreground. In the mixture of influences, that of Degas is strong. Degas also conveyed the intimacy of small interiors, but always with a moodiness wider in its evocative reach than the gentle domesticity that pervades a typical Vuillard.

Bonnard also abandoned the restrictions of the early Nabi manner to accept a variety of stimuli. In pictures in the intimist spirit [Plate 30, p. 371] he abandoned the subdued color scheme of intimism to experiment with unusual, somewhat dissonant color combinations in a way that influenced the fauves—to be seen hereafter—and then, in turn, he was influenced by them. In his final manner, as in *Bowl of Fruit* [431, p. 370], Bonnard may seem at a glance impressionist. Upon second glance the colors are seen to be forced to greater intensities, in combinations arbitrary rather than based on impressionism's optical laws. And the shapes, such as the dark shadow under the bowl, are designed more decoratively than impressionism's approximation of natural effects allowed.

Fantastic and Visionary Art: Redon

The post-impressionist "period," if it can be called that, was one of trauma during which impressionism, as the climax of realism, was transformed into what we call, just now, "modern art." Two other painters are of special importance in this connection, the symbolist Odilon Redon and the primitive Henri, or "Douanier," Rousseau. Both were contemporaries of Cézanne and the impressionists, hence a little older than van Gogh, Seurat, and Gauguin, all of whom, however, they outlived. Against the classicism of Cézanne and Seurat, the emotionalism of van Gogh, and the decorative exoticism of Gauguin, they oppose an art of fantasy.

If the reader has been a little confused about symbolism, synthetism, the Nabis, and all the other isms and painters mentioned since impressionism, it is nobody's fault. These movements were ill defined and they overlapped not only among themselves but with other movements that were developing or, like impressionism, fading. Odilon Redon (1840–1916),

430 Edouard Vuillard. *Woman Sweeping.* c. 1892. Oil on panel, 18 × 19″ (46 × 48 cm). Phillips Collection, Washington, D.C.

whose life of seventy-six years began the year before Cézanne's and ended ten years after it, is usually called a symbolist. The critic Albert Aurier tried to define symbolism, in 1891, as an effort to "clothe the idea in a form perceptible to the senses," not a very helpful description since it could apply to almost any form of genuinely creative art, painting or otherwise. But all manifestations of symbolism were somewhat tied up with the idea that the painter's goal was not to investigate the world around him but to explore the world of dream and mystery. Symbolists like Gauguin, whom Aurier considered the leader of the movement, explored this mysterious world through forms connected with primitive, archaic, or exotic ones, which were presumably closer to the world of dream and mystery than the world of the Paris boulevards could ever be. But critics today would be likely to call Redon, rather than Gauguin, the purest symbolist painter.

Redon explored a private and fantastic world, rather than Gauguin's borrowed exotic one. Redon's bias is already apparent when we read that he said that Ingres was "sterile" and "bourgeois," while Delacroix's "least scrawl" communicated life to the observer. But Redon was not interested in Delacroix's statement of the vitality of life or in anybody's effort to achieve a generalized statement of human emotion. He was concerned with ambiguities, and he said so, which puts a considerable disadvantage upon critics who object to his art as a rather ambiguous one. "My drawings inspire, and are not to be defined. They determine nothing. They place us, as does music, in the ambiguous realm of the undetermined. They are a kind of a metaphor." But Redon's most famous phrase is the neat description of his intention: to "put the logic of the visible at the service of the invisible." Thus when he paints a bouquet of flowers [432, p. 373] they are not flowers with scent and body, cut in the garden and put into water to be enjoyed and painted as flowers, but the blossoming of a dream, incorporeal, "a varied arabesque or maze unfolding," full of mystery and suggestion.

To the person for whom a vase of flowers is a vase of flowers, the quality of mystery in these pictures may seem to be nothing much more than a certain fuzziness combined with unusually luminous color. In that case, Redon's more completely unreal, more conventionally dream-like compositions like his *Orpheus* [433, p. 373]

431 Pierre Bonnard. *Bowl of Fruit.* 1933. Oil on canvas, 22½ × 21¼″ (57 × 54 cm). Philadelphia Museum of Art (bequest of Lisa Norris Elkins).

may be more satisfying expressions of the symbolist ideal. Through such a picture, the less apparently mystical dreams of flowers and butterflies may be approached. Part of Redon's appeal, once one knows him, is that his world remains private. One may enter it, and be welcome, but one is never urged to do so. During his lifetime Redon worked quietly, not at all interested in making a great stir. But the literary symbolists, headed by the poet Stéphane Mallarmé, discovered him for themselves; and such painters as Gauguin, the Nabis, and finally the young Matisse all sought him out and were to become his devoted admirers.

"Douanier" Rousseau

Within the complications and intercomplications of nineteenth-century painting, the idea of giving concrete expression to supernatural mysteries or mysterious yearnings crops up persistently. Blake, Friedrich, and Runge held it;

Plate 29 Paul Gauguin. *Manao Tupapau (The Spirit of the Dead Watching).* 1892. Oil on canvas, 28¾ × 36¾" (73 × 92 cm). Albright-Knox Art Gallery, Buffalo, N.Y. (A. Conger Goodyear Collection).

Plate 30 Paul Bonnard. *Dining Room in the Country.* 1913. Oil on canvas, 5'4¾" × 6'9" (1.64 × 2.06 m). Minneapolis Institute of Arts (John R. Van Derlip Fund).

Plate 31 Henri Rousseau. *The Sleeping Gypsy.* 1897. Oil on canvas, 4'3″ × 6'7″ (1.3 × 2.01 m). Museum of Modern Art, New York (gift of Mrs. Simon Guggenheim).

Plate 32 Henri Matisse. *Madame Matisse (The Green Line).* 1905. Oil on canvas, 16 × 12¾″ (41 × 32 cm). Statens Museum for Kunst, Copenhagen.

432 Odilon Redon. *Vase of Flowers.* c. 1912–1914.
Pastel on cardboard, 28¼ × 18″ (72 × 42 cm).
Albright-Knox Art Gallery, Buffalo, N.Y. (Room of
Contemporary Art Fund, 1940).

433 Odilon Redon. *Orpheus.* After 1913. Pastel, 27½ × 22¼″
(70 × 57 cm). Cleveland Museum of Art (purchase, J. H. Wade
Fund).

Böcklin held it when he tried to bring the world
of fantasy and dread within our grasp by repre-
senting fantasies in objectively realistic detail.
The Pre-Raphaelites held it in their odd way
when they tried to recapture the spiritual es-
sence of the biblical and medieval worlds by
reproducing them—they thought—explicitly.
Böcklin and other fantasists might have said that
they wanted to make "improbable beings live
humanly according to the laws of the probable"
or to "give the illusion of life to the most unreal
creations." But these two quotations are from
Redon, whose art is more conventionally vi-
sionary, in its luminous, apparitionlike quality,
than the precisely defined painting of his com-
panions in their voyages of exploration into
hidden realms.

The century's most curious revelation within
this shadowy territory was made half by chance,
like so many discoveries, by Henri Rousseau
(1844–1910), who first set about reproducing

the real world as photographically as he knew
how and then discovered that he had created a
world of enchantment instead. While Böcklin
and Redon theorized about the interchangea-
bility of mystery and reality, about how to make
the real unreal and the unreal real, about how
to dematerialize the world around us or to ma-
terialize the one we cannot see, Rousseau did
not theorize at all. Yet he materialized the
promised land of mystery for searchers who
were more knowledgeable about it than he was.

Rousseau was a minor official in the French
Customs, hence "Douanier" Rousseau, as he is
most frequently called. He began as a hobby
painter, the nineteenth-century phenomenon of
the "Sunday painter" who might take his cheap
paintbox out into the park for an afternoon's
relaxation or copy a favorite postcard at home
on a rainy day or try a portrait of a friend or a
member of the family, preferably from a nice
clear snapshot. His earliest paintings have all

the characteristic naïvetés of style inherent in the work of beginners feeling their way with intense interest but technical innocence. The most usual of these characteristics include extreme carefulness of outline, a smoothing out of the paint, a finicky blending of one tone into another, and a fascination with fine detail to whatever extent technical limitations may permit its execution. All of this is combined with the stiff, simple forms, the inaccurate proportions, and the skew-wise perspective of the beginner.

By most standards, these are not only shortcomings but fatal shortcomings—but not by quite all standards. A picture may have all these characteristics yet may combine them in a pattern of great charm or expressiveness. From the beginning, Rousseau had a sense for the agreeable or expressive placement of objects in a composition, and especially for the patterning of natural forms, such as the leaves of plants or the silhouettes of trees.

The unreality of Rousseau is a paradoxical combination of fantasy and factualness; the painter offers each object in his street scenes and country landscapes with unquestioning acceptance of their perfect ordinariness, yet not one of the objects is ordinary after he paints it. The human figures are so isolated and so immobile, the trees are so neatly patterned and their foliage so meticulously rigid and delicate, the streets, houses, walls are so pristine, yet so familiar as elements of daily life—everything, in short, is so commonplace and yet so uncommonly revealed that reality and unreality reach perfect fusion and one is indistinguishable from the other. We cannot say that Rousseau shows us a new world, for we have seen all these things many times; yet we cannot say, either, that this is a world we know, for these things exist in new relationships and even in new shapes. It becomes a world of dream, whose reality the dreamer accepts without question, and whose fantasy he recognizes only upon awakening. But instead of fading, the dream is preserved like a fly in amber. And it is a curious fly, not quite like the ones we are familiar with, not quite like any other fly we have seen before.

Rousseau was an industrious painter and he began to show his pictures wherever he could. At the exhibitions of the Indépendants he began to attract the attention of sophisticates who recognized the decorative quality and the poetry that distinguished his work from that of the armies of other Sunday painters who resembled him superficially. He left his comfortable position with the Customs to live on a small pension and spend his time painting. This was a dangerous point for Rousseau; upon the point of becoming a professional painter rather than an enthusiastic amateur, he was ready to study under conventional teachers and to master the techniques of realistic drawing and painting which, if he had mastered them, would have cost him the original style he had developed for himself. But he was lucky enough to receive good advice. The painters and literary figures who were beginning to make something of a darling of him were not the only ones who recognized the exceptional nature of his work. According to a later statement by Rousseau, even old Gérôme, the academic tyrant who was professor at the École des Beaux-Arts, advised him to guard his naïveté.

Rousseau did guard his naïveté. But naïveté obviously stops being naïveté once it is guarded, and false naïveté can be a most offensive affectation. Rousseau set about creating for himself a personal style based on the forms that had been spontaneous to him as a beginner. This style, as he developed it, is the paradoxical one of a highly cultivated manner based on primitive simplicities, a dangerous combination and one that has never come off very well for Rousseau's imitators. Nor have any other "modern primitives," even those who begin as genuine ones, approached Rousseau's stature. Dealers and collectors continue to scout hopefully to ferret them out, but at their best they usually turn out to be charming but inconsequential, bizarre but only bizarre, or sincere yet somehow at once ponderous and shallow.* Rousseau may be charming, bizarre, and even sometimes ponderous. In *The Young Girl* [434], for instance, he is all of these. But these are secondary characteristics in a painting where the primary ones are monumentality and magic.

* Some exceptions are Louis Vivin (1861–1936), Camille Bombois (1883–1970), and André Bauchant (1873–1958), all French. The Americans John Kane (1860–1934) and Horace Pippin (1888–1946), especially the latter with his engaging historical pictures, are close to the tradition of American folk art (although Kane was born in Scotland). The largest popular audience ever awarded a primitive painter came to another American, Anna Mary Robertson Moses, called "Grandma" Moses, who was born in 1860 and died a hundred and one years later.

434 Henri Rousseau. *The Young Girl*. c. 1894. Oil on canvas, 24 × 18″ (61 × 46 cm). Philadelphia Museum of Art (gift of Mr. and Mrs. R. Sturgis Ingersoll).

Rousseau was a late bloomer. His first signed pictures are from 1880, when he was already thirty-six years old, and he did not begin to exhibit with the Indépendants until he was forty-two. In the interim he possibly copied pictures in the Louvre; at any rate, there is a record of issuance of a copyist's permit to him. The jungle fantasies for which he is most widely known did not appear until 1891, when he was approaching fifty. He was a happy eccentric, part visionary and part petit bourgeois. He eked out his pension by giving lessons in painting, music, and harmony, and he even wrote a five-act drama, *The Revenge of a Russian Orphan*, which was produced but demonstrated that his unusual qualities as an artist were limited to painting, even though his naïveté was not.

According to his own story, Rousseau did military service in Mexico as one of the troops in the half-hearted expedition to keep Maximilian on the throne there. If this was true (there is good reason to doubt it, since there is no proof and Rousseau was given to fabrications which he half believed himself) he would have been twenty-two at the time, and might have carried back with him the memory of exotic foliage and exotic people. But as a matter of fact he could not have seen the wild parrots, monkeys, leopards, and other beasts, or the particular plant forms he painted, for the good reason that they did not exist in the parts of Mexico he would have seen. His experience there would have been limited to the cities and the actually not very exotic countryside in which cacti, palms, and other semitropical plants did exist, but not in the profusion of jungles and not too frequently of the types Rousseau painted. His reference sources were the zoo, the botanical gardens, and postcards and photographs of exotic creatures and places. The references are not especially important since the true source of his pictures was his own imagination, whatever actual or secondhand experience he may have had with exotic places. Actual experience would probably have diluted his imagination.

In the jungle pictures [435, p. 376] he is free to give full indulgence to his passion for the design of leaves, blossoms, and branches. They grow in luxuriant and unnatural profusion, ordered into clear and unnatural patterns, combining the most fantastic imagery with the most unquestioning definition. Their existence is impossible, yet undeniable. Reason tells us that these are fantasies or apparitions; our senses tell us that they are tangible fact. The conflicting halves of this paradox, formulated as a theory by Böcklin and Redon, were balanced and harmonized by Rousseau because the paradox existed in his own personality.

Rousseau was fifty-three when he created *The Sleeping Gypsy* [Plate 31, p. 372], the climactic painting of his total work. In its own area, the area of fantastic and visionary art, *The Sleeping Gypsy* occupies a position comparable only to those occupied by Seurat's *La Grande Jatte,* Cézanne's *The Great Bathers,* and van Gogh's *The Starry Night.*

The Sleeping Gypsy cannot be accepted as a "primitive" painting except in the stylistic sense of the word. There is nothing unconsidered in its expressive effectiveness, no "lucky acci-

435 Henri Rousseau. *The Dream.* 1910. Oil on canvas, 6'8½" × 9'9½" (2.04 × 2.98 m). Museum of Modern Art, New York (gift of Nelson A. Rockefeller).

dents," no groping, and no compromise. The pattern of the lion's mane, running in serpentine rivulets, the odd backward turning of the tuft of hair at the end of the tail, the careful sprinkling of stars in the sky, the patterned lines of hills on the horizon, the dune where the gypsy lies and the lion stands, the gypsy's robe— whatever elements, instinctive or theoretical, account for the creation of these forms, they are the creation of a born artist who has matured as a creative designer through observation and experience. Rousseau paints each of the fantastic parts of this fantastic combination with the apparently objective innocence of his streets, houses, and ordinary city trees; fantasy or nightmare is accepted as unquestioningly as the everyday world, and represented as uncompromisingly. In Böcklin, and sometimes even in Redon, the real and the unreal may still be identified as incompatible elements brought into a kind of truce with one another, but in Rousseau they cannot be separated because it was never necessary for him to combine them in the first place. In his conception of *The Sleeping Gypsy* they must have existed together, as one, from the beginning.

part four

The Twentieth Century

chapter 25

Fauvism and Expressionism

The Position of Matisse and Picasso

If modern art "begins nowhere because it begins everywhere," as was pointed out at the beginning of this book, it also ends nowhere. The creative impulse that distinguishes human beings from animals will continue to generate new expressions as long as there is human life on our planet. But it is necessary to end a book somewhere, and this one, having begun in a general way with the landmark of the French Revolution, will end—in a general way—with World War I, allowing for some extensions beyond that date here and there. The war's dates, 1914–1918, coincide with another landmark: it was in 1913 that a puzzled and frequently belligerently hostile American public received its introduction to the revolutionary movements that followed impressionism, including fauvism and cubism.

Since any discussion of art since 1900 is only marking time until it compares the leaders of these two movements, respectively Matisse and Picasso, they must be introduced immediately. Matisse and Picasso are without question the two most important painters of the first half of our century as a whole. The art of these two men, sometimes overlapping and sometimes in conflict, set the pace for more painters and determined the taste of more collectors than that of any other artists during the period. The men themselves enjoyed success during their lifetimes comparable only to that of such painters as Raphael, Titian, and Rubens, who were courted by kings and popes. Even Monet and Renoir and Degas, who lived long enough to see themselves generally successful and widely recognized, were only moderately successful and recognized in comparison with Matisse and Picasso, whose names were known everywhere relatively early in their careers, whose work was multiplied in, quite literally, millions of reproductions, and

whose most casual scribbles came to be coveted by collectors. (Their most casual scribbles can be pretty good.) More books and articles have been published on them than on any other two painters of any place or times. Even if the future should make a drastic re-evaluation of their work, it cannot alter the historical fact that Matisse and Picasso exerted an influence as wide, apparently as deep, and certainly as revolutionary during their own lifetimes as have any painters who have ever lived.

Seventy-five years after the first scandals of fauvism and cubism, Matisse and Picasso may still puzzle a percentage of the general public, but the percentage is small, and diminishing. Their work is illustrated not only in every art publication, which is natural, but in every publication designed for popular consumption as well. They have found their way into elementary schoolbooks where Gainsborough's *The Blue Boy, Whistler's Mother,* and *The Sower* formerly elevated the taste of the very young. They sell in reproduction by the gross to hotels, motels, and the decorators of housing developments. Housewives who had already put *Whistler's Mother* in the attic to make room for a reproduction of a Renoir or even a van Gogh or a Gauguin have pushed on to Matisse and Picasso, whether they understand them or not.

There are several reasons for this phenomenon of mass acceptance of paintings that would ordinarily appeal to only a limited audience. The educational techniques of American museums, led by the Museum of Modern Art in New York; the fact that the painters as personalities made good copy for popular magazines, which must find new copy of some kind every issue; and the new processes of color reproduction that make color so bright and attractive, even when it is inaccurate—all these factors have contributed to an impressive structure of general interest. But the foundation supporting this structure is less apparent; it is to be found in the history of the relationship of the public to the art of the impressionists and the postimpressionists. People today are aware that the painters they most enjoy—like Renoir, whom they love, and especially van Gogh and Gauguin, whom they find attractive—had to endure contumely and hardship during their lifetimes. They know the stories of the terrible lives of van Gogh and Gauguin through popular biographies and movies. On the premise that history repeats itself, they are willing to accept the chance that the painters whose art is incomprehensible to them today are the ones most likely to succeed with posterity. It is as if the public feels a sense of mass guilt for the persecutions to which late-nineteenth-century painters were subjected and is trying to atone four generations later by accepting with humility a kind of painting it would ordinarily reject on sight.

This humility is engaging, and encouraging in its way. Less encouragingly, it is too often flavored by the snob value attached to the appreciation of paintings that only millionaires can afford to buy, that only intellectuals can explain, and that museums display with the same techniques used in the display of expensive merchandise. The taste for the extremes of modern art, in other words, is built on false values at least as often as not. Its popularization in magazines and reproductions is usually commercial opportunism; its dissemination through museums is a powerful educational force, but education concerning it is often confused with propaganda for it. It is all very curious, and the greatest tribute to the paintings of Matisse and Picasso is the fact that everyone is not sick unto death of them. The strongest proof that they are worth all the proselytization is that as works of art their paintings and sculpture have withstood the excesses of the proselytizers. In spite of mistakes and abuses, the missionary work has served its purpose; for the first time in a century, the lag between creative art and public taste, which has bedeviled original painters since the romantic revival, is beginning to shorten.

Fauvism and Expressionism

This chapter is concerned with fauvism and the related movement of expressionism, but cubism was developing at the same time. It will be necessary to refer to cubism here and there in discussing fauvism and expressionism, since all three isms impinged on one another. It would be a good idea for the reader to glance just now at some of the illustrations in the following chapter and bear them in mind, in a general way, as examples of what cubism looks like. This will leave us free in this chapter to make occasional references to cubism in something less than a vacuum. There are strong cubist reflections, for instance, in the first Matisse illustrated [438, p. 382].

Fauvism, it must be said in the beginning, is a word derived from the French for wild beast—*fauve*. There are other words, but not many, less appropriate as a descriptive name for the group of painters to whom the label was attached. The fauves included some of the most highly civilized painters ever to put color on canvas. They did use broad strong areas of pure color that seemed crude, savage, to certain shocked and puzzled critics in 1905. But not even the most offended critic could find wild-beastiness today in the later developments of the fauve painters. Objections would be safer at the opposite pole of hyperrefinement.

Fauvism was a spontaneous development, generated in France. It slightly preceded and contributed significantly to expressionism, which had its centers in Germany. Both movements were returns to the colorism of van Gogh and Gauguin after the interlude during which

436 Gustave Moreau. *The Apparition (Dance of Salome)*. c. 1876. Oil on canvas, 21⅛ × 17⅜″ (54 × 45 cm). Fogg Art Museum, Harvard University, Cambridge, Mass. (Grenville L. Winthrop bequest).

the intimists, particularly Vuillard, had rejected bright pigmentation for a muted palette. Fauvism coalesced in 1905, two years after the death of Gauguin, and although it drew upon pointillism and from Cézanne, and from van Gogh, in the end Gauguin was probably the dominant influence. Fauvism and expressionism developed from the same sources on one side of their romantic family trees; they were, so to speak, first cousins, sharing in part a common ancestry, but with differences as important as their similarities.

Matisse: Early Experiences and Discoveries

Henri Matisse (1869–1954), the central figure in fauvism, was well on his way to becoming a lawyer (as Degas and Manet, among others, had been) when he began to paint. When he was twenty-two he induced his father to let him abandon law for art and went to Paris to study under Bouguereau, who was then an old man full of honors, an international success, and the dean of the academicians. This was in 1891 and 1892, a complicated time when Monet, Renoir, Degas, Cézanne, Lautrec, Redon, Puvis de Chavannes, Gauguin, and Douanier Rousseau were all at work. Seurat's early death had occurred the year of Matisse's arrival in Paris, and van Gogh had died only the year before. Vuillard and Bonnard, who were Matisse's age within a year or two, had begun their careers. Most of the men who were to develop expressionism were adolescents in Germany. The old guard of the academicians was still well entrenched; even old Meissonier had just died, at the age of seventy-five. In France the decade from 1890 to 1900 offered everything at once.

Matisse was not long in choosing his way—at least, he was not long in rejecting Bouguereau as a prelude to doing so. Although Matisse was a provincial young man he was no philistine, and he soon recognized the banality of Bouguereau's art and the sterility of his teaching. He managed to enter instead the studio of Gustave Moreau (1826–1898), a painter whose rather decadent exoticism [436] was academically acceptable as a continuation of Delacroix's romanticism. Moreau had been appointed to the teaching staff of the École des Beaux-Arts. He was an exceptional man, without much acquaintance with experimental art yet unprejudiced in any direction,

437 Jan Davidz de Heem. *Still Life.* 1640. Oil on canvas, 4'10⅝'' × 6'8'' (1.49 × 2.03 m). Louvre, Paris.

438 Henri Matisse. *Variation on a Still Life by de Heem.* 1915/1916/1917. Oil on canvas, 5'11'' × 7'3¾'' (1.8 × 2.23 m). Private collection.

439 Henri Matisse. *The Dinner Table (La Desserte)*. 1897. Oil on canvas, 3'3¼'' × 4'3½'' (1 × 1.31 m). Collection Stavros S. Niarchos.

alert to the special character of whatever experimental painting came to his attention, even though in his own work he stuck close to tradition. Moreau gave Matisse his first education in art, not so much as his drawing and painting instructor as his guide to the art of the past, ranging over the whole field of masters dear to the academic heart and some who were not. Soon Matisse was copying in the Louvre, partly as a way of studying and partly because the sale of copies produced a small income. These were "free" copies rather than painstaking reproductions. Primarily, Matisse was studying pictorial structure through copying rather than meticulously imitating the surface of another man's canvas as a mechanical routine. The integration of this study into his full development as a painter was demonstrated by his return, more than twenty years later, to a de Heem still life [437] to restudy it in a now-famous variation [438].

All this while, Matisse was hardly aware of the impressionists, much less of such painters as Cézanne, van Gogh, and Gauguin. But discovery and conversion began to come rapidly in 1896 and 1897. After a few tentative impressionist excursions he set about his first major picture, *The Dinner Table (La Desserte)* [439], in impres-

sionist technique, and exhibited it in the Salon of the Société Nationale (a dissenting academic organization, created by Meissonier as the result of a quarrel within the ranks of the Salon proper in 1890, and at that time headed by Puvis de Chavannes, who had nominated Matisse for membership). *La Desserte,* a fine impressionist painting by the most exacting standards, drew indignant criticisms from conservative painters, but Moreau defended it.

During the next few years, still regarding himself as a student and rather surprisingly sequestered considering the turmoil surrounding him in the Paris art world, Matisse felt his way among the crosscurrents of the end of the century. What he was learning is shown by the pictures and sculpture he acquired for himself: at considerable financial sacrifice he purchased a small Cézanne study of three bathers and a plaster bust by Rodin, and he exchanged one of his own paintings for a head of a boy by Gauguin. Rodin seems at first an odd influence on Matisse, but Matisse's *Slave* [440, p. 384], a very early piece, shows how closely he followed Rodin [441, p. 384], and we will see shortly that Rodin also influenced Matisse in certain drawings. Matisse had also wanted to buy a certain *Arlésienne* by van Gogh, but had given it up for

440 Henri Matisse. *The Slave*. 1900–1903. Bronze, height 36⅛″ (92 cm). Baltimore Museum of Art (Cone Collection).

441 Auguste Rodin. Study for monument to Balzac. 1895. Bronze, height 30″ (76 cm). Private collection.

the Cézanne, of which he wrote, many years later when he presented it to the Museum of the City of Paris, "it has sustained me spiritually in the critical moments of my career as an artist." The influences of Cézanne, Gauguin, and even of Rodin are apparent in Matisse's *La Coiffure* [442] painted at this time, with its bold planes, its uncompromising force, and its emphatically defined silhouettes.

These early years of first experiment and discoveries were difficult ones for Matisse. He had

abandoned a promising beginning toward conventional success, with encouraging recognition and some sales, and soon found himself in the familiar position of the experimenter—bad notices when he managed to exhibit at all, and no purchasers. He had married and had three children. But in 1905, a climactic year in his development and in the history of modern art, the situation improved dramatically and his career as a leader among contemporary painters began in earnest.

442 Henri Matisse. *La Coiffure*. 1901. Oil on canvas, 37½ × 31⅝″ (95 × 80 cm). National Gallery of Art, Washington, D.C. (Chester Dale Collection).

443 Henri Matisse. *Olive Trees, Collioure*. 1905. Oil on canvas, 18 × 21¾″ (46 × 55 cm). Collection the artist's estate.

Matisse: The Birth of Fauvism

Matisse's palette had been brightened by some essays in pointillism, and now during the summer of 1905, in the village of Collioure on the Mediterranean, he came into a sudden realization of new meanings in color. (He was nearly thirty-five years old.) *Olive Trees, Collioure* [443] at a careless glance might be dismissed as a pointillist sketch. Actually the color—pure reds, greens, oranges, violets applied in strokes of fairly uniform size—has nothing to do with pointillist theory. The different colors do not fuse into harmonious tonalities but maintain their own intense identities, clashing against one another and setting up a "movement" of their own as color, a movement that is incorporated into the more familiar kind of movement of the rather obvious swirling linear patterns. Matisse was learning that color as pure color could have its own rhythms, its own structure, that color could be exalted for itself rather than used as a descriptive or decorative accessory to other elements of a picture.

By this idea, a tree trunk could be vermilion, a sky could be solid orange, a face could be divided down its middle by a green line with contrasting colors on either side as part of a color structure owing no allegiance to the actual color of trees, skies, or faces but existing as an independent abstraction. Gauguin had anticipated this idea in what was now an elementary way, and therein lies his grandparentage of fauvism. But Gauguin's color, when it departed arbitrarily from the colors of nature, was arbitrary in the service of mood or of decorative effect, which is a good step removed from a full conception of abstract color structure.

What "color structure" means is well demonstrated by the famous head of Madame Matisse usually called *The Green Line* [Plate 32, p. 372]. On the right the face is pink, on the left, a yellow ochre. The background is divided into three large areas of green, vermilion, and rose-violet. These areas are not screens, pictures, or any other background objects; they are purely areas of color. All three are echoed in the dress. The hair is dark blue, as are the contour lines of the dress. On the pink side of the face the contour line is red, on the left side, green. The pink and ochre have some relationship to natural color, but when we reach the light, brilliant stripe of yellow-green dividing them down the middle of the face, the purely arbitrary use of

color for structure is dramatized. Without the green stripe the face would be pallid, lost in the center of the violent color surrounding it. The question may be asked: In that case, why not modify the surrounding color so that the face could compete with it instead of introducing the arbitrary green stripe? The answer is that the painter wants to use color at maximum intensity, and since the green stripe is necessary— as color—in that particular place, he uses it instead of sacrificing color intensity elsewhere. For that matter, the shape of the stripe and its position in the composition, as well as its color, is necessary as part of the pictorial structure. If it is covered up, even in a black-and-white reproduction, the structure is weakened. If it is covered in the original or in a good color reproduction, the structure is destroyed. And how did Matisse arrive at this particular color for this particular stripe? Through a general knowledge of color theory in the first place, of course, but more importantly through highly developed sensibilities and instincts in its use, plus a certain amount of trial and error in preliminary studies.

The Green Line is an abstract construction of color, but it is also an arresting image. It is not to be taken as a portrait of Madame Matisse in either a realistic or an expressionistic, interpretative way, although it suggests her features. The strong masklike character reflects the stylized forms of African sculpture—a new interest with Matisse, and one that was to have an even stronger impact on Picasso in the development of cubism. Matisse was twelve years older than Picasso and, for whatever interest the fact may have in the general tendency to balance one man's innovations against the other's, it is probable that Matisse introduced Picasso to African sculpture at a time when cubism was still germinating as a buried seed. Picasso and Matisse had made one another's acquaintance and were being collected in the same circles; a conspicuous patron was the American Gertrude Stein. The two men met frequently at her apartment and maintained a courteous but wary attitude toward one another as if they already realized that during the next decades they would become rival representatives of two mainstreams of twentieth-century painting for critics, painters, and collectors.

Picasso was only beginning to attract his circle, but Matisse's was already pretty well formed. Surrounding him, having varying de-grees of contact with him, drawing ideas from him and contributing their own, were a group of colorists who became the fauves as a result of the landmark Salon d'Automne of 1905. Fauvism was never systematic; it had no program and no formalized theory. It was never an organized school of painting, and as a group the fauves soon lost their unity, building their own directions from the original stimulus. And as a "school" of painting, the birth of fauvism all but took its participants by surprise.

The Salon d'Automne had been organized two years before the famous 1905 exhibition by a group of thoughtful painters and liberal critics who were equally dissatisfied with the conservatism of the regular academic Salons with their ingrown juries, and the anarchy of the Indépendants with no juries at all. The organizers of the Salon d'Automne solved the jury problem by selecting its members by lot. The 1905 jury hung the work of Matisse and eleven other colorists in one room together; one critic, commenting on a small bronze in the Florentine Renaissance manner exhibited in the same room, said *"Donatello parmi les fauves!"*— Donatello among the wild beasts—and *fauvism* as a term and the fauves as a group were born, to the usual sounds of furious hubbub familiar since the Salon des Refusés forty-two years before. But there was a new note in the hubbub, and a more sympathetic one. The circle of liberal critics had widened. Where one reactionary critic found that the fauve pictures had "nothing whatever to do with painting," a liberal one recognized that Matisse's art was "painting outside of every contingency, painting in itself, the act of pure painting," and while the first saw "aberrated daubs and splotches of color," the other found that "the rational mind" of the painter perfectly controlled every element introduced into the painting. Adventurous and perspicacious collectors were also increasing in number, putting an end to stories like the youthful Monet's or van Gogh's and Gauguin's.

While the excitement of the Salon d'Automne was still boiling, Matisse began a large composition as a crystallization and perhaps as a manifesto of fauvist ideas. *The Joy of Life* is a faulty picture, rather flimsy and monotonous compositionally and disturbingly mannered, although it is of historical interest in showing that Matisse was experimenting with some of the structural ideas that were to be involved in cubism as well as elements that were to affect expressionism in

444 Henri Matisse. *Blue Nude.* 1907. Oil on canvas, 3'1¼" × 4'7⅛" (.92 × 1.4 m). Baltimore Museum of Art (Cone Collection).

445 Henri Matisse. *Reclining Nude I.* 1907. Bronze, height 13½" (34 cm). Baltimore Museum of Art (Cone Collection).

its more abstract forms. The *Blue Nude* of 1907 [444] is a more successful study in the same direction, combining arbitrary color, sinuosities of line, and dislocations of form, which are of course extremely disturbing if the painting is regarded only as a picture of a female nude but are extraordinarily forceful otherwise.

With pictures like the *Blue Nude* Matisse was attracting enough attention to warrant the publication of his theories the following year, 1908. Matisse was nearly forty; he is unique among painters in having reached intellectual maturity before his career as a creative artist began in earnest In effect, he has no "youthful" period. All his pre-fauve work is essentially studious, thoughtfully preparatory.

His *Notes of a Painter* play a double theme: the importance of feeling, of pure sensation, of the painter's response to the world on one hand, and, on the other, the means by which these feelings may be transmuted into form and color. As a generality this is the problem of all serious painters; in the case of Matisse, the *Notes* imply everywhere a love of joyousness. He finally says: "What I dream of is an art of balance, of purity and serenity devoid of troubling or depressing subject-matter, an art which

might be for every mental worker, be he business man or writer, like an appeasing influence, like a mental soother, something like a good armchair in which to rest from physical fatigue." Even granting some exaggeration and some awkwardness of expression (or of translation from French) this is hardly the spirit of the *Blue Nude,* painted just before the notes were written, nor is it the spirit of the sculpture with which Matisse was occupying himself at the same time [445, p. 387]. The *Blue Nude* and the sculpture were solutions of structural problems Matisse had set himself. Having served their purpose, the violent dislocations soon give way to forms no less vital but more serene or joyous as the fauvist upheaval was assimilated.

Pure fauvism was of brief duration not only with Matisse but with the other members of the group as well. Before we follow Matisse's subsequent development, a few comments on the other fauves should be interpolated.

Other Fauve Painters

André Derain (1880–1954) worked with Matisse at Collioure in 1905, and painted the fauvist "portrait" of him [446] there. Derain was one of the first of the original group to depart from fauvism, and he cut off from it with exceptional completeness. When the competing cubist furor broke, Derain joined that party briefly, then for the rest of a commercially very successful career shifted from style to style under the influence of a dozen traditional schools, as in a portrait of the artist's niece [447], where Corot, fauvism, and eighteenth-century sensibility are combined in an image of great sweetness.

Derain was a painter with a flair for modifying traditional styles by imposing agreeable modernisms upon them; or perhaps his flair was for modifying the radical discoveries of other painters by adapting them to acceptably traditional surfaces. He was, in either case, a painter of fashionable good taste and great discretion. His detractors think of him as a parasite on both the past and the present, but his admirers are satisfied that his middle-of-the-road art is neither a subterfuge nor an opportunistic compromise. Some critics award Derain unique stature as the only twentieth-century painter to achieve an individual compound of the great tradition of French culture as a whole with the

446 André Derain. *Henri Matisse.* 1905. Oil on canvas, 13 × 16″ (33 × 41 cm). Philadelphia Museum of Art (A. E. Gallatin Collection).

447 André Derain. *The Artist's Niece.* Before 1939. Oil on canvas, 37⅜ × 30⅜″ (95 × 77 cm). Private collection.

448 Maurice de Vlaminck. *Village in the Snow*. Date unknown. Watercolor and gouache, 18 × 21″ (46 × 53 cm). Philadelphia Museum of Art (gift of Howard A. Wolf).

449 Albert Marquet. *Docks at Hamburg*. 1909. Oil on canvas, 27¼ × 32″ (69 × 81 cm). Private collection.

Maurice de Vlaminck (1876–1958) was a great friend of Derain's in their early days. They discovered van Gogh together, and it was Derain who introduced Vlaminck to Matisse. Among the cultivated and intellectual fauves, Vlaminck was an exceptional personality— more nearly *fauve* than they in his peasant vigor and his rambunctious muscularity. He was one of the few fauves who never toyed with cubism; he rejected it on sight as overintellectualized. But he abandoned the brilliant pure colors of fauvism to develop a dramatic landscape style giving a stormy and sinister character to simple village streets or peasant cottages painted in broad spreads and slashes of Prussian blue, black, touches of acid green, and spectral lights [448]. At their most effective these landscapes take on an ominous mood. Their shortcoming is their repetitiousness; reduced to a formula, both the threat and the vigor turn back into paint.

Albert Marquet (1875–1947) was especially close to Matisse in friendship, but his connection with fauvism was not a strong one in spite of his participation in the original exhibition. He was a sober painter, and a quiet man. Rivers and bridges and harbors were his favorite subjects, and he painted them with an ordered simplicity that recalls Corot, although he simplified his compositions into the flattened color areas associated with fauvism, The color itself, however, is more likely to be subdued than vivid. Marquet is a minor painter who was content to be one. His pictures are agreeable partly because he never tried to force himself beyond his modest potential; they are admirable because he was never content to work below it [449].

Othon Friesz (1879–1949) painted a few unusually personal and sensitive fauve works, then abandoned the movement for a reactionary and sterile style. Henri Manguin (1874–1945) and Raoul Dufy (1877–1953) capitalized in the most lighthearted way on the brightness of fauve color. Dufy, after a period of conscientious effort to build himself a solid, monumental style on the model of Cézanne, realized the true nature of his talent and accepted it. He became the most engaging painter of chic and superficial subjects since the eighteenth century. He was helped toward this decision by Paul Poiret, the influential couturier, who commissioned Dufy to design fabrics. It is usual to say that Dufy sold himself out for easy

spirit of his own time. This would place him in a position similar to the one accorded Renoir as the great traditionalist as well as one of the great innovators of the latter half of the nineteenth century. This opinion is particularly held in France where, of course, it is most legitimate.

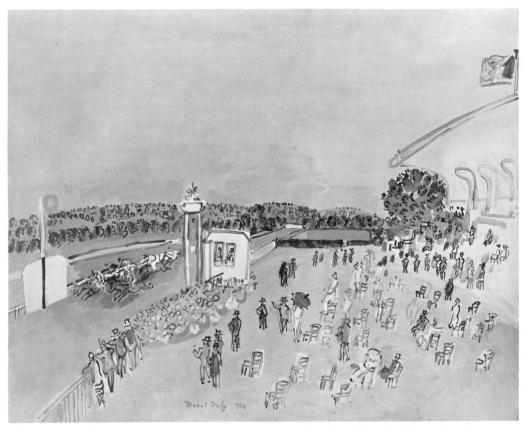

450 Raoul Dufy. *Racetrack at Deauville*. 1929. Oil on canvas, 25⅜ × 32″ (65 × 82 cm). Fogg Art Museum, Harvard University, Cambridge, Mass.

success, but this is an injustice. To exchange his bright and sparkling pictures for the second-rate Cézannesque productions he might have continued to work at would have been a very poor trade for everyone concerned. He developed a style in which swatches of decorative colors were freely applied to the canvas (or the paper—he used watercolor a great deal) and then more or less pulled together by economical calligraphic notations describing objects [450]. Racetracks, yacht basins, formal gardens, theater interiors, and other places of cheerful and expensive congregation were his favorite themes. They were most appropriate ones, too, for his manner.

Dufy's manner has been plagiarized so freely by fashionable commercial artists that it has become synonymous with expensive elegance. His fecundity was extreme, and his style was one that could have become an automatically repetitious formula (as Vlaminck's did), yet

Dufy retained a vivacity which suggests always that he took the greatest pleasure in what he was doing. The economy of his drawing, with its shorthand quality, conceals more variety and more observation than he is generally given credit for.

But the great names of the fauve group (unless we include Derain's) are Matisse, Braque, and Rouault. Braque turned to cubism and will be discussed with it. For Rouault, fauvism was a way station toward an intensely individual form of expression.

Rouault

Georges Rouault (1871–1958) was also a student of Moreau's, and he met Matisse in Moreau's studio. He is an anomaly in his century, a truly religious Christian painter. Perhaps it is necessary to point out that this is not the

same thing as a painter of Christian subjects. There were many such artists, of course, and Rouault's earliest paintings are close to their tradition, although infused with a more visionary quality than most—thanks no doubt to the influence of Moreau.

Rouault was a devout Catholic, but his fervent Christianity is concerned less with personal redemption than with humane sociological values. He is horrified by man's inhumanity to man, appalled at poverty and misery. His Christianity is not concerned with mystical revelation but with the spiritual union of all humankind, which is violated by every instance of cruelty or other degradation. The expert illustration of Bible stories was not an adequate release for Rouault as a Christian painter; it was necessary for him to discover a more personal and intense expression.

451 Georges Rouault. *The Sirens*. 1906. Gouache, 28 × 22" (71 × 56 cm). Private collection.

By 1911 Rouault had passed through fauvism to an expressionism more remindful of the Germans than of any French tradition. He disregarded fauvism's bright colors and essentially happy mood in favor of a restricted and rather turgid palette in the service of tragic and pathetic subjects. *The Sirens* [451] is painted in an oppressive tonality dominated by cold and rather sour grays, morbid gray-violets, and the blackish colors of the deliberately coarse and ugly outlines defining the swollen bodies and brutalized faces of two naked prostitutes, symbols of human corruption through the cruelties, injustices, and miseries that we inflict or whose existence we tolerate. The spirit of the picture is partly sociological, but more importantly it is religious, in the painter's identification of himself with the sufferings of humanity.

Rouault was never affected by medievalism as an imitation of the forms of medieval art (as the Pre-Raphaelites, for instance, were). But in certain ways his art is a continuation of medieval forms in a twentieth-century idiom. His heavy, simplified, powerful volumes in pictures like *At the Circus: The Mad Clown* [452, p. 392] have been compared to those of Romanesque sculpture—the sculpture of the early Middle Ages. The reference is a little forced, however, and the resemblances may be largely coincidental. The Romanesque sculptors in their century, and Rouault in his, approached the problem of expression from opposite poles technically. The early sculptors, working at the beginning of a tradition with virtually no reference to a body of sculpture in the past, were inventing forms whose simplicity was imposed as much by technical limitations as by anything else. They were probably striving for a higher degree of imitative realism than they managed to achieve, all expressive values aside. Rouault, on the other hand, is discarding the whole tradition of imitative realism, which had become so technically expert that it was next to photographic, and is finding his means of expression through simplifications which he imposes upon himself. The common denominator between primitive medieval art and the art of Rouault is not a technical one but a spiritual one: both are concerned with the theme of human frailty and hope of redemption. The medieval sculptors expounded the theme by illustrating the Bible story; Rouault is never so specific, but in pictures like *The Mad Clown* the theme is implicit just as it is in *The Sirens*. The male clown with

452 Georges Rouault. *At the Circus: The Mad Clown.* 1907–1910. Oil on cardboard, 29½ × 22½'' (75 × 57 cm). Philadelphia Museum of Art (Louis E. Stern Collection).

453 Georges Rouault. *Crucifixion.* c. 1918. Oil and gouache on paper, 41¼ × 29⅝'' (105 × 75 cm). Collection Henry P. McIlhenny, Philadelphia.

his broken face, chopped out in broad sculpturesque planes, and the young girl with her heavy, coarsening one are symbols of the human tragedy, which is the death of the spirit through corruption. Rouault reveals spiritual corruption through corruption of the flesh. But through his identification of himself with the subjects, and by the consciousness of tragedy that he stirs in us by these images, he also makes the picture a statement of hope for redemption through compassion.

If the forms of medieval sculpture were echoed only in a roundabout way in Rouault's style, those of medieval stained glass influenced it quite directly. He had been apprenticed, at fourteen, to a maker of stained glass and had worked on the restoration of medieval windows. Even in early expressionistic pictures like *The Sirens,* the dark outlines begin to suggest the leaded joints of stained-glass windows, and shortly Rouault abandoned his heavy color

schemes for areas of brilliant pigments even more definitely confined and separated from one another by black outlines. In some areas the color may have the flat purity of enamel— another medieval craft; in others, heavy strokes dragged across rough surfaces may suggest the surface irregularities and the luminous variations of medieval glass. In this manner Rouault painted landscapes, biblical subjects [453], and more of the clowns and other performers of circuses and pantomimes that had always interested him. He did these in great numbers, and it is a mistake to try to read emotional intensities into all of them. By implication and association these intensities may be present, if diminished, but there are also many pictures where sheer decorative invention and color are at least as important, and as rewarding.

Rouault was also one of the great printmakers of the age; many people would not hesitate to give him the title of greatest in his century.

The prints in his *Miserere* are landmarks in the development of graphic techniques in which expression is integrated with technical devices. They are the most important prints from this point of view since Goya's, which they suggest in other ways also. Like Goya, Rouault reveals the whole category of human bestiality and viciousness; unlike Goya, however, he combines recognition of these realities with the mystical convictions we have already seen in his paintings. Technically, Goya was an innovator in that he approached the print as a self-contained medium, capitalizing on its inherent character and its expressive potential rather than using it as a means of reproducing painting or as a substitute for drawing. Rouault expanded the range of the print by combining any number of techniques on a single plate, creating his printing

454 Georges Rouault. *Dura Lex Sed Lex (Harsh Law, But Law),* from *Miserere.* 1926. Composite processes, $22\frac{5}{8} \times 17\frac{1}{8}''$ (57×43 cm). Philadelphia Museum of Art (Joseph E. Temple Fund).

surface not only by conventional means, such as etching and engraving with the burin, but also by such roughening devices as files, sandpaper, edged rollers and scrapers, and wide brush strokes of acid—upon a foundation, sometimes, of photogravure. He approached a copper plate not with the idea that he was a draftsman or a technician, but with the idea that he was an artist creating a printing surface that must yield its expressive maximum through a design created in textures. From these plates in black and white on paper he achieved as much depth, variety, and richness as he did in full color manipulated in relief on canvas [454].

Matisse after Fauvism

By 1907, only two years after the fauvist paroxysm of the Salon d'Automne of 1905, fauvism had reached its climax as a movement with some kind of unity among the men who composed the group. The more tightly organized movement of cubism was supplanting it as the most spectacular development in contemporary painting. Cubism was a more sensational departure from tradition than fauvism had been, since its distortions were more extreme, and it was more adaptable to development by a closely allied group of painters, since its theory was more objective, less dependent on personal sensitivities. The fauves began to go their own ways, as we have just seen them doing.

Of all the fauves, Matisse had always been the one most concerned with formal organization. The apparent spontaneity and the fluidity of his compositions is deceptive. Like Delacroix before him, Matisse was always intent on maintaining the impression of spontaneity in the completed canvas even though its final organization of form and color was the result of preliminary calculation, trial, and error.

Variations on the sinuous rhythms and the lyrical expression of *The Joy of Life* continued to preoccupy Matisse until they culminated in a pair of large murals, *Dance* and *Music,* commissioned by a wealthy Russian, Sergei Shchukin, to decorate the stairwell of his house in Moscow. *Dance* is a reduction to final terms of composition in flat color and rhythmic line. It appears to have been improvised as it was painted, but it was preceded by studies [455, p. 394] in which the relationships of one line and area to another were modified into final balance.

Matisse was working in other directions at the same time, attacking especially the problem of formal monumentality combined with the dynamic color of fauvism. Sometimes his experiments deviated briefly in unexpected directions. In one exceptional canvas, the portrait of *Mlle. Yvonne Landsberg* [456] of 1914, the whirling rhythms of *Dance* have been disciplined into a pattern of arcs abstracted from a powerfully static figure, which they unite with the surrounding space. The interpenetration of form and space is a characteristic of cubism, as we will see, but in rectangular planes. In *Mlle. Landsberg* Matisse has experimented with a similar interpenetration, but in a way suggesting swelling rhythms in which space and figure echo one another in a kind of formal arabesque. *Mlle. Landsberg* is unique in its devices, although it is so effective that it might have served as the source of a whole movement in analytical painting based on curving spatial rhythms instead of cubism's rectangular structures. But Matisse did not follow up this direction; his preoccupation with vibrant areas of color would not allow the disintegration and merging of one form into another.

During the next five years Matisse created many semiabstract compositions, drawing upon cubism just as, indirectly, he had contributed to its origin. In 1916 he had returned to his early copy of the de Heem still life to make his semicubist variation on it [438], and during the same period, in compositions like the *Piano Lesson* [457], his angular structures also echo cubist theories. But these angularities are a surface exaggeration of the vestigial cubism in Matisse's work at this time. Basically the *Piano Lesson* is a structure in which the linear skeleton and the pattern of geometrical areas are still dependent upon color for their life and their balance. Also, this picture, which may appear a little thin and flat at first, grows richer upon closer acquaintance. There is, for instance, the interplay between the almost jaunty little figurine of the nude in the lower left, which at first is hardly noticeable, with the elongated, angular figure at the upper right, a parent or teacher supervising the boy at the piano. There is also a kind of counterpoint between the arbitrary abstract elements and the fairly realistic representation of others—the metronome and the music rack of the piano where even the name, Pleyel, is shown in reverse as we see it from behind, as part of a filigree. All these balanced contradic-

455 Henri Matisse. *Dance* (first version). 1909. Oil on canvas, 8′6½″ × 12′9½″ (2.6 × 3.9 m). Museum of Modern Art, New York (gift of Nelson A. Rockefeller in honor of Alfred H. Barr, Jr.).

456 Henri Matisse. *Mlle. Yvonne Landsberg.* 1914. Oil on canvas, 4′9¼″ × 3′6″ (1.45 × 1.07 m). Philadelphia Museum of Art (Louise and Walter Arensberg Collection).

457 Henri Matisse. *Piano Lesson*. 1916. Oil on canvas, 8′½″ × 6′11¾″ (2.45 × 2.13 m). Museum of Modern Art, New York (Mrs. Simon Guggenheim Fund).

tions are in the spirit of the picture, which is an engaging, rather affectionately humorous subject contradictorily presented in a spare and carefully calculated scheme, a combination of intimacy and austerity.

Up to this point in his development, Matisse has evidently been intent upon harmonizing the joyous, intimate, and sensuous spirit that is inherent in his art with the disciplines necessary to lift it above mere charm or triviality. Around 1917, as if with a sigh of relief, he yielded himself to his "good armchair," largely abandoning the disciplines for an interim of the most relaxed, most spontaneous, and least intellectualized painting of his career. At this

stage he becomes the connoisseur of sensory delights that make him the twentieth-century inheritor of such pre-Revolutionary masters as Boucher, and of Renoir in Renoir's most intimate and informal work. His paint is applied more lusciously, and more casually, than before. His subjects have more consistently to do with pleasure, ease, and luxury. Angularities and severities of compositional structure yield to grace and, above all, to semirealism. In spite of perspective violations *The Moorish Screen* [458, p. 396] from this period could almost be a quick sketch by an impressionist or even a notation by a realist, although the emphasis on ornamental patterns would be characteristic of

458 Henri Matisse. *The Moorish Screen.* 1921. Oil on canvas, 36¼ × 29″ (92 × 74 cm). Philadelphia Museum of Art (Lisa Norris Elkins Fund).

459 Henri Matisse. *Decorative Figure on an Ornamental Background.* 1927. Oil on canvas, 4′3½″ × 3′2⅜″ (1.31 × .97 m). Musée National d'Art Moderne, Paris.

neither. Oriental elements, which had been a large factor in Matisse's work since a first visit to Morocco in 1911, are especially conspicuous here in the form of decorative accessories such as carpets, screens, tiles, and the like. The whole picture is related to the glazed brilliance of Eastern patterned tiles.

Matisse was now working largely in Nice, a city dedicated to relaxation and surface attractions. His bright, comparatively naturalistic pictures pleased new collectors and even a fairly wide public, having as they did the cachet of approval by the most discerning critics, yet being much easier to understand than Matisse's work had been heretofore. But for all their charm, these agreeable and ornamental paintings had sacrificed much of their strength; for their grace, they have paid in subtlety. At this point Matisse might have followed the path of certain other fauves, notably Dufy, to settle for seduction and chic after the innovations of fauvism and the rigors of compositions like the *Piano Lesson* that had served the purpose of

giving him a facile command of color and structure at less demanding levels.

Matisse was never to return to the abstractions of the *Piano Lesson* and other pictures of that period—at least, not in obvious ways. But he had never been a painter who was content to develop a formula and hold to it and he never became one. *Decorative Figure on an Ornamental Background* [459], done six years after *The Moorish Screen,* rejects the sketchy realism and rather fluid painting of the earlier picture for a return to bold definitions and more arbitrary patterning, but retains the opulence that will be characteristic of Matisse from now on. *Decorative Figure* is essentially one of Matisse's great still-life compositions rather than one of his great nudes, for the figure is like an ornamental sculpture in the ensemble of other decorative objects and patterns.

All the foregoing summaries of major stages in Matisse's development have omitted the subdivisions, the brief periods of retreat from one direction, of return to variations of earlier peri-

460 Henri Matisse. *The Knife Thrower,* from *Jazz.* 1947. Color stencil after cut paper original, 15⅞ × 25½" (40 × 65 cm). Philadelphia Museum of Art (John D. McIlhenny Collection).

ods. Like every painter who continues to grow, Matisse draws upon all that he has learned, sometimes consciously, sometimes spontaneously, but he is never content to work only in repetitions or recombinations of past successes. His first mistrust of Bouguereau, his first suspicion that that tremendous academic reputation might be an inflated one, came when he found that Bouguereau was not only making an exact copy of one of his most successful pictures but making it from another copy made some time before.

In spite of excursions in various directions and all the divisions and subdivisions of his work into periods,* Matisse's development was generally in the direction of two-dimensional pattern, and in his very late years he produced a series of brilliant conceits in cut-and-pasted papers in vivid color. One series was called *Jazz* [460]; all the more surprising, then, that their flat, bright shapes should be adapted, in

Matisse's last work, to the stained-glass windows of a chapel.

In the late 1940s, when he was approaching eighty, Matisse abruptly committed himself to the decoration of an entire chapel—stained-glass windows, murals, ornamental tiles, altar, crucifix, confessional doors, chasubles, even the spire on the exterior—for the Dominican nuns in the little town of Vence near Nice. Matisse underwrote some of the expense himself. Nothing in his worldly art had ever suggested that his last great work would be a religious one for which he volunteered, but everything in its ornamental character was adaptable to architectural use.

For that matter, the decoration of the chapel at Vence is not a religious work in the way it would have been if Rouault, for instance, had done it. Matisse had never been a devout man and he experienced no conversion now, although there was a great deal of distorted publicity at the time attributing such a reason to his decision to do the chapel. He undertook the assignment in part because of his friendship for

* These may be followed in detail in Alfred Barr's *Matisse: His Art and His Public.*

461 Henri Matisse. Interior, Rosary Chapel, Vence, showing stained glass window and mural, 1951.

one of the nuns but largely, it seems, in the spirit of adventurous enthusiasm that had stayed with him into his old age [461]. "At last," he said, "we are going to have a happy chapel!" and he made no effort to synthesize any fraudulent mysticism in his preliminary designs. These were happy indeed, so happy that when a Communist acquaintance of Matisse's saw them he said, "When we take over, we'll use it for a night club."

Matisse approached the decorations of the chapel as an abstract problem, a balancing of "a surface of light and color against a solid wall covered with black drawings." The scheme has little to do with the Christian mysteries except in its use of some of their familiar symbols, but it has a spareness and restraint, in spite of its bright colors, which is more appropriate to a chapel than it would be to a night club; it is pure, fresh, and joyous rather than frivolous and sensuous. The "murals" that balance the

462 Henri Matisse. *Girl in a Low Cut Dress*. 1939. Pen and ink, 15 × 22″ (38 × 56 cm). Collection the artist's estate.

463 Henri Matisse. *Three Friends.* 1927. Pen and ink, 15 × 20″ (38 × 51 cm). Musée National d'Art Moderne, Paris.

464 Auguste Rodin. *Imploration.* Date unknown. Pencil with watercolor wash, 12 × 19″ (30 × 48 cm). Collection Mr. and Mrs. Adolf Schaap, Jenkintown, Pa.

bright animated shapes of the windows are ceramic wall decorations in the form of thin line drawings in black on flat backgrounds. They are a last statement of Matisse's development as a graphic artist, which was from elaboration to maximum simplicity.

Girl in a Low Cut Dress [462] is a typical example of Matisse's line drawing at its most economical; it recalls Rodin, once more, in Matisse's art, especially with the bridge of *Three Friends* [463] in comparison with Rodin's *Imploration* [464], even if we grant that the resemblance be-

tween the ornamental suggestions in the background of *Three Friends* and the free washes of color in *Imploration* may be coincidental. Rodin's voluptuousness disappears in Matisse's crisper, brighter images, but the free line, capturing an immediate reaction to the model as well as describing the essence of formal contours, is common to them both. There the similarity ends. Rodin's sensuousness was always part of some mystery, some yearning, close to romantic anguish. Matisse's sensuousness is a response to the joy of the tangible world.

Expressionism: Precursors

By the definition of expressionism as "the free distortion of form and color through which a painter gives visual form to inner sensations or emotions," fauvism is a form of expressionism. But usually expressionism's "inner sensations or emotions" connote pathos, violence, morbidity, or tragedy. Van Gogh is an expressionist within this definition. But by the narrowest definition of all, expressionism was a movement in twentieth-century painting that originated in Germany and continued to develop there in the work of several successive groups of painters who applied these general principles in their own intense and particular ways.

With the usual exceptions, the purest expressionist painters have been northerners—Scandinavians, Dutchmen, Germans, and some Russians. Van Gogh was one who, even though he painted in Paris and in the South of France, remained a foreigner to those places emotionally as well as nationally. He is admired and respected in France, but he has found no very close followers among French painters because he is without the qualities that temper the French recognition of the terribleness of life—logical perception, worship of Reason, a sense of moderation. Nor has van Gogh the gaiety and elegance that are constants in French art and life, and so large an element in fauvism. Fauvism had secondary connections with van Gogh, but he was the natural father of German expressionism.

In addition to van Gogh, German expressionism found prophets in the Swiss Ferdinand Hodler (1853–1918), born the same year as van Gogh, the Belgian James Ensor (1860–1949), and the Norwegian Edvard Munch (1863–1944), whose birth date encloses the three men within a decade of van Gogh as to age. Ensor and Munch knew the work of van Gogh and Gauguin and were in part formed by it, but Hodler was a rather isolated painter whose connections with postimpressionism and expressionism are spotty and interrupted. They were made largely through the success of a single picture, *The Night* [465].

Hodler became a painter after making a difficult choice between art and science. The science remains apparent in his art, with its tight precise forms and what can only be called its

465 Ferdinand Hodler. *The Night.* 1890. Oil on canvas, 3'5¾" × 9'10" (1.06 × 3 m). Kunstmuseum, Bern.

objective quality. For in spite of the fact that *The Night* proposes a fantastic subject, the drawing of the nude figures enacting it is next to scientific in the explicitness of its description. We are right back to the painting of another Swiss — Böcklin.* There is the same realistic-fantastic fusion, but Hodler's picture has a discipline that is foreign to Böcklin. The discipline was a specific one invented by Hodler himself. It was compositional, and he called it *parallelism;* it dictated the arrangement of the figures in layers above one another in parallels to the picture plane.

The Night was a great success in conventional circles in Paris when it was exhibited there in 1891, the year after it was painted. And without any question the handsome bodies represented in it exert an eerie pull on the imagination even while one suspects that the picture is a tour de force, that it is essentially a group of tableaux-vivants, arrestingly combined and meticulously executed. Both its mysticism and its modernism are a little false; it is not so much mystical as it is spooky, and it is not so much an original picture as it is a streamlined version of a Salon exercise.

The Night would come off better if it were not asked to meet such strong competition from its contemporaries; as a structure the picture is an elementary exercise when we remember *La Grande Jatte* [Plate 25, p. 337], painted five years before, and the tightening of contours that lifts the drawing of Hodler's figures a notch above first-rate conventional studio exercises is only a first step in the direction Gauguin traveled. As a matter of fact, the picture hardly fits in anywhere: it is not altogether academic; its structural elements cannot quite make it post-impressionist (although Hodler belongs to a group of Germans who rejected, or never accepted, the broken forms of impressionism); and its symbolism is pedantic and seems even more so when we think of it as one of a series of pictures Hodler painted after its success, with such highflown titles as *Disillusioned Souls* and *Glance into Infinity.* Its rather tenuous connection with expressionism has to do with its revelation of a state of mind, but it employs none of the distortions that in true expressionism give us the feeling that the revelation has been torn

by the roots from the painter's consciousness and displayed, mangled and palpitating, upon the canvas.

In the cases of Ensor and Munch, the connection with expressionism is more direct. Munch summed up his art in six words so pat that they make further verbal description superfluous. "I hear the scream in nature," he said. He had firsthand experience with the brutality with which life can treat us. His family seemed to be dogged by death and anguish; he observed, although he did not experience, the desperate poverty of the Oslo slums. He paints from a hopeless conviction of our aloneness in the world, our vulnerability to misfortune and spiritual violation. The sense of aloneness is frequently the theme or the personal source of expressionist art and is suggested in Hodler's *The Night;* each of the figures is spiritually isolated, even when embraced with another. And we know to what extent van Gogh's painting was a release from the aloneness he felt within himself.

It has been observed that Daumier, when he showed people in railroad carriages, or waiting in the station, or walking on the street, sometimes shows them as solitary within their own thoughts, alone in the crowd. But they share with their fellow human beings the important consolation of their common humanity. They move within the same world as their fellows and it is a world, ultimately, of warmth and meaning. But the individuals in Munch's *Anxiety* [466, p. 402] are caged within their own neuroses. The forms are established as strong, thick, black and red lines or heavy, solid, black masses, except for the faces, and these are barely indicated by the palest, most tenuous little strokes, as if obliterated by the spirit's inward turning. The pale staring eyes see nothing.

Anxiety at best and terror at worst are the poles of Munch's conception of life. The young girl in *Puberty* [467, p. 402] is haunted by fears that are all the more terrifying because they are unidentifiable. The haunted girl in Gauguin's *Spirit of the Dead Watching* [Plate 29, p. 371] is fortunate by comparison: the spirits that threaten her may be invisible but they make themselves known, and can be placated by incantation and sacrifice. No such recourse is open to Munch's adolescent. She knows only that she is to be the victim of malevolent forces at work within her own body and in the world surrounding her. Munch may be able to identify

* Another Swiss forebear was Holbein the Younger (1497–1543), the Renaissance master whose polished surface and sharply defined linear contours were models for Hodler.

466 Edvard Munch. *Anxiety.* 1896. Color lithograph, 16⅜ × 15⅜″ (42 × 39 cm). Museum of Modern Art, New York (Abby Aldrich Rockefeller Fund).

467 Edvard Munch. *Puberty.* 1895. Oil on canvas, 4′11″ × 3′7″ (1.52 × 1.1 m). National Gallery, Oslo.

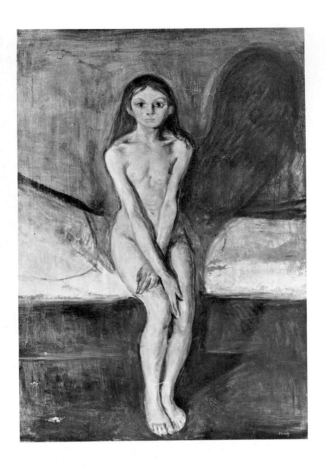

these worldly forces as the social evils he has observed, but the girl knows only that she is helpless before them. The flaw in Munch's art is that this mood, being unrelieved, becomes monotonous. Adolescence is certainly a time of uncertainties and imbalance, but it is also a time of passionate curiosity and exciting discovery. Making no concessions, Munch suffers from the mistaken idea, an immature one, that pessimism and profundity are synonymous in any observation of the human condition.

As for Ensor, he is at least as much a fantasist as an expressionist. His typical pictures involve skeletons and masked creatures in bizarre, grotesque scenes of sinister gaiety. His color is strong and bright, so that at first glance each picture is a carnival, a group of funnyfaces or Mardi-gras revelers, for a moment. The *Skeletons Trying to Warm Themselves* [468] are puppets from a Punch and Judy show—briefly—before they become parts of a nightmare.

Ensor's most ambitious picture was *Entry of Christ into Brussels* [469], more than fourteen feet long, which, according to his fellow Belgian, the architect and designer Henry van de Velde (an originator and spokesman of

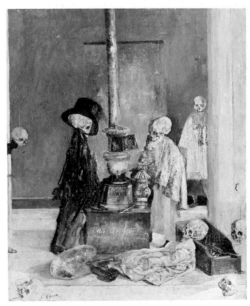

468 James Ensor. *Skeletons Trying to Warm Themselves.* 1889. Oil on canvas, 29½ × 23⅝″ (75 × 60 cm). Private collection.

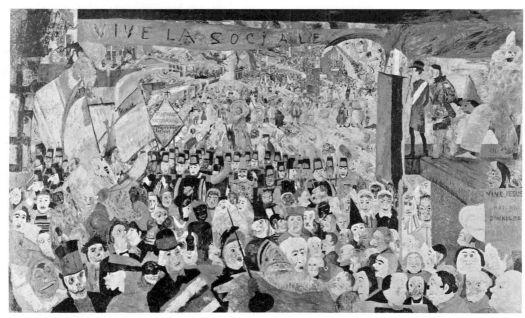

469 James Ensor. *The Entry of Christ into Brussels in 1889.* 1888. Oil on canvas, 8'5½" × 14'1½" (2.58 × 4.31 m). Koninklijk Museum voor Schone Kunsten, Antwerp.

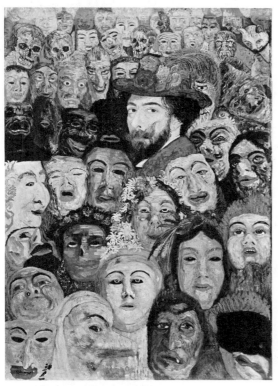

470 James Ensor. *Self-Portrait with Masks.* 1889. Oil on canvas, 47½" × 31½" (121 × 80 cm). Private collection, Belgium.

the theories of Art Nouveau), was an effort to create a sensation by painting a picture even larger than *La Grande Jatte.* Seurat's masterpiece had just been exhibited in Brussels and had made such a sensation that it was difficult to see for the crowds surrounding it. As a companion piece inviting comparison with *La Grande Jatte,* however, the *Entry of Christ into Brussels* is an excellent foil demonstrating Seurat's virtues. Ensor's picture is rather wearing, too loosely organized to unify so large a surface, and crowded with anecdotal detail that seems to have been piled up simply to get as much in the picture as possible. Ensor's world is more directly and disturbingly summed up in his *Self-Portrait with Masks* [470]. Masks and skeletons are Ensor's symbols, respectively, of falsity and mortality. That his fantasies have this direct and conscious relationship to an interpretation of this world in personal emotionalized terms makes Ensor an expressionist as well as a painter of the other-world of dream.

Expressionism: "Die Brücke"

With these comments behind us, the flowering of expressionism in Germany can be outlined as a matter of organizations formed for its

proselytization, and of personal variations on the expressionist idea. The earliest of the organizations was *Die Brücke,* meaning The Bridge, formed by a group of pupils at the Dresden Technical School and their friends. Some twenty years younger than Munch and Ensor, some thirty younger than van Gogh, they were directly influenced by these painters and also learned a great deal from the fauves, who had just declared themselves. The Bridge was founded in 1905, began to break up with the usual internal dissensions by 1907, and was finally dissolved in 1913 while its members continued to paint along its general lines.

Emil Nolde (1867–1956) was an exception among the members of The Bridge in being somewhat older than the others and, at the same time, something of an adopted son to them. He had passed through an early period when he did rather pretty picturesque land-scapes, and had followed it with an impressionist phase, then developed an interest in stormy color. The young men who founded The Bridge recognized his color as potentially expressionist, and under their influence he developed the typical preoccupation with personal and highly emotionalized statement.

The painters of The Bridge had their individual anguishes—sociological, political, sexual, and religious—and Nolde's were religious. Like the other members of the group, he is an artist who must be accepted on his own terms, or not at all. His form of religious statement cannot be stomached if religious statement is limited to the areas of mystical reflection or miraculous revelation in which it ordinarily falls in painting, or even within the area of humanitarian compassion typical of Rouault. Nolde's *Life of Maria Aegyptiaca* [471], told in three episodes, the first showing her sinful life before conver-

471 Emil Nolde. *Life of Maria Aegyptiaca,* First Episode: "Early Sinful Life." 1912. Oil on canvas, 33¾ × 39¼″ (86 × 100 cm). Kunsthalle, Hamburg.

472 Karl Schmidt-Rottluff. *The Way to Emmaus*. 1918. Woodcut, 15½ × 19½″ (39 × 50 cm). Philadelphia Museum of Art (gift of Dr. George J. Roth).

sion, the second her conversion, and the third her death, is shocking in its ugliness. But shock and ugliness, even revulsion, are Nolde's medium of religious expression. We must suppose that the painter reaches some kind of self-purification through the rejection of all grace either spiritual or aesthetic, through embracing all baseness and grossness, revealing it, devouring it, and expelling it in forms of abhorrent ugliness, forms smeared with the colors of blood and putrefaction. Here is van Gogh's personal catharsis intensified to such a pitch that it must be either recognized as profound or rejected as ludicrous.

Nolde left The Bridge as early as 1907, but his association with the group had led to his special fulfillment in pictures of this kind. Like other expressionist painters who were still at work during the late 1930s he was in disfavor under Hitler's regime, which sought to eliminate all "unhealthy" manifestations from German art and to create a new one out of the whole cloth. Hitlerian art was a kind of galumphing realism intended to indicate that Germany was a nation of jolly extroverts bursting with health and

without a neurosis to their name, certainly an ideal opposed to the mood of The Bridge. Many of Nolde's paintings were confiscated along with those of his colleagues, and he was one of those who had the further distinction of being forbidden to paint at all.

Karl Schmidt-Rottluff (1884–1976) was another of this select group. He had been a founding member of The Bridge and had even invented its name. After a beginning in which fauvist tendencies flavored his work he shifted to a primitivism inspired by African sculpture, which was exerting influence on the expressionists, the fauves, and the cubists all at the same time for different reasons. The expressionists were attracted by its harsh primitive vigor. In France the fauves and cubists also felt the appeal of this quality, so refreshing an injection after the hyperrefinements of fin-de-siècle art, but they intellectualized their use of primitive forms while the Germans sought to recapture the directness of emotional statement they felt existed there. Schmidt-Rottluff's *The Way to Emmaus* [472] is doubly influenced by African sculpture [1]—witness the heads—and Gothic

woodcuts of a simple and crude kind. The expressionists felt that there was a minimum of technical barrier between the artist and the observer in the earliest and most primitive woodcuts, and referred first of all to German ones, a part of their program to revitalize German art. Some of the best work of The Bridge took the form of woodcuts, but their innovation of crude cutting had been anticipated by Gauguin. He had already capitalized on crude cutting and rough printing in Tahiti, as in *Women at the River (Auti te Pape)* [473], although as usual with Gauguin this "primitive" directness is combined with Parisian subtleties. The woodcut is printed in exquisite tints of soft pinks, browns, and greens, with of course black, and in spite of the roughness of its lines it is nicely calculated, rhythmic in its organization, and as sophisticated as a Japanese print, which it suggests as much as it does primitive art. But *The Way to Emmaus* is gashed out of the wood as if in fear that any refinement must reduce the force of communication between artist and observer.

This force is remarkably retained, and the prints of The Bridge may end as their most distinctive achievement. The *Portrait of a Man* [474], possibly a self-portrait, by Erich Heckel (1883–1970) is less insistent than *The Way to*

474 Erich Heckel. *Portrait of a Man.* 1919(?). Color woodcut, 18¼ × 12¼″ (46 × 31 cm). National Gallery of Art, Washington, D.C. (Rosenwald Collection).

473 Paul Gauguin. *Women at the River (Auti Te Pape).* 1893–1895. Woodcut, 8⅛ × 13½″ (21 × 34 cm). Art Institute of Chicago (gift of Frank B. Hubachek).

Emmaus, but it wears better. With its emaciation, its introspection, its air of neurotic apprehensions, it comes as close as any single work can come to being a psychological portrait of The Bridge as a whole. In color the print is dominated by the pale olive-green of the face and hands, played against background areas of modified blue and brown, with the master block printed over them in sooty black. The woodiness of the blocks is emphasized in both cutting and printing. Woodblocks interested Heckel to such an extent that he carried their effects over into his painting, a curious reversal since color woodblocks originated as a substitute for painted pictures.

Ernst Ludwig Kirchner (1880–1938) is usually thought of as the most typical painter of The Bridge. A list of the influences at work in his art makes him sound like an eclectic: first naturalistic, then briefly pointillist, he shifted to an admiration for van Gogh and Munch, used fauvist color for a while, admired Japanese art and African sculpture like all other investigative young painters at the time, and finally adopted the angularities of cubism. Cubism was a form of spatial analysis but it interested Kirchner only as an expression of energy. His work is the most tightly organized of any of the group, no doubt because he began as a student of architecture and even received his degree in it. With Heckel and Schmidt-Rottluff he was the third in the trio of Dresden Technical School pupils who founded The Bridge.

In early pictures, Kirchner had worked in the flat color areas of fauvism but he is his own man in *Street, Berlin* [475], even though other influences, especially cubism, remain obvious. The rational angularities of cubism are turned into hectic, slashing patterns to express the theme that became Kirchner's major one—the tension, the neurasthenic agitation, the sinister viciousness, of the city. In the manner of the *Street* he painted people in gatherings where they are crowded together in an acid atmosphere, their isolation not so much a matter of melancholy aloneness as part of a cold, vicious distraction without unifying purpose. The *Street* was painted in 1913, just before World War I; Berlin at that time acted as a catalyst to fuse the various influences at work on Kirchner and made an individual painter of him.

During the war Kirchner was invalided out, not by wounds but by nervous instability. He spent the rest of his life in Switzerland. Painting again, he lost much of his individuality in a study of spatial cubism and rhythmic semifauvist landscapes. He committed suicide in 1938, partly because Hitler had condemned some six hundred of his works as "degenerate." Degenerate his art may have been, but in that case Kirchner was only performing the timeless function of the painter who reveals the essence of the time and place—Germany between wars—surrounding him.*

475 Ernst Ludwig Kirchner. *Street, Berlin.* 1913. Oil on canvas, 47½ × 35⅞″ (121 × 91 cm). Museum of Modern Art, New York (purchase).

* Otto Mueller (1874–1930) and Max Pechstein (1881–1955) should be mentioned as the remaining important members of The Bridge. Their work is discussed by association in these remarks on other painters; it is not illustrated or further discussed here to avoid repetition, not to dismiss these two painters as negligible talents.

Some members of The Bridge turned once in a while to sculpture, especially Schmidt-Rottluff and Kirchner. But the sculptor most closely allied to The Bridge in spirit was not affiliated with them or with any other expressionist group—Ernst Barlach (1870–1938). Barlach worked quite directly in the tradition of German Romanesque sculpture without being at all a parasite upon it. His bulky, vigorously chopped, often heavily textured forms have the human immediacy of some of the smaller medieval sculptures, rather than the monumental character of major portal figures. In medieval churches one comes on these small carvings, sometimes tucked away nearly out of sight; they are likely to be carved more freely and more personally than larger pieces in more conspicuous locations. The German examples are individualized by exceptional directness, sometimes an awkwardness in their strength, an exaggerated realism that may approach caricature. Barlach draws upon this tradition without reverting to it. Compositionally his figures are most frequently marked by swinging or lunging rhythms brought into balance by counter-rhythms in opposing line and mass [476].

Barlach was also one of the fine graphic artists of expressionism. His woodcuts have about them a feeling of carving; his prints retain to the highest degree the sense of the block's woodiness, the feeling of the knife or the gouge, which is typical of the prints of The Bridge.

Expressionism: "Der Blaue Reiter"

In the expressionism of The Bridge, subject is of basic importance, no matter how violently the forms are distorted in the process of revealing inner responses to external reality. In a second German expressionist group, *Der Blaue Reiter* (The Blue Rider), subject is less important and finally disappears altogether, taking recognizable images away with it. In other words, the art of The Blue Rider was increasingly abstract and finally became nonobjective. The term *nonobjective* (sometimes *nonfigurative* in subtle distinction) describes completely abstract art that is independent of visual reality even as a starting point for the derivation of forms.

The Rider group is a more cheerful one than The Bridge, more influenced by Gauguin than

476 Ernst Barlach. *Man Drawing a Sword.* 1911. Wood, height 29½″ (75 cm). Cranbrook Academy of Art, Bloomfield Hills, Mich.

by van Gogh, interested in rhythmical, "musical" compositions composed of sweeping curves and flowing lines rather than harsh, moody, restless, or abrupt ones. The group was not formed until the last month of 1911, some years after The Bridge, which it eventually absorbed, and grew out of a series of exhibitions held in Munich when all the advanced art groups of the city combined to hold international exhibitions of work by artists from Cézanne forward. Munich was extremely active in painting, but heretofore the sound, brownish, anecdotal academic work produced there in great quantities had not been as seriously under attack as traditional painting had been in Paris. The artists of The Blue Rider broke away from the large amorphous group that was organizing

exhibitions to introduce the French rebels to Germany. Their background was international rather than specifically German, thus differentiating them from The Bridge; their influence, too, was international in contrast with the more self-contained earlier group.

The two organizing members of The Blue Rider were Franz Marc (1880–1916), a contemporary of the men we have just seen, and Wassily Kandinsky (1866–1944), somewhat older and of Russian origin, who had been a lawyer, had developed as a painter along fauvist lines, and had exhibited in Bridge shows. Marc was killed in the battle of Verdun before he had brought his work to the point of complete abstraction, as he seemed to be in the process of doing. Kandinsky is another story: the appearance of his first completely nonrepresentational work in 1910 is a historic event of great consequence, and he formulated his ideas in a treatise, *Concerning the Spiritual in Art,* which has been a handbook since its publication in 1912.

He divorced painting from subject matter and tried to create mood by the psychological impact of line and color alone.

Kandinsky's "improvisations" [477] of spontaneously applied color "mean" nothing, in the sense of direct allegory or symbol. They are based on the reasonable assumption that if a model painted in a red dress affects the observer differently from the same model painted the same way in a blue dress, then the color alone accounts for the difference. In that case, simply a red shape or simply a blue shape must mean something, must strike up a "corresponding vibration in the human soul," to borrow a phrase Kandinsky used in a slightly different context. Also, if an object described in squiggly broken lines is different in psychological effect from the same object described in smooth, even, tightly defined line, then the squiggly broken lines and the smooth even ones must have their own inherent psychological quality, all subject matter aside. Thus a painting can have a

477 Wassily Kandinsky. *Improvisation.* 1914. Oil on canvas, 30¾ × 39⅜″ (78 × 100 cm). Philadelphia Museum of Art (Louise and Walter Arensberg Collection).

mood through its lines and colors without a subject. To make the divorce from subject complete, Kandinsky ordinarily gave no titles to his paintings, identifying his improvisations by a number or by date or by some phrase to distinguish one from another but not to give a literary suggestion as to what it was "about."

In contrast to the improvisations with their expressionistically free arrangements, Kandinsky also composed in patterns of sharply defined geometrical forms [478]. These forms might be flat, regular, geometrical ones or sharp-edged ones of irregular shapes, and might be filled with color or not, and might, as in the illustration selected here, include a scattering of more accidental forms whose disposition is taken into account in the arrangement of the more calculated ones. Although he rejected images, Kandinsky never thought of his nonobjective paintings as being divorced from nature, and from time to time, as in *Fish Form* [479], he allowed nature to be recognizable within extreme geometrical conventionalizations. He may or may not have been thinking of this picture when he wrote that the essential difference between a line and a fish is that "the fish can swim, eat, and be eaten. It has then, capacities of which the line is deprived. These capacities of the fish are necessary extras for the fish itself and for the kitchen, but not for painting. And so, not being necessary, they are superfluous. That is why I like the line better than the fish—at least in my painting." *Fish Form* makes a concession to image—but it remains more line than fish.

Among the painters formally and informally connected with The Blue Rider, four must be mentioned. Another Russian, Alexey von Jawlensky (1864–1941), developed a preoccupation with large, formalized, rather hieratic heads, sometimes expressionist in character and sometimes highly abstracted. Heinrich Campendonck (1889–1957) painted charming peasant scenes with a fairy-tale quality reflecting the naïveté of folk art. Lyonel Feininger (1871–1956), an American born of German immigrants, returned to Europe for study and after earlier contacts with Kandinsky was a member of the "Four Blues"—Kandinsky, Jawlensky, Feininger, and Paul Klee—who constituted a secondary revival of the Rider group. Feininger's art is a particularly distinguished one with close cubist affiliations. It is crystal clear, precisely joined in sharp-edged planes

478 Wassily Kandinsky. *Geometrical Forms*. 1928. Watercolor and ink on paper, 19 × 11″ (48 × 28 cm). Philadelphia Museum of Art (Louise and Walter Arensberg Collection).

that sometimes define recognizable objects or sometimes lose the object in abstract planar extensions [480], but always retain a poetic flavor that is expressionist within the cubist variation. Feininger's construction of planes often suggests abstract architecture, and he was an instructor in the Bauhaus, the school of fine arts and crafts centered around architecture and established in Germany at the end of World War I.

479 Wassily Kandinsky. *Fish Form.* 1928. Watercolor and ink on paper, 12⅝ × 19⅝″ (32 × 50 cm). Philadelphia Museum of Art (Louise and Walter Arensberg Collection).

480 Lyonel Feininger. *The Steamer Odin, II.* 1927. Oil on canvas, 26½ × 39½″ (67 × 100 cm). Museum of Modern Art, New York (Lillie P. Bliss bequest)

The Bauhaus was probably the most effective coordinating factor in the chaotic picture of modern art, and it developed teaching methods in connection with this coordination that are now disseminated all over the world.

Expressionism: "Die Neue Sachlichkeit"

During the last years of World War I and the years just following it, German painters expressed their spiritual shock in some of the most horrifying images since Goya. They rejected the intellectualism and the generally happy spirit of The Blue Rider, but they rejected also the kind of emotional intensity typical of The Bridge. Personal neurotic apprehensions like those expressed by Heckel and Kirchner now seemed puny in comparison with the horror of a world that had revealed itself as a social and political organization given over to mass murder and moral anarchy. The new expressionism was called *Die Neue Sachlichkeit* (The New Objectivity). Objectivity is precisely the reverse of expressionist emotionalism, and the term belies the sense of outrage that animates these painters at the end of the war and immediately after it. "The New Objectivity" refers more aptly to the political and social apathy, the hopelessness, the acceptance of corruption and misery and degradation as the natural state of things that was characteristic of the later postwar years. In its turn this condition was to bring with it a nihilistic art denying the legitimacy of all logic, all order, all effort, all feeling, all plan—an art reveling in morbid nonsense with the painters of The New Objectivity taking part.

Even Goya would have been appalled before the war portfolio of Otto Dix (1891–1969). *The Disasters of War* as Goya reported them are a record of inhumanity and brutal folly, but Dix's *Der Krieg* shows the dissolution of matter and spirit into putrescence and senselessness. Goya is a spectator of atrocities; we observe them with him and react as human beings capable of normal emotional and intellectual responses. But Dix is not an observer; he is a victim of insanity and butchery. In *Meeting a Madman at Night* [481] horror exists alone, beyond moral or social indignation, with a kind of wild idiocy. The final horror is that there is something grotesquely comical about the ghoul, like a blackface comedian gone mad.

481 Otto Dix. *Meeting a Madman at Night,* from *Der Krieg.* 1924. Etching, aquatint, and drypoint; 10¼ × 7⅝″ (26 × 19 cm). Museum of Modern Art, New York (gift of Abby Aldrich Rockefeller).

Humor to sharpen horror was used with savage precision by George Grosz (1893–1959) in his satires of the bourgeoisie, the clergy, the military, and the bureaucrats who in his eyes were responsible for the war. *Fit for Active Service* [482], done in the last years of the war when German boys, old men, and broken men were being sent to the front, is funny on the surface and all the more frightful for being so. The fat, secure doctor, the trimly groomed officers with their monocles and their beast-faces raddled by vice, the kowtowing clerks and flunkies, are drawn in Grosz's typically cruel, sharp line, like a razor lancing a carbuncle, but the skeleton is contrastingly represented in macabre complications of thin, knobby bones, vestigial organs, and obscene dangling fluffs of

482 George Grosz. *Fit for Active Service.* 1916–1917. Pen and brush, India ink, 20 × 14³⁄₈″ (51 × 37 cm). Museum of Modern Art, New York (A. Conger Goodyear Fund)

483 (right) George Grosz. *Street Scene.* 1915. Lithograph, 10½ × 8½″ (27 × 22 cm). Philadelphia Museum of Art (Thomas Skelton Harrison Fund).

hair and thready bits of rotten flesh. Grosz's city streets are filled with desperate, evil beings reduced to subhuman levels by vice, poverty, or corruption; the windows of his houses are vignettes of suicide, lust, and murder [483]. In his watercolors [484, 485; p. 414], Grosz paints with the most delicate, the most sensitive, of techniques, in colors as sweet and fresh as the tenderest flowers, to represent obese or stunted prostitutes, shriveled harridans, starving children, piglike profiteers, every scene of depravity, misery, and ugliness. This use of paradox—humor to enhance horror, loveliness to reveal ugliness with a new repulsiveness—is prophetic of the perversity of the irrational, nihilistic art soon to be discussed here as dada.

Independent Expressionists

Max Beckmann (1884–1950) was a contemporary of the three German expressionist groups just seen, falling by birth date about midway

between the older and younger men. Without being strongly attached to any group he participated in their early exhibitions. He is something of a summary of the German expressionist experience and adds to it an important element, a correlation with traditional art.

More than any of the other expressionists Beckmann studied the old masters, particularly the early Renaissance forms of Piero della Francesca and the late medieval ones of French painting as well as Cézanne, who was not a powerful direct influence on the other expressionists, and van Gogh, who of course was. And, most important of all, he was the direct heir of another German, Hans von Marées (1837–1887).

His dates show that as a nineteenth-century painter contemporary with the French impressionists, Marées is introduced out of chronology here. But he painted so unobtrusively among his contemporaries that, even more than Cézanne, he is more significant as a part of twentieth-century painting than as part of the

484 George Grosz. *Maid Arranging the Hair of a Corpulent Woman.* c. 1925. Watercolor, 24⅞ × 18¾″ (63 × 48 cm). Philadelphia Museum of Art (gift of Bernard Davis).

485 Detail of Figure 484.

painting of his own lifetime. He is commonly referred to nowadays as a German Cézanne, sometimes also as a parallel to Puvis de Chavannes. In either case, he rejected the imitative realism and the rather heavy-handed symbolical romanticism that surrounded him and worked instead to translate philosophical ideas into terms of monumental form. This might mean classicism, but (again like Cézanne) Marées believed that monumental harmonies could be fused with direct vividness of living matter. The figure in his *Man with the Standard* [486] is typical of the solid power, the generalized statement without recourse to beautifying formula, of Marées' art. Contemporary German painters have been happy to find in Marées a Germanic postimpressionist, the only strong transitional figure between nineteenth-century traditions indigenous to Germanic culture and twentieth-century innovations, including expressionism, which found their major development in Germany. Beck-

mann is the closest of all modern Germans to Marées, and extends to a conclusion the expressive Germanisms initiated or continued by the nineteenth-century painter.

Beckmann brought to expressionism Marées' monumentality of form, and thus universalized the personalism of the other expressionists. His symbolism is social in origin rather than neurotically ingrown, and it is expressed in formally ordered compositions on the grand scale. He widened the scope of expressionism, discarded it as a vehicle for personal confession and private emotionalism or nihilistic social comment, and gave to it the strength and capacity to speak not only of the artist, but of all humankind.

Beckman has never offered an explicit key to the symbolism of the three panels in *Departure* [487], but it is apparent that the two side panels are concerned with evil in their scenes of torture and foul mutilation painted in harsh, violent complications of form and color, while the

center one is concerned with salvation, clear and serene as it is, painted in pure, brilliant, harmonious colors and broad simple forms existing in ample space. There are echoes of Christian iconography that cannot be missed. In the first place, the triptych form is that of an altarpiece. Without being at all a figure of Christ, the figure of the king in the central panel recalls Christ, partly because the net over the side of the boat recalls the miraculous draught of fishes. Beckmann said that the picture spoke to him of truths impossible for him to put into words. Whatever it meant to the painter, its

486 Hans von Marées. *Man with the Standard.* Date unknown. Oil on canvas, 19⅜ × 13¾″ (49 × 35 cm). Kunsthalle, Bremen.

487 Max Beckmann. *Departure.* 1932–1933. Oil on canvas; center panel 7′3¾″ × 3′9⅜″ (2.15 × 1.15 m); side panels each 7′3¾″ × 3′3¼″ (2.15 × 1 m). Museum of Modern Art, New York (anonymous gift).

theme can be sensed as a problem of good and evil common to us all.

Beckmann is an expressionist who is conscious that his personal emotional experience must be the wellspring of his art, but that it must be universalized if his paintings are to endure as something more than isolated phenomena or curiosities. He might have said: "I want to make of expressionism something solid and durable like the art of the museums."

Among other major expressionists, Oskar Kokoschka (1886–1980) was even more loosely connected than Beckmann with expressionism as an organized movement, but like Beckmann he emerges as one of the significant painters produced by the expressionist spirit. An Aus-

trian, he began his career in the last days of the old Empire surrounded by its special atmosphere of decay, nervous sensitivity, and elegant indulgence. These elements are reflected in Kokoschka's work, but its unconventionality brought him under violent official attack. The Austrian Crown Prince said that "every bone in his body should be broken." This was in 1911; it is easy to believe, in retrospect, that Kokoschka's art gave offense because it gave expression to the spiritual morbidity of the time and its moribund culture rather than supplying cheerful assurance that all was well, as official painting was doing. Kokoschka's *The Tempest* [488], which is also called *The Vortex* or *The Wind's Bride,* showing two lovers in a small barque

488 Oskar Kokoschka. *The Tempest (The Wind's Bride).* 1914. Oil on panel, 3′4¼″ × 6′3¼″ (1.02 × 1.91 m). Kunstmuseum, Basel.

489 Oskar Kokoschka. *London, Large Thames View I.* 1926. Oil on canvas, 2'11⅜" × 4'3¼" (.9 × 1.3 m). Albright-Knox Art Gallery, Buffalo, N.Y. (Room of Contemporary Art Fund, 1941).

captured within menacing forms apparently abstracted from those of storm clouds, heavy seas, and mountainous landscape, is a sinister and frightening picture, although at the heart of the surrounding violence the lovers have found refuge in one another. It was painted in 1914, just before the beginning of World War I.

In color *The Tempest* is expressively cold, heavy, even turgid. But by 1919, after the war, (during which he was seriously wounded), Kokoschka settled in Dresden as a teacher at the Academy. Under the influence of The Bridge his color brightened, with generous use of clear vermilions, azures, and emeralds. His landscapes and particularly his cityscapes [489] combine staccato accents with flowing lines; they are ebullient, vital, and elegant. And his portraits are acute explorations of personality in which the features of the sitter seem to have been created not by the usual processes of biol-

ogy but by the force of inner nature that has molded them to correspond with its individual character [490, p. 418].

In Germany Käthe Kollwitz (1867–1945) was affected by expressionism in her deeply emotionalized protests against the fate of the poor, both before and after World War I. Kollwitz painted very little, but her etchings, woodcuts, and lithographs are among the most forceful graphic productions of the early twentieth century. Unlike Grosz and other painters of The New Objectivity who observed and commented on the same desperate scene, Kollwitz was never able to protect herself within a shell of intellectualism or cynicism. Her anguish is undiminished from print to print [491, p. 418].

Certain other artists even less closely connected with German expressionism, especially stylistically, are expressionist in the broad definition as using emotionally expressive distor-

490 Oskar Kokoschka. *Herwarth Walden*. 1910. Pen and black ink over graphite, 11⅛ × 8⅝″ (29 × 22 cm). Fogg Art Museum, Harvard University, Cambridge, Mass. (purchase, Friends of Art and Music at Harvard).

491 Käthe Kollwitz. *Death and the Mother*. 1934. Lithograph, 20⅛ × 14⅜″ (51 × 37 cm). Private collection.

tions. One of the most conspicuous is Amedeo Modigliani (1884–1920), whose elongated forms combine a taut, wiry precision of outline with his typical neurotic languor of mood [3]. Modigliani, an Italian working in Paris, has a legend exceeded in picturesqueness only by van Gogh's and Gauguin's.* Poverty-stricken, theatrically handsome, tragically doomed by tuberculosis, and spectacularly dissipated, he was the culmination of the romantic tradition of the Parisian bohemian painter or poet. To the long list of influences that were compounded into his very personal style as a painter, Modi-

*Another inhabitant of Modigliani's bohemia was Maurice Utrillo (1883–1955), the son of a professional model, Suzanne Valadon, who became a respectable painter in her own right. Utrillo is unclassifiable as a painter except as a member of the "School of Paris" of the early twentieth century. Fauvism, expressionism, cubism, may all be read into his perspectives of the streets of Montmartre or of small towns, but so may the quiet, gentle art of Corot.

gliani added elements from the archaic Greeks when he worked in sculpture [492], as he did particularly between 1909 and 1915. But in spite of obvious derivations, Modigliani's art is never a mere pastiche of secondhand forms. Everything serves the expression of a tender, despairing sensuality in his painting, or of a decorative hieratic reserve in his sculpture.

In Germany, living his short life during the same years as Modigliani, the sculptor Wilhelm Lehmbruck (1881–1919) began as a student at the Düsseldorf Academy, then developed a personal style under Italian and French influences. Like Modigliani's, Lehmbruck's manner is based on extreme elongations, but it is without archaic and primitive references. Unlike the German expressionist painters with whom he is too often grouped for convenience, Lehmbruck respected the tradition of classical idealism, including its realistic elements. His *Kneeling Woman* [493] may be designed with stylistic elongations, but its modeling is not only de-

tailed but respectful of normal anatomical structure. His surface is even an impressionistic one, subdued in flesh passages but marked in hair and drapery. Lehmbruck worked in Paris between 1910 and 1914, and was first influenced by Aristide Maillol (1861–1944), who brought to French sculpture a renewal of classical concepts of repose, serenity, balance, and stability. Lehmbruck's *Standing Woman* [494, p. 420], done only the year before the *Kneeling Woman,* is Maillolesque to such a degree that it might almost be taken as a work by that master. But even in the *Kneeling Woman,* the harmonious serenity of Lehmbruck's fully developed style ties him at least as closely to the classical tradition as his elongations tie him to the ro-

mantic-expressionist one. His work suggests a degree of fulfillment not granted his harassed expressionist compatriots.

Expressionism in America

In America Marsden Hartley (1877–1943) was a pioneer expressionist, a bridge between the newly developing European movements and the nascent internationalization of American art. Hartley was a contemporary of the doggedly American Ash Can group, but he spent as much time as he could abroad, even exhibiting with The Blue Rider group in Munich and Berlin. Hartley was born in Maine, grew up in Cleve-

492 Amedeo Modigliani. *Head.* Date unknown. Limestone, height 27″ (69 cm). Philadelphia Museum of Art (gift of Mrs. Maurice J. Speiser).

493 Wilhelm Lehmbruck. *Kneeling Woman.* 1911. Cast stone; height 5′9½″ (1.77 m), base 4′8″ × 2′3″ (1.42 × .69 m). Museum of Modern Art, New York (Abby Aldrich Rockefeller Fund).

494 Wilhelm Lehmbruck. *Standing Woman*. 1910. Bronze (cast 1916–1917); height 6′3⅛″ (1.91 m). Museum of Modern Art, New York (anonymous gift).

land, studied for a while in New York, and then alternated between Europe and the United States. In his final style [495] he strives for a kind of raw power that might be called American, marked by broad, deliberately crude forms, harsh color, and slashing contrapuntal arrangements. His courage and perseverance were admirable. So, frequently, is his painting, yet he seems too often to be giving an intelligent dem-

onstration of expressionist theory, not often enough releasing an emotional force that demanded the use of expressionist devices. Arthur G. Dove (1880–1946), another American who studied for a while in Europe, shares Hartley's position as an eminent pioneer in his own country and went beyond Hartley in the direction of pure abstraction and personal colorism. But it remained for John Marin (1870–1953) to absorb European influences and then to develop them in an art as legitimately American as it was personal.

Marin's expressionism developed through a logical sequence of creative experiences. He studied first (after a brief experience as an engineer) at the Pennsylvania Academy of the Fine Arts, where his teachers were still wholeheartedly dedicated to factual realism. This was in 1899. In Paris between 1905 and 1911 he progressed into impressionism, including etchings in Whistler's tradition. By the end of his stay in Paris he was beginning to be affected by current European developments, particularly fauvism, and shortly after that he worked in a free adaptation of cubism.

Cubism involved, as we will shortly be seeing, a disintegration of form, a shattering and reassembling of objects reduced for the most part to their rectangular equivalents. We will see too that its basis was analytical rather than emotional. But Marin fused the two apparent incompatibles—analytical cubism and emotionalized expressionism—into a vividly personal style that gave pictorial form to the clangor, the vitality, the surge, the bursting sparkling energy of the American city.

While the Ash Can School was painting the city as a genre subject, Marin began to paint it as an idea, as a manifestation of the most exciting aspect of the American spirit, its enthusiasm, its youth, its violent growth, an aspect that reached its climax during the years between the two world wars when Marin was working at his peak.

Marin's expressions of New York City transform the static, monolithic forms of skyscrapers, the flatness of streets and sidewalks, into abstractions of energy and excitement. The forms of the city tilt, break, and interrupt one another until they all but disappear as recognizable objects, abstracted to the point of pure expression [496]. And in his paintings of the Maine coast the same transmutation is apparent until finally the rocks of the earth, the water of the ocean, and

495 Marsden Hartley. *Hurricane Island, Vinalhaven, Maine*. 1942. Oil on masonite, 30 × 40¼″ (76 × 102 cm). Philadelphia Museum of Art (gift of Mrs. Herbert C. Morris).

496 John Marin. *Lower Manhattan (Composing Derived from Top of Woolworth)*. 1922. Watercolor and charcoal with paper cutout attached with thread, 21⅝ × 26⅞″ (55 × 68 cm). Museum of Modern Art, New York (acquired through Lillie P. Bliss Bequest).

the sailboats, which for Marin are an expression of the force of the movement of air, become abstractions of the vital energy of nature, just as the New York pictures are abstractions of the vital energy of the city.

Several chapters back, in the mild world of impressionism, we saw that Jackson Pollock's *Autumn Rhythm* had ancestral affiliations with Monet's very late work when a passage from *Water Lilies* was extracted from context [270, 271, and 272]. Similarly, the innate prophecy of expressionist techniques like that in the *Moise Kisling* [497] by Chaim Soutine (1894–1943) is revealed by framing off and enlarging a detail of the sitter's right eye [498]. Soutine, a Lithuanian working in Paris, painted in a manner recalling at once van Gogh, El Greco, and the German expressionists—anticipating at the same time the vigorous style of Willem de Kooning (1904–), a leader in the abstract-expressionist school that dominated painting internationally during the early 1960s [499].

This comparison is not altogether a stunt. By Kandinsky's theory that color and form can exist alone as expressive means without reference to the imitation of visual reality, the sweeps and slashes and gobbets of color extracted from the Soutine should be expressive even though they

497 Chaim Soutine. *Moise Kisling.* Date unknown. Oil on canvas, 39 × 27¼″ (99 × 69 cm). Philadelphia Museum of Art (gift of Arthur Wiesenberger).

498 Detail of Figure 497.

are no longer recognizable as the description of one of the eyes in the portrait. If Soutine's colors, brush strokes, and shapes carry the expressive burden of his canvas, as they undeniably do in very large part, then they should continue to be expressive independently. De Kooning's painting is inchoate, fragmentary, and senseless unless we accept the totality of Kandinsky's premise that a painter, through talent, training, and experience (for de Kooning is talented, trained, and experienced), reaches the point where he may express himself best by attacking his canvas vigorously, by improvising abstractions of form and color, painting without schematic preparations, drawing spontaneously upon all that he has learned of shape and color as expressive means.

While the de Kooning, painted in 1958, takes us beyond the chronological limits of this book, the argument also takes us as far back as Delacroix. When we remember his warning that "All precautions have to be taken to make execution swift and decisive in order not to lose the extraordinary impression accompanying the conception," we find Delacroix stating a principle that is pushed to its abstract limits by painters today following the immediate precedents of pictorial expressionism.

499 Willem de Kooning. *Detour.* 1958. Oil on canvas, 4′11″ × 3′6″ (1.5 × 1.07 m). Courtesy Sidney Janis Gallery, New York.

chapter 26

Cubism and Abstract Art

Cubism: The Early Picasso

Cubism was born unexpectedly in 1907 without the benefit of theory and from curiously mixed parentage: Cézanne on one side, and the sculpture of ancient and primitive peoples on the other. It appeared first in the work of two young men named Pablo Picasso (1881–1973) and Georges Braque (1887–1963).

Picasso, a Spaniard, had come to Paris at the age of nineteen after a prodigious conquest of the academies in Barcelona and Madrid. At twelve he was a competent draftsman [500], and thereafter as a student he ran the historical gamut of styles from academic formula straight through impressionism, mastering them all with the facility of a mimic and the understanding of an artist. Whole books have been devoted to his work during the seven years from his arrival in Paris to his first cubist painting. Here a brief summary will suffice.

During his first year or so in Paris, Picasso worked in a manner close to Toulouse-Lautrec's but bursting everywhere with restlessness, as if impatient to shift into a new direction. *Old Woman* [501] of 1901, the year of Lautrec's death, looks as if Lautrec himself might have painted it after discovering pointillism and adapting it to a violent flashing expressionism. Yet in the same year—his twenty-first—Picasso, in a typical shift of direction, painted a serene, pensive *Harlequin* [502] with controlled outlines, decisive pattern and broad flat areas of color, probably related to Gauguin's. This *Harlequin* is somewhat romantic in mood, decorative in arrangement, classical in its sense of control, rather affected in its selection of posture and subject, and altogether attractive in itself. Picasso is showing, as he will do again and again, that he can be everything at once.

500 Pablo Picasso. Drawing from a cast of the figure of Dionysus (east pediment of the Parthenon). 1893–1894 Conté, 18¼ × 25¼″ (46 × 64 cm). Private collection.

The direction hinted at in this picture is not followed up until later. (Not only could Picasso be everything at once; he could also travel in all directions at once, seeming to abandon one direction in painting for a while and then suddenly resuming it at another level as if it had been developing of itself during the lapse of time.) During the next few years he painted in two manners called the "blue" and "rose" periods. A single example will have to suffice as typical of the blue pictures, *The Old Guitarist* [503, p. 426] of 1903. Pathetic in its subject, stylized with its elongated figure posed in a cramped, angular attitude, and painted in frigid blues and blue-greens, it follows closely the basic recipe of the period. This is a style of great sophistication in which the pathos is altogether superficial, a very young man's style. Among the influences at work are the painting of El Greco and the early medieval French sculpture of the school of Languedoc—at least by the internal evidence of stylistic resemblance.

501 Pablo Picasso. *Old Woman.* 1901. Oil on canvas, 26⅜ × 20½″ (67 × 52 cm). Philadelphia Museum of Art (Louise and Walter Arensberg Collection).

502 Pablo Picasso. *Harlequin.* 1901. Oil on canvas, 32⅝ × 24⅛″ (83 × 61 cm). Metropolitan Museum of Art, New York (gift of Mr. and Mrs. John L. Loeb, 1960).

503 Pablo Picasso. *The Old Guitarist.* 1903. Oil on canvas, 37⅜ × 28″ (95 × 71 cm). Art Institute of Chicago (Helen Birch Bartlett Memorial Collection).

504 Pablo Picasso. *La Toilette.* 1906. Oil on canvas, 4′11½″ × 3′3″ (1.51 × .99 m). Albright-Knox Art Gallery, Buffalo, N.Y. (Fellows for Life of 1926 Fund).

The blue period softens into the "circus" period and then merges in 1905 into the rose period, with the change in dominating color suggested by the tags and, above all, a change in mood. Charm replaces pathos, grace takes the place of angularity; sometimes there is a strong classical flavor, as in the entrancing *La Toilette* [504] with its references to Greek vase painting. Of all his multitudinous periods this is the one that accounts for Picasso's widest popularity. The affectation that is an uncomfortable element in the early blue pictures, conflicting as it does with subjects of poverty and misery, is appropriate to the charming, sometimes feminine air of the later ones, as the harsh blues and greens turn into soft gray-blues and merge with rose. It is a period of brilliant technical display. Almost any picture of these years could serve as an example; a fine one is *Boy with Bouquet*

[505], where we are offered a bunch of flowers by one of the adolescent harlequins, actors, acrobats, and theatrical vagabonds who replace starving unfortunates as the major performers, and will continue to appear among Picasso's cast of thousands from now on.

The main areas of *Boy with Bouquet* are established in audacious scrubs and strokes of color and then, in a demonstration of infallible draftsmanship, the features are described with a few lines struck in with almost insolent virtuosity. Had Picasso died in 1906, the charging bull of modern art would have been remembered as a delicate aesthete who revived the eighteenth-century spirit at its most sensitive, a twentieth-century Watteau. During this time Picasso planned a large composition of adolescent youths and horses. The studies he made for it [506] are consummately in this spirit.

505 Pablo Picasso. *Boy with Bouquet*. 1905. Gouache, 25½ × 21⅜″ (64 × 54 cm). Private collection.

506 Pablo Picasso. *Boy Leading a Horse*. 1905. Oil on canvas, 8′3″ × 4′9¼″ (2.21 × 1.45 m). Collection William S. Paley.

But with the restlessness of an explorer or an inventor, Picasso changed again at the end of 1906 in a way that is important as an early step toward cubism. He began to discipline his graceful figures into new sculptural forms with an imposition of decisive geometrical regularities. Already indicated in *Lady with a Fan* [219], the new discipline is even more emphatic in *Woman with Loaves* [507, p. 428], with its geometrical solids built firmly upon one another into a compact whole. The ovoid form of the torso is surmounted by the white cylinder of the cap, which is pierced to reveal the simplified sculptural form of the head. The two loaves of bread rest on top of this structure like architectural members surmounting a column.

Woman with Loaves was painted in the summer of 1906 (despite the date 1905, added in error beneath the signature). Earlier that year

Picasso had begun a portrait of *Gertrude Stein* [508, p. 428], the American writer who had set herself up in Paris a few years earlier and had already become a major patron, proselytizer, and practitioner in the international intellectual avant-garde. After eighty sittings Picasso had wiped out the face of her portrait. Whatever the face had been like, it was obvious that in the rest of the picture Cézanne is very much present. When Picasso returned to the picture after the summer interval during which he painted *Woman with Loaves,* the new force at work in his art produced the masklike face (painted without the model) so at variance with the Cézannesque forms that surround it. In his *Self-Portrait* [509, p. 428] painted immediately afterward, the masklike quality has increased, and its severe half-primitive quality has extended to the figure also.

507 Pablo Picasso. *Woman with Loaves.* 1906. Oil on canvas, 39 × 27½″ (99 × 70 cm). Philadelphia Museum of Art (gift of Charles Ingersoll).

508 Pablo Picasso. *Gertrude Stein.* 1906. Oil on canvas, 39⅜ × 32″ (100 × 81 cm). Metropolitan Museum of Art, New York (bequest of Gertrude Stein, 1946).

Cubism: Its Beginnings

By his own statement, in *Woman with Loaves,* the Stein portrait, and his own portrait, Picasso was influenced by Iberian sculpture, the archaic sculpture of pre-Roman Spain. But the two portraits look as if Picasso had already discovered African sculpture at about this time, and the ingredients for cubism were assembled. These were: Cézanne, with his concept of volume and space as abstract geometry to be dealt with at whatever necessary rejection of their natural relationships; African and archaic sculpture, with their untheoretical but exciting reduction of natural forms to geometrical equivalents, plus an element of the bizarre and the savage that was a stimulating injection into the hyperrefinements of European painting; and finally the intuitive genius of Picasso and the deductive mind of Braque to merge these components

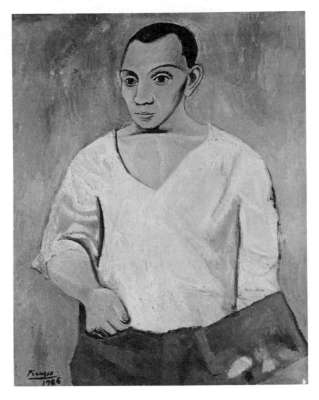

509 Pablo Picasso. *Self-Portrait.* 1906. Oil on canvas, 36 × 28″ (91 × 71 cm). Philadelphia Museum of Art (A. E. Gallatin Collection).

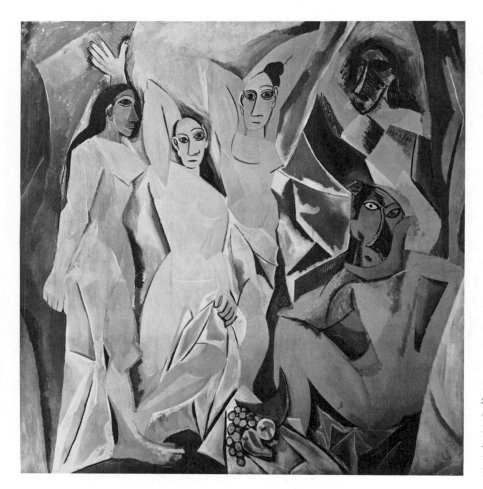

510 Pablo Picasso. *Les Demoiselles d'Avignon.* 1907. Oil on canvas, 8′ × 7′8′′ (2.44 × 2.34 m). Museum of Modern Art, New York (acquired through the Lillie P. Bliss Bequest).

with dashes of several others in their search for new expressive means.

This new expression was soon to have a name, *cubism,* and to be codified into a theory. But for the moment it manifested itself half formed in a large painting by Picasso that, although technically ambiguous, is decisively the beginning point of cubism. A composition of five nude female figures [510], the traditional bathers motif, it was later dubbed *Les Demoiselles d'Avignon* as a jape, and has continued to be called so as a convenience.

Everyone admits that these five *demoiselles* are among the unloveliest females in the history of art, and no one pretends that the picture is an unqualified success in every way, but on the other hand no student of contemporary painting denies its position as a landmark. It is a discordant picture, not only in the way it ruptures, fractures, and dislocates form with a violence that would no doubt have appalled Cézanne,

but in the disharmony of its own parts. On the left the standing figure is hieratic in its formality, posed in a standard attitude of Egyptian and archaic Greek sculpture. But by the time the right side of the picture is reached, this formality has given way to a jagged, swinging, crashing line, and the African mask makes its impact with full force in the grotesque faces. For a few months during the next year, 1908, Picasso went through a "Negro" period, with close parallels to African prototypes.

The developmental period of cubism, 1907–1909, is often called its "Cézanne phase," on the basis of pictures like Braque's *Road near L'Estaque* [511, p. 430], with its combination of geometrical simplification and faceted shapes. But in spirit the picture is anything but Cézannesque. The shapes themselves are bolder and more obvious than Cézanne's, and they have a nervousness, an insistence, a thrust, a harsh, angular movement that exaggerates the

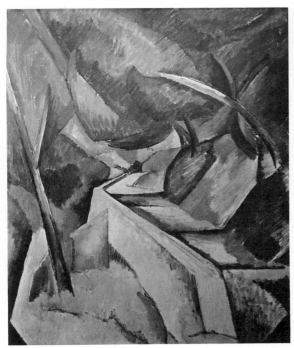

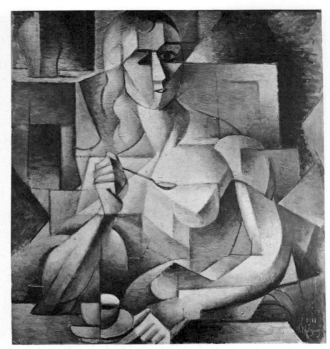

511 Georges Braque. *Road near L'Estaque.* 1908. Oil on canvas, 23¾ × 19¾″ (60 × 50 cm). Museum of Modern Art, New York (anonymous gift).

512 Jean Metzinger. *Tea Time.* 1911. Oil on panel, 29¾ × 27⅜″ (76 × 70 cm). Philadelphia Museum of Art (Louise and Walter Arensberg Collection).

sense of vibrant life typical of a Cézanne landscape but sacrifices the classical order that also permeates Cézanne's world.

Cubism: Analytical Phase

After 1909 and up into 1912 the introduction and development of a complication known as *simultaneity* brings cubism into its own as a reolutionary concept. The idea behind simultaneity is simple enough. The forms in Metzinger's *Tea Time* [512],* which suffers the unfortunate secondary title *Mona Lisa with a Teaspoon,* are broken into large facets or planes. But something else is happening too: in places these planes grow transparent in order to reveal

other planes behind them; they cross and merge with these other planes. At the left a teacup and saucer are divided down their middle by a line on one side of which they are seen head-on while on the other side they are seen from above. Theoretically we know more about the teacup because we see it from two angles at once, which is impossible when a teacup and saucer are represented in conventional perspective, which allows a view from only one angle at a time. Metzinger's teacup demonstrates in an elementary way the device of simultaneity—the simultaneous revelation of more than one aspect of an object in an effort to express the total image. In the case of the teacup the process is simple. Elsewhere in the picture the crossing and merging transparent

*Jean Metzinger (1883–1956) developed certain nuances of style during this period of analytical cubism that give his work a lightsome quality quite opposed to the Spartan analytical diagrams of Braque and Picasso. Yet Metzinger was of a scientific turn of mind. Before discovering a more rewarding pseudoscience in analytical cubism, he had been attracted by the codification and systematic approach of neo-

impressionism. At the end of the period of analytical cubism, he wrote its doctrinal statement, *Du Cubisme,* with his colleague Albert Gleizes (1881–1953). Both Metzinger and Gleizes were among the cubists who insisted on the use of color, while Braque and Picasso were shelving the problem in favor of pure analysis in tans, creams, and grays, perhaps unready to complicate matters by following Cézanne's color theories.

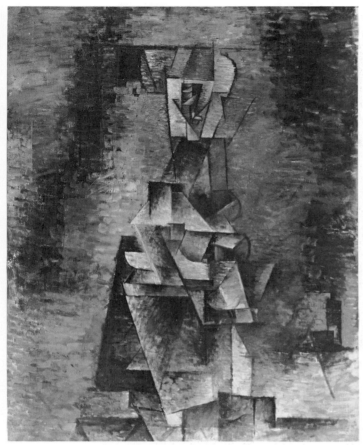

513 Pablo Picasso. *Female Nude*. 1910–1911. Oil on canvas, 38¾ × 20⅜″ (98 × 52 cm). Philadelphia Museum of Art (Louise and Walter Arensberg Collection.

perspective; The fourth dimension is movement in depth and time, or space-time, by the simultaneous presentation of multiple aspects of an object. A new systematic distortion is necessary for this new dimension, since the old one of perspective has been outgrown.

But as the process of analytical cubism was explored, the objects subjected to its elaborations were destroyed. Picasso's *Female Nude* [513] is a fourth-dimensional complication of forms which began, no doubt, as forms similar to those in the upper right figure in *Les Demoiselles d'Avignon*. But as the planes overlap, turn on edge, recede, progress, lie flat, or turn at conflicting angles, the object from which they originated is lost rather than totally revealed. Cubism during these stages of development was also investigated in sculpture. Picasso's *Head of Fernande* [514] is a direct translation of "facet" cubism from painting into three dimen-

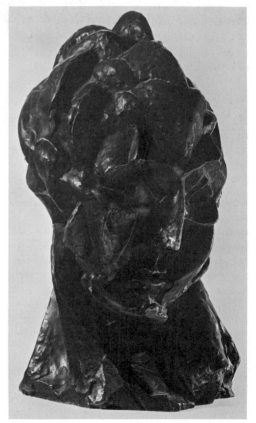

514. Pablo Picasso. *Head of Fernande.* 1909. Bronze, 19¼″ (48.9 cm) high. Art Gallery of Ontario, Toronto.

planes are a more complicated application of the same idea. The left half of the head, if the right half is ignored or covered up, yields a profile. At the same time, it is included in a view of the full face. The argument that we have neither a good profile nor a good full face by usual representational standards is beside the point. The cubist is not interested in usual representational standards. It is as if he were walking around the objects he is analyzing, as one is free to walk around a piece of sculpture for successive views. But he must represent all these views at once.

This is the famous "fourth dimension" in painting. For centuries painters had been satisfied to represent an illusion of three dimensions on a two-dimensional surface by means of the systematic distortion known as perspective. The third dimension in painting is depth by

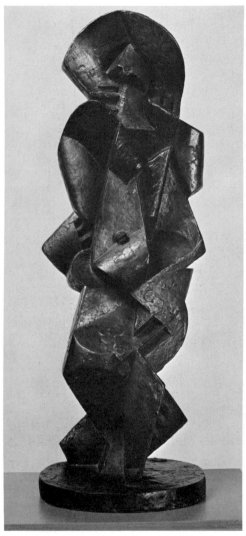

515 Jacques Lipchitz. *Bather III*. 1917. Bronze, 28¼ × 10 × 10¼" (72 × 25 × 26 cm). Art Gallery of Ontario, Toronto (gift of Sam and Ayala Zacks, 1970).

sions, while *Bather III* [515] by Jacques Lipchitz (1891–1973) paradoxically shifts the transparent planes of analytical cubism back into solids.

Occasionally it is still necessary to reassure the layman as to the seriousness of cubist experiments with form, even though these experiments have long since been absorbed into the general experience of the contemporary artist. Historically the importance of the experiments is that they forced one aspect of Cézanne's revolution to a point so extreme that no painter willing to think twice about the expression of form

can ever again be satisfied with its simple imitation in photographic light and shade. Even the most specifically realistic painting today, as employed by painters of any perception, is based on analysis of underlying forms rather than on the imitation of their various surfaces. Theories and history aside, these analytical cubist paintings are aesthetically rewarding in themselves, even if on a somewhat rarefied level. But they soon served their purpose for the cubists, and in 1912 their severities were abandoned for a more relaxed approach called synthetic cubism.

Cubism: Synthetic Phase—Gris

Analytical cubism tended to lose sight of expressive values except by standards too esoteric to mean much to anyone not absorbed in the movement. Also the painter's stylistic individuality had been somewhat fettered. Synthetic cubism turned each painter loose to find his own way within the vast general field of free invention along cubist lines that was now opened up by a new way of conceiving form, while analytical cubism took its proper place as a preliminary exploratory exercise (no matter how complicated, no matter how studded with expressive exceptions). Color returned in force, sometimes related to the natural colors of the formal motifs, sometimes arbitrary. The shapes of objects were used as a basis for playful compositions in every combination and recombination of abstract shapes invented imaginatively, subject to no rule or theory. Picasso and Braque, whose analytical cubist studies had often been all but indistinguishable from one another's, diverged in opposing directions. A third young man who had shared with them in the development of analytical cubism now took his place as the poet of the movement. This was Juan Gris (1887–1927), the pseudonym of José Victoriano González, like Picasso a Spaniard who had put the academic routine behind him in his own country and had come to Paris.

In *Dish of Fruit* [516], a typical Gris still life, it is easy to recognize the general shape of a compote with its base, neck, and bowl and to identify a couple of colored shapes as pieces of fruit. The tabletop and even something like the bowl's shadow, to the right of the base, are also recognizable. The rectangular shape defined by a triple outline in the background might be a repetition of the table form or might have been

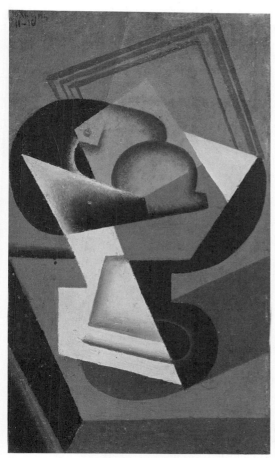

516 Juan Gris. *Dish of Fruit.* 1916. Oil on canvas, 15¾ × 9″ (40 × 23 cm). Philadelphia Museum of Art (A. E. Gallatin Collection).

517 Juan Gris. *The Open Window.* 1917. Oil on panel, 39⅜ × 29⅝″ (100 × 75 cm). Philadelphia Museum of Art (Louise and Walter Arensberg Collection).

suggested by a napkin or doily. Or it could be a picture frame on the wall. No forms need be recognizable in specific detail, but each has been played with inventively and the shapes colored most ornamentally to produce a combination of forms and colors that would not have been reached without the preliminary puzzle-solving of analytical cubism. In *The Open Window* [517] it is possible to see that the window, or what we would call a French door, is opened onto a balcony with a tree beyond it. We can even tell that the long double doors are three-paned. Along the left-hand side of the picture the left door is represented with comparative realism. On the right, the forms are more broken, but a piece of cloth patterned in large dots and gathered across the lowest pane is immediately recognizable. The picture's mood is gentle and quiet, retaining as it does the con-

notation of a pleasant room with a window opening out to trees and composed as it is in simple shapes dominated by soft blues, grays, and modified whites.

In synthetic cubism shapes and colors may be determined by the painter's sensitivity alone; thus painting has returned to the old basis, the painter's reaction to the world and his interpretation of it in colored forms. But it has returned with a new vocabulary, a vocabulary more flexible than analytical cubism had promised. Synthetic cubism leaves the painter unfettered by anything except the limitations of his own inventive ingenuity. Although all cubist paintings may look alike to a novice and the idea of any one form of cubism being more poetic than another may seem absurd, acquaintance reveals the poetic quality of a Gris beneath its surface similarity to other cubist paintings. Gris always

insisted that a high degree of recognizability should be retained in a painting. In the hands of Picasso and Braque, analytical cubism had abandoned the appeal of subject, the response to the world, which had been the basis of impressionism and had been continued, with variations, in Cézanne, Gauguin, van Gogh, and Seurat. Cubist subject matter had been reduced to a small list of motifs closely connected with the studio or with the café as an adjunct of the studio, such motifs as tables with bowls of fruit and glasses of wine, a few musical instruments, and posed models. But Gris frequently invested these motifs with more personal associations. *The Open Window* is one of several recollections of his quarters on the Rue Ravignan where a group of writers and painters inhabited a disreputable old building called the Bateau-Lavoir. Picasso lived there for a while. For the avant-garde in general, the Bateau-Lavoir became a kind of club, taking its place in the tradition of Courbet's Brasserie des Martyrs and the impressionists' Café Guerbois. But the associative interest of *The Open Window* is not enough to account for the poetic feeling that permeates it. The color is gentler, the forms more placid, their combinations more serene than in other cubist painting; with these abstract elements rather than with any specifically evocative images Gris creates a cubist poetry. He is cubism's Corot.

A Cubist Variant: Léger

Cubism's unexpected flexibility, once it was freed by the personalism of its synthetic phase, produced one of its brightest variants in the art of Fernand Léger (1881–1955). After a spell as an architect's apprentice and a brief foray into the Academy's school, Léger discovered Cézanne and then met Braque and Picasso in 1910. Under their influence he worked for a while in a complicated variation of facet cubism, as in *Essai pour Trois Portraits* [518], an early prophecy of the driving, pistonlike energies that were to fascinate him later on. But Léger was always a more direct and less complicated person than his colleagues, and he fretted under the intellectualism of formal analysis. By 1913 he had resolved the shifting, overlapping complexities of analytical cubism into a new manner where cubes and cylinders began to appear more solidly and more boldly in brighter colors. *Contrast of Forms* [519], painted in 1913, is typical of

518 Fernand Léger. *Essai pour Trois Portraits.* 1910–1911. Oil on canvas, 6′4¾″ × 3′9⅞″ (1.95 × 1.17 m). Milwaukee Art Center.

a group where Léger combines strong, simple shapes in pure primary colors—red, blue, and yellow—with a great deal of white and strong defining lines in black. In spite of the crowding of the forms, which jostle and shoulder one another over the whole area of the canvas, a comparison of *Contrast of Forms* with *Essai* should show not only that *Contrast of Forms* is a logical continuation of the earlier picture but that it is a step in the direction of clarity and specific definition.

Even so, Léger is still feeling his way, and it was not until after World War I (during which he was mobilized and stopped painting) that he found what he wanted to do. While Gris employed cubism pensively, Léger adapted it to the clangorous mechanized life of the city. On the theory that art should take on a mechanical character in a mechanical age, he developed a style in which every form, if not actually derived from a mechanical motif, took on the character

of a gear, a flywheel, a piston, or some other machine part. By his own statement his daily contact with machines during the war might account for his new fascination with a mechanistic art, and his wartime "contact with violent and crude reality" completed his divorce from the hyperrefinements of analytical cubism.

The City [520], a large canvas, is the climax of his new style and probably the key picture in his total work. Some of the most easily identified motifs are girders, poles, puffs of smoke, and in the center a flight of steps reduced to light and dark bands behind the mechanized human figures who descend them. The colors are pure and bright, even garish and strident, dominated by several brilliant patches of lemon yellow and red cut through from top to bottom by a pole of a rosy violet color. For the most

519 Fernand Léger. *Contrast of Forms.* 1913. Oil on canvas, 4'3⅜" × 3'2⅜" (1.3 × .97 m). Philadelphia Museum of Art (Louise and Walter Arensberg Collection).

520 Fernand Léger. *The City.* 1919. Oil on canvas, 7'7" × 9'8½" (2.31 × 2.96 m). Philadelphia Museum of Art (A. E. Gallatin Collection).

part the forms are unmodeled, exceptions being the human figures, the puffs of smoke, and the pole, which are modeled into smooth spheres and cylinders.

In many ways the forms of *The City* are so obvious that they seem too easy. Subtleties must not be read into Léger; rather, a hearty vigor, a kind of primitivism. He is the most easily imitated of painters, and he has suffered from a blight of fourth-rate talents who have adopted his formula and revealed its limitations without redeeming them by his strength and enthusiasm. Léger's art is meaningless if it is distorted by a search for intellectualities that do not exist in it. His anti-intellectualism is usually refreshing; at other times it palls, and one is relieved to get away from his insistent colors, his obvious forms, and his eventually monotonous conventionalization, and get back to paintings offering less surface excitement and more contemplative depth. (Of course this may be a matter of personal taste; it may be just as true that it is a relief to get away from paintings full of subtleties and enjoy Léger's single-directedness.)

Between 1931 and 1939 Léger made three visits to the United States. He was rapturous over the spectacle of energy and extroverted activity the country presented to him. He loved the skyscrapers, jazz, the noise, the lack of inhibitions (as it seemed to him), and above all the bustle and movement of New York and Chicago. The forms he had composed in *The City* had been static; now he set out to create compositions of movement with flowing lines everywhere. In a series of paintings of swimmers or divers, for which he had already found the germ in observing beach crowds in Marseilles just before sailing, he summarized his new preoccupation with contrasts of movement. Yet he reduced his compositions to rigorously controlled, ultimately balanced rhythms not at all hectic or clamorous, as is apparent in *Divers on Yellow Background* [521].

Because his work is precise and held tightly under control, Léger's "classicism" is often referred to, and in one of the most ambitious of his very late works, *Leisure* [522], he accepts the nomination for a post in the classical tradition of French painting. One of the figures holds a sheet of paper bearing the inscription "Hom-

521 Fernand Léger. *Divers on Yellow Background.* 1941. Oil on canvas, 6'3¾" × 7'3½" (1.92 × 2.22 m). Art Institute of Chicago (gift of Mr. and Mrs. Maurice E. Culberg).

mage à Louis David." The inscription may be half mocking, but it is also at least half serious in this extraordinarily synthetic picture. To capture its flavor one must understand not only its connection with David's *The Sabines* [10] but also with modern primitive paintings. In America, Léger professed the most enthusiastic admiration for the art of Edward Hicks, and he owed his greatest debt of all to Douanier Rousseau. The ingredients that went into the fabrication of *Leisure,* then, were of bizarre diversity: the classicism of David, the mechanistic character of the modern world, the innocence of an American Quaker minister (Hicks), and the naïve-sophisticated style of an eccentric customs collector. Actually, of course, Léger is only a little classical, only speciously mechanistic, and not very innocent. He is a painter with an emphatically personal style in which native vigor and a curious affectation compete with one another—and frequently come to terms. On these occasions Léger is a fine artist; on most others, he is at least a fine designer

Cubism: Some Subdivisions

With the liberation of cubist forms into the field of general expression, it was inevitable that the ranks of the cubists, which had grown like weeds, should break into smaller groups with their own theories. For a while one ism shouldered another in the enthusiasm for further experiment and refinements and hope of discovery. In 1912, a year when cubism shot out in a dozen directions, Robert Delaunay (1885–1941) formulated "orphism," or color orchestration, in which he tried to free cubism from the dun hues that had affected it during the analytical period and from its later dependence on subject matter. As an orphist he painted a series of "window compositions" [523, p. 438] in planes something like overlapping sheets of bright colored glass. Although he did not follow up the directions these paintings set, other painters soon did so.

Francis Picabia (1879–1953) was also involved in orphism, but at the same time he

523 Robert Delaunay. *Windows.* 1912. Oil on canvas, 13½ × 35″ (34 × 89 cm). Philadelphia Museum of Art (A. E. Gallatin Collection).

thought that cubism could be a vehicle for the expression of ideas. He had begun as an imitator of Sisley and spent his life enthusiastically investigating every new ism that turned up without going very deeply into any of them. The painting he called *Physical Culture* [524] is already tainted with Picabia's weakness for impertinence that later led him to use such titles as *You'll Never Sell It, I Don't Want to Paint Any More,* and *What Do You Call That?* What might be called "dynamic cubism," apparent in *Physical Culture,* is most vivaciously present in Marcel Duchamp's (1887–1968) celebrated *Nude Descending a Staircase* [525]. It is a painting of considerable historical importance since it became the key exhibit of the 1913 Armory Show in New York. Upon their first exposure to radical modernism, Americans reacted with the vehemence of Frenchmen when confronted with a work of art that offended them. Guards had to protect the most controversial paintings from attack by an enraged public. This at least was true in New York and later in Chicago; Bostoners retained their aplomb.

One unsympathetic critic labeled *Nude Descending a Staircase* once and for all "an explosion in a shingle factory." The jibe was perceptive, up to a point. The figure is indeed shattered into shinglelike planes that merge and overlap in a pattern of great energy. But the jibe falls short in that the shattered figure is not chaotic. Contrarily, it is reassembled into a pattern of great order and vivacity, more expressive of bright descending movement than an imitative painting of a nude descending a staircase could be. But for a public that still admired

524 Francis Picabia. *Physical Culture.* 1913. Oil on canvas, 35¼ × 46″ (90 × 117 cm). Philadelphia Museum of Art (Louise and Walter Arensberg Collection).

Burne-Jones' *The Golden Stairs* [526], showing eighteen young women in pretty costumes descending a staircase in a series of graceful attitudes, a picture of one nude young woman descending a staircase in many more than eighteen attitudes was incomprehensible and infuriating. The fact that after half a century *Nude Descending* has a persistent capacity to interest the sympathetic and irritate the antagonistic, while other sensational novelties have flared up and faded away by the dozen, is as good a proof as another that it is much more

525 Marcel Duchamp. *Nude Descending a Staircase (No. 2)*. 1912. Oil on canvas, 4'10'' × 2'11'' (1.47 × .89 m). Philadelphia Museum of Art (Louise and Walter Arensberg Collection).

526 Edward Burne-Jones. *The Golden Stairs.* 1880. Oil on canvas, 8'10'' × 3'10'' (2.69 × 1.17 m). Tate Gallery, London.

than a well-timed tour de force. It is an enduring landmark and a work of art with extensions beyond cubism. One of these is its deliberately provocative title which, like Picabia's nonsensical ones, is allied to two other movements, dada and surrealism.

Duchamp's painter brother Gaston (1875–1963), who adopted the pseudonym Jacques Villon, worked in a personal variation on cubism, always rather quiet and elegant, even-

tually developing lucent configurations of great distinction. In the history of cubism he has a special place as the head of a group who met at his studio in the early days for discussion and theorizing. In 1912 they named themselves the Section d'Or after the mathematical formula for proportional harmonies that has already been commented on in connection with neoimpressionism. The Section d'Or organized a huge exhibition, and all the men mentioned here—

Metzinger and Gleizes, Gris and Léger, Delaunay and Picabia and Marcel Duchamp—took part in it, as did Roger de la Fresnaye (1885–1925), Louis Marcoussis (1883–1941), André Lhote (1885–1962), and many others. As a climactic point in cubism's coming of age it summarized the forces at work before their dissemination with such profound effect upon the general field of painting. Picasso and Braque alone, the two major figures in cubism's development and the two painters who subsequently drew most significantly upon it, were not represented. The immediate reason was that the exhibition was held in a commercial gallery where for contractual reasons they could not show. Psychologically their absence was appropriate, for while it is possible to think of the men who did exhibit as being, first of all, cubists, it is impossible not to think of Braque and Picasso as being, first of all, painters. But before they can be further discussed here, a little attention must be given to a movement called *futurism*.

Futurism

Futurism was a parenthetical Italian movement that promised for a moment to become an important one but ended by draining off into cubism. The kinetic factor so apparent in *Nude Descending a Staircase* was basic in futurism's program. *Dynamism* was their favorite word.

Futurism began as a literary movement in 1909 after cubism was well under way. An Italian litterateur, Filippo Tommaso Marinetti, decided that it was the obligation of the modern creative mind to celebrate such factors in modern life as its speed and aggressiveness. He advocated tearing down all institutions dedicated to the preservation of the past such as museums, libraries, and schools, and issued a declamatory manifesto as a call to arms. No museums, libraries, or schools were lost. (This happened in Paris, although Marinetti was Italian.) Marinetti's literary rebellion was taken up by a group of painters who were at the moment working within the general confines of neo-impressionism, and one of them, Umberto Boccioni (1882–1916), followed Marinetti's ideas in a similar manifesto exhorting the young painters of Italy to arise to the fray. The manifesto was also signed by Luigi Russolo (1885–1947), Giacomo Balla (1871–1958), Carlo Carrà (1881–1966), and Gino Severini

(1883–1966) and was followed by a succession of sequel manifestos. They were distributed by the thousands, sometimes by such stunts as scattering from Italian belltowers. There was always a strong element of public theatricalism in futurist behavior, and it is difficult to read their proclamations without an uncomfortable feeling that the theories were formulated with more attention to shock value than to convictions sincerely held. Urgent and literary in tone, they are composed of such phrases as ". . . fight relentlessly against the fanatical, irresponsible, and snobbish religion of the past, which is nourished by the baneful existence of museums . . . groveling admiration for old canvases . . . criminal disdain for everything young, new, and pulsating with life . . . tyranny of the words *harmony* and *good taste*." Artists were admonished to "glorify the life of today, unceasingly and violently transformed by victorious science." Instead of the religious atmosphere that "weighed upon the souls" of their ancestors, they should draw inspiration from the liners, battleships, airplanes, submarines, and railroads that made an "iron network of speed enveloping the earth."

One way to express motion was to follow Boccioni's statement that "a galloping horse has not four legs; it has twenty." That such was also the case with dogs was demonstrated by Balla in his *Dynamism of a Dog on a Leash* [527].

The painters planned a Paris exhibition as an opening gun outside Italy after a sensational debut in Milan, but when they compared their work, full of neoimpressionist overtones, with what Braque and Picasso were doing—this was in 1910—they saw that for all their rampant modernism they were already a step behind. They performed a tactical retreat and the exhibition did not materialize until 1912, when analytical cubism had just about run its course and been assimilated as part of futurist theory.

The simple multiple-exposure approach of *Dog on a Leash* did not quite fulfill the expression of "universal dynamism," "dynamic sensation itself," "plastic dynamism" or "the translation of objects according to the *lines of force* which characterize them." The cubist idea of simultaneity was adapted to "put the spectator at the center of the picture," since the various sensations converging upon him simultaneously from every side involved the same principle as analytical cubism's multiple simultaneous vision. But the futurists' adaptation of the idea

527 Giacomo Balla. *Dynamism of a Dog on a Leash*. 1912. Oil on canvas, 35⅜ × 43¼″ (90 × 110 cm). Albright-Knox Art Gallery, Buffalo, N.Y. (bequest of A. Conger Goodyear to George F. Goodyear, life interest).

also involved strong expressive color, and their shattered forms were often organized on a skeleton of strong directional lines, as in Russolo's *Dynamism of an Automobile* [528]. In Severini's *Dynamic Hieroglyphic of the Bal Tabarin* [529, p. 442] the spectator is put at the center of that famous pleasure spot and is surrounded by choppy, whirling forms in extremely cheerful colors further enlivened by a scattering of real sequins.

Surprisingly, futurism's contribution may end up in the field of sculpture, where it would seem least likely to succeed. Boccioni's *Unique Forms of Continuity in Space* [530, p. 443] is a large, arresting bronze in which the forms seem to have been shaped by rushing air, air whose currents we can almost feel extending beyond the fluttering shapes of the metal just as they penetrate into it in other places. The dynamic "lines of force" we have just seen as severely angular ones in Russolo's interpretation of a moving automobile now weave and twist, materializing as solids. A striding figure is still discernible as the motif for the composition, and if *Unique Forms of Continuity in Space* is innova-

528 Luigi Russolo. *Dynamism of an Automobile*. 1913. Oil on canvas, 3′5½″ × 4′7″ (1.05 × 1.4 m). Musée National d'Art Moderne, Paris.

529 Gino Severini. *Dynamic Hieroglyphic of the Bal Tabarin.* 1912. Oil on canvas with sequins, 5'3⅝" × 5'1½" (1.62 × 1.56 m). Museum of Modern Art, New York (acquired through the Lillie P. Bliss Bequest).

tional, it is also linked firmly to the tradition of baroque sculpture such as Bernini's *Apollo and Daphne* [531], where flapping draperies, wind-filled hair, and extended arms and legs fly out into surrounding space and also receive space into the hollows and voids carved into the marble. The difference is that Bernini is most apparently creating idealized realistic forms while the futurist is most apparently creating abstract ones. But both sculptors are creating compositions where solid form and the forms of space merge and interlock.

World War I wrote *finis* to futurism as a potentially significant organized movement although an army of small painters continued to go through its paces into the 1930s. To postwar Europe, futurism's theoretical advocation of destruction and violence was less attractive after four years of experience with the real thing.

Diehard futurists continued to study "dynamism" in more and more abstract form, yet futurism somehow never supplied nourishment for growth as cubism did. In retrospect its brief flourishing is revealed as a forced growth—all foliage and no roots. Of the signers of the original manifesto, Balla alone continued to develop, rather thinly, in the direction he had helped to set. Severini tried a few war motifs in 1915, including an *Armored Train,* but soon turned to doing doves, fruit, and other happy and nondynamic subjects in an adaptation of synthetic cubism that was especially popular with interior decorators. Carrà joined a dream-world school of "metaphysical" painting, which will be discussed in due time. We may now return to the postanalytical careers of Braque and Picasso to discover cubism relenting in its severity and enlarging its scope of expression.

530 Umberto Boccioni. *Unique Forms of Continuity in Space*. 1913. Bronze (cast 1931); height 43⅞″ (111 cm). Museum of Modern Art, New York (acquired through the Lillie P. Bliss Bequest).

531 Gianlorenzo Bernini. *Apollo and Daphne*. 1622–1625. Marble, life-size. Galleria Borghese, Rome.

Braque

The two major analytical cubists, Braque and Picasso, as has been said, were briefly allied so closely that their work is distinguishable from one another's only by fine points. Picasso's *Man with Violin* [532, p. 444] and Braque's *Man with a Guitar* [533, p. 444], both painted in 1911 at the climax of analytical cubism, are evidence enough. Yet even here a difference appears when the two paintings are compared within the confines of analytical cubism instead of within the context of painting in general. The Picasso shifts and vibrates within its geometrical framework, the Braque is more static, more self-contained; it is as if the multitude of planes in the Picasso have expanded to the limits of the structure they compose, while those in the Braque have contracted into a new stability.

The difference between the two painters indicated here will be widened as they develop in their own directions. Picasso will become the romantic of the movement—all energy, fire, restlessness, invention, emotion. Braque will develop into its classical master—controlled, reflective, harmonious, working toward an idea of perfection within limits as opposed to the romantic yearning for limitless expression.

With analytical cubism behind him, Braque's first departure was to restore the inherently ornamental character of the same objects that had figured in his analytical compositions—bowls of fruit, tables, goblets, compotes, musical instruments. The origin of *collage,* which is the making of pictures or compositions by pasting together bits of paper, cloth, and the like, is not certain. Like cubism it seems to have appeared spontaneously from several sources

532 Pablo Picasso. *Man with Violin.* 1911. Oil on canvas, 39½ × 28⅞″ (100 × 73 cm). Philadelphia Museum of Art (Louise and Walter Arensberg Collection).

533 Georges Braque. *Man with a Guitar.* 1911. Oil on canvas, 45¾ × 31⅞″ (116 × 81 cm). Museum of Modern Art, New York (acquired through the Lillie P. Bliss Bequest).

534 Georges Braque. *Musical Forms (Guitar and Clarinet).* 1918. Collage, 30⅜ × 37⅜″ (77 × 95 cm). Philadelphia Museum of Art (Louise and Walter Arensberg Collection).

at once, but Braque certainly had a great deal to do with its origin and he used it with particular felicity. In *Musical Forms (Guitar and Clarinet)* [534], the corrugated-cardboard clarinet is the most unexpected element, but other areas are also papers of different textures. The whites are a ribbed drawing paper, the largest halftone area is a brown wrapping paper, and the black upon close examination is a paper printed with an imitation of a very fine wood grain. The upper part of the guitar form is the kind of paper used to cover pasteboard cigar boxes, again simulating wood grain, and again a printed paper, not a simulation by the painter.

The rectangles at lower right and far-left center are printed with a slightly raised netlike pattern. With a few lines in crayon and a background painted blue-gray, that is the scheme. The col-

One value of collage is that it opens our eyes to colors and textures we have ignored because they are commonplace. Behind the origin of collage, too, there may be ultimately the rejection of the old academic idea that painting must display technical skill of a conventional kind. By fabricating "pictures" from odds and ends of worthless material the artist makes the ultimate denial of the validity of academic technique as an end in itself. But for Braque the value of collage was in experiments with texture, an introduction to an element that continued to preoccupy him in other ways.

Surface texture became an integral decorative factor in his painting and from this time forward he cultivated it, sometimes depending only on the paint's own thinness or thickness, sometimes roughening it with mixtures of sand or other grainy matter, sometimes scratching or pressing textures into it, but always incorporating texture as part of his organization of form, line, and color.

By the 1920s Braque was master of a personal cubist idiom combining spatial play with exquisitely integrated shapes [535]. During the mid-1920s he began to use the human figure, usually a female nude, in addition to tables and composes of fruit and musical instruments.

Woman with a Mandolin [536], a synthesis of his work up until the middle 1930s, is tapestry-like in its textural richness. Braque's color here as elsewhere is indescribable, partly because no color is describable to much effect, but largely because he is the most individual decorative colorist of his generation. No color is pure; greens are olives, sages, and occasional lime greens. Modified purples are juxtaposed with citrons and blacks. When reds occur they occur suddenly and spectacularly, but also in off-shades that unify them with Braque's special family of colors—colors that have become a stock in trade for interior decorator.

535 Georges Braque. *The Round Table.* 1929. Oil on canvas, 4'10" × 3'9" (1.47 × 1.14 m). Phillips Collection, Washington, D.C.

536 Georges Braque. *Woman with a Mandolin.* 1937. Oil on canvas, 4'3¼" × 3'2¼" (1.3 × .97 m). Museum of Modern Art, New York (Mrs. Simon Guggenheim Fund).

It is time to insert a reminder that before he was a cubist Braque was briefly a member of the fauve group. And of all painters, he alone made a balanced fusion of fauvist principles of color with cubist ideas of form. His *Woman with a Mandolin* may eventually stand as the richest summary, within the boundaries of single pictures, of the abstract style of the first half of the twentieth century. If every painting by Picasso, every painting by Matisse, and every painting by Braque were gathered together and all but a single painting had to be destroyed, Braque's *Woman with a Mandolin* could not summarize the total, but it might come closest of them all to being the representative example.

Picasso: Cubist and Classical Variations

Picasso was certainly the most fecund painter who ever lived. In sheer quantity his work is fantastic, his invention phenomenal, his range staggering. From his thousands of paintings, prints, and drawings it would be possible to cull several groups of work that would be creditable as the lifeworks of several painters of varying temperaments. And it would be simple to divide his total work between two classifications as the work of two tremendously productive artists, one of them a man of tender sentiments, the other a man appalled by life's terribleness and releasing his fury against it in cathartic images of horror, brutishness, and terror.

Picasso's abrupt changes of style, his sudden terminations and redirections, his harking back to principles he seemed to have exhausted years before to revive them in more inventive forms, the sudden appearance from time to time of individual paintings that seem isolated experiments and may remain so for years, lying fallow until they are suddenly continued in a whole group of paintings—all this variation, turning, and shifting would be vacillation or chaos if it were not unified by the presence of the single force which was Picasso himself. He had a headlong vigor, an all-encompassing vitality, that refused to accept any achievement as final in the expression of a world so contradictory that experience of it must well forth in image after image to record his multitudinous response to its inexhaustible excitements. No single style of image could suffice in his search for an ultimate summation that he never found.

We have already seen him as a young man influenced by Toulouse-Lautrec, then synthesizing a more individual style in his speciously pathetic images of the blue period, next relenting with the gentle harlequins, adolescents, and performers of the "circus" period, finally merging into the graceful classical echoes of the rose period—then abruptly creating *Les Demoiselles d'Avignon* and going into cubism.

Immediately after the exhaustion of analytical cubism in 1912, Picasso made some of the same adjustments we have seen in Braque, including play with collage. For several years thereafter he explored synthetic cubism in a period of creative eruption. The most inventive of painters exceeded himself in demonstrating the area over which he could range with ebullience, assurance, excitement, and sometimes profundity. It is necessary in understanding Picasso to remember this range. With Picasso, each picture must be approached individually. After one of his most profound statements he may create a piece of pure legerdemain.

In his celebrated and extremely complex *Painter and Model* [537], a painter (right) works from a model (left) and both are abstracted according to free applications of cubist ideas. But the shattered and distorted head of the model appears reassembled on the painter's canvas in a clear profile, the only realistically identifiable element in the composition. This turnabout, a tour-de-force variation on the picture-within-a-picture theme, is clever enough to have been borrowed by cartoonists in popular magazines. But it is also a comment on the nature of cubist vision, and beyond that an informal philosophical reflection on the relationship of the painter's art to the visible world.

Even while he was reaching the cubist culmination, Picasso was working on a second group of drawings and paintings of an opposite character, a new version of the monumental classical figure type so dear to the academicians. The opposite of cubistic, Picasso's new figures were solid and unviolated as mass [538]. Exaggerated heaviness, overlarge hands, extreme simplification into geometrical masses, add to their ponderous, indissoluble unity, a reaction against the disintegration of solids in cubism. In these pictures Picasso returned to the weightiness and definition of the portrait of *Gertrude Stein* [508], but as usual he was not so much returning as resurrecting and transfiguring. His art is a

537 Pablo Picasso. *Painter and Model.* 1928. Oil on canvas, 4'3⅛" × 5'4¼" (1.3 × 1.63 m). Museum of Modern Art, New York (Sidney and Harriet Janis Collection).

538 Pablo Picasso. *The Bather.* 1922. Oil on panel, 7½ × 5½" (19 × 14 cm). Wadsworth Atheneum, Hartford, Conn. (Ella Gallup Sumner and Mary Catlin Sumner Collection).

constant series of transmutations of the forms of one period into the forms of another. Among the sudden brilliant variations in the classical period is *Woman in White* [539, p. 448], where the ponderousness is ameliorated by the vivacity of the technique. The picture is painted in thin veils of pigment with contrasting heavily loaded lights (particularly in the face) and quick, decisive lines to define the features, all capped by the delicate calligraphic indications of the hair, suggesting Oriental painting and completing an image of great repose, alertly alive

The next years include a cycle of paintings stemming from cubism but involving sweeping curves and circles, often described in heavy black lines enclosing bright glassy colors. *Girl before a Mirror* [540, p. 448] of 1932 has become a standard example of this "stained glass" manner. Cubist ideas of simultaneity are brought back to their earliest and simplest devices, as in the combination profile and full face of the girl, but the invention is free, subject to no restrictions cubist or otherwise in the creation of scintillating patterns. Like most of Picasso's major canvases, *Girl before a Mirror* has

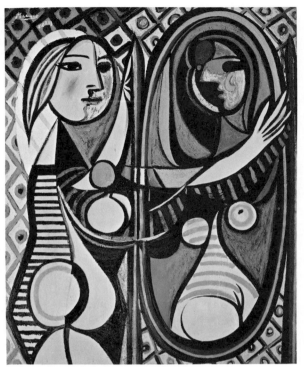

539 Pablo Picasso. *Woman in White.* 1923. Oil on canvas, 39 × 31½″ (99 × 80 cm). Metropolitan Museum of Art, New York (Rogers Fund, 1951, acquired from Museum of Modern Art, Lillie P. Bliss Collection).

540 Pablo Picasso. *Girl before a Mirror.* 1932. Oil on canvas, 5′4″ × 4′3¼″ (1.63 × 1.3 m). Museum of Modern Art, New York (gift of Mrs. Simon Guggenheim).

been the subject of elaborate psychoanalytical interpretations. The full rounded or globular forms of the figure, their unity with the long rounded forms of the mirror, or pier glass, the simultaneous identification and transformation of figure and reflection, the suggestion of interior as well as exterior anatomical forms—all are rich material for analysis and could be interpreted in any one of a dozen ways by a dozen schools of psychologists. As a purely visual spectacle, *Girl before a Mirror* is one of the most vibrant of Picasso's works. Its combination of almost savage force with the extremest sophistication is frequent in Picasso's work from now on.

Picasso: « Minotauromachia » and « Guernica »

Shortly after *Girl before a Mirror,* a new theme, ominous and violent, appears and soon dominates Picasso's conceptions, the double theme of the bullfight, which is a ceremony of death,

and the Minotaur, that monster half bull and half man who in Greek legend devoured his annual tribute of seven youths and seven maidens delivered into his labyrinth by the Athenians. The violent theme coincides with a disturbed period in Picasso's life and culminates in one of his most elaborate works, a large etching full of personal symbols, *Minotauromachia* [541]. The symbolism of the various figures may or may not have been explicit in Picasso's mind, but in a general way it is apparent without a key. The theme is first of all a conflict between good and evil, between innocence and corruption, between life and death. On the right the Minotaur with its powerful male human body and its grotesque beast's head advances with the sword of a bullfighter. A female figure in matador's costume lies dead across the back of a terrified horse, a reference of course to the pitiful nags who are sacrificed to the horns of the bull in the early stages of a bullfight. But at the left a little girl holds a bunch of flowers—it might be the one offered us years before by the *Boy with*

Bouquet [505]—and holds a gleaming light, serene in her confidence of its power against the Minotaur, who shields himself from it—or is about to extinguish it. The little girl wears a tam-o'-shanter and stands as primly as a child in a storybook illustration. Behind her a male figure suggestive of Christ ascends a ladder. The conflict is witnessed by a pair of young women on a balcony where a dove perches. On one side the scene takes place against a background of the wall of the house, on the other against a deep stretch of sea where a tiny sailboat appears like an afterthought. One may make of these symbols whatever explicit interpretation seems necessary, but beyond a certain point explicit interpretation is superfluous. The pictorial images evoke emotional associations without identifying tags.

Minotauromachia served as prototype for an explosive picture that now appears: Picasso's most deeply felt, most emotionalized, most vehement painting, his masterpiece if a single one must be chosen from so many candidates—*Guernica* [542, p. 450].

In April 1937 the ancient and holy city of Guernica in northern Spain was attacked by German bombers supporting General Francisco Franco in the Spanish Civil War. Guernica was not particularly a strategic target; its destruction was primarily a test run, the first practical application of the military theory of saturation bombing, a rehearsal for World War II. Picasso's outrage as a Spaniard and as a human being produced *Guernica* in a matter of weeks. It is a large canvas—more than twenty-five feet long—painted entirely in blacks, whites, and grays. Distortions take on a new horribleness; there is a blatant and tragic ugliness to the human creatures who shriek, howl, and die. A bomb has fallen into the courtyard or barn of a farmhouse. A horse screams in the center of the composition. A bull, symbol of violence, rises triumphant at the left. The large area—almost 300 square feet—is organized on one of the oldest schemes in Western art: it is essentially a triptych on the formula of a Renaissance altarpiece with a central portion and two folding wings. The two winglike side elements, which

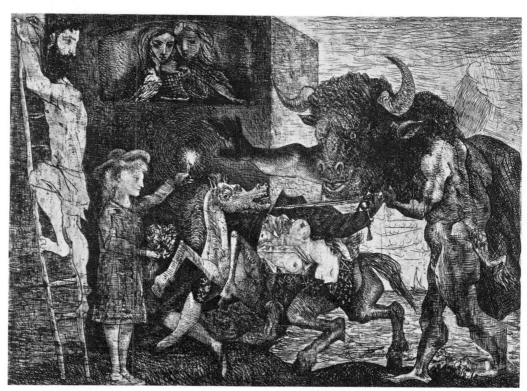

541 Pablo Picasso. *Minotauromachia.* 1935. Etching, 19½ × 27⅜″ (50 × 70 cm). Philadelphia Museum of Art (gift of Henry P. McIlhenny).

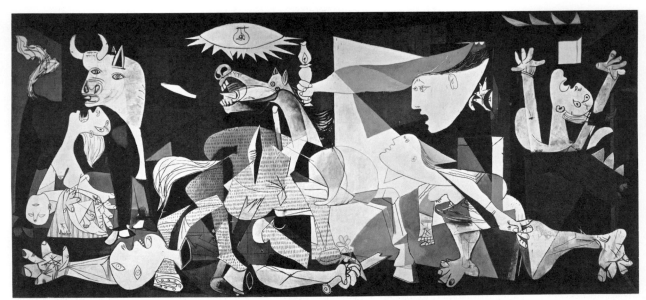

542 Pablo Picasso. *Guernica.* 1937. Oil on canvas, 11'5½'' × 25'5¾'' (3.49 × 7.77 m). On extended loan to The Museum of Modern Art, New York, from the artist's estate.

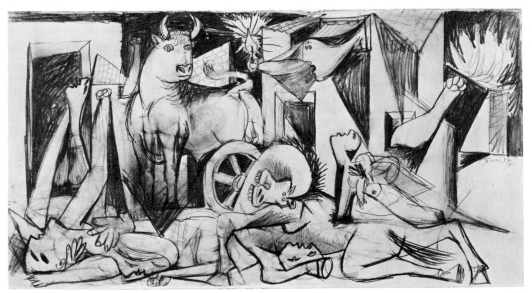

543 Pablo Picasso. *Composition Study (Guernica* study). 1937. Pencil on white paper, 9½ × 17⅞'' (24 × 45 cm). On extended loan to The Museum of Modern Art, New York, from the artist's estate.

in an altarpiece would have been occupied by flanking saints, show on one side a mother who screeches as she holds the body of her child and on the other a woman who falls through the floor of a burning building. The triangular central motif, which in an altarpiece might have built up to a madonna enthroned among adoring saints, is packed with mangled human and animal forms including a symbolical severed arm and hand still grasping a broken sword. Comparison of the completed picture with a preliminary composition study [543] shows that Picasso built the central triangular mass and flanked it with the two "wings" by reorganizing

544 Pablo Picasso. *Weeping Head with Handkerchief* (Postscript after *Guernica*). 1937. Oil and ink on canvas, 21⅜ × 18⅜″ (55 × 46 cm). On extended loan to The Museum of Modern Art, New York, from the artist's estate.

painted with gaiety, brightness, and opulence. Following Matisse's death late in 1954, there was a spurt of Matisselike Picassos in bright flat colors with fauvist echoes that could be interpreted as a form of tribute to a worthy antagonist in an undeclared war in which, happily, both opponents were victors.

The Nonobjective Conclusion

The cubists are abstract painters because, by the dictionary definition, their compositions are "creations suggested by concrete objects or organic figures which are transformed by the artist into nonrepresentational designs with recognizable elements." The term *nonobjective* (or, sometimes, *nonfigurative*) has been coined to distinguish this kind of abstraction, with its partial departure from representation, from total abstraction where representational elements are entirely eliminated.

When analytical cubism abstracted concrete objects to the point where only fragmentary elements were recognizable, the nonobjective conclusion to the process of abstraction that had begun with Cézanne was indicated. If the object had virtually disappeared, to such an extent that the aesthetic and psychological satisfactions of painting were to be found in planes as planes, rather than as parts of objects, why bother with the objects as a point of departure? Not only why bother, but why tolerate any vestigial remains?

We have already seen how synthetic cubism responded to this question. Instead of eliminating the subject it returned to it, and Picasso even developed a symbolical and emotionalized art where the recognizability of the objects was necessary to an understanding of the picture. *Guernica* would certainly not make the sense it does if the anguished horse and the ravished and brutalized human beings were not recognizable as the victims of a frightful social crime.

But certain other painters rejected subject entirely for pure abstraction—for nonobjectivity. We have seen that Kandinsky painted his first altogether nonrepresentational composition in 1910—a record. Within the next few years a Russian cubist named Kasimir Malevich (1878–1935) made the transition from abstract to nonobjective geometrical painting in a single jump of even more spectacular decisiveness, probably after a study of Kandinsky's theories.

a more chaotic scheme composed of the same vocabulary of elements.

Some of the impact of *Guernica* comes from the frightening combination of the ludicrous and the grotesque with the tragic. The eyes askew in heads, the hands and feet with swollen fingers and toes, like hideous mutations—all these monstrous deformities, all the ugliness, are reminders that death by the violence of war is abominable and obscene. Picasso's drawings for *Guernica* include some of the most ghastly images in the history of horror and fantasy [544].

After *Guernica* Picasso kept varying his style with elements of the grotesque and the horrible persisting. Yet in the middle of nightmarish grotesqueries there will appear a drawing or a small painting recalling the tenderness of the early acrobats, harlequins, and boys leading horses, and in his last few years Picasso often

Malevich exhibited a black square placed neatly on a white ground (the black square was painstakingly filled in with pencil) as a demonstration of his theory that art must leave behind all dependence on motif. The square represented nothing at all, was an abstraction of no concrete object. It was simply a geometrical area of black against a geometrical area of white, differing from Kandinsky's painting in that it "expressed" nothing. *Suprematism* was the name Malevich gave his new theory, which limited the painter's vocabulary to the rectangle, the circle, the triangle, and the cross. The third dimension was ruled out—instead of cubes, rectangles; instead of cones, triangles; instead of spheres, circles. It was permissible to combine several of these forms in a single painting, but since the aim of suprematism was to create the ultimate work of art, the black square against white was the supreme suprematist composition. At least it seemed so for five years, until in 1918 Malevich conceived a white square on a white ground [545]. Beyond that not even he could go. The trouble with an ultimate is its finality, and it was Malevich's misfortune that in two paintings he had exhausted the possibilities of suprematism as a theory, and there was not much left to do with it except to defend it in dialectics.

But during these same years, the years between the black square and the white square, another painter was involved in more subtle considerations of the idea that had inspired suprematism. His name was Piet Mondrian (1872–1944), and his theory came to be called *neoplasticism.*

Mondrian had begun as a conventional painter working in a broad form of impressionism, turning out picturesque subjects—boats in canals and other stock picturesque items of his native Holland. But by 1906 he was beginning to conventionalize his landscapes into flat patterns, hunting out any hints of nature's geometry in fields, river banks, and the pattern of leafless branches of trees [546] or the man-made geometry of houses, barns, and sometimes city buildings. Cézanne also had used geometrization as a basis for translating the visual world into "cubes, cones, and spheres," but Mondrian, uninterested in solid geometry, reduced his subjects to planes and lines. Passing through stages of simplification (or, he would have said, purification), tree branches were reduced to abstract linear configurations like those in *Composition 1916* [547] while architectural

545 Kasimir Malevich. *Suprematist Composition: White on White.* 1918 (?). Oil on canvas, 31¼″ (79 cm) square. Museum of Modern Art, New York.

546 Piet Mondrian. *Trees II* (study). 1912. Drawing. Gemeentemuseum, The Hague.

forms became rectangular areas of color held within grids of black lines. In the postwar years Mondrian developed this type of composition into his typical patterns of black horizontal and vertical lines on a white ground with areas of pure color in paintings like *Composition with Yellow* [548].

547 Piet Mondrian. *Composition 1916.* 1916. Oil on canvas, with wood strip nailed to bottom edge; $46\frac{7}{8} \times 29\frac{5}{8}''$ (119 × 75 cm). Solomon R. Guggenheim Museum, New York.

548 Piet Mondrian. *Composition with Yellow.* 1936. Oil on canvas, $28\frac{3}{4} \times 26''$ (73 × 66 cm). Philadelphia Museum of Art (Louise and Walter Arensberg Collection).

Mondrian wrote extensively and his theories include ideas like these, when pared down to apply to paintings of the type just mentioned:

1. All painting is composed of line and color. Line and color are the essence of painting. Hence they must be freed from their bondage to the imitation of nature and allowed to exist for themselves.

2. Painting occupies a plane surface. The plane surface is integral with the physical and psychological being of the painting. Hence the plane surface must be respected, must be allowed to declare itself, must not be falsified by imitations of volume. Painting must be as flat as the surface it is painted on.

3. Painters striving for universality of expression have always simplified forms. The simpler the form, the more nearly it is universal. Hence the simplest form of all, the rectangle, must constitute the sole form if painting is to achieve universality.

4. The purer the color, the more appropriate it is to this universality. The only pure colors are the primary ones, which cannot be mixed from other colors but exist in themselves; red, yellow, and blue. Hence they alone may be used, each pure in itself.

Granting that Mondrian's theory is valid and that his sensitivity as an artist is adequate to apply the theory successfully, does he reach the perfection that should thus be possible? If so, the yellow filling two rectangles in *Composition with Yellow* could not be changed to red or blue, and could not be shifted elsewhere in the composition without making other changes to bring the arrangement back into balance. And so on. While tests of this kind push the idea to the limits of absurdity, the test is implicit in the theory. It can be applied with equal legitimacy to Seurat's *La Grande Jatte* [Plate 25, p. 337], which is composed from a similar point of view except that its elements are "impure" in shape and color, subservient as they are to images of the real world no matter how conventionalized these images are. By Mondrian's standards *La Grande Jatte,* for all its impeccable order and for all its departures from visual fact, is a compromise between painting and photography.

Mondrian's goal was the neoclassical one: perfection within imposed limitations. The danger he ran, even at best, was toward chilliness and sterility. The same goal and the same dan-

gers were involved in neoclassicism; they affected David. The difference is that the limitations on nineteenth-century neoclassical artists were merely damanding, while those on Mondrian were excruciating. Whether these limitations were so extreme that they precluded the possibility of Mondrian's ever being anything more than a phenomenon fascinating to students and specialists is a question that cannot be answered at such close range. But in the meanwhile Mondrian appears to have reached the nonobjective conclusion implied by the abstract elements (but *only* the abstract elements) of a classical tradition that includes Poussin, David, Cézanne, and cubism.

Abstraction and Sculpture

Among major twentieth-century sculptors whose direction was set before World War I, the most important is easily Constantin Brancusi (1876–1957). Like Picasso and Matisse, Brancusi was influenced by the powerful, simplified forms of primitive sculpture. Unlike those two painters, however, he developed these forms into a sleekly abstract style exemplified during the 1920s with his famous *Bird in Space.*

Bird in Space [549] is known everywhere, partly because one of the many versions of this elongated form became conspicuous as the center of a dispute between the United States Customs, who wanted to tax it as bric-a-brac, and its owner, who wanted it to enter the country duty-free as a work of art—more as a matter of principle than because of the tax involved. The contest, with its decision in favor of the owner, was an introduction to the theory of abstract art for many people who would never have picked up a book on aesthetics but who did read newspaper excerpts from the testimony of artists and aestheticians who defended Brancusi's beautifully tooled bronze object.

As a work of art, *Bird in Space* is at least a highly ornamental form, but this is true, also, of fine bric-a-brac. As sculpture, it is an invented shape of great purity and a certain expressive quality depending heavily upon our knowledge of the title. Many of Brancusi's works depend, for their full effect, upon the associations of a verbal clue (*White Negress, Chimera, The Prodigial Son, The Fish, Bird, Penguins,* to name a few). But his *Sculpture for the Blind* [550] is an exercise in pure sculptural form. By

549 Constantin Brancusi. *Bird in Space.* 1925. Polished bronze, height 4′1¾″ (1.26 m). Philadelphia Museum of Art (Louise and Walter Arensberg Collection).

its title alone this is a piece of sculpture to be handled, to be felt for its polished surface and the infinitely subtle variations of its generally egg-shaped volume. As a piece of sculpture for the sighted, *Sculpture for the Blind,* like most of Brancusi's work, would be seen ideally as it revolved slowly, so that its contours as defined by their edges and by the areas of shadow, light, and reflections, would reveal themselves in an uninterrupted flow. Even more ideally, it might

550 Constantin Brancusi. *Sculpture for the Blind.* 1924. Marble, height 6″ (15 cm). Philadelphia Museum of Art (Louise and Walter Arensberg Collection).

551 Constantin Brancusi. *The Kiss.* 1908. Limestone, height 23″ (58 cm). Philadelphia Museum of Art (Louise and Walter Arensberg Collection).

be seen miraculously suspended in space, turning now in one direction, now in another.

Whether working in wood, stone, or metal, Brancusi is a purist in his veneration for the primary sculptural principle of the symbiotic relationship between form and material. The broad, heavy forms of *The Kiss* [551]—done in 1908 and hence a close sculptural cousin to Matisse's *The Green Line* [Plate 32, p. 372] and Picasso's *Les Demoiselles d'Avignon* [510]—are appropriate to the grainy limestone in which it is carved, just as the polished surfaces of *Sculpture for the Blind* are appropriate to marble, and the gleaming elongations of *Bird in Space* to bronze. This love of the sculptor's materials for their own sake, the adaptation of form to the expression of the materials' inherent character, is a constant in Brancusi's work—or almost a constant. An exception is a marble version of *Bird in Space,* called *Yellow Bird,* where the veined and brittle stone was forced into a form of such character that the weight of the upper mass was too much for the narrow necklike lowest part. As a practical failing, the neck has cracked. The psychological failing is more important, leaving us as it does with an uncomfortable feeling of violation of the material.

Whatever else they are, Brancusi's forms are solid masses, self-contained volumes of matter. This remark may seem too obvious to be worth setting down. It would be, if it were not necessary as an introduction to the concept of form introduced in *constructivism,* a movement born at about the same time as neoplasticism. Constructivism was a Russian development led by Vladimir Tatlin (1885–1953), finding its major spokesmen in the brothers Naum Gabo (1890–1977) and Antoine Pevsner (1886–1962), who brought it into the international orbit via Paris and Germany.

A first principle of constructivism was that it denied solid volumes (like Brancusi's) as an expression of space. Gabo's *Linear Construction* [552, p. 456] had better be looked at for a moment before this idea is tackled by anyone not yet a little familiar with it. *Linear Construction* is built of transparent plastic. It is a piece of abstract sculpture, if you wish—more properly, however, a construction, just as it is called—which denies sculptural mass by its open design as well as by its transparent material. We have said that ideally Brancusi's *Sculpture for the Blind* would be seen in motion, so that its total mass could be examined in a flow of successive

552 Naum Gabo. *Linear Construction.* 1942–1943. Plastic with nylon string, height 24¼″ (62 cm). Phillips Collection, Washington, D.C.

aspects. But Gabo's *Linear Construction* has no mass* and is, in effect, visible from all points of view at once. True, the object takes on variations—and fascinating ones—from different angles, but essentially it is visible as a whole, in all its complications, from any angle.

A little thought on the theories of analytical cubism will show that constructivism overlaps it. Cubist simultaneity sought to represent many aspects of the object at one time. *Linear Construction* actually does so. The "object" is not an

object at all, in the sense of being a tangible form. It is a spatial design. One enters the spatial shapes, visually; if this is sculpture, it is a molding of pure space. "Volume" and "space" now take on new meanings. Volume is no longer mass surrounded by empty space; space is no longer emptiness; space and volume are identical.

Constructivism, with a birth date of about 1920, spawned innumerable mutants to become probably the dominant force in sculpture in the middle decades of our century—a century in which sculpture has come back into its own after its near-eclipse between Canova and Rodin.

* Unless one wants to be finicky about definitions. The transparent plastic has mass, strictly speaking, but psychologically it does not.

chapter 27

Fantasy and Dada

The Persistence of Fantasy

Fantasists—painters of a personal world of dream, the supernatural, and the materialization of the impossible—have always tended to be loners or eccentric figures in the history of art. The nineteenth century—the bourgeois century—was particularly incompatible to them, perhaps because the persistent impulse toward fantastic expression drained off into the most exotic aspects of romanticism. But by the end of the century, with painting dominated by the mundane aspects of impressionism, the impulse toward more poetic expression was too strong to be denied. Gauguin was a near-fantasist in his search for the bizarre and wonderful, but found it less in his own imagination than by proxy as an observer of the superstitions of the South Seas. After Blake, at the very beginning of the century, Douanier Rousseau at its very end offered the first deep explorations of a world that never was. Redon, too, made explorations, and Böcklin, in pictures like *The Isle of the Dead,* [324] tried to. But his pictures remained arrangements of costumed models posed in a stage set with stage props rather than figures of fantasy existing in another world.

In the early twentieth century Böcklin's hopes came to maturity in the work of an Italian who had been born in Greece, Giorgio de Chirico (1888–1978), who reached Italy by way of Munich where, as a student, he copied some of Böcklin's pictures while he was finding his way to what he wanted to do. After a period of Böcklinesque work, Chirico devised a dream world of his own as tangible as Böcklin's but free from Böcklin's fatal ponderousness. What Chirico wrote about the theory of his "metaphysical painting" is usually muzzy or contradictory. Why not? He was a poetic painter, not a writer or an amateur psychiatrist.

457

Chirico's pictures are complete without their titles, and in some cases are better off without them, but a list of some of the typical ones evokes his mood: *Melancholy and Mystery of a Street; Enigma of the Oracle; Nostalgia of the Infinite; Lassitude of the Infinite; Melancolia; Uncertainty of the Poet; Joys and Enigmas of a Strange Hour; Anguish of Departure; Joy of Return.*

Chirico's dream world is a world without nightmare yet with sinister undertones. His personal vocabulary—well illustrated by *The Soothsayer's Recompense* [553]—includes deserted city squares, solitary figures or statues, arcaded galleries, and occasionally a rushing train or a billowing smokestack, which in Chirico's static and enchanted world lose their association with the world of industry and engineer-ing and become fantasms, curiosities, silent and ominous. In some of his city squares there are inexplicable vans, great packing cases that, one feels, are filled with the paraphernalia of necromancy. In spite of deep clear skies and glimpses of distant landscape we are never led into infinite space but are held within architectural boundaries, within walled areas illuminated by flat, steady, golden light radiating across the picture from some low-lying source, casting long thin blots of shadows along pavements and against walls.

Chirico explains nothing, yet his inexplicable cityscapes are haunted with deep memories of the grace and logic of the classical world. If we hunt an explanation of this classical echo hanging so eerily in Chirico's sinister realm, it is easy to find it in the Renaissance-classical parentage

553 Giorgio de Chirico. *The Soothsayer's Recompense.* 1913. Oil on canvas, 4′5⅜″ × 5′11″ (1.36 × 1.8 m). Philadelphia Museum of Art (Louise and Walter Arensberg Collection).

of the simplified architecture (in its turn a re-flection of Chirico's own Italian cities and towns and his memories of Greece) and in the sculptures, which are not inventions but identifiable statues that played their parts in Chirico's personal experience. These may be classical, but they may also be nineteenth-century hack work of the most prosaic kind, transformed, like the trains and smokestacks, into images of magical suggestion. In the end, it is the sense of transformation that identifies Chirico's art.

In other types of pictures Chirico's reference to antiquity is quite direct and sometimes symbolical. *The Philosopher* [554] combines a familiar classical bust (that Chirico, like most academic students, probably had studied from cast in school) with symbols of thought and learning that merge with the body of the philosopher. The head is drawn with respectful observance of conventional draftsmanship but there is an infiltration of cubist devices in the books. Chirico was only lightly affected by abstraction. In a series of pictures of mannequins, for instance *The Poet and His Muse* [555, p. 460], he builds geometrical forms sometimes draped, as here, in classical togas. The geometry of such pictures is less cubist than it is a genuflection to classical mathematics, even when the togas and directly classical trappings are absent. The pictures are part Picasso and part Euclid but entirely Chirico in their final dependence on a personal romanticism. Even the symbols of engineering and mechanical drawing that fill them are personal and romantic. Chirico's father was a construction engineer for railroads who died while his son was still a boy; Chirico's trains, smokestacks, and engineering symbols spring from emotional, not theoretical or mechanistic, sources.*

Chirico's dream world has an air of suspension in time that makes his chronological development come as an afterthought, yet his art developed within quite concise boundaries of periods. He continued his Böcklinesque painting in Italy between 1909 and 1911; the haunted piazzas were done in Paris in 1913 and 1914 (against the current of cubism, which dominated the scene); his classical mannequins first appeared in 1915, in which year he returned to Italy. He was in military service in Ferrara in 1917 when he and the futurist painter Carlo Carrà propounded "metaphysical painting" as a school. Until that time Chirico's ideas had been stated in a general poetical way—when he set them down at all:

Profound statements must be drawn from the most secret recesses of the artist's being, where no murmuring torrent, no bird song, no rustle of leaves, can distract him. . . . I remember one vivid winter's day at Versailles. Silence and calm reigned supreme.

554 Giorgio de Chirico. *The Philosopher*. Date unknown. Oil on canvas, 39½ × 29½'' (100 × 75 cm). Philadelphia Museum of Art (bequest of Fiske and Marie Kimball).

* Chirico also devised a classical subject in which mammoth sculpturesque horses with heavy luxuriant manes and tails like flowing stone rear and whinny near fragments of classical architecture. With their decorative quality, especially since pictures of horses are always popular, these had a great vogue and were repeated too often, not only by Chirico himself but in adaptations on fabrics and such incidentals as lamp bases, ash trays, bookends, and the like. They still have illegitimate descendants in gift shops.

Everything gazed at me with mysterious, questioning eyes. And then I realized that every corner of the place, every column, every window, possessed a spirit, an impenetrable soul I grew aware of the mystery which urges men to create strange forms, and the creation appeared more extraordinary than the creators.

Written in 1913, these words are in the unspecific and romantic mood of his dream-architectural cityscapes, and are more metaphysical than his later expositions of "metaphysical" painting. Architecture in his early work, and architecture as he saw it "gazing at him with mysterious, questioning eyes" that day at Versailles, is part of a mysterious expression of the soul. But six years later he wrote more objectively:

Among the many senses that modern painters have lost, we must number the sense of architecture. The edifice accompanying the human figure, whether alone or in a group, whether in a scene from life or in an historical drama, was a great concern of the ancients. They applied themselves to it with loving and severe spirit, studying and perfecting the laws of perspective [laws which, significantly, Chirico had violated in his early pictures, thus increasing the sense of otherworldliness]. . . . A landscape enclosed in the arch of a portico or in the square of a rectangle acquires a greater metaphysical value, because it is solidified and isolated from the surrounding space. Architecture completes nature.

While all this is true as far as it goes, there is nothing new here, nothing that would be foreign to any elementary academic course in picture-making, except for the metaphysical tag, which is dubiously grafted on. Chirico's painting began to lose its magic as he began to theorize explicitly about it—perhaps because of the theorizing, more probably because some psychological change led him not only to theorizing but to a change in his way of painting. After a series of still lifes where objects seem to enact dramas of their own, more heavily painted and with coarse outlines, Chirico rejected the whole modern movement and reverted to a style that would have been at home in the Salon of 1855.

Chagall

The happiest fantasist of them all was Marc Chagall (1887–), a Russian who came to Paris in his early twenties and has called it home ever

555 Giorgio de Chirico. *The Poet and His Muse.* c. 1925. Oil on canvas, 35¾ × 29″ (91 × 74 cm). Philadelphia Museum of Art (Louise and Walter Arensberg Collection).

since. Even so, he has remained a Russian painter—a Russian of old Russia, not the Russia of collectives but the Russia he remembers as a man who was a boy there before the revolution. Memories of Russian villages, folklore, and fairy tales impregnate his work, although such phrases as "tragic awareness" and "social consciousness" are popular with some of his admirers who feel obliged to discover in his art something more than tenderness and joy, as if these were not enough.

Arriving in Paris just as cubism was emerging, Chagall soon joined the movement, but he was of too ebullient a nature to subject himself to its analytical disciplines. In *The Poet, or Half Past Three* [556] his play with cubism is particularly apparent, as well as a dash of fauvism in the patterning of flowers scattered in the upper right. But the picture's character is determined by its cheerful color, by the humorous symbol-

556 Marc Chagall *The Poet, or Half Past Three.* 1911. Oil on canvas, 6'5½" × 4'9½" (1.97 × 1.46 m). Philadelphia Museum of Art (Louise and Walter Arensberg Collection).

ism of the poet's head put on upside down—poets are visionary and impractical fellows—and the happy green cat with a rosy belly who begs for attention at the poet's elbow.

The Poet, painted in 1911, is one of the pictures that establish Chagall among those painters who, that early, were transforming cubism by rejecting the drab color of its analytical phase and, in Chagall's case especially, rejecting

also its intellectualized abstraction for a return to personal, intimate, poetic, or emotional statement. Chagall soon discovered that the conflict between the theoretical nature of cubism and the bubbling personalism of painters like himself was an unnecessary one. He solved the conflict sensibly by attempting no reconciliation but abandoning the field and going his own way in his own world.

557 Marc Chagall. *I and the Village.* 1911. Oil on canvas, 6'3⅝" × 4'11⅝" (1.92 × 1.51 m). Museum of Modern Art, New York (Mrs. Simon Guggenheim Fund).

And it is always a happy world. In *I and the Village* [557], painted the same year, 1911, there is no suggestion of the pressures that were soon to explode in the revolution; rather, old Russia is shown as a pastoral paradise (blended, however, with Parisian chic) where a cow dreams happily of a milkmaid, and lovers (one right side up, one upside down) set out happily to labor in the fields. Cubist and fauvist elements in this presentation of what is essentially a fairy tale are juggled at will.

Abstraction of any kind soon ceased to play anything but a purely decorative part for Chagall. A consummate example of his mature style is *Bouquet with Flying Lovers* [558] with its airborne couple, its bouquet of flowers that seem made of some kind of glowing powder, its rooster (a member of Chagall's stock company), and his amiable cow in an almost invisible sketch at upper left—a kind of Janus with a cow's face and a human face paired and a body in the form of a cello, which it is playing.

If ever there was a painter who can be taken at face value without analysis of inner meanings, it is Chagall. It is true that he has done religious and literary pictures where "tragic awareness" is present at least by implication in the subject. These appeared especially in the 1940s, when racial persecutions and the death of his wife were sobering and saddening. But in the mass his art is deeply joyous, or lightly playful, above all warm and tender in spirit. The only melancholy aspect of his work is its increasingly nostalgic tone as the world changes. The nostalgia for his Russian village was conscious; the nostalgia for a vanished bohemian life in Paris now attaches itself to pictures like *Bouquet with Flying Lovers,* where the studio window, the bridge (probably the Pont Neuf), the little boat on the river with two more lovers evoke a life that has vanished even in Paris under the wheels of automobiles, the shadows of skyscrapers, and a synthetic commercialized bohemia where once the most vital ideas of what art was and what it might become were conceived and then disseminated around the rest of the world.

Klee

The temptation in talking about Paul Klee (1879–1940) is to say that he must be discussed either in a sentence or two or in a long book, and settle for the sentences. No other painter of consequence seems so trivial from picture to picture; no other painter has quite Klee's characteristic of depending on his total work for his meaning. The hundredth Klee one sees enriches the first ninety-nine; the hundred and first adds to the lot. If this is also true of, for instance, Picasso, still a single picture of his blue period, or any other period, may stand alone as an independent work of art worthwhile in itself. But a single picture by Klee is like a sentence from a long essay or even a phrase from it; it means something in itself but not much; it needs its place in context. If we already know the essay, a phrase from it takes on meaning from behind and beyond.

Klee was one of those painters who developed along the lines of historical summary. He began as a representational draftsman, passed through the influences of Cézanne, van Gogh, and Ensor, and then met the men with whom he would be a member of The Blue Rider group of German expressionists. (Klee had a German father and a Swiss mother; his father was a musician, as were Klee and his wife.) He exhibited with The Blue Rider in their second show, in 1911. The following year he met Picasso and Delaunay, among other cubists, just as analytical cubism was terminating its course. He was never a member of a surrealist group, but fantasy had always been strong in his painting; his earliest very personal works are grotesqueries with the tone of irony and the interest in abnormal states of mind that would always remain with him. But it is not the variety of these early periods that makes it necessary to know Klee through so many pictures if one is to know him at all. His early work may even be

558 Marc Chagall. *Bouquet with Flying Lovers.* c. 1934–1947. Oil on canvas, 4'3⅜'' × 3'2⅜'' (1.3 × .97 m). Tate Gallery, London.

ignored; Klee is the Klee of the fantasies where cubism, free form, and inventive play are combined in what Francis Henry Taylor called a "fourth dimensional innocence"—an innocence arrived at through sophistication. This is quite different from the yearning for innocence we saw so far back in this book when another German, Runge, painted his *Naked Infant in a Meadow* [34]. Klee's "innocence" has nothing to do with inexperience and the vision of a fresh world. It is an entering into the state of mind of a child through intellectualizing experience, just as his participation in abnormal states of mind is arrived at by rational examination of these states. The philosophical amplifications of this idea, and speculations as to its worth or its viciousness as a channel for expression, have supplied material for enough books on Klee to suggest that his art is the summation of both the intellectual and the emotional redirections of painting most peculiar to the twentieth century—pure theoretical abstraction on one hand and free invention from inner experience on the other. Many critics believe that Klee is precisely this summation. In view of all this, three pictures which seem to have been executed by a talented and careful child may seem anticlimactic [559–561]. Paul Klee is an artist's artist, a philosopher's philosopher, and the master fantasist of them all.

559 Paul Klee. *Jörg.* 1924. Watercolor, 9¼ × 11¼'' (23 × 29 cm). Philadelphia Museum of Art (Louise and Walter Arensberg Collection).

560 Paul Klee. *But the Red Roof.* c. 1930. Tempera, 23⅝ × 35¾" (60 × 91 cm). Philadelphia Museum of Art (Louise and Walter Arensberg Collection).

561 Paul Klee. *Diana.* 1931. Oil on panel, 37½ × 23⅝" (95 × 60 cm). Private collection.

Dada

During World War I, beginning in 1915 and enduring until 1922, an international anti-art art movement called dada flourished in spite of its primary declaration that art was dead—that "art is stupid," that "everything one sees is false," and that art must be destroyed and abandoned. Nonsense alone made sense. Dada was a cult of the irreverent, the absurd, and the totally meaningless.

Inspired by the insanity of war, dada's premise was that if the world had been unable to think its way to rational behavior in three millennia, it was pointless for artists to pretend to find order and meaning in its chaos. Dada rejected every moral, social, and aesthetic code. (The name *dada* was supposedly found by opening a dictionary at random, but it is fortuitously apt enough to make one wonder.) The aesthetic of dada was that there is no aesthetic, since an aesthetic is built on reason and the world had demonstrated that it was without reason. Before the movement settled in Paris it had centers in Berlin, Cologne, and Zurich, with a brief and artificially sustained one in New York. But everywhere the dadaists soon discovered that their movement was self-defeating by its very intention; it is simply impossible to be nothing at all. They came closest to achieving their goal of negation in a literary way, when poems were composed by picking words out of a hat and combining them at random. Dada

exhibitions included work by men we have already seen: Grosz (who formed the Berlin group), Kandinsky, Kokoschka, Modigliani, Chirico, and Picasso, none of whom fit well into the dada definition, Picabia, who does, and Duchamp, who does and who doesn't.

The Cologne group was led by the German Max Ernst (1891–1976) and the Alsatian Jean Hans Arp (1888–1966), who had been prominent in the movement's initiation in Zurich. Their "fatagaga" pictures (the word was coined from the descriptive phrase *"fabrication de tableaux garantis gazométriques"*) were nonsense concoctions in which cut-out pictures were combined in startling and irrational juxtapositions enhanced by varying amounts of additional drawing or painting and given provocative titles: *Here Everything Is Floating,* for instance. Such things as botanical charts, anatomical engravings, and illustrations for technical books would be retouched fantastically and called *The gramineous bicycle garnished with bells the pilfered greybeards and the echinoderms bending the spine to look for caresses,* or *Sitting Buddha, ask for your doctor,* or *Trophy,*

562 Max Ernst. *Two Children Are Threatened by a Nightingale.* 1924. Oil on wood with wood construction, 27½ × 22½ × 4½'' (70 × 57 × 11 cm). Museum of Modern Art, New York (purchase).

563 Marcel Duchamp. *Why Not Sneeze, Rose Sélavy?.* Marble blocks, thermometer, wood, and cuttlebone in small bird cage; height 4½'' (11 cm). Philadelphia Museum of Art (Louise and Walter Arensberg Collection).

466 *Fantasy and Dada*

hypertrophied. But even here dada was self-defeating since, although the images were supposedly nonsensical, psychoanalysis was demonstrating at this time that fantasy was the expression of an inner consciousness. Hence the concoction could be held to have meaning in spite of the concocter; the fact that he had chosen these particular bits and pieces to combine in this particular way told something about his subconscious mind just as his dreams must do. This is virtually the basis of surrealism, the movement that followed in the 1920s, and it is here that dada parented surrealism and merged with it. Max Ernst's *Two Children Are Threatened by*

564 Marcel Duchamp. *The Bride Stripped Bare by Her Bachelors, Even.* 1915–1923. Oil and wire on glass, height 9′1¼″ (2.77 m). Philadelphia Museum of Art (Louise and Walter Arensberg Collection).

a Nightingale [562], done in 1924, is a classic example. With its real wooden gate and its absurd title and general irrationality the picture is tied to dada, but it begins to take on a threateningly rational quality when it is seen as a vision or dream.

Within the nutshell of dada the chaos became even greater than the chaos of the world. Members and groups disinherited one another so rapidly and with so many crisscrosses between cliques that no one was certain who was dada and who was not. When several dadaists proclaimed themselves Communists, the Communists disclaimed them in horror. Police closed dada exhibitions because the movement was antisocial as well as antiaesthetic. Members laughed at one another and at themselves. Marcel Duchamp exhibited a urinal in New York with the title *Fountain.* The international collaboration of the American Morton Schamberg and the German Elsa von Freytag Loringhoven bore fruit in the form of a miter box combined with a plumbing trap and called *God.* Duchamp produced a quantity of "ready-mades," which were mass-produced objects sometimes exhibited singly and sometimes nonsensically combined. One of the most complicated is *Why Not Sneeze, Rose Sélavy?* [563], a small birdcage filled with marble blocks in the shape of lump sugar, a thermometer, and some wood and cuttlebone, with the lettering of the title underneath it. "Rose Sélavy" was a name invented as a play on the phrase *"Rose c'est la vie."* The list could go on for a long time. Duchamp's most impertinent concoction was a colorprint of the *Mona Lisa* to which he had added a mustache.

It should also be pointed out that Duchamp's nonsense items were the logical end result of a progression that began with the deliberately provocative title of *Nude Descending a Staircase* [525], a title with prophetic overtones of dada and surrealism. Duchamp's earlier work had been realistic, Cézannesque, and semi-expressionistic in turn. The ready-mades were his last works, although he incorporated repetitions of some previous designs in a large glass window called *The Bride Stripped Bare by Her Bachelors, Even* [564] as late as 1923. During shipment the two panes of the window were cracked in a pattern that has added an interesting fillip not at all out of keeping with dada aesthetic.

Among other dadaists, Kurt Schwitters (1887–1948) was working with *merzbild* (trash pic-

tures, or rubbish or litter pictures), in which he combined odds and ends such as corks, wire, odd buttons, nails, waste paper, wood fragments—anything [565]. But he was disinherited as "reactionary." After all, the cubists had done this kind of thing with collage, and Schwitters' combinations of trash elements were not random and senseless. Like collage they were designed with a nice eye to balance.

Dada was at least as much a literary movement as an art movement. During its heyday its liveliest center was the *Cabaret Voltaire* (an ironic choice of namesake, since Voltaire was the great man of the Age of Reason) in Zurich. This combination literary club, exhibition gallery, and theater was the scene of dada's most flagrant shenanigans. One suspects that after the first flare it must have become a tiresome place. Nothing palls so quickly as excessive novelty; dada was like a costume party (come as a jackanapes) which was fun for the first half-hour while the guests were arriving, but an awful bore after the first few laughs. Dada died because it insisted upon maintaining its original stance of negation, in which there is never much sustenance.

Dada makes an excellent closing point for this book, in which artists in one group after another have invented ways to "clarify, intensify, or enlarge" the chaotic material of life. By attempting to reject everything, dada proved only that art is inviolable. Max Ernst once said to the author of this book "Marcel was fooling—but people took him seriously." Duchamp himself seemed surprised at the extent of his following in the 1960s, when he became a demigod for artists in movements as different as pop art and early conceptual art. Like all art movements of any historical consequence, dada was both an end and a beginning.

565 Kurt Schwitters. *Merz Konstruktion.* 1921. Painted wood, wire and paper; $14\frac{1}{2} \times 8\frac{1}{2}''$ (37 × 22 cm). Philadelphia Museum of Art (A. E. Gallatin Collection).

Index

Page numbers in **boldface** type indicate the page on which a work of art is reproduced.